KURT SCHWITTERS

DATE DUE

			PRINTED IN U.S.A.

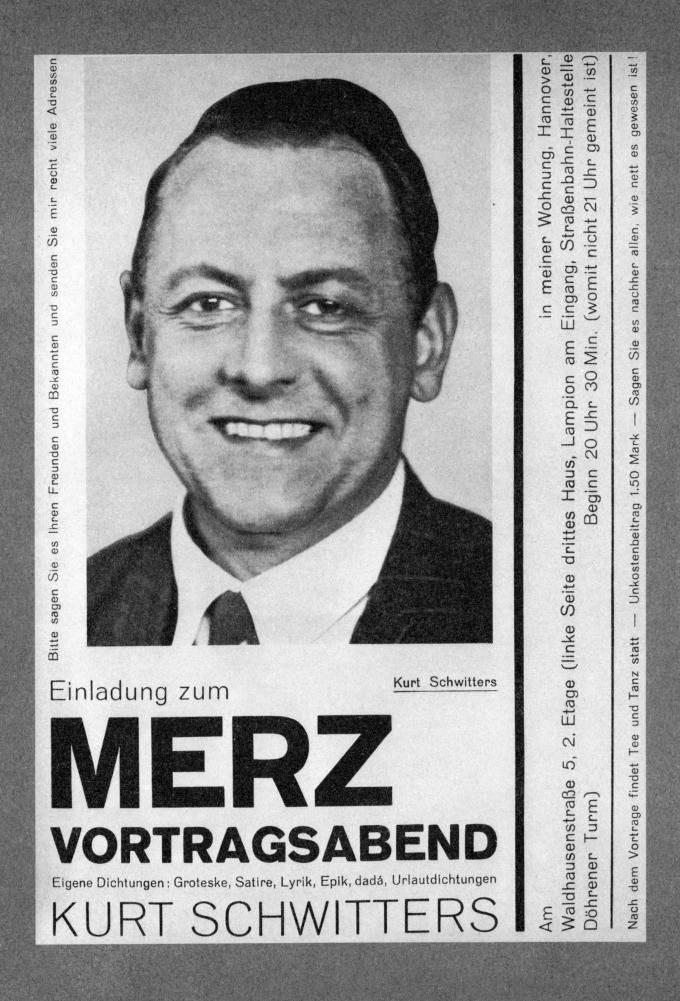

Kurt Schwitters

Einladung zum

MERZ
VORTRAGSABEND

Eigene Dichtungen: Groteske, Satire, Lyrik, Epik, dadá, Urlautdichtungen

KURT SCHWITTERS

Bitte sagen Sie es Ihren Freunden und Bekannten und senden Sie mir recht viele Adressen

in meiner Wohnung, Hannover, Waldhausenstraße 5, 2. Etage (linke Seite drittes Haus, Lampion am Eingang, Straßenbahn-Haltestelle Döhrener Turm) Beginn 20 Uhr 30 Min. (womit nicht 21 Uhr gemeint ist)

Am Nach dem Vortrage findet Tee und Tanz statt — Unkostenbeitrag 1.50 Mark — Sagen Sie es nachher allen, wie nett es gewesen ist!

JOHN ELDERFIELD
KURT SCHWITTERS

WITH 356 ILLUSTRATIONS, 32 IN COLOR

THAMES AND HUDSON

Frontispiece: Announcement for a Merz evening at Schwitters' house in Hannover, mid 1920s

First published in the USA in 1985 by Thames and Hudson Inc., 500 Fifth Avenue, New York, New York 10110

First paperback edition 1987

Library of Congress Catalog Card Number 85–50284

Filmset in Great Britain by Foremost Typesetting, London
Printed and bound in Spain by Artes Graficas Toledo S.P.A.
D.L. TO–1397–1987

CONTENTS

Preface 7

1 Prologue: Schwitters before Merz 12

PART 1 THE INVENTION OF MERZ, 1918–1921

2 The Kaspar David Friedrich of the Dadaist Revolution 30
3 *Merzbilder*: The Art of Assemblage 49
4 Collage: Medium and Meaning 71
5 Poetry, Performance, and the Total Work of Art 94

PART 2 THE DEVELOPMENT OF MERZ, 1922–1948

6 Merz in the Machine Age 120
7 Phantasmagoria and Dream Grotto 144
8 The City and the Country 172
9 Schwitters in Exile 197

10 Postscript: Merz and Modernism 224

Color and monochrome plates 241

Notes to the Text 386
Selected Bibliography 406
List of Illustrations 412
Index 419

FOR A NOBLE LADY

□ This book is published on the occasion of an exhibition of Kurt Schwitters' work—the most comprehensive such exhibition yet assembled—at The Museum of Modern Art, New York, in 1985, subsequently shown at the Tate Gallery, London, and the Sprengel Museum, Hannover. Its genesis, however, goes back some twenty years, to a visit I made to the English Lake District, where I saw Schwitters' last *Merzbau* shortly before it was dismantled. I had previously seen a few of his collages and assemblages, made when he lived in Germany, and was puzzled by what seemed to me then the irreconcilable difference between the organic forms of the last *Merzbau,* in its rural setting, and the crisp, Cubist-derived structures of the earlier collages, with their urban materials. Even the most rudimentary research soon showed that this was but one of many apparently contradictory aspects of Schwitters' work, which encompassed an extraordinarily wide range of activities, and that it was extremely difficult to grasp the totality of his achievement without either distorting or oversimplifying it. Since that time, I have attempted to make myself familiar with as much of Schwitters' work as possible and with his artistic and broadly cultural context, and have learned that no single volume can hope to cover in detail all that he produced. This book, despite its length, is not exhaustive; but it does aim at providing a clear picture of Schwitters' art as a unified whole and of the ambitions and influences that informed it.

Any attempt to grasp the totality of Schwitters' art is necessarily affected by the knowledge of his life, for he was, it seems, as complex a person as his work, and intrinsically so fascinating a subject that his art is often treated merely as an adjunct to his personality. I do provide basic biographical information, and do refer to the complexities of his personality in the hope of elucidating problematic aspects of his art, but this book is by no means about Schwitters' life. It is an historical and critical study of his work. It is historical in seeking to establish, more fully than hitherto, a firmly chronological narrative account of his artistic development, and one which integrates, insofar as is commensurate with the demands of clarity and logic, the different areas within which he worked. It is critical in that it weighs the relative importance of different areas, and of the works produced within them, and in that it seeks not only to document Schwitters' production but, more importantly, to present a single large view of it.

After the Prologue, which considers the development of Schwitters' early work, Part 1 of the book treats the crucial years, 1918 through 1921, when the forms and procedures of his mature art were established. Here, I treat in separate chapters: Schwitters' place in the contemporary avant-garde, especially the relation of his one-man movement, Merz, to Expressionism and Dada; the development of his early assemblages, or *Merzbilder*; of his early collages, or *Merzzeichnungen*; and of his early poetry and performances,

leading to his attempts to establish, through theater, a *Gesamtkunstwerk,* or total work of art. Part 2 treats the development of his art after these pioneering years: first, his relationship to the International Constructivism of the 1920s; second, the building of the *Merzbau* in his Hannover home, and the meaning of this fascinating work which preoccupied him from 1923 until he was forced to leave Germany in 1937; third, the development of his work in other media from 1922 until 1937; and finally, his work in all media made in exile in Norway and then in England, where he died in 1948. A postscript attempts to place Schwitters' art in the general context of modernism, and suggests some ways in which our interpretations of modernism might be reconsidered in the light of what we have learned about one of its most enigmatic creators.

Inevitably, the view of Schwitters presented here will not necessarily be the view of all observers of his work. I have paid more attention to his imaginative writings than is customary in studies of the visual arts, but make no claim of having comprehensively covered this aspect of his work. I have passed quickly over certain aspects of his visual art, finding them of lesser interest, and have devoted a great deal of space to some works, for example the Hannover *Merzbau,* which others might find less central to his achievement than I do. More importance, certainly, has been given to the late work than in any previous study of the artist. And I have made a point of finding room to discuss questions of meaning and interpretation—not only specific questions of iconography and artistic theory but also general, discursive questions about the content of Schwitters' art and, to some extent, of that of his contemporaries—even though this necessarily displaced more detailed treatment of other issues which some readers might well feel are of more pressing concern. Any historical work is selective in the facts it uses to form its narrative; any critical work is opinionated as well as selective. Some readers will find me perhaps too permissive in the range of art and ideas I deem worthy of serious discussion, but I do believe that a more severe editing of Schwitters' work would do a disservice to the understanding of its totality. Others will feel that I have edited too much, to which I can only reply that if I have done so it was in an attempt to discover the essential, important Schwitters (insofar as I understand him) among the thousands of works which constitute his artistic *oeuvre.*

When my interest in Schwitters first began, there was very little published on him at all: outside contemporary sources, only books of remembrances by Stefan Themerson (1958) and Käte Steinitz (1963), the short history of the unpublished Schwitters-Hausmann pamphlet, *Pin* (1962), and a few interesting articles and exhibition catalogs, notably Werner Schmalenbach's catalog for the first important posthumous retrospective exhibition, at the Kestner-Gesellschaft, Hannover (1956), and the catalogs of exhibitions at the Pasadena Art Museum (1962) and Marlborough Fine Art, London (1963). I then, and later, benefited from discussions and correspondence with a number of Schwitters' former friends: Raoul Hausmann, E.L.T. Mesens, Harry Pierce and Käte Steinitz (all now deceased); also Harry Bickerstaff, Stefan Themerson, Fred Uhlman, and, notably, Edith Thomas, Schwitters' companion in his last years. For twenty years, Edith Thomas has been an untiring source not only of information and assistance but also of friendship. Likewise, but from a later date, has Gilbert Lloyd. From the earliest period of my interest in Schwitters, Marlborough Fine Art, London, has been unsparing

in its help, and Gilbert Lloyd personally has done much to help make this book and exhibition possible.

My work on Schwitters has benefited inestimably from the pioneering researches and publications of Werner Schmalenbach, director of the Kunstsammlung Nordrhein-Westfalen in Düsseldorf. When, encouraged by the late Arnold Noach, for whom I had written on Schwitters as an undergraduate at the University of Leeds, I began to work again on the artist in the late 1960s, I had the benefit of Dr. Schmalenbach's standard 1967 monograph; all those who study Schwitters are indebted to this volume. I also had the benefit of the advice of my friend John Golding, for whom I began preparing a doctoral dissertation on Schwitters at the Courtauld Institute of Art of the University of London. Dr. Golding read my own first studies of the artist, published around 1970, and urged me to try to write a narrative account of Schwitters' work as a whole: one that did not separate his different activities but that stressed their interrelationship and their common basis in the principles of collage. Before this dissertation was completed, two major contributions to the Schwitters literature had appeared: Friedhelm Lach's first volumes of his monumental collection of Schwitters' writings (1973–81) and Ernst Nündel's edition of the letters (1975). Additionally, Lach's small monograph (1971), a special issue of *Text + Kritik* (1972), and the catalogs of the Städtische Kunsthalle, Düsseldorf (1971) and Marlborough Fine Art, London (1972) exhibitions, made valuable additions to our understanding of the artist.

My 1975 dissertation on Schwitters, and the articles I published based on its research (1969–77), established the general scope of this book, and some sections of it follow quite closely the arguments and evidence established then. However, this is an entirely new publication, which has been rewritten in the light both of my own and others' subsequent research and of my changed ideas about many details of Schwitters' work. Since 1975, the following exhibition catalogs have published previously unfamiliar works: Galerie Gmurzynska, Cologne (1978); Galerie Gmurzynska, FIAC Grand Palais, Paris (1980); Marlborough Fine Art, London (1981); Fundación Juan March, Madrid (1982); Seibu Museum of Art, Tokyo (1983). Most of this book was established, in outline, by the end of the 1970s; I did not have occasion to alter it after the publication of small monographs by Heinz Hirscher and Krisztina Passuth in 1978 and by Nündel in 1981, and did not choose to modify my discussion of Schwitters' writings after the appearance of detailed studies by Bernd Scheffer (1978) and Helmut Heissenbüttel (1983). I did, however, read with great interest, if not necessarily with agreement, Annegreth Nill's 1981 articles on iconography and learned new information on the Hannover *Merzbau* from Dietmar Elger's article in the first issue of the *Kurt Schwitters Almanach* (1982). After final and very extensive revision of this book in 1984, during preparation for The Museum of Modern Art exhibition, Elger's book on the *Merzbau* appeared (1984); I have been able to refer to it only in the notes to the text.

My main indebtedness, however, over the past few years' work on Schwitters, climaxing in the revision of this book and preparation of the exhibition, is not to other publications, but to a group of individuals, without whom these projects simply could not have been realized. To three people in particular, I owe my deepest thanks. First, David Britt of Thames and Hudson, with whom I first discussed the idea of a book on Schwitters

some ten years ago. He has been a constant, and extremely patient, source of encouragement and advice: he edited an earlier version of this text, suggesting major changes in the organization of the material, and edited the text as it now stands; this book is much the better for his work. Second, my grateful thanks go to Ernst Schwitters, the artist's son who eagerly responded to the challenge of a major retrospective exhibition of Schwitters' work, who opened his archives to me, and who gave me the benefits of long conversations about his father, and who helped in numerous ways to make the exhibition possible. Third, Beatrice Kernan, Assistant Curator in The Department of Drawings of The Museum of Modern Art, worked as my assistant on both book and exhibition: she has dealt with a myriad of problems ranging from questions of art-historical research to administration of loans with absolute professionalism, often under the pressure of alarming deadlines; I have learned as well as benefited a great deal from her efforts and it has been a great pleasure, and relief, to be able to rely on her own commitment to this project.

I also owe a great debt of thanks to many others. First and foremost to the lenders to the exhibition, who most generously agreed to part with important and often fragile works for a lengthy period. As this book goes to press, confirmed lenders to the exhibition are: Lily Auchincloss, Erica Brausen, Irène Liatowitsch-Diener, Mrs. Gianluigi Gabetti, Mrs. Antonina Gmurzynska, Krystyna Gmurzynska, Mr. and Mrs. Murray A. Gribin, E.W. Kornfeld, Mr. and Mrs. Dirk Lohan, Peter Ludwig, Donald B. Marron, David Neuman, Mr. and Mrs. Morton Neumann, Muriel Kallis Newman, The Trustees of Procultart, Inc., Mr. and Mrs. Michael Ringier, Judith Rothschild, Dr. Werner Schmalenbach, Mrs. Edith Thomas, Branco Weiss, Philippe-Guy Woog, and a number of lenders who wish to remain anonymous. Also, the following museums and galleries: Nationalgalerie, Berlin; The Albright-Knox Art Gallery, Buffalo; Museum Ludwig, Cologne; Kunstsammlung Nordrhein-Westfalen, Düsseldorf; Musée d'Art et d'Histoire, Geneva; Sprengel Museum, Hannover; The Tate Gallery, London; The Los Angeles County Museum of Art; Wilhelm-Hack-Museum, Ludwigshafen; Insel Hombroich, Neuss; Yale University Art Gallery, New Haven; The Museum of Modern Art, New York; The Solomon R. Guggenheim Museum, New York; Philadelphia Museum of Art; Moderna Museet, Stockholm; Staatsgalerie, Stuttgart; The Phillips Collection, Washington, D.C.; Galerie Kornfeld, Bern; Galerie Gmurzynska, Cologne; Lords Gallery, London; Marlborough Fine Art Ltd., London; Galerie Stangl, Munich; Carus Gallery, New York; Sidney Janis Gallery, New York; Prakapas Gallery, New York.

For their help in tracing or securing loans for the exhibition, I am especially grateful to Gilbert Lloyd and to Krystyna Gmurzynska; also to Ernst Beyeler, Dominique Bozo, Anne d'Harnoncourt, Christian Geelhaar, Philip Granville, Annely and David Juda, E.W. Kornfeld, Ernst Nolte, Helen Serger, John Stoller, Harold Szeemann, Alain Tarica and Maurice Tuchman. Among those who went to much trouble to assist the research and documentation of this project are Dawn Ades, Wilhelm Arntz, Vivian Barnett, Hans Bolliger, Arthur Cohen, Mary Giffard, Hans Kleinschmidt, Rudolf Kuenzli, Arthur Minters, Angelica Rudenstine, Yris Solomon and Nicholas Wadley.

Additionally, thanks go to Alan Bowness of the Tate Gallery, London, and Joachim Büchner of the Sprengel Museum, Hannover, directors of the two museums where the

exhibition is seen after its New York showing. The Museum of Modern Art is grateful for their cordial cooperation. These showings of the exhibition were organized under the auspices of the International Council of The Museum of Modern Art.

Within The Museum of Modern Art, I am indebted to Waldo Rasmussen and Elizabeth Streibert, Director and Assistant Director of the International Program; Richard Palmer, Coordinator of Exhibitions; Antoinette King, Director of Conservation; Eloise Ricciardelli, Registrar; and the staff members of these and other Museum departments who worked on the exhibition. Within my own department, Ms. Kernan and myself were aided by the tireless efforts of Mary Jickling, who accomplished an extraordinary amount of secretarial and administrative work under the pressure of imminent deadlines. Special thanks are also due to Kathleen Curry for her important contribution, as well as to Pamela Lewis, Alice Trier, Rebecca Saunders, and Ronald Slye. Others within The Museum of Modern Art who have helped in various ways to realize this book and exhibition are: Ann Craddock, Patricia Houlihan, Nancy Kranz, John Limpert, Jr., Frederic C. McCabe, Jr., and Richard Tooke. The Museum itself is extremely grateful for a generous grant from the National Endowment for the Arts toward the costs of the exhibition.

It remains only to add a few explanatory notes. The numbers in the margins of the text refer to the illustrations on page 241–384, color plates being numbered in roman numerals. In that illustration section works are referred to in abbreviated form, full credit lines being provided in the List of Illustrations, pages 412–418. Superior numbers in the text refer to the Notes on pages 386–405, which are likewise given in abbreviated form, full details of publications cited in the text being provided in the Selected Bibliography, pages 406–411. All works specifically discussed are illustrated; for those referred to in passing but not illustrated, details of sources for reproductions are provided in the Notes.

1 PROLOGUE: SCHWITTERS BEFORE MERZ

☐ In the winter of 1918–19 Germany plunged into revolution; the Great War was ended and the Weimar Republic proclaimed. When the revolution reached the solidly bourgeois city of Hannover, Kurt Hermann Eduard Karl Julius Schwitters was working as a mechanical draftsman in the Wülfel ironworks outside the city, while painting and writing poetry in his spare time. He was thirty-one, and beginning to make a small reputation for himself: that June, some of his paintings had been exhibited at the renowned Sturm gallery in Berlin. The only child of a comfortably well-off shopkeeper and property owner, Schwitters still lived in his parents' home at Waldhausenstrasse 5 in Hannover although he had been married for three years and a son had just been born. But then, like his parents, Schwitters was always thrifty. He also had a good sense of self-preservation. When called to the colors in 1917, he had managed to get himself declared unfit for active duty, and was conscripted for work as a draftsman instead: he had, by all accounts, feigned stupidity, then bribed the army doctor just to be sure. "I preserved myself," he said later, "for the fatherland and for the history of art by bravery behind the lines."[1]

Hannover was one of the first German cities to feel the effects of the revolution. There was little disturbance; it was too orderly a city for that.[2] But even for the apolitical Schwitters, the tone of the moment was a utopian and an ecstatic one. "I felt myself free," he wrote of his feelings at the time, "and had to shout out my jubilation to the world."[3] He quit his job to devote himself full time to being an artist, saying that the revolution had brought with it a sudden sense of release from the tensions and frustrations of the war, and the chance for a new start.[4] Artists and intellectuals all over Germany were voicing similar sentiments: an old order had irrevocably been destroyed. For Schwitters, the new order was literally to be made from the remnants of the old. "Everything had broken down . . . new things had to be made from fragments."[5] That winter of 1918–19 he started to make collages and assemblages from all kinds of refuse and found materials: "new art forms out of the remains of a former culture."[6] In July 1919, when some of these works were exhibited at the Sturm gallery, Schwitters chose the word "Merz" to describe them. He was conscious that they were his most important and original works to date and wanted to separate them from anything that had ever been done before:

I called my new manner of working from the principle of using any material MERZ. That is the second syllable of Kommerz [commerce]. It originated from the Merzbild [Merzpicture], a picture in which the word MERZ, cut-out and glued-on from an advertisement for the KOMMERZ- UND PRIVATBANK [Commercial and Private Bank], could be read in between abstract forms. The word MERZ had become a part

42

of the picture by being attuned with the other parts, so it had to stay there. You will understand that I called a picture with the word MERZ the MERZbild in the same way that I called a picture with "und" [and] the und-bild and a picture with the word "Arbeiter" [worker] the Arbeiterbild. When I first exhibited these pasted and nailed pictures at the Sturm [gallery] in Berlin, I searched for a generic term for this new kind of picture, because I could not define them with older concepts like Expressionism, Cubism, Futurism or whatever. So I named all my pictures as a species MERZbilder after the most characteristic one. Later I expanded the title Merz, first to include my poetry, which I had written since 1917, and finally to all my relevant activities. Now I call myself MERZ.[7]

52
46

The principle of assemblage that the word Merz signified was the crucial innovation of Schwitters' life, and established the framework for all his subsequent mature work. And yet, this principle itself was hardly original: collage had been invented by Picasso and Braque in 1912, and was in common use well before Schwitters first adopted it. If Merz was, in Schwitters' terms, a new art made from the remains of an old order, it was so not only in the sense of using old materials. It came out of his earlier development as a painter of portraits and landscapes, and from his ever-increasing awareness of advanced idioms which gradually modified, and then suddenly exploded, the conventionality of his earlier work. Schwitters' breakthrough, however sudden it may appear at first sight, had been slowly prepared for.

Of course, all that great ferment of artistic and literary activity that accompanied the German revolution—from the utopian architectural projects of the Arbeitsrat für Kunst to the boom in the Expressionist theater and film and the activism of the Berlin Dadaists—had also been long prepared, and was in effect but the climactic fulfillment of well-established vocabularies and ideas. For Schwitters, however, the vocabularies and ideas of avant-garde art were relatively new. The creation of Merz was the completion of his artistic education.

□ When Merz was so named in 1919, Schwitters had been painting seriously for ten years, largely in different naturalistic styles. Since Merz itself was neither naturalistic nor painted but abstract and assembled, it comes as a surprise to find how much importance Schwitters attached to his naturalistic painting.[8] He never in fact entirely abandoned it, but continued to produce landscapes and portraits right up to his death in 1948. While emphasizing the generic novelty of Merz, he nevertheless also claimed that its invention was no total break with the past, nor any iconoclastic gesture against earlier painting, including his own, but that it was the end result of earlier "forming."[9] The importance to Schwitters of his naturalistic painting was that through it, he said, he learned how all art was based upon measurement and adjustment.[10] From this point onwards, he developed his own painting until it was all adjustment: the manipulation of a variable but finite number of pictorial elements. According to Schwitters, this conception forms a bridge between the earlier work, where the manipulation was a means to an end (initially, accuracy of representation), and the later, purely formal, manipulation of found materials in the *Merzbilder*.

In an article written in 1920, when this bridge had been crossed, Schwitters described how his art had changed. From the classifications he used in this article, published in the Munich journal *Der Ararat,* and from the generic titles that he began applying to groups of his works in 1917, we can distinguish the following five separate developmental stages of his early art: Academic painting (1909–14), Impressionism (1914–17), Expressionism (1917), Abstraction (1917–18), then Merz itself (1918–19).[11] This makes the development seem somewhat more logical and clear-cut than it was; both the validity of Schwitters' titles for certain stages of his work and the dates I have assigned to them above will need to be qualified. However, Schwitters' own version of "an unbroken line of development" from Academy to Merz is broadly supported by the paintings that still exist, or are known through photographs, from these early years.

Few paintings remain from Schwitters' years at the Dresden Kunstakademie between 1909 and 1914, but those that we know confirm, at least so far as his own art was concerned, his observation that academic painting all comes down to a labor of patience; "this you can learn if you are in good health and not color blind."[12] Although his period as a student coincided with the dissemination of the major German Expressionist styles, and although Dresden itself then housed the Brücke group (Pechstein, Kirchner, Schmitt-Rottluff, Heckel and Bleyl), his art was totally untouched by modernism in any form. He apparently wrote theoretical treatises on abstract art, but his own still-lifes from these years were timid, cramped and utterly conventional.[13] It was not until he left the academy that his work began its move through borrowed forms, and not until the winter of 1916–17 that its movement through these forms began to be rapid enough, or its results interesting enough, to deserve serious attention.

In the winter of 1916–17, Schwitters took a protracted, and belated, honeymoon at Opherdicke in Westphalia, where he became absorbed in landscape painting.[14] It was through landscape painting, by and large, that he began the transition to artistic maturity: at first tentative and fumbling, but from the time of the Opherdicke visit with slowly increasing authority. "First I succeeded in freeing myself from the literal reproduction of all details," he wrote of the changes that had begun in 1914. "I contented myself with the intensive treatment of light effects through sketch-like painting (Impressionism)."[15] The paintings he made after leaving the Dresden academy did in fact become much looser, more "sketch-like" in appearance. But there is little that can be called "Impressionist" about his first independent works. The generally somber mood that characterizes the student paintings is little changed; and while the color is more freely applied, its range is still restricted to the tonal variations of a dominant mood, making some pictures very nearly monochromatic. A landscape of 1914, *Überschwemmte Wiesen (Flooded Fields),* has a certain spontaneous openness of effect which recalls Impressionism (and there may have been more like this), but when Schwitters adopted a regularized Impressionist-style brushstroke in 1916–17, it was so dense and heavy—and so monotonous in its regularity—that the work becomes less Impressionist as a result. Instead of opening the surface to optical penetration, the heavy and evenly accented brushstrokes all but close it off. Exaggerating the tactility of the surface, while keeping the color of a fairly even intensity and restricted range of hues, produced a manner of painting that was bound to stay quite flat, as *Landschaft aus Opherdicke (Landscape from Opherdicke)* of 1917

shows. Of course, tonal variations modify the flatness of this painting, but tonal variety itself is the creation of Schwitters' heavy green brushstrokes: small impastoed planes jostling with each other across a narrow upright surface, a surface of such material density that even the introduction of perspectival drawing cannot allay its dominance. And the very rarity of such drawing in Schwitters' early landscapes—most of the motifs he chose in this period were decidedly frontal in character[16]—suggests that, even at this early stage, he was coming to see his art as a matter of surfaces.

The effect, however, of such over-confined subjects, and of Schwitters' coarsely hatched treatment of them, was often a dense, clogged surface of even and uninteresting uniformity within which the motif was all but lost. Schwitters was impelled, therefore, to reinforce his compositions with a different kind of drawing, both to excavate the motif from the surface and to provide stability and accent for his painting. He would put in accents, nearly always in lines of dark paint, emphasizing salient contours of the motif: the pitch of a roof, a tree-trunk, the edge of a road or river. He emphasized, he said, "the main lines by exaggeration, the forms by limiting myself to what was most essential, and by outlining."[17] The result of this is that the paintings seem to contain two quite specific methods of handling. In *Landschaft aus Opherdicke,* the interiors of the different forms almost fuse with each other to create a generalized green mood. The drawing is left to carry the burden of information about the motif. This separation of drawing from painterly surface continues to be crucial in his development towards abstract art.

In some respects, this treatment is no more than a reinforced Impressionism, and as such draws upon familiar post-Impressionist idioms. The reciprocation between contours and hatched brushstrokes derives ultimately from the work of Cézanne, while their energetic movement is indebted to Van Gogh. As with Van Gogh, Schwitters' drawing is as much diagrammatic as truly descriptive, being so exaggerated at times as to constitute little more than a primitive shorthand. Although painting from nature, Schwitters is creating conceptual rather than perceptual symbols for objects, and is attempting, somewhat naively, to make the rendering of the motif serve expressive before descriptive ends. "The personal grasp of nature now seemed the most important thing to me," he wrote. "The picture became an intermediary between me and the spectator. I had impressions [*Eindrücke*], painted a picture in accordance with them: the picture has expression [*Ausdruck*]."[18]

The more advanced Opherdicke landscapes are, in fact, Expressionist paintings, in precisely the same sense that Van Gogh's landscapes are Expressionist paintings. In the visual arts the term *Expressionismus* was first popularly used in German very much as "Post-Impressionism" was first used in English: that is to say, to define a wide range of modern styles that came after Impressionism. Hence, it was first used of the Brücke painter Max Pechstein's work in 1910 and of French Fauve and early Cubist painting in 1911, and by 1912 was being applied (at the Cologne Sonderbund exhibition) not only to Brücke and Blaue Reiter art (to Kandinsky, Franz Marc and their colleagues) but also to artists like Munch and Van Gogh.[19] In this wider sense, the word Expressionism conveys a rejection of the empirical and perceptual basis of the "impression" and a development, beyond the confines of Impressionism itself, of its subjective and conceptual implications. Schwitters' landscapes of 1916–17 are Expressionist in this sense. The

word gradually came to have a more restricted application after the dramatic impact of Cubism and Futurism in 1910–12, promoted by Herwarth Walden's Der Sturm gallery (of which more later), which introduced an angular, distorted, violently emotional style into German art. Expressionism in this sense appears in Schwitters' work in 1916–17 in a set of portraits of his wife.

These portraits fall into two groups: some close to the style of the landscapes and presumably also painted at Opherdicke, and some seemingly more conservative in approach but in fact reflecting the influence of specific Expressionist sources. Characteristic of the first group is *Vision* of 1916–17, in which the hatched brushstrokes of the landscapes reappear, sometimes so regularly applied as to seem independent of the form, with the result that only the overlaid sign-like outlines keep the subject fully visible. However, this weighted, summary drawing seems far more forceful when allied to an innately expressive subject than when applied to landscape. Line, though still fulfilling a descriptive function, begins to take on a new and independent weight from what it describes; though still clumsy, it heightens, externalizes and actually contains the expression of the subject. In such portraits of his wife, Schwitters becomes a fully Expressionist painter, now subordinating any pretense of realism to the realization of his subject's emotions and his own. We see this, in *Vision*, in the unabashedly introspective and "spiritual" expression of the subject and in the harshly primitive angularity of its treatment.

It is, indeed, as much the subject of *Vision* as Schwitters' treatment of it that causes us to consider it a fully Expressionist work. Comparison with the stylistically similar, but seemingly less Expressionist, *Landschaft aus Opherdicke* confirms this. Schwitters' turn to Expressionism therefore came to mean a turn away from landscape painting. As he opened his work to the influence of contemporary art, he did so in paintings of intrinsically more emotive subjects: first portraits, then imaginary and invented scenes. Schwitters' art thus became increasingly hermetic—distanced from the observed world—especially after he returned from Opherdicke to Hannover in 1917.

It cannot be accidental that this change in his work coincides exactly with the awakening of Hannover as a center for advanced art.[20] The year 1916 saw the foundation of the Kestner-Gesellschaft in the city, a private institution which sponsored exhibitions of contemporary art, both that of prominent Expressionists and of local artists. In June of 1917, its exhibition of younger Hannoverian artists initiated a Sezession group in opposition to the semiofficial and conservative Kunstverein. Schwitters (who had been exhibiting with the Kunstverein since 1911) was represented at the 1917 Kestner exhibition by a now lost *Trauernde* (*Mourning Woman*) of 1916, apparently influenced by the work of Paula Modersohn-Becker, which was becoming well known in Hannover at this time.[21] In 1917, a large Kestner exhibition was devoted to her work. It included her famous *Selbstbildnis mit Kamelienzweig* (*Self-Portrait with Camelia*) of 1906–07, which Schwitters recalled in his *Helma Schwitters mit Blume* (*Helma Schwitters with a Flower*) of 1917.

The flower motif is doubly interesting in view of the "Anna Blume" theme which Schwitters was to develop in poetry in 1919. This painting of his wife could well serve as a portrait of that sentimental bourgeois lady. But the Anna Blume of the poem was if

anything a satire on the kind of solemn sentimentality which fills this painting and which affects the entire group of similar portraits of Schwitters' wife. This group of portraits represents Schwitters' first attempt to assimilate a modern style. It was less useful to him than his other, more painterly, portrait manner, and his subsequent development was away from this kind of illustrated expressiveness and towards a tying of expression to pictorial elements themselves. In this, he was helped by subsequent Kestner exhibitions, among them presentations of Emil Nolde, August Macke, and Ludwig Meidner in 1918.[22]

Given Schwitters' new interest in Expressionism, it is probable that, once exposed to it in Hannover, he soon tracked it down to its principal source at the Sturm gallery in Berlin. This gallery took its name from the magazine *Der Sturm,* founded by the impresario Herwarth Walden in March 1910 to promote what was just then beginning to be called Expressionism in literature and in art. Opened in 1912, the Sturm gallery created an immediate success in bringing to Berlin work by the Italian Futurists, by the Munich Blaue Reiter group, and by certain Cubist and Cubist-influenced artists, notably Delaunay, Feininger and Chagall. Walden's importance to Berlin, and to German art, was soon fully secure; the *Erste deutsche Herbstsalon* (First German Autumn Salon) he organized in September–November 1913 was both the first full-scale German review of international modernism (exceeding in scope the Cologne Sonderbund exhibition the previous year) and the single most important exhibition in popularizing Expressionist art. By the time that Schwitters began looking at new art, Sturm and Expressionism were virtually synonymous.

We do not know when Schwitters first visited the Sturm gallery. It was probably in 1917, after his return to Hannover from Opherdicke, from which time Expressionist influences become apparent in his work. If so, he could well have seen the Sturm exhibitions of Feininger and Chagall in September and October of 1917, the highlights of that year's program, even if he had missed the Kandinsky and Marc exhibitions in September and November of the previous year. In any case, given the wide circulation and importance of the magazine *Der Sturm,* Schwitters could hardly have remained for long unaffected by Sturm art once he began to take an interest in modernist styles.

He was certainly familiar with the gallery's policy by early 1918. Rudolf Blümner, the Sturm poet, gave a recital at the Kestner-Gesellschaft in January of that year; by then Schwitters was himself writing Expressionist verse and would surely have attended. Moreover, he had become friendly with a group of artists and intellectuals who met at the Café Kröpcke in Hannover. This included the soon-to-be publishers of Schwitters' work, Paul Steegemann and Christof Spengemann, the latter being a friend of Herwarth Walden. It was possibly at Spengemann's urging that Schwitters made personal contact with Walden in Berlin. In any event, two of the paintings Schwitters had sent to the first Hannover Sezession exhibition in February 1918 were accepted for inclusion in a group show at the Sturm gallery in June, and Schwitters wrote to Spengemann on June 12 saying he was going to Berlin to meet Walden.[23] The artistic philosophy of the Sturm group was to be of crucial significance to Schwitters' conception of the function and scope of his own work. It will be discussed in detail once we have followed Schwitters' artistic development through to the time he became an active member of the Sturm circle.

Schwitters announced his affiliation with Expressionist art in the titles of a small but important group of his 1917 paintings. Each one he called an *Expression*. None, unfortunately, appears to have survived, although three are known through photographs: *G Expression 1* (*Der Wald*) (*The Forest*); *G Expression 2* (*Die Sonne im Hochgebirge*) (*Sun in the High Mountains*), and *G Expression 3* (*Die Liebe*) (*Love*). Whether there were more, and when exactly in 1917 they were painted, is uncertain. For Schwitters, 1917 was a year of swift and varied activity, of trial (and error) and experiment, rather than of a clearly defined and sustained development from one work to the next. This remained so until at least the invention of Merz (and even after that continued, to some extent, to be a characteristic of his working method), which often makes it difficult to place an individual painting absolutely securely. Schwitters seems to have initiated new directions in rapid succession but not really to have abandoned any of them. He threw nothing away, not even used styles. As he was to write much later: "I can never give up or entirely forget a period of time during which I worked with great energy—I am still an impressionist even while I am Merz."[24] Hence the confusing accumulation of different manners in his early painting, and the continual return to styles irrelevant to the innovative ambition of his art. But in terms of ambition, a clear line of development does emerge, and in this development the *Expression* paintings quite clearly follow on from the landscapes and portraits of 1916–17. They are at once the summation of his naturalistic work—allying the emotional quality of portraiture to the greater pictorial freedom of landscape—and the means of escape from naturalism, and into abstraction.

The *Expressionen* are also far more open to stylistic influences than are the works in other genres. If they suffer as a result of this, seeming eclectic and unresolved, they do stand to demonstrate Schwitters' quickening determination to engage his art to modernist themes. Indeed, he seems to have consciously deployed different idioms in order to vary the "expression" of each work. *Die Sonne im Hochgebirge* is unmistakably indebted to Kandinsky (as may possibly be Schwitters' generic titling of this group of paintings; something quite new to his art).[25] *Die Liebe* has something of Franz Marc's religiosity in its allegorical format (here transposed from animal to human subjects), although at the same time it is possessed of an almost *Jugendstil* languor.[26] The earliest of the three paintings, *Der Wald* is far more restrained, both in expression and in style; but, given the subsequent course of Schwitters' art, it is the most interesting. All landscape, and lacking, therefore, a specific and isolated motif to focus expression, the painting comprises a linear pattern of tree branches, spreading across the entire surface, which both establish that surface and themselves bear the full expressive weight. There is no feeling of separation between the expression invested in the subject and the painting that contains it. Far more than in any previous painting (and far more than in the two *Expression* pictures which follow), Schwitters here brought into affiliation the formal and expressive components of his art. That this affiliation is weakened in the second and third *Expressionen* shows that Schwitters did not yet recognize the significance of what he had achieved, but that he strove at this stage for expression *per se*, even at the expense of stylistic consistency. He still saw expression as largely invested in subject-matter, to such an extent indeed that style itself is accommodated to different subjects, or at least to the rendering of the different expressions these subjects evoked. Hence the dense and

abrupt linearism of *Der Wald,* the soft and languorous forms of *Die Liebe* and the atmospherically broken surface of *Die Sonne im Hochgebirge.* Although the results of this approach are not very impressive, the method itself is significant: the conscious adjustment of elements from a discrete pictorial vocabulary, so as to achieve different kinds of expression, demonstrates—really for the first time—what was to become a point of principle in Schwitters' art, that every line, form and color, and every combination of these, has a particular expressive character.[27] This is the true bridge between naturalistic painting and abstraction. As Schwitters himself put it: "The individualized and specialized observation of nature now gives way to an increasingly objective and theoretical study of the picture and its laws."[28]

☐ Schwitters' art thus broke through to abstraction in 1917, a breakthrough almost as important as the use of extra-artistic elements a year later, since the character of his transition to abstract art—by emphasizing the expressive potential of individual formal elements—held implicit the possibility of the later innovation. Schwitters described it as follows:

> Any desire to reproduce natural forms limits the force and consistency of working out an expression. I abandoned all reproduction of natural elements and painted only with pictorial elements. These are my *Abstraktionen* [*Abstractions*]. I adjusted the elements of the pictures against each other . . . not for the purpose of reproducing nature but with the aim of expression.[29]

His claim to have abandoned naturalistic painting is not, in fact, true. In the years of modernist experiment, 1917–19, Schwitters used landscape as the basis of many of his invented subject pictures and made observed landscapes using the styles developed in the studio-painted works. On occasion, later more purely abstract works incorporate naturalistic elements, for Schwitters found that "representations of nature, inartistic in themselves, can be elements in a picture, if they are played off against other elements."[30] And he painted landscapes thereafter, in the conservative style of the Opherdicke period, for the rest of his life. However, within the context of the stylistic development that Schwitters laid out in his *Der Ararat* article of 1920, which I am following here and from which the two preceding quotations derive, it is correct to say that naturalistic painting was superseded in 1917–18 and abstraction realized. As we have seen, after the Opherdicke period of 1916–17, landscape painting was supplanted as the focus of Schwitters' most advanced work, portraits and then invented subjects taking on the pioneering role. The *Abstraktionen* of 1917–18 continue to evoke landscape, but their pictorial unity is not based on that evocation; rather, on abstract considerations internal to the individual works.

12, 20, 23

Not until we reach the last decade of Schwitters' life, spent in mostly rural areas of Norway and England, and when the experience of landscape directly affected his abstract work, will there be occasion to refer again to examples of Schwitters' landscape painting. It is important to remember, however, that Schwitters himself felt strongly that the study of nature through landscape painting was a necessary way of replenishing his imagination, even in the period of his most obviously urban collages and assemblages.[31]

And it is certainly relevant to an understanding of Schwitters' whole esthetic that his attitude to nature, as codified in his formative years, was a somewhat sentimental and romantic one, which accrued to itself visionary and even mystical overtones when brought into contact with Expressionism. For, as we shall see, the move from rural to urban themes that accompanied the creation of Merz seemed to carry to the industrial metropolis, as represented in Schwitters' art, some of the earlier romanticism, as well as a feeling of nostalgia for the natural world that had been left behind.

Schwitters' insistence that "an unbroken line of development leads from the naturalistic studies to the Merz abstraction"[32] not only refers to the process of increasing stylistic sophistication being plotted here: it is evidence of his belief that his Merz abstractions look back to and draw sustenance from a particular attitude to nature that characterized his artistic beginnings.

At the age of fourteen, Schwitters, already a sickly and withdrawn child, suffered the first of the epileptic seizures that were to plague him intermittently throughout his life. It came after a garden he had carefully nurtured—with roses, strawberries, a manmade hill and an artificial pond—was destroyed in his presence by some local children.[33] So serious was the seizure that this produced that Schwitters was an invalid for two years, and it was during this period that he became interested in art: first in poetry, then in music, finally in painting. Such, at least, is Schwitters' own version of his artistic beginnings. This story of the discovery of art as a solace and a refuge after an illness associated with unhappy worldly experience is not unique to Schwitters. It is a part of the mythological literature of artistic autobiography: Matisse's account of his beginnings as an artist is not dissimilar. What is special to Schwitters' version, however, is that he turned to art (or tells us that he did) after the idealized form of nature he had physically cultivated had been destroyed. Art, it seems, could serve to rebuild a new form of nature, safe from interference.

Schwitters' first *Abstraktion* painting was entitled *Der verwunschene Garten* (*The Enchanted Garden*). When he came to write the account of his early artistic development for *Der Ararat* in 1920, he began it by mentioning his childhood garden.[34] He ended it by printing a selection of his poetry from 1909 to the present, presumably to show that as in his painting so in his poetry there was an unbroken development from naturalism to Merz. The 1909 poem "Herbst" ("Autumn")—Schwitters' earliest extant poem; indeed, the only pre-modern poem that he published—is extremely conventional, but it deserves quoting here because it reveals a cloyingly sentimental aspect of his personality not at all visible in his academic paintings of the same period:

Es schweigt der Wald in Weh.	The forest is silent in grief.
Er muss geduldig leiden,	She must patiently suffer
Dass nun sein lieber Bräutigam,	Her dear betrothed,
Der Sommer, wird scheiden.	The summer, to depart.
Noch hält er zärtlich ihn im Arm	In grief and anguish still,
Und quälet sich mit Schmerzen.	She holds him in her arms.
Du klagtest, Liebchen, wenn ich schied,	You wept, my love, when I departed,
Ruht' ich noch dir am Herzen.	Could I now but rest on your heart.[35]

Schwitters so obviously overreaches himself here in striving for sublimity that he falls instead into the pretentious and the absurd. It would be wrong to read too much into such a juvenile work, for the voice that speaks through it is as much an inherited—and deteriorated—Romanticist one as Schwitters' own. Nevertheless, the lamenting, melancholy tone and the overt personification of nature are interesting, not because they are original but because they are the elements of German Romanticism that Schwitters reformulates in his later, modern poetry—and in his later visual work as well.

The poet, whose medium is words, can learn to speak his thoughts more quickly than the painter.[36] It is not until 1917 that Schwitters' painting gives us a hint of the moody personality of his early poetry, and it does so through the medium of Expressionism. By 1917, Schwitters' poetry was influenced by Expressionism, in particular by the highly emotive, grammatically disjointed style of Expressionist poetry practiced within the Sturm group. Choosing to dismiss his earlier work, he dated his beginnings as a poet to that year. In 1917, therefore, the poetic and the visual sides of his art came into parallel. The structure, meaning and development of his poetry we will consider later. Relevant now, however, is its treatment of nature, both intrinsically and in relation to the contemporaneous visual work. This *c.* 1917–18 work,[37] "Erhabenheit" ("Loftiness"), is typical of its period:

Kirchen türmen ein Mensch	Churches tower a man
Lastet Sonne Hochgebirge	Burdens sun mountain-chain
Steil durchbrechen	Break through steeply
Glut verrinnt umragen Zacken	Glow runs off intower peaks
Leiberheiss—seelennah.	Bodyhot—soulnear.
Wärme umglutet Gluten!	Warmth inblazens blazes!
_ _ _ _ _	_ _ _ _ _
Klein ich?	Small I?
Gross!	Huge!
Arm ich?	Poor I?
Reich!	Rich!
Wuchtet Riesen Hochgebirge,	Weighs giant mountain-chain,
Wuchtet Riesen ich!	Weights giant I!
Kirchen türmen, lastet steil!	Churches tower, burdens steep!
Gluten Mensch wuchtet lasten Sonne.	Blaze man weighs burden sun.
Ich?	I?
Umglute	Inblaze
Steil!	Steep!
!	!

The melancholy tone of the early poem is transformed here into an ecstatic, Expressionist celebration of nature and of the poet's pantheistic communion with it. In either case, however, nature is possessed with emotions. It is less a substance than a sensation, and the objects of nature, therefore, are less important in themselves than are the emotions they can be understood to contain. The poet's task, it seems, is to uncover such emotions: no longer conventionally, through personification of the kind that fell into

pathetic fallacy, but through dramatic juxtaposition of declamatory lines of broken and distorted words and word-fragments, most of them begun with active verbs. And if the formal desperation of this method implies desperation in the poet's search for contact with nature, then that too is part of the attitude to nature contained in poems of this kind. For all the celebratory rhetoric, this poem is not without anxiety. Nature is not comfortably present but gains its reality from the reactions that it provokes. Because it seems overwhelming and out of reach, the poet is driven to extreme measures in order to reclaim it. In 1917, quite as much as in 1909, Schwitters is a *sentimentalisch* poet, in Schiller's sense of that word: a poet who seems to have lost direct contact with nature and, unable to react purely instinctually to it, constructs it for himself formally, and therefore as a sought-for ideal.

The same might reasonably be said of Schwitters' paintings of this period with allusions to nature, notably the *Expressionen* of 1917. Indeed, the *Expression* painting, *Die Sonne im Hochgebirge,* is thematically very similar to the poem, "Erhabenheit," with its blazing sun and giant chain of mountains, and is also a construction of nature. And when Schwitters used the Expressionist style developed in studio works like this to render observed landscapes, the same concordance of literary and visual themes persisted. Even in 1919, just prior to the creation of Merz,[38] *Hochgebirgsfriedhof* (*Mountain Graveyard*) uses the same sun, mountain and church iconography.

We shall soon see how these very forms find their place in Schwitters' Dada drawings of 1919 and also, more thoroughly disguised, in his *Merzbilder*. Before then, however, Schwitters ceased to use allusions to nature to give coherence to his paintings. He continued to use natural elements, but within an increasingly abstract, anti-naturalistic space. The creation of such a space was the achievement of his 1917–18 *Abstraktionen*.

Few of these works still exist, but it seems that around forty were made.[39] At first, they were little more than *Expressionen* in abstract guise. "To begin with, we continue to try to paint special, specific moods . . . ,"Schwitters stated,[40] and therefore treated the subject of *Raumkristalle* (*Space Crystals*) in a different style to that of *Die Eisenbetonstimmung* (*The Spirit of Reinforced Concrete*)—his first demonstrably modern subject—and chose yet another approach for *Der Bindeschlips* (*The Bow Tie*)—his first mundane one. Nevertheless, his style did begin to stabilize itself in the *Abstraktionen*: into a generally somber range of colors (brown and gray-blues) supported by a skeletal framework of black lines, sometimes curved but more often tense, sharp and abbreviated, that stretch over the whole surface. *Die Gewalten* (*The Forces*), an early work in the series, from September 1917, is still tentative in its use of this vocabulary, and refers in some respects (including its title) to Marc, the curved central forms being reminiscent of abstracted animals. *Der Bindeschlips* and *Schlafender Kristall* (*Sleeping Crystal*)[41] of 1918, however, are far more assured. Schwitters' pictorial grammar has been tightened and simplified into a clear two-part structure of loosely gestural tone painting and tense linear scaffolding. This newly severe and geometricized manner shows for the first time the absorbed influence of Cubism in Schwitters' art.

Schwitters was undoubtedly affected by Cubism from the end of 1917, most helpfully in these *Abstraktionen* but also in some stylized landscapes and in a series of important pencil and chalk drawings of this period to be considered shortly. It was an experience

crucial to his development into assemblage. The two-part structure of the *Abstraktionen*—inconceivable without the knowledge of some form of Cubist art—began a direction that led eventually to a replacement of the painted linear armature by a constructed one. However, Schwitters' experience of the Cubist style was essentially a second-hand one, derived from sources often very far from its original Parisian form. His direct contact with French art was limited to work that had entered Germany before the war cut off relations between the two countries. Certainly, his principal guide to modern art, the Sturm gallery, had an interpretation of Cubism that seemed not merely ignorant of the importance of Picasso's work but antipathetical towards it.[42] It is safe to assume, therefore, that he was principally affected by Cubism through the strong Cubist, or at least cubistic, strain that had, from around 1910 to 1912, replaced Fauvism as the principal stylistic influence in Expressionist art, and that was to be found in those Expressionist paintings that were Schwitters' early models: the Mackes and Meidners he saw in Hannover and the Marcs, Feiningers and Chagalls—and all the lesser German Cubists—he saw in Berlin. Cubism was therefore absorbed into Schwitters' Expressionism rather than quite replacing it.

Expressionism was not a single esthetic style, but a melting pot for a whole range of formal ideas any combination of which could serve as "expression" to the dictates of an individual artist. In the case of Cubism, it was the "harder," more graphic, and indeed more literary side of the movement that found special favor in Germany. Robert Delaunay, and his follower in Germany, Feininger, were particularly important in this context.[43] Their urban subjects fitted well with the metropolitan, literary interests of Expressionism and their hard linearism with the jagged emotionality of Expressionist art. These two artists, and their interpretations of Cubism, were promoted in Berlin by Herwarth Walden, who in any case preferred the even more dynamic variants of Cubism as practiced by the Italian Futurists.[44] Indeed, all of the artists most influential for Schwitters' development were represented by the Sturm gallery: Kandinsky and Marc, the Futurists, Archipenko, Delaunay, Feininger and Chagall. Schwitters certainly must have been familiar with Walden's treatise on modernism, *Einblick in Kunst,* published in 1917; and its subtitle, *Expressionismus, Futurismus, Kubismus,* exactly summarizes the constituents of his style.

For Schwitters, therefore, any reference to Cubism in his art is not primarily to the original French movement, but to an international geometric style which included artists as different as Marc, Boccioni, Chagall, Feininger, and many more; a style that had been established in its different forms before 1914 and that still remained synonymous in Germany with advanced art. At its simplest it meant a merely "cubified" art, what Gertrude Stein called scathingly the painting of houses out of plumb,[45] and at its worst it meant what Schwitters' friend, Hans Arp, described as "the mystic hamburger," "a meat loaf made from minced Cubism and Futurism."[46] Schwitters approached both of these things at times, but soon evolved a quite personal interpretation of Cubist techniques which, though completely divorced from true Cubist ideals, initiated in his art a new structural authority which remained its strength until the very last decade of his life.

In 1918 he was undoubtedly expanding his art into new territories, and we see him experimenting with many different versions of a Cubo-Expressionist style. His

9 *Verschneite Häuser* (*Snowcovered Houses*) of 1918 is almost a textbook Expressionist
10 painting, comparable in its angular distortions to those of artists like Meidner, whose
work Schwitters saw at the Kestner-Gesellschaft that year: "A house," in the poet
Kasimir Edschmid's words, "is no longer merely a subject for an artist, consisting of
stone, ugly or beautiful; it has to be looked at until its true form has been recognized,
until it is liberated from the muffled restraint of a false reality, until everything that is
latent within it is expressed."[47]

Such a concern for latent forces within the visible world—but using a broader stylistic
range to release them—is also evident in an important 1918 series of pencil, chalk and
charcoal drawings. All too few seem to have survived from the well over one hundred
produced,[48] but even from these it is quite clear that Schwitters was testing the limits of a
new vocabulary. Some drawings are of mountain forms, recalling the *Expression* paint-
ing, *Die Sonne im Hochgebirge,* except that the draftsmanship is far more severe and
generally far more abstract in its diagonal configurations.[49] Many, however, are views of
cities, similarly angularized, and clearly Expressionist in their distortions. We see echoes
of Meidner, of Feininger, and, in a number of works showing figures trapped in geomet-
14, 13 rical webs, of Kirchner's famous Berlin street scenes of 1913–14.[50] *Z42. Der Einsame*
(*The Lonely One*) derives ultimately from this source, though the web is so dense and so
much a part of the surface as to be there as much for its own sake as for what it denotes.

15 This is not the case, obviously, with *Z122. Die Versuchung des heiligen Antonius* (*The
Temptation of St. Anthony*), one of a small group of drawings devoted to this subject.
While thematically comparable to *Der Einsame* in showing an image of discontent, it
does so in a far more literal and introspective manner, risking ugliness in order to present
so dark a picture of erotic misery. This is a side of Schwitters most often sublimated in his
visual work. It appears in his early poetry and imaginative prose, and will play a crucial,
albeit concealed, role in the environmental construction he called the *Merzbau.* Its
appearance in 1918, in the context of these Cubo-Expressionist experiments, reminds us
that Schwitters' move to abstraction, though a move away from such literal imagery, did
not mean the abandonment of emotional subject-matter. Indeed, the achievement of
Merz, as we shall see, is to an important extent the energizing of abstraction with
subject-matter.

Before this happened, however, an almost absolute degree of abstraction was realized.
17 *Z57. Abstraktion* is clearly without any specific source and is essentially a style study in
Futurist dynamics: the tense, slightly curved and hard black lines and directional hatch-
ing evoke a feeling of momentum across the sheet, and imply the rounded surfaces of
16 abstract solids in a way reminiscent of Boccioni's work of 1913 and 1914.[51] Only one
19 known drawing, *Achsenzeichnung* (*Axle-Drawing*) of July 1917 (and therefore the
earliest known of the series) shows some subtlety of touch that is reminiscent in feeling of
18 Analytical Cubism itself. And even here, the total abstractness of the drawing separates it
from its parent source. Although Schwitters is obviously learning from different Cubist-
based styles, he is far from original Cubism. In all of his abstract drawings, he organizes
the flat surface not by forms derived from perceptual analysis, but by means of token
abstracted units added to the container of the picture. This continues to be his pictorial
method, right through to the *Merzbilder* themselves.

Schwitters' hard, wire-like line in these drawings, as well as the new urban iconography (appearing for the first time in his art in 1918), would seem to set the pattern for the early *Merzbilder*. However, the drawings still give the impression of being experiments with new idioms. By contrast, the *Abstraktionen* and especially *Der Bindeschlips* and the later *Entschleierung* (*Unveiling*), are the true springboards for Schwitters' mature art. They certainly reveal a far more consistent use of a Cubist-based vocabulary in their play of hard linearism and loose brushwork, the severely restricted palette, and the fade-out of the motifs towards the edges. And yet, even here, it was merely to the stylistic vocabulary of Cubism that Schwitters was drawn. He coopted from Cubism regularized, geometric drawing and tonal shading, but the real structural issues (of achieving a flatness energized by these elements but resistant to their disruptions) he left untouched. Hence, for all their seeming abstractness, many of the *Abstraktionen* rely on still very conventional forms of modeling which hollow the space away from the surface and compromise its flatness. *Der Bindeschlips* is holed-through towards the center. The shaded and lined-off facets in a number of the works are more like the representations of an abstract sculpture than the components of a truly abstract painting. In general, the linearism of these paintings seems as applied as it was to the early landscapes: imposed in order to structure a continuously blended background, and, as such, nearly separate from it. Seeking to paint only with pictorial elements, he took from German interpretations of Cubism those elements which confirmed both the dominant linearism and the somber tonality of his pre-Cubist style.

For all their heaviness of painting, the *Abstraktionen* depend very crucially on their drawing. Modulation is virtually replaced by infilling, and the linear framework of "signs" both specifies the implied volumes and holds the last vestiges of realist content. The relation of this framework to the loose painting which surrounds it is as yet unclear. From one work to the next, and indeed within individual pictures, Schwitters vacillates between an integration and distinction of linear and tonal structures, at times stranding his descriptive drawing on top of a generalized painterly surface, at others bringing drawing and surface together and using the painterly surface to reinforce the image suggested by the drawing. Just how drawing and surface do interact is to be of essential importance in the later assembled works, and comes to affect the degree to which added objects are assimilated into Schwitters' pictures. For what is at issue here is the relationship between the separate expressive life of the descriptive drawing (and later the added materials) and the pictorial unity of the work that contains them.

If here lines and tones (later objects and surfaces) are adjusted one to the other, this is to affirm their structural rather than referential connections, by tying the "subjects" to the painting itself. If lines (later objects) read as identifiably separate components, the likelihood of their functioning referentially is increased. In 1918, however, this contradistinction was not yet fully apparent—at least so far as meaning was concerned—and the implied choice at this stage was between a volumetric and a planar interpretation of painting; between the junction of line and plane to hollow out volume and the separation of these elements to effect a far flatter kind of picture. The strongest, and the most cohesive, of the *Abstraktionen,* the *Entschleierung* of late 1918,[52] shows that Schwitters opted for flatness. Having made this decision, it was but a short step into assemblage: the

weight and simplicity of the linear vocabulary seen in *Entschleierung* renders it available for transformation into the "real" lines that Schwitters was about to use. A glance forward to *Das Arbeiterbild* (*The Worker Picture*) of the following year shows just how direct the transformation was to be.

46

As yet, however, the vocabulary of lines and circles still seems to possess some kind of schematic external reference. It recalls certain of Schwitters' mountain-subject drawings and paintings: *Entschleierung* and *Hochgebirgsfriedhof* may be two different versions of the same subject. But there is an opposite reading of *Entschleierung* to a landscape one. Schwitters wrote of his experiences at the Wülfel ironworks from 1917 to 1918 that "there I learned to love the wheel, and came to realize that machines are also abstractions of the human mind. Since that time I have loved to combine machinery with abstract painting to create a total work of art."[53] It is tempting, therefore, to see a dark "machinist" iconography of wheels and pulleys in this work. If this is so, then the painting probably owes something to Schwitters' experience of a new and wider range of modern art, including that of Francis Picabia and the Futurists, which requires discussion in the context of his work of the following year. Certainly, within a very short time after the completion of *Entschleierung,* these same forms were being directly rendered as wheels, levers and the like. In an undated woodcut, published in *Das Kestnerbuch* in 1919, and extremely reminiscent of Giacomo Balla in composition, this is not yet fully apparent;[54] but in a lithograph of 1919, which appeared in the first issue of *Der Zweemann* that November,[55] the machinist source is specific. By then, of course, Schwitters was using actual wheels in his assemblages. Whether drawn and real wheels merely fill in blank abstract circles; whether these are already implicit in *Entschleierung;* or whether the earlier suns and mountains were transformed into the apparatus of a machine environment: these are things not easily decided. There was certainly a change from rural to urban iconography in Schwitters' art in 1918, and it may not be amiss to see this painting as a bridge between the two modes. Schwitters remained attached to nature while fascinated by the metropolis. The pull of one against the other continues to be an important theme in his work.

I

21

22

If this ambiguity shows us anything, it is that Schwitters has pared down his formal vocabulary away from direct and specific references of any kind. From a concern with meanings as invested in subjects, and in the expression of the elements that comprised such subjects, he has here achieved a fullness of abstraction wherein individually weighted lines are subjects in themselves. And having achieved this, Schwitters ceased to vary his compositions a great deal from one work to the next, as he had done when allowing expression to dictate and to dominate style. "Today, the striving for expression seems to me to be injurious to art . . . ,"he was soon to write. "The work of art comes into being through the artistic evaluation of its elements. . . . Only forming is essential."[56]

□ This, we should note, is the third time that Schwitters has talked of liberating himself from some aspect of his earlier work in order to achieve an important breakthrough. First, with the "Impressionist" paintings, he freed himself from "the literal reproduction of all details" characteristic of his student works in order to achieve a "personal grasp of nature." Here, painting is seen as telling of the artist's personal impressions of the world.

Second, with the *Expression* paintings, he freed himself from "any desire to reproduce natural forms" because they limited "the force and consistency of working out an expression." Here, painting is seen as the agent of personal expression itself. Finally, with the mature *Abstraktion* paintings, he freed himself from "striving for expression" because it seemed to be "injurious to art." Here, painting tells mainly of its own innate formal relationships.

Once expression *per se* was no longer a conscious aim, this expunged from Schwitters' work the often wilful self-projection that weakened the earlier *Abstraktionen,* as it had the *Expressionen* before them. The effect was to heighten the real expressive feeling of the art, which came to depend above all else upon Schwitters' control of a strictly delimited vocabulary of formal elements. This is at once the summation of his early work and its springboard for a whole variety of new directions. Merz itself was to be the ulitimate liberation: "Merz," he wrote, "stands for freedom from all fetters, for the sake of artistic creation. Freedom is not lack of restraint, but the product of strict artistic discipline."[57]

This ultimate artistic liberation was linked to a personal and emotional one, that effected by the ending of the Great War and the outbreak of the German Revolution. During the war, he said, "I could not use what I had brought from the Academy; the new useful ideas were still not ready; while all around me raged an imbecilic struggle about things that have never concerned me."[58] But once it ended, he noted, "I felt myself free."[59]

Reviewing Schwitters' early work, we see that he had been continually plagued by the whole problem of "expression," by the question of what was the relationship of art to the outside world on the one hand and to the artist on the other. As we have learned, he was extremely withdrawn and moody, subject to bouts of nervous illness, both as a child and as a young man. "My basic trait is melancholy," he once wrote.[60] Henceforward, art was to be both an escape from his introverted self into the outside world and an escape from the urgencies of the outside world into one of his own making. A sense of alternating involvement and detachment with respect to his external environment was to characterize virtually everything that he did. It was to characterize his personality too, for by all accounts he was, in his adult life, at times utterly gregarious and extravert in behavior and at others excessively self-protective. Thus, many stories are told about his conviviality, about the flamboyance of his public appearances, about his fondness for playing the clown; but also about his miserliness, his bourgeois appearance and attributes, his unwillingness to let anything disturb his private world.

The development of his early work shows a movement first to personalize the world for himself, then to flood images of the world with his own subjectivity, only, however, finally to seek an escape from subjectivity in the separate world of art. The irony, of course, is that this escape from subjectivity finally carried Schwitters—in the *Merzbilder*—back to the point from which he had begun, to an obsession with the literal details of the external world. Although Merz was indeed the ultimate liberation, the sense of conflict and opposition between the external world and the personality and privacy of the artist continued as an active and irritant force in Schwitters' subsequent work. Indeed, if anything, the very form of his collages and assemblages exacerbated it,

for they are the product of opposing forces that pull both to the world from which their materials derive and to the separate world of art in which they exist.

For Schwitters, the war years had been a time of hesitation and obscurity. This was soon to change. Before 1918, he had been a painter and draftsman (and in a small way a poet). Before that year was out, he had made his first collages, and also his first "assembled" poems of joined-together words and phrases. He was soon to create relief assemblages, architectural models, "nonsense" drawings, sculpture, theatrical projects and satirical verse, while continuing to paint landscapes and portraits at the same time. In June 1918, as we have seen, some of Schwitters' *Abstraktionen* were exhibited at the Sturm gallery in Berlin. The year which followed this exhibition was probably the fullest and most crucial of his career. He established then the entire framework of his mature art—in all its different forms— and at the end of the year, in July 1919, baptized it Merz. Between these two summers, Schwitters transformed himself from a parochial Hannoverian artist into an active member of the German avant-garde.

1. THE INVENTION OF MERZ

1918–1921

2 THE KASPAR DAVID FRIEDRICH OF THE DADAIST REVOLUTION

□ On June 27, 1918, Schwitters signed his name for the first time in the guest book of Herwarth Walden in Berlin and joined the Sturm group. Not only was the Sturm affiliation an important opening for Schwitters, bringing him into an active and influential organization with branches in all different aspects of the arts; the organization itself became the model from which Schwitters' own one-man movement, Merz, was developed.

By the time that Schwitters introduced himself to Walden in 1918, the Sturm organization had become virtually a cultural empire. Besides the original *Der Sturm* magazine and art gallery, there was also a publishing house (Sturm-Verlag), a school (Sturm-Schule), a theater (Sturm-Bühne), a picture-book series (Sturm-Bilderbücher, publishing theater projects and work by the group's artists), recitation evenings (Sturm-Abende, held both on the Berlin premises and in other German cities), and a network of contacts which brought foreign art to Berlin and loan exhibitions of Sturm art to countries outside Germany. The Zurich Galerie Dada of 1917 depended largely on Sturm exhibitions.[1] By 1920, the contacts were to spread to America, with exhibitions there of Sturm artists under the auspices of the Société Anonyme.[2]

But as the Sturm organization had grown in size, it had also grown soft and permissive. Originally, Walden's policies had been icily exclusive. By 1918, however, his standards had relaxed considerably, and Der Sturm had lost much of the focal importance it had held before the war. Writing of Sturm exhibitions in 1920, the critic Paul Westheim was four-fifths correct when he asked "whether after as many years it will not be . . . embarrassing to be reminded of Bauer, Wauer, Nell Walden, Schwitters and Nebel."[3] Schwitters' earliest Sturm appearances were in this sort of context. His first show, in June 1918, was in company with Albert Bloch, Emmy Klinker and Elisabeth Niemann. And yet, Walden was not beyond showing together artists of very different stature: Schwitters' second Sturm exhibition (January 1919) was with Johannes Molzahn and Paul Klee.

Even though Der Sturm was not as vital as it once had been, Walden's promotional activities were clearly important to Schwitters. They helped bring him to public attention in 1919 and they showed him just how much a keen sense of public relations could achieve. When he finally loosened his Sturm contacts around 1923, Schwitters became an impresario on his own behalf. The Sturm affiliation, however, had a yet wider significance for Schwitters' art: it provided him with the working model of a multidisciplinary artistic enterprise on which Merz would be based. Although Schwitters had been interested since his youth in literature and music as well as the visual arts, before his contact with the Sturm circle in 1917 his idea of being an artist had meant simply being a painter. Sturm taught him of the possibility of a common approach to many different

arts; the synthesist traditions of the Italian Futurists, and of Kandinsky and Marc's Blaue Reiter group, were the principal formative components of Sturm ideas. And crucially important here, the multidisciplinary emphasis of the Sturm group did not bring with it a negation of the importance of the individual arts or of their individual purity. The arts were all to come together, yet each would remain free. Schwitters' understanding both of the scope of Merz and of its artistic purity was certainly affected by this idea.

□ Schwitters' artistic breakthrough in 1919 involved not only the creation of the assemblages and collages for which he is best known, but also work in a wide variety of media, all of which used the assemblage principle. Once Merz was baptized in July 1919, all of these soon made their public appearances: "nonsense" drawings and assemblages (*Merzbilder*) in Schwitters' Sturm exhibition that same month; the famous Merz poem "An Anna Blume" the month after. Before the year was out Schwitters had produced Merz prose, collages (*Merzzeichnungen*), rubber-stamp drawings, sculptures, a theatrical project, and more beside. By 1920, moreover, he was talking of his conception of Merz "as a sum total of the individual art forms" and concluding: "My ultimate aspiration is the union of art and non-art in the Merz total world view [*Merz-Gesamtweltbild*]."[4]

Schwitters talked a great deal of wanting to combine all the arts in a synthesis, a *Gesamtkunstwerk* or total art work. In practise, however, what he did mainly was "to efface the boundaries between the arts"[5] not in fact by linking all of them together, but by applying the common principle of assemblage to each of the arts he worked in. This often meant that one art would blur into another: for example, the relief assemblages combined elements of painting and of sculpture and the collages elements of painting and (in their applied labels and texts) poetry. But this is by no means the same thing as a total art work. The *Merzbühne* (Merz-theater) that Schwitters proposed in 1919 would have been a total art work had it been capable of being realized. We will see (in Chapter 5) how this fascinating concept was probably motivated in part by Kandinsky's idea of a synthesis of the arts through theater, as expressed in the pages of *Der blaue Reiter*. But what Schwitters took mainly from Blaue Reiter theory, as transmitted through the Sturm group, was the idea of an analogy between the languages and methods of different arts, recognition of which was necessary before any artistic synthesis could be achieved.

"Each art has its own language," Kandinsky had written in *Der blaue Reiter*. "Therefore the methods of the various arts are completely different externally." However: "*In their innermost core* these methods are wholly identical: their final goal obliterates external differences and reveals their inner identity."[6] The old German Romantic idea of the *Gesamtkunstwerk*, which engendered Richard Wagner's belief in a total integration of music, drama and spectacle so that none would dominate at the expense of the others, was basically additive in conception. But for Kandinsky and his friends, the "inner identity" between the arts had to be revealed before the process of addition could begin. In talking about this, Kandinsky took as his motif Goethe's complaint that "in painting the knowledge of the thorough bass [*Generalbass*] has been missing for a long time; a recognized theory in painting, as it exists in music, is lacking."[7] From this idea that a musician playing the thorough (or through) bass—i.e., the continuo—works out his

harmonies from the bass-line provided by the composer, Kandinsky proposed that the painter too should be searching for "the mystical inner construction"[8] that lies behind and determines his formal harmonies. Once this was done, he could then begin to "tear down the walls between the arts."[9]

In 1920, Schwitters discussed the idea of a grammar of expressive form and even talked about the possibility of "a catechism of the media of expression," only to conclude, however, that the idea was useless because the content of a form could not be described.[10] Although each element of form and each combination of forms "has a definite expression," "the expression of a picture cannot be put into words, any more than the expression of a word, such as the word 'and' for example, can be painted." Like Kandinsky, he considered that each basic formal unit in a picture or a poem had a unique expressive content that it was the artist's task to reveal. Such content was shaped by the medium in which it was conceived and could not be translated out of that medium. Nevertheless, insofar as the content of an art is shaped by its medium, the arts can express a common content by adopting a common organizational method—one that is expressly designed to reveal the internal content of the materials it uses.

Each work of art, Schwitters continued, "comes into being through artistic evaluation of its elements." To artistically "evaluate" one element against the next is to unveil their basic spiritual content, because art itself is "a primordial concept [*Urbegriff*], exalted as the godhead, inexplicable as life." Kandinsky had written that the artist must unveil the spirit in matter,[11] and "even dead matter is living spirit."[12] The relevance for Schwitters is obvious. Schwitters' idea of his materials as constituting a grammar of artistic elements, each of which holds an undefinable "expression" and which together provide a primordial and spiritual content for the work of art that they combine to build, derives essentially from Blaue Reiter theory. So does his idea that such a grammar of expression could be made to apply to a wide variety of arts. "The pursuit of diverse forms was an artistic necessity for me," he wrote. "The reason for it was not any desire to expand the field of my activity, but to be an artist."[13] To be a real artist, then, was to develop a method that was applicable to many different arts and thus hope eventually to draw them together in a grand synthesis.

This brings us to the second of the reasons why it is so important that Schwitters emerged as a mature artist within the context of the Sturm group and associated himself with its interpretation of the multidisciplinary idea. It aimed at a spiritual renaissance before a social one. The artists of the Blaue Reiter had talked of the ending of nineteenth-century materialism and the beginning of a new spiritual epoch. They were always concerned with things other than just art. Still, art itself was to be the path through which cultural change was to be achieved, not social action. This was Walden's attitude too. He refused to acknowledge any connection between art and direct political or social activity, and closed the pages of *Der Sturm,* even during the most horrifying moments of the Great War, to anything that seemed to him to suggest otherwise. Although the synthesist, multidisciplinary idea which he favored, being in essence a reformative one, did often bring with it an overt social content, that whole "social" side of the idea he avoided, or censored, in order to stress the "spiritual" side. Hence, although *Der Sturm* applauded the Futurists' creation of a dynamic and unhinged syntax of form, expressive of the

primitive vitality of modern life and equally applicable to painting and sculpture, to poetry, to music and even to architecture, one finds no echo at all of the Futurists' worship of technology in the pages of the magazine: nothing at all before 1921, in fact, on the relationship of art and the machine environment.[14] Anything that even hinted at direct social application was to be avoided. This was Schwitters' attitude too.

Schwitters' own understanding of art was never as completely spiritual and Expressionist as that of Walden and his fellow Sturm artists. Still, he obviously valued the Sturm emphasis on artistic purity, for he wrote in 1920 that it was because "Der Sturm exhibits only works of art" that he had approached the gallery in the first place, to exhibit his "purest form of the oil-painting genre," the *Abstraktionen* of 1918.[15] This does not seem a particularly informative statement until one remembers that even such an unassuming preference for pure art as this was by no means a popular stance in the avant-garde of 1918, that attitudes such as Schwitters' had been under heavy attack in Germany through the period of the war, and that in the spring preceding Schwitters' first Sturm showing, such attacks had reached a new peak of intensity in the activities of the recently founded Berlin Dada group, which singled out the Sturm group as a symbol of what it found bankrupt in German art.

Der Sturm had been in existence for only a year when opposition to its apolitical stance had begun to focus around the periodical *Die Aktion*, founded by Franz Pfemfert in 1911. From the very start, *Die Aktion* had been "a weekly magazine of politics, [as well as] literature, art"; but with the outbreak of the war it started to become explicitly associated with left-wing ideals, initiating in its pages the idea of a society of "Activist" intellectuals who would work against the war and for social revolution. And to a majority of Schwitters' artistic contemporaries, as well as elders, this seemed to be the only viable position, given the intense local pressure of social and political events. In terms of specifically artistic modernism, Walden's group was certainly more advanced; but Walden's unwillingness to declare a position on the social front meant that as the war developed—and especially as it ended, in defeat and then in revolution—there was a gradual erosion of Der Sturm's place at the forefront of avant-garde activity. With few exceptions, those who were to become Dadaists in Berlin had, through the war, allied themselves to the Activist rather than the Sturm cause, even though the specific social proposals voiced in *Die Aktion* were often absurdly utopian and unrealistic—to such an extent indeed that the Dadaists came to repudiate all Expressionism, not only the Sturm variety.[16] As the Dadaist Raoul Hausmann explained later:

> The tendency of that review [*Die Aktion*] was not very clear, not very stable, but to our eyes it was preferable to Herwarth Walden's expressly avant-garde review, *Der Sturm*, because he was a Hohenzollern collaborator and had, for example, published a Prussian Song of Songs which we found odious.[17]

Hausmann's colleagues were Franz Jung, Johannes Baader, Hannah Hoech and some others who had originally come together around Franz Jung's philosophical and psychological journal *Die freie Strasse*, and who formed one of the two wings of Berlin Dada. The other wing, comprising mainly Wieland Herzfelde, his brother John Heartfield, and George Grosz, and focused around the journal *Die neue Jugend* (published by the

Herzfeldes' Malik-Verlag), was more specifically political. The two groups came together around Richard Huelsenbeck, after his return to Berlin from Zurich late in 1916 (bringing the word "Dada" with him) to form the Berlin Dada circle, which was officially established under the name Club Dada in the spring of 1918.[18] By the spring of 1919, Schwitters was to come into direct conflict with Huelsenbeck and the Berlin Dadaists because of his Sturm connections.

Dada, however, as originally founded by the poet-philosopher Hugo Ball in Zurich in 1916, owed a very great deal to exactly the same sources that informed Schwitters' art. Ball had met Kandinsky in Munich in 1912 and became familiar with the Blaue Reiter circle. He had also participated, together with Huelsenbeck, in a pro-Futurist soirée in Berlin. Zurich Dada was not only a provocative protest movement directed against the rationalist and bourgeois values that Ball believed responsible for the First World War, but also a remedial one, intended—by stressing the instinctive and the primitive—to unearth the same kind of secret inner language, and through it the same synthesis of culture, that the artists of the Blaue Reiter wanted to find. It was only when Ball withdrew in 1917 that the character of Dada changed. Under Tristan Tzara, in Zurich and later in Paris, it became an aggressively experimental and increasingly Gallicized movement, dedicated to the shocking and the mystifying virtually for their own sakes. Even this Dada mutation was not incompatible with Schwitters' ideas, for it had transformed the original Dada impulse into what was unmistakably an international art movement.

Under Huelsenbeck, however, when he returned to Berlin from Zurich in 1917, Dada became something very different indeed, and implacably opposed to what Schwitters and his connections stood for. The problem was not so much that Huelsenbeck condemned virtually all existing art: Schwitters was enough of his own man to believe that he too had escaped the styles of the recent past. Rather, it was Huelsenbeck's insistence—faced by the blunt realities of wartime Berlin—that if a new cultural epoch was to be created, it was not through the "spiritual" side of the synthesist tradition but through the "social" one: by remodeling life itself. In the final count, perhaps both "spiritual" and "social" traditions shared an understanding of art as not merely something to be enjoyed but something active and effective; even so, the introvert ecstaticism of the Sturm group was at the opposite pole to the kind of extravert asceticism practiced by the Berlin Dadaists at the time Schwitters aligned himself to Der Sturm.

The first target of Berlin Dada was Expressionism, and especially Sturm Expressionism: its inwardness, its spirituality, its isolation from social conditions, its middle-class support. The objections had been clearly and loudly voiced by the time (June 1918) that Schwitters addressed himself to the Sturm group. Schwitters' association with Der Sturm was an alignment to art, outside of social or political commitment. It was therefore, implicitly at least, anti-Dada.

I say that it was *implicitly* an anti-Dada alignment. When Schwitters joined the Sturm group in the spring of 1918, he was still a provincial and part-time artist working as a draftsman at the Wülfel ironworks. His full-time devotion to art and complete orientation to the Berlin art world came about only after the German revolution of October-November 1918. It seems unlikely, therefore, that he knew much, if anything, about Dada when he joined Der Sturm. Even if he did, the kind of art that he was then making

had nothing in common with Berlin Dada. In Huelsenbeck's first Berlin lecture of February 1918, he condemned Cubism, Expressionism and Abstraction as no longer useful or relevant to the contemporary situation.[19] At that time, Schwitters was making his Cubo-Expressionist drawings and *Abstraktion* paintings. Huelsenbeck's First (German) Dada Manifesto of April 1918 had spoken of three techniques that he did think were useful and relevant: "bruitism," "simultaneity," and "the new medium," that is to say, sound poetry, simultaneous group performance and collage.[20] Not until Merz was invented in the winter of 1918–19 could Schwitters agree.

Collage itself was common property in avant-garde circles certainly by the end of the First World War (it was practiced within the Sturm group); so Schwitters' use of the technique does not necessarily require prior knowledge of Dada art. However, given the fact that Walden had been in contact with the Zurich Dadaists since 1917, lending Sturm art to the Galerie Dada, it is inconceivable that Schwitters could have long remained ignorant at least of Zurich Dada art after he had joined Der Sturm.

The greatest of the Zurich Dada artists, Hans Arp, claims to have first met Schwitters in 1918 at the Café des Westens in Berlin.[21] If so, this was obviously late in 1918, after Schwitters started to move in Berlin art circles. As we shall see, some of Schwitters' very first collages, made at the end of 1918, are indebted to Arp, and his "nonsense" and rubber-stamp drawings of 1919 to a range of Dada examples. Certainly by early 1919 he was receiving Zurich Dada publications and was in correspondence with Tristan Tzara.[22] It may well have been Tzara or Arp who encouraged Schwitters to get in touch with the Dada group that had established itself in Berlin. Given the connections that existed between Der Sturm and Zurich Dada, it would have been entirely appropriate for them to have done so, and entirely understandable for Schwitters to want to make contact with what he thought would be a sympathetic artistic organization. He was in for a rude surprise.

It was "in the Café des Westens, one evening in 1918," Raoul Hausmann recalls, that Schwitters turned up and introduced himself, saying, "I am a painter and I nail my pictures together." "This seemed both new and interesting," Hausmann noted. They talked; Schwitters recited some of his poems, which reminded Hausmann of the Sturm poet August Stramm's work, and finally asked to join Club Dada.[23] This meeting took place no sooner than the very end of 1918, and probably in fact early the next year; for, as we shall see, Schwitters' first assemblages, to which he referred, seem to have been made between January and June of 1919. The creation of these works, Schwitters acknowledged, was in part a jubilant response to the liberating upheavals of the German revolution. "One can even shout out through refuse," he said, "and this is what I did, nailing and gluing it together."[24] Although this was not in any way a socially activist stance, "it was," he conceded, "to some extent a social viewpoint" that informed the creation of Merz.[25] It was perhaps only natural, therefore, that he should turn with interest to the activities of the Dadaists; and he may possibly have turned to them in ignorance of the depth of their opposition to the Sturm group, given his only recent acquaintance with the Berlin art world. In any case, when Schwitters came into the Berlin art world, it was at a moment when partisan stances had temporarily loosened, the Revolution itself having bonded together, albeit for a short time, the different factions of

the avant-garde. This was epitomized by the foundation of the Novembergruppe (November Group) in the month of the Revolution, to whose exhibitions associates of the Sturm, Aktion and Dada circles all contributed.[26]

In this situation, Dada activity faltered for a moment.[27] After all, if the old systems had physically been destroyed, dissent seemed no longer to be necessary. Certainly, the majority of the avant-garde welcomed the change. But the events of early 1919 proved the celebration to have been premature, at least so far as the left was concerned, and Dada revived itself to attack the compromise of the newly-established Republic, and all those who supported it. And for the Berlin Dadaists, or at least for Huelsenbeck, Schwitters' brand of purely artistic revolution was anathema. Huelsenbeck had split from the Zurich Dadaists and returned to Berlin precisely on this point of principle: it was not enough to make the new art; one had also to live the new life, and try to shape its future.

> To us [as he wrote later] art—as far as we admitted its existence—was one expression of human creative power, but only one—and one in which a person could too easily become entangled. Art, to Schwitters, was as important as the forest is to the forester. The remodeling of life seemed to us to be of prime importance and made us take part in political movements. But Schwitters wanted to have it expressed only by means of artistic symbols. . . .[28]

The day after Schwitters and Hausmann had met, there was a meeting of the Dadaists' General Council in Huelsenbeck's apartment. "I discovered," Hausmann reports, "that a little was known about this Schwitters after all. Huelsenbeck had taken an aversion to him."[29] When Club Dada had been announced in April 1918, Huelsenbeck had written: "You can join without commitments."[30] What he had really meant, however, was "You can join only without any other commitments." Sturm and Dada were judged irreconcilable in Berlin. Accordingly, Schwitters' application to join Club Dada was now rejected. When Schwitters wrote, therefore, that he chose the word Merz in July 1919 to describe his work because he could not define it with older concepts like Cubism, Futurism and Expressionism, we should probably add that he also chose it because he was not allowed to describe his work by the word Dada.

Matters did not rest there, however: a public quarrel between Schwitters and Huelsenbeck soon developed once it became clear that Schwitters was not so easily dismissed from consideration as someone engaging in Dadaist activity, whatever it was called. It was but one of the many conflicts of personality and of principle that were highly characteristic of Dadaism as a whole, for all its espousal of individual freedom. What happened is worth describing because it serves to clarify both Schwitters' precise status as a Dadaist and the way in which the title Merz came to describe not only Schwitters' pictures but all his artistic activities.

□ The immediate cause of the quarrel was the publication, and immense success, of Schwitters' poem "An Anna Blume," which first appeared in *Der Sturm* in August 1919.[31] After being refused membership of Club Dada, Schwitters had employed the word Merz to describe the assemblages he exhibited in July 1919. With this exhibition it became clear that Schwitters was an artist to be reckoned with, but it was the appearance

of "An Anna Blume" a month later that brought Schwitters to national attention. Schwitters collected scraps of conversation and newspaper cuttings just as he collected scraps of paper and other materials; it was out of these "banalities" as he called them, and his own delight in verbal nonsense, that "An Anna Blume" was composed. Here is the poem, together with Schwitters' own English-language version in which the heroine's name becomes "Eve Blossom."[32]

Oh Du, Geliebte meiner 27 Sinne, ich liebe Dir!

Du, Deiner, Dich Dir, ich Dir, Du mir,——wir?

Das gehört beiläufig nicht hierher!

Wer bist Du, ungezähltes Frauenzimmer, Du bist, bist Du?

Die Leute sagen, Du wärest.

Lass sie sagen, sie wissen nicht, wie der Kirchturm steht.

Du trägst den Hut auf Deinen Füssen und wanderst auf die Hände,

Auf den Händen wanderst Du.

Halloh, Deine roten Kleider, in weisse Falten zersägt,

Rot liebe ich Anna Blume, rot liebe ich Dir.

Du, Deiner, Dich Dir, ich Dir, Du mir,——wir?

Das gehört beiläufig in die kalte Glut!

Anna Blume, rote Anna Blume, wie sagen die Leute?

 Preisfrage:

 1. Anna Blume hat ein Vogel,

 2. Anna Blume ist rot.

 3. Welche Farbe hat der Vogel?

Blau ist die Farbe Deines gelben Haares,

Rot ist die Farbe Deines grünen Vogels.

Du schlichtes Mädchen in Alltagskleid,

Du liebes grünes Tier, ich liebe Dir!

Du Deiner Dich Dir, ich Dir, Du mir,——wir!

Das gehört beiläufig in die——Glutenkiste.

Anna Blume, Anna, A———N———N———A!

Ich träufle Deinen Namen.

Dein Name tropft wie weiches Rindertalg.

Weisst Du es Anna, weisst Du es schon,

Man kann Dich auch von hinten lesen,

Und Du, Du Herrlichste von allen,

Du bist von hinten, wie von vorne:

A———N———N———A.

Rindertalg träufelt STREICHELN über meinen Rücken.

Anna Blume,

Du tropfes Tier,

Ich——liebe——Dir!

O thou, beloved of my twenty-seven senses,
I love thine!
Thou thee thee thine, I thine, thou mine, we?
That (by the way) is beside the point!
Who art thou, uncounted woman,
Thou art, art thou?
People say, thou werst,
Let them say, they don't know what they are talking about.
Thou wearest thine hat on thy feet, and wanderest on thine hands,
On thine hands thou wanderest
Hallo, thy red dress, sawn into white folds,
Red I love eve Blossom, red I love thine,
Thou thee thee thine, I thine, thou mine, we?
That (by the way) belongs to the cold glow!
eve Blossom, red eve Blossom what do people say?
PRIZE QUESTION: 1. eve Blossom is red,
2. eve Blossom has wheels,
3. what colour are the wheels?
Blue is the colour of your yellow hair,
Red is the whirl of your green wheels,
Thou simple maiden in everyday dress,
Thou small green animal,
I love thine!
Thou thee thee thine, I thine, thou mine, we?
That (by the way) belongs to the glowing brazier!
eve Blossom,
eve,
E—V—E,
E easy, V victory, E easy,
I trickle your name.
Your name drops like soft tallow.
Do you know it, eve,
Do you already know it?
One can also read you from the back
And you, you most glorious of all,
You are from the back as from the front,
E—V—E.
Easy victory.
Tallow trickles to strike over my back!
eve Blossom,
Thou drippy animal,
I
Love
Thine!
I love you!!!!

It is now difficult to understand either the wide public response to the poem—it became almost a popular hit—or why Huelsenbeck should have taken such strong exception to it. But Werner Schmalenbach provides an answer to both of these questions, when he writes that "petty-bourgeois sentimentality is made fun of—but in petty-bourgeois language . . . Thus the poem could become a real love poem, a love poem in which grammar and vocabulary were tangled up not only because Dada demanded it but because the—pretended—intoxication of love demanded it."[33] Huelsenbeck thought that it revealed "an idealism made dainty by madness" and was finally "rather silly."[34] He found it not only lacking in aggression and truly deflating irony but the product of a taste actually attached to the most banal bourgeois values and the most romantic bourgeois sentiments, as well as mocking them—and so indeed it was.

"An Anna Blume" is both a Dadaist poem, with all its banalities and its nonsense, and a sentimentalized Expressionist one, for the bliss that goes with the banality is not entirely satirical. If the first name of this "simple maiden," Anna Blume, bespeaks her palindromic perfection, as Schwitters constantly reminds us it does, then, as Rex Last has noted, her second name inevitably recalls the Romantic ideal of the "Blue Flower," symbol of mystical aspiration to the infinite.[35] Moreover, as the imagery in the poem spins cosmically as well as comically around, it moves through a spectrum of primary hues only to come finally to rest on another color with even older primal associations. The heroine is described as a "grünes Tier" (a green animal). Green is the traditional German color of romantic love; and Anna additionally personifies the elusive, magical powers of nature,[36] which Schwitters opposes to those of the ordinary, rational world. He celebrates such powers even as he ironizes them by acknowledging that belief in them leads easily to sloppy bourgeois sentimentality.

He does not so much parody the Romantic ideal as transform it into the language of cliché, thereby both to reduce romantic love to a bourgeois consumer product and to withdraw from reality the bourgeois consumer object (Anna herself) into a private, pretend-world of romantic fantasy. The separateness of this world, moreover, is importantly a creation of the structure that Schwitters has woven from the 'nonsensical' fragments the poem comprises. Divided into three sections (each opened by a hyperbolic declaration of love), that tell of the poet's devotion to Anna Blume, of her appearance, and of her animal sexuality, the poem is in fact a structured, linguistically complex ode to the beautiful in the banal. In short, it is both ironic and idealistic, both avant-garde and bourgeois, like Schwitters himself.

When Paul Steegemann, who was Huelsenbeck's Hannover publisher as well as Schwitters', brought out later in 1919 an anthology of Schwitters' poems highlighting "An Anna Blume" in its title,[37] Huelsenbeck was obviously annoyed; and well he might have been, for on the cover of the anthology Schwitters had inscribed the word "Dada." 33 The public success of this "silly" poem was continuing, unabated. (By 1920 it had reached such a pitch that a pamphlet called *Die Wahrheit über Anna Blume* [*The Truth about Anna Blume*] was published as well as a collection of comments on the poem—and the streets of Hannover were plastered with posters of it.)[38] Huelsenbeck was frantically trying to publicize the Dada cause. Not only was Schwitters proving more adept as a publicist but he was coopting the Dada name in his campaign. Huelsenbeck's grievance

is understandable. But Schwitters in turn must have been annoyed when he was excluded from the signatories of a Dada manifesto published by his friend Christof Spengemann in the first issue of the Hannover journal *Der Zweemann* in November 1919, especially so because it was signed not only by Berlin Dadaists but by the Zurich Dadaists with whom Schwitters had established friendly relations, and because Schwitters himself had, with Arp and Tzara, helped to organize the issue in which the manifesto appeared.[39]

In December 1919 Huelsenbeck visited Hannover, and the two opponents finally met. "He disliked my fighting ways," Huelsenbeck wrote of the encounter, "and I liked his static, snug middle-class world even less."[40] Huelsenbeck's worst suspicions about Schwitters' bourgeois tastes were confirmed: "Here we had the German forest, and a wooden bench complete with hearts carved on it."[41] "He lived like a lower middle-class Victorian . . . we called him the abstract Spitzweg, the Kaspar David Friedrich of the Dadaist revolution."[42] It cannot have been a pleasant meeting.

Huelsenbeck learned from Schwitters that he had been trying to help Tristan Tzara to arrange for a special issue of *Der Zweemann* to be published that would comprise a selection of Tzara's writings—including some that Tzara had also submitted to Huelsenbeck for *Dadaco*, a Dada anthology that he, Huelsenbeck, was organizing with Tzara's cooperation.[43] "Kindly shed some light on this," he wrote tersely to Tzara, telling him, in effect, that he had to choose between the two projects. Schwitters' *Das Merzbild* was apparently to have been published in *Dadaco*. This was presumably Tzara's doing, for Schwitters had sent Tzara photographs of his work for inclusion in the Zurich Dada magazine, *Der Zeltweg,* and Tzara's role in *Dadaco* was to submit material representative of the Dadaists with whom he was connected.[44] Whether Schwitters' work would have survived Huelsenbeck's editing of *Dadaco* we cannot tell, for neither this anthology nor the special Tzara issue of *Der Zweemann* in fact materialized. What we can tell is that, after finally meeting Schwitters, Huelsenbeck seemed determined to isolate him from other Dadaists.

When, in May 1920, Huelsenbeck wrote the introduction for his *Dada Almanach*—which used some of the material collected for *Dadaco* and contained writings and manifestos by Dadaists of every persuasion—he made a point of officially repudiating Schwitters' association with the Dada movement: "Dada rejects emphatically and as a matter of principle works like the famous 'Anna Blume' of Kurt Schwitters."[45] Needless to say, nothing by Schwitters was included in the anthology. One of the reprinted items in the anthology, however, was a list of Dada "Presidents" taken from the February 1920 issue of the Zurich periodical, *Dada*—and Huelsenbeck must have missed the fact that Schwitters' name was included.[46] It is not usual to attribute editorial mistakes to the Dada principle of chance, but this one, perhaps, should be.

Huelsenbeck was successful in keeping Schwitters at least out of the Berlin Dada circle. His work was not admitted into the famous Berlin Dada Fair held at the Burchard gallery in June 1920. Indeed, one of the exhibits there (by Rudolph Schlichter) was entitled *Der Tod der Anna Blume* (*The Death of Anna Blume*). When Schwitters tried to call on George Grosz, he was refused entry.[47] In retaliation Schwitters had stickers printed for the cover of his volume of lithographs, *Die Kathedrale,* already in press. They read "Beware": "*Vorsicht: Anti-Dada.*"[48] He was preparing his counter-attack.

26

The counter-attack was written in December 1920 and appeared in the Munich periodical, *Der Ararat,* in January of the following year. Entitled "Merz," it was a confident and important statement about the development of the *Merzbilder* from Schwitters' earlier painting (some of these passages I quoted in Chapter 1); about the necessity of maintaining strict artistic discipline; and about the adaptability of the Merz principle to the widest of artistic activities. It was also an explicit dissociation on Schwitters' part from the socio-political tendencies of Dada, and from Huelsenbeck's views in particular:

> In his introduction to the recently published Dada Almanach, Huelsenbeck writes: "Dada is making a kind of propaganda against culture." Thus *Huelsendadaismus* is politically oriented, against art and against culture. I am tolerant and allow everyone his own view of the world, but am compelled to state that such an outlook is alien to Merz. Merz aims, as a matter of principle, only at art, because no man can serve two masters.[49]

Schwitters was not isolated from *all* the Dadaists in holding such views, and he went on to claim that Merz was in fact more true to the original spirit of Dada than Huelsenbeck's version of it. *Huelsendadaismus,* or husk Dadaism, was not, he wrote, the true, original Dadaism but merely a variety of it which, "amid loud howls, singing of the *Marseillaise,* and distribution of kicks with the elbows," had peeled away from the "core" Dadaism (*Kerndadaismus*) of Tzara and Arp: "Merz maintains a close artistic friendship with Core Dadaism Merz energetically and as a matter of principle rejects Herr Richard Huelsenbeck's inconsequential and dilettantish views on art." The "core" Dadaists were to be commended for maintaining "the good old tradition of abstract art." Huelsenbeck was "a man who lacks artistic judgment [and] is not entitled to write about art."[50]

The Zurich confrontation between Tzara's and Huelsenbeck's interpretations of Dada, as artistic movement versus medium for social change, was being revived by Schwitters to serve his own ends. And he had timed his attack on Huelsenbeck very well. The Dada Fair of June 1920 landed some of the Berlin Dadaists in court. Officers of the Lüttwitz Corps, affronted by one of the exhibits—the dummy of a German officer with a pig's head, bearing the slogan, "Hanged by the Revolution"—had sued for defamation. Instead of using the courts to defend their social ideals, the Dadaists had enrolled as principal defence witness Paul Schmidt of the Dresden Museum who, Hausmann writes, "had not much difficulty convincing the judge that all the dadaist horrors were only juvenile tricks, and easily forgiven practical jokes." Berlin Dada as a socio-political organization was discredited: "the formidable Trojan horse full of dangers was no more than an old thing tilting at windmills."[51]

The Dada alliance between the more art-oriented *Freie Strasse* group and more political Malik-Verlag circle, always somewhat uneasy, was broken. Schwitters seized his advantage and cemented allegiances with the former, particularly with Raoul Hausmann, while continuing his association with Arp and Tzara. Art, separated from direct social or political action, had carried the day. Huelsenbeck faded from the scene. In 1921, Schwitters and Hausmann made a lecture tour to Prague, advertised as "Anti-

Dada and Merz." The same year, both of them began contributing to Theo van Does-burg's *De Stijl* magazine. By 1923, in the second issue of his own magazine *Merz*, Schwitters was able to enroll Tzara, Arp and Van Doesburg (such was the new give-and-take that had developed) as signatories of a "Manifest Proletkunst" ("Prolet-Art Manifesto") that was against politicized art:

> Art is a spiritual function of man, which aims at freeing him from life's chaos (tragedy). Art is free in the use of its means in any way it likes, but is bound to its own laws and to its laws alone. The minute it becomes art it becomes much more sublime than a class distinction between proletariat and bourgeoisie.[52]

There will be more to say later on the assertively spiritual as well as formalist understanding of art Schwitters expresses here, and more also on Schwitters' specifically artistic contacts with Arp and Tzara as well as with the "artists" of the Berlin Dada group, and how through these contacts Dada in Germany elided into Constructivism. For the moment, however, it should merely be noted that although an official affiliation of Dada and Merz was never managed, in the final count the two cannot be totally separated. Schwitters clearly saw the relationship, and (excepting Huelsenbeck) so did the Dadaists, even the political ones; so too did the general public.[53] In the Germany of 1919, Schwitters' attachment to extra-artistic materials was a Dadaist characteristic, as was the seemingly illogical combination of disparate materials he favored. Likewise his interest in the broadly naive, nonsensical and primitive, which manifested itself in his drawings and writings as well as in his public behavior. All this was Dadaist, even if the level of Schwitters' commitment to the autonomy of art was not. He himself put it best, writing to Hausmann much later: "I was a dadaist without intending to be one." His so-called Dadaist characteristics, he said, were "the means for making art, art which is not dada, but the result of it."[54]

This was written in 1947. Even as late as that, Schwitters continued to write about his relation to Dada. He had hardly anything to say, however, about Der Sturm (other than dedicating some early poems to Sturm artists and writers),[55] although it was his affiliation with the Sturm group that helped to bring him public acclaim. From June 1919 until January 1923, when the *Merz* magazine appeared, Schwitters had contributed to *Der Sturm* approximately every other month, as well as producing a volume in the *Sturm-Bilderbücher* series, containing reproductions of his work. He was also in this same period contributing to other periodicals, as well as producing four volumes of poetry and prose;[56] nevertheless, he was mainly a Sturm artist. Werner Schmalenbach has called Schwitters a late Expressionist in Dadaist clothing.[57] Perhaps the point is best reversed and Schwitters might be thought of as practicing his own personal form of Dada as fine art within a late-Expressionist context. Schwitters' contact with Der Sturm preceded his Dadaism, and, in its multidisciplinary emphasis, prepared him for it—although its apolitical, purist stand and its spiritual understanding of art separated him from it. Perhaps Schwitters himself best expressed his relationship to the two groups in a lithograph in the 1920 *Die Kathedrale* portfolio, when he put the words "Merz" and "Sturm" together inside a rectangle with the word "Dada" just outside.

25

□ Schwitters' later silence on Der Sturm is understandable, however. Der Sturm may have been a major focus for Expressionist art, but it was a promotional rather than an artistic organization. Although there was a broad Sturm philosophy of art, there was no individual Sturm style in painting; Walden merely exhibited existing Expressionist art. There was, however, a Sturm style in poetry. Central to it was the *Wortreihe* or word-chain method, which placed great stress on the linking-together of "clenched" word-units in an alogical but assertively constructional way. This short poem from 1918 may serve for the moment to illustrate Schwitters' version of the style:

Ich werde gegangen	*I am went*
Ich taumeltürme	I whirl-heap
Welkes windes Blatt	Wilted winds leaf
Häuser augen Menschen Klippen	Houses eyes men cliffs
Schmiege Taumel Wind	Bevel whirl wind
Menschen steinen Häuser Klippen	Men stone houses cliffs
Taumeltürme blutes Blatt.	Whirl-heap bloods leaf.[58]

It was within this kind of format that the interposed "banalities" that characterize "An Anna Blume" and Schwitters' more personal poetic style first appeared. There will be more to say later about Sturm poetics in the context of Schwitters' writings in Chapter 5. What deserves notice now is their relationship to Schwitters' visual art, for Schwitters himself once claimed that poetry was the first of the arts of assemblage that he practiced and that it was by combining poetry and painting that Merz itself was born.

Writing in 1919 and 1920 about the changes in his art that produced the first assemblages, Schwitters clearly stated: "To begin with I concerned myself with other art forms, for example poetry. Elements of poetry are letters, syllables, words, sentences. Poetry arises from the interaction of these elements."[59] "As word is played off against word in poetry," he added, so in an assemblage or a collage, "factor is played off against factor, material against material."[60] Schwitters' first contact with the Sturm group had been with its literary side. He had fully absorbed the Sturm manner in his poetry before beginning to make assemblages. Given the suddenness of Schwitters' move into assemblage in the winter of 1918–19, it is reasonable to believe that his poetic experiments and knowledge of Sturm poetic theory were at least influential in creating this move. The Sturm idea of making poetry through the rapid juxtapositions and unfettered free associations of individual word-units and short phrases which first affect the reader as units of evocative sound rather than as units of commonsense meaning, and which gain new meaning by virtue of their accumulations, has obvious relevance to the art of pictorial assemblage too. As Schwitters wrote later:

In poetry, words and sentences are nothing but parts. Their relation to one another is not the customary one of everyday speech, which after all has a different purpose: to express something. In poetry, words are torn from their former context, dissociated [*entformelt*] and brought into a new artistic context, they become formal parts of the poem, nothing more.[61]

The *Merzbilder* were explained in exactly the same way.

This, of course, was written after the *Merzbilder* themselves had been created: such a direct relationship between the early poetry and the early assemblages may have occurred to Schwitters only in retrospect. Although he did talk of having first used the assemblage principle in poetry, one cannot be absolutely certain that he means he developed a poetic form and simply transposed it to his painting. What is certain, however, is his insistence that the assemblage principle was completely established only when he stopped thinking of poetry and painting in separate terms and began to fuse the two forms physically.

> My aim is the total work of art [*Gesamtkunstwerk*], which combines all branches of art into an artistic unit First, I combined individual categories of art. I have pasted together poems from words and sentences so as to produce a rhythmic design. I have on the other hand pasted up pictures and drawings so that sentences could be read in them. I have driven nails into pictures so as to produce a plastic relief apart from the pictorial quality of the paintings. I did this so as to efface the boundaries between the arts.[62]

Schwitters seems to be referring here, first to poems like "An Anna Blume," second to his collages, and third to his relief assemblages. But it is not entirely clear that the first of these categories refers exclusively to poetry, for although Schwitters' poetry of 1919 does create a rhythmic juxtaposition of elements, it hardly produces "a rhythmic design" and therefore does not efface the boundaries between poetry and design. However, some of the forms of graphic art that Schwitters began making early in 1919 do combine, to varying degrees, the literary and the visual. This early graphic art is divisible into two bodies of work: what are usually called Dadaist drawings and rubber-stamp drawings. The rubber-stamp drawings literally combine typographical and graphic forms. The Dadaist drawings that precede them do not consistently do so. However, they occupy a very similar place in Schwitters' *oeuvre* to "assembled" poems like "An Anna Blume."

33 One of these drawings in fact decorated the cover of *Anna Blume. Dichtungen*, Schwitters' first book of collected poetry, when it appeared in 1919.

II, 30, 34, 134 If drawings like this are indeed to be described as Dadaist, they are, nevertheless, not yet truly Merz, for like the transitional Sturm-Merz poems they involved the addition of (this time visual) banalities to what is still a basically Expressionist structure. As such, they extend the preoccupations of Schwitters' Expressionist chalk drawings and abstract oil paintings of 1917–18 discussed in Chapter 1; indeed, a number of them reuse (and, of course, revise) the church motif of his Expressionist paintings. I referred in Chapter 1 to two abstract prints of 1919 which relate very closely to the Expressionist paintings: a

21 woodcut published in *Das Kestnerbuch* and a lithograph which appeared in the Novem-
22 ber 1919 issue of *Der Zweemann*, the latter being specifically machinist in subject-
33 matter. Comparison of the *Zweemann* lithograph and the cover illustration for *Anna Blume. Dichtungen* shows how Schwitters' Expressionism has been opened to include new iconographic motifs: in the latter work, a naively drawn toy train chugs along what in the former work are Expressionist lines of force.

Schwitters obviously thought of these "Dadaist" drawings as constituting a distinct genre since he prefixed most of their titles with the designation "*Aq.*" (for *Aquarell*)—most of them are watercolors—just as he had prefixed the titles of his earlier chalk

drawings with "*Z*" for *Zeichnung*. (The prefix "*Mz*," for *Merzzeichnung*, was reserved for the collages.) There were probably around forty of them, all from 1919 and 1920, not including book-cover designs and magazine illustrations; not all are watercolors, but all clearly belong to the same genre.[63] Some are purely abstract; one is almost straightforwardly realistic. The majority, however, introduce into Schwitters' visual work for the first—and with few exceptions the last—time a fantastic, and at times almost insane, subject-matter of windmills, buckets, trains, fish, churches, houses and pin-figures, which together form a chaotic, invented world. Women are transformed into bottles, upside-down figures stroll like flies across ceilings, houses and churches grow pigs' tails and change into little trains which slide over crudely drawn cog-wheels and down steeply inclined lines of force.

Titles like *Aq.1 Das Herz geht vom Zucker zum Kaffee* (*The Heart goes from Sugar to Coffee*) reinforce the oddness of this invented world, while suggesting that a kind of logic lies behind it. In effect, Schwitters dissociates objects from their normal contexts only to weave them into odd little narratives, whose meaning we grasp—insofar as we do grasp it—though the dual mechanisms of synecdoche and metonymy. Each element in a drawing is a substitute (by metonymy) for the larger object referred to; each element tells (by synecdoche) of the world, domestic or industrial or quaintly archaic, from which it was taken; and each drawing usually tells of more than a single world. But when we see a number of things presented together we tend to look for affinities, or causal connections, between them and thereby discover in each of these drawings a fictional universe in which the original functions and meanings of the objects it contains have been altered. "In the world in which Anna Blume lives . . . ," Schwitters wrote of the cover of *Anna Blume. Dichtungen*, "people walk on their heads, windmills turn and locomotives run backwards, [and] Dada also exists."[64] As we see in the bottom left corner of *Das Herz geht vom Zucker zum Kaffee*, Schwitters himself appears in this world too. In its composition of lines and circles it resembles his earlier paintings and drawings—and his contemporaneous assemblages—but in its content it is indeed the world of "An Anna Blume" and other Schwitters writings of this same period.

These drawings seem to reveal familiarity with work by other Dadaists, including the mock-machinist drawings of Francis Picabia and the drawings and prints of fantastic constructions by Max Ernst—though neither of these artists presented such anomalous juxtapositions as Schwitters did.[65] It is more than likely that some of George Grosz's drawings and watercolors of tumultuous and irrational city life lie behind Schwitters' venture into the fantastic.[66] Perhaps it was the lighter side of Grosz that influenced these works, for Schwitters always eschewed the aggressive in Dada for its nonsensical aspects. As he wrote:

> I play off sense against nonsense. I prefer nonsense, but that is a purely personal matter. I feel sorry for nonsense because up to now it has so rarely been artistically molded; that is why I love nonsense. Here I must mention Dadaism, which like myself cultivates nonsense.[67]

But not only the Dadaists cultivated nonsense, and Schwitters' precise rendering of it in these drawings probably owes much to two non-Dadaist influences. First, to the work

II

28
27

32

59 of Paul Klee, with whom Schwitters had exhibited in January 1919. The combination in certain of Klee's earlier drawings and prints of a Cubo-Expressionist formal matrix and whimsical figurative imagery was surely important for Schwitters' experiments in a similar direction in 1919. Second, to the work of Marc Chagall (whose dealer in Germany was Herwarth Walden). In *Anna Blume. Dichtungen*, Schwitters published a poem "An eine Zeichnung Marc Chagalls" (To a Drawing by Marc Chagall)".[68] The

36 drawing in question appears to be Chagall's *Der Trinker* (*The Drinker*) of 1913, where the floating head and bottle, and generally irrational disposition of forms, directly anticipates Schwitters' "Dadaist" drawings.

Some of the drawings of 1919 and 1920 have numbers, words and phrases inscribed across them in Schwitters' hand: "31," "Anna Blume," "Franz Müller," and so forth. On other drawings, among the usual eccentric paraphernalia, are printed renderings of labels and rubber stamps. Works such as these all relate to a distinct group of contemporaneous drawings which use drawn linear elements together with stamped-on words and phrases (and occasionally pieces of pasted-on paper), and which directly combine the visual and the (broadly) poetic. In so doing, they gradually escape the distinctly literary and anecdotal connotations of the Dadaist drawings. At least, they bring the literary and the visual so firmly together as to create a new and quite personal medium. Schwitters undoubtedly realized that he had discovered a new medium in making these works, for he continued to produce them into the 1920s (some date to 1923). Some of them are not easily separated from his purely typographical collages and from examples of what he called his *i-Zeichnungen* (*i*-drawings)—carefully cropped details from printers' reject material—that he made from 1920 onwards.[69] And, of course, the use of words and phrases together with other materials was to play a consistent part in many of his collages; while his abstract or "concrete" poems of the mid 1920s, and typographically complex books of the same period, can likewise be seen as developing from this same source. Particularly for what they generated later, these are important works in Schwitters' artistic development.

31, 138 The rubber-stamp drawings form three general groups.[70] Those in the first, and probably the earliest (dating mostly from 1919), contain images similar to those in the Dadaist drawings, though now more openly distributed across the sheets and complemented by the patterns of the repeated rubber-stamp phrases. Second, a group of

29 fifteen drawings reproduced in Schwitters' *Sturm-Bilderbuch IV* of 1920. Some of these resemble the drawings of the first group; others, however, instead of seeming to contain two distinct sets of structural elements (stamped-on phrases and Dadaist drawing), use only fragments of applied drawing, which are now largely subordinated to the typographical elements themselves, to create a far less anecdotal effect. Moreover, among the stamped-on words and phrases are pieces of stamp edging, small price tags, circular rubber stamps, and occasionally pieces of cut and torn paper. To a large extent, these take the place of the earlier drawn elements, and although they are often reinforced by hand-drawn marks (circular stamps changed into cog-wheels, lines into levers, and trains and windmills rested on these lines), the effect of these works is not only more inherently abstract than the others but as close to that of collage as of drawing. The third

38 group of rubber-stamp drawings (nearly all later ones, from 1923) dispense entirely with

hand-made additions, but since they also, generally speaking, dispense with anything other than repeated, stamped phrases they seem far closer to Schwitters' abstract poetry of the mid 1920s than to his collages.

In suggesting this three-part division of these works, I inevitably exaggerate their differences. Although the earlier drawings are most Dadaist in effect, there are only a few of the later ones which escape being humorous—either in their added drawing or by some distinct witticism in the use of the pictorial language itself. Here again, though, the earlier ones depend far more on their drawing for their humor, as with the absurd animal in *Komisches Tier* (*Funny Beast*) of 1919, reminiscent in some respects of Klee, while the later ones are "drawn" by stamped-on elements themselves. Hence, for example, the punning of circular stamps and cog-wheels, joined by stamp-edge levers. Hence also, in *Der Kritiker* (*The Critic*) of 1921, the use of nine repeated Der Sturm's for the critic's hair, while from below his mouth streams "Walden Herwarth Walden Herwarth Walden Herwarth Walden . . ." In the earlier drawings, the reciprocal balance of nonsense drawing and seemingly irrelevant phrases from the rubber stamps—"Drucksache" (Printed Matter), "Berlin-Friedenau," "Belegexemplar" (Voucher Copy), and so on, most of them presumably borrowed from the Sturm mail-room—creates an effect not too dissimilar to that of some of Schwitters' Dadaist book-cover designs. It could well be that Schwitters' interest in typography, which dates from the time of these first cover designs, also motivated the rubber-stamp drawings. Certainly, it is fast becoming difficult to dissociate the separate aspects of Schwitters' art.

Both book designs and rubber-stamp drawings reveal familiarity with contemporaneous Dada work. The "Club Dada" issue of *Die freie Strasse* and Hausmann's first poster-poems and manifestos on the expanded use of new materials, all dating from 1918, prepare for Schwitters' typographical experiments.[71] Moreover, not only was Schwitters aware of Berlin Dada work from early 1919, but in May 1919 he wrote to Tzara in Zurich thanking him for sending "Dada leaflets."[72] *Dada 4–5* was published that month, with a title-page of cog-wheels and abstract lines by Francis Picabia, while three months earlier Picabia's Zurich issue of *391* had been produced.[73] Picabia's influence does seem to be a dominant one in many of the rubber-stamp drawings: not only in the machinist emphasis but in the way (as in much of Picabia's work) the lettering is scattered across the sheets to form a series of definite, linear patterns mirroring the linearity of the hand-made drawing. This is in sharp contrast with the heavier, more static rhythms of Berlin Dada designs. However, Schwitters' interest in typography in a visual-poetic context does not necessarily require Dadaist precedents. Given his Sturm contacts and his own practise of poetry, it is all but certain he knew of Marinetti's *Parole in libertà* and probably Guillaume Apollinaire's *Calligrammes* as well.[74] In addition, Christian Morgenstern's *Galgenlieder* volume of 1905 was familiar to the German avant-garde (the Berlin Dadaists certainly knew of it).[75] The famous "abstract" poem, "Fisches Nachtgesang" ("Fish's Nightsong") must have appealed to Schwitters, for its humor as well as for its daring form.

Whatever the external sources of these drawings were (and it is impossible to specify them exactly, since visual-poetic experiments were becoming commonplace in avant-garde activity by 1919), Schwitters' own personal touch is still very evident: not only in

35, 37

24

28

40

the naive humor but in the schematic, Expressionist-derived drawing (never quite as diagrammatic as Picabia's). Nevertheless, something had changed since the Expressionism of 1918, and Schwitters' involvement with visual-poetic experiment does seem in part to have produced it. I have already mentioned (Chapter 1) Schwitters' knowledge of Cubist-based art since the end of 1917. In 1919, a second and different kind of Cubist charge galvanized his art; it derived from Cubist poetics and Cubist interest in typography, for these were the ultimate sources of most avant-garde poetic experiments.

In Schwitters' paintings and drawings of 1918, his version of Cubism meant two things: angular, stylized forms, and a flattened surface divided between coarse drawing and painterly surround. Nowhere in the early work, however, does one recognize anything of the Cubists' keen and sensitive awareness of the semantic function of their painted marks, which was as integral a part as any of the Cubist style. Schwitters' marks, in contrast, were crude reductive images, simplifications of the basic forms of observed data. Seeing the rubber-stamp drawings, however, and being confronted with the various alphabetical and numerical symbols, "one realizes that the arcs and planes surrounding them are also to be read as symbols, and they are no more to be considered the visual counterparts of reality than a word is to be considered identical with the thing to which it refers."[76]

This was written of the typographical components of Cubist painting, and although Schwitters uses his typography to far more whimsical effect than did the Cubists, one is forced to conclude that his experiments with words as meaningful units, to be assembled in poetic-visual form, were as crucial to his development of collage as the Cubists' use of typography was to theirs. Certainly, Schwitters' development from Sturm poetry to rubber-stamp drawings assisted that crucial change in his art early in 1919 from the abstracted representation of reality to the presentation of reality through token symbols in the assemblages and collages.

All this was achieved, as Schwitters said, because he wanted "to efface the boundaries between the arts."[77] And yet, no sooner had the poetic and the visual been brought together than they were sent their own separate ways. The rubber-stamp drawings led Schwitters into a new and surprising kind of poetry, as 1923 "drawings" like *Bussum* show. The principles they employed, however, were certainly important for the collages. In the *Kathedrale* portfolio of prints of 1920, Schwitters juxtaposed linear Dadaist works, close in effect to the rubber-stamp drawings, with a group of marvelously inventive prints, made with pieces of shoe leather and fragments of patterned paper, and stylistically similar to certain of Arp's early collages. The materials in these and other similar prints are used as much for the patterns created by their edges as for their surface shape; but they show, for the first time in Schwitters' graphic art, the beginning of a turn away from Expressionist-derived linearity and toward the consistent use of flat, intuitively juxtaposed materials which characterizes his mature collage style. These works seem somewhat unresolved in their balance of line and plane; but Schwitters made this very irresolution work for him in a highly dramatic way in the group of large assemblages he began to make in the winter of 1918–19. These early *Merzbilder* are perhaps the greatest of all his works.

38

39, 41

□ "At the end of 1918," Schwitters wrote, "I realized that all values only exist in relationship to each other and that restriction to a single material is one-sided and small-minded. From this insight I formed Merz, above all as the sum of individual art forms, Merz-painting, Merz poetry."[1] There is some circumstantial evidence that the first assemblages—the "most characteristic" of which, *Merzbild,* gave Merz its name— were made at the end of 1918.[2] The earliest we know, however, are dated to 1919. It seems unlikely that any were completed by the time of Schwitters' January 1919 exhibition at the Sturm gallery—unless he chose not to show them then. At least five, and probably more, were in existence by the end of April 1919.[3] They were first exhibited at the Sturm gallery in July 1919.[4] It was from the time of this exhibition, moreover, that we find the earliest writings on Schwitters' new work. Walter Mehring reviewed the show in *Der Cicerone,*[5] and in a subsequent issue of the magazine, the Hannover critic Christof Spengemann (who had previewed Schwitters' work in *Das hohe Ufer* in June)[6] wrote the first major text on his friend's work, illustrated by *Abstraktionen,* Dadaist drawings and *Merzbilder.*[7] In *Der Sturm* in July, Schwitters himself published a short statement, entitled "Die Merzmalerei," describing the principles upon which his new pictures were based.[8]

As with his earlier paintings and drawings, Schwitters used a numbering system for many of the assemblages as well as giving some simply descriptive titles. Although his system is somewhat complicated, and not altogether consistent, it allows us to establish a rudimentary chronology for these works, and additionally shows us that Schwitters made a distinction between relief assemblages (whose titles he came to prefix with the letter "A") and works which are technically large collages (prefixed with the letter "B").[9] In considering these works, therefore, it is appropriate to follow Schwitters' lead and deal separately with the two groups as we follow their progress in 1919 and then in 1920, the two great years of their production. It first needs saying, however, that the two groups do belong together stylistically. They share the same formal vocabulary; their effects and moods are often very similar; and they emerged at the same time. Although Schwitters considered the reliefs the more characteristic—and they are in fact in the majority—he clearly worked in both areas simultaneously without feeling that one was subordinate to the other. At least, he did so in 1919 and into 1920, after which the two forms began to combine. Since the reliefs outlasted the large collages, and eventually absorbed some of their features, it is as well to commence with these, the most dramatic of Schwitters' early works.

□ Although some of the relief assemblages are very small, the majority are quite consistently larger than any of Schwitters' previous paintings. Most are 30–40 inches (75–100 cm) high and 20–30 inches (60–75 cm) wide. The largest, *Das Arbeiterbild* (*The Worker Picture*), is just short of 50 inches (125 cm) high. In 1919 the scale of Schwitters' work moves almost beyond the normal cabinet-picture context. It was not only increasing in size: he was simultaneously making very small collages. But in both cases he seems to have deliberately chosen a format, as well as a medium, other than that of traditional easel painting. And yet, his assemblages are certainly still dependent upon the forms of easel painting as Schwitters himself had earlier practiced it, and it is not at all surprising that this is so. Up until the end of 1918, the direction of his art lay very firmly within the context of oil painting. His concern with what he called "adjustments," although prefiguring the manipulative form of the assemblages, was essentially with impasto, with touch, and with the organization of a wet painterly surface. When he moved into assemblage it was only natural that he transferred these same concerns to the new medium. Assemblage, however, is in principle a "dry" medium: a medium of discrete material units placed on surfaces, put into pictures and not actually created within them: the picture is a container in a way no handmade painting can ever be. Assemblage is also an art of synthesis, stressing composition, construction and the external control of the work rather than the inventions and nuances of the artist's hand. It is of major importance to an understanding of Schwitters' work to keep in mind that he came to assemblage from the "wet" processes of oil painting. This largely dictates the character of his early works in the new form, and its implications are never quite absent from any of his assemblages.

We have already seen how, by the end of 1918, Schwitters had created a simplified painterly style organized by means of strident dark lines. It is in this setting that the earliest assemblages appear: they are best described as hybrid paintings modified to contain extraneous material. Indeed, Schwitters' first statement about his new work dealt precisely with this issue: how materials added to paintings could function analogously to purely painted forms. Published in the July 1919 issue of *Der Sturm* under the telling title, "Die Merzmalerei" ("Merzpainting"), it is not only Schwitters' earliest but also his clearest and most coherent pronouncement on the principles of his assemblages; it deserves quoting virtually in full.

> *Merzbilder* are abstract works of art. The word Merz denotes essentially the combination of all conceivable materials for artistic purposes, and technically the principle of equal evaluation of the individual materials. *Merzmalerei* makes use not only of paint and canvas, brush and palette, but of all materials perceptible to the eye and of all required implements. Moreover, it is unimportant whether or not the material used was already formed for some purpose or other. A perambulator wheel, wire-netting, string and cotton wool are factors having equal rights with paint. The artist creates through the choice, distribution and metamorphosis of the materials.
>
> The metamorphosis of materials can be produced by their distribution over the picture surface. This can be reinforced by dividing, deforming, overlapping, or painting over. In *Merzmalerei*, the box top, playing card and newspaper clipping become

46

surfaces; string, brushstroke and pencil stroke become line; wire-netting becomes over-painting or pasted-on greaseproof paper becomes varnish; cotton becomes softness.

Merzmalerei aims at direct expression by shortening the interval between the intuition and realization of the work of art.[10]

The three crucial factors in the creation of the assemblages, then, are the choice of materials, their distribution and organization over the picture surface, and their metamorphosis (*Entformung*) into purely formal elements. By *Entformung*, Schwitters means that just as in a painting a handmade mark becomes a line, so does a length of string or wire in a *Merzbild,* and so on. This does not preclude the use of handmade marks. Since found and fabricated elements function analogously, they can be used together. However, Schwitters clearly came to prefer found to fabricated forms, and was more successful when he kept to them.

One of the first *Merzbilder,* if not indeed the very first, was *Merzbild 1A. Der Irrenarzt* (*The Alienist*).[11] Schwitters sometimes chose deliberately misleading titles for his works to make the point that "the title has no connection with an abstract picture."[12] In this case, however, the picture is clearly not abstract—despite what was said in the *Der Sturm* article—and the title seems designed to encourage a reading of this work not only as a portrait but as a portrait of a psychiatrist, whose head is filled with the jumbled debris of his patients' obsessions—perhaps Schwitters'. Or perhaps Schwitters himself is the psychiatrist (the profile is not unlike that in the contemporary drawing, *Das Herz geht vom Zucker zum Kaffee*), and he is analyzing the debris for the meanings it can reveal. 43

II

Writing about the early *Merzbilder,* Schwitters' friend Christof Spengemann pointed out—presumably after discussion with the artist—that the "soul" of the work was much more important than its visible aspects.[13] In any event, the possibility of such readings of *Der Irrenarzt* is due to the fact that materials do not so much become directly abstract elements as imitate the functions—many of them representational—that painted elements hitherto fulfilled. A piece of shaped wood stands for the subject's collar, and a circular board for his cheek. And if the cigarette especially catches our eye, it is partly because—unlike the other elements of the picture—it is at one and the same time representational and real. In the *Der Sturm* article, Schwitters suggests that both found and fabricated elements have a kind of common ground as pure form; but he also says that they have their own individual characters, and that found elements have, as he puts it, equal rights with painted ones. In *Der Irrenarzt* this is not really what happens. Schwitters achieves *Entformung* not by asking us to see the various materials as pure forms, but by making them look like painted ones, and therefore pure. In consequence, most of the found materials lose something of their own character.

Schwitters was to insist that what he called the *Eigengift* of materials, their own special essence or poison (the word *Gift* carries both meanings), had to be abandoned when they were put into pictures.[14] But he meant by this not that they should function as if they were some other kind of material (i.e. paint), rather that their *Eigengift* should be lost in their *Entformung* itself. All materials, he said, have to be used "on an equal footing," and all "lose their individual character, their own essence, by being evaluated against each other; by becoming dematerialized they become material for the picture." The work of

art comes into being through the artistic evaluation of its elements . . . only forming is essential."[15]

Der Irrenarzt is close in spirit to Schwitters' Dada ink drawings and watercolors, examples of which were included in the July 1919 Der Sturm exhibition. Also in the exhibition was the picture that Schwitters considered the most typical of his new works, *Das Merzbild* itself. In Schwitters' account of the discovery of Merz (quoted at the beginning of Chapter 1), he mentioned *Das Merzbild, Das Undbild* (*The And Picture*) and *Das Arbeiterbild* (*The Worker Picture*) as examples of how the principle of Merz was first manifested. *Das Merzbild* is lost,[16] but from photographs we can conjecture why Schwitters chose this as the work after which the new approach should be named. It represents a middle position between the large, openly distributed *Das Arbeiterbild* and the smaller, more tightly constructed *Das Undbild*. The mysteriousness of its identifying word-fragment obviously influenced Schwitters' decision—and, initially at least, he withheld the source of the name "Merz"[17]—but it is, in fact, the characteristic work.

The most impressive work in the July 1919 exhibition, however, was *Das Arbeiterbild*. This is remarkably close in format to the *Abstraktion, Entschleierung* of the previous year, a purely painted work; except of course that the linear scaffolding is now composed of non-artistic materials. As befits the size of this assemblage, the materials used are similarly large: long planks and strips of wood, a wooden disk some twenty inches in diameter, part of an even larger wheel, large flat pieces of wood and cardboard and some chicken-wire. By nailing high-relief objects, some of which actually cast shadows because of their considerable bulk, on to a surface composed of flatter materials, Schwitters extends the principle of a complementary two-part structure of image and ground established in the earlier, purely painted work.

There is, however, a mediating picture in this respect, namely *Das Kreisen* (*Revolving*) of 1919. In this work, very narrow linear elements—rope, wooden and metal hoops—are used, and only a small number of planar materials. The ground is kept free of the kind of rectilinear and angular forms that appear in *Das Arbeiterbild,* and is painted in a soft tonal manner. In addition, the planar materials are all circular and also painted in the same way, in order to create an effect of diagonal lines and circles suspended across a "painterly" ground, and at times seemingly embedded into it. This is a direct transposition of the painted linearism of *Entschleierung* into real materials. But, of course, this transposition brings with it a complete change of effect. The thin linear materials are far crisper than were the roughly painted lines. The work is flatter, and spatially more upright. In this respect it bears comparison with certain of Chagall's earlier paintings, especially his *Half Past Three* (also known as *The Poet*) of 1911, which was hanging in Herwarth Walden's apartment when *Das Kreisen* was made.[18] Schwitters referred to his own chronological place in Der Sturm as following Chagall.[19] Chagall's combination of circular and angular forms, albeit in a figurative-based composition, directly prefigures Schwitters' assemblage style. Although the principal source of Schwitters' *Merzbilder* is his own earlier paintings—themselves influenced by Cubist, Futurist and Expressionist art—the collage-like treatment in the top right-hand corner of *Half Past Three* may perhaps have suggested to Schwitters how real materials could perform analogously to painted elements.

It is tempting to assume that, since *Das Kreisen* falls stylistically between *Entschleierung* and *Das Arbeiterbild*, this is the order in which these three works were made. However, artistic development is not as logical and linear a process as we might imagine. *Das Kreisen* may well be from later in 1919, for it seems to relate to a poem by Schwitters, dedicated to the Sturm painter, Johannes Molzahn (with whom Schwitters had exhibited in January 1919), and published in the December 1919 issue of *Der Zweemann*.[20] The poem was prompted by a hostile review of Molzahn's work. It draws on the cosmic themes of "Das Manifest des absoluten Expressionismus" ("The Manifesto of Absolute Expressionism") that Molzahn had published in September 1919,[21] and refers to the title of a 1918 Molzahn drawing published on the cover of *Der Sturm* in June 44 1919: *Kreisen*.[22]

Kreisen Welten du.
Du kreist Welten.
Du überwindest zwitschern Apyl den Wassern die Maschine.
Welten schleudern Raum.
Du schleuderst Welten Raum.
Welten wenden die neue Maschine dir.
Dir.
Du deiner die neue Maschine Raum.
Und Achsen brechen Ewigkeit.
Das Werk, dem wir, uns Erbe, du.

Turning worlds thou.
Thou turnest worlds.
Thou subduest chirping Apyl to the waters the machine.
Worlds hurl space.
Thou hurlest worlds space.
Worlds turn the new machine to thee.
To thee.
Thou, thine the new machine space.
And axles break eternity.
The work, to which we, to ourselves heir, thou.

This is interesting not only because it helps to date *Das Kreisen* more precisely but because it casts light on the emotive meaning of this picture. Walter Mehring's review of the July 1919 exhibition pointed out that Schwitters was making a kind of "expressionistic genre-art"—a "trash-romantic" art that transcends Picasso's collages by allowing materials to carry a sensual stimulus akin to that found in primitive art.[23] Christof Spengemann's review said that the most important aspect of the pictures was their feeling of "cosmic harmony," and that Schwitters was preoccupied with universal themes as much in these new works as in his earlier abstractions after nature.[24] Schwitters' poem confirms interpretations of this sort, and further suggests that the cosmic harmonies he had previously found in nature he now finds in the noisy apparatus of a world dominated by machines.

V, 23

43

It was in large part the functional similarity between the physical "lines" and "circles" in *Das Kreisen* and the painted lines and circles in works like *Entschleierung* that allowed Schwitters to directly transpose the cosmic Expressionist ethos of his paintings into this particular assemblage. As a structural method, however, it somewhat inhibits the separate life of the materials that *Das Kreisen* contains. In *Der Irrenarzt,* Schwitters had used found materials in imitation of representational painted forms. In *Das Kreisen,* the representational element is removed, but the imitative one remains: the materials are replacements for, and are composed in imitation of, the earlier painted forms. Schwitters was deeply concerned with the problem of converting his found, non-artistic materials into art, and his tendency to fit them into *a priori* compositions, derived from earlier painting, is explicable in this way. But at the same time, he was also determined to consolidate Merz as a new kind of art, quite separate from previous movements in art and their compositional methods—indeed, quite separate from painting itself. He does this, naturally enough, by increasing the proportion of the added materials and by stressing their physical nature. This does not, however, entirely solve his difficulties. The assemblages as a whole reveal spatial and semantic ambiguities according to how their materials are used, and these ambiguities all contribute to the central dilemma: how can works so dependent upon *a priori* structures derived from painting ever create for themselves a coherent identity?

The "lines" and "circles" in *Das Kreisen* are analogous to painted lines and circles; however, being physical in a way painted lines are not, they inevitably push themselves forward into the perceiver's space, establishing themselves as belonging as much to the world outside as to the plane to which they are fastened. That is to say, the implication of a complementary forward-backward structure, visible in the painted work, is exaggerated. This picture is unavoidably a kind of abstract theater of forms, which inhabit rather than actually create the pictorial space; none of the assemblages escapes this effect. But what would seem somewhat unresolved in an exclusively painted work is justified in pictures that are in essence "containers." Moreover, Schwitters has modified too blatant a figure-ground effect by carrying oil paint over and around the relief elements, thus camouflaging them back to the plane. And the physicality of the whole picture as an *object* makes its suspended materials belong. The rough burlap surface and the inclusion of the frame as part of the composition (an innovation that Mehring's review applauds)[25] are both crucial in this respect.

46

Das Kreisen, moreover, remains the baldest of the early assemblages: increasingly, Schwitters admitted materials of widely varying degrees of relief, some of which, therefore, have spatially (and hence connotatively) ambiguous functions. In *Das Arbeiterbild,* not only are the bold "lines" created by wide planks rather than by rope and wire, which therefore offsets the draftsmanlike effect (which dominates *Das Kreisen*), but Schwitters has introduced a whole group of angular wooden planes to help mediate them with the surface. Color is again used to camouflage the elements together, although at times it has an opposite effect, appearing to float certain forms clear of the surfaces on which they are placed. Moreover, Schwitters has reserved the mediating planes for the lower half of the picture, anchoring the elements towards the top only by applied painting. This method is developed to particularly dramatic effect in the finest of the 1919

group of assemblages, the *Konstruktion für edle Frauen* (*Construction for Noble* VII
Ladies).

This is a slightly smaller picture than *Das Arbeiterbild*, but the effect is far more grandiose, and largely because more materials are used. *Das Arbeiterbild* presents a bold geometric effect, but still an imposed linear one; in the *Konstruktion*, however, the same bold linearism is manifestly more contained in a rich claustrophobic multitude of materials of widely differing sources and sizes. Juxtaposed elements, similar in form, but varied in bulk, work to grade through the space, except where they cross the darkly painted (and hence deeply hollowed) areas of exposed ground which set them in relief. Because the picture is dominated by tall green-painted planks, joined together like pseudo-functional levers with fragments of wheels attached to them, the effect is partly of a neo-Picabian machine of weights and balances standing on the bottom of the frame.

There is also a comparison to be made with certain of Archipenko's earlier constructions, such as his *Femme à l'éventail* (*Woman with Fan*) of 1914, which likewise makes 64
use of the tension set up between elements of considerable relief (including found objects) and the painted box-like space to which they are adjusted. Of course, Schwitters' work is far more inherently abstract than Archipenko's, but Schwitters did single out this artist as an important influence,[26] and both of their works share an involvement with bracing relief elements against the perimeters of a picture-frame contained space.

This acceptance of the traditional "frame" of painting is important to Schwitters' early assemblages, and separates them, for example, from the Cubist constructions of Picasso, which he almost certainly knew, if only in reproduction.[27] Indeed, he could have known a rare Picasso construction that was made within a traditional frame. By and 63
large, however, Picasso's constructions read as relief sculptures or objects, whereas Schwitters' are relief pictures. In this respect, they resemble Max Ernst's few Dada reliefs, such as the famous *Fruits of Long Experience,* which is contemporary with the 65
Merzbilder. It was only after his affiliation with Constructivist artists in 1922 that Schwitters began to think of escaping the traditional picture frame. Only one early relief does so (an untitled work of 1921); and that, as we shall see, was influenced by Constructivist art. In *Konstruktion für edle Frauen,* Schwitters emphasizes the frame by fixing to it 70
the materials in highest relief, thus to emphasize the holistic, enclosed identity of the picture itself. "Only in a limited space," he once wrote, "is it possible to assign compositional values to each part in relation to other parts."[28] For a picture to seem other than a sampling of found elements from the world at large, these elements had to be made to belong to their new context.

This is not to suggest that when Schwitters made these works he thought only of formal or esthetic problems. His own writings stressed the esthetic and played down the iconographic; it is clear, nevertheless, that a number of the *Merzbilder* admit specifically iconographic interpretations, and I will shortly be suggesting some readings of this kind. It is also clear, thanks to a letter that Schwitters wrote on this subject,[29] that a kind of improvisatory free-association method dictated the choice of the materials he used. Writing in English in 1946 about his early pictures, he said first that he worked "out of the material; and *with all relationships* which are connected with the material." It is possible to assume that he meant all the formal relationships the materials suggested.

However, the example he gives of this in practise—in the creation of *Konstruktion für edle Frauen*—reveals that he had more than this in mind:

> If you looked carefully you would see 7 women's heads on the picture. When I had almost finished, I knew that there was lacking something. I went into the Eilenriede, the town forest of Hanover and found there half of the engine of a children's train. I knew at once, that belonged on the picture and put it at the right spot. But where was the other half engine? I got quite uncomfortable, because I could not finish the picture without having the other half. I went in the opposite direction of the Eilenriede into the Masch, not a forest, but meadows. The first thing I saw was the second part, the opposite side of the same children's engine. Of course I don't know what was the reason that I at all needed the ruins of the children's toy, but there is a reason, and this reason made the composition of spiritual values correspondent to the composition in colours and to the composition in lines and black and white. You must feel that, then you feel also that the picture is ready and is a *construction for distinguished ladies*, eminent ladies.

I have been unable to find *seven* women's heads in the picture, but the two parts of the child's engine are certainly there. The Eilenriede in Hannover contains not only the city's zoological garden but also the Wilhelm-Busch-Wiese, a meadow named for that famous humorist of the city's past. The Maschpark, by contrast, contains the town-hall and the Kestner-Museum, and abuts the Landesmuseum—and the Sprengel Museum with its plaza that bears Kurt Schwitters' name. His walks around the city were not entirely aimless, it seems. The impossible coincidence of his story is reminiscent of Wilhelm Busch, and it gains something as a story once we realize that it was in museum-territory that the final piece of this artistic puzzle was found. What the story mainly tells us, however, is that Schwitters sought out specific objects, with particular emotive associations as well as esthetic values, in order to construct his pictures, and that a picture was considered finished only when the emotive and esthetic content seemed to correspond.

Schwitters did not know, he tells us, the reason he needed that child's toy to finish *Konstruktion für edle Frauen*. But there was a reason, and it was what brought the emotive and esthetic content of the picture together. It is tempting to speculate— and the thought quickly comes to mind that this image of childhood was especially appropriate in a construction for ladies that otherwise seems dominated by machine-like forms. And yet, we cannot know this any more than Schwitters could. What we do know, from Schwitters' story, is that his combination of anomalous materials is not due to a love of the paradoxical or the chaotic for their own sakes but that an intuitive logic, responsive to meaning along with form, underlies his choices of materials as well as their organization. And if it seems, from this story, to be a very unusual kind of logic, then we need to remind ourselves of T.S. Eliot's defence of similarly constructed poetry: "There is a logic of the imagination as well as a logic of concepts." The *Merzbilder* are all imaginatively rebuilt worlds.

☐ The problem that Schwitters faced in the large *Merzbilder*, of escaping painting-based composition, did not affect to the same degree the small assemblages that he made. Rather, the opposite is true: the materials speak so much for themselves that their *Eigengift* is hardly modified at all, as *Merzbild 9A. Bild mit Damestein* (*Picture with* 47 *Checker*) reveals. Schwitters obviously realized that he should try to avoid tampering with his materials too much in the way of underpainting and overpainting and let them, rather, create the composition themselves.[30] The danger, however, was that they might seem to be no more than *objets trouvés*. Only rarely does Schwitters fall into this trap; his Cubist organizational sense prevents it. Nevertheless, the smaller works of this kind do occupy a very precarious position between being formalized works of art and rare, precious or bizarre curiosities.

This is undoubtedly an important aspect of Schwitters' artistic personality: the artist as collector of anomalies. The story of the creation of *Konstruktion für edle Frauen* tells us that, on his walks around Hannover, he was finding materials from which to build imaginary worlds. In this respect, he resembles a traveler to strange lands, bringing back with him a collection of exotic souvenirs (and tall stories—for he collected these too) from which to make a travel book full of wonderful lies.[31] Except, of course, the lands he visited were familiar ones. It was what he found that made them seem unusual. And back in his studio, working with the objects he found, he resembles an Elector of Saxony in his *Wunderkammer*, setting and mounting the display cases of a cabinet of curiosities.

The travel metaphor helps to explain Schwitters' attraction to the used and fragmented. He collected brand-new and often *kitsch* objects, as modern travelers are apt to do. But like the eighteenth-century travelers of the Picturesque, he was, by and large, more interested in roughness than smoothness and in the fragmented rather than the whole. The crumbling remains of the present were his principal materials, and they tell not only of his spatial travels but also of his mental travels: his restless attempts to find a kind of perfection and order—innocence, even—in the ruins of the world. He is, in this sense, an archeological traveler who seeks to reverse the process of ruin, and therefore of history; who works against the decay of meaning in things. And since ruins can be seen as emblems of the mind's own history too, his search is also for patterns of meaning that can "stave off the personal equivalent of cracked masonry and fallen pillars,"[32] that is to say, for personal order as well as artistic.

The image of Schwitters as a collector of curiosities reinforces this interpretation—and when we come to consider the *Merzbau* he built in his house in Hannover, we will see just how unusual his *Wunderkammer* was. Exotic specimens of natural history; certain bizarre kinds of still-life paintings; nineteenth-century engravings of toys on shelves and compartments; the framed collections of objects by psychopathic patients which the 49 Surrealists were to admire:[33] things of this kind have an obvious relevance to Schwitters' work. But it can be a misleading one. So can be the comparison with the framed objects that began to appear in Giorgio de Chirico's paintings during the period of the First 50 World War, and which Schwitters certainly knew.[34] In the final count, he was less interested in the simply nostalgic or evocative poetry of the materials he collected than in making them into formalized art. As the story of *Konstruktion für edle Frauen* makes clear, the "spiritual" or personally evocative values suggested by an object had to be

made to correspond to the picture's esthetic values, and this meant that the individual essence of objects had to be tempered, if not indeed effaced.

Schwitters' determination to do this, even in his small works, is demonstrated by *Merzbild 13A. Der kleine Merzel (Small Merzel)*, where coins and disks are added to what is in effect a Cubo-Expressionist painting. The result is not successful. *Merzbild Rossfett,* in contrast, achieves a wonderful balance between the material and the esthetic. To a greater extent than any larger work we have looked at, its composition seems to have emerged from the sheer manipulation of the materials themselves. The elements are displayed on a surface as bare as that of *Das Kreisen,* consisting of three upright painted boards. However, since the materials used are all emphatically planar, and since they are never very far from the edges of the small picture area (emphasized by the heavy frame), the work seems both flatter and more homogeneous than any of the larger pictures. Furthermore, the way in which the grid-like internal divisions echo the enclosing shape adds formal coherence, and accentuates the feeling of a graspable whole.

Merzbild Rossfett allows us to isolate the three principal factors important to the coherence of the *Merzbilder* as a whole: the relationship of materials, first to the flatness of the surface (planar materials tending to belong there more naturally than linear ones), second to the size of the surface (materials needing to be of a large enough size and bulk for the size of picture in which they are used), and third to the shape of the surface (materials that echo that shape seeming the most securely positioned within it). I am not saying that Schwitters himself approached his work in so analytical a way; neither am I suggesting that when he fulfilled these three requirements to a maximum he was most successful. His was clearly a very intuitive approach to pictorial composition, and he did not—judging by the results—in fact want absolute stability in his work. Nevertheless, he did want order, and these were important methods of achieving it.

In *Das Undbild,* planar materials predominate; in this case, however, they are mostly the paper planes of collage. Here we find Schwitters anticipating the combination of paper and relief materials that characterizes the major assemblages of 1920, and anticipating too the escape from the linearity of his earlier style which these assemblages provided. In *Das Undbild*—unlike *Das Kreisen,* for example—material forms do not simply replace painted ones. They are used as much for the linear patterns created by their edges as for the flat shapes they provide; but these shapes (their separate identities reinforced by the differences in the printed matter they bear) have their importance in locking the work together, jigsaw-like, into one surface. And while this surface as a whole is still tonal in effect, the single blue triangle offers the new possibility of intense planar color so crucial to the mature collages. In order for color like this to appear, flat shapes had to be there to receive it. Thus, although the emphasis is still on line, there is certainly no sense of a two-part structure of linear figure against painterly ground.

The reduced size of the materials in *Das Undbild* (appropriate to its small size) meant that they could be managed in a more intuitive way. This allows Schwitters to compose the surface as a whole, rather than composing, as it were, on top of the surface, as was the case with larger works. Moreover, the relatively standardized relief of the materials goes far to avoid that sense of formal and referential conflict that combinations of high and low relief elements produced. But in this sense it is exceptional. In 1920, Schwitters

continued to grapple with the problem of using high and low relief assemblages and of the large collage pictures he had also been making in 1919.

☐ The earliest of the large collages—most designated with the "B" prefix to their titles—are more aptly described as collage paintings, for like the earliest relief assemblages they use added materials within a context derivative of Schwitters' preceding abstract paintings. *Merz 1B. Bild mit rotem Kreuz (Picture with Red Cross)*, included in the July 1919 **54** Der Sturm exhibition and presumably made very early that year, certainly reads like a painting, for the collaged elements neither fill nor compose the surface but seem to float within a painterly space. *Merzbild 5B. Rot-Herz-Kirche (Red-Heart-Church)*, dated on **57** the reverse April 26, 1919, is more completely filled, but is still, in essence, a painted-over collage in which the pasted rectangles of paper are all used for the linear patterns their edges create. That is to say, the collaged elements themselves seem contrived to fill out a generalized *a priori* linear framework. We can see fragments of handmade illustrative drawing similar to that of Schwitters' contemporaneous Dadaist and rubber-stamp drawings, but by and large the materials are disguised by the applied tonal washes and cannot be separately identified. Although compositionally similar to the relief assemblages—and using the same combination of lines and circles—early large collages like this do not merely make their materials function like painted ones but actually efface the identity of their materials as well: to create in paint a somewhat sentimental equivalent of the weathered look of the materials that Schwitters favored. This is not to say, of course, that this is an unsuccessful picture; merely that it is a more conservative one than those which escape the context of painting.

Judged stylistically, *Das Huthbild (The Huth Picture)* of 1919 would seem to have **53** been among the first of the large collages in which Schwitters kept the pasted papers freer of applied painting, and kept them smaller, and therefore more manageable, as well. The result is an emphatically frontal work comparable to the reliefs, and one which avoids the atmospheric, dissolved spaces of the early large collages. As with the *Merzbild* **III** *Rossfett* assemblage, Schwitters is helped here by a general grid pattern to which all the elements are adjusted, this emphasizing their planar character. But Schwitters still seems nervous of filling the entire surface of other than very small works with planar forms, and he bunches the materials, Cubist-like, to the center, causing them to seem to float there in isolation from the picture's edges. Nevertheless, *Das Huthbild,* more than any other of the early large collages, showed how the flatness and frontality of materials could be used to achieve surface coherence. Schwitters did not pursue this direction: instead, he continued to work within Expressionist lines. But he did lighten his palette.

Merzbild 9B. Das grosse Ichbild (The Great Ich Picture) and *Bild mit heller Mitte* **58, IV** *(Picture with Light Center)* (both probably made towards the end of 1919) are compositionally quite close to *Merzbild 5B. Rot-Herz-Kirche* and similarly camouflage their **57** materials under washes of color. They eschew, however, the darkish tonalities of the earlier work, and from largely pale, tan-colored washes over light papers create an overall internal light source for themselves, substantiated by the radiating angular forms clustered around light centers. There are some stronger, saturated colors as well, mostly the same deep blues and greens with red and orange highlights as appear in *Das Undbild,* **52**

but with few exceptions the color is atmospherically painted onto the pictures and continues to take on the appearance of infilling between the still predominantly linear structures. This is not yet completely planar, surface color. It becomes so in the rare instances where it is inherent in the very substances of applied surface materials, but Schwitters could not allow this to occur too frequently within the kind of structures he was using. Works like these are not, in fact, surface-organized pictures but atmospheric and illusionistic ones; where materials are left free of applied painting to show their own intrinsic colors they seem either to float off the surface or to push the surrounding areas back into depth. The same is true of the fragments of typography in these pictures, where (as in the 1911 pictures of Picasso and Braque) printed letters "force the painted surface to measure up to something rigid,"[35] but at the same time initiate a shuttling of attention between surface and depth.

The relationship of Schwitters' collages to Cubist principles will be considered in some detail in Chapter 4. It should be noted now, however, that his large collages of 1919 do not fully accept the constructional basis of Cubist collage. Their linearity, illusionism and painterly "shading" speak rather of an alignment with earlier, Analytical Cubist procedures, an alignment which proved to be irreconcilable (both for the Cubists and for Schwitters) with the "Synthetic" part-to-part organization of planar material units that the practise of collage seemed ultimately to demand.

Whereas the classic Analytical Cubist painting was created through the process of *abstraction*—that is to say, by the "analysis" of an observed motif—both the Cubist collage and the Synthetic Cubist painting that emerged after the invention of collage were created through the process of *construction*——that is to say, by the juxtaposition and "synthesis" of elements from a preexisting vocabulary of materials or forms. The fragments of stenciled typography in Analytical Cubist paintings had already, before the invention of collage in 1912, drawn attention to the surface of the painting as a flat support for applied elements; but once construction became the logic of Cubist art, the flatness of the surface was emphasized in a new way. Once Cubism became a matter of combining flat materials (in collage) or flatly painted forms (in Synthetic Cubism), the illusionism and painterly shading characteristic of Analytical Cubism began to disappear: to contain such flat materials or forms successfully seemed to require a resistant flat surface to receive them.

Schwitters' large collages of 1919 do not present a resistant flat surface to the eye. Their primary relationship to Cubism is to Cubism as it existed before collage was invented. Hence, works like *Das Huthbild* look generally back to Analytical Cubism through the mediation of such sources as Robert Delaunay's *Window* paintings, and those like *Das grosse Ichbild* through Futurist compositions. Other works, like *Rot-Herz-Kirche,* are reminiscent of Klee's use of illustrative, and at times physically applied, imagery within a linear, Analytical Cubist scaffolding. And occasionally, the Analytical Cubist comparison becomes explicit: *Bild mit rotem Kreuz* for example is essentially a collaged version, complete with centralized composition, raking diagonals, and atmospherically luminous spaces, of a work like Braque's *Le Portugais* of eight years earlier. The Analytical-Cubist-derived sense of internal lighting provided by these large collages offered one form of pictorial coherence; however, in 1920, when Schwitters brought

53
55
58, 60
57, 59
54
56

together the methods of the large collages and large assemblages it was to avoid illusionism of this kind, using darker and far more opaque colors and forms which were far more assertively planar and bulky in kind.

A great deal of the success of the 1919 relief assemblage, *Konstruktion für edle Frauen,* VII
was due to its rich deep color and solidly packed forms. In *Merzbild 25A. Das Sternen-* 62
bild (The Stars Picture) and *Ausgerenkte Kräfte (Disjointed Forces)*, both of 1920, 61
Schwitters combined the solid bulky forms of the 1919 relief assemblages with a background of paper planes derived from the large collages. He allows darker tones to dominate, with flashes of intense and sometimes brilliant color besides. Unlike the 1919 reliefs, the grounds here are entirely filled with added materials. Unlike the 1919 large collages, these materials are affirmatively opaque, even when they are covered with applied paint. There are occasional transparencies, but these appear as colored glazes covering materials rather than as emanations of an internal light. Moreover, far more materials can be individually identified: not only the heavy relief forms but also the flat papers which form the ground. And since Schwitters has introduced here several large flat wooden and cardboard planes as well as paper ones, the elements of varying degrees of relief so overlap—both physically and optically, according to the colors they present—that the sense of one continuous ground surface is to some extent dissolved. In this respect, these works absorb the effect of a dissolved back plane from the large collages. But whereas there all the forms seem to lie behind an imaginary, transparent front surface, here the front plane too is dissolved, broken by the projecting relief elements. The effect is of materials that seem to be virtually held in suspension. Although these are very physical works, the remarkable dissolution of forward and backward planes creates an almost disembodied effect.

And yet, everything is pulled together and contained: not only by the heavy painted frame of *Ausgerenkte Kräfte,* which one can hardly avoid noticing, or by the length of rope that snakes up *Das Sternenbild,* holding the picture upright, or by the diagonal wooden lath that braces this picture against its frame, but also by the surface as a whole. The relief objects cast shadows upon it, and clearly are seen to be nailed and fastened across it—or better, nailed and fastened across other relief materials, also casting shadows and also strongly physical in appearance. A sturdy, self-contained and self-generated sense of completeness is achieved in works of this kind. They ideally fit the Cubist notion of the *tableau-objet,* the work of art with its own tangible presence, its own materials, its own formal integrity as an object in a world of objects. The idea of art as making, as construction, and the sense of physical directness, unmodified by illusionism, that Cubist collage had achieved is repeated here in a beautifully original form.

It is possible that the new physicality of these 1920 works by Schwitters owes something to his knowledge of Cubist-influenced Russian and Ukrainian Constructivist reliefs, news of which reached Germany that year,[36] and in particular to the reliefs of Ivan Puni, who had moved to Berlin in 1920 and begun forming certain Dadaist contacts and also remaking the reliefs he had been forced to leave behind in Russia.[37] Schwitters may have known about Puni before 1920, for one of the "noble ladies" to whom the 1919 assemblage, *Konstruktion für edle Frauen,* was dedicated was apparently Puni's wife.[38] He certainly soon learned of Puni's work since Puni exhibited at Der Sturm from 1921

onwards. Schwitters' reliefs were to become very overtly Constructivist in 1922–23 as a result of his increased contact with artists of that persuasion. Even by 1920, however, he seems to have absorbed something from the Constructivist idea of a "culture of materials," which led him to produce more physical, bulky reliefs than hitherto. By 1921, an untitled construction prominently features an approximately 60° segment from a wooden circle, which so closely resembles a characteristic motif of Puni's work as to make it almost inconceivable without Puni's example. The way in which this construction escapes the confines of a picture-frame further suggests Constructivist influence.

This relief, however, is unique in showing such overt borrowings, and even then the result of the borrowings is entirely Schwitters' own. In 1920, in some of his most dramatic *Merzbilder,* the influence is more subtly absorbed. Works like *Ausgerenkte Kräfte* and *Das Sternenbild,* both of that year, are neither paintings nor relief sculptures. They lack the continuous plane surface of paintings and the spatial excavation or spatial layering that we find in sculptural reliefs. Instead, there is at the same time *no* surface, *no* ground—it being wholly subservient to the materials of the work—and *nothing but* surface, *nothing but* ground, no feeling of separation of the materials one from another. Picasso's Cubist constructions, and those of the Constructivists, do indeed prepare for what Schwitters achieves. But the medium of the assembled *picture* is what he makes his own. Schwitters begins in 1920 to address the surface of his work as a responsive rather than an inert object, and makes of his art an affair not merely of placing materials and covering surfaces but of animating and actually creating surfaces "through the choice, distribution and metamorphosis of materials."[39]

We can never forget, however, that these materials are not neutral or conventional pictorial elements but found materials, "non-art" ones. Indeed, many of the assemblages contain slogans that obviously tell of the outside world, and this, of course, serves to compromise their artistic "purity." Most refer only in the most general terms to the urban environment in which Schwitters lived. The tram tickets, postage-stamps, coins and newspaper advertisements, and their eye-catching numbers and fragmented phrases, all combine to evoke a definite period atmosphere, but, more often than not, without describing a particular moment or place. They do tell of the disjointedness and claustrophobia of the modern world, of a commercial and bureaucratic world dominated by pieces of paper: papers that identify you; papers that allow you to travel; papers that you need to move from one country to another (for passports and visas only became standard in Europe after the outbreak of the First World War); paper with which you buy things (and which soon is devalued); paper with which to wrap your purchases; and paper, of course, to read. Together—in their jumble of cross-references and in their fragmentation—they evoke a kind of spiritual homelessness. Their shifting and repositioning is like that of the frontiers of countries hacked about by the war;[40] which associates their "modern" qualities with that sense of attraction to ruins I referred to earlier. And like the redrafting of frontiers, Schwitters' activity is a spatial and a disjunctive one that repudiates the traditional, temporal continuity of European history (and the narrative artistic forms that went along with that continuity). At the same time, that older order is sorely missed, and out of the anxious ruins Schwitters attempts to rebuild its modern equivalent.

Papers not only intended to be read but which provide specific, identifiable references do appear in some works. *Das Huthbild,* for example, refers to the Der Sturm group and to some of its members. It is named after the Weinhaus Huth, a bar near the Sturm gallery on Potsdamer Strasse,[41] and therefore might be said to "represent" a Sturm group gathering. *Merzbild Rossfett* jokes on the juxtaposition of its title ("Horsefat") with the advertisements for various toilet preparations below. A few of the earlier assemblages, moreover, combine cut-out phrases to produce an unmistakable "message." It may be just accidental that as one reads down *Das Undbild* one finds *burg* (upside down, to the top left), the *und* itself, then *erde* at the bottom of the picture—to produce the phrase "castle and earth" or, if *erde* is from *Pferde,* "castle and horses"; in two assemblages, however, the messages they contain must clearly have been intended. *Das Arbeiterbild* not only presents us, in vivid red newsprint, with the word *Arbeiter* ("Worker"), but adds above it the fragment: *Unter diesen Gesichtspunkten sind die meisten letzten Streiks* ("In these respects most of the recent strikes are"). During the civil strife of 1919, when this picture was made, to place such fragments amidst a composition that resembles a broken-down machine was virtually to create a Luddite manifesto. True, this image dedicated to the Red Worker may seem to be romanticized by the inclusion of what looks like a black crescent moon at the center, but in this context it reads suspiciously like a parody of a romantic landscape. Or perhaps it is in fact a reference to a larger and more benign world than that of workers and strikes, providing in the picture a polarity of manmade and natural themes not unlike that of the "castle and earth" in *Das Undbild.* We cannot really be sure. As we saw earlier with a poem like "An Anna Blume," Schwitters is contemptuous of Expressionist idealism and somehow nostalgic for it, at one and the same time.

53

III

52

46

Schwitters wrote that when one of his titles was taken from a word-fragment in a picture it generally expressed his "feeling belonging to the spirit of the picture." If it was a town name (a number of the smaller collages are thus titled), it did not mean that he had necessarily visited that town but rather that there seemed to be "a kind of connection" between the emotive "value" of the picture and the name of the town. The title *Hopf,* he used as an example, could not be reduced to a verbal meaning. "I don't know, HOPF may be part of Schöpfung (creation)." But Merz is "feeling without knowing." His titles, like his pictures themselves and the word-fragments in them, were intended to express "what cannot be understood, what only can be seen." Their meaning was an "abstract meaning" and they even constituted "a poem about the picture."[42]

Das Kreisen (a title that has already been analyzed) and *Ausgerenkte Kräfte* are not abstract titles, but they are certainly abstractions of feelings. Both evoke "cosmic" Expressionist themes. So does the second of Schwitters' early assemblages containing obviously intended topical messages—*Das Sternenbild* (*The Stars Picture*), a title which also suggests *Sternbild,* "constellation." Here, the polarity of "cosmic" theme (as presented both by the title and by the composition suggestive of radiant celestial orbs) and contemporary meaning (as presented by the fragmented texts) is even more evident than in the case of *Das Arbeiterbild.* Among the cut-out phrases, we read: [R]*eichsk*[*anzler*] ("Reich Chancellor"), *blutigen* ("bloody"), *Offener Brief E . . .* ("Open Letter E . . ."), *Mathias; Die Korrupt*[*ion*] ("Corruption"), *Generalleutnant* ("Lieutenant-General");

62

erhöhung ("increase"); *Hungersn[ot]* ("Starvation"). The date is 1920, and Mathias Erzberger, the Finance Minister of the new Republic, has been forced to resign after the well-to-do, protesting against severe taxation, organized a smear campaign to discredit him as a supposedly corrupt agent of Germany's enemies. It is also the date of the Kapp-Putsch, when the President and Reich Chancellor were forced to flee Berlin, of a general strike broken with terror and bloodshed, of dissent in the armed forces, of unemployment and inflation. Schwitters' picture alludes to all of these things. It does so, however, from an almost neutral position. Although certainly no celebration of the events it describes, neither is it an overt criticism of them: it is by no means the statement of a political activist. The only political party Schwitters ever supported was one he invented himself: the K.A.P.D. (Kaiserliche ANNA BLUME Partei Deutschlands).[43]

Das Sternenbild may be the most socially documentary of Schwitters' assemblages, but precisely because its social references are in the form of documentary quotations, it can, while telling vividly of its times, still remain uninvolved. "For me," Schwitters once wrote, "art is too precious to be misused as a tool; I prefer to distance myself from contemporary events But I am more deeply rooted in my time than the politicians who hover over the decade."[44]

If anything is implicitly criticized in *Das Sternenbild,* it may perhaps be the Expressionist cosmology suggested by the title, for is it not ironic to make a *Sternenwelt* or celestial sphere out of such utterly tawdry materials? But here again, as with *Das Arbeiterbild,* we cannot really be sure. Schwitters did talk of shouting out his exaltation through garbage and of seeking to build a new world from fragments of the old.[45] There is certainly a declamatory, exuberant feeling to the early assemblages, as there is to the early poems, with their comparable strong and abrupt rhythms, arbitrarily juxtaposed quotations and cosmic references. An attitude of ecstatic release and liberation characterizes Schwitters' early work as a whole. As Friedhelm Lach well expresses it: "Liberation became the focal concept of Schwitters' art. At first [in the pre-Merz work] it was liberation from entanglement in his own emotions, from spiritual depression and melancholy."[46] Then it was the liberation from the depressions of war, and from the older world, that the peace and then the revolution provided. "I felt myself freed," he wrote, "and had to shout out my jubilation to the world."[47] Merz was both the expression of that jubilation and an expression of liberation itself: "Merz stands for freedom from all fetters, for the sake of artistic creation."[48] To free himself from earlier styles and from conventional materials was to find personal liberation as well.

But this, as Schwitters says, was "for the sake of artistic creation," and we find a curious paradox here: his use of liberated materials may have effected a sense of personal release, but only at the risk of imprisoning him in the sordid literal reality of which these materials spoke. To make art, as he understood it, from such components required that they be somehow dissociated from the literal world, liberated from all contextual considerations. The search for this kind of liberation was the true driving force of Schwitters' early work. Hence his insistence that "the material is as unimportant as I myself; only forming is essential."[49] And yet we cannot really forget that the materials of Schwitters' assemblages do have their own personality, nor indeed that Schwitters himself does. Hence that special tension in the assemblages between their exuberance of feeling and

their tawdry documentation, and between both of these things and their sense of firm structural order. This tension is a part—and a large part too—of their compelling power. Schwitters may seek to nullify the "personality" of the materials by carefully adjusting them to the surface of the work; but, no matter how much the relief of the materials is graded, one inevitably reads these pictures as gradually encroaching upon the viewer's space: the greater the relief of the objects (or the more their separate identities are made manifest), the more they seem to encroach. They may belong to, and create, surfaces, but they are also objects in themselves.

In the earliest of his assemblages, Schwitters used "non-art" materials as direct replacements for conventional formal elements, and in so doing created an immediate duality of formal design and associative reference in our perception of these works. This duality is accentuated by his placement of these materials on top of worked, painterly grounds, so that the materials seem to belong equally and alternatively to the outside world and to their formal "containers." They alternate between having a self-sufficient denotive status as material objects and being sucked back into the greater object which contains them. However, the denotive status of the materials is further offset by the fact that they act as the formal replacements of more conventional materials. Reworking originally painted themes with materials which allowed colors, surfaces and textures difficult to produce by painting alone was for Schwitters a way of broadening the scope of his art—while the "conventional" nature of the compositions that these new materials filled was enough to stress their primarily formal intent. Doubtless aware of the inherent associative strength of his material sources (as well as the irony of his using them for esthetic purposes), he felt always compelled to emphasize in his writings that they were used only as form. In *Merz 1* he wrote:

> What the material denoted before its use in the work of art is a matter of indifference so long as it is correctly evaluated and given artistic meaning in the work of art All that matters in a work of art is that all parts should be interrelated and evaluated against each other The picture is a self-contained work of art. It refers to nothing outside of itself. Nor can a consistent work of art refer to anything outside of itself without loosening its ties to art.[50]

The assemblage technique, however, does not readily create structures that depend exclusively upon internal, syntactical connections. A tension between inner and outer reference always remains. Moreover, by 1920, Schwitters' organizational methods had become more responsive to the character of his materials. By the end of that year, in his article in *Der Ararat*, he indeed suggested that any *a priori* notion brought to the creation of a work of art was necessarily injurious.[51] He began each work of art, he said, only with the medium; to what end, he did not initially know. In fact, even to decide in advance upon a particular medium was unimportant: all that really mattered was choosing the specific materials that a picture seemed to require.

> Because the medium is unimportant, I take any material whatsover if the picture requires it. When I adjust materials of different kinds to each other, I have taken a step beyond mere oil painting, for in addition to setting off color against color, line against line, form against form, etc., I set off material against material.

The materials Schwitters used were of far more than purely formal significance to him, despite what he writes to the contrary; but even within Schwitters' own evaluation of the situation it is clear that his problem was how to contain their evocative power. As a later practitioner of assemblage, Jasper Johns, put it: "An object that tells of the loss, destruction, disappearance of objects. Does not speak of itself. Tells of others. Will it include them?"[52]

□ Many years after the first assemblages had been made, Schwitters made the following statement on what had motivated them:

> When I also produced, together with pictures painted exclusively with oil paint, these *Merzbilder,* I did not . . . intend to demonstrate that from now onwards pictures could only be made of junk; in them I merely made exclusive use of materials which other artists, like Picasso, had used only in conjunction with other materials. If I have been successful with these compositions . . . I believe that I have enlarged the domain of art somewhat, without in the process endangering the standing of great works of art of any age.[53]

He makes it quite obvious that his intentions were not at all didactic (or Dadaist, really) but that he sought new forms to extend (and even to preserve) tradition. To make art exclusively from found materials was for him far more significant than merely to use found materials in art. That is to say, he understood (and herein lies much of his importance) that collage could achieve a newly separate status within a neo-Cubist style. Besides Schwitters, the only painters of his generation to find significant new possibilities within geometric Cubism were Mondrian, Malevich and Klee.[54] Schwitters' contribution was to define the medium of collage so fully as to preempt it as a vehicle for Cubist art during his own lifetime.

What most characterizes the collage medium is that it creates an art of additive surfaces. It affirms planarity and shape, and it declares the procedures by which it is made. Moreover, it can readily hold color as a property of its surfaces, and reference as an innate attribute of its contents. To this end, it is most coherent when it is all collage, or mostly so, and Schwitters' pictures confirm this. The early assemblages derived from painting, so they took over morphological features belonging to painting; and yet, the presence of non-painting elements inevitably modified their use of the language of painting, because Schwitters increasingly organized his pictures according to the demands of the materials themselves. This was to become the underlying logic of his art.

In the assemblages, however, and especially those of 1919, the earlier "striving for expression" is still not avoided (although Schwitters had theoretically repudiated it). Simply replacing representations of his environment with its representative tokens was not itself the crucial issue of his art. True, the "reality" is of a different kind, but this merely puts expression to work in a new way. And if the materials are left stranded on the surfaces of what in effect are paintings, they tend to form individual relationships with the viewer, often at the expense of the integrity of the internal structure. Schwitters' art achieves full maturity only when materials are no longer used so that they appear to be substitutes for conventional pictorial elements: when what we see no longer appears to

be a painting modified by the use of non-art materials, but a picture whose very structure was created from the adjustment of materials themselves and in which materials declare their own characters rather than assuming others'.

This had happened by 1920. Although the compositional structure of work like *Das Sternenbild* and *Ausgerenkte Kräfte* still makes reference to earlier art (and not only Schwitters' own), it is actually the creation of Schwitters' gathering-together and combination of physical material elements. In this situation the materials have if anything a greater presence than ever before. No longer functioning as if they were painted lines and planes, as in the 1919 assemblages, their own intrinsic characters achieve greater importance. But because they can no longer be viewed as alien elements in a painting context, there is no longer quite the same sense of opposition or conflict between the "non-art" materials and their "artistic" container. It is the known (artistic) and the unknown (non-artistic) together, Schwitters once wrote,[55] that is important: the unknown varying and modifying the known, to create a new kind of order. And in this respect, Schwitters separates himself from Dada:

> I compared Dadaism in its most serious form with Merz and came to this conclusion: whereas Dadaism merely poses antitheses, Merz reconciles antitheses by assigning relative values to every element in the work of art. Pure Merz is art, pure Dadaism is non-art; in both cases deliberately so.[56]

Dada poses antitheses: by juxtaposing heterogeneous elements and leaving a feeling of unconnectedness between them, by opposing the artistic and non-artistic. Merz, in contrast, reconciles antitheses: by combining elements homogeneously, by harmonizing the artistic and non-artistic. In striving for homogeneity, Schwitters not only expelled (with very few exceptions) any kind of narrative relationship between his materials, but came to stress the very gathering-together of materials above all else. He had moved into assemblage as a way, he said, of reinforcing existing concerns with relationships.[57] Relationship came to be identified with value, and inherited formal devices gave way to the spontaneously additive process. Both "compositional" notions and the individual characteristics of the materials were to be subordinated to that process itself.

If this happens in the relief assemblages of 1920, in the large collages of that year it does not—at least, not to the same degree. *Merzbild Einunddreissig* (*Thirty-one*) and VI *Merzbild 31B. Strahlenwelt* (*Radiating World*), for example, exaggerate the central 66 compositional focus of the best of the large 1919 collages (such as *Bild mit heller Mitte* and *Das grosse Ich-Bild*) and adapt it to the same rich color as the reliefs done in the same 58 period. Like the 1919 collages, they use overpainting and glazing, and provide a sense of having internal light sources; but they seem more tangible. They push more strongly up to the surface, and read as much in surface as in depth. Their materials are vividly present to us, especially in *Merzbild Einunddreissig*. Far freer from that Cubist chiaroscuro feeling than are the comparable 1919 works, they still depend on Analytical Cubist precepts in a way that the 1920 reliefs do not.

Perhaps Schwitters recognized the limitations of this method, for he stopped making centralized collages of such a size. Centralization became an important organizational method in his small collages around 1920; however, the reduced size of these works

meant that their materials could evenly fill out their surfaces, obviating the sense of chiaroscuro entirely. Schwitters continued to be interested in transparencies. Many of the smaller collages use transparent and translucent papers, and his few 1921 experiments in *Hinterglasmalerei*—painting on the underside of glass—a medium that Kandinsky had used for its ability to express internal, spiritual light, can likewise be attributed to his Expressionist-derived fascination with the "soul" of the work behind its visible surface.[58] In 1920, however, in his large-scale work at least, transparencies were put aside along with Expressionist compositions.

But the direction he took in his large 1920 assemblages was not towards a consolidation of the methods of works like *Das Sternenbild* and *Ausgerenkte Kräfte* but to an abandonment of high relief as well—for a combination of medium-thickness collage materials and scattered relief elements in a general all-over effect. Without either large forms or strong pictorial accents, these works suffer as a result.[59] The smaller pictures of 1920 are generally more successful (although of course less dramatic than the larger ones). But unlike most of the small works of 1919, these are either virtually small flat collages with only very few relief elements—like *Das Bäumerbild*—and therefore hardly separable from the collages proper, or very spare reliefs of simple presented forms on bare surfaces.[60] Schwitters seems to have been floundering somewhat, unable to decide quite what his next move should be. Two 1920 pictures, *Bild mit Raumgewächsen* (*Picture with Spatial Growths*) and *Merzbild 29A. Bild mit Drehrad* (*Picture with Flywheel*), were later judged to be unsatisfactory, and Schwitters reworked them in the 1930s, changing the title of the former to *Bild mit 2 kleinen Hunden* (*Picture with 2 Small Dogs*).[61] Both are now very impressive, but it is difficult to be sure what he added later. *Bild mit Drehrad* seems to retain more of its original state, but it is nevertheless anomalous among the early works in its horizontal format and in its totally explicit machinist iconography.

The lack of resolution persisted in 1921. *Merzbild 46a. Das Kegelbild* (*The Skittle Picture*) shows Schwitters abandoning the attempt to make large-scale relief assemblages which merge materials and surface together, and opting instead for simply presenting relief materials upon a flat bare surface. This was, in a sense, a return to the method of *Das Kreisen*, except that the physical bulk of the added materials is now much greater. Whereas *Das Kreisen* appeared to subsume the physical character of the materials to make them function as if they were conventional pictorial elements, here we see only their physicality. The materials are here as pure phenomena. These works show the two poles of Schwitters' art: materials subordinated to pictorial devices, and materials standing only for themselves. The best of his work lies somewhere in between.

Das Kegelbild heralds a group of both painted and unpainted constructions that Schwitters started to make from around 1922. These, however, are clearly so different in character from the assemblages that they deserve separate discussion. The latest works he made that properly belong with the assemblages are a small group of pictures of 1920 and 1921 which break entirely with the concentric or diagonal forms of most of the works hitherto mentioned, in favor of grid format.[62] Some are not especially successful, but *Das Kirschbild* (*The Cherry Picture*) of 1921—the finest of this group—is one of Schwitters' most inspired pictures. (Its title puns on "Kurtchen," Schwitters' pet name.)

It uses some high-relief and bulky objects but is dominated by rectangular-shaped pieces of carefully graded relief and size which line up with, and to some extent duplicate, the proportions of the picture edges. The pieces all appear to have breathing-space in the form of darker and more irregularly shaped fragments behind them. In consequence, the picture stays open in feeling, its planes seeming to reach for each other across the illusion of an expansive but taut space. The materials seem to control and to direct the flow of the pictorial space; they exist as materials and are used as materials, and not as if they were something else. The very natural and intuitive freedom yet sense of ordered containment manifested in this wonderful picture is like that of the small collages of this period, to which we will soon turn. In another of the 1921 reliefs, however, Schwitters dispenses 70 with a picture frame and allows the wooden planes actually to push out beyond the enclosing rectangle into free space.

□ To recapitulate quickly, from 1919 to 1921, we see the following stylistic developments in Schwitters' *Merzbilder*: a move from painting into assemblage by allowing materials to take the place of conventional pictorial elements; and Schwitters' gradual realization that the new transactions between surfaces and objects differed from those between surface and paint. The problem, however, of carrying over painterly ideas into assemblage was that Schwitters tended to use flat elements less on their own account than for the linear structure their edges created, and that he used a high proportion of linear high-relief elements, which functioned as if they were painted lines. Added to this was the problem of making the added forms seem to belong to the surfaces they were attached to. Since Schwitters was concerned to lose the *Eigengift*, or individual essence, of the materials, this came to mean using fewer and fewer high-relief elements, for these were the ones which tended to form individual relationships with the viewer and therefore seemed to surrender their *Eigengift* less easily. But this was complicated by the scale of the works, which seemed to demand large materials, despite the difficulty both of their containment and of their being managed in an intuitive way. Whenever Schwitters used mostly small materials in these works, the pictures tended to lack focus, which meant falling back upon *a priori* compositional structures.

While many of the 1919 *Merzbilder* are extremely impressive works indeed, it was only in 1920 that Schwitters found a new way of using small and large materials together and of so packing the picture surface as to avoid all feeling of merely presented forms. And only when he organized his pictures as surfaces, and with opaque rather than transparent colors, was he able to approximate to this success in works that managed without elements in high relief. This finally meant a synthetic part-to-part compositional method, one that saw the very activity of picture-making somehow differently from before: as pieces making a whole rather than as an *a priori* whole made up of pieces, and structure itself as something to be discovered actually in the process of assemblage.

The surprising thing is that, away from the difficult large-scale format, Schwitters had been doing this in the often very tiny collages to be discussed in the following chapter. It is significant, however, that the problems of transition between his different modes of work are more apparent in the larger assemblages, closer in size to a usual picture-making context than the collages. Indeed, Schwitters called the collages *Merz-*

zeichnungen, or Merz-drawings, thus separating them from the painting medium from the start; he only later felt the need to explain that they should also be regarded as pictures.[63] It is also interesting that Schwitters' later stylistic reassessments are likewise more easily recognized in larger high-relief works (this is no less true of the Constructivist-biased reliefs of the middle and later 1920s than of the "rural" assemblages of the 1930s and 1940s), while the collages reveal changes of emphasis more subtly. The smaller size of the collages seems to have allowed more personal control (indeed, of a kind usually associated with drawings) than the works I have described as modified paintings. What is more, the flat material planes of the collages could more easily perform simultaneously as structural and referential motifs, thus tending to resolve some of the ambiguities which give the assemblages of the early "revolutionary" years their special character. The early *Merzbilder* are indeed full of ambiguities and internal tensions, of contradictions and dissonances; and from almost the very beginning, early in 1919, to 1921, these problematic aspects of the pictures are what give them their drama and their excitement.

☐ Schwitters is undoubtedly best known for the collages that he made in very large numbers from late 1918 until his death thirty years later. His was an almost diaristic method, forming the materials that surrounded him into miniature epistles of everyday experience. It was Apollinaire who observed that the materials of a collage are already "steeped in humanity."[1] He was writing of Picasso and Braque, but his words seem even more appropriate to Schwitters, the very character and mood of whose collages are more crucially dependent upon the evocative nature of their materials. Schwitters' disclaimers notwithstanding, the *Eigengift*, or individual essence, of each of the materials in a collage is clearly important, and it is differences in materials, and in the moods that they create, as much as differences in styles that separate the collages one from the next. Schwitters created a vast *oeuvre* not because his formal methods were inexhaustible but because his materials were.

Still, his formal methods did undergo change and revision. The extent and pattern of this change is disguised in part by the fact that once he had established a particular stylistic form, he would often continue to use it even while subsequent ones were being explored. (We saw something similar in his early oil paintings discussed in Chapter 1.) The effect, therefore, at least at first sight, of Schwitters' collage output is not so much of stylistic unfolding as of stylistic accumulation. We can, however, follow his stylistic development by charting the first appearances of the different formal devices that he used. As we do so, we will notice that Schwitters thoughtfully explored a variety of stylistic forms and procedures, and that some were indeed put aside, others conflated, and new ones developed, as he gradually discovered the structures with which he was most comfortable. How he began making collages under Dada influence in late 1918, then shifted direction in 1919 and 1920, after working on the large assemblages, to consolidate his mature collage style, is the principal subject of what follows.

☐ In the very earliest of Schwitters' collages, his commitment to abstraction is candidly stated. *Zeichnung A2. Hansi*, dated 1918,[2] is a very stable, simply composed work. Its calm, orderly structure makes use of neither the linearity of the assemblages nor the multiple overlappings and centralized compositions of the large-scale collages. The paper fragments already work as frontal surfaces and present themselves frankly as areas of color. While Schwitters continued to struggle with illusionism, tonality and inherited Expressionism in the larger works, more advanced smaller works like this were already in existence. He made at least six collages in this "A" series in 1918.[3] This apparent contradiction has naturally created doubts as to the dating of these works, especially

IX

since most 1919-20 collages are far closer to the contemporary large-scale works. By and large, he did not arrive at so uncomplicated a method of composition until 1922.

The problem is only explicable if we remember Schwitters' susceptibility to outside influences. There is no reason why works like *Hansi* should not belong to 1918, since their total freedom from the linearity of Schwitters' paintings, drawings and assemblages seems to indicate a first experiment with abstract collage, directly motivated by Hans Arp's work in this medium. Schwitters apparently first met Arp in 1918 in Berlin,[4] and knew his collages either directly or from reproductions. The strongly geometric composition of *Hansi* and its flat, clear and relatively large shapes (in proportion to the size of the work), made from relatively clean papers, all point to the influence of the kind of collage Arp had been making since 1915 and which had been illustrated in various Dadaist magazines, including, for example, *Cabaret Voltaire*, which Schwitters had probably seen.[5] Schwitters may well have been looking at other artists' collages as well: there were several minor members of the Sturm group who began to make collages around the same time,[6] and one of Hausmann's 1918 collages is similar in approach to Schwitters'. That too, however, is derivative of Arp. The very title of *Hansi* suggests that Arp's influence was the dominant one.[7]

Hansi and its companions precede the *Merzbilder*. In the July 1919 *Der Sturm* exhibition, where the *Merzbilder* were first shown, there were some works that the critic Walter Mehring described as *Aphorismen* (*Aphorisms*).[8] He referred to these as drawings, and said that they provided, in small size, the effect of the large pictures in the exhibition. The earliest of these *Aphorismen* date from 1918, but very few of them still exist. Some were indeed drawings—seemingly random scribbles in ink and watercolor.[9] Others were fragments of found, heavily worn or stained paper containing snatches of Gothic type similar to that in some of the *Merzbilder*. But Schwitters, from the time of this exhibition, referred to his collages as drawings—as *Merzzeichnungen*—and true collages may conceivably have been included in the show as well.[10]

Like the interposed "banalities" of Schwitters' Dada poems, the *Aphorismen* seem to have been conceived as pithy quotations from the world that produced the *Merzbilder*; their title certainly suggests that. Schwitters would later coin the phrase, *i-Zeichnungen* (*i*-drawings), to describe unmodified pieces cut out of waste material and artistically presented; some of the *Aphorismen* are therefore *i-Zeichnungen*, in fact. None, however, at all resembles the 1918 collages like *Hansi*. The 1918 *Aphorismen* set the tone, though not the method, for the *Merzbilder*; the 1918 collages, like *Hansi*, prefigure their constructional approach. When Schwitters regularly began making collages in 1919–20, the constructional approach of course persisted, but it was tailored to fit the more Expressionist tone of the *Aphorismen* and of the *Merzbilder* themselves. Having begun making collages under Arp's influence, he then set aside the clarity and simplicity he had achieved, and began the process of finding his own collage style.

The only feature of *Hansi* that can be said to derive from Expressionism is the short-armed "cruciform" motif in the center, which bears comparison with the crosses in Schwitters' contemporary paintings.[11] But it is used in a calm, distanced and anti-Expressionist manner. In contrast, Schwitters' few extant collages of 1919 show him turning to the same line and circle motifs and the same kind of worn materials as the

Merzbilder. The fact that Schwitters designated his collages *Merzzeichnungen* (and only later qualified this description by saying that they were, in fact, complete and independent creations) suggests that he first thought of them as subsidiary to the *Merzbilder* in a similar way to his Dada drawings. The 1919 collage, *Der Sturm*, actually holds a middle 73 position between the Dada drawings and the relief assemblages. Other 1919 collages are close in feeling to the large collaged *Merzbilder* of that year.[12] Even in 1920, a number of the collages give the impression of being *Merzbilder* conceived on a small scale—the dramatic *Mz 150. Oskar* is a case in point—and therefore not easily distinguishable from 71 the small-sized *Merzbilder* themselves.

It was only, in fact, in 1920 that Schwitters began to consistently produce collages with a character that is entirely their own. Those we shall consider first are close in spirit to the *Merzbilder*, and are among the most expressive and serious of his collages. They share a strong emphasis on texture, on highly tactile effects, using fabric, loose burlap or sacking and even wood, together with paper, and often use the paper in a crumpled form—even at times with torn rather than cut edges, which is unusual for Schwitters. Like the early assemblages, they have a distinctive period flavor: the rough, worn materials seem to epitomize Schwitters' early ideal of building a new art "from the fragments of a former culture."[13] In composition, however, they separate themselves from the *Merzbilder* as truly independent works.

These early collages may be divided into five groups, which were made concurrently, mostly in 1920. The first developed from 1918 *Aphorismen* like *Zeitu*, with its declama- 76 tory Gothic type and heavy stains. *Mai 191* resembles a section of a wall with fragments X of torn posters. Its mention of electrical- and metal-workers' strikes, and so on, must be alluding to the same disturbances of spring 1919 to which *Das Arbeiterbild* also refers. 46 Both of these works, in fact, admit interpretation as sympathetic reactions by the pacifist Schwitters to the brutal suppression of the workers' Soviet in Bavaria on May 1, 1919. Is it accidental, we inevitably ask, that *Mai 191* is dominated by faded versions of the black, red and gold of the revolutionary Republican flag?

Das Bäumerbild (*The Bäumer Picture*) contains references to the troubles of forming 75 international alliances, over which are placed the drawn image of a table and cropped photographs of a man and a woman. It was made in 1920, the year the League of Nations was established and the year after the Paris Peace Conference and the Treaty of Versailles, and presumably refers to these events (the man appears to be in uniform); in which case, the table is a conference table and the heavy red circle on top of the table is a seal attached to the document beneath. But the man is made to resemble a strange Dadaist sculpture, and the woman is holding a flower. Schwitters' 1918-19 story "Revolution in Revon" (to be discussed in Chapter 5) was advertised as a love story, set during the German Revolution, of Anna Blume and Franz Müller. Anna Blume, of course, is identified by a flower; Franz Müller is described in the story as resembling one of Schwitters' sculptures. They could well be the figures in this collage, which therefore refers not only to the troubled alliances of nations but (like some other obviously referential collages) to a happier alliance of the sexes as well.[14]

The marriage of Schwitters' friend and fellow-exhibitor at the Hannover Sezession, Otto Hohlt, was the occasion that prompted the 1920 collage known usually as *fec* (from 77

"fec[it] 1920' besides Schwitters' signature).[15] Here, words and phrases are cut out and arranged to resemble a poster, albeit one whose message is very obscure. It is contemporaneous with *Das Sternenbild*, which referred to political disorder and corruption, and seems to allude, among other things, to Berlin political trials. But what is especially telling about this work is that, whereas Schwitters allows relatively explicit meanings to be grasped from those collages whose message-content is clearly second in importance to their esthetic structure, when he produces a work whose message-content is primary, the meaning of the message is kept deliberately obscure.

The kind of "documentary realism" evident in this first group of early collages was by no means new: Carlo Carrà's *"Free-Word" Painting (Patriotic Celebration)* of 1914 and Maximilian Mopp's *trompe-l'oeil* work *The World War* of 1916 are but two of many precedents. Schwitters' approach falls mid-way between these two: the "documents" are obviously modified but not to such an extent as to efface the poster or newspaper-like format. Indeed, the experience of the collages is not at all unlike that of trying to follow a complicated and sensational story in a badly torn newspaper. Both the content and the fragmentation of the messages serve to evoke a sense of confused and incomplete understanding of a disordered world. And the sensationalism of the never-fully-explained events is only heightened by the declamatory manifesto-like form of their presentation.

The 1920 collages, *Ebing* and *Mz 79. Herz-Klee (Heart-Clover)*, are typical of the second of the groups of early works that I am distinguishing. Here, word-fragments are combined with worn, and often torn, materials, and the irregular boundaries of the materials so merge with each other that they create an overall mood or atmosphere as purely nostalgic as Schwitters ever permitted himself. Again, the association of walls with fragments of torn posters presents itself. But Schwitters seems almost to be painting with his materials in works of this kind; by contrast, the crisp-cut edges of the vast majority of the collages were important to their formal coherence and to their man-made, urban connotations. It is difficult at first to recognize that a work like *Ebing* is composed of entirely separate pieces. Schwitters underplays the "constructional" aspect of collage as he emphasizes the "painterly" aspect. He often sought a balance between the two. The stress placed here on the painterly reminds us that the collages, like the assemblages, were made by an artist who had previously been mainly an oil-painter and who continued to make paintings along with collages.

Herz-Klee is not as fully painterly as *Ebing*, and also relates to the third group of early collages: dramatic and often rather dark works made from a combination of printed and plain materials in which compositional geometry has greater importance. *Herz-Klee* is a fascinating hybrid, partly a painterly collage, and partly dependent on the kinds of composition used in the *Merzbilder*. But its deployment of large rectangular units, which seem to fall down the length of the sheet, is not to be found in either the painterly collages or the 1919-20 *Merzbilder*. The 1920 collage, *Mz 170. Leere im Raum (Void in Space)*, has even more of this gravity-based effect, and a far tauter geometry. Its structure is based on the juxtaposition of flat planes to an extent not realized in any of the 1919-20 *Merzbilder*; but it contains similar topical references—in this case, to the Berlin Majority Socialists and to the Treaty of Versailles they supported—and alludes, in its title, to

similar "cosmic," Expressionist themes. Its mood is Expressionist and gloomy. Its order, however, is far more Cubist, and stable.

The same is true of the fourth group of collages: boldly geometric works such as *Mz 144. Siegel PJ*. Their heavily textured materials and dramatic contrasts associate these collages with the *Merzbilder*, but it is clear that they constitute an independent form. These are not only richly evocative works but totally abstract ones. Schwitters eschews specific topical references and allows the materials to speak for themselves. Historically, they are important works. At the same time, however, the large size of their components in relation to the total surface area causes them to seem as if cut out of larger wholes. 78

It was only when, in the fifth group of early collages, Schwitters reduced somewhat the size of units he used that his characteristic collage method was established. *Merzz 101. Dorf (Village)* and *Mz 169. Formen im Raum (Forms in Space)*, both of 1920, combine fragments of typography, a "painterly" manipulation of materials, geometric-organized compositions and tactile materials—that is to say, the characteristic features of the previous four groups of collages we have looked at. They bring these components together in their richly overlapping structures, which are at the same time dense and complex and extremely lucid in their organization. 109, XI

I have presented the early collages in so schematic a manner in order to isolate the range of their structures and their relationship to the *Merzbilder*, not to suggest that Schwitters moved chronologically from one group to the next. The mature collages were not the result of a logical, linear development. We know this from the numbering of his early works: for example, *Mz 169. Formen im Raum*, which is characteristic of Schwitters' fully developed style, immediately preceded the more overtly Expressionist *Mz 170. Leere im Raum*.[16] Schwitters simultaneously explored a broad range of stylistic and procedural options in 1920 before settling on the kind of collage that combined as many of these options as possible, and from collages like *Formen im Raum* moved on to consolidate what he had achieved. 81

Even in 1920, moreover—and even before *Formen im Raum* and similar works had been made—Schwitters had produced a number of collages that totally escape the war-weary look of all of those considered so far. *Merzz 19*, for example, exhibits a geometric clarity as great as that of *Mz 144. Siegel PJ* but without using heavily textured materials, and is as fully developed stylistically as any 1920 collage. I have dealt first with the five groups of more Expressionist works because collages of these kinds peter out after 1920. (There are later examples—*Mz 192* of 1921 is a case in point—but they are rare.) But it is important to realize that, even as Schwitters was making his broadly Expressionist collages, he was also making much clearer and crisper ones. Some of the earlier 1920 collages in fact anticipate the kind of rigorous geometry that Schwitters was not to consolidate until 1922. *Merzzeichnung 83. Zeichnung F*, for example, with its simple grid-pattern, precedes the Expressionist *Mz 170. Leere im Raum*. Likewise, *Merzz 22*— though not that far compositionally from *Mz 169. Formen im Raum*—sets aside "painterly" effects for a bolder kind of planarity. And *Mz 163. mit frau, schwitzend (with woman, sweating)* reveals an astonishing vividness of color very different from the more muted hues generally characteristic of 1920 collages and more akin to what Schwitters would develop later. 105
78
79
106
81, 113
111

In 1920, then, he was exploring a quite remarkable range of options, and we have to conclude from this that 1920 was indeed the year when Schwitters' career as a maker of collages was truly established. It was in the same year, we remember, that he conflated the methods of the two different kinds of *Merzbilder*: the "A" relief type and the "B" large-collage type. If Schwitters' 1919 collages complement the *Merzbilder* and are subordinate to them, in 1920 the pendulum began to swing the other way.

By 1920, the materials of the *Merzbilder* were regularly filling their surfaces, for as the methods of the "A" and "B" *Merzbilder* were combined, the barer surfaces of some of the "A" works necessarily disappeared. It was at this point that the small collages could not only benefit from the methods of the large-scale pictures but could actually employ their methods to more coherent effect. Their surfaces could be more quickly and intuitively filled. The limited size of the collages meant that Schwitters could always keep in direct contact with their edges and never had to cover large, open surfaces. This being so, he could manage without imposed compositional devices to join the forms. He could also use materials of similar thickness across the work, thereby allaying the two-part reading—of referential high-relief forms and low-relief "background"—that most of the assemblages suggest. This was not easily possible in the assemblages without their seeming visually too flat. In these large works, flatness tended to cause the separate pieces to become isolated from one another, and required applied glazes, or the use of closely related hues, to keep them together. With the collages, in contrast, individual colors could be released with a new force. And finally, since fewer materials were needed in any single work, there would be fewer internal edges. The linearity of the work was therefore held in check, and countered by the manifest planarity of the materials themselves.

None of these advantages were available to the assemblages. By 1921, the collages were affecting their large-scale counterparts, such as *Das Kirschbild*, and Schwitters' mature collage *oeuvre* was fully established.

VIII

□ Even after isolating the options that Schwitters explored in consolidating his approach to collage, the collages themselves still seem to display a bewildering diversity of effect. Are we justified in speaking of a characteristic collage style or collage method? I said earlier that the vastness of Schwitters' collage output—he must have produced in his lifetime over 2,000 collages[17]—was attributable to the inexhaustibility of his materials and not of his formal methods, and I will presently be analyzing the basic stylistic and procedural approaches that he used. It should be noted, however, that while his materials were indeed inexhaustible, the *kinds* of materials available to him were not. For a start, the collages are made mainly of paper, most being technically *papiers collés*; and while there are of course many kinds of paper there are not that many. It would be a merely mechanical task to catalog Schwitters' materials. This has been done for Braque's *papiers collés*, and with interesting results, for his materials were fairly limited in kind.[18] Such a listing for Schwitters would show only that he used paper of virtually every possible origin and description that was available to him.

Schwitters' stylistic and procedural changes did bring with them changes in materials. For example, the Expressionist-influenced structures of 1920 we have been looking at were realized by using worn and tactile materials, and the more purely geometric com-

positions by cleaner ones. The even more stringent style that began to be consolidated in 1922 led Schwitters to use totally unmarked pieces of paper, lest anything detract from the abstract coloristic impact of these works. At the same time, however, he used worn materials in very abstract collages and clean materials in very allusive ones. Materials, styles and procedures together provided a storehouse of possibilities from which he would draw, virtually at will. Concentration on any one of these three topics—and clarity requires that they be separated to some extent for analysis—causes the others to seem to evaporate. Schwitters' art needs to approached on at least these three levels, and as we consider one we must keep in mind that we are only considering a part of the whole.

Among the variety of Schwitters' materials, one kind is rare: paper containing photographs or other illustrative matter. His belief in abstraction brought with it a rejection of illustration. Moreover, the Expressionist sources of his art meant that he was suspicious of any purely descriptive rendering of the world; that had been finally set aside when Expressionism first influenced him. For the Berlin Dadaists, in contrast, collage—or "the new material" as they called it—was important because of its illustrative possibilities and because it allowed them to oppose Expressionism: it could present in "real" (photographic) images the direct reality of the social world and thus repudiate the internally generated basis of Expressionist art.[19] Schwitters never shared the Berliners' sociopolitical concerns. However, when he created Merz he had become impatient with "striving for expression" and was certainly preoccupied with "real" materials. In the early years of Merz, he made a number of collages using illustrative elements, which bear comparison with the Berlin Dadaists' so-called photomontages. These are among the most Dadaist of his works, for their illustrative components press them towards narrative subject-matter, even to narrative structures. Because his art developed from abstract sources, very few of his works permit the narrative and fewer still contain images of the human figure; yet the works of this kind that he made in his early years formed the prototype for a small but interesting thread in his subsequent development. Not the least remarkable feature of his art was the swiftness with which it moved in the early years, and the way he opened up many different futures.

Die Handlung spielt in Theben (*The Action Takes Place in Thebes*)—made possibly as early as 1918-19—shows Schwitters straightforwardly presenting an odd mixture of images with an eye to their greatest legibility, as if they were on a notice board. In consequence, their freedom from compositional preconceptions is very apparent. It seems reasonable to assume that such a concern for legibility at least confirmed (if not itself suggested) the possibility of an art whose logic would be entirely that of the materials themselves. If so, works like this are important in the development of Schwitters' constructional approach to collage, as well as being fascinating oddities. Disregarding for a moment the wealth of descriptive incident this work contains, and concentrating instead on its composition, we find it is based entirely on rectilinear forms, built up to create a solidly constructed wall of matter that is structurally far more stable than most of the abstract works of this period. Moreover, since Schwitters' materials convey information, their planarity rather than their edge patterning is necessarily emphasized. But here, anecdote wins out over form. *Die Handlung spielt in Theben* is an early

84

pictorial version of Schwitters' Anna Blume theme, his gentle mockery of the fashionable bourgeois lady. The form of this and similar works may well have been suggested to Schwitters by his realization that the women in fashion drawings—and indeed in photographs—of a particular period all tend to look exactly alike. Here, Annas from photographs and fashion drawings are mixed up with their art-historical counterparts— the smiling angel of Rheims, a Madonna by Stefan Lochner—all set among scenes of Anna's own period.

As with Schwitters' collages in general, the photomontages interrelate through their subject-matter. If by including high art fragments in *Die Handlung spielt in Theben* Schwitters seems to be satirizing them, this impression is even greater in a later work, *Mz 151. Wenzel Kind (Knave Child)* of 1921, where a racehorse nudges into Schwitters' reworking of the *Sistine Madonna*. The Madonna herself is defiled by an Anna Blume head (like Duchamp's whiskered Mona Lisa), while the putti, who in Raphael's painting stand for the presence of ordinary human nature, are replaced by machine parts. *Amerika ist angenehm berührt* (America is pleasantly affected) is the puzzling announcement at the top. More reasonable, perhaps, is the statement attached to the paper that covers the putti: *Gedankenvoll liess Victor das Blatt sinken* (Thoughtfully, Victor let the paper fall). But what is intended by this is hard to tell.

In *Das Engelbild (The Angel Picture)*—probably of 1920 despite its inscribed 1918 date[20]—amid what looks like machine parts but is really Schwitters' own Dada sculpture *Die Kultpumpe (The Cult Pump)*, the putti themselves appear, seemingly unconcerned by their move to such tawdry surroundings. The racehorse in *Wenzel Kind* relates to those in the 1918-19 *König Eduard (King Edward)*, which celebrates the 1909 state visit of Edward VII of England to Berlin, and his meeting with the Kaiser, Wilhelm II. As the text relates, the two monarchs are seen on a ride to the Friedrich Monument. It is interesting to note how this work suggests that Schwitters at times may have kept or sought out old materials: ten years old in this case, unless it derived from a history book, an anniversary publication on the state visit or, more likely, a commemoration of the Kaiser's abdication in 1918. Certainly, to realize that this collage, illustrative of imperial pursuits, was made at the very moment of the Kaiser's downfall adds potency to its meaning.

The juxtaposition of woman and machine parts in *Wenzel Kind* associates it with Berlin Dada photomontages, especially with the work of Raoul Hausmann. The machine-woman image is specified, and the connection with Hausmann made obvious, in *Mz 239. Frau-Uhr (Woman-Watch)* of 1921. By this date, Schwitters was in close contact with Hausmann, and he was certainly influenced, in works of this kind, by Berlin Dada art. What is uncertain is whether his earlier collages with illustrative materials, such as *Die Handlung spielt in Theben* and *König Eduard*, can be attributed to Berlin Dada influence. These collages have been dated 1918, but that is probably too early. However, they are stylistically different from the Berlin Dada-influenced works and would seem to precede them.[21] If Schwitters learned of photomontage from Hausmann (who claims that he introduced Schwitters to the technique),[22] it could not have been when the two first met, either late in 1918 or, more probably, early in 1919.[23] Hausmann has insisted that he "invented" photomontage (it was, of course, a favorite Victorian

pastime) in the summer of 1918.[24] This, however, is clearly impossible, for the earliest of his photomontages— a design for his broadsheet, *Synthetisches Cino der Malerei* (*Synthetic Cinema of Painting*)—was almost certainly made in 1919; the broadsheet itself formed part of the projected Dada anthology, *Dadaco* (mentioned in Chapter 2), which was intended for publication at the end of that year.[25] None of Hausmann's other extant photomontages (nor any of Heartfield's or Grosz's—two others who have claimed the invention)[26] has been given a date prior to 1919. Although the principle of photomontage is visible in Berlin Dada publications produced before Schwitters adopted collage (for example, in the combination of printers' vignettes which decorated the pages of *Neue Jugend* in 1917),[27] it is by no means certain that Schwitters' earliest photomontages postdate those by Berlin Dadaists. We should probably therefore add Schwitters' name to the already long list of possible inventors of this technique.

In 1920, however, Schwitters began to be affected by the Berliners' ideas. He never adopted the De Chirico-influenced spaces that appear in many Berlin Dada photomontages, but he did develop a similar kind of art/fashion and fashion/machine subject-matter. In one of Hausmann's early photomontages, a pattern of cut-out photographs of men's legs is collaged onto the cover of Max Ernst's 1919 album *Fiat Modes*[28]—itself, of course, having fashion as its subject and fashion, moreover, related to art. Its full title was *Fiat Modes. Pereat Ars* ("Let there be fashion; let art perish"). Hausmann was interested in fashion and like Vladimir Tatlin, whom he particularly admired, also designed clothes.[29] He wrote in his article "PRÉsentismus" of 1921 that the beauty of daily life was determined by the mannequin and the art of wigmakers and hairdressers as well as by the precision of technical construction.[30] Mannequins appear in several of his works, and are sometimes robot-like in appearance and sometimes juxtaposed with figures with machine parts for brains and hearts.[31] Similar images appear in the work of several other Berlin Dadaists, and the connection between fashion, art and the machine was cemented in 1920 by the invention of the word "photomontage" itself. Heartfield called himself a "*Monteur*" (mechanic) as a sign of identification with the engineers and electricians who wore blue overalls (*Monteuranzüge*).[32]

Schwitters was also interested in fashion. His parents had owned a ladies' clothes shop.[33] He was to plan a volume on fashion in 1924.[34] Given the interest in bourgeois customs evident in his writings, it was perhaps only natural that he should be attracted to the use of fashion imagery in his collages. *Mz 158. Das Kotsbild* (*The Kots Picture*) of 95
1920 shows this clearly, and is particularly interesting in revealing just how much the imagery of Schwitters' illustrative collages does interrelate. The motif of a man and woman walking under some trees with a head floating above them also appears in one of his 1920 *i-Zeichnungen*, which he specifically identified as a "fashion" drawing: *Zeich-* 92
nung 16. Mode I (*Fashion I*). The smartly coiffured woman in the top right of *Das Kotsbild* reappears in slightly different forms in several other works. In *Mz 180. Figurine* 91
of 1921, her dress is replaced by a piece of cut-out newspaper (representing a dress pattern?) while Schwitters' short text underneath the work ("Paper is the great fashion . . .")[35] relates fashion cutting to the act of collage itself.

The fashion drawings in *Das Kotsbild* reappear in several other collages,[36] and Schwitters also made use of them in his book-cover designs, thus identifying these prim

young ladies with his favorite heroine, Anna Blume, whose name is pasted across *Das Kotsbild* itself. One of these ladies appears, this time wearing a hat, on the frontispiece of *Memoiren Anna Blumes in Bleie (Memoirs of Anna Blume in Lead [Pencil])* (1922), and we know that Schwitters meant her to represent Anna, for he collaged a similar image over a postcard of one of his student paintings, a still-life of a book and chalice. Inscribed across the open pages of the book are the words: *Ich liebe dir ANNA.* Schwitters' attitudes to his subject were indeed more affectionate than those of the Berlin Dadaists. The scatter of machine images in the photomontages have never the cold, robot-like hardness they do in Berlin work, and the machine-hearted *Frau-Uhr* even seems to poke fun at the Berliners' machinist obsessions in its clearly comical effect. If, however, we return to *Das Kotsbild* for the last time, it becomes apparent that Schwitters was not totally in love with his fashionable ladies, for the various pasted texts that lie across this work associate *Anna Blume* and the subject of women's professions (*Frauenberufe*) not only with commercial interests—the Polish bank-note, *Bezugsschein* (goods order or ration card), *Preisang[abe]* (price quotation)—but also with animal ones: with chamois-dressed cowhide (*Sämischgares Rindleder*), dog collars (*Hundehalsbänder*) and even with filth (*Kot*). And if we are still not quite certain that the animality of Anna is the subject of the collage, the fact that Schwitters sets his images of our modish heroine above one of a dog is to make sure that we do not miss the point.

Most of the photomontages date from 1918-19 to 1922 although Schwitters continued to make them throughout the 1920s, some with fashion images, others with machine forms. He was also to return to photomontage in his last years. But only rarely does his work offer so specific a reading as *Das Kotsbild*. While occasional early assemblages and collages provide thematically consistent topical references, and while (as we shall see later) a few of the abstract collages seem to contain definite iconographic schemes, works of this kind are exceptional in Schwitters' *oeuvre*, which usually alludes more generally to the outside world without trying to shape it in a programmatic way. Hence, the marvelous 1922 collage *Die Sattlermappe (The Saddler Portfolio)* shows Anna Blume (so identified) beside images of Napoleon (or a soldier who resembled him) and a Hamburg café-goer, and the names of Goethe, the Kaiser and Bismarck, as if to say that all these people inhabit the same world; but quite what it is that brings them together here is deliberately withheld.

This collage may have been made in a large notebook, for the right-hand one of the two sheets resembles pages in a scrap-book that Schwitters kept. This would help to explain its disjointed character. It also bears comparison with the collaged postcards that Schwitters sent to some of his friends, which themselves remind us how rooted in his daily life his collages were. The left-hand sheet of *Die Sattlermappe*, however, with its juxtaposition of illustrative materials and bold typography, is not only less casual but is stylistically rather different from the photomontages hitherto discussed. Its geometry tells of the increasing formalization of Schwitters' art in 1922, but its juxtapositions look back once again to Berlin Dada: they are not that far removed from *Dada Cino*, a collage of 1920 that Hausmann dedicated to Schwitters on April 9, 1921, telling him that Dada entrusts its heart to Merz. Works such as this are among the most fascinating of Schwitters' productions. Indeed, it can reasonably be said that his works in any medium that we

find most fascinating are precisely those that call for an iconographical reading. This is not to say, however, that these are Schwitters' most profound works. It is often true, as Northrop Frye has observed, that the most profound work of art "draws us to a point at which we seem to see an enormous number of converging patterns of significance."[37] Nevertheless, works of art that offer rich iconographical readings are not intrinsically better, of course, than works that offer less or even nothing in this regard. In Schwitters' case, we need to be particularly careful not to confuse interest and achievement, if only because his most interesting works, in this sense, are often not his most achieved.[38]

These are, in fact, exceptional works. Indeed, works that readily permit narrative connections to be made between their components are exceptional. And certainly, except for the Dadaist drawings discussed earlier and for the photomontages, the rampant fantasy of a significant portion of Schwitters' literary work was usually kept out of his visual art. Although the amusing titles of some of his collages belie their obvious seriousness, and although a number contain humorous or provocative word-fragments, the humor is always contained by, and subject to, the rigorous abstraction that organizes most of his work.

☐ I said earlier that Schwitters' collages, despite their apparently bewildering diversity, made use of a very limited number of stylistic and procedural methods. By stylistic methods, I mean methods derived from existing modern styles. By procedural methods, I mean methods derived from the physical act of making collages. Let us now take up the development of Schwitters' abstract collages where we left it in 1920, and consider the basic principles of their creation.

The classic collages of 1920-22, indeed the majority of Schwitters' subsequent collages, can best be formally analyzed with the aid of dichotomy, for his stylistic and procedural methods each veer toward one of two poles. Compositionally, they tend to either a radiating (or oblique) format with the papers pasted in various diagonal positions across the sheet, or to a rectilinear grid format, with many of the papers mirroring the shape of the sheet itself.

The first of these formats is closest to that of the 1919-20 *Merzbilder*—especially the "B" type of large collages—and derives from the same stylistic sources, especially from Futurism. Schwitters made a number of centrifugal or centripetal collages in 1920-22— *Mz 322. bunt (many-colored)* of 1921 is a good example—that are quite close to Futurist models. More often than not, however, he would temper the Futurist sense of momentum by causing the centralized burst of activity to seem suspended in space, and often to seem as if suspended in the act of falling down the sheet. *Mz 313. Otto* of 1921 is thereby a more typical work.

101, 103

102

What causes the sense of materials in suspension is not only the expressed planarity of the materials themselves—the broader the surfaces they present, the more they seem fixed in place; the narrower, the greater their sense of linear velocity—it is also their anchoring by more stable, rectilinear forms. In *Otto*, Schwitters has placed the more volatile, angular pieces on top of a generalized grid. This opposite compositional method, the rectilinear grid format, derives very directly from Cubist collage. *Merzz 19* and *Merzzeichnung 83. Zeichnung F*, both of 1920, show Schwitters adopting more

105

106

107 relaxed and more rigid versions of a Cubist collage style. Both of these works, we should note, make use of a bold number or letter on a frontal, rectangular piece of paper as a way of catching the viewer's eye and carrying it into the composition. There are Cubist

108 prototypes for this device, and we see something comparable in Klee—the use of typographical elements for their inherent geometry. It became a favorite of Schwitters'. I return to it shortly in a more detailed discussion of Schwitters' relationship to Cubist art.

Grid-based composition became increasingly more frequent, especially from 1922 when Schwitters made contact with Constructivist artists, and diagonal ones less common. Centralized ones almost entirely disappear: the demands of formal stability precluded them. But if there is a "typical" Schwitters collage, it is one that combines the formal stability of the grid format with carefully plotted diagonal movements that

120 enliven the rectilinear geometry without diminishing its solidity. *Mz 271. Kammer* (*Cupboard*) of 1921 is a collage of exactly this kind.

The pasting of papers in collage has a beginning and an end which the work can reveal to a greater or lesser degree. From this proposition we can deduce the two opposite procedural methods that Schwitters' collages reveal. If the work is built outwards from

113 the center—as in the case of *Merzz 22, 1920*—the last pastings occupy its perimeters and

111 the edges achieve special prominence. If it is built inwards—as with *Mz 163. mit frau, schwitzend* (*with woman, sweating*) of 1920—this keeps the last-pasted elements away from the edges, and causes some of them to seem to float on the surface. Schwitters' most Futurist-influenced compositions tend to disguise the location of beginning and end in order to produce their all-over, contrapuntal effects, and so do his very "painterly" collages. By and large, however, he veers in one or the other of these directions—though

112 again, the works we think of as perhaps most typical, like *Mz 316. ische gelb* (*ish yellow*) of 1921, are precisely those that seem to perfectly combine them. Of course, the extent to which either method is noticed is affected by the disposition of colors and by the compositional form itself.

Besides signal-like letters or numbers, other devices became particular Schwitters

113 favorites. The single, cutting diagonal that runs across *Merzz 22* of 1920 was used, in

114 different forms, in several of that year's works. In *Mz 88. Rotstrich* (*Red Stroke*), the title

XI draws attention to it. In *Mz 169. Formen im Raum* it is a broad, pointing diagonal, veiled

117 by a transparent paper square, and in *Zeichnung I9. Hebel 2* (*Lever 2*), it is a feather sandwiched between a cluster of rectangles. One of the earliest examples of its use, if not

115 the very earliest, is in *Mz 39. russisches bild* (*russian picture*), where it is a tangible beam

116 or rod very like those in Puni's reliefs. Whether or not this device derived from Constructivist art (the title of *russisches bild* suggests that it did), Schwitters quickly made it his own. In the *Merzbilder*—as in the preceding abstract paintings—Schwitters conceived of formal elements as each having its own unique expressive possibilities; so, in the *Merzzeichnungen*, he is highly responsive to the variety of weights and forces that differently shaped papers possess. His collages are sensitively balanced constructions, delicate machines whose parts tip in opposing directions, are tuned and adjusted, reset, and come to rest in perfect equilibrium.

Many, as observed earlier, give the impression of being suspended in the process of gentle fall, their materials seemingly having drifted towards the bottom of the sheet.

Others respond to gravity in a rather different way: by resting solidly on the bottom edge itself. *Mz 334. Verbürgt rein* (*Warranted Pure*) of 1921 thus almost resembles the forms 118
of a stylized landscape with a horizon in the background. Gravity-based compositions like this may owe something to a simple procedural factor: Schwitters' tendency to join materials to the edge nearest to him while he was working. It is a compositional device that he could, however, have borrowed from Cubist paintings. We have already noticed something similar in the *Merzbild, Konstruktion für edle Frauen*. Moreover, a number of VII
collages—the most striking example is *Mz 299. für V.I. Kuron* of 1921—are composed 121
along an implied central vertical axis, with materials converging or splaying out, echoing the position of the artist's body as he works. Here again, though, this kind of composition may be traced back into Cubism: it is a reversed form of the tent-like diagonals in Picasso's and Braque's Analytical Cubist portraits, and seen in Schwitters' own early 56
assemblages like *Bild mit rotem Kreuz* of 1919. Gravity-based compositions of this kind 54
have the advantage of seeming to express very directly how the materials, spreading down the sheet, themselves create and delimit spaces. Likewise in the outward-built collages: the boundaries arrived at seem just large enough to accommodate the materials they contain, while the materials positioned at the edges both define the literal shape of the work and reflect back into the center.

There are few instances of collages with no edge alignments at all, and this serves to confirm just how much Schwitters' collage style was founded in Cubist design principles. *Mz 308. Grau* (*Gray*) of 1921 appears to be built mainly inwards (its central forms 119
reading most strongly), but here the Cubist axiality of Schwitters' style could hardly be more pronounced, being emphasized by the "pure" colors and the regular, clear-cut shapes of the materials used. Even in those rare cases when Schwitters tears all the edges of his materials, the axiality of the printed matter reminds us once again of his Cubist sources. Occasional collages—like *Mz 321. Blaukreuz oval* (*Blue Cross Oval*) of 1921— 110
are even composed within a typical Analytical Cubist oval. Inside the oval, however, is a Synthetic not Analytical Cubist composition.

Although individual collages thus reflect the stylistic influence of Analytical Cubism and its derivatives, Schwitters' collage style as a whole is more basically dependent upon the principles of Synthetic Cubism. The following characteristics of Cubist painting after 1912, as typified by Picasso's 1913-14 *Card Player*, were certainly crucial to his mature 128
work:

First, the essentially abstract space of Synthetic Cubism which replaced the more illusionistic and atmospheric painterly continuum of the Analytical style and which even the most blatant kind of "real" images could not disturb. A similar non-illusionistic abstractness of space (unviolated even by specifically illustrative images) characterizes nearly all of Schwitters' small-scale collages, at least until his last years.

Second, the "constructional" nature of Synthetic Cubist compositions. By 1913, Synthetic Cubism had replaced the earlier intuitive realization of the form of the subject-matter in the act of painting itself by an arrangement of flat, colored and broadly geometric planes, each of which synthesized the artist's knowledge of the object (or part of the object) he had looked at. The art was now a matter of manipulating a somehow preexisting vocabulary of elements, and the painting became a kind of container within

which the elements were placed—in arrangements, moreover, which were far freer from the patterns of external reality than before. Schwitters' collages are likewise freely constructed from preexisting geometric parts.

Third, Synthetic Cubism's representation of the world was a fully conceptual one. No longer were forms copied or realized after nature; they were in effect signs: signs which in Synthetic Cubism stood for objects but which could hold more generalized meanings. In Schwitters' case, the units that refer to the world are objects themselves, but the Synthetic Cubist conception of a work of art as a "readable" amalgam of schematic "meaningful" units still lies behind his structural method.

107 It was, of course, the invention of collage in 1912 that led to the creation of Synthetic Cubism. The new, pasted-on shapes in works like Picasso's 1913 *Guitar* spread their non-illusionistic flatness across the works, put an end to sculptural shading and emphasized the built-up or constructional character of the works themselves and their material or object-like existence. Cubist collage, however, like all other aspects of Cubist art, was realist in intention and thus firmly separates itself from Schwitters' art. The materials in Cubist collage represented or suggested, both in their shapes and in their colors, objects other than themselves. Their composition too was based on observed subjects in the outside world. That is to say, although the materials were of course used for their pictorial or "abstract" qualities, they had also a representational function.

With Schwitters' collages, in contrast, the pictorial or abstract is balanced not by the representational but by what might be called the representative. No matter how closely his compositions approach Cubist geometry, his materials function not as representations of external reality but as its representative tokens. This being so, Schwitters is not limited to any naturalistic color or compositional arrangement, and we see in his work a fully non-illusionistic flatness, a full use of all parts of the pictorial surface (unprejudiced by composition hierarchies), and a liberated use of color. Moreover, while in Cubist collage there is often a certain sense of dislocation between colored materials and formal structure (with materials being added to an *a priori* drawn structure, and sign-like drawing being placed over materials), there is no such dislocation in Schwitters' art. Form and materials are one.

Whereas the Cubists still thought of their added materials as rather unusual, anomalous things—to be carefully chosen from the everyday world, then affixed to the surfaces of their paintings or drawings where they stood out like casually dressed guests at a formal reception—Schwitters does not allow of such a division between materials and esthetic context. It is the adjustment of the materials themselves that gives the work its form. As we noticed in considering his assemblages, he had come to the collage method from oil painting, and from a preoccupation with texture and touch, and the organization of wet "painterly" surfaces. In many of the collages, and particularly the early ones, he seems to "paint" with his new materials. Materials are added to materials in a cumulative and improvisatory process that makes some of these works into dense, many-layered sandwiches, some sections of which tend even to billow or to sag, so heavy are the accumulations of paper that they contain.

Käte Steinitz remembers how Schwitters' home was infused with a distinctive "Schwitters aroma" produced not only by cooking smells and by the guinea pigs he kept,

but by pots of hot glue and homemade starch (presumably flour paste) that he had ready for making collages.[39] And his medium was as much the glue or paste as the pieces of paper that he found. According to one of his friends, Charlotte Weidler, when he was making a collage, its whole surface became a wet, slippery mass:

> He spread flour and water over the paper, then moved and shuffled and manipulated his scraps of paper around in the paste while the paper was wet. With his fingertips he worked little pieces of crumpled paper into the wet surface In this way he used flour both as paste and as paint.[40]

Often, the papers were washed before being used (which accounts in part for the faded colors of some collages) and added to the work still dripping.[41] New scraps were added on top of previous ones and the constantly wet surface built up in relief until the desired configuration was reached. At times, the edges of the now thickened sheet were then cropped to size to fix the balance of the composition even more exactly.

Not all of the collages by any means are dense sandwiches of found matter bonded together in this way. Some contain far fewer materials, with virtually every piece used being visible in the completed work. But with very few exceptions indeed, the intuitive arrangement of colored papers creates the very form of the work itself. Although there is always (except where Schwitters used totally clean papers) an implied opposition between the *Eigengift* innate in materials and the new esthetic or abstract qualities that Schwitters confers on them, we hardly ever get that Cubist sense of found materials being added to what is still in effect a painting or a drawing. The early assemblages have some of this hybrid feeling; the collages do not. Their structure and logic is entirely that of the materials from which they are composed. Schwitters was not the first to carry collage to this logical conclusion. Arp, for example, in the Zurich collages which Schwitters learned from, did the same; except he tended to repress any kind of external reference in favor of the purely pictorial or abstract, and when he did return to referential forms he did so by shaping his materials to suggest the silhouettes of organic objects. Schwitters, in contrast, always kept to abstract contours and compositions, balancing the pictorial and the representative in the very materials themselves.

This is the truly central feature of Schwitters' collages, and was established only when he began to form them from flat planar materials. Only by using flat planes could the pictorial and the representative exist simultaneously, and only by this method was Schwitters' remarkable sense of color (formally one of the most important of his achievements, and the one which symbolized all that the more aggressive Dadaists objected to in his work) able to develop. It has been suggested that collage itself was invented by the Cubists as a way of reintroducing color into their paintings, and that only after the invention of collage could they use color in other than a neutral way.[42] Certainly, sharp color contrasts were inimical to Analytical Cubism, since each color area would have had to be shaded in terms of its own particular hue. This would have destroyed the uniform illusionistic space and have caused the separate colored shapes to seem isolated from one another.[43] Schwitters' early large-scale collaged *Merzbilder* are similar to Analytical Cubist pictures in this respect. Only when he turned to a "Synthetic" part-to-part method of combining flat colored planes did his art achieve its maturity.

Schwitters' full color sense emerged only gradually. There is nothing in his early paintings, and only a little in his first assemblages and large collages, to prepare us for the striking coloristic impact of the collages from 1920 onwards. Many of the collages from 1918-20 use similar color schemes to those in the assemblages: a predominantly "natu-

XI ral" look of browns and tans—as in *Formen im Raum*—punctuated in some cases by
X areas of more intense hue; contrasted, but faded, tones—as in *Mai 191*; or deeply
IX sonorous harmonies—as in *Hansi*. The early collages tend also, as we have seen, to make use of strong textural interest and a somewhat "painterly" overlapping of materials. Tactile effects of this kind necessarily work against the visibility of colors. Schwitters rarely abandoned such effects (only very few collages rely solely on vivid, side-by-side juxtapositions), but he increasingly allowed flat opaque elements to dominate his art, and with this the clarity of his color was strengthened.

Many works of 1921–22 (and afterwards too) continue to give prominence to one color or one range of closely related colors, but now with heightened effect, as for

XV example with the soft beiges and yellows and dull reds of the 1922 *Der Weihnachts-*
XI *mann (Santa Claus)*. Comparison with, say, *Formen im Raum* 1920 gives the impression that Schwitters is gradually unveiling the force of his colors. Even in 1921, in fact, he had already increased the tone of his color. But only in exceptional 1921 collages—like

119 *Grau*—is it vividly contrasting color. Schwitters often worked best when giving a single color prominence; and this does provide a certain continuity in his development from painting to assemblage to collage. And yet, the initial monochromatic effect of even collages like *Formen im Raum* is not used (as in the collage-type *Merzbilder*) to create an overall luminous space, but for the sake of pictorial coherence. Increasingly—as in *Mz*

XIII *410. irgendsowas (something or other)* of 1922—it is there to provide a stable setting for the unexpected juxtapositions of frank, pure hues that are set off against the dominant tonalities.

This is, in effect, Fauvist color within a Cubist system.[44] The differences of value inherent in different hues used at full intensity are accepted for the sake of the optical

XV vigor that their contrasts create. Works like *Der Weihnachtsmann* of 1922, use such contrasts of hue to enliven a section of work: in this example, the contrasting hues play off against the vivid contrasts of dark and light across the rest of the surface. Others, like

XIV *Mz 252. Farbige Quadrate (Colored Squares)* of 1921, make the whole composition a matter of patterned color contrasts. But no matter how strong the hues that differentiate certain of the flat paper planes, only rarely do they become isolated from the rest of the work—because they themselves physically occupy the individual and overlaid planes of which the work is composed. In the best of Schwitters' work, color unifies, ties and flattens, while allowing often vivid side-by-side juxtapositions at the same time. In the early large collages, light seems to be located—Impressionist- or Cubist-like—within the works, but in the small collages it often seems to bounce off or be reflected from them in a Fauvist manner.

Only occasionally, however, did Schwitters use high-keyed Fauvist contrasts right across a collage, lest the multitude of colors cancel each other out. *Grau* comes closest to this; and the fact that the use of so many colors blurs the force of each, resulting in an overall optical grayness, is acknowledged in the title. *Farbige Quadrate* is more typical in

this respect, for when Schwitters made collages with unmarked materials so as to con-
centrate on color, he tended to soften a number of the colors to allow others
dominance—and when, as here, he employed an assertively directional composition, this
further helped to tie the colors together. In fact, many works of 1921–22 contain very
few full-intensity hues, and a number none at all. Even in 1923, we find collages like *Mz
231. Miss Blanche,* which rely on close-toned adjustments of muted or washed-out XII
colors, together with delicate overlaid transparencies, in order to release color very
gradually to the eye, and to assist in the creation of an all-over flattened space.

In such a system, however, illusionism can never be absent, no matter how flat the
materials are or how much they lock in, one with the next. Overlapping, the optical shifts
provided by color juxtapositions, the relative size, isolation and difference in material or
shape of the individual units, all contrive to induce a feeling of space in the collages: a
shallow space, it is true, but still greater than the physical depth of those works. Indeed,
in an art such as Schwitters', which uses an accumulation of distinct and separate units,
the principal formal problem was to generate a sense of spatial unity that would over-
come the natural tendency of flat objects to stay separately isolated across the two-
dimensional plane on which they were placed. Schwitters' color choices were important
in creating this; so too were the kinds of geometric composition he used, the usually
regular sizes of his pictorial units, and the small dimensions of the work itself. The
regular sizes of the materials were particularly important to their assimilation in the
Cubist grid or the Futurist-derived centralized or diagonal compositions Schwitters
used. In some collages, units of widely different sizes are used (with smaller elements over
larger ones), but generally they tend to be of a similar size, and similar shape too: usually
rectangular, though often wedge-shaped in the centralized compositions—in any case,
close enough to each other in character to give structural uniformity to the work.

Schwitters gradually abandoned the circular forms that had figured so prominently in
the *Merzbilder*. They persist in some centralized collages of 1921—as the focus of their
centralization—but Schwitters clearly came to realize that formally unique elements
isolate themselves from the others, and therefore do not become fully "dematerialized"
in the way he said he wanted them to be. He was by no means loath to include very
curious materials—the color disc in *Der Weihnachtsmann,* for example, or the images of XV
spiders in two works of 1921—to enliven the geometry of his work, which could at times 122, 123
become somewhat bland; but he seems increasingly to have avoided giving prominence
to eccentrically shaped pieces, lest they draw undue attention to themselves at the
expense of the whole work. He was not concerned, as Arp was, or later Matisse in his
cut-outs, with shaping or forming the pieces of material, but with assembling materials
of essentially neutral shape. Although the papers do show a definite human touch in the
way they are cut (or occasionally torn), they are rarely contoured, rarely given intrinsi-
cally sculptural silhouettes—again, lest they separate themselves from their neighbors.

The same motive probably explains Schwitters' general avoidance of the curvilinear,
even in the fragments of typography in the collages: here he tended to isolate rectilinear
rather than curved letters, or more usually cut-out groups of letters or words, with the
result that the axial form of the lettering reflects and corroborates the grid format of the
whole work.[45] Increasingly—and possibly influenced by certain of Klee's watercolors— 108

Schwitters used axial letters (and numbers) and word fragments to help focus and stabilize his compositions, and soon the Gothic lettering characteristic of early collages almost entirely disappeared. This further reinforces the air of classical restraint and formalization that more frequent use of rigorously geometric material provides.

The addition of typographical fragments also helps to reinforce the scale of the collages, emphasizing their small, page-like dimensions, and nearly all of the collages contain some kind of material that reminds us of their size. Smallness was necessary to Schwitters, so that his collages could be spontaneously and intuitively created, but also to keep them coherent, to keep all the small pieces in proximity to the rectangular limits of the sheet. He reduced the size of the materials he used and multiplied them in number so that their own individual characters are subordinated to the abstract totality of the whole work. Merz meant not only assemblage, but abstraction as well.

Schwitters' commitment to abstraction was very nearly absolute. His pronouncements upon his work frequently stress its absolute autonomy:

> The picture is a self-contained work of art. It refers to nothing outside of itself. Nor can a consistent work of art refer to anything outside of itself without loosening its ties to art A consistent work of art must be abstract.[46]

This particular statement appeared in 1923 in the first issue of Schwitters' magazine, *Merz*. By then, his work had become even more rigorous—for in 1922 he had become friendly with artists such as Theo van Doesburg and El Lissitzky—and so it remained, by and large, until the end of the decade. He continued, nevertheless, to produce extremely

126, 127 allusive collages. An untitled 1922 collage known as *Emerka* and *Mz 387. Kaltensundheim* of the same year can serve to illustrate the opposite poles of Schwitters' art as he formed his Constructivist alliance. The former is as strictly organized as the severest

128 Synthetic Cubist painting. The latter is delicate, moody—and, in the final count, still an Expressionist work; but one in which the heatedness of Expressionism has been tempered and cooled. The cluster of papers toward the center evokes a hand of cards thrown down on a table. Schwitters had included playing cards in a number of *Merzbilder*.[47] Their metaphorical significance carries into the collages as well, for making a collage is like playing an adult game with similarly meaningful pieces of card or paper. To compare

129 *Kaltensundheim* with Otto Dix's frightening 1920 *Kartenspielende Kriegskrüppel* (*Card-Playing War-Cripples*) is to see both a stylistic and a thematic connection between the two works, and an enormous gulf—for Schwitters' sublimated Expressionism retreats from the brute, sordid realities of Dix's pictures into personal patterns of play. He escapes the realities of the world from which his waste materials derived; he brings his materials indoors, and from them creates a quiet, contemplative order, and a sense of peace.

□ Of all the features of Schwitters' art, it is the character of his materials which has provoked most comment, occasioning various interpretations of his intentions ranging from social satire to pure mysticism.[48] Such concern for intentions has too frequently involved a quarrying for latent content which undervalues the structure of the work, and ignores the fact that the structural and psychological aspects of Schwitters' work are

parallel and complementary, each as available through the "form" of the work as the other. And, certainly, the work can do without any of those special dispensations, favoring psychological "rightness" over formal quality, that are sometimes demanded for artists in the Dada-Surrealist tradition.

. Occasional collages do seem to demand understanding on solely associative terms, but only when their materials are displayed as mere found objects with no attempt to fuse them structurally with their neighbors. Indeed, the more that individual materials appear to be autonomous and separate within any work, the more likely it is that they function as triggers for non-pictorial associations. Conversely, the more materials lock in one with the next—and Schwitters' preoccupation with "forming" and avoidance of eccentrically shaped materials meant that this is what usually happened—the less likely it is that we read them in a purely referential way. Of course, the referential status of the materials is not, and cannot be, effaced. No matter how securely the materials are combined and contained by the inherent geometry of the work, a feeling of tension and opposition necessarily remains—as it does in virtually all collages—between the world of art which receives the "foreign" materials and the world of external reality from which they derived. Schwitters would probably have agreed with Edouard, in Gide's "Cubist" novel, *Les Faux-Monnayeurs* (*The Counterfeiters*), who wrote in his journal:

> I am beginning to catch sight of what I might call the "deep-lying subject" of my book. It is—it will be—no doubt, the rivalry between the real world and the representation of it which we make to ourselves. The manner in which the world of appearances imposes itself upon us, and the manner in which we try to impose on the outside world our own interpretation—this is the drama of our lives.[49]

In Schwitters' *Merzbilder*—as earlier in Cubist collages—this distinction or rivalry was directly expressed in the hybrid status of the works themselves: they used foreign elements in what were still recognizably paintings. Schwitters' *Merzzeichnungen*, being composed entirely of pasted materials, do not have this hybrid form. A distinction between art and reality still remains, however, because the materials in any work can never be perceived to function simultaneously as both "form" and "reference" although they exist as such. A useful analogy here is the figure-ground illusion, for we either, or alternatively, see the materials for themselves or for their structural function. No sooner do we recognize an individual object than we are forced to let it go in favor of the neighboring object to which it is adjusted. In terms of reference, therefore, the "fixation pauses" (to borrow an image from reading), during which association reactions can occur, are at odds with the "saccades" between them.[50] Since it takes a deliberate effort to keep focusing on individual materials, the viewer is pushed into searching for a common denominator between them (in an emotional as well as structural or iconographical sense). This enforced scanning means that each work is fully experienced only when the viewer somehow reconstructs the activity of Schwitters' creation.

As Meyer Schapiro has observed, collage itself lies in a tradition deriving from still-life painting, which enjoys the manipulation of objects of use, objects smaller than ourselves which owe their presence to human actions and purposes. It conveys man's sense of control over his material environment, invites our empathy towards others' control, and

must refer to fields of interest other than the strictly pictorial, expressing "an empirical standpoint wherein our knowledge of proximate objects . . . is the model or ground of all knowledge . . . 'the reality of what we can see is what we can handle.'"[51]

To consider the collages as a whole means being made continually aware of their strict formal control, of their abstractness. But this is also, in a sense, to generalize them.[52] When taken singly, their abstraction, though in no sense effaced, becomes a curiously elusive aspect of their total effect. The abstract structure of a collage is no longer reinforced by the structures of other collages. It is not style that we notice first but materials—and partly because the materials do not seem to fill in an *a priori* structural framework (as they do in the early *Merzbilder*), but rather to create an intuitive structure in their juxtapositions. The effect of each of Schwitters' mature collages is not of a (stylistically predetermined) whole made up of pieces, but of pieces making a whole. In the viewing—as well as in the making—of these works, structure and abstraction is discovered in the relationships generated by the stimuli of individual, and inescapably "real," materials.

Schwitters, we remember, said that in creating his work he "always responded to the stimulus of details not formed by myself."[53] From the context of this statement it is clear that he was referring to the esthetic stimuli that found materials provided. Most of his pronouncements on the function and status of materials are in this vein. On a few occasions, however, he did acknowledge that they held meanings for him other than the purely esthetic: because they were the remains of a broken-down system or culture which he was reconstituting in a new way.[54]

Schwitters' son has emphasized the social connotations of such an approach, writing that his father "saw the great weariness and ruin which surrounded him everywhere after the war, and also how, by making use of the qualities associated with these characteristics, he could rebuild a better, sounder, more honest culture."[55] This, however, cannot explain Schwitters' continued use of collage beyond the early turbulent years. Herbert Read, who knew the artist in England, suggested that there was "in his whole attitude to art a deep protest against the chromium-plated conception of modernism. The bourgeois loves slickness and polish: Schwitters hates them."[56] Schwitters himself seems to have countenanced such an interpretation when, on two occasions, he gave alternative derivations for the name Merz. Instead of acknowledging that it was simply a chance fragment cut from the phrase *Commerz- und Privatbank,* he once wrote: "Commerce=com mercurio. Mercury is the messenger god and the god of commerce. Mercantile art"—suggesting thereby that the choice of the word *Commerz* was deliberate, and that his art was conceived as a special kind of product (he came, we remember, from a business background and was an adept businessman himself), but one that came out of, and was cut free from, the commercial world.[57] On another occasion, he withheld the fact it came from *Commerz,* and said it came instead from *ausmerzen* (to reject), meaning that he was using what others had rejected and thrown away.[58]

Still, it is somewhat unfair to blame the bourgeoisie for "chromium-plated modernism" which was, if anything, the invention of artists of Schwitters' own generation. If, as is indeed the case, his work shows him to be opposed to a chromium-plated taste, then this is evidence less of an anti-bourgeois than of an anti-modern sensibility—or at least

anti-*moderne* one, opposed to the shiny Art Deco paraphernalia that "young moderns" bought in the 1920s, and buy still. Schwitters' own home looked very old-fashioned.[59] Certainly, his obsessive collecting of materials is not an anti-bourgeois characteristic at all, but a direct expression of a petit-bourgeois love of preserving things.[60] If Schwitters, as an artist, stands outside bourgeois society and is critical of many of its standards, he is attached to it nonetheless. His poetry and prose speak nostalgically of his own social class, while the collages—and, as we shall see, that part of his home environment he built himself—reveal something of a cluttered Victorian taste, though one in which, as William Rubin points out, "Victorian sentimentality has been purified into sentiment."[61] Moreover, the kind of allusions to everyday life made by Schwitters' art seem to express an ambivalence to the modern urban environment which was his principal subject. It is presented, by synecdoche, not as a vast optimistic arena of action and excitement, but as an enclosed, intimate and fragile place, remembered only by commonplace objects, the expendable icons[62] of a mass-production age.

From 1922 onwards, Schwitters' collages would regularly tell of the modern world in thematically related choices of materials. By then, he had become a member of the broadly European avant-garde, and was associated with artists for whom the idea of a shiny modern environment was a very appealing one. At that point, the collages begin to describe the cities he visited, those that he imagined himself visiting, sections of cities, particular factories even. Before 1922, however, directly thematic abstract collages are not that common. Leaving aside early, transitional works (like the 1919 *Der Sturm*, with its references to the Sturm group, and the typography-dominated Expressionist works of 1919–20), we see that Schwitters made explicitly thematic, illustrative collages on the one hand and extremely abstract collages on the other. The illustrative works admit an almost narrative reading of their parts; the abstract works hardly ever. *Merzz 19* and *Merzz 22,* obviously made around the same time in 1920, are unusual therefore in the common sources of most of their materials: cigarette stamps with war tax, potato ration stamps, and streetcar tickets, which join to provide a picture of postwar inflation, poor food, and extreme restlessness. It has been suggested that *Merzz 19* resembles a composition of advertising hoardings against a cloudy sky.[63] That may be pressing the point of thematic unity too far, but the comparison is a reasonable one.

73

75, 77, 80, X

105

113

However, it is not the kind of reading that most of the early abstract collages allow. They tell of Schwitters' own personal interests and habits, even about his favorite kind of chocolate (Hansi-Schokolade), and they tell of a culture dominated by numbers, prices, movement and multiplication, and about its spiritual as well as material poverty. But they do so, by and large, in a non-programmatic way. Moreover, insofar as they are referential, they carry references in their structures as well as their materials. If *Merzz 19* resembles billboards, *Merzz 101. Dorf* (*Village*) suggests a secure, tent-like construction, something atavistic made from modern materials, a refuge within the city itself.

109

Schwitters talked of the structure of the city as a kind of collage of parts added to parts.[64] We notice urban references in the structure of most of his collages: in the claustrophobic tightness of many of the works; in their insistent rectilinearity; in their deliberately unexotic and non-narrative, that is to say non-hierarchical, arrangements which separate him from Ernst or Hausmann and which speak in their own ways of the

arbitrary mixture of materials and sensations in urban living. Even here, however, the juxtapositions offer little of that sense of the chaos of the modern city that we find, for example, in Futurist collages. While Schwitters was making some of his most memorable works, Walter Benjamin was writing of the city as source of modern shock, of the city that submits its inhabitants to a constant barrage of discontinuous impressions.[65] Something of this effect infiltrates Schwitters' work, but mostly in the early "revolutionary" years. By and large, what Schwitters gives us is what has been left behind when the chaos and excitement died down. Although firmly located in time and space, his work seems always to tell not of a vividly experienced present but of a wistfully remembered past. And this is not just because the period of their creation has itself now passed; the diaristic, memento-like form of the collages meant that they were, even at the moment of their creation, records of an expedition in urban archeology.

Rather than expressing urban chaos, then, Schwitters' work orders and ameliorates it. "Art," he wrote, "is a spiritual function of man, which aims at freeing him from life's chaos."[66] There was something highly Romantic in Schwitters' outlook—as Huelsenbeck was quick to note when he called him "the Kaspar David Friedrich of the Dadaist revolution."[67] But if Schwitters' spiritual understanding of art does generally belong to a tradition of German Romanticism, it was more immediately indebted to the Expressionists' interpretation of that tradition. Werner Schmalenbach correctly points out that many of the assemblages are closer to Franz Marc's forest landscapes than to programmatic Dada art, and that there are echoes of the cosmic awareness of Expressionism in a number of Schwitters' titles.[68] But perhaps the most important feature of Expressionist, and specifically Blaue Reiter, ideology that points directly to Schwitters is its concern with the "life" of inanimate objects.

We saw in Chapter 2 how Schwitters was broadly indebted to the Blaue Reiter artists' belief in an inner spiritual content that lies beneath the realistic outer shell or specific form of all of the arts and thus links them together. For Kandinsky, this "inner sound," as he often called it, was also to be discovered beneath the realistic form of the world and its individual objects. He therefore advised artists to avoid tasteful, outer beauty and go beyond the mere realism of the world's outer shell.[69] The world, he wrote in *Der blaue Reiter*, "is a cosmos of spiritually effective beings. Even dead matter is living spirit."[70] In Kandinsky's *Rückblicke* (published by Herwarth Walden in 1913), Schwitters could have read an even more explicit expression of the idea:

> Everything "dead" trembled. Not only the stars, moon, wood, flowers, of which the poets sing, but also a cigarette butt lying in the ash tray, a patient white trouser button looking up from a puddle in the street . . . everything shows me its face, its innermost being, its secret soul . . .[71]

Schwitters was never as explicit as this, being too much of a formalist to admit that the materials he used carried a spiritual charge. But he did write that his was a generally spiritual, even a Christian art.[72] Schwitters' belief in self-discipline and in a benevolent order of creation might be called Christian. However, his spirituality is broader than that. Like many other Dadaists, he seems to have felt that the order of the world was in part hopelessly absurd and in part dynamic and charged. He rejected the Expressionist

idea of ecstatic union with nature, yet he retained its primitivism. We sense in his work a belief even in animism and hylozoism—primitive ideas that objects have souls and that God and matter are one and the same; which helps to explain his preoccupation with having to tame the *Eigengift* in things. And he did write to Herbert Read thanking him for describing his art as mystical.[73] Read had said that there was a "philosophical, even a mystical justification for taking up the stones which the builders rejected and making something of them, even the headstones of the corner."[74] So pleased was Schwitters with this that he wrote also to Margaret Miller in New York: "He writes about the mystic very very good. It could not be more understanding. *Please read it!*"[75]

We are reminded how Merz, for Schwitters, was a symbol of freedom and liberation. The liberation that it afforded was indeed essentially a spiritual one: "Self-absorption in art," he said, "is like service to the divine in that it liberates man from everyday cares."[76] Once more it was Huelsenbeck who recognized the ambivalence in all this: that while on the one hand Schwitters' work expressed the raw reality of his times, it also revealed a "deep hankering after the primitive, the simple form. He wanted to get away from the complicated, overcharged, perspectively seen present."[77]

This is but one ambivalence among many. Merz reconciles opposites, Schwitters once wrote.[78] And indeed it does: the Dadaist in favor of fine art, the anti-bourgeois member of the bourgeoisie, the urban iconography and primitivist ideas, the involvement and obsession with a material environment, yet sense of estrangement from it. Basic to all of these, however, is the ambivalence which most directly presents itself to us in the work itself, namely that balance, or alternatively tension, between the abstract and therefore impersonal forms of Schwitters' art and the utterly personal materials that engender them. And Schwitters' materials are indeed personal: they refer not only to their former uses, nor only to their estrangement from these uses, but also to Schwitters himself. He speaks as a *bricoleur,* "not only *with* things . . . but also through the medium of things: giving an account of his personality and life by the choices he makes."[79]

Just how much he did identify with his materials, and just how much, therefore, he felt it necessary to submit them to art's ordering, must necessarily be a persistent topic in any discussion of Schwitters' work. Not only is it central to an understanding of the individual media he used, it is also crucially important to Schwitters' conception of his ideal "total work of art." His "ultimate aspiration" was not just "a sum total of the individual art forms"; it was also "the union of art and non-art in the Merz total world view."[80]

Only by fusing, on the grandest and most interdisciplinary of scales, artistic, formal structures with inartistic, personal materials could the "total work of art" be properly created. His ultimate "total work of art" was to be the *Merzbau,* which joined curious personal mementos and abstract three-dimensional structures in an amazing architectural environment that he began to build in his home in Hannover in 1923. He began, however, by positing not an architectural but a theatrical total work of art. In the *Merzbühne* (Merz-theater), materials act as "characters" in a "living" assemblage that draws both on the principles of his visual art and on the disturbing and fantastic writing Schwitters had begun to produce even before Merz was invented. His literary work —which we will consider next— was as important for his "total work of art" as any of the visual arts he practiced, precisely because its materials were so obsessively personal.

5 POETRY, PERFORMANCE, AND THE TOTAL WORK OF ART

☐ For Schwitters, Merz meant assemblage, that is to say, a principle or method of working rather than a specific genre or medium of art. Although Merz derived originally from a painting context, once it had been formally established in July 1919 it was quickly expanded in a whole variety of directions, some remote from painting but all in their different ways using distinct and individual material units—be they objects, words or graphic forms—in an additive and constructed way. In swift succession there appeared Merz sculptures, Merz drawings, Merz poems and prose, Merz performances and Merz theater, and on a grander scale, the environmental *Merzbau* which gradually obliterated the interior of Schwitters' house. All this, however, Schwitters insisted, was not merely a program of diversification. When he announced his expansion of Merz in October 1919, he explained that his ambition was to create a *Gesamtkunstwerk,* or total work of art.[1] Even the early *Merzbilder,* he once suggested, were but preparatory studies for such a conception: the lower echelons of a hierarchy of expression that reached gradually beyond the individual arts, effacing their boundaries, and which would eventually transform the whole of life—or at least Schwitters' life—into a kind of total Merz activity.[2] "Now I call myself MERZ," he proclaimed after a decade working towards this end.[3]

At times, Schwitters did indeed sign himself "Merz." For those who knew him, certainly, Schwitters the man was to be identified with that name just as much as was the art he produced. For them, the character of Merz was not to be separated from his character: his humor, his childlike enthusiasms, his unconventional behavior, as well as his occasional arrogance and bourgeois smugness, seemed to surround Merz, the art, on every side—as did his own name in a more frequent signature, "Kurt Merz Schwitters."

For us, of course, no such identification of man and art is possible: we may know his biography (or much of it) as well as his art, but we can only imagine the man that his friends and contemporaries knew. Even for us, however, Schwitters the man simply forces his attention on us as we consider his art, and particularly his art that escapes the two-dimensional, for whereas Schwitters' work in painting, collage and two-dimensional assemblage is only implicitly autobiographical, outside these forms it is often explicitly so. The *Merzbau,* Schwitters' fullest attempt to realize a personal *Gesamtkunstwerk,* cannot be properly understood without some knowledge of the curious private mythology which he derived from the situations of his everyday life and which manifests itself most clearly in his writings—although appreciation of its forms and structure requires knowledge of his two-dimensional art. Likewise, the theory of *Merzbühne* (or Merz-theater) obviously joins together the visual and the literary sides of his activities. In each of these projects we see Schwitters seeking to contain under one widely embracing canopy the autobiographical and literary on the one hand and the visual and constructed on the other. They were his most determined attempts to fuse art

and life: his own art, in all its various forms, with his own life and the lives and situations with which he came into contact.

The collage technique itself was inherently suited to an enterprise of this kind. Since its modern inception in Cubism and Futurism it had acknowledged the penetration of the work of art by tokens of the wider environment, and had proven applicable equally to verbal and to visual composition. In Schwitters' case, the arts he practiced not only share a common structure, the principle of assemblage, but are interrelated and mixable. Painting and poetry come together in the pasted words and phrases of the collages; the ready-found phrases of the poems are joined in collage-like word-chains; the Dadaist and rubber-stamp drawings juxtapose literary and graphic forms in one structure, while the imagery of these drawings is also to be found in Schwitters' poems and prose, and in some of the early Dadaist sculptures as well. Schwitters emphasized the reciprocal relationship of his visual and literary work, saying he made poems that could be looked at as drawings, collages that could partly be read, and pictures that contained elements of collage, of poetry, and indeed of sculpture too. "I did this," he said in 1920, "so as to efface the boundaries between the arts," adding: "The ultimate total Merz work of art is the Merz-theater Only the Merz-theater is distinguished by the fusion of all factors into a total work of art."[4]

□ In order to understand properly what attracted Schwitters to a total theatrical work of art, we must begin by considering his early poetry and prose. In Chapter 2, we looked at Schwitters' most famous early poem, "An Anna Blume," and noted how he had transformed romantic and idealist sentiments into the language of cliché, and created by means of an imposed, irrational structure a separate and insulated world of private fantasy. It was also noted there how this poem emerged out of Schwitters' involvement in Sturm poetics, and especially in poetic principles developed by the Sturm poet, Stramm.

Stramm himself was deeply affected by Futurist experimental literature, which Herwarth Walden had introduced to Germany shortly after *Der Sturm* was founded. Walden had printed Marinetti's "Technical Manifesto of Futurist Literature" in *Der Sturm* and had invited Marinetti himself to lecture in Berlin in 1913. One result of this was that Stramm made virtually a new beginning as a writer, developing a style based upon Marinetti's *Parole in libertà*, only more emotionally charged, and very quickly became the most formally experimental of all the Sturm (if not indeed of all the Expressionist) poets. After Stramm's death in 1915, his work became the chief literary model for the Sturm writers, and by the time that Schwitters joined the circle in 1918 there was something approaching a Sturm poetic in existence.[5]

In principle, Sturm word theory was concerned with the creation of a highly compressed language system of "clenched" word-units within an alogical and anti-narrative structure. The total length of a poem was severely compressed (in Stramm, usually to six lines), so was the length of individual lines (single-word lines being common), and the very form of poems too (Stramm's works physically often resemble inverted triangles). Following Futurist directives, sentences were reduced to verbs, nouns and adjectives; articles and conjunctions were all but eliminated, so were prefixes, suffixes and inflexional endings from individual words; verbs were often kept in the infinitive to create an

active, excited effect. Great stress was placed upon individual words: on words not merely as vehicles of information but of emotional value. Schwitters himself points to this, when writing that "abstract poetry evaluates values against values. One might even say 'Words against Words.' This does not produce sense, but generates a cosmic feeling [*Weltgefühl*]."[6] This "cosmic feeling" (also evoked by the titles of some of Schwitters' early assemblages) was created by means of sets of neologisms—each capable of holding rich and multiple meanings—which affect the reader first as units of evocative sound and only secondarily as specifically denotive elements. The effect of Sturm poetry is dissonantly musical, serving to isolate the purely phonetic element of poetry, breaking syntactical (narrative) continuity for a hard sonorist stammer of individually active word-units in a loose *Wortreihe* (word-chain) arrangement.

The assertively constructional character of Sturm poetics has already been noted (in Chapter 2) as a possible influence on Schwitters' development of his assemblage style. What also requires emphasis here is its highly emotional nature; for applied, as often it was, to cosmic, erotic or violent imagery it served to produce an ever-tightening chain of rhetorical, infinitive-riddled and high-pitched outbursts, close to the limits of intelligibility, that gain in intensity as they rush down to the final single-word line.

Schwitters used Sturm techniques very directly indeed and often appears to be no more than a mere Stramm imitator. There is in his work, however, certainly less propulsion, less sense of an ever-concentrating emotion, even though he, too, frequently used highly emotional themes. These two excerpts are fairly typical. The first is from "Grünes Kind" (Green Child) of around 1918,[7] which deals with a child's nightmare flight from imprisonment and shooting:

[. . .]
Blut—
Angst—
Jagen—
Fliegen—
Schreien—
Blut grinst gelb-hell-gelb
Gelbgrün—
Hellgelbgrün—
Schwefelgelbgrün—
Hellschwefelgelbgrün—
Blut grinst hellschwefelgelbgrün.

Wenn ich das grüne Blut waschen
 könnte!
Blut waschen—
Baden Blut—
Blut baden.
O du wonnig weisses Blut meiner
 Braut!

[. . .]

[. . .]
Blood—
Fear—
Chase—
Fly—
Scream—
Blood grins yellow-bright-yellow
Yellowgreen—
Brightyellowgreen—
Brimstoneyellowgreen—
Brightbrimstoneyellowgreen—
Blood grimaces brightbrimstoneyel-
 lowgreen.
Could I but wash the green blood!

Blood wash—
Bathe blood—
Blood bathe.
O thou rapturous white blood of my
 bride!

[. . .]

The poem as a whole certainly evokes a chase, being dominated by sequences of rhythmically repeated one-word lines (Jagen/Fliegen/Schreien, and so on), but since the entire work is in fact very long (over 100 lines), the effect is so to prolong the chase that it seems to lead nowhere. Moreover, Schwitters tends occasionally to insert lines that owe their existence neither to what they contribute to the sense of the poem as a whole, nor to what the sense of previous lines suggests, but to what individual sounds in previous lines seem rhythmically to require. The last line quoted above is generated in exactly this way. The anomalous "weisses" and "Braut" seem to be introduced so that "weisses Blut meiner Braut" can echo "grüne Blut waschen könnte"; and although the child is in fact fleeing to its mother, the thought that links washing to whiteness to the image of a bride is never developed, but reads as an autonomous insertion within the poem because linguistic virtuosity demanded it. Something comparable produced the sequence of five lines beginning with "Blut grinst gelb-hell-gelb": not only, as in "An Anna Blume," a thematic need to move through lists of colors until the green of romance and nature is reached; but sheer delight on Schwitters' part with the internal mechanics of poetic composition. And the effect of this preoccupation with sheer form is to deflect attention to a considerable extent from the thematic violence described in the work, so that form and subject balance and oppose each other rather than coincide.

This is not to say, however, that Schwitters' subjects are mere pretexts for formalist pattern-making. Rather, it is the very tension provided between frequently grotesque or taboo subjects and formal-linguistic play—and our realization that such subjects are made into subjects of play—that gives the poems their curious and distinctive mood. (It is a tension not unlike that between worldly objects and abstract structures in the assemblages.) His early writings are full of threatening or disturbing images which are themselves distorted through linguistic inventiveness. Consider this second excerpt. from "Nachte" (Nights), also of around 1918,[8] a thinly disguised fantasy of sex:

Innige Nächte	Fervent nights
Gluten Qual	Blaze anguish
Zittert Glut Wonne	Quivers blaze rapture
Schmerzhaft umeint	Painfully be-oned
Siedend nächtigt Brunst	Seething nights lust
Peitscht Feuer Blitz	Whips fire flash
Zuckend Schwüle	Steamy pang
O, wenn ich das Fischlein baden könnte!	O, could I but bathe the little Fish!
Zagt ein Innen	Quails a with-in
Zittert enteint	Quivers un-one'd
Giert schwül	Lusts damply
Herb	Pungent
Du	You
Duft der Braut	Scent of the Bride
Rosen gleissen im Garten	Roses glisten in garden
Schlank stachelt Fisch in der Peitscheluft	Sleekly stabs fish in the whip-air
[. . .]	[. . .]

Here again, Schwitters submits his subject—the actions· and the emotions of love-making—to the inventiveness of his flexible, freely associating mind, to produce what amounts to a list of individual images whose internal phonetic consistency tends to isolate them somewhat from their neighbors.[9] While alliteration and assonance are used to link together the parts of the chain, the sense of internalization and circularity produced by phrases like "Zittert enteint" and "gleissen im Garten" works against this linkage—as also does the introduction of lines (like "O, wenn ich . . .") that suddenly break the linguistic, and therefore emotional, concentration of the poem. Soon, such almost parenthetical appeals were to become truly parenthetical asides that have no logical connection at all to the narrative development of the poems in which they appear.

In virtually all of his early poetry, Schwitters projects the sense of a world of sensations—and often disturbingly visceral ones—cut off from external reality. Although his poems do obviously allude to objects of the world, they usually do so by means of the internal, bodily reactions these objects provoke. Hence, lines like "Glant zersieden Zeterzachen/Reiselbäume schiffen grinsen Blumen" (Gleamt beseeth zigzags/ Drizzle-trees piss grimace flowers), from the 1919 poem "Molkenschwere Silberblätt-erblüte" ("Wheyweight Silverleaf-Blossoms"),[10] presumably are describing the effects of a lightning storm in a forest, but internalize and compress the sheer activity of what is happening so that it is presented to us not as an event but as the experience of one, and an experience, moreover, that is indivisible from the linguistic virtuosity that carries it.

Schwitters increasingly enforced this sense of removal from the facts of external reality: not, however, by exaggerating the dramatic impact of his poetic work but by defusing it. To oppose "serious" Expressionist-derived language and disturbing imagery with often extremely funny insertions that irretrievably deflate the force of their surrounding lines was to further distance from reality what was described. Hence, the same sexual fish imagery that we find in "Nächte" also appears in "Schreizen" ("Screak"),[11] but with a very surprising ending:

[. . .]
Dill fischen deiner Finger Karpfen,
 blut entgegen.
Still fischen Dill den Schreiz.
(Es wird gebeten, Hunde an der
Leine zu führen.)

[. . .]
Dill are fishing your fingers' carp, to
 meet blood.
Still fish dill the screak.
(It is requested that dogs be kept on a
leash.)

Schwitters collected "banalities" of this kind, and dedicated the fourth issue of his *Merz* magazine to them. Often they end poems, as in the case of "Schreizen," but we also find sections of "serious" writing interrupted by phrases such as "dem Reinen ist alles rein, und wenn es auch dreckiges Wasser ist" (to the pure all things are pure, even dirty water) and "Tote brauchen keine Köpfe mehr" (The dead need no heads).[12] Here again, when set beside emotive and disturbing images, they serve both to offset and to oppose their grotesque companions, and to induce in the reader a sense of confusion and unreality that distances what is written from the logic of the external world.

Schwitters' use of interposed banalities in his poems exactly parallels his use of found objects and materials in his assemblages and collages. In each case, the presence of found

materials gradually modifies the Expressionist structures within which they first appear, and the rhetoric of the earlier work is dampened to the extent that Schwitters discovers new structures from the very act of combining the materials themselves. But poetry and painting are not the same endeavor. Schwitters did produce some poems purely from banalities; most, however, introduce banalities into Expressionist-derived structures. The same might be said of his use of found materials in the early assemblages— nevertheless, the brute reality of the materials in the assemblages is very different to the comic reality of those in the poems. Both kinds of materials were banal when taken from the world. In the poems, banal they remain. In the assemblages, they are used abstractly and their banality is transformed.

Nevertheless, Schwitters insisted on the similarity of the two forms. "Merz poetry is abstract," he wrote in *Anna Blume. Dichtungen* of 1919. "It is analogous to Merz painting in making use of given elements such as sentences cut out of newspapers or taken down from catalogs, posters, etc., with or without alteration."[13] And if Merz poetry was analogous in method to Merz painting, it was also, Schwitters insisted, analogous in effect. In the pictures materials are transformed by being placed in their new setting; similarly "in poetry, words are torn from their former context, dissociated, and brought into a new artistic context they become formal parts of the poem, nothing else."[14] All poetry, however—if it uses words, even distorted and nonsensical ones—is inevitably referential in some way. Schwitters was eventually to produce truly abstract poetry, but was forced to turn to simple letters and numbers in order to do so. And some of these works, even, are referential, as we shall see later. Certainly, the effect of the early Merz poems and prose poems is by no means purely abstract; rather the opposite. As Schwitters transcended his Sturm sources, his writing became if anything more "realistic," as excerpts from advertisements, official notices, sentimental publications and everyday speech were collaged together with fragments of Expressionist rhetoric to create fantastic and funny word-streams that cannot help but refer to the outside world. And yet, the references to the world provided in these works are of a very peculiar kind. If Schwitters' materials are realistic, the contexts in which they are placed are not. What emerges is neither abstraction nor realism but a kind of improvisatory fantasy that has all the hermeticism of an abstract work and the directness and vividness of a realist one.

This excerpt from "Die Zwiebel" ("The Onion"), a mad story telling of a man's self-organized butchery and reassembly, well illustrates the character of Schwitters' Merz poetry at its crazy best. In this section of the poem, the hero's reassembly begins:

. . . I was very curious to see how they planned to bring me to life again. (ism-sorter by Jefim Golycheff.) It is strictly forbidden to touch objects in the collection. I felt dizzy. (Strindberg quietly undermine Stramm.) Our dear old teacher always liked to season his lectures with a touch of humor, and rightly so. (Sunray.) I don't believe in anything at all. (Trombone festival.) Your guess was right! Appeal in trying times to bible-toting, evangelical schoolmarms. (Everything the man should know about pregnancy and childbirth!) Your mouth is a saw. (Dentist sunshine.) The butcher again took up his club (the tragedy of becoming human), stood before me (the conduct of the husband during pregnancy), and gently laid the club against my split skull. (Yet

Rudolf Bauer is an artist.) Anna Blume wait lilac blue roses shoot spike gaps lunk-lump bed. (Ripe for the plucking, fervently one.) A partial explanation misses the mark. Then the butcher leapt back with a mighty bound. (The colonel is and will remain a gentleman, even if he's an idiot.) The woman must know all. There was an ear-splitting crack as the club sprang loose from my skull. The means hereto are offered by a work intended for women readers only. Table of Contents: 1. How to win love. 2. The tamed shrew. 3. What girls like in a man. 4. Something about kissing. 5. How to make an impression. 6. On being turned down. 7. Is misogamy justified? 8. Causes of chastity. 9. Older opinions. 10. How to attack moderation. 11. Good advice. 12. Is love blind? 13. How to recognize true love. 14. The husband's premarital past. 15. The most intimate of intimacies. 16. The new faith. 17. The dark star. The butcher sprang back into his original starting position. (He shall be your lord and master.) The mainstay of the firm, however, remains chaste and pure. (Jamais embrassé.) The fragments of my skull flew together; I was, so to speak, back in one piece again. (Sweet moment.) You ain't et your fritters and the pickles is too greasy. The theater, as a matter of fact, exists solely for humans who, in fact, are inhuman. Delivery on receipt of payment; the book is richly illustrated. It was an odd sensation—being alive again. . . .[15]

This lunatic cutting from absurd narratives to not wholly irrelevant quotations and parenthetical asides characterizes much of Schwitters' Merz poetry as a whole, but particularly that of the early years. In the case of "Die Zwiebel," the theme of the story itself, butchery and reassembly, can be viewed as a metaphor of the Merz method of making the new from the destruction of the old. But it is also a metaphor that draws, however ironically, on the Expressionist notion of the New Man who emerges spiritually reborn out of the chaos of the past only after suffering and self-sacrifice.[16] In Schwitters' story, however, there is no true renewal, merely a reassembly of what was there to begin with. Schwitters was clearly fascinated by the sheer process of dissection for its own sake—or rather, for the sensational drama it allowed him to unfold. We will find a similar manipulation of an epic Expressionist theme—also dealing with the question of change and renewal—in his text on the Merz-theater, and again for the sheer drama of its parts, so that nothing is actually "achieved" except the experience of the drama itself. The story of "Die Zwiebel" develops—both narratively and stylistically—from a flat and unemotional beginning, when preparations for the butchery are described, to increasingly dissonant and disjunctive passages telling of the ever more gruesome and repulsive acts that are performed upon the victim. But then, everything reverses upon itself (as what has been done is magically undone), thus closing off the story from reality, as if nothing had happened at all.

There is one "result" of the events described. The whole scene is witnessed by the king who has ordered it to take place, and by attendants, including "two spotless maids," Anna and Emma. "Es war mir ein angenehmer Gedanke," the victim notes, "dass diese beiden hübschen Mädchen mein Blut quirlen und meine inneren Teile waschen und zubereiten sollten." (It was pleasant for me to think that these two pretty girls would whisk up my blood and wash and lay out my inner organs.)[17] The king's daughter arrives

late: "Soeben habe ich meine Schwester als Wetterhahn auf den Kirchturm ge-spiesst . . .," she apologizes. "Der Blitzableiter war sehr verrostet und wollte nicht recht durch den Bauch meiner Schwester spiessen." (I've just this moment finished impaling my sister on the church-spire as a weathercock . . . The lightning rod was rusty, and I had trouble forcing it through my sister's stomach.)[18] Then the princess sings the *Interna-tionale* and the dissection begins. In a particularly unpleasant episode, the king, having first tasted the victim's blood, then decides to sample his eyes: "Runde Kugeln innen glatten Schleim sprangen aus die Augen sanfte Hände voll entgegen. Auf einem Teller, Messer, Gabel servierte man die Augen." (Round balls smooth slime within leapt out of the eyes towards soft hands. On a plate, knife, fork the eyes were served up.)[19] But the eyes burn holes through the king's stomach and he falls ill, complaining of being poisoned, at which point the princess orders the victim's reassembly (as quoted above). When the story closes, it is the king who is dead and the victim whole—and rejecting the princess's pleas that her father be saved. Wax candles are placed in the cavities in his stomach; as flames burst through these holes, his entire body explodes and the former victim is cheered by all the bystanders.

Now, if the moral of this story is that the meek shall inherit the earth, then to tell it in the form of a sado-masochistic reverie is unusual, to say the least. While the story undoubtedly alludes, as has been claimed,[20] to the ending of the Great War, the over-throw of the Kaiser and the rebirth of German democracy (there are, from time to time, parenthetical references to capitalism and socialism), whatever social message it has takes obvious second place to its personal and sexual one. Not all of "Die Zwiebel" is as gruesome as the passages I have quoted. Some of it is extremely funny, and some of the unpleasantness is canceled out by the irrelevant banalities which interrupt the plot. But the whole torture sequence—so enjoyed by the victim and performed with the help of two pretty girls—obviously does read as a bizarre interweaving of the themes of castra-tion and of sexual intercourse, with the culmination of the first theme (the eye-eating episode) coinciding with the climax of the second, as the then reformed and refreshed victim wins omnipotence over his nominal oppressor and approval from his peers, and the erotic pain and pleasure alike are ended.

Schwitters may indeed be presenting us with an anti-authoritarian fable in which sexual and personal fulfillment (and the approval of sexual perversity that in this case goes with it) is to be gained only by a kind of passive submission to authority that allows authority to poison and to subvert itself. ("Revolution in Revon" also stresses the radical consequences of passivity, and links them to a similar social theme.) But what is peculiar about "Die Zwiebel" is not only that its obvious political message is so overwhelmed by the sensational plot as hardly to be taken seriously: it is that the plot itself, and indeed the action it contains, is, for all its unpleasantness, so utterly unreal.

Because of the reversal of the story line, the hero emerges unchanged, thus virtually canceling out the point of the story as a story. And just as the form of the narration thus subverts narrative development, so the conflicting stylistic methods that form the narra-tion tend to cancel each other out. This, added to the fact that the victim as first-person narrator describes his torture in a tone of almost cheerful detachment, subverts the reality of individual events as well of the story as a whole. A conflict therefore exists

between the content of the story and the form in which it is presented, which serves to distance the described events in their formal manipulation and create "an abstract pattern that is removed from the pain of existence into a private fantasy world."[21] (How different in effect is the torture machine of Kafka's "In der Strafkolonie" ["In the Penal Colony"], published the same year.) Just as Schwitters' collages and assemblages efface the *Eigengift* of their raw materials because their creator assumes an attitude of esthetic distance from the very things he so obsessively collects, so early writings like "Die Zwiebel" tell of a similarly voyeuristic sensibility. In "Die Zwiebel," of course, the formal hermeticism of the work reinforces far more explicitly than does the hermeticism of the collages the idea that removal from the "real" world means retreat into a private and somewhat narcissistic one. But the mechanism is the same. And the result is also the same: an art that anesthetizes the "reality" of the objects and events that it documents, however sordid or however sensational they are. In "Die Zwiebel," the onion is peeled and put back together again without any tears being shed.

The events described in "Revolution in Revon" are certainly less offensive than those in "Die Zwiebel." However, this work shows an even more extreme formal manipulation of its nominal subject. "Ursachen und Beginn der grossen glorreichen Revolution in Revon" (Causes and Outbreak of the great and glorious Revolution in Revon) was published in *Der Sturm* in 1922, but was apparently written in the winter of 1918–19,[22] that is to say around the same time as "Die Zwiebel" and shortly after the German Revolution to which it also alludes. Although announced as the first chapter of an "Anna Blume love-story" called *Franz Müllers Drahtfrühling* (*Franz Müller's Wire Springtime*), it reads as a self-sufficient work, and is probably Schwitters' most important and competent piece of prose writing. Basically a very simple story of how a man standing and doing nothing causes a revolution to break out, it has a highly complex narrative structure.

After an irrelevant introductory poem about elephants, the story begins with a section of dialogue of a child asking its mother about the standing and silent man, and the gathering of a crowd around the inoffensive figure. The first important action is the entrance of an agitator, Alves Bäsenstiel (who appeared in "Die Zwiebel"), and an art critic, Herr Doktor Leopold Feuerhake, and his wife Frau Doktor Amalie. Whereas the crowd was merely curious about the immobility of the unknown man, these three are indignant, and Frau Amalie becomes hysterical. The action is now interrupted by a poem, "Viereck"; then the preceding episodes of dialogue, action and hysteria are repeated in shortened form, followed by longer versions of the elephant and "Viereck" poems (now including parts to be sung and whistled). Whereas the story of "Die Zwiebel" simply reverses upon itself, "Revolution in Revon" jolts backwards and forwards in time, and when new action begins to take place we continue to be side-tracked by diversions and repetitions. Thus, after another reprise of the first section of dialogue, Anna Blume appears (accompanied by quotations from "An Anna Blume"), only to be ignored by all concerned as Frau Amalie becomes even more hysterical. But that comes to nothing since the elephant poem is repeated yet again. Then, however, a rush of action takes place. Frau Amalie faints and is carried off; Anna Blume recognizes the man as Franz Müller and as a work of art since he is dressed like a Merz-sculpture; Bäsenstiel incites the crowd against the standing man; a miraculous vision is manifested in the form

of a yellow haystack in the sky with the letters P R A on the side (a reversal, of course, of Arp's name); and the police arrive to quell the disturbance. Then action alternates with hysteria as suddenly the man turns his head to one side. At this, the crowd riots, a child is crushed to death between two fat women, and shorter members of the crowd use the corpse to stand on so they can see what is happening. The man then walks away. Panic breaks out and more people are crushed to death. As Parliament is recalled, a crippled youth runs through the streets of Revon proclaiming the outbreak of the great and glorious revolution. Yet again, the elephants are introduced, and the story ends.

Now, why all this diversion and repetition? It could be argued that it heightens suspense by delaying action. But Schwitters' side-trackings are so assertive that one cannot but conclude that he was as much interested in the form of what he wrote as the story he had to tell. Phrases, sentence-sequences and whole passages of text are repeated to create musical patterns throughout the work; and sections of poetry, of dialogue and of described action, developing into crises of hysteria, are so interwoven as to create a contrapuntal rhythm between these distinct forms of narration which complements the development of the actual incidents of the story. Schwitters' "Revolution" is a definitely ordered if not an orderly one. And as with "Die Zwiebel," not only the complex time structure but also the frequent stylistic shifts and the sheer verbal word play of "Revolution in Revon" serve to isolate it from the real world from which it ultimately derives. As Rex Last has aptly noted: "The combined effect of this polyvalency of style, time, and viewpoint is to produce within the reader a sensation of alternating involvement and detachment, of being everywhere and nowhere—in effect, of inhabiting and exploring Schwitters' own private world of the imagination."[23] Thus, although we have it on record that "Revon" was but a shallow disguise for Hannover (the last syllables of which, reversed, provide its name), and that Schwitters did work, as it were, "from life"[24] and therefore could not but make reference to his times and their social and political dilemmas, it is evident that he used his outer environment to build for himself a personal and fantastic abstract world.

This is not to say, however, that the story of "Revolution in Revon" is merely a pretext for formal virtuosity on Schwitters' part. The standing man of Revon is clearly a fanciful self-portrait of the apolitical artist attacked by critics and social agitators—the withdrawn artist, misunderstood by the inhabitants of bourgeois, no-nonsense Hannover where everyone was properly employed, and where (as Käte Steinitz writes), "nobody was ever supposed to be found standing inert, passive and calm in the midst of the city, like a frozen puzzle."[25] I shall have reason to return later (in Chapter 7) to what "Revolution in Revon" tells us about Schwitters' relation to his immediate environment; for the moment, let us simply notice that, like "Die Zwiebel," it draws on environmental material to create a world in which the artist, as passive victim of the oppression his passivity invites, gains first attention and then omnipotence (even to causing the whole order of the world to be changed).

The world it creates is one in which fantasy is given full rein, because materials drawn from the environment are rearranged and subordinated to structures drawn not from the world but from the artist's own imagination. A private and privileged environment (but one that was populated with the raw material of the outside world); a place in which

"found" objects and events could be controlled and manipulated on the grandest of scales; an insulated world that was both fantastic and formalized, and over which its creator reigned supreme: this was how Schwitters imagined his "total work of art."

☐ In order to realize this "total work of art," Schwitters turned to the theater. Merz-theater, however, relates not only to his contemporaneous writings, but also draws on a kind of theatrical activity with which he was personally familiar, and which deserves mention before examining the theory and form of Merz-theater itself. I refer to the cabaret. Schwitters not only wrote poetry and prose, he also recited it, often in company with other authors. And following the tradition of the Neopathetisches Cabaret in Berlin and the Cabaret Voltaire in Zurich, he made of these recitations almost an art form of their own. Käte Steinitz says that "the real force of [" Revolution in Revon"] . . . was the voice of Kurt Schwitters . . . This voice, during the never-ending repetitions, brought Merz-evening audiences to despair, but also released from them thundering volleys of compulsive laughter."[26] Apparently, most people remembered chiefly the dialogue theme of "Mama, da steht ein Mann," "varied each time with different intonation—soft or loud, unaccented or emphatic, demanding or pleading, fearful or fearless, pathetic or heroic":[27]

"Mama," sagte das Kind; die Mutter: "Ja". — "Mama" — "Ja" — "Mama" — "Ja" — "Mama, da steht ein Mann!" — "Ja" — "Mama, da steht ein Mann!" — "Ja" — "Mama, da steht ein Mann." — "Wo?" — "Mama, da steht ein Mann." — "Wo?" — "Mama, da steht ein Mann." — "Wo steht ein Mann?" — "Mama, da steht ein Mann!" — "Wo steht ein Mann?" — "Mama, da steht ein Mann!" — "Ach was!" — "Mama, da steht ein Mann!" — "Lass doch den Mann stehen." — "Mama, da steht ein Mann!" Die Mutter kommt. Tatsächlich steht da ein Mann.

"Mama," said the child; the mother: "Yes." — "Mama" — "Yes" — "Mama" — "Yes" — "Mama, there's a man standing there!" — "Yes" — "Mama, there's a man standing there!" — "Yes" — "Mama, there's a man standing there." — "Where?" — "Mama, there's a man standing there." — "Where?" — "Mama, there's a man standing there" — "Where is a man standing?" — "Mama, there's a man standing there" — "Where is a man standing?" — "Mama, there's a man standing there!" — "For heaven's sake!" — "Mama, there's a man standing there!" — "Let him stand there." — "Mama, there's a man standing there!" The mother comes. There *is* a man standing there.[28]

Schwitters was by all accounts a brilliant and an enthusiastic performer with an enormous voice (it has been preserved on a gramophone record)[29] and an innate sense of how best to rally or to provoke an audience. He was also extremely funny. Neither warbling birdsong while perched up in a tree, nor barking from an improvised kennel, was exceptional behavior for this huge, bulky, soberly-dressed man. An unrepentant practical joker and extravert clown, he clearly thrived on public attention and courted invitations to lecture and to recite in order to get it. His earliest recitals were given in the Sturm gallery in Berlin and at the Kestner-Gesellschaft and at his own home in Hanno-

ver. Many who heard him have testified to his success. Hans Richter, for example, has written how generals and dowagers whose early consternation and indignation gave way to orgies of laughter were finally overwhelmed by the force of his performance and "came to Schwitters . . . almost stuttering with admiration and gratitude."[30] One of the most important early performances was in the fall of 1921 when he went to Prague with Raoul Hausmann, for it was there that he heard Hausmann recite his phonetic poems, one of which began with the line "fmsbwtäzäu" and inspired Schwitters' famous "Ursonate," or "Sonata in Primeval Sounds," to be discussed later. Probably the most successful, however, were the performances given in the company of Theo van Doesburg in Holland at the beginning of 1923. They were probably the closest that Schwitters came to realizing (as opposed to theorizing about) total theater and are worth describing here, if only to remind ourselves that if one side of Merz-theater looks to the introverted fantasies of Schwitters' writings, another draws on nothing but Dadaist high spirits.

"Our appearance in Holland," wrote Schwitters in the "Holland Dada" issue of the *Merz* magazine, "was one triumphal march." He continued:

> All Holland is now dada, because it has always certainly been dada. Our public feels that it is DADA, and believes it must scream dada, shout dada, whisper dada, sing dada, howl dada, grumble dada. No sooner had any one of us, who carried the dadaist movement into Holland, stepped onto the podium than there was awakened in the public the slumbering dadaist instinct, and we were received with dadaist howls and gnashings of teeth.[31]

It happened thus:[32] the tour was scheduled to begin with a performance at the Hague Kunstkring on December 27, 1922, but, because Schwitters had problems with his passport, it was postponed until January 10. Van Doesburg began the proceedings. Solemnly attired in dinner jacket, black shirt and white tie—but with a matching white-powdered face—he started to give an explanatory lecture on Dadaism (based on his article, "Wat is Dada?").[33] He said that the Dadaists would do something unexpected, Schwitters recalled.[34] "Just then I stood up in the audience and barked loudly." ("Frantic applause and noisy cheers," reported a contemporary newspaper.)[35] "A few people fainted and were carried out, and the newspapers reported that what 'Dada' means is 'bark'." (This alone netted them a second evening, in Haarlem; but there Schwitters blew his nose instead, and the papers dutifully reported that.)[36] When Van Doesburg had finished his lecture, Schwitters recited his "Revolution in Revon," which apparently caused an uproar. According to some reports the disorder was not quelled without the intervention of the police and the expulsion of some demonstrators. For light relief, there was announced some Dada piano music to be played by Van Doesburg's wife, Petro, whose style, however, has been described as more De Stijl than Dada, "with a definite affinity to squares and rectangles."[37] But when the piece turned out to be a funeral march by the modern Italian composer, Vittorio Rieti ("a strange cacophony," said one newspaper),[38] the commotion began again, and was only turned to cheers when the music ended.

The only other contributor to the evening then appeared, Van Doesburg's fellow De Stijl member, Vilmos Huszár. "No Dadaist," Schwitters had to admit, "he showed off an

animated doll in the Constructivist manner."[39] This puppet play was accompanied by more Dada piano and by Schwitters' sound-poems. Then Schwitters recited his poem, "An Anna Blume," followed—to everybody's surprise—by some Heine, accompanied at Schwitters' insistence by a Chopin Etude. But when Schwitters changed back to sound-poems again, reciting them so as to mimic the melody of the Chopin, the audience disturbance started again. It was finally quietened, however, by some sharp words from Van Doesburg, and the evening ended with a brisk "Rag-time Dada" on the piano (in fact, the jazz section of Satie's score from *Parade*).

This eminently successful repertoire was repeated in Haarlem, Amsterdam, Rotterdam, and elsewhere throughout Holland. The tour finally ended in Utrecht, where Schwitters was presented with a nine-foot high bouquet of rotting flowers, with some bones and other debris attached, and a putrid laurel wreath, all apparently stolen from the local cemetery. The donors were some masked, bible-carrying Dutchmen, one of whom began to read to the audience. Van Doesburg was called over to translate, but misunderstood Schwitters' directions and threw gifts and donor together into the music pit.

> The success was unprecedented [Schwitters wrote]. To be sure, the original man was gone, but the whole crowd stood up as one man. The police wept, and the public fought furiously among themselves, everyone trying to save a little bit of the bouquet; all around, people gave us and each other black eyes and bloody noses. It was an unparalleled Dadaist triumph.[40]

Clearly, Schwitters' performances were not always as riotous as this—and one imagines that this particular event gained a good deal in the telling—but it does stand as a reminder that the fantasy of the Merz-theater has some kind of relationship to reality. It is in effect a formalization (albeit a somewhat disorderly one) of his interests and experience in performance: a formalization which derives its principles from those of the *Merzbilder*. The Merz-theater (*Merzbühne*), as Schwitters describes it, is an animated three-dimensional *Merzbild* of epic proportions, fusing different media into a total assault upon all of the senses.

□ The theory of the *Merzbühne* was first published in 1919, in Herwarth Walden's *Sturm-Bühne* series,[41] and was thereafter reprinted (in sometimes slightly revised forms) on half a dozen occasions between 1919 and 1923. Throughout this period, Schwitters' expansion of Merz beyond picture-making was largely towards literature. Between 1919 and 1923, he published four volumes of poetry and prose and over sixty poems and prose poems. The theater, therefore, was a natural choice for his attempted fusion of the arts, since it combined the literary and the visual sides of his activities. It was also a traditional and popular choice. Since Wagner's premonition of an "art form of the future" that would integrate music, drama and spectacle—if not, indeed, earlier still—the belief in a theatrical *Gesamtkunstwerk* had been an integral part of European, and particularly German, cultural history. Schwitters was obviously familiar with this idea. Certainly, its revival and redefinition by the authors of *Der blaue Reiter* must have held Schwitters' attention, and especially so Kandinsky's essay "Über Bühnenkomposition" ("On Stage Composition"), where he argued for a new post-Wagnerian synthesis of the arts in

theater to be created through recognition of their common formal and spiritual language.[42]

However, Schwitters' theatrical interests do not necessarily require Kandinsky behind them. His appearance on the artistic scene coincided with a great boom in the German theater.[43] In 1919, Berlin saw the opening of the Grosse Schauspielhaus under Max Reinhardt's direction, Leopold Jessner's first production at the reorganized Staatstheater, and the production of Ernst Toller's *Die Wandlung* (*Transfiguration*) at the short-lived Tribüne theater, whose immediate success opened the way for other young Expressionist playwrights. Jessner's innovative settings, using immense flights of stairs and atmospheric lighting, and Reinhardt's preoccupation with mass spectacle, brought new experimental vigor to the German theater and tied together notions of an expanded theatrical spectacle reaching back to Adolphe Appia and Edward Gordon Craig, and to Wagner himself. From 1919 to 1923, the theater became the fullest of the Expressionist arts, combining literary innovation with imaginative settings derived ultimately from Expressionist painting. Add to this a similar vigor in the Expressionist cinema since the appearance of *Das Kabinett des Dr. Caligari* (released in February 1920 at the Berlin Marmorhaus) with sets by Schwitters' fellow Sturm artists,[44] and we see that he had ready-made exemplars for combining the literary and the visual in a new grand unity.

There are also local indications of Schwitters' contact with theatrical experiment. When he introduced himself to Herwarth Walden in Berlin in June 1918, the *Sturm-Bühne* was in the process of being founded under the direction of Lothar Schreyer, and August Stramm's play *Sancta Susanna* was being rehearsed.[45] We have already noted Stramm's importance to Schwitters' early poetry. Stramm's highly experimental theatrical work, which all but dispensed with traditional narrative composition, would soon be applauded by artists like László Moholy-Nagy for opening the way to a theater of total abstraction.[46] Schwitters' own idea of total theater, as expressed in the theory of the *Merzbühne*, extended Stramm's approach into the realm of abstract spectacle wherein setting, sound and action combine on equal terms:

> The *Merzbühne* work of art is an abstract work of art. Drama and opera grow as a rule out of the form of the written text, a text which by itself, without the stage, is already a well-rounded work. Stage-set, music and performance serve merely to illustrate this text, which is itself already an illustration of the action. In contrast to drama or opera, all parts of the *Merzbühne* work are inseparably bound together: it cannot be written, read or listened to, it can only be experienced in the theater. Until now, a distinction was made between stage-set, text and score in a theatrical production. Each factor was prepared separately and could also be separately appreciated. Only the *Merzbühne* is distinguished by the fusion of all factors into a total work of art . . . As word is set against word in poetry, so here factor is set against factor, material against material. The stage-set can be conceived in approximately similar terms to a *Merzbild*.[47]

Schwitters' argument here seems to be indebted in part to Kandinsky's "Über Bühnenkomposition," and specifically to Kandinsky's insistence that in the new theater no one element should "illustrate" another, but that all should be given "equal rights"; also to Kandinsky's conception of his own total drama, *Der gelbe Klang* (*The Yellow*

Sound), as a series of individual "pictures."[48] The development of plot through a sense of organic "becoming" and unfolding that characterizes *Der gelbe Klang* also is to be found in Schwitters' work—but whereas Kandinsky's "play" is stately and sonorous, Schwitters' is excited, frenetic, and far more "nonsensical" besides.

Reading the *Merzbühne* text, one's first impression is of a hallucinatory continuum of almost randomly combined images which suggest that Schwitters was trying to confuse different media rather than synthesize them. Further study, however, reveals that, as with "Die Zwiebel" and "Revolution in Revon," the absurdity and disorder evoked by the parts and incidents of this very strange piece of writing are balanced and offset by the sure sense of order that structures them. As in the collages or assemblages, the individually evocative parts are shaped into a coherent whole, albeit one whose kind of coherence is rather unusual, to say the least. First, Schwitters describes the general setting of the *Merzbühne*, then the active components and how they combine:

> Materials for the stage set are all solid, liquid and gaseous bodies, such as white wall, man, wire-entanglement, waterjet, blue distance, cone of light. Use is made of surfaces, which can compress or can dissolve into meshes; surfaces which can fold like curtains, expand or shrink. Objects will be allowed to move and revolve, and lines will be allowed to expand into surfaces. Parts will be inserted into the stage set, and parts taken out. Materials for the score are all the tones and noises that violin, drum, trombone, sewing-machine, tick-tock clock, waterjet, etc. are capable of producing. Materials for the text are all experiences that stimulate the intelligence and the emotions. . . . The parts of the set move and transform themselves, and the set lives its life.[49]

This, then, is the setting; and we see what Schwitters meant when he said that "the stage-set can be conceived in approximately similar terms to a *Merzbild*." He is positing a kind of animated *Merzbild* of gigantic dimensions; and then he goes on to explain how each class of its materials is expected to behave. First to appear are surfaces. As he describes these and their companions in his Expressionist-derived language it becomes increasingly clear that it is these materials themselves that are the real stars of the *Merzbühne*:

> Take gigantic surfaces, conceived as imaginative infinity, cloak them with color, shift them menacingly and break with vaulting their smooth bashfulness. Shatter and embroil finite parts, and twist perforating parts of night infinitely together. Paste smoothing surfaces over each other.[50]

After surfaces come lines:

> Wire lines movement, actual movement ascends actual tow-rope of a wire mesh. Flaming lines, crawling lines, expansive lines interweave. Let lines fight with each other and caress each other in generous affection. Points should burst like stars among them, dance around, and materialize one another to form a line. Bend the lines, break and smash angles, throttling and whirling around a point. In waves of whirling storm let a line rush by, tangible in wire.

And lines lead naturally to meshes, nets and veils:

Make lines drawing sketch a net glazing. Nets enclose, contract Anthony's torment. Cause nets to billow into flames, and dissolve into lines, thicken into surfaces. Net the nets. Make veils flutter, soft folds fall, make wadding drip and water spray. Lift up air soft and white through thousand-candlepower arc lamps.

These animated pasted planes, wire lines and veils in the form of nets correspond, of course, to some of the principal formal components of the early assemblages, made while Schwitters was writing this text. The same is true of the machine forms which Schwitters introduces next. In the *Sturm-Bilderbuch* which he published shortly after the description of the *Merzbühne*, he wrote that he had come to like "the combination of abstract painting and machinery as a total work of art."[51] He continued; "I created Merz primarily as a sum of individual art forms, Merz-painting, Merz-poetry. The *Merzbühne* is an attempt to go beyond the art form to the fusion of the total work of art."

It does indeed seem plausible that it was Schwitters' use of machine parts in his pictures that led him to the noisy threshold of the *Gesamtkunstwerk*. Machine images enter his work in 1919, not only literally so in the assemblages but also in the prints and drawings as well. These whimsical combinations of cog-wheels, locomotives, railway-lines, buckets, windmills, rubber-stamped phrases and the like share the same formal vocabulary as the assemblages but use it to create a private illogical world. If one wants to visualize what the *Merzbühne* might have looked like, one can do no better than turn to these drawings, where (as is also the case with the *Merzbühne* text) excerpted refer- 29, 134, 138 ences to the outside world, rendered in an Expressionist-derived style, are jumbled together in Dadaist confusion. Some might well have been conceived as illustrations for this machinist passage on the *Merzbühne*:

Then take wheels and axles, throw them up and let them sing (mighty erections of aquatic giants). Axles dance midwheel roll globes barrel. Cogs nose out teeth, find a sewing-machine that yawns. Turn up or bowed down, the sewing-machine beheads itself, feet upwards. Take a dentist's drill, a meat-mincing machine, a track-scraper for tramcars, buses and automobiles, bicycles, tandems and their tires, also ersatz war-time tires and deform them. Take lights and deform them as brutally as possible. Make locomotives crash into one another, curtains and portieres make threads of spiderwebs dance with window-frames and break whining glass. Bring steam-boilers to an explosion to make railway mist. Take petticoats and other similar articles, shoes and false hair, also ice-skates. . . .

The lists of components continue and continue as Schwitters indulges his fantasy of a great, uninhibited collecting spree on the vastest of scales. Beneath this maker of miniatures there obviously lurked a megalomaniac trash-collector ready to cart off virtually everything in sight. Even men, women and children would not be safe:

People can be used, even.
People can be tied to backdrops.
People can be used actively, even in their everyday positions, they can speak on two legs, even in rational sentences.

Everything was grist for the mill, brought together, and the different materials combined:

> Now begin to wed the materials to each other. For example, marry the oilcloth cover with the Building Society, bring the map cleaner into a relationship with the marriage between Anna Blume and A-natural, concert pitch. Give the globe to the surface to consume and cause a cracked angle to be destroyed by the beam of a 22-thousand-candlepower arc lamp. Make a person walk on his hands and wear a hat on his feet, like Anna Blume. . . .

And so it continues. Sound and music are introduced and interweave with all the materials. Eventually things begin to quieten down, "light darkens the stage, even the sewing-machine is dark," and the performance ends.

I have quoted so extensively from this text not only because it describes the first of Schwitters' two main conceptions of his personal *Gesamtkunstwerk* (the other was the *Merzbau*) and is therefore intrinsically important; not only because it was historically important in prefiguring much subsequent theatrical fantasy art, from the participatory "total theater" of the 1920s to the "Happenings" of the 1950s. It also deserves attention because it gives us a telling glimpse of the mind behind the assemblages and collages, and a glimpse of it, moreover, in the very act of collecting and combining materials. If our knowledge of the assemblages helps us to appreciate how Schwitters could have conceived the *Merzbühne* by mentally expanding and animating their formats to this impossible scale, by the same count our reading of the *Merzbühne* text informs our understanding of the kind of associative fantasy that went into the making of the smaller works. Although, of course, the *Merzbühne* was unrealizable, and we should not therefore press this point too far, we do see from it how Schwitters freely associated between materials of widely different character by virtue of their analogies of form and by the way in which one particular shape seemed to suggest a series of variants upon it, so that, for example, a point evokes a star, which evokes lines, which evokes nets, and so on. What is more, the shattering and deformation, then reassembly, of materials in the *Merzbühne* text is not so very far from what is described in "Die Zwiebel." Both rejoice in the processes of change and in the rapid juxtapositions and unfettered free associations that serve to create it, and also in the containment of this emotive activity by refusing to allow it actually to lead to anything.

Of course, the sense of explicitly personal violence that imbues "Die Zwiebel" is missing in the *Merzbühne* text. Since its principal actors are objects and materials not human beings, its noisy drama is far more a generalized one. But the gradual dilution of urgent emotional themes characterizes the development of Schwitters' literary work as a whole. To manipulate the structure of a work in a collage-like way was to dissociate its individual parts from the sources and the emotions from which they derived. It was also, as it were, to authenticate them: to present them in this "quoted" form. They are therefore at one and the same time less realistic, being separated from their context, and more real, having the authority of documents or records. The collage method itself conferred importance on its sources as it sealed them off from the world from which they derived. Certainly in the *Merzbühne* text we see an utter absorption both in the very

mechanics of assemblage—so that formal elements seem possessed by a kind of potential energy as active, kinetic forces in the space they inhabit—and in the oddities of juxtaposition thus created, which make us think that the pictures too were generated from a story-telling sensibility. Earlier, I characterized Schwitters' collage method as a diaristic one. He himself spoke of the *Merzbilder* as studies for the kind of *Gesamtkunstwerk* that the *Merzbühne* was intended to be.[52] They might well be thought of as smaller and immobile scenes from the continuing play of animistic objects which Schwitters made his life's work. An important assemblage that he made towards the end of his life seems to confirm this interpretation. It is constructed beneath a proscenium arch, on which the word "Drama" is inscribed.

300

In the *Merzbühne* text, it is particularly noticeable how the "play" begins in abstractness, then this is relaxed to take in specific, and ever more absurd, objects and materials, just as in the earliest assemblages the formal pattern of planes, lines and veils is filled in with increasingly definite details. It goes beyond the assemblages, however, to include not only the iconographic elements of the early drawings but characters and situations from Schwitters' other writings. The same mixture of images—of sewing-machines, locomotives, boilers and so on—appears in a number of his prose works before 1923; and we notice that he was unable to resist introducing Anna Blume at the very end.

Of course, even the abstractness of the opening section is not a purely formal one. The description of shifting gigantic surfaces, points bursting like stars, whirling globes, and the like requires comparison with the cosmic effects of Expressionist writing, as does also the movement of the text from this universal and primitive constant of form—what he himself called the *Urbegriff*[53]—to specific realizations of these forms taken from life. We find similar plots (if one can use this word here) in other of the more fanciful writings of Expressionist authors. For example, the architect Bruno Taut's play, *Der Weltbaumeister* (The Cosmic Architect) of 1920, describes a cycle of activity from basic and rudimentary architectural forms to the creation of actual settlements.[54]

Schwitters' style of presentation, however, is derived largely from contemporary German interpretations of Futurist principles. As in "Die Zwiebel" and "Revolution in Revon," Schwitters uses the full arsenal of Futurist literary devices he learned from Stramm and the other Sturm poets. The chains of pictorial sensations and analogies of which Marinetti wrote in the "Technical Manifesto of Futurist Literature" appear here. So do the "telegraphic images" and parenthetical interruptions to control the pace of the writing. The syntax is unhinged. Neologisms, alliterations, onomatopoeia and the rhythmical repetition of vowel sounds all abound. (Inevitably, translation can only provide a fraction of these effects.) Although supposedly a proposal for a theatrical piece that "can only be experienced in the theater" and "cannot be written, read or listened to,"[55] it is ineluctably tied to a logic that is a verbal one. New elements are introduced as much for verbal effect as anything else, and the whole conception was only possible within the flexible, free-association method of Schwitters' writing. Here, materials can interact visually and verbally at the same time. Spider webs on windows become broken glass. Arc lamps hurl up air. Visual fantasies provoke word fantasies. Slogans and banalities can be slipped in. Everything is kept in a state of perpetual animation. It was, of course, unrealizable, so securely was it founded in its literary form.

☐ What is more, any attempt to realize the *Merzbühne* as real theater would not only excise the kind of free associations available to the reader, it would at the same time necessarily impoverish its totality of appeal. Theater as total as the *Merzbühne* is imaginable; but outside the imagination, and its omnipotent fantasies, it is not credible at all. As we shall see later, Schwitters did propose a practical form of Merz theater. In doing so, however, he was forced to severely limit its scope, and the Constructivist-influenced designs he produced cannot reasonably be considered as versions of a *Gesamtkunstwerk*.

I have pointed out how the *Merzbühne* relates to Schwitters' drawings and assemblages on one hand and to his writings on the other. It is, indeed, crucially important to understand that while his idea of the *Gesamtkunstwerk* was manifested in the theater, the basis of his idea was to realize, and animate, in three-dimensional space the forms and images of his two-dimensional art, both visual and literary. If Schwitters was willing to settle for an inanimate kind of *Gesamtkunstwerk,* theater as such would not be the obvious way of achieving it; sculpture and architecture would. An architectural *Gesamtkunstwerk* would sacrifice the animation of theater only to gain in stability: it would be a permanent work, not a transient one. Whereas the *Merzbühne* resisted translation out of its written form, a *Merzbau*—or Merz-building—could actually be realized.

Schwitters' interest in the *Gesamtkunstwerk* coincided not only with those Expressionist theatrical experiments that may have influenced his own turn to the theater, but also with Expressionist architectural experiments. In 1919, when the *Merzbühne* was being proposed, the Bauhaus foundation-manifesto was announcing a new union of the arts around architecture.[56] That same year, Schwitters himself began to make small assembled sculptures and architectural models. Not until 1923 did he fully commit himself to an architectural *Gesamtkunstwerk*; the reasons for this will be addressed later, in a discussion of the *Merzbau* itself. Even in 1919, however, his three-dimensional assemblages reveal interests that go beyond the simply sculptural; in 1920, it is already clear that an alternative to a theatrical *Gesamtkunstwerk* was under consideration. All of these sculptures have the appearance of small, whimsical tableaux and consequently relate in spirit to the *Merzbühne*. They were, eventually, it seems, built into the *Merzbau*. They might therefore be considered as intermediaries between Schwitters' two attempts to create a *Gesamtkunstwerk;* even possibly the sources for both of them. In a more specific sense, moreover, Schwitters' sculpture—although undoubtedly a minor part of his *oeuvre*—is the connecting link beteen the visual arts he practiced, the avenue through which objects had to pass to leave the confines of painting-based activities to reach the threshold of the total work of art.

Excepting some early academic portrait busts,[57] these constructions were Schwitters' first ventures into sculpture. It is impossible to be sure how many were made; none now exist, though six are known through photographs. Of these, *Der Lustgalgen (The Pleasure Gallows)* and *Die Kultpumpe (The Cult Pump)* may well have been the earliest. They would seem to date from 1919, and it was to these two works that Schwitters referred when first discussing his sculptures in print, saying they "are like the *Merzbilder* in being composed of various materials" but "are conceived as sculptures in the round and present any desired number of views."[58]

135
133

Because they were conceived in the round, the materials they use, though indeed close to those in the contemporary assemblages, cannot function as analogues of conventional formal elements in the same way as they do in the two-dimensional works. The greater literal presence of sculpture prevents this happening, at least to the same degree. Once transferred from a two- to a three-dimensional space, the materials Schwitters used were inevitably far more difficult to form, for, as he acknowledged, "only in a limited space is it possible to assign compositional values to each part in relation to other parts."[59] In consequence, the materials of the sculpture keep their individuality, their *Eigengift*, far more.

Schwitters talked of his admiration for Archipenko's sculpture,[60] but Schwitters' own constructions seem among the most openly Dadaist of all his works. They evoke comparison with Ernst's and Baargeld's assemblages, made in Cologne around the same time,[61] and with works like Marcel Janco's *Construction 3* of 1917, which Schwitters is almost certain to have seen in reproduction.[62] However, they mainly relate to Schwitters' own drawings and watercolors of 1919. These, like the sculptures, were part of Schwitters' expansion of Merz away from the formal context of painting to admit more private and more literary allusions. Their relationship to the *Merzbühne* text has already been mentioned. In drawings and sculpture alike, reference wins out over form. At times, they share a common iconography.

132

134

The sculpture *Haus Merz* (*Merz House*) of 1920[63] is remarkably close to the small, naively drawn churches that appear in the drawings. Schwitters is also recorded as having made a windmill sculpture, another familiar motif of the graphic work.[64] Likewise, such individual components of the drawings as a lighted candle, machine handle and dressmaker's dummy all combine in the sculpture *Die heilige Bekümmernis* (*The Holy Affliction*).[65] Imagery of this kind, drawn from mechanical, domestic and commercial sources, and irrationally combined, is also to be found in Schwitters' writings (the *Merzbühne* text is only the most obvious example), and the sculptures seem to relate to these as well. Titles like *Der Lustgalgen* recall the masochistic theme of stories such as "Die Zwiebel." A sculpture apparently never photographed, but described as "a board, through the middle of which ten inches of a broomstick [*Besenstiel*] stuck out, the tip slightly charred. At the end of the board, a little block of wood, painted red on top,"[66] may have been intended to evoke one of the characters of "Revolution in Revon," Alves Bäsenstiel—just as the *Merzbild, Franz Müllers Drahtfrühling* (*Franz Müller's Wire Springtime*), refers to the hero of this and other tales.[67]

136

138

161

Schwitters' works in different media were, in effect, the interrelated products of a single private mythology, a mythology that shows itself most obviously in his writings but which infiltrates, to a greater or lesser extent, his other work as well. His prose fantasies were written against the background of the 1918 Revolution and the disturbances of the early years of the Weimar Republic. They tell both of the violence and disorder of that time and of the alternative, hermetic world of fantasy that Schwitters created by way of escape. The drawings and sculptures give the impression of an ordered mechanical world suddenly gone askew. Sculptures like *Der Lustgalgen* and *Die Kultpumpe* resemble derelict industrial buildings or miniature monuments of industrial rubble.

When Schwitters describes the invention of Merz as a way of rebuilding from the fragments of the past, and speaks of wanting to expand this idea to the broader dimensions of the total work of art,[68] we are reminded that many of his contemporaries harbored similarly utopian schemes, though most in a less fantastic way and with specific social ambitions in mind. To a significant extent, Schwitters' preoccupation with the *Gesamtkunstwerk* was the product of the post-Revolutionary period during which his artistic ideals were formulated. The idea of creating a new beginning after war and revolution was perhaps most evident in advanced architectural circles (for obvious reasons, given the condition of cities like Berlin, ravaged by street-fighting) and fostered the creation of organizations like the Arbeitsrat für Kunst (Workers' Council for Art, or Art Soviet), under whose auspices Walter Gropius, Bruno Taut and their colleagues proselytized for an architecture of the future. Although Schwitters never joined this or any other of these new organizations (having his own one-man movement to promote), and although his interpretation of the total work of art, in its almost anti-social format, seems at first sight to be diametrically opposed to their ideas, there are some significant parallels, and a few specific connections, that deserve notice.

Schwitters had studied architecture at the Technical University in Hannover for two semesters in 1918, that is to say, immediately preceding his invention of Merz. The sculpture *Haus Merz* of 1920 is certainly of architectural inspiration: a model church, with a spinning top for a spire, a trouser button for the clock face, and its nave filled with cog-wheels (probably the mechanism of a watch). Schwitters called it his "first piece of Merz-architecture" and quoted, obviously with approval, what his friend Christof Spengemann had to say about it:

> In *Haus Merz* I see the cathedral. No, building as the expression of a truly spiritual vision of the kind that lifts us into the infinite: absolute art. This cathedral cannot be worshiped in. The inside is so filled with wheels that no room is left for people. . . . This is absolute architecture, the only meaning of which is artistic.[69]

This reads suspiciously like a parody of contemporaneous architectural writing, such as produced by the Arbeitsrat für Kunst, and the mock seriousness of tone is even more noticeable in Spengemann's longer original text.[70] And yet, Schwitters does quote it as a serious explanation of the sculpture. If this serves only to raise the additional question (and one only too familiar when considering Schwitters' work) of just how seriously one should take his more fanciful writings, it should be remembered that despite his predilection for nonsense he was indeed committed to a spiritual and absolute art. While his Dadaist sculptures are unconvincing as unique objects, they become slightly more credible when thought of as models for an environmental total work of art. The tableau-like *Lustgalgen* and *Kultpumpe* presage the intimate grottos of the *Merzbau*.

Spengemann's reference to "the cathedral" in connection with *Haus Merz* becomes explicable when we know that, for advanced architectural thought in the Germany of this period, the cathedral was the dominant symbol of Expressionist ideals. As most famously shown in Feininger's woodcut for the Bauhaus Proclamation, it stood for the unity of the arts, and recalled an imagined Gothic utopia when preindustrial man existed in close harmony with nature and in social equilibrium.[71] A visionary Expressionist

139

architect, such as Walter Gropius still was in 1919, could therefore write that art's ultimate goal was "the creative idea of the Cathedral of the Future [*Zukunftskathedrale*], which will once more encompass everything in one form, architecture and sculpture and painting."[72] Gropius' message to practitioners of the fine arts was loud and clear, and almost Dadaist in its iconoclasm: "Smash the frames of Salon art around your paintings, go into the buildings, endow them with fairy tales of color, engrave your ideas onto their naked walls and—build in fantasy, without regard for technical difficulties."[73]

Although Gropius and his Arbeitsrat colleagues were thinking of public and collaborative monuments, and Schwitters of private and individualistic ones, their sentiments were not so entirely different. The "protest" of Expressionist architecture was for a return to the *Urbegriff*—to the primeval origins of forms—and, though certainly a reaction against the structures of contemporary society, existed autonomously with respect to the real social conditions of the times. This same disinterested, and therefore apolitical, rebellion was shared by Schwitters. He entitled his 1920 portfolio of lithographs *Die Kathedrale*. His own Cathedral of the Future, the *Merzbau*, he also called the "Kathedrale des erotischen Elends" (Cathedral of Erotic Misery).

The confrontation of Dada and Expressionism in postwar Berlin was not as clear cut as it sometimes appears. All of the Dadaists had emerged out of an Expressionist past, and when Club Dada showed signs of collapse, some of its members renewed their Expressionist affiliations. Hausmann, Richter and Eggeling joined the Sturm-dominated Novembergruppe, and Jefim Golysheff was an active member of the Arbeitsrat für Kunst itself.[74] Conversely, there were certain Dadaist elements within Expressionist architecture. Carl Krayl's *Haus eines Dada* was illustrated in Bruno Taut's first *Frühlicht* publication in 1920; and the Dada character of his work was commented on within his circle, Hans Luckhardt associating it with the primordial and primitive side of their activity.[75] A further work by Krayl was illustrated in *Frühlicht* when it reappeared in Magdeburg in 1921/22, and beside it a sculpture by Schwitters, an assembly of weather-beaten timber, identified in an accompanying text as *Schloss und Kathedrale mit Hofbrunnen* (*Castle and Cathedral with Courtyard Well*).[76]

141

140

Interestingly, this sculpture (or model) is Schwitters' only known early construction which approximates to a unity of materials, and perhaps it was for this reason that it met with Taut's editorial approval. Although almost inconceivable as architecture, it is no more so than most of the other designs Taut published. Indeed, its organic interpretation of the cathedral theme bears a certain resemblance to some of the "form-fantasies" created by the Luckhardt brothers, just as the Hannover *Merzbau* (whose forms Schwitters once compared to those of Gothic architecture)[77] looks back to the alliance of the organic and the crystalline that characterized much of the work produced within Taut's circle.[78] Although the cathedral concept, and that of an organic architecture, was not peculiar to the Arbeitsrat architects (they merely codified themes already current at that time), to look at Schwitters in this context is to be reminded that the *Merzbau* and the models that precede it are not only eccentricities comparable to the naive constructions of Ferdinand Cheval and Simone Rodilla,[79] but bizarre offshoots from the Expressionist "Cathedral of the Future."

137

Schwitters was contemptuous of the exaggerated emotionalism of Expressionism,[80] but he began his artistic career within the auspices of that esthetic, and some of its precepts remained with him. His insistence on the priority of form concealed an essentially spiritual and primitivist understanding of the nature of art: of art as an *Urbegriff*, "a spiritual function of man, which aims at freeing him from life's chaos (tragedy)."[81] And despite the urban geometry of Schwitters' materials and pictorial style, he saw the autonomy of art as analogous to that of a natural organism: "like Nature," he said.[82] This seeming dichotomy of urban themes and organicist conception is important to Schwitters' later development. For the moment, however, we need merely note that his understanding of art's function as a spiritual one speaks of another dichotomy, also familiar from Expressionism, namely that of the artist and his material environment. This is an important theme since it brings to the fore Schwitters' special relationship to the materials he took from life and hence the precise manner in which his *Merz-Gesamtweltbild* (Merz total world picture) was formulated.

In one sense, the entire assemblage basis of Schwitters' art is founded upon an opposition of inner and outer reality, manifesting itself at several different levels of meaning. His work acknowledges a penetration of the artist's personal world by evocative tokens of everyday life, but at the same time seeks to exorcize that penetration through esthetic forming. Once accepted into Schwitters' art, however, his materials speak not only—nor indeed primarily—on their own behalf, but on behalf of Schwitters himself: as expressive tokens of his personality. Their *Eigengift* is effaced not only for art's sake but because they function as emblems of the self within the context of art. In the Expressionist "ego-drama"—as critics described the plays with rebellious young heroes by Walter Hasenclever, Hanns Johst, and some others—the personality of the hero is expressed through the characters with whom he is in contact. They have no personality of their own, being essentially personifications of the different aspects of the hero's inner nature. For Schwitters, Merz was a method of ordering the world with himself at the center—an ego-drama, in which the inner life of the hero, Schwitters himself, is personified in the materials and objects that surrounded him.

It is no mere figure of speech to say that Schwitters identified with these objects. Just how much they filled his life may be gauged by his need to keep them constantly around him. He apparently never traveled anywhere without a suitcase of materials and of works in progress.[83] His obsessional collecting of objects of all kinds is equally well documented.[84] His whole working life was spent in their company, and he transformed much of his house in Hannover to accommodate them. When used in his pictures, they obviously do refer to their former uses, despite Schwitters' denials, but they also have internal and personal significance. Schwitters speaks "not only with things . . . but through the medium of things: giving an account of his personality and life by the choices he makes."[85] The metaphor of containment or inclusion he frequently used is at heart an image of possession, of things taken from the world, dematerialized, and made to belong to himself. And on occasion he did concede that his feelings had been poured into these forms and it was this that kept his work from mere decoration.[86]

Schwitters' metaphor of containment refers generally to how the evocative power of materials should be held in check by the "forming" process lest it overwhelm the work.[87]

But parallel to this runs another, and far more guarded, image: that the inclusion of objects in art shields their personal meaningfulness as well.[88] This helps explain Schwitters' collaboration, in 1921, with a Hannover marquetry craftsman called Albert Schulze in order to produce a set of small, decorated boxes, based on collaged designs, in which 142, 143 Schwitters apparently kept all sorts of refuse.[89] Here, art literally contains things of personal significance. In the closing of the lid, the artistic process is symbolized: the formalized exterior shuts in the personal disorder and seems, magically, to have transformed it into an esthetically ordered state.

Art, as Schwitters conceived it, served as an escape from everyday life into "contemplative self-absorption." "Self-absorption in art," he wrote, "is like service to the divine in that it liberates man from everyday cares."[90] "It makes man free from petty everyday things and raises him above himself and his passions."[91] "Art does not try to influence one or be effective, but to liberate one from life."[92] Although the spirituality of passages like these is decidedly Expressionist, Schwitters' avoidance of the disquieting is not. To the Expressionist, the artist's work (in Kasimir Edschmid's famous phrase) was an outburst of his inner self, a turning loose of his reactions to the world from his position of isolation: a dramatization of that isolation which served only to seal it all the more.[93] In Schwitters, we see an entirely different kind of self-engrossment: one that immerses itself in the world only to retreat, then mold and alter it after Schwitters' own private specifications; one that represents all elements of the world as Schwitters' own. Collage has often lent itself to an endeavor of this kind. One thinks particularly here of an artist like Joseph Cornell, or of Matisse in his later years: both private and self-protective figures, jealously guarding the self-created worlds they collaged around themselves. Schwitters was doing the same. Despite the broad inclusiveness of his understanding of art and despite the outward-looking nature of his procedures, he was not extending art into everyday life but doing exactly the opposite: subordinating external reality to one of his own making. And if this is also an Expressionist stance, he yet separates himself from Expressionism in seeking not to represent his subjectivity before the outside world but rather to contain it, secreting his own self-centered universe behind an artistic front.

In acknowledging the autonomy of art, as he constantly did, in word as well as deed, Schwitters was driven to submit to art's discipline those very aspects of his work that held particularized, personal meaning. This is, of course, a part of all serious art, though it rarely expresses itself as directly as it did in Schwitters' case, where the dichotomy between things personal and things esthetic was emphasized by the very structure of his work—for assemblage as he practiced it involved the inclusion of things personal within the context of an abstract, and therefore impersonal, medium. His unremitting insistence upon the importance of esthetic values, and rejection of expression as injurious to these values,[94] suggests some kind of real conflict between his respect for art's identity and for the objects which carried his own identity.

In the small-scale space of the collages, the conflict is resolved: the personal and the abstract find perfect equilibrium. But once objects left the limited spaces of two-dimensional art on their path towards the *Gesamtkunstwerk,* they seemed to be beyond the reach of strict formal control, as the early Dadaist sculptures show. Schwitters was never able to develop an assemblage style for free-standing sculpture that used abstractly

the same kind of evocative materials that appear elsewhere in his art. The abstract sculptures he began making around the time he began the *Merzbau* do sometimes employ found objects. They are, however, far more regularized and "finished" in appearance, and their components more neutral in character, than the Dadaist sculptures. They clearly belong to a rather different sculptural conception. Many of them, in any case, were made of plaster built up on an armature of found objects. Here again—as with the boxes—objects are physically concealed beneath an artistic front.

In the development of the *Merzbau* we will find the connecting link between Schwitters' two distinct bodies of sculpture. The beginnings of the *Merzbau* show how Schwitters' Dadaist sculptures were metamorphosed into an environmental art form. Its subsequent development into a geometricized labyrinth behind which were hidden "grottos" of found objects brings together, on the grandest of scales, the formal containment of objects, and masking of their personal meaning, that lies at the core of Schwitters' art. The form of the labyrinth, moreover, reveals the effects of Schwitters' most determined attempt to put rigorous, stable order into his art as a whole. I refer here to his alliance with Constructivism.

2. THE DEVELOPMENT OF MERZ

1922-1948

6 MERZ IN THE MACHINE AGE

□ Although Schwitters is most often celebrated as a Dadaist, his Constructivist alliance of the 1920s should not come as too much of a surprise. We have seen enough of Schwitters' art, and of his own understanding of it, to know how deep was his commitment to formal values. Indeed, it was his commitment to such values that kept him from official membership of any Dada circle. It brought him friendship with the Constructivists in the 1920s. From around 1922 his work began to show the influence of International Constructivism, and for nearly a decade the influence remained an active one.

It is sometimes suggested that this caused Schwitters to abandon his own special kind of intuitive forming in favor of formalist orthodoxy, and that his association with the Constructivists meant the renunciation of the liveliest part of his nature: was, in short, a cul-de-sac. Although there is some truth in this, not all of this work of the 1920s is "formalist" in the narrow, ascetic sense. Schwitters kept away from the more dogmatic side of Constructivism just as he had kept away from that side of Dadaism.

The tendency of labels to harden in time sometimes makes us forget that there was in fact no single 1920s Constructivist ideology. The term "Constructivist" seems to have been first adopted as an official group title by the First Working Group of Constructivists, established in Moscow in March 1921 by seven vanguard artists, including Alexander Rodchenko and Varvara Stepanova, whose program rejected purely esthetic activities in favor of what they called "material-intellectual production," which in practise meant applied and industrial art.[1] But the term itself, and closely related ones—like "construction," "constructive," and "constructional"—had been in general use in avant-garde circles across Europe for some time, to refer to a wide variety of additive and usually (but not always) abstract compositional structures, in two-and three-dimensional art, made possible by the innovations of Cubism.

It is clearly inappropriate to apply the term "Constructivist," as often happens, to virtually all post-Cubist geometric abstract art, down even to the present day.[2] And yet, we can hardly prevent the meanings of words from changing. If custom and usage broadened the meaning of "Constructivism" in the 1920s so that (as Osip Brik pointed out in 1923)[3] artists, instead of saying "composition" said "construction," and instead of saying "to create" said "to construct"—when all they were doing was "the same old things: little pictures, landscapes, portraits"—then all we can reasonably do is try to limit the term somewhat, both historically and stylistically. I use it here to refer to post-Cubist geometric abstract art where the additive "construction" of individual formal "elements" was a primary concern, in the period that began with Vladimir Tatlin's

1914 reliefs and ended with the final break-up of pioneering European art at the beginning of the Second World War. It is important to distinguish between "Russian Constructivism," with its functional emphasis, and the "International Constructivism" of the West in the 1920s, which had mainly esthetic concerns. Even International Constructivism, however, was not exactly an artistic *movement,* but an amalgam of movements and artists who recognized a common purpose in the idea of a constructed art-form appropriate to the reconstruction of European society after the First World War.

The 1920s were a period of great give-and-take, allowing many artists to work together without too much concern for individual affiliations. Schwitters' gregarious temperament seemed to blossom through confrontation with ideas and styles which paralleled his own: he was stimulated by them, and stole readily, but creatively, from them. Certain aspects of his art did suffer, and sometimes very considerably, from Constructivist influences, but others blossomed.

Although a complete picture of Schwitters' importance cannot be constructed on the basis of his formalist work alone, his "formalism" is a part of it. To grasp how it was expanded in the 1920s is of essential importance to a full understanding of Merz, for Merz itself was, to a significant extent, a post-Dada phenomenon, and in some ways a part of the *rappel à l'ordre* of the 1920s which in Germany meant Constructivism. Even in 1919, when Merz was baptized, Dada as a whole was beginning to move into decline; by 1923 it had definitely passed. That year saw the initiation of Schwitters' *Merz* magazine, the widening of his publicity for the Merz idea and its expansion into yet new fields. Although the principles had all been established between 1919 and 1923, what followed was the rationalization of these principles and the demonstration of their widest possibilities.

□ Schwitters' turn from Dada to Constructivism was not unique: many of the Dada artists moved in the same direction. Dada is usually associated with Surrealism, and, as far as the literary and Romantic side of the movement is concerned, this is correct: Surrealism did take over from Dada and develop it. Outside literature, however, and particularly outside France, the picture is very different. In Germany and in the plastic arts, the true successor of Dada was Constructivism.[4] The Dada component of Constructivism, though controversial at the time, and often passed over now, was an important one nonetheless. Indeed, the creation of International Constructivism out of the stylistic components of Dutch and Russian art was to a crucial extent catalyzed by former Dadaists, Schwitters included.

The beginning of what former Dadaists would often call the new constructive alternative—and therefore the beginning of the end for German Dada—goes back to the German Revolution of 1918, which saw a relaxation in the partisan stances of the German avant-garde. The quarrels of Dadaists and Expressionists, and of Expressionists of differing persuasions, were temporarily forgotten in a moment of optimism for the future: all the artists of Berlin Dada showed work in the first exhibition of the Expressionist-dominated Novembergruppe. At the beginning of 1919, moreover, the Novembergruppe started to make contact with foreign utopian organizations. Before

the end of January, a consortium of Russian artists, including Kandinsky, sent an "Auf-ruf der russischen Künstler" ("Proclamation of Russian artists") to the Arbeitsrat für Kunst (the architectural inner cell of the Novembergruppe) informing them of the great artistic experiment that had been taking place since the Soviet Revolution.[5] The Arbeits-rat, in return, suggested an exchange of exhibitions of German and Russian art.[6] And by the late spring of 1919, Lyonel Feininger, a principal organizer of the Novembergruppe, was in contact with the De Stijl group.[7] Although most of the Novembergruppe were committed Expressionists, and did not respond actively to the new stimulus that foreign geometricism provided, there were some who did. In 1920, a loose circle began to develop within the organization—and soon outside of it as well—that began to proselytize for a new, ordered art, and to practice it.[8]

Berlin had become by this time something like a vast railroad station, with refugees from Russia and Eastern Europe, and visitors from the Low Countries and from other cities in Germany. The Constructivist circle that emerged between 1920 and 1922 was an affirmatively international one. It included: Raoul Hausmann, the Dadaist who most strongly committed himself to the Novembergruppe; Hans Richter, the former Zurich Dadaist who joined the organization after arriving in Berlin in 1919; László Moholy-Nagy, who had arrived from Budapest via Vienna in 1920 (and with whom Schwitters shared a studio in Berlin in 1921); Theo van Doesburg, who after the departure of Mondrian for Paris in February 1919 began to establish contacts first with Dadaists and then, through Richter, with this circle; and El Lissitzky, who arrived from Russia in 1921. There were many others as well: also from Russia, Ilya Ehrenburg and Ivan Puni, and in 1922 Naum Gabo and Antoine Pevsner; from Holland, Mart Stam and Cornelis van Eesteren; from Sweden, Viking Eggeling; Schwitters' friend and frequent visitor, Hans Arp, and soon Schwitters himself.

The principal developments towards International Constructivism can be summa-rized as follows. In 1920, recent Russian art was beginning to be known in Berlin. In that year, Konstantin Umanskij published in German his book *Neue Kunst in Russland, 1914–19* (*New Art in Russia, 1914–19*), in which he mentioned Tatlin's "machine art"—and Tatlin himself was celebrated by a special poster at the Berlin Dada Fair.[9] It was, however, towards Holland that most of the early contacts were made. In 1920, Van Doesburg visited Richter as part of his travels to publicize his review *De Stijl*, and suggested that Richter found a new post-Expressionist journal dedicated to "the new art."[10] Such a magazine, *G* (for *Gestaltung*), was not to emerge for three years, but the way in which Richter, a German "constructive" Dadaist, was able to find common ground with a Dutch abstractionist—who in turn allied himself to Dada: first by adopt-ing a Dada pseudonym, I. K. Bonset, in 1920 to publish Dada-type poems in *De Stijl*,[11] and second by founding his own Dada magazine *Mécano* in 1922[12]—typifies the kind of interchange that was beginning to emerge.

A similar pattern is visible in Hausmann's post-Dada activities. Having separated himself from his political Dada colleagues late in 1920, he too began to look to Holland. In March of 1921, he published an article on Dada in *De Stijl*, and in September another one, "PRÉsentismus," which spoke explicitly of the need for a new esthetic appropriate to modern life and revived Huelsenbeck's Dadaist "New Man" as a technological being

for whom a kind of classicized Futurist environment should be created.[13] Also in September, he made a lecture tour to Prague with his Berlin Dada colleague, Hannah Hoech, and with Schwitters, advertising it as "Anti-Dada und Merz." "Dada has missed its mark," he wrote later, ". . . and I declared myself Anti-Dada and Presentist and with Schwitters resumed the struggle on another scheme."[14] Both Hausmann's Presentism and Schwitters' Merz were, even in 1921, post-Dadaist and proto-Constructivist in conception, and both readily associable with the proclaimed Neo-Dadaism that Van Doesburg espoused at this time under his Bonset pseudonym. By July of that year Schwitters too began contributing to *De Stijl*.[15]

Schwitters, however, did not contribute to what should probably be considered the first organized move to codify International Constructivism. In October 1921, Hausmann, Arp, Moholy-Nagy and Puni published the brief but important "Aufruf zur elementaren Kunst" ("Call for an Elementary Art") in *De Stijl*.[16] The call was for an art that was topical, anti-individualist, built up of basic formal elements, and dedicated to attaining a universal style. Van Doesburg's influence is evident, though so—in the idea of "elements"—is that of the Russian Suprematists (via Puni and Moholy-Nagy), and the iconoclastic dismissal of the past is Dadaist in source. Once again, the diverse origins and affiliations of the signatories show the highly eclectic basis of the Constructivism that was developing. The mixture continues in 1922, but now with a stronger Russian component. In March, Lissitzky and Ilya Ehrenburg founded in Berlin the trilingual magazine *Veshch/Gegenstand/Objet* (*Object*), announcing in its first editorial title, "The Blockade of Russia is coming to an End."[17] In October, the important and influential "Erste russische Kunstausstellung" ("First Russian Art Exhibition") at the Van Dieman gallery in Berlin brought new Russian art itself, in considerable depth, to the German public.

It was in 1922 that International Constructivism was formally, if not officially, established. The *Veshch* editorial proclaimed that "Art today is international We stand at the outset of a great creative period." It was to be characterized by an international brotherhood of "object" builders—be they painters, poets or architects—who would construct their works in full cognizance of all the apparatus of the modern world. Two months later, in May 1922, the Junges Rheinland group (a Novembergruppe-type organization) invited members of the Novembergruppe and other German avant-garde groups to a "Congress of International Progressive Artists" at Düsseldorf.[18] Van Doesburg, Lissitzky and Richter were among those who attended, and almost by chance these three most vocal protagonists of a Constructivist approach found themselves affirming their solidarity. Faced on the first day of the proceedings by majority decisions of the mostly Expressionist congress that they could not accept, they joined forces: each signed statements representing Dutch, Russian and German Constructivists, which attacked the subjectivist, individualist majority, and they declared the creation of a new "Internationale Fraktion der Konstruktivisten" (International Party of Constructivists).

The Düsseldorf Congress thus effectively separated the Constructivists from the Expressionists; it also, however, brought Constructivists and Dadaists together for the first time, and with somewhat stormy results. In *Veshch,* Lissitzky had condemned Dada as anachronistic: "The days of destroying, laying siege and undermining lie behind us . . ."

he wrote. "Now is the time to build on ground that has been cleared."[19] However, to those whom we today might call progressive Dadaists, like Hausmann and Schwitters, the "destructive" character of Dada had not been an end in itself; nor was it just a means to an end, that of construction after the period of destruction (though that was, in part, how they justified their activities). Rather, destruction and construction together—in an active polarity—were essential to the internal logic of their work: the demolition of elements of an old culture to rebuild, from these very fragments, a new one.[20] It was this polarity that attracted Van Doesburg to Dada and caused him to practice it under the *persona* of Bonset. But Van Doesburg tried to keep his Dadaist Bonset *persona* separate from his De Stijl *persona*. Apparently, among his De Stijl collaborators, only the architect J. J. P. Oud originally knew the secret,[21] though by the time of the Düsseldorf Congress it must certainly have become public knowledge; after all, two issues of Van Doesburg-Bonset's co-edited *Mécano* had already appeared. In any case, Van Doesburg's alliance with Lissitzky and Richter at Düsseldorf must have appeared somewhat two-faced to the Dadaists there, for on the second day of the Congress, Hausmann denounced both the Expressionist majority and the seceding International Constructivists, saying "he was no more International than he was a cannibal," and walked out. The Congress ended in disarray.

Some of the Dadaists, however, had supported the Constructivist faction (Richter signed his statement of affiliation on behalf of Eggeling and Janco as well as himself). And one of those who had joined Hausmann in reproaching Van Doesburg, an ex-Bauhaus student called Werner Graeff, who was to collaborate with Richter on *G*, suggested that a smaller Congress of Dadaists and Constructivists be organized. Van Doesburg took over the arrangements and decided it would be held in Weimar that September.[22] He had been living in Weimar since May 1921, having settled there in the belief that he would be offered a teaching post at the Bauhaus, and not having received the post he was glad to be able to upset the smooth-running of that still mainly Expressionist institution by means of a Dadaist-Constructivist invasion.[23]

Schwitters had apparently not participated in the Düsseldorf Congress, but around the time of his first contributions to *De Stijl*, in July 1921, he had suggested to Van Doesburg that they organize a joint Dada performance.[24] The time for this was now obviously ripe, and it was organized to coincide with the Weimar Congress on September 25, 1922.[25] Arp was to come too, and Schwitters arranged for Tzara to attend. The group assembled on the 23rd at Walter Dexel's house in Jena, where they planned their strategy (and where on the 26th they presented another performance), and traveled to Weimar full of high spirits. The De Stijl-Dada evening that they presented developed the format for the later Van Doesburg-Schwitters tour of Holland described in Chapter 5. If their presence in Weimar was a nuisance to the Bauhaus director, Walter Gropius, who felt they were a distraction to his students (as indeed they were), it was also the cause of some annoyance to the more hard-line Constructivists who came to the Congress.[26] Having only just separated themselves from the Expressionists at Düsseldorf, they had once again the disruptive Dadaists to contend with. They did not want them at the Congress. This time, however, Van Doesburg sided with the Dadaists, and it was the more intransigent of the Constructivists who had to withdraw. The Weimar Congress therefore turned into a

144

Dada performance, and what the Constructivists thought was to have been the birthplace of a new movement became the grand finale of an old one.[27] The Düsseldorf agreement establishing an "Internationale Fraktion der Konstruktivisten" was never officially ratified, and Constructivism remained a principle rather than an institution.

This is worth recounting not only to remind ourselves of the accidents and misunderstandings from which history is made but because the continuance of Constructivism, not as a fixed united organization, but as a constellation of many different and separate parts, meant that there was a place within it for an artist like Schwitters. Indeed, once the Weimar Congress dissolved and the Jena performance had been staged, the group traveled to Hannover for a "Dadarevon" evening on September 30 at the Garvens gallery, where Schwitters was having an exhibition.[28] Not only were Schwitters, Arp, Tzara, and Van Doesburg there but also Hausmann and Hoech and Moholy-Nagy and Lissitzky. Hannover was now on the Constructivist circuit, and Schwitters an accepted member of the new avant-garde.

By 1922, the artistic climate of Hannover was very far indeed from what it had been before the war.[29] The foundation of the Kestner-Gesellschaft in 1916 and of the Hannover Sezession in 1917, the creation of a Sturm (and then Dada) outpost around the publishers Spengemann and Steegemann in 1918, and then Schwitters' own propaganda for Merz in 1919, had begun to give the city an avant-garde reputation. In the early 1920s this reputation was considerably enhanced. As Schwitters began widening his circle of contacts he started bringing a whole succession of visitors to Hannover. So did Paul Küppers, director of the Kestner-Gesellschaft, and Eckart von Sydow who took over after Küppers' death in January 1922.

It was probably Alexander Dorner, sometime president of the Kestner-Gesellschaft and from 1922 director of the Niedersächsiches Landesmuseum, who did most for the city. His enthusiastic commitment to Constructivism as the "art of our time" brought him contacts with a very wide range of avant-garde artists, and he promoted their work at the Kestner-Gesellschaft and in the Hannover museums. Exhibitions of De Stijl, Bauhaus and Russian art, of modern architecture and design, of Kandinsky, Moholy-Nagy, the G group, and many more, were seen in Hannover through the 1920s. A series of distinguished visitors were brought to speak at the Kestner-Gesellschaft: not only the exhibitors, but such as Hans Prinzhorn, Paul Rand, Bruno Taut, Herwarth Walden, and Mary Wigman, as well as outside patrons such as Katherine Dreier, who bought work by Hannover artists for her Société Anonyme. And Alfred Barr was attracted to Hannover, to buy work for The Museum of Modern Art. Dorner also brought Gropius to Hannover in 1923, the year of the important Bauhaus exhibition which marked its shift away from its Expressionist past, to lecture on the theme of the unity of art and technology (surely another significant incident for Schwitters' awareness of the new machine-age themes). And it was Dorner who transformed the Landesgalerie with period "atmosphere rooms," including Lissitzky's famous "Kabinett der Abstrakten" (Room of Abstracts) of 1927 and the equally exciting, but unfinished, "Raum unserer Zeit" (Room of our Time) designed by Moholy-Nagy in 1930. This sort of inspired patronage was matched by Dorner's purchasing, and before 1937 the Landesgalerie had probably the largest collection of modern art in Germany.

Moreover, Dorner did not neglect Hannover's own artists. He was initially critical of Schwitters' work, writing a hostile review of his forementioned 1922 exhibition at the Garvens gallery in Hannover (to which Schwitters replied in kind).[30] And no sooner had he come to terms with Schwitters' collages, and recognized their affinity with Constructivist art, than he was shown the *Merzbau*—which appalled him at first; but he survived the experience and became a supporter of Schwitters' work.[31] He also took a keen interest in the Gruppe K (for *Konstruktivismus*) of 1924, a Hannoverian version of the G group, which included Friedrich Vordemberge-Gildewart, Hans Nitzschke and Friedrich Kayser. And when Schwitters was instrumental in combining the K group with Carl Buchheister, Cesar Domela and Rudolf Jahns to form the organization, "die abstrakten hannover," in 1927,[32] Dorner became one of their strongest supporters. As a Berlin journal of 1931 commented: "That abstract artists such as Schwitters, the architect and designer Nitzschke, Vordemberge, and Buchheister, could become so important in Hannover is due to the promotion Dorner gave them in his museum."[33]

Of course, Dorner did not reform Hannover singlehanded, nor was it just he and Schwitters that managed it. The Garvens gallery, the industrialist patrons Hermann Bahlsen and Fritz Beindorf, the other artists, and not least the enlightened and enthusiastic public which developed through the 1920s, all helped to make Hannover one of the most important centers of German modernism.[34]

All this was beginning when Schwitters brought the Constructivists to Hannover in 1922, and when his work began to be strongly influenced by Constructivist ideas. As we saw earlier (in Chapters 3 and 4) Schwitters' work was first affected by Constructivism in 1920. In that year, however, the influence was absorbed within the framework of what is obviously still a Dada art. It was only later that Constructivist ideas more profoundly changed the character of his work. In collage this had happened by 1922, when he became part of the Dada-Constructivist community; for then the Expressionist connotations of the 1919–20 collages were almost entirely expelled. In assemblage, on the other hand, after the difficulties he had experienced in 1921, he seems to have produced nothing in 1922, and the Constructivist influence made its appearance only in 1923.

The question of the date of Constructivist influence arises only because of an important statement by Schwitters, which appeared in the "Katalog" issue of *Merz*, no. 20, 1927. It accompanied a major retrospective of his work, and reviewed his stylistic development to that date. In this statement, he draws a dividing line in his development in 1924:

> Gradually my study of materials and pictorial laws bore fruit and allowed me to select and condense my effects, so that, in 1925, I made my first attempts at great rigor, simplification and more universal expression. . . . They are still Merz, for I have always responded to the stimulus of details not formed by myself. Yet, there are fewer stimuli, and their contrapuntal elaboration has become so important that the works should be referred to primarily as compositions and only secondarily as Merz.[35]

If this seems surprising, given the drastic changes in his art *before* 1924, then how he continues adds to the difficulty. His works of 1924, he said, were "typical transitional pictures, foreshadowing the new, straightforward approach, which I did not . . . really

hit on until 1926."[36] Schwitters can hardly be referring to his establishment of a Constructivist style. In fact, as we shall see later in more detail, he is referring to changes in his art in the mid 1920s that unlocked Constructivist geometry in order to allow the elements from which the geometry was composed to function in a more vivid and self-contained way. I anticipate in introducing the 1927 statement by Schwitters for the following reasons. First, because it has been taken to refer to Constructivist influence, and the development of his art in the 1920s thus confused. And second, because it alerts us to the fact that what is most new and personal in his art of the 1920s is not solely to be attributed to the greater simplification and more overt geometrization that Constructivist influence brought. Rather, it was through simplification and geometrization that a more radical change in Schwitters' art was begun.

Just how mistaken it is to see the novelty of Schwitters' art of the 1920s solely in its new geometric order becomes evident when we remember how intrinsic was compositional geometry to his original collage style. Even in 1920–21 (as we saw in Chapter 4), he was tending to concentrate on grid-like compositions. The influence of Constructivism in 1921–22 consolidated an already established trend. Some collages that seem to reveal new Constructivist influences—like *Farbige Quadrate* of 1921—may in fact show XIV Schwitters returning to the kind of 1916 Arp compositions that motivated his very first abstract collages in 1918.[37] The geometric side of Arp's work made that artist, too, acceptable in the Constructivist community; it becomes ever more difficult to ascribe definite influences in the 1920s, for what developed then was indeed an ecumenical style. But it is reasonable to isolate in Schwitters' 1922 collage the influence of the two most important, and easily separable, components of International Constructivism: new Dutch and Russian art. Not only do individual collages show him borrowing specific forms and devices from these sources, but the two artists (other than Hannoverians) who became his closest new colleagues in the 1920s were from Holland and the Soviet Union: Van Doesburg and Lissitzky.

Schwitters, as noted earlier, began contributing to *De Stijl* in July 1921. He first met Van Doesburg on a visit to Weimar that year,[38] and also that same year Van Doesburg visited Schwitters in Hannover. If 1921 collages like *Mz 336. Dreieins (Three-One)* 146 cannot with absolute certainty be ascribed to De Stijl influence, the 1922 *Mz "er"* most 149 surely can. Its limitation not only to horizontal and vertical forms but almost entirely to primary colors (except for three green-gray rectangles, the collage is made from red, yellow, and white materials, with black lettering) derives from the vocabulary of De Stijl 151 painting. This is not to say that it is a De Stijl work: the slightly irregular, hand-cut edges and the visual relief from geometry provided by the rounded lettering make it unmistakably Schwitters' own. But the stability and simplification of this and other 1922 collages owe a lot to De Stijl influence. *Mz 380. Schlotheim* even suggests that Schwitters may 152 have been starting to think about the De Stijl belief in a planned, modern environment. *Inhalt:* (contents:) pasted in the top right corner is matched, in the bottom left, by the title *Schlotheim* (*Schlot,* smokestack; *heim,* home).

After the 1922 Weimar Congress, and the Jena and Hannover performances that followed it, all of which brought Schwitters and Van Doesburg closer together, their De Stijl-Dada tour of the Netherlands, at the very beginning of 1923, cemented their

friendship. In Holland, Schwitters must have been exposed to greater quantity and range of De Stijl art (and architecture) than he had seen hitherto; what this did to his own art (and architecture) we will see later. But it is clear that the Dutch visit was crucially important to his development. His increasing friendship with Constructivist artists in 1921 and 1922 had offered him the kind of artistic companionship he had been unable to find within the orbit of Dadaism. When he came back from Holland, it was as if he had determined to make a new start. He reorganized his studio—for an artist, often a sure sign of a decisive change.

It was there, and then, that the *Merzbau* was begun—and that may well have been affected by the architectural experiments he saw in Holland. But another new project took precedence for the next two years—and one that instead of turning him inward, as 147 the *Merzbau* did, opened him to the Constructivist world. This was his magazine, *Merz,* founded upon his return from Holland in January 1923.

A rash of small Constructivist magazines had begun to appear across Europe; Schwitters had access to virtually all of them. He was represented in the Lissitzky-Richter-Graeff magazine *G* published in Berlin; in Moholy-Nagy's and Ludwig Kassák's *Buch neuer Künstler* (Vienna); in the Polish Constructivists' *Blok* (Warsaw); in the Czech Constructivists' *Pásmo* and *Fronta;* in the Hungarian *MA;* in *De Stijl;* and in many more. Similarly, his own magazine, *Merz,* sought contributions from all these other parts of the International Constructivist galaxy. If 1922 had been the year of meetings and congresses that brought together the International Constructivist avant-garde, 1923 saw the period of the "little magazines" properly established, and for Schwitters, his full-scale launching onto the European art community. "Schwitters' *Merz* journal," wrote his friend Käte Steinitz, "came into being, in part, because of his tremendous need for an arena of exchange . . . [it] soon brought Kurt Schwitters (and with him, Hannover) into the very center of the contemporary developments in the international art world."[39]

□ *Merz 1* was devoted to "Holland Dada," and mainly celebrates the De Stijl-Dada tour undertaken by Schwitters and Van Doesburg early in 1923, with an article by Schwitters on what had happened there, and contributions from Van Doesburg (and I. K. Bonset), Antony Kok, and Vilmos Huszár, as well as by the Dadaists Hoech and Picabia. It is essentially a Dadaist magazine, both in tone and in appearance (being somewhat reminiscent in this respect of *Der Dada,* the Berlin journal), and this is also true of the three other magazine issues of 1923. (*Merz 3* and *Merz 5* are excepted here, being volumes of lithographs by Schwitters and Arp respectively.) In *Merz 2* (April 1923), Van Doesburg is again well represented, but as in *Merz 1* mainly by Dadaist poetry. *Merz 4* (July 1923) sees the introduction of French Dadaism, with contributions by Tristan Tzara, Georges Ribemont-Dessaignes and Philippe Soupault; and Arp figures prominently in *Merz 6* (October 1923). At the same time, however, an increase in Constructivist contributions is very evident. In *Merz 2,* a De Stijl painting by Van Doesburg is reproduced; and in *Merz 4* architecture by Rietveld, Oud and Van Doesburg, an abstract poem by Hausmann, and contributions from Moholy-Nagy and Lissitzky. *Merz 6* sees the first major

text from a formalist standpoint, Mondrian's "Het Neo-Plasticisme," Schwitters' abstract scherzo from his "Ursonate," and reproductions of work by Huszár, Lissitzky, Tatlin (the *Monument to the Third International*) and Mondrian. In *Merz* in 1923, therefore, we see a Dada magazine gradually being modified by Dutch and then East European Constructivist influences.

Schwitters' own contributions confirm this. Even in *Merz 1,* after describing the events of the Dutch tour, he shows himself affected by De Stijl theories. Describing Dada as a mirror that reflects the confusion of the age, he says that it reveals "the vast stylelessness of our culture" and therefore "will awaken a great longing, a strong desire for Style [*Stijl*]. That is when our really important work begins. We will turn against Dada and fight only for Style."[40] This sounds like sheer revisionism on Schwitters' part. And yet, Schwitters had always sought to turn Dada into a vehicle for form. He is simply rephrasing long-standing beliefs in a new vocabulary, and in so doing finds a sense of affinity with Van Doesburg, who talked of his own interest in Dada in similar terms: Dada was important to the creation of a new style because in its confusion it destroyed earlier static and materialist concepts of reality and proclaimed a vision of the world in flux from which the process of reconstruction could begin. As he summarized this later:

> Out of the chaos of the old, shattered world, Dadaism created with the word a new imaginary world, the world of metamorphosis, pure poetry. It is no accident that the two diametrically opposed tendencies, Neo-Plasticism and Dadaism . . . formed a parallel.[41]

Van Doesburg is specifically referring to poetry, which was the only kind of Dadaism he consistently practiced. And poetry more than painting—especially abstract, phonetic poetry—was probably the strongest bond between Dada and Constructivism. By 1920, following his introduction to Dada ideas from Tzara, Van Doesburg was writing a kind of abstract poetry under his Bonset pseudonym.[42] These "X-Beelden," as he called them, were not too distant in approach from Schwitters' developed Sturm-Dada poems, being also influenced by Futurist ideas and concerned with the destruction and abstraction of the subject to create a new dynamic construction of works and sounds. Moreover, his aphoristic Dada novel, *Het andere gezicht* (*The Opposite Face*) of 1920/21, comes particularly close to Schwitters, both in its sharp attacks on bourgeois values and in its espousal of the nonsensical: "If a deeper meaning underlies 'nonsense' than that of the everyday norm, then 'nonsense' is not just permissible but even necessary. Thus it falls to Dada to create new, *transcendent* norms."[43] Schwitters certainly agreed.

The parallel between their poetic developments extends further than this, for both moved in 1921–22 to a more inherently abstract kind of poetry where word abstractions tied to objects were replaced by pure sounds as the primitive elements of poetic composition, and both did so following the influence of Hausmann's work. Van Doesburg met Hausmann late in 1920, and in mid 1921 began writing his "Letter Sound Poems" tied to the laws of sound, sound ratios and sound contrasts.[44] When Schwitters accompanied Hausmann on the "Anti-Dada und Merz" journey to Prague in September, he heard Hausmann recite his sound poem "fmsbw," which became the basis of his own "Ursonate," his most important piece of phonetic verse.[45] By 1922, Schwitters was publishing

poems that were in essence rhythmical sequences of words, letters and numbers. "Abstract poetry," he wrote in 1924, "has released words from their associations—this is its great merit—by paying special attention to sound it plays off word against word, more particularly, idea against idea.[46]

We shall be returning to Schwitters' poems of the 1920s in Chapter 8 in the context of his typographical experiments of this period. Suffice for the moment to note that abstract poetry became a sort of universal tongue in the early 1920s, a Constructivist Esperanto which exemplified at once the destruction of old forms and meanings and the building of a new basic language. "The reconstruction of poetry is impossible without destruction. Destruction of syntax is the first, indispensable, preliminary task of the new poetry," wrote Van Doesburg in *Mécano* in 1923, citing Schwitters' importance to the new destructive-constructive ideal.[47]

Schwitters, of course, had long been writing in these terms, not only about his poetry but about his pictures as well, for the collage technique itself was the basis of the new poetry. Collage was the single medium which most clearly expressed the destruction of established artistic structures (in its introduction of the non-artistic) and meanings (in its dislocation of conventional narrative connections) and the building from the old of a new vocabulary of basic elements of form. It was not just with hindsight, then, that Schwitters wrote in his article on "Konsequente Dichtung" ("Consistent Poetry") in *G* in 1924 that the logical and consistent evaluation of parts which characterized abstract poetry was also the structural logic of Dadaist assemblages.[48] He had always insisted that his collages and assemblages evidenced a part-to-part evaluation of their materials, and that art itself was the expression of primordial constants, consistent and self-contained, subject to basic laws.[49]

If abstract poetry, then, was the particular medium that brought artists like Schwitters and Van Doesburg together, this in its turn reflected their more basic common concern with a constructed language of elemental forms. This was something in which the progressive Dadaists all believed in their different ways, and explains why not only Schwitters but Arp, Hausmann, Richter and others beside were able to make common cause with the Constructivists. In Schwitters' *Merz* magazine, like Richter's *G* and many other similar journals, "the aims of the new and unrestricted (Dada) and the aims of the enduring (Constructivism) go together, and condition each other. To embrace and integrate these two tendencies was the purpose of the magazine . . ."[50] Schwitters had long sought an enduring form of Dada; he now began looking for a new and unrestricted interpretation of Constructivism.

In 1924, Van Doesburg returned the compliment of "Holland Dada" by bringing two De Stijl exhibitions to Hannover (one to the Kestner-Gesellschaft, the other to the gallery Der Quader) and lecturing there. It was during this visit that he met Schwitters' friend Vordemberge-Gildewart, and enrolled him as a member of the De Stijl group.[51] Presumably Schwitters was invited to join as well. For his friendship with Van Doesburg continued right up to Van Doesburg's death, and even more unlikely characters than Schwitters became members. He never did join, however; and although he often expressed solidarity between Merz and De Stijl, even to ascribing common aims to the two movements, in the final count he clearly valued his independence.

There was, however, one specific Merz-De Stijl collaboration. In 1925, Schwitters and Van Doesburg (and Käte Steinitz) produced a children's book, *Die Scheuche* (*The Scarecrow*), as a special number (14–15) of the *Merz* magazine. In 1924, Schwitters had produced the book *Hahnepeter* with illustrations by Steinitz as *Merz* no. 12 (as well as under his Apossverlag imprint). Van Doesburg saw this when visiting Hannover.

155

> Couldn't we make another picture book [he suggested], an even more radical one, using nothing but typographical elements? Lissitzky had once designed a book of poems in a new typographical style. We would try the same method but make it entirely different.[52]

The reference is either to Lissitzky's *Pro Dva Kvadrata* (*Story of Two Squares*) of 1920, which Van Doesburg had published in *De Stijl* in 1922, or to Lissitzky's version of Mayakovsky's collection of poems *Dlya Golosa* (*For the Voice*), published in 1923.[53] *Die Scheuche* is indeed different, but influenced by Lissitzky nevertheless.

156

It thus happened that the single Schwitters-Van Doesburg collaboration was motivated by a work by Lissitzky, the second important personality to change Schwitters' Hannover world, and to more crucial effect. Lissitzky, like Schwitters, sought to combine a wide number of interests under the umbrella of a single all-encompassing idea, which he called "Proun" and which aimed at transcending painting to create a Constructivist architectural *Gesamtkunstwerk*.[54] Lissitzky, moreover, was a man of great persuasiveness as well as of remarkable prestige as ambassador-at-large for the new Soviet culture. Arriving in Berlin in 1921, he virtually took over the nascent *G* group. In 1922, he produced his independent journal, *Veshch*, and played an important part in the Düsseldorf and Weimar Congresses. Van Doesburg gave over to him a double issue of *De Stijl* that year.[55] Schwitters was to grant him the same for *Merz* in 1924.

In the first issue of *Veshch*, Lissitzky had condemned Dada as anachronistic.[56] In the third issue, reviewing a group of 1922 Berlin exhibitions, he had some harsh things to say about Der Sturm. "This giant ocean liner," he wrote, "has changed into a shabby little tramp." Of the artists he discussed—Archipenko, Kandinsky, Léger, Moholy-Nagy and Schwitters—only Léger and Moholy-Nagy met with his full approval, for their organized, logical forms and urban iconography. Schwitters, he thought, had an eye for color and facility in organizing his materials: "These attributes together produce a remarkable result. . . . Nevertheless, Schwitters is not advancing beyond what he achieved in his early works."[57] Schwitters was normally very sensitive indeed about adverse criticism, but clearly Lissitzky was a special case, for not only did he refrain from publishing the usual hostile reply but he invited Lissitzky to Hannover to see more of his work, to be exhibited at the Garvens gallery in October, and to attend the "Dadarevon" soirée on September 30 which was to accompany the exhibition. This was the performance mentioned earlier, which followed the Weimar Congress. Schwitters arranged Lissitzky's accommodation in Hannover and introduced him to the Kestner-Gesellschaft and to the Hannover artistic scene as a whole.[58]

On October 15, 1922—after the opening of Schwitters' Garvens gallery exhibition and before his departure for Holland—the Van Dieman gallery's "Erste russische Kunstausstellung" opened in Berlin.[59] It was an extremely important event in modern German

culture, for it presented, for the first time in that country, a broad and impressive range of the new Russian art. The catalog (whose cover was designed by Lissitzky) lists 593 entries, some of them whole series of works; more than half of them were conservative by 1922 standards, but the very modern selection must have seemed extraordinary, and eye-opening to German artists. On the second floor of the gallery were a large group of Suprematist works by Malevich and his pupils and many examples of the Russian Constructivist school: both "utilitarian" works (that is to say graphic design objects) and paintings, drawings, watercolors, sculptures and reliefs. Lissitzky was well represented, as were Tatlin, Gabo, Rodchenko, Medunetzky, and many more.

148 Schwitters must certainly have seen the exhibition. His 1922 collage, *Mz 448. Moskau*
150 (*Moscow*), must surely be an immediate response to the Malevich paintings he saw there.[60] It is at one and the same time a signal of his receptiveness to the new and an indication that he was capable of more fully absorbing Russian influences than Dutch ones. While obviously derivative of Malevich's forms, it also has that sense of tactile solidity that Malevich's paintings have as objects, and that is characteristic of Russian modernist art as a whole. A similar solidity had characterized Schwitters' own art for the past four years. It was something he knew about and could use. De Stijl art, in contrast, seemed rather too neat. Schwitters did learn from the vocabulary and composition of De Stijl painting, but never seemed comfortable with the fact that it was so clean, and when he tried to approximate it closely he was usually unsuccessful. Russian art, however, had a rawness and vigor that he must have found appealing. The reliefs that he began making shortly after the Van Dieman exhibition, in 1923, have a comparable object-like sturdiness to those by Tatlin and other Constructivists. Indeed, it could well be the case that his return to relief-assemblage in 1923 was itself prompted by his experience of Russian art.

Unlike Dutch art, moreover, Russian art comprised a variety of styles. It was open and inclusive in a way that Schwitters the eclectic and synthesizer liked art to be, and Schwitters the collector of styles as well as materials made good use of it. Among the Russians, Lissitzky was the most open and inclusive, and if not an eclectic certainly a synthesizer. We can readily understand that the two artists became fast friends. When Lissitzky had visited Hannover, in late September 1922, Schwitters had arranged for the Kestner-Gesellschaft to purchase a group of Lissitzky's watercolors, and an exhibition of his work was planned there. This took place in January-February 1923, at which time the society commissioned a portfolio of his prints. These were produced under the title *Kestnermappe* in June, when Lissitzky came to Hannover again to lecture on Russian art. He returned in August to produce a second portfolio,[61] and through 1923, therefore, had a great deal of contact with Schwitters. According to Paul Küppers' widow Sophie, whom Lissitzky married in 1927, it was then that the two men became good friends: "The friendly, sociable Schwitters was devoted to Lissitzky, who was his exact opposite—so clear, precise and logical. He suggested to him that he edit an issue of the periodical *Merz*."[62] Lissitzky, however, became ill in Hannover that autumn from tuberculosis, and his doctor (Käte Steinitz's husband) recommended that he go to a sanatorium at Davos in Switzerland to recover, which he did in February 1924. The Lissitzky-Schwitters issue of *Merz* was therefore coedited by mail.

The first issue of *Merz* in 1924 (no. 7, January) had been, in many respects, more Dadaist in tone than the later issues of 1923, although Schwitters did announce on the title page: "MERZ ist Form." In any event, it was his final Dadaist fling.

At this moment, he was asked by the Polish Constructivist magazine, *Blok*, to write an article on Dada.[63] He began it by saying: "I'm not a Dadaist." Dada, he continued, is a means or an instrument and therefore unable to determine a person's character, as a true ideology (*Weltanschauung*) can. Dada grows out of an ideology—that of reform—but Dada itself is not about reform; rather, about ridiculing the tradition that needed reform. And while Dada is successful in mocking and destroying the dead part of tradition, that would have perished in any case; whatever is strong about the past resists Dada. It is, in effect, a merciful executioner, killing off quickly what was already condemned to die; but it is not a requiem; rather, a happy, fancy game—a divine amusement. And insofar as it is a game, he allows, he is a Dadaist after all.

Affirming next the dangers of spurious transcendentalism in a year when skyscrapers were being built across Germany, when radio and mass communications were developing, and when art and life were returning to normal, he said that Dada was still alive, and would always be alive. Anything new will necessarily grow old, yet Dada will continually reappear to weed out stupidity. But now, it works quietly and secretly—like the Salvation Army! Therefore the "old" Dadaism of 1918, whose main function was to kill off Expressionism, is now replaced by a "young" Dadaism of 1924, and artists as varied as Lissitzky, Moholy-Nagy, Gropius, Mies van der Rohe, Richter, and Schwitters himself, all are helped by Dada. For Dada, as a mirror on the times, can reflect not only the old and dead part of tradition but also the new and vital. The old *dáda* ("I ask you to pay special attention to the accent!") has given way to the new *dadá*. "Dadá is a mirror image of the original Dáda. . . ." The magazine, *Merz*, he said, "shall serve Dadá for abstraction and for construction." Having thus convincingly explained to his Constructivist audience that he was not a Dadaist, that he was a Dadaist, and that Mies van der Rohe, even, was a Dadaist, he concluded: "the constructional formation of life in Germany has become so interesting that we have taken the liberty of publishing the next issue of *Merz*, 8–9 called 'nasci,' without Dadá."

With *Merz* 8–9 (April-July 1924), coedited with Lissitzky and entitled "Nasci" ("Being Born" or "Becoming"), Schwitters moved very firmly into the Constructivist camp. Both the tone and the appearance of the magazine are new. In appearance, it is a manifesto for the New Typography; in content, a testament to Schwitters' new ideals, and as such it drew praise from Van Doesburg, Moholy-Nagy and Gropius (those supposed new "Dadáists") among others.[64] It represents, moreover, the clearest exposition of Schwitters' own interpretation of the Constructivist esthetic, for through contact with Lissitzky's ideas, Schwitters was able to find a version of this esthetic which corroborated his existing, pre-Constructivist, ideas about art and its formal autonomy but spiritual and primitivist base. This may be described as a constructive vision of nature.[65] First from "Nasci," and then from associated documents of the 1920s, we can see how International Constructivism modified Schwitters' understanding of his art, but at the same time confirmed and clarified for him some of its most basic principles.

153 □ The front cover of "Nasci" bore in heavy red capitals a dictionary definition of the word Nature:

NATURE, FROM THE LATIN NASCI, I.E., TO BECOME OR COME INTO BEING, EVERYTHING THAT THROUGH ITS OWN FORCE DEVELOPS, FORMS OR MOVES.[66]

The magazine is, in effect, a word and picture book demonstrating analogies between geometric and natural forms and positing a vocabulary of vitalist and primordial elements which are seen as the bases of constructions of every kind, be they in nature, art and architecture or in objects of utility. Its subject, that is to say, is universal Elementarism.

Elementarism at its simplest meant the construction of works of art from basic geometric forms viewed as universal constants, an idea deeply embedded in academic design theory, deriving ultimately from Plato's proposition, in the *Philebus,* that absolute and eternal beauty resides in geometric forms.[67] This longstanding, traditional idea became, however, a revolutionary one in the 1920s. The Dadaists had subverted existing stylistic categories and artistic laws; for those who accepted this repudiation of the past it was imperative that the laws of art be reestablished on sounder foundations. Once again, then, we find a Dadaist coefficient in the ingredients of the new art. We find it, in fact, in the earliest German Elementarist statement, the Hausmann-Arp-Moholy-Puni "Aufruf zur Elementaren Kunst" of October 1921, which called for "the regeneration of art" through a new, non-philosophical and anti-individualist art "built up of its own elements alone."

The obvious, immediate sources of such a position were awareness of Malevich's "Suprematist Elements" and of De Stijl painting, but the spiritual, cosmic iconologies of both are implicitly rejected by the "Aufruf" signatories. It was a tougher, more strictly regulated kind of Elementarism that was being looked for.[68] In April 1922, *Veshch* demanded the creation of new "basic laws," and in Düsseldorf that May, the Internationale Fraktion der Konstruktivisten looked forward to "the systemization of the means of expression to produce results that are universally comprehensible."[69]

It was Van Doesburg who was the first to come forward with a firm program in the Elementarist debate, and thus established the terms of the argument which Lissitzky and Schwitters, in "Nasci," were to enter. In "Der Wille zum Stil" ("The Will to Style"), a lecture Van Doesburg had given late in 1921, and published in *De Stijl* in 1922 (and which formed the basis of his own statement at the Düsseldorf Congress), he said that an elemental style could be created only by overcoming nature ("die Überwindung des Natürlichen") with scientifically rigorous methods.[70] And in his article "Zur elementaren Gestaltung," published in Richter's *G* magazine in July 1923, he enlarged on this, and presented in diagrammatic form what he called a *Generalbass* (thorough bass, or rules of harmony) for each of the visual arts, intended both to differentiate between them and to give them a common "consistency" such as scientific disciplines already possessed.[71] His talk of a *Generalbass* looks directly back to Kandinsky's ideas (discussed in Chapter 2) on a universal language of art. Kandinsky, however, was referring to a generalized spiritual language that lay beneath, and controlled, the formal

means of any of the arts. Van Doesburg, always more practical, is talking about the formal means themselves, and specifically about the basic geometric elements from which, he believed, each art should be composed.

Van Doesburg's transformation of the ideal of the *Generalbass* from a spiritual to a utilitarian system may well have been affected by Richter's experiments, begun in collaboration with Viking Eggeling, to create a *Generalbass der Malerei* (Thorough Bass of Painting) based on a single principle of analogy and contrast,[72] since he chose one of Richter's drawings to illustrate "Der Wille zum Stil." Richter, however, had said that the artist should work as nature worked, focusing on principles not forms;[73] Van Doesburg rejected the organic analogy. Although De Stijl posited a cosmic geometry that lay behind natural appearances, it had always been an anti-naturalist movement. Since nature was brute matter concealing a truer reality (the geometric architecture of the universe), it was necessary to separate man from nature to create the new style.[74]

Van Doesburg had absorbed from Dada the notion of reality as flux, and in "Der Wille zum Stil" uses Bergsonian ideas to support this proposition.[75] Art, like life itself, was said to involve a struggle for equilibrium within flux. In art, this could be attained by discovering a thorough bass of form. In life, it could only be found by overcoming the flux of nature. For Van Doesburg this meant turning to the metropolis and specifically to the machine, which for him replaced myth as an analogue of human creativity.[76] In "Der Wille zum Stil" he acknowledged the importance of Dada in recognizing the machine as an instrument of social liberation; he insisted that since "culture in its widest sense means independence from nature, we must not wonder that the machine stands in the forefront of our cultural will-to-style"; and he invented in passing a new and influential term for the particular Elementarist esthetic that was emerging. "The spiritual and practical needs of our time," he said, "are realized in constructive sensibility. Only the machine can realize this constructive sensibility. The new possibilities of the machine have created an esthetic expressive of our time, which I once called 'the Mechanical Esthetic'."[77]

It was this Mechanical or Machine Esthetic that Van Doesburg was promulgating as the inevitable twin pillar, with Elementarism, of the new Constructivist ideal. He was not suggesting, however, that mere admiration of machine *forms* would be enough, but that the economical *processes* of the machine showed the way to a more "constructive" sensibility. Hence the fifth De Stijl manifesto of 1923 spoke not only of a "Great Age of Construction" that would replace "art" and all speculative personal ideals; it also spoke of admiration of the machine *per se* as one of the things to be avoided; this too was the product of a personalized taste, and not to be part of the new order.[78]

This would seem to have been not only Van Doesburg's way of finally separating himself from Dada and its machine iconography, but also a way of separating his ideas from those of the Bauhaus (which announced the unity of art with technology in 1923) and particularly from those of the contributors to *L'Esprit nouveau,* and from Le Corbusier's *Vers une architecture* (*Towards an Architecture*), which was published that same year.[79] Neither the Bauhaus idea of art made through technology nor Le Corbusier's admiration of technological forms themselves appears in Van Doesburg's program; for Van Doesburg, all forms of art and production were the product of objective laws. The machine merely showed them at their most economical.

From what we have already heard of Schwitters' views on art, it is obvious that he would have found the Machine Esthetic a disturbing concept. Although he had used machine imagery in his early work, it had been if anything from an anti-machinist standpoint: according to his close friend Arp, Schwitters deplored the way that materialism was "denaturing" man.[80] This being so, it becomes clear why Schwitters' art was only marginally affected by Van Doesburg, despite their close personal friendship; and why Schwitters was so won over by Lissitzky. For while Lissitzky was an industrial designer as well as an artist (as Schwitters, indeed, was), and affected by the utilitarian wing of Russian Constructivism (which proposed that artists move from their studios into factories), he was neither a whole-hearted supporter of "production art" nor was he infatuated by the machine, which he viewed as only a primitive tool.[81] Rather, he sought to enclose the utilitarian aspects of Constructivism within a Suprematist philosophy of art, derived from Malevich, that was spiritual and anti-materialist in kind.[82]

The Lissitzky-Schwitters introduction to "Nasci" opens, therefore, with the complaint:

> We have had ENOUGH of perpetually hearing MACHINE,
> MACHINE,
> MACHINE,
> MACHINE,
>
> when it comes to modern art production.[83]

This turns out, however, not to be an attack on the machine *per se* but on what Lissitzky called elsewhere "material fetishism,"[84] the elevation of technological over esthetic principles, and on an anti-individualist and anti-naturalist understanding of Elementarism. In fact, Lissitzky optimistically insisted that the machine is but a tool, and

> all tools set forces in motion, which are directed to the crystallization of amorphous nature—that is the aim of nature itself . . . [therefore] The machine has not separated us from nature; through it we have discovered a new nature never before surmised.[85]

The processes of the machine, that is to say, were not to be elevated over natural processes; they were seen to be identical. In "Nasci" and in his contemporaneous writings Lissitzky proposed an organicist analogy between the methods of art and science, the idea that artistic creativity or "invention" is a "universal" or "biomechanical" force similar to growth in nature and to the "economical" processes of the machine: a duality of "Element und Erfindung" ("Element and Invention").[86] In this way, he was able to reconcile artistic individualism with universalist Constructivism in a classic victory of spirit over matter.

This was clearly far more palatable to Schwitters than the more materialist versions of the Machine Esthetic. In the issue of *Merz* preceding "Nasci" he had distinguished his own updated, Constructivist-influenced, Merz-Style from De Stijl and Bauhaus principles, which he found lacking in artistic creativity because of their collectivist concerns, and insufficiently universal as well:[87] "Style," he insisted, "is creation based on normative forms in accordance with individual laws." "Merz . . . seeks to preserve so far as is possible artistic creation within universal Style." He had, from his Dada years, talked of

such a balance of individual freedom and formal restraint and wrote that "Merz stands for freedom from all fetters for the sake of artistic creation. Freedom is not lack of restraint, but the product of strict artistic discipline."[88] When he first became acquainted with Constructivist ideas, he affirmed that he wanted a spiritual rather than a social art.[89]

It was to Lissitzky's version of Elementarism, therefore, that he was drawn, for it alone showed a way of reconciling Schwitters' spiritualist and anti-materialist ideas with urban and geometric forms, and a way too of finding a place for nature in the world of the machine. In an article published in the English magazine *Ray* in 1927, called "Art and the Times," Schwitters pointed to the importance of "Nasci" in demonstrating how the primordial and eternal qualities of art still had their place in contemporary life:

> By traffic with the world we become that which we could become; and we become as attentive inhabitants of the world more and more related to the world. Now we see the equal endeavor growing, becoming, and passing away—with us, as with our surrounding world; and this fact becomes especially clear and distinct in respect to a work of art. If you can see the essence of a work of art, then it appears to you . . . as a unity. The unity is limited as regards the time or period and the place, as a thing that grows out of itself, which rests within itself, and which does not differ in essence from other things or entities in Nature. The imitative picture formerly differed considerably from the surrounding world: it was essentially a pale imitation, whereas the new naturalistic work of art grows as nature itself, that is to say, is more internally related to nature than an imitation possibly could be. I refer here to the publication NASCI which I composed with Lissitzky. There you will see clearly demonstrated the essential likeness of a drawing by Lissitzky to a crystal, of a high building by Mies van der Rohe to the austere construction of an upper thighbone; you will recognize the constructive tendency of the position of the leaves to the stem. . . .[90]

154

Neither the idea of a "unity" behind appearances, nor that of a symbolism of equivalents between art and nature, is new; nor, of course, is the notion that artistic and natural creation are analogous. What is striking about "Nasci," however, is the way in which these propositions are combined and linked to machine-age themes, to provide what is best described as an organicist version of Elementarist theory. Modern art is compatible with modern science, not because it adopts technological principles, but because the principles common to both art and machine construction are "natural" ones. Form, that is to say, is the picture of a process:

> Modern art, following a completely intuitive and independent course, has reached the same results as modern science. Like science, it has reduced form to its basic elements in order to reconstruct it according to the universal laws of nature; and in doing this, both have arrived at the same formula: EVERY FORM IS THE FROZEN INSTANTANEOUS PICTURE OF A PROCESS. THUS A WORK OF ART IS A STOPPING PLACE ON THE ROAD OF BECOMING AND NOT THE FIXED GOAL.[91]

Against the illustrations mentioned by Schwitters in *Ray,* there appears the slogan: "We know no problems of form but only those of construction. Form is not the aim but the

result of our work."[92] Art, therefore, as a "limb of nature," is the product of dynamic natural processes, and form is the stable and consistent "unity" that such an organic dynamism inevitably creates.

The introduction to "Nasci," which outlines this argument, was largely Lissitzky's work. Schwitters, as coeditor, had naturally to vet it. There were some disagreements, and some compromises to be made on both sides.[93] But Schwitters was clearly happy with the final result, as the article from *Ray* demonstrates. It should not be too quickly assumed, however, that Schwitters had simply allied himself to Lissitzky's own ideals. Lissitzky was important in showing Schwitters a form of Constructivist theory with which he could readily identify, but in the final count he acted as a catalyst. "Nasci" draws together four important and interrelated preexisting currents of thought which related organicism to abstraction, and these require discussion here if we are to grasp the full implications of Schwitters' Constructivist alliance—that is, its relation to his earlier work and its significance, not only for what he produced in a distinctly Constructivist style in the 1920s but for the body of what at first seems to be anti-Constructivist work he produced in this same period, and afterwards.

The first of these currents derives from the French philosopher, Henri Bergson, and ultimately from Romanticism: the idea that all natural forms are not fixed, and therefore inert, but are the products of "becoming." Reality, for Bergson, was in a state of constant flux, and what is commonly understood as "form" was only a single "snapshot view" of part of duration: "a mere cut made by thought in universal becoming."[94] For art to be as alive or "vital" as nature meant that its forms should seem to reflect the universal laws of becoming. In practice, this meant first, that each form was, in effect, chosen from the flux of the world and second, that a form would be "vital" to the extent that it expressed natural rhythms. The first part of this proposition was already familiar to Schwitters, for it had been basic to his artistic method since the foundation of Merz. The second part, however, was new, for Merz had originally meant choosing forms of a neutral shape. But after "Nasci," Schwitters began concentrating on intrinsically rhythmical forms: in his *i-Zeichnungen* (*i*-drawings), then in his collages, and eventually in the modeled organic sculptures that he built in the *Merzbau*.

Bergson's ideas were easily compatible with the Dadaists' belief in reality as flux. They were also compatible with certain of the beliefs held by the abstract artists Schwitters was now exposed to. The second of the currents of thought that lie behind "Nasci" derives from Malevich. When Lissitzky was preparing "Nasci" with Schwitters, not only was he in correspondence with Malevich, but he was engaged in translating a number of Malevich's writings, including the first Suprematist manifesto and "On New Systems in Art," "On Poetry" and "God is Not Cast Down."[95] In these texts, Malevich condemns imitative art yet never denies the validity of studying nature: not for its specific instances but in order to appreciate its "material masses" after which independent pictorial forms were to be created:[96]

The painter does not regard the world as a collection of objects—forests and rivers as such—but as painterly growths: painting grows as a forest, mountain or rock . . . in constructing painterly forms it is essential to have a system for their construction, a

law for the constructional interrelationship of forms. As soon as such a construction is built up it will express a new physical conclusion and become objectivity alongside the other painterly growths of the world.[97]

For Malevich, it was Cézanne's reduction of the forms of nature to geometric solids that began this process, which led to a disintegration of representational objects (in Cubism), and their replacement by added, collaged elements which worked against representation and towards a "super reality" of a transcendental nature.[98] Beyond this "zero of form" developed the "new realism" of Suprematism, whose elements live "like all living forms of nature,"[99] that is to say, are the products of a universal form-creating process and are expressive of a kind of ideal spiritual repose. "What philosophy!" Lissitzky wrote.[100]

We might take it that Schwitters was equally impressed. It is hard to believe that he did not hear a great deal of Malevich from Lissitzky; indeed, it is more than likely that he saw Lissitzky's translations, which were typed in Hannover by Käte Steinitz.[101] Malevich's writings would not only have provided justification for Schwitters' own development from naturalistic painting to collage, but would have reassured him that to move on to an increasingly formalized and Elementarist art was both a logical, well-trodden path and one which meant no surrender of either his spiritual ideals or his interest in objects of the world and in nature itself.

In "Nasci," Malevich's *Black Square* occupied pride of place on the first page. But the "elements" of form cited in "Nasci," though generally indebted to Malevich, owe their specific formulation to another, unnamed source. Beside an illustration of a crystal, the elements are listed: crystal, sphere, plane, rod, strip, spiral, cone, characterized thus:

> These are the underlying shapes out of which everything is made. They are sufficient to ensure optimal operation of the total world processes. All that exists is a combination of these seven primordial forms. This is all that architecture, engineering, crystallography and chemistry, geography and astronomy, art, all kinds of crafts, indeed the whole world is about.[102]

The seven primordial forms listed here reappear four years later in Moholy-Nagy's *Von Material zu Architektur,* where they are illustrated. This time, however, a source is given:

> Until a short time ago, geometrical elements, such as the sphere, cone, cylinder, cube, prism, and pyramid, were taken as the foundation of sculpture. But biotechnical elements now have been added Biotechnical elements formerly entered more particularly into technology, where the functional conception called for the greatest economy. Raoul Francé has distinguished seven biotechnical constructional elements; crystal, sphere, cone, plate, strip, rod and spiral (screw); he says that these are the basic technical elements of the whole world. They suffice for all its processes. . . .[103]

Francé, the author of popular scientific works, had interested Lissitzky at the time he was working on "Nasci." On March 10, 1924, he wrote to Sophie Küppers telling her "to be quite sure you buy the book by Francé called *Bios,*" and saying he would send Francé a copy of "Nasci" when it was completed.[104] Francé, of course, was merely

summarizing—and simplifying—new developments in the natural sciences, but this kind of popularized organicism was the third of the currents of thought behind "Nasci." It was useful both to Lissitzky and to Schwitters in providing a justification of their ideas that was no less "scientific" than that which the anti-naturalist faction of International Constructivism possessed, and one, moreover, which corroborated Malevich's notion of universal form. They were able to claim, therefore, that geometry and abstraction were not only the province of cultivated urban man (as De Stijl theory insisted) but were what linked modern man to his natural roots.

This, in effect, was to view geometric abstraction not only as a modern style but also as a primordial one. And here we find the third current of thought that lies behind "Nasci," namely the idea that abstraction is in fact primarily a "natural" rather than a "cultivated" style. As Robert Goldwater showed, the concern for universal basic laws that characterized the reductivist movements of the 1920s is a form of primitivism.[105] In Germany, a primitivist interpretation of abstraction was derived largely from the writings of Alois Riegl and had been adapted by Wilhelm Worringer in such a way as to be used to justify the (nearly) abstract art of the Expressionists. In 1923 (the year before "Nasci") there appeared in Germany two important general books on primitive art, W. Hausenstein's *Klassiker und Barbaren* (*Classics and Barbarians*)[106] and Herbert Kuehn's *Die Kunst der Primitiven* (*The Art of Primitives*).[107] Kuehn's book has been described as the first comprehensive review of primitive art.[108] Like its theoretical sources it distinguished between naturalistic and abstract styles, seeing in the latter a concern for the eternal and essential, and for universal laws such as basic forms were assumed to possess. By the early 1920s, therefore, there was this further justification for bringing together the organic and geometric in a new unity of contemporary and primordial significance.

What is more, the terms of the discussion of primitivism in Germany looked back to Ferdinand Tönnies' famous book of 1887 in which he distinguished between the security and wholeness of a "community" (*Gemeinschaft*) and the rootlessness and artificiality of a "society" (*Gesellschaft*).[109] Oswald Spengler's enormously influential *Untergang des Abendlandes* (*Decline of the West*) appeared in the 1918–22 period preceding "Nasci"; extrapolating on Tönnies' ideas, it painted a frightening picture of cultures, having exhausted their creative possibilities, turning into civilizations, in which the arts gave way to technology and vast cities destroyed the landscape. Dada had opposed the pernicious effects of technology with its own brand of "primitivism": the creation of sound poetry and fetish objects. It was just as important, "Nasci" implicitly argues, that the new Constructivist alternative to Dada be cautious about the civilization that was emerging in the stabilized Germany of 1924. Unless the modern, geometric forms could maintain contact with the primordial and the organic, Dadaism would have been in vain.

□ "Nasci" deserves such lengthy discussion because it usefully encapsulates the principal theoretical features of Schwitters' Constructivist alliance as established in its first full year, and shows that his interpretation of the new esthetic was a free and flexible one and that it was easily reconciled with his existing ideas. Additionally, it helps to explain why Schwitters (as quoted earlier in this chapter) spoke of the year 1924 as when he made his

"first attempts at greater rigor, simplification and more universal expression,"[110] and began then to disengage the "elements" of his art from too rigid geometric compositions in order to let them function as units of meaning in a more "universal" way.

How this developed in Schwitters' collages and especially reliefs will be discussed in detail in Chapter 8, after we have followed the growth of the Hannover *Merzbau,* for it was in the building of the *Merzbau* that the "Nasci" idea of primordial elements achieved its most extraordinary realization. First, however, we need to bring up to date the progress of Schwitters' earlier *Gesamtkunstwerk* project, the *Merzbühne:* because what happened to the *Merzbühne* idea between 1919, when it was first proposed, and 1924, when a practicable form of Merz-theater was actually designed, caused Schwitters to step up his work on the *Merzbau* in 1925; and because the form of Merz-theater he established in 1924 was the first unmistakable and important demonstration of his new Elementarist version of the Constructivist esthetic.

In the *Der Ararat* version of the *Merzbühne* text, published in January 1921, Schwitters had concluded by saying that its original appearance had aroused the interest of the actor and theatrical producer, Franz Rolan, and that they had together begun to work out in detail the practical possibilities of realizing the *Merzbühne,* with the result that a manuscript was ready for publication.[111] This eventually appeared under both their names in *Der Sturm* in 1923, and was subsequently reprinted in the catalog of the Internationale Ausstellung neuer Theatertechnik (International Exhibition of New Theater Technology), an exhibition organized in Vienna in 1924. At this exhibition designs for Schwitters' new version of Merz-theater were displayed: this was the *Normalbühne Merz* (Normal or Standard Merz-theater).[112]

157, 158

The designs show Schwitters' adoption of a Constructivist vocabulary of basic "normative" forms, and his theater is, in effect, an animated Constructivist picture. In that sense, it fulfills, in these new terms, the ambition (proclaimed in the earlier *Merzbühne* text) of a *Merzbild* brought to life. And in his many writings on the *Normalbühne Merz,* not only did he stress its practicability (he badly wanted someone to help him realize it), he also insisted that it was a theater of action.[113] In fact, it looks rather ponderous. Certainly, the designs reflect none of the fantasy and truly imaginative movement of the original *Merzbühne.* His attempt to realize Merz-theater had carried it further from, not nearer to, the *Gesamtkunstwerk,* and Schwitters acknowledged the very different natures of the two projects.

Schwitters knew Lissitzky's proposals for an *elektro-mechanische Schau* (electro-mechanical show): the suite of lithographs based on designs for Kruchenykh's Futurist opera *Sieg über die Sonne* (*Victory over the Sun*) was published in Hannover in 1923.[114] He also knew experimental theater projects by Bauhaus artists, including Moholy-Nagy, whose contribution to *Die Bühne im Bauhaus* (*The Theater in the Bauhaus,* 1925) recorded ambitions towards creating what he called "total stage action."[115] And yet, Schwitters' designs are less ambitious than those of his Constructivist friends. Having accepted the notion of a practicable stage, he made it a totally functional one and returned to a conventional division of theatrical elements between actors, stage properties and stage-set. These he described as the individual, the typical, and the normal, with the idea that the "normal" element, the stage-set, would remain the same for any

play produced. It was to be "as simple and as inconspicuous as possible . . . [composed of] the simplest forms and colors—straight lines, the circle, the flat surface, cubes, parts of cubes—black, gray, white, red."[116]

157, 158 The model shown at the Vienna exhibition of 1924 was of a picture-frame stage, or what he called a peep-show stage (*Guckkastenbühne*).[117] Schwitters also, however, prepared an arena-stage (*Raumbühne*) version, which was exhibited at the International Exposition of Theater Technique in New York in 1926 and of which a preparatory

160 design of 1925 remains that gives us some idea of the intended scale of the work.[118] The stage itself was to be circular, some 24 feet (7.6 m) in diameter, and upon it an L-shaped platform, 3 feet (1 m) high, reached by a flight of steps and a lower narrow platform beside it. Above this floats a narrow square slab, labeled "Hochstand (Glas)" ("rostrum [glass]"), supported on one side by 11 foot (3.5 m) high posts standing on the circular base (next to what looks like a trapdoor) suspended from above at the other side. From this slab, a rope ladder snakes up into the flies some 33 feet (10 m) above the stage. Also from the flies, two large beams—one vertical, one horizontal—are suspended. A large disk (or sphere?) 6 feet (2 m) in diameter, and a sixty-degree segment of another disk 15 feet (4.5 m) in diameter seem placed to swing down and across the production like huge pendulums. There is no indication where the audience is to be placed, but presumably they surround the circular stage.

In contrast, the photographs of the model—constructed behind a proscenium arch—suggest a more distinct separation of audience and action, while the machinery for moving the stage elements is hidden. As a result, the huge elevated forms appear more the "actors" of this stage than merely a setting, and therefore suggest comparison with certain Bauhaus stage productions, for example, with the mechanical ballets of basic

159 forms designed by Heinz Loew and Kurt Schmidt, both contemporary to Schwitters' theatrical work. The effect of an abstract theater of forms is heightened here by the considerable bulk of the elements Schwitters uses, and by the presence of narrow wings on each side, from whose entrances further elements could be introduced: another segment of a circle, a semicircle and a rectangular block (while in the center of the stage a smaller hemisphere seems to have appeared from the trapdoor). Beyond the wings can be seen the steps that appear in the 1925 drawing, but the effect of the model is far more severe. The drawing still expresses something of the fantasy of the *Merzbühne;* once realized, even as a model, formalism dominates. The closer Schwitters' theatrical ideas came to being realized, the less vivid and exciting and less "total" in conception they became.

One wonders, inevitably, what kind of play would take place in such an arena: whether it would be of formal elements alone (as might be inferred from the model), or whether in fact actors would be used, as Schwitters' writings imply. (A figure is shown in the drawing.)[119] In *Merz 20,* Schwitters said that the *Normalbühne Merz* was "a stage with the simplest forms, which can serve as a neutral background for any kind of action. It can easily be reset, and is meant to stress the action by means of changes made during the action. The wings are gray in front and black at the back, and can be rotated, the sun above is red."[120] The set, then, was to reinforce the development of the plot in somewhat the same way as it did in the "stylistic" theater of the Russian Constructivists.[121] Lissitzky had discussed Russian theater in a lecture given in Hannover on June 16, 1923, and

there spoke of a three-part division of theatrical elements in terms very similar to those used later by Schwitters in his 1925 description of the *Normalbühne Merz*.[122] But more interesting than the exact sources of Schwitters' functional theater (which cannot be specifically pinned down since functional theater was becoming commonplace in avant-garde circles by the mid 1920s), is the fact that it is firmly on the "stylistic" side. As his ideas on the theater moved from theory to drawing to model form, the stage space became narrower and more limited, finally comprising a series of flat planes parallel to the proscenium and mimicking the space of abstract painting.

This "picture-frame" theater, however, represents only one side of Constructivist theatrical experiment. On the other is the participatory theater, the theater of mass spectacle, the theater of totality. Schwitters could hardly have been unaware of this other side, especially considering how his own ideas on the theater had begun. It does seem surprising, then, that he was so unaffected by it. Even the arena-stage version of the *Normalbühne Merz* hardly qualifies as total theater. His Constructivist alliance may explain the functional appearance of the *Normalbühne Merz* and its use of elemental forms, but it cannot explain why he abandoned the notion of a theatrical *Gesamtkunstwerk*. The *Merzbühne* itself had been Dadaist and Expressionist in style, and therefore unlikely to have satisfied Schwitters' new, more formalist standards; but the principle of total theater that he rejected in the *Normalbühne Merz* is in no sense anti-Constructivist. Lissitzky's *elektro-mechanische Schau* is a theater of totality. So are Moholy-Nagy's various published projects. As an idea, total theater was very much in the air in the early and mid 1920s. The catalog of the Vienna Neue Theatertechnik exhibition of 1924 (where the *Normalbühne Merz* was presented) testifies to this, as do *Die Bühne in Bauhaus* of 1925 and the special music and theater number of the Hungarian Constructivist journal *MA* in 1924; in 1922, the periodical *Die Form* had published a special issue on "Das Bühnenbild in Gesamtkunstwerk" ("The Stage-Picture in the Total Work of Art").[123] Schwitters' ideas had anticipated all of these, yet he chose not to extend them at the very time they were becoming popular.

There can be only one satisfactory explanation: that Schwitters had found a more rewarding path towards the *Gesamtkunstwerk*, and that once he found it, theater ceased to be so important to him, at least in this way. In 1923 (that is, between the *Merzbühne* and the *Normalbühne Merz*), he had begun to join some Dadaist constructions in his studio to the studio walls by building materials out from the walls to meet them. This continually developing environment, which Schwitters called his *Merzbau*, became the new route to the total work of art. As he worked on it through the 1920s, his interest in a theatrical *Gesamtkunstwerk* of the extravagant kind that is recorded in the *Merzbühne* text gradually faded. He continued to write plays and dramatic fragments (twenty-three are recorded in all, from 1922 to 1946, though a number are quite short) and attempted to produce them.[124] He did manage to stage a revue, *Mit Hilfe der Technik* (*With the Help of Technology*), in December 1928 in collaboration with Käte Steinitz.[125] From Steinitz's descriptions, it was an impressively comic work; and from reading the published text one could easily imagine its near science-fiction fantasy being performed upon the *Normalbühne Merz*. But it was not, and Schwitters' theatrical *Gesamtkunstwerk* was never realized. The *Merzbau* was. Schwitters regarded it as his greatest work.

7 PHANTASMAGORIA AND DREAM GROTTO

□ The appearance of artists' studios cannot always be predicted from their work. Schwitters' could conceivably have been orderly, given his preoccupation with structure and formal values. But it was not. In 1920, certainly, it was extremely chaotic, as this contemporary report reveals:

> The visitor to this most holy place, the master's studio, is struck by a holy shudder, and only then dares raise his eyes when he has found a little spot for himself, but where he cannot stay because there is not enough room to stand. The interior does not give the impression of being a studio but a carpentry shop. Planks, cigar chests, wheels from a perambulator for Merz-sculptures, various carpentry tools for the "nailed-together" pictures, are lying between bundles of newspapers, as are the necessary materials for the "pasted" pictures and for the Anna Blume poems. With loving care, broken light-switches, damaged neckties, colored lids from Camembert cheese boxes, colored buttons torn off clothes, and tram-tickets are all stored up to find a grateful use in future creations.[1]

Photographs of Schwitters' studio around 1920 indeed show a room overflowing with the objects he had collected, and its walls "Merzed" over with collages and pictures. One such photograph, printed in the Berlin *Börsenkurier*,[2] reveals Schwitters standing beside one of the Dadaist constructions referred to in Chapter 5, entitled *Die heilige Bekümmernis* (*The Holy Affliction*). This is noticeably different in character to the other known early constructions, being about chest height and comprising a dressmaker's dummy standing on what looks like a tall stool or sculpture stand. In some respects, it resembles the kind of models exhibited at the Berlin Dada Fair of 1920. On a long cord around the dummy's neck is hung a curious box, open at the front, whose interior and front surface are collaged over with inscriptions and pictures. A crank-handle (possibly from a coffee grinder) is attached to one side, and on top there is a lighted candle. Also around the dummy's neck is hung a begging notice, suggesting that the box is intended as a street-vendor's tray, except that the handle makes it suggest a toy theater or street organ. Given the title of the work, and the halo-like plate behind the missing head, it may also allude to St. Uncumber (die Heilige Kümmernis), the female martyr who sprouted a beard to save her virginity—just the kind of incident to appeal to Schwitters.[3] Be that as it may, the construction was characterized in the *Börsenkurier* as a "psycho-analytical composition" (with the comment: "and if this be madness, then there's method in't"), though Hans Richter refers to it as Schwitters' Christmas tree.[4] It does, in fact, bear the inscription "Wahnsinn! Fröhliche Weihnachten" ("Madness! Happy Christmas"), which would seem to support both interpretations. This weird construction has disappeared,

like all the other Dada objects. Schwitters built them into the grottos of the *Merzbau*. Quite where they went is impossible to know since most of the grottos were closed by the time the *Merzbau* was photographed. In this case, however, there are clues both to its place in the *Merzbau* and to the particular interpretation Schwitters placed upon it.

In his 1930 description of the *Merzbau* in the "erstes Veilchenheft" ("first violet book") issue of the *Merz* magazine, published in 1931, Schwitters wrote that after its elaborate lighting system had short-circuited, he placed "little Christmas candles everywhere in the structure . . . [that] when lit make the whole thing one big, unreal illuminated Christmas tree."[5] And in describing the contents of the grottos, he spoke of one that contained "the organ, which you turn anti-clockwise to play 'Silent Night, Holy Night' and 'Come Ye Little Children' and beside it 'The 10% disabled War Veteran'." This sounds as if he could be referring to *Die heilige Bekümmernis*. If so, this construction provides a rare glimpse of the kind of material which was to inhabit the closed *Merzbau* caves, and shows the manner in which their literary content was expressed. This headless war veteran playing popular Christmas carols reintroduces the theme of grotesque black humor (and of topical reference) that we have already met in Schwitters' writings, and will encounter again beneath the stylized surfaces of the *Merzbau*.

Schwitters' sometimes referred to the *Merzbau* as the Merz-column (*Merzsäule*), the great column, or even just the column, since its true beginning was a column-like Dada structure that he built.[6] An account of its first appearance in Schwitters' studio is provided by Käte Steinitz:

> One day something appeared in the studio which looked like a cross between a cylinder or wooden barrel and a table-high tree stump with the bark run wild. It had evolved from a chaotic heap of various materials: wood, cardboard, scraps of iron, broken furniture, and picture frames. Soon, however, the object lost all relationship to anything made by man or nature. Kurt called it a "column."[7]

Unfortunately, she gives no indication when this took place. It was certainly in existence by Christmas 1919, when Huelsenbeck visited Schwitters:

> This tower or tree or house had apertures, concavities, and hollows in which Schwitters said he kept souvenirs, photos, birth dates, and other respectable and less respectable data. The room was a mixture of hopeless disarray and meticulous accuracy. You could see incipient collages, wooden sculptures, pictures of stone and plaster. Books, whose pages rustled in time to our steps, were lying about. Materials of all kinds, rags, limestone, cufflinks, logs of all sizes, newspaper clippings.
>
> We asked him for details, but Schwitters shrugged: "It's all crap . . ."[8]

If Schwitters' column was indeed in existence before the end of 1919, it was therefore certainly begun without knowledge of the Berlin Dadaist Johannes Baader's column construction of 1920 entitled *Das grosse Plasto-Dio-Dada-Drama "Deutschlands Grösse und Untergang"* (*The Great Plastic Dio-Dada-Drama "Germany's Greatness and Downfall"*), which resembles in some respects the Merz-column as first photographed in 1920. Baader's work must certainly have come to Schwitters' attention, for it was described in Huelsenbeck's *Dada Almanach* in 1920, and its literary content

164

outlined.[9] While Baader's work held a mainly political message, which was alien to Schwitters' work, it may nevertheless have encouraged him to develop the *Merzbau*. For Schwitters' concept of an architectural *Gesamtkunstwerk* did not simply require that it be on an impressive and then an environmental scale: primarily, he required of it a form that would hold a specific content, the kind of private and fantastic imagery that had appeared in his literary works. The Merz-column would seem to have been an autobiographical depository from the very start, and as such the locus of associative fantasies. But Baader's obviously program-bearing construction may well have encouraged Schwitters consciously to build the objects that evoked such fantasies into tableaux or grottos that told of specific themes. Certainly, this was the direction the *Merzbau* took.

In the spring of 1920, Max Ernst visited Schwitters.[10] Ernst, however, was fascinated mostly with Schwitters' wife, for when he had last seen her she had been dressed in an assortment of ancient clothing so that she resembled a walking thrift shop. Ernst records Schwitters' proud comment: "I have never spent a penny on her clothes, they were all passed down in the family." Ernst did, however, notice the column. The walls of the studio, he relates, were bare, but the floor was littered with disordered piles of collected objects from which, Schwitters said, he had built his "Merz-column" which then rose to almost two-thirds the height of the room. This seems to be the height of the Merz-column we know through two early photographs.

162 The first of these photographs was published in the magazine *G* in 1924, and then in the book *Die Kunstismen* (*The Isms of Art*) in 1925.[11] In both cases, it was labeled "Atelier"; in the latter, the date "1920" that appears between it and a photograph of a 1920 assemblage may well have been intended to apply to both images. The photograph is indistinct, but obviously shows a tall column, surmounted by the sculpture of a head, standing in the corner of a room whose walls are packed with collage materials and works of art. The zig-zag configuration of the corner allows us to identify where this photograph was taken, for there was only one room in the house at Waldhausenstrasse 5, where Schwitters lived and worked, with that particular feature, as plans of this house recently discovered by Dietmar Elger reveal.[12] Moreover, Ernst Schwitters has con-
165 firmed that Room 1 on the plan shown here was indeed, according to what his father told him, the original studio, where the Dada sculptures, including the column, were built.[13]

Ernst Schwitters reports that his father moved from this studio in 1920, and while he was certainly able to move the column with him, the process of covering and collaging walls around the column had obviously to begin again.[14] The 1920 report quoted at the beginning of this chapter presumably refers to the original, chaotic studio; likewise, a report published on October 13, 1920, which refers to similar working conditions.[15] We know from Dietmar Elger's researches that the move had taken place, or at least had been decided on by March 19, 1921, for that is the date of the plans he discovered, which were drawn up to comply with ordinances, made necessary by the postwar housing shortage, that dealt with compulsory billeting in private dwellings.

The large house, which belonged to Schwitters' father, was divided into at least four separate apartments, and Schwitters was forced to give up his original, large studio. Under the new division, his own living quarters comprised three rooms at the front of the

house on the floor above the original studio, that is to say, on the second floor (first floor, European style); one of these, Schwitters designated the Biedermeier Room, and another (presumably later) the Stijl room. Quite where he now worked, and kept the column and his other works of art, is uncertain.[16] According to Ernst Schwitters, it was either in the winter of 1921–22 or of 1922–23 that he began to work in his new studio (Room 2 on the plan shown here), which was right at the back of the house on the ground floor, overlooking the Eilenriede, the town forest of Hannover (where one of the crucial parts of *Konstruktion für edle Frauen* was found).[17] This room abutted an open balcony (3), VII visible through an ordinary sash window; a room used later by Ernst Schwitters as a playroom (4), which did have access to the balcony; and a kitchen used by the tenants who still occupied the pair of rooms which comprised the original studio (1). It was in the new studio (2) that the *Merzbau* truly began to grow, and this remained its center and heart.

A column generally resembling that of 1920, but probably a new one (for the head that 176 surmounts it seems more realistic), is seen in one of the photographs that Werner Schmalenbach first published in 1967. Among the materials collaged to the front of the column's base are sheets from the "Holland Dada" issue of the *Merz* magazine of January 1923.[18] The relative bareness of the setting and the sight of what looks like a door in the background suggests that this photograph was taken not much later than early 1923, for this column was subsequently shielded from the door, as can be seen in a later photograph to be discussed shortly. Since our next source of information about the *Merzbau* dates from 1925, it is quite possible that this column, and Schwitters' studio, remained in its 1923 state for a while, and that the photograph was taken later. In any event, it shows the *Merzbau* (if we can yet call it that) in a very early state.

This early chronology is worth establishing as precisely as possible because of the many current misconceptions as to how the *Merzbau* developed. It is often assumed that Schwitters was thinking in environmental terms around 1919 when he began working in three dimensions, and that the *Merzbau* intuitively developed from the accumulated debris in his studio.[19] It is indeed true that the photograph of the earlier, 1920 column shows what might be termed a total artistic environment, but it is no more so than many cluttered studios. Only in 1923, however, could the *Merzbau* as we know it have been begun. Writing about his "great column," in December 1930, Schwitters said that it had been under construction for seven years and that its literary content dated from 1923.[20] He was referring to yet another column, whose title, *Kathedrale des erotischen Elends* (*Cathedral of Erotic Misery*), has often been applied (even by close friends of the artist, like Käte Steinitz)[21] to the *Merzbau* as a whole. Schwitters must at times have used the titles, *Kathedrale des erotischen Elends* (or *KdeE,* for short) and *Merzbau*, interchangeably, for his friends to have picked it up, but his December 1930 article makes it quite clear that the *KdeE* was but one of "about ten" columns. It is the third that we have seen so far—by 1923—and we can reasonably assume that as soon as these three columns were in place in the 1923 studio the process of creating a total environment began.

According to Ernst Schwitters, this process began when his father became interested in the relationship between the columns or sculptures and the pictures that he hung on the walls behind them:

His pictures would decorate the walls, his sculptures standing along the walls. As anybody who has ever hung pictures knows, an interrelation between the pictures results. Kurt Schwitters, with his particular interest in the interaction of the components of his works, quite naturally reacted to this. He started by tying strings to emphasize this interaction. Eventually they became wires, then were replaced with wooden structures which, in turn, were joined with plaster of Paris. This structure grew and grew and eventually filled several rooms on various floors of our home, resembling a huge abstract grotto.[22]

When exactly this began to happen we cannot tell. One thing is clear: in none of Schwitters' early references to a *Gesamtkunstwerk* does he mention the *Merzbau*. Indeed, he did not even admit in print to its existence until 1931.[23] For such a self-publicist, this seems astonishing. We must remember, however, that in the mid and later 1920s, Schwitters was proselytizing for International Constructivist art and practicing his own version of it. "We will turn against Dada and fight only for style (Stijl)," he wrote in the "Holland Dada" issue of *Merz* in January 1923.[24] And in *Merz* no. 6 that October: "Merz allies itself with the ideals of joint artistic activity, as already realized, for example, in Holland (De Stijl) and to some extent in Russia."[25] While it is true that the *Merzbau* itself became increasingly geometric in character, and while its environmental form may have been influenced by Constructivist ideas, it could never have fully qualified as a Constructivist work. Although it developed from a Dadaist source to a stylized exterior, it was never a "joint artistic activity" telling metaphorically of a harmonized social environment, but a way for Schwitters to preserve his individuality in a period of increasingly impersonalized styles.

Thus, while the *Merzbau* was certainly not kept a secret, for it was shown to visitors (though only close friends, apparently, were given a close look at the grottos),[26] neither was it widely publicized. Schwitters agreed to have published in 1924 and 1925 the forementioned photograph of his 1920 studio, but that was to show what his old Dada art had been like.[27] Even when reviewing his achievement of a "new form of expression" in the important "Katalog" issue of *Merz* in 1927 he did not mention the Merzbau. Only in 1931, the year of his assemblage *Neues Merzbild* (*New Merzpicture*) which signals the ending of his Constructivist alliance, did he make details of the *Merzbau* public,[28] and only in 1933 were photographs of it published—ten years after it was begun.[29] His silence about the *Merzbau* in his writings of the 1920s suggests that he viewed it rather separately from the Constructivist-influenced work that he produced in that decade, or at least that he recognized the inherent contradiction of producing so utterly personalized a monument while publicly supporting an opposite party line.

Inevitably, this raises problems as to how the work developed, and by and large we have to rely on eye-witness accounts. There are, however, a few hints in Schwitters' writings of the 1920s of his interest in developing an architectural *Gesamtkunstwerk*. We remember, for example, the discussion of *Haus Merz* as his "Cathedral," "his first piece of Merz architecture" in *Der Ararat* in January 1921, and his publication of *Schloss und Kathedrale mit Hofbrunnen* in Bruno Taut's *Frühlicht* in spring 1922. In a

XXI

136

140

text accompanying the *Frühlicht* illustration, Schwitters spoke of his impatience with conventional architectural materials, and recommended a combination of the old and the new, as in the *Merzbilder,* so as to go beyond mere house-building towards—yet again—"the idea of a new total work of art."[30] The *Merzbau,* as we shall see, looks back stylistically to forms popularized in Taut's circle. It was not, however, until Schwitters was exposed to post-Expressionist architectural ideas in Holland early in 1923 that he began to develop his ideas in this field, and began to see in architecture rather than in theater a possible new route to his own personal *Gesamtkunstwerk.*

In 1923, the fifth De Stijl manifesto, *Vers une construction collective (Towards a Collective Construction)*, announced the ending of "the epoch of destruction"—characterized by "the idea of 'art' as an illusion separated from real life"—and the beginning of a new epoch of construction, in which "art and life are no longer two separate domains" but are melded through "the construction of our surroundings according to creative laws."[31] This was the moment when the De Stijl group under Van Doesburg finally made official its environmental and architectural stance and its opposition to the separate autonomy of the individual arts. Henceforth, these were to combine under the name of "Style" (*Stijl*); and "Style" and "Art" became antithetical terms. Schwitters' call (in 1923) for artists to "turn against Dada and fight only for style (*Stijl*)" mirrors Van Doesburg's sentiments, as does his frequent use, in the writings of the 1920s, of the Art-Style polarity.[32] Art was personal and individual, and mirrored life as it existed; Style was impersonal and social, and sought to transform life. Art was individual media; Style was the *Gesamtkunstwerk.*

From what we have learned of Schwitters' ideas, we can see that this antithesis was ultimately unworkable in his terms, for he believed both in a personalized art and in a total work of art. Yet, such was his infatuation with the new Constructive art that he spoke at times against things personal and individual, and even—like Van Doesburg and his colleagues—insisted that "today the striving for Style is greater than the striving for art."[33] By 1927, he was on the brink of repudiating Merz itself, claiming that his works were now so completely formalized that they "should be referred to primarily as compositions and only secondarily as Merz."[34] An uncomfortable spirit of ideological self-criticism runs through Schwitters' writings from 1923 until the end of the 1920s, speaking of the real quandary in which he found himself. He valued his Constructivist contacts, and willingly transformed his work to accommodate their influence, for they confirmed and strengthened his belief in a disciplined abstract art. And yet, they did so to such a degree as to threaten the very personality of his work itself, and lead him into the cold orthodoxy of "Style." He proselytized for the new architecture in the *Merz* magazine, launched a series of architectural publications, and collaborated with architects and designers.[35] But he did so as a fellow-traveler, albeit a very talented one. In the final count he was unwilling to see art subordinated to its social environment, and drew back in deed if not in word. While undoubtedly influenced by the new environmental concerns of the 1920s, he could not submit the environment he built to the constraints and dogmas of that period's style.

In his few essays specifically on architecture, Schwitters tends to present it in such restricted, functional terms—so exclusively within the parameters of "Style"—as to

virtually exclude from it any artistic potential at all. In the article, "Urteile eines Laien über neue Architektur" ("A Layman's Verdict on New Architecture"),[36] he asks for architecture more objectively attuned to social needs, and criticizes architects for their individuality, which, he says, is the prerogative of artists alone. "I am for a clear separation. The purpose of architecture is not to gratify obscure artistic urges. One should live one's life fully in painting, then, having let off steam, one can view architecture clearly and objectively." This is the familiar Art/Style antithesis in a new and exaggerated form.

But what Schwitters recommended to others and what he practiced himself were clearly very different, as is shown by his very first article on the new architecture of the 1920s, published in January 1923.[37] He begins by complaining of the impracticability of contemporary architecture: it "pays too little attention to habitability, takes too little account of the way people change a room by their presence. Merely by walking into it, a person can upset the balance of an artistically well-balanced room." But is Schwitters speaking as a dogmatic functionalist or tongue-in-cheek? When he goes on to consider how the design of a room can take such circumstances into account, we know for sure. It is to be a mechanically controlled room. Indications of the occupant's customary routes will be built into the design, and a system of weights and balances will change the form of the room according to who enters it. The anti-mechanical pose of the *Merzbühne* has been transformed to become a parody of functionalist architecture. But whereas the *Merzbühne* was never built, Schwitters confides that he has been working on an actual room of the kind he has described:

> All that I can say now is that experiments are being undertaken with white mice, which live in *Merzbilder* especially constructed for this purpose. Also under construction I have *Merzbilder* that will restore by mechanical means the balance disturbed by the movements of the mice. As they bump into wires, the lighting changes automatically. The mechanized room is the only logical one, which can be artificially formed and still be habitable.

That last sentence was surely not written with a straight face. But before we write off this 1923 article as utter fantasy, we should know that Schwitters' close friend, Käte Steinitz, tells us how one section of the *Merzbau* (though probably a later one) was called "the Guinea Pig House or White Palace," and that it was constructed by Schwitters as part of his experiments with a mechanical room.[38] And there is a photograph of the *Merzbau* which shows that guinea pigs did indeed inhabit it. Why Schwitters replaced white mice with guinea pigs is, I suppose, as fit a subject for scholarly study as many others, but we need not dwell on it here. Suffice it to say that despite its air of improbability, the 1923 article on a mechanical room probably refers to the beginning of the *Merzbau,* or at least to the beginning of Schwitters' attempt to create a personalized version of the modernist interiors he was learning about in this period.

188

Schwitters' Constructivist contacts were important for the beginning of the *Merzbau.* Although it was certainly the most developed and fantastic home-made environment of its period, it was by no means unique. The interdisciplinary preoccupations of Constructivism meant that artists as well as professional architects became involved in questions of environmental design. Exhibitions of Constructivist art—like Puni's at the Sturm

gallery in 1921—were often conceived as total environments. And some artists in the International Constructivist community—Van Doesburg and Lissitzky, for example— actually began to work as architects. Moreover, a certain amount of what might be called amateur building also took place, and Schwitters' own building of this kind was almost certainly influenced by that of his colleagues. One important source for his work was an interior by his friend Erich Buchholz. While working on a series of wooden geometric bas-reliefs (exhibited at the Sturm gallery in December 1921), Buchholz began transforming the interior of his Berlin apartment—furniture as well as floor and walls— 181 in a simplified Constructivist style. His idea, he said, was to eliminate traditional discrete pictures on the wall so that reliefs, assemblages, carpet and furniture together would create "the arrangement and structure of the entire room."[39] We know that the room attracted considerable attention and that Schwitters joined discussions there on the topic of space and architecture.[40] A number of the reliefs that he made in the mid 1920s bear a striking resemblance to those in Buchholz's interior. They also resemble much other Constructivist art, but Schwitters' experience of Buchholz's distinctly architectural use of the relief form in 1922 may well have encouraged him to begin his own home-made relief environment the following year.

Other artists too were thinking along the same lines, and 1923 saw the creation of additional projects that sought to articulate environmental space by means of relief assemblages. Lack of funds prevented Buchholz from accepting an invitation to design an environment for the 1923 Grosse Berliner Kunstausstellung,[41] but at that exhibition—which was divided into individual cubicles for each of the participating artists—Schwitters could have seen three fascinating works of this kind. One was a striking three-part relief assemblage by Buchholz's friend, the Hungarian László Peri, which directed the viewer spatially across the span of a single wall.[42] Another was a collaborative venture by the De Stijl architect Gerrit Rietveld and painter Vilmos Hus- 183 zár, a project for an interior organized and inflected by means of large colored rectangles that also overlapped adjacent surfaces and—assisted by similarly constructed furniture—coordinated the total space.[43] The third, and for Schwitters probably the most influential, project at the exhibition was Lissitzky's first *Prounenraum* (Proun 185 Room).

Schwitters' notion of Merz as a multimedia form was complementary in some respects to Lissitzky's idea of Proun (an acronym for "project for the affirmation of the new"). Both terms were applied to the pictures and drawings the respective artists made, but both ultimately aimed at an architectural *Gesamtkunstwerk*. Lissitzky described Proun as an "interchange station between painting and architecture."[44] The illusionistic Proun paintings of simplified three-dimensional elements that he started to make in 1919 set the pattern for his subsequent architectural work, since the represented forms seemed to float free of their surfaces and to "assault" space.[45] Similarly, Schwitters' first *Merzbilder*, also of 1919, began his preoccupation with spatially affective relief forms. Lissitzky's Berlin *Prounenraum* was structured by means of painted and relief elements that directed the viewer around the architectural space and dissolved and merged the separate walls.[46] For Schwitters, who must certainly have known of this work,[47] it may have been just the sort of stimulus he needed when he began work on the *Merzbau* the same year.

There was, however, yet another contemporary architectural influence on the form of the *Merzbau,* and one that seems in fact to have first led Schwitters to think of expanding it to environmental scale. This was his experience not only of De Stijl theory but of actual De Stijl work during his tour of the Netherlands with Van Doesburg early in 1923. When Schwitters was in Holland, Van Doesburg's interests in architecture were beginning to come to fruition, and he was working with Van Eesteren and Rietveld on a projected house and studio for Léonce Rosenberg, the Parisian art dealer. The commission was never completed, but the ideas it generated led to the manifesto *Vers une construction collective,* calling for the transposition of advanced pictorial and structural ideas to the creation of usable structures and for the replacement of art as such by a new union of art and life in the constructed environment.[48] Seeing Van Doesburg's work may well have prompted Schwitters to begin his own personalized version of the new architecture, for it was immediately upon his return from Holland that the *Merzbau* was properly begun.

In fact, as we saw in Chapter 6, Schwitters changed the whole pattern of his artistic life following his return from Holland. It was then that the *Merz* magazine was started. Of the seventeen issues produced, fourteen date from the years 1923 through 1925. Given his other commitments, work on the *Merzbau* was obviously slow at first. It seemed only to have become an obsession with him late in 1925, which is perhaps why he began to lose interest in the *Merz* magazine, and even why he considered transforming it into an architectural publication, that year.[49] By then the *Merzbau* had begun to grow.

Hans Richter visited Schwitters in 1925. This is how he described the studio:

At the end of a passage on the second floor [*sic*] of the house that Schwitters had inherited, a door led into a moderately large room. In the center of this room stood a plaster abstract sculpture . . . it filled about half the room and reached almost to the ceiling. It resembled, if anything Schwitters made ever resembled anything else at all, earlier sculptures by Domela or Vantongerloo. But this was more than a sculpture; it was a living, daily changing document on Schwitters and his friends. He explained it to me, and I saw that the whole thing was an aggregate of hollow space, a structure of concave and convex forms which hollowed and inflated the whole sculpture.[50]

It is clear from photographs of the *Merzbau* that parts of it were significantly indebted to De Stijl influence. For example, the tall pillar next to the so-called *blaues Fenster* (Blue Window) and the pedestal-like constructions that flank a number of the walls bear a strong resemblance to the kind of De Stijl architectural work that Schwitters would have known, as well as to the work of De Stijl sculptors like Vantongerloo. Moreover, Richter's description is corroborated by Ernst Schwitters, who remembers the *Merzbau* as having in fact begun to grow from "a sculpture in the De Stijl manner, which Schwitters called a 'column.' After being exhibited at the Der Sturm gallery in Berlin, it was set up in Schwitters' studio."[51] Schwitters had made some De Stijl-influenced sculptures in 1923, but did not exhibit at Der Sturm that year.[52] It is certain, then, that the De Stijl sculpture appeared in Schwitters' studio later than that seen in the 1923 photographs. It was probably in 1924–25, therefore, that the period of joining pictures and sculptures with string and wire gave way to the creation of a fully environmental, sculptural interior.

246

In *Fantastic Art, Dada and Surrealism* (1936), Alfred Barr illustrated a section of the *Merzbau,* entitled the "Gold Grotto," which he dated to 1925.[53] The photograph, however, was taken around 1932,[54] and Barr's date for the grotto cannot be confirmed. But Ernst Schwitters does say that his father first housed his Dadaist works "in wood and plaster constructions in which they were visible through panes of glass" and it was from this point that the *Merzbau* really began to grow.[55] And it must have grown very quickly indeed, for by 1925–26, he says, Schwitters' studio was all but filled with such grottos, and also with larger wood and plaster constructions, mainly white but with touches of color here and there. The Barr photograph is in fact of a corner section of the studio, and shows two separate, glass-boxed assemblages with angular rib-like forms in the background. There are further photographs of the *Merzbau,* taken around 1930, which show this same area from other viewpoints,[56] including one, entitled *"die grosse Gruppe"* (the Big Group)[57] which shows an area of ceiling which connects with the upper part of the Barr illustration and another which shows both the Gold Grotto and the Big Group.[58]

169

168

170

Further glazed grottos are visible in the *c.* 1930 photograph of the Blue Window and of the section of the *Merzbau* where the 1923 column (surmounted by a realistic head) was placed. The visible remainder of that column shows that not all of the Dadaist constructions are enclosed in glass, and this is confirmed by two previously unpublished photographs, taken in 1928, of the column, *Kathedrale des erotischen Elends,* which reveal a clutter of miniature objects, nailed and collaged together, and apparently growing up the studio walls.

175

178

187, 189

On March 12, 1927, the founding-meeting of the group "die abstrakten hannover" took place in Schwitters' apartment. After the meeting, Schwitters took Rudolf Jahns and his wife to see "the column":

Even the way to it, along a narrow corridor, revealed some interesting things. I remember one chest, about 50 cm [20 in.] long: the back half-closed by a board, the front covered with a wire screen. Two strange creatures with big, dirty white bodies were lying inside on hay. Each of them had only one thick, S-shaped, bent black leg. The chest was filled with a mysterious half-light, which meant that one sensed rather than saw these creatures. They were two large porcelain insulators, such as one sees on telegraph poles beside traintracks. Their appearance was entirely transformed.

Then we entered the column itself through a narrow door, which was more like a grotto: plaster construction was hanging over the door-paneling. . . . Schwitters asked me to go through the grotto alone. So I went into the construction which, with all its bends, resembled a snail-shell and a grotto at the same time. The path by which you reached the middle was very narrow because new structures and assemblages, as well as existing grottos and Merz-reliefs, hung over from all sides into the still-unoccupied part of the room. Right at the back, to the left of the entrance, hung a bottle containing Schwitters' urine, in which everlasting flowers were floating. Then there were grottos of various types and shapes, whose entrances were not always on the same level. If you walked all the way around, you finally reached the middle, where I found a place to sit, and sat down.

I then experienced a strange, enrapturing feeling. This room had a very special life of its own. The sound of my footsteps faded away and there was absolute silence. There was only the form of the grotto whirling around me, and when I was able to find words to describe it they alluded to the absolute in art. I saw the grotto again soon afterwards, and it had changed once more. Many of the grottos were [covered up] and my impression was more of a unified whole.[59]

Hans Richter made another visit in 1928, and he too commented on how the *Merzbau* had changed:

All the little holes and concavities that we had formerly "occupied" [by proxy, through personal mementos] were no longer to be seen. "They are all deep down inside," Schwitters explained. They were concealed by the monstrous growth of the column, covered by other sculptural excrescences, new people, new shapes, colors and details. The pillar had previously looked more or less Constructivist, but was now more curvilinear.[60]

By 1930, when Schwitters himself described the *Merzbau,* the construction in the main studio was virtually complete, and the three stages in its development that we have followed—Dada constructions, geometric glazed grottos, and curvilinear forms—were layered on top of each other, like the Romanesque, Gothic, and late Gothic styles of an ancient cathedral.

As the structure grows bigger and bigger [Schwitters wrote], valleys, hollows, caves appear, and these lead a life of their own within the overall structure. The juxtaposed surfaces give rise to forms twisting in every direction, spiraling upward. An arrangement of the most strictly geometric cubes covers the whole, underneath which shapes are curiously bent or otherwise twisted until their complete dissolution is achieved But the column has been under construction for seven years and has taken on a more and more severely formal character, in keeping with my spiritual development, especially insofar as the outer sculpture is concerned. The overall impression is thus more or less reminiscent of Cubist painting or Gothic architecture (not a bit!).[61]

175
167 The "Gothic" character of the work is well illustrated in a photograph of a corner of the *Merzbau,* published in *abstraction, création* in 1934 (taken from point A on the plan shown here). Large diagonal ribs, rising from geometric piers, arch across the Blue Window[62] in the background. Of all the views of the *Merzbau,* this is the most cathedral-like in character. The strong rising forms reach up to dissolve the ceiling into a vault of faceted planes, towards which also rise more regular forms—De Stijl-like constructions—and sandwiched within this architectural fantasy are tall glass-fronted grottos containing found objects. The tall form with the large, block-like capital to the
178 very left of this photograph reappears at the right-hand side of another photograph of the *Merzbau* (taken from point B on the plan), also a corner view, but this one showing a free-standing grotto containing the partly hidden 1923 column.[63] The portal surmounted by two typographical emblems that we see beside the grotto is also visible at the

very right of a photograph (taken from point C on the plan) of the Gold Grotto. These 170
three photographs therefore represent different but interconnecting views of the same
room, looking towards three of its corners and the walls between them. (The photograph
of the Big Group, taken from point D on the plan, shows slightly more of the ceiling seen 168
in the photograph of the Gold Grotto.) The three main photographs were taken at the
same time, around 1930,[64] and together provide a complete picture of a large part of the
first studio in its substantially completed state. With the help of Ernst Schwitters' recol-
lections (which filled in the missing pieces), its principal components—as shown on the
plan—can be quickly summarized. 167

As you entered the room, which was 4.4 x 5.4 m (14½ x 17½ ft.) in size and roughly
4m (13 ft.) high,[65] a partition on your right hid from view the grotto containing the 1923 178
column. Moving around in front of that grotto, you would see to the left of the grotto a
tall column with upright geometric elements. There was a space between the grotto and
the column, with another glazed grotto at the back of it. Moving further left, you would
come to the portal. Entering that you would find a staircase that bent to the left as it rose;
from its upmost point, it was possible to look through the open ribs of the Big Group and
across the room to the *Kathedrale des erotischen Elends* (*KdeE*). The staircase then
curved downwards and readmitted you to the center of the room, unless the exit was
blocked (as it is in the photograph taken from point C) by a large movable column with 170
wing-like shapes attached to its rectangular top.

There are no photographs to help us in the next section, but we know that in the center
of the back wall of the studio was a large window overlooking the Eilenriede, which
therefore provided sight of the natural world halfway around the tour of this hermetic
interior. To the left of the window, and in the corner adjacent to it, was the *KdeE* and its
complex of grottos. This formed a general diagonal across the corner (and the photo-
graphs we have of it were presumably taken from both points E and F);[66] if you went 187, 188, 189
behind the diagonal wall you found a stairway to climb, which allowed you to look into
the grottos on various levels at that side, including one containing a record-player
(operated by a handle) which had been tampered with in such a way that it played
backwards. To the left of the *KdeE* was the Blue Window, in front of which a sculpture 175
called *Madonna* was placed some time between 1930–32 and 1936;[67] the sculpture does 249
not appear in the photograph of the Blue Window mentioned earlier. Turning left from
the Blue Window, you would find yourself back at the entrance of the studio, where this
guided tour comes to an end.

Before continuing to explore some other rooms in Schwitters' house, let us pause
briefly to look at a remarkable, very businesslike summary that Schwitters made of the
materials and time needed to build from scratch a room that would generally resemble
the one we have just visited:

> Materials . . . about 100 bags of plaster, an equal quantity of wood and plywood, 70
> kg spackle putty, 70 kg paint, 30 kg varnish . . . working hours: for a column, 5–6
> weeks; for a niche, 2–3 months; for an interior about 3/4 year.

He would need a carpenter, glassworker and electrician for the technical work. Their
expenses, and his own costs for travel and accommodation, would be extras.

This comes from a letter that Schwitters wrote to Alfred Barr in 1936, hoping to persuade him to commission a *Merzbau* in America.[68] In the letter, he also summarizes the intended impact of the interior:

In order to avoid mistakes, I must expressly tell you that my working method is not a question of interior design, i.e. decorative style; that by no means do I construct an interior for people to live in, for that could be done far better by the new architects. I am building an abstract (cubist) sculpture into which people can go. From the directions and movements of the constructed surfaces, there emanate imaginary planes which act as directions and movements in space and which intersect each other in empty space. The suggestive impact of the sculpture is based on the fact that people themselves cross these imaginary planes as they go into the sculpture. It is the dynamic of the impact that is especially important to me. I am building a composition without boundaries, each individual part is at the same time a frame for the neighboring parts, all parts are mutually interdependent.

By now, he is talking of a purely Constructivist environment. To recapitulate: between 1919 and 1921, he made a number of Dada columns; by 1923, he had moved them into a new studio; between 1923 and 1926 he transformed them into an increasingly geometric environment; between 1926 and 1932, he enlarged this environment in a more curvilinear style. The work he told Barr in 1936 could be done in nine months had taken him, in fact, already nine years to accomplish.

And the *Merzbau* was not restricted to this one room—which brings us to the most popularized feature of it, its phenomenal growth. Stories abound of how it spread to fill the ground floor of the house, only to break through the ceiling into the floor above—thereby displacing either Schwitters' own family or some of his tenants (the reports vary)—from where it continued onto the roof.[69] These stories are not true. What actually happened is far less dramatic; at the same time, once the development of the *Merzbau* is removed from the realm of myth and fanciful exaggeration, and the facts explained, what it loses in fantasy it gains in credibility. The building is now destroyed, so we cannot really tell what it was like, despite the wonderful photographs and despite a recent reconstruction of the shell of the first studio.[70] No photographs exist, in any case, of anything but the first studio. To learn the facts of its further development, however, and strip from them the kind of anecdotal elements that have become attached to Schwitters and his art in general, is to make the *Merzbau* fully available for analysis and evaluation. It was not the by-product of an amusingly eccentric way of life, but a visually and thematically remarkable, complex and ambitious work of art.

165 The facts can be told quickly. By 1925–26, the first studio (Room 2 on the ground-floor plan) had become so filled with constructions that Schwitters was forced to expand into his son's adjacent playroom (4 on the plan), requiring his son to move to a new playroom upstairs, and onto the balcony (3 on the plan), which abutted both of these rooms. At first, the former playroom was used purely as a studio (there being no room to make pictures in the original one), but it soon began to be transformed, *Merzbau* style. By the time this room was begun, however, Schwitters knew the sort of environmental effects he wanted, and there was none of the temporal layering that we observed in the

first studio. Stylistically, too, this room was apparently rather different, comprising very large cubic forms suspended from the ceiling. While working on these features, Schwitters created a new, false ceiling roughly one-third way down the room (which was the same height as the first studio: about 4m [13 ft.]), to produce a small, windowless room above, and he used this as his bedroom for a number of years. From the former playroom, he also extended the *Merzbau* onto the adjoining balcony, which was glazed to enclose it.

Independently of this development, and toward the end of the 1920s, Schwitters took over a small attic room, about 2.5 x 3 m (8 x 10 ft.) in size, at the front of the house, under the eaves and therefore with a sloping ceiling. There was insufficient room for large cubic constructions of the kind built in the former playroom, so this new room had smaller elements, more like those in the main studio but more curvilinear, as befitting their later date. This room had a readymade skylight, through which a column was built, with a staircase that gave access to a small platform about 1 m (3 ft.) down from the apex of the roof at the front of the house. This platform was not built until around 1936 and was used for sunbathing. Also in the 1930s—around 1934–35—Schwitters cut a hole in the floor of the ground-floor balcony and carried a staircase down to the courtyard below. The ground-floor, in fact, was actually above true street-level, being set on a basement that was half above and half below the ground (as can be seen from a photograph of the exterior of the house). At the back of the house, there was around 1.8 m (6 ft.) between the ground-floor balcony and the courtyard, and Schwitters enclosed this space too, and also took in an adjacent basement room.[71] By this time (in the 1930s), it should be added, a carpenter, a painter, and an electrician were helping Schwitters on the construction, as well as his son, Ernst; and even visitors to the house were prevailed upon to work.[72] In 1936, when the courtyard floor beneath the balcony was being prepared, an old well was discovered; this was excavated and a spiral staircase carried down to the water level. The principal sculptural motif of this final addition to the *Merzbau* was arrow-shaped, pointing down to the water, where it was reflected, to point back upwards—thereby reminding visitors to this most astonishing structure that the *Merzbau*, while not as vast as is commonly assumed, did in fact stretch, after thirteen years of building, from the subterranean to the sky.

166

In December 1936, Schwitters left Germany, a refugee from Nazi oppression. The *Merzbau* "is unfinished, and on principle,"[73] he had written in 1930—and it could have been continued almost indefinitely. It was not; Schwitters never returned to Germany. The entire *Merzbau* was destroyed by Allied bombing on the night of October 8–9, 1943.

☐ Even when fact has been separated from fantasy, and we now know what the *Merzbau* actually comprised, it is still a puzzling work, different in scope and ambition from anything else Schwitters created. What is especially difficult to fathom is the relationship between the Dadaist beginnings of the work and its Constructivist conclusion. We can now understand the stylistic and procedural changes that transformed it, but its identity as a single, coherent work of art remains elusive. It could reasonably be argued that it was not, in fact, a work of art of this kind; rather one whose identity was as fluid as its

developing form, and that only around 1930 did it achieve a relatively coherent identity, along with its relatively consistent Constructivist form. Schwitters' 1936 proposal for an American *Merzbau* certainly demonstrates that by then he knew exactly what its impact was intended to be. But the Hannover *Merzbau* was worked on for thirteen years, and was not the nine-month construction he proposed to Alfred Barr.

To seek its identity only in its "finished" form, as we necessarily do in more ordinary works of art, would be to dismiss the possibility that some common denominator is to be found that was the motivating force of its entire period of construction. To say that its motive was the creation of a total, environmental art-work is not enough, for what we necessarily must ask ourselves is: why did its form change? If we reply that it changed because Schwitters' style changed in the 1920s from Dada to Constructivism, then we must ask: what was it, in Constructivism, that allowed him to bring to fruition, within its esthetic, a Dada idea? (This question is also posed, of course, by his other work of the 1920s.) Furthermore: unless we are willing to believe that the later stages of the *Merzbau* simply effaced and canceled the earlier ones—which would lead to the conclusion that Constructivism allowed Schwitters to realize what Dada did not—we must view the *Merzbau* not simply in terms of stylistic development but in terms of stylistic accumulation; indeed, in terms of stylistic lamination. This is precisely what the photographs that remain of it show. The Constructivist veneer was indeed what tied the *Merzbau* together and gave it its "finished" identity. Its real identity, however, needs to be excavated from the compacted layers of thirteen years' work, and only an archeological expedition can find it.

Schwitters left plenty of clues as to where we should look, for his 1930 statement on the *KdeE* dealt mainly with the *content* of this particular column. But before considering the *KdeE,* which is somewhat indistinct in the photographs that remain of it, let us look again at the 1923 photograph of the column with the child's head on top, for it allows us to see very clearly the kinds of materials Schwitters built into the *Merzbau.*

The column seems to be about six feet (1.80 m) in height, and consists of a tall, rectangular and collaged base, surmounted by a wood and plaster column, decorated with tiny figurines, twigs, some glued-on disks and other ephemera. The base contains mainly collaged sheets of paper from recent publications, including the "Anthologie Bonset" issue of *De Stijl* (November 1921) and the "Holland Dada" issue of *Merz* (January 1923), and a framed collage called *Der erste Tag* (*The First Day*).[74] On the narrow ledge between column and base, we see a broken portrait bust, a model house, a sheet of drawings, and a statuette of a half-naked figure climbing a palm tree, labeled *KUENSTLER* (Artist). Above this stands a kitsch "Mrs. Squirrel" figurine, and fixed to the side of the column is a small bottle (or candle holder?) containing artificial flowers. Near the top of the structure two pieces of wood protrude in such a way as to give the impression of a pair of horns. At the very top there is the child's head.

In the *Merzbau* photographs of 1930, only the upper part of the construction is visible. The child's head has been stripped of its covering. Beneath the head, only the uppermost of the two "horns" is still there, and the area beneath it seems to have been covered with plaster. The uppermost horn now looks uncannily like the headless neck of a torso standing in front of, and below, the child, and cut off at the waist by the shelf on which it

176

177

178, 179

is resting. All that is visible of the remaining materials is the tail of the squirrel figurine which becomes the headless figure's penis, giving an explicitly sexual character to the group. A long glass rod has been added, as well as dramatic concealed lighting, which, helped by the niche-like placement of the whole, gives to it the appearance of a grotesque shrine. What is more, the child's head (we know from Ernst Schwitters) is not simply any plaster sculpture, but a cast taken from the head of Schwitters' other son after his death in infancy. The collage, *Der erste Tag,* which originally hung on the column was dominated by scenes of putti and angels, taken from (among other sources) Stefan Lochner's *Madonna in the Rose Bower.*[75] The combination of tawdry, temporal objects, sexually suggestive ones, the decapitated torso, the dead child's head, and the reminder of Christ's "first day" produces a bizarre and unsettling *memento mori.*

Just below the platform surrounding this shrine there appear to be further collected objects set behind a glazed window, and on the adjacent surface of wall the caricature of a woman's head—Wilhelm Busch's "Fromme Helene"—is visible.[76] Schwitters apparently constructed a system of sliding doors, movable compartments and secret panels for the *Merzbau.*[77] It is more than likely that some of the panels in the vicinity of this group could be removed to show further details. However, there already is enough visible evidence here to reveal the extraordinary nature of even just this one fragment of the *Merzbau.* Schwitters had earlier made pictures on the subjects of Sodom and Gomorrah and the Cross of the Redeemer, and some of his small Dada sculptures, as well as his Dada writings, are suggestive of a taste for the macabre. But nothing quite prepares us for this.

178

180

In Schwitters' account of another column, the *KdeE,* is a description of the "grosse Grotte der Liebe" (Big Love Grotto). This also contained the images of a child's head and artificial flowers, and sexually suggestive references:

> The love grotto alone takes up approximately 1/4 of the base of the column; a wide outside stair leads to it, underneath which stands the female lavatory attendant of life in a long narrow corridor with scattered camel dung. Two children greet us and step into life; owing to damage only part of a mother and child remain. Shiny and broken objects set the mood. In the middle a couple is embracing: he has no head, she no arms; between his legs he is holding a huge blank cartridge. The big twisted-around child's head with the syphilitic eyes is warning the embracing couple to be careful. This is disturbing, but there is reassurance in the little bottle of my own urine in which immortelles are suspended.[78]

While the photographs of the *KdeE* are less distinct than that of the 1923 column, the larger of them allows us to see the "outside stair" and, above and to the left of it, part of the mother and child.

187, 189

What all of these photographs show is that the contents of the *Merzbau* columns and grottos were really quite small. Schwitters' "life-size" narrative is extrapolated from miniaturist forms. According to Vordemberge-Gildewart, some of the grottos were large enough to admit two or three people.[79] He must have been referring, however, to features like the portal and stairway behind the Big Group. By and large, the grottos must have been (as Hans Richter recalled) "little holes and concavities."[80] The photograph of

169

the Gold Grotto supports this. It shows small glass cabinets containing a jumble of found objects, with parts of a doll prominently placed. There was a much larger glass-fronted cabinet beside the Blue Window. This seems to have been about six feet (1.80 m) high, but here again its component parts were evidently very small. Although the architectural elements of the *Merzbau* were large and dramatic, and the construction itself expansive and immense, at its heart was a hallucinatory confusion of tiny fetish objects displayed like specimens in glass boxes: a miniature theater of the absurd.

175

The separate grottos, according to Käte Steinitz, "were on different levels and never directly one above the other. If someone wanted to visit all the caves, he had to go all the way around the column."[81] "In each cave was a sediment of impressions and emotions, with significant literary and symbolic allusions."[82] There were biographical, topographical, and symbolic grottos, each containing objects relevant to the person, place, or theme to which it was dedicated. The biographical grottos are probably the most celebrated because Schwitters made off with his friends' belongings to fill them. When Sophie Taeuber stayed with Schwitters, she awoke to find her bra had disappeared, hidden away in some secret cave that bore her name. Moholy-Nagy lost his socks in the same way.[83] "I remember that Kurt built into [the *Merzbau*] a lost key of mine which I had been searching for desperately," Käte Steinitz recalls. "He placed the key next to a medical prescription written by Dr. Steinitz [Käte's husband] and the box of pills Schwitters bought but never took."[84]

> He cut off a lock of my hair [Hans Richter said], and put it in my hole. A thick pencil, filched from Mies van der Rohe's drawing-board, lay in *his* cavity. In others there were a piece of shoelace, a half-smoked cigarette, a nailparing, a piece of tie (Doesburg), a broken pen. There were also some odd (and more than odd) things such as a dental bridge with several teeth on it, and even a little bottle of urine bearing the donor's name. All these were placed in the separate holes reserved for the individual entries. Schwitters gave some of us several holes each, as the spirit moved him . . . and the column grew.[85]

Käte Steinitz remembers further grottos:

> The Goethe Cave, the Nibelungen Cave, and the Cave of Murderers, where little plastic figures were bleeding with lipstick . . . the cave in which a bottle of urine was solemnly displayed so that the rays of light that fell on it turned the liquid to gold. In addition to the Cave of Deprecated Heroes, there were Caves of Hero Worship, Caves of Friendship, an Arp Cave, a Moholy-Nagy Cave, a Gabo Cave, and a Mondrian Cave. Hannah Hoech was allowed two caves for her photo-collages.[86]

In the various published accounts of the *Merzbau,* some forty different grottos are mentioned in all.[87] There may well have been more. "The very secret caves were probably never seen by anybody except Walden, Giedion and Arp," Käte Steinitz says.[88] Schwitters mentioned these three names as the only ones who would be likely to understand his true intentions. Unfortunately, none of the three has reported them in the kind of detail one would really like.[89] This, however, is Schwitters' own account of his *KdeE* (the *Cathedral of Erotic Misery*):[90]

Each grotto takes its character from some principal components. There is the Nibelungen Hoard with the glittering treasure; the Kyffhäuser with the stone table; the Goethe Grotto with one of Goethe's legs as a relic and a lot of pencils worn down to stubs; the submerged personal-union city of Braunschweig-Lüneburg with houses from Weimar by Feininger, Persil adverts, and with my design of the official emblem of the city of Karlsruhe; the Sex-Crime Cavern with an abominably mutilated corpse of an unfortunate young girl, painted tomato-red, and splendid votive offerings; the Ruhr district with authentic brown coal and authentic gas coke; an art exhibition with paintings and sculptures by Michelangelo and myself being viewed by a dog on a leash; the dog kennel with lavatory and a red dog; the organ, which you turn anti-clockwise to play "Silent Night, Holy Night" and "Come Ye Little Children"; the 10% disabled war veteran with his daughter who has no head but is still well pre-served; the Mona Hausmann, consisting of a reproduction of the Mona Lisa with the pasted-on face of Raoul Hausmann covering over the stereotyped smile; the brothel with the 3-legged lady made by Hannah Hoech; and the great Grotto of Love.

At this point, Schwitters describes the Love Grotto in more detail, as quoted earlier, before concluding in more general terms:

I have recounted only a tiny part of the literary content of the column. Besides, many grottos have vanished from sight under later additions, for example, Luther's Corner. The literary content is dadaist: that goes without saying, for it dates from the year 1923, and I was a Dadaist then . . . I have given a fairly detailed description of the *KdeE,* because this is the first reference to it in print, and because it is very hard to understand because of its ambiguities.

He is of course right. The two photographs of the *KdeE* give us a general idea of what it was like, and in the smaller one we can even find "Mona Hausmann";[91] but even with the help of photographs—and Schwitters' text—the *Merzbau* remains a baffling work. 187, 189

Schwitters' description itself is baffling: not for its illogicalities and fantasies (these we have come to expect) but for its obsessional fixation with human object-parts and with the themes of sexual violence, death, and desecration. Grottos and incidents with names such as "the disabled war veteran," "the Cave of Murderers," "the Brothel," and "the Sex-Crime Cavern," as well as the eccentric sexual encounter described earlier, populate Schwitters' *Kathedrale des erotischen Elends* (*Cathedral of Erotic Misery*). In 1924, just after the *Merzbau* was started, the calm of Hannover society was shattered by a series of sex-murders, committed by the notorious Fritz Haarmann; these may well have in-fluenced the content of the *KdeE*. The name itself, Schwitters perversely said, "is only a designation. It has no bearing on the content."[92] Nevertheless, we have to take it into account. Carola Giedion-Welcker suggests that the initials *KdeE* are an allusion to those of a Berlin department store, the Kaufhaus des Westens or KdW.[93] If so, then Schwitters' stock-in-trade, as well as the bazaar itself, is an altogether abnormal one.

This is not the whole picture, of course. Many of the grottos were frankly whimsical, or were simply dedicated to friends, just as some of Schwitters' collages and construc-tions were. Even so, the mood of the grottos seems to have been one of black humor, very

far from the exuberant and clownish side of Schwitters' character most often reported. These claustrophobic, fetish-lined caves point in an altogether different direction. Käte Steinitz recognized this when she asked Schwitters: "You call the Expressionists painters of their own sour souls, but aren't you emptying your own sour soul into the caves?"[94]

It is unfortunate that we have to rely mostly on published and oral reports to judge the effect of the *Merzbau,* especially since Schwitters, by and large, showed the grottos themselves only to sympathetic friends. Not unnaturally, their accounts are biased. It is as well, therefore, to remind ourselves of the impact of the secret grottos on those less prepared. Lissitzky and his future wife Sophie Küppers "gazed in astonishment" at the *Merzbau* in 1923, and she has said that she was "unable to draw the line between originality and madness in Schwitters' creations."[95] Alexander Dorner, whose encouragement for advanced art through the 1920s needs no defense, and who personally did much to advance Schwitters' career, was at first simply appalled. He admired the *Merzbilder* as "positive pioneering experiments." Confronted with the *Merzbau,* however, he felt that the "free expression of the socially uncontrolled self had here bridged the gap between sanity and madness." It was "a kind of fecal smearing—a sick and sickening relapse into the social irresponsibility of the infant who plays with trash and filth."[96] Of course, Dorner's sympathies lay primarily with Constructivist art, puritan in its looks and assumed to possess a social justification, and this must partly account for his reaction. Nevertheless, the strong repulsion he so evidently felt serves to temper such more publicized responses to the *Merzbau,* as, say, Carola Giedion-Welcker's who wrote of it as being "a little world of branching and building where the imagination is free to climb at will."[97] It hardly seems possible that they are talking about the same work.

The *Merzbau* was a puzzling experience even for Schwitters' supporters, as is testified by the widely differing and often erroneous reports as to what it actually comprised. For the present, let us concentrate upon two of its basic characteristics. Firstly, its imagery was essentially autobiographical and frequently erotic, tempered sometimes by humor but often of a disturbingly near-sadistic kind. And secondly, this imagery was increasingly hidden beneath the geometric surfaces that Schwitters applied to the *Merzbau* throughout the 1920s and 1930s.

In 1923, when Schwitters began consciously to form the *Merzbau,* his art was undergoing a change towards the geometric. It would be wrong, however, to interpret the development of this work merely as the victory of geometric Constructivism over Schwitters' personalized Dadaism. His geometric pictures of the 1920s are often disappointing, and whether Schwitters realized this or not, it is reasonable to assume that he did miss the opportunity to personalize his work through evocative objects in the same way as before. The *Merzbau* did allow him to retain contact with these kinds of objects, and this seems to have been, in large part, why it was so important to him. The significance he came to attach to it seems to testify that it was the single work which totally satisfied his ambitions, which carried the full stamp of his identity—as indeed did the autobiographical fragments hidden beneath its geometric shell.

This shell, moreover, was by no means a second start effacing the original conception. Although the fragments it concealed were "downgraded" by being covered over, they

were downgraded only in the same sense as were materials in Schwitters' Merz pictures: by being submitted to the formal matrix of Cubo-Expressionism. Although Constructivist in many of its details, the *Merzbau* is essentially a piece of Expressionist architecture. Its form is as regressive as the content it conceals. And while its architectural structure does cover, and therefore formalize, the "darkest erotic caves" of the project's beginning, something of the original claustrophobic fantasy seems to have been projected outwards to give shape to the enclosing shell.

In describing the growth of the *Merzbau*, Schwitters used the image of a developing city, where "the Board of Works must check to see that the new house does not spoil the whole appearance of the city."[98] In the same way, he said, he would evaluate and then add new objects to the *Merzbau*, but would find at times that "a new direction must be created, wholly or partially over the bodies of previous objects. In this way, I leave things as they are, only covering them up either wholly or partially, as a sign of their downgrading as individual units."

This idea of absorbing an original form by the addition of a new overall covering had previously appeared in an article on color in architecture Schwitters published in January 1924, around the time he had begun to enclose the *Merzbau* grottos.[99] He suggested that different sectors of cities be painted in different colors, saying that "should some already existing form, especially one not originally intended to be colored, now be colored, the effect will be to dissociate the form, and thus make it material for the creation of a higher form by subsuming the original form under an all-over one." This is Schwitters' familiar idea of *Entformung*—the metamorphosis or dissociation of a form from its original context through esthetic ordering—given a new twist. In transposing the idea from a two-dimensional to an architectural framework, he creates the dissociation through covering over a form (here, by color) rather than through juxtaposing it with others. And this is what happened to the *Merzbau*.

In writing about color and architecture, Schwitters was thinking of Bruno Taut's colored house fronts of 1924.[100] But if there was a relationship between Taut's ideas and Schwitters', it was the early Taut of the Arbeitsrat für Kunst and not the later, more sober-minded, one. The forms of the *Merzbau* are undoubtedly Expressionist in origin despite their Constructivist overlay. As noted earlier, Schwitters' "Cathedral" recalls Taut's crystalline *Zukunftskathedrale* in its various forms, just as it recalls similar projects by the Luckhardt brothers, and others from the Arbeitsrat circle.[101] It also bears interesting comparison with the work of Antoni Gaudí, who was rapidly becoming known in Germany at this time, and whose architecture was illustrated in the same issue of *Frühlicht* to which Schwitters contributed.[102] There is a remarkable similarity between certain of Gaudí's buildings—especially the Colonia Güell chapel of 1898–1914—and the forms of the *Merzbau*.

Schwitters may also have known such realized work as the Arbeitsrat members achieved. The angular, facet-roofed dance casino at the Scala-Palast in Berlin, designed in 1920 by the architect Walter Würzbach and the sculptor Rudolf Belling, is an important precedent for the *Merzbau*, especially in the design of its ceiling, and particularly since the work was done directly and improvisatorily from clay models without preliminary drawings.[103] It is also possible that Schwitters learned something from Gropius'

172

137

171

174

182 and Meyer's Sommerfeld house of 1920–21, where Joost Schmidt's carved reliefs (possibly indebted to Schwitters' early assemblages) decorate the angular, Expressionist-based design of the lobby and staircase. But there are many prototypes for the *Merzbau*

173 in Expressionist architecture. Certainly, Hans Poelzig's Grosses Schauspielhaus (Grand Theater) in Berlin of 1919, would have been known to Schwitters: its stalactital form surely exerted some influence on the design of the *Merzbau*. By 1923, however, when Schwitters began to work on the *Merzbau,* Expressionism in architecture was all but finished. In the *Merzbau*—as in all of Schwitters' other works—there is nothing especially new or innovative about its style. It is the very obsessiveness with which he used common styles which is so remarkable.

The work of the Expressionist architects, and of those who influenced them, is of course obsessive in its own way; but there is nothing in their projects to prepare us for the introverted, and blatantly literary, mythology which Schwitters wove around the forms of his private architecture. There is, however, one important Expressionist parallel, and even precedent, for Schwitters' peculiar brand of fantasy, and that is the Expressionist film. It is well known that Expressionist painting influenced the design of German films after the First World War. In Schwitters' case, one is tempted to see the influence working in the opposite direction. The forms of the *Merzbau* have often been compared to the

184 splintery Brücke-style settings of Robert Wiene's *Das Kabinett des Dr. Caligari*.[104] Schwitters was an avid film-goer,[105] and was surely familiar with this important work. Its sets were created by his fellow Sturm artists. They established the pattern for future Expressionist productions, many of which were also designed by painters or architects. For example, Poelzig created the "medieval" sets for Paul Wegener's second *Golem* film in 1920, which uses forms that generally resemble those of the *Merzbau*. The parallel

186 with Wiene's *Raskolnikow* of 1923 (the year the *Merzbau* was begun) is even more striking.

The point here is not only that both Expressionist film sets and the *Merzbau* share a common stylistic source and therefore stylistic vocabulary, but that they also share something of the same mythology. The film-makers, as Siegfried Kracauer has observed, "preferred the command of an artificial universe to dependence upon a haphazard outer world."[106] The *Merzbau* was an artificial universe created from haphazard fragments of the world itself. If the film-makers were turning inward, away from reality, Schwitters was turning inward the forms of reality themselves, and to similar ends.

There are certain specific devices common to the *Merzbau* and to the German Expressionist film that suggest direct influence of filmic themes upon the *Merzbau's* content. To begin with, there is the "laboratory-made fairy illuminations" of Expressionist films,[107] the obsession with dramatic lighting as what Lotte Eisner calls a space-forming factor.[108] The *Merzbau* had at one time a complex lighting system. When seen under controlled illumination, it must have appeared far more mysterious—sinister, even, at times—than photographs generally reveal. Even from photographs, we can see how lighting emphasizes the cave-like forms of the grottos, throwing into relief their diagonal ribs and columns, giving a moody, unreal feeling to the whole and to the individual objects they contain. Schwitters' enclosure of groups of objects by placing them within the ribs of grottos or in illuminated glass-fronted boxes also parallels the film-makers' ideas, parti-

cularly their use of fixed framing to isolate details, details so accumulated and so saturated with symbolic significance as to render their documentation unreal. A relevant example of this kind of focus on presented detail, so as to blur the distinction between artifice and reality, is Paul Leni's *Das Wachsfigurenkabinett* (*Chamber of Horrors*) of 1924, whose isolated figures set against jagged settings and grotesquely exhibited waxworks recall Schwitters' use of dolls and kitsch figurines in the *Merzbau* grottos.[109] Likewise, the combination of Expressionist settings and realist forms in a section of Fritz Lang's *Dr. Mabuse, der Spieler* (*Dr. Mabuse, the Gambler*) of 1922 has the same unbalancing effect—mixing the real and the imaginary—as the contrasting of documentary details and stylized surfaces in the *Merzbau*.

Moreover, Schwitters' *Merzbau* (like his early writings) uses similar themes to those popularized in film: coarse sex, the grotesque and even the horrific. Stylistically, the *Merzbau* may owe much to the concept of the Expressionist *Kathedrale*, but there is another side to it: the enclosed, claustrophobic and fetish-lined caves. To Alexander Dorner and others who found the *Merzbau* disturbing, Schwitters must have appeared as a kind of "demoniac bourgeois" (to borrow Eisner's phrase),[110] the kindly, well-natured proprietor of a Chamber of Horrors.

"Do not ask for soulful moods," Schwitters once warned his audience.[111] And yet, this darker side of the *Merzbau* cannot be dismissed. We cannot, of course, be sure that Schwitters' own report of its content is entirely serious. But even if we knew for certain that he was being merely provocative, it would still be revealing that he chose to be so in a grotesque as well as an amusing and fantastic way. To conclude simply that the imagery of the *Merzbau* was private and personal to Schwitters is clearly not enough: not necessarily because of a desire to learn *more* about his private obsessions, but because it is intriguing that he reserved such private imagery for the *Merzbau*, and hardly ever allowed it in other of his visual works. Indeed, I might go further than this and ask: was it the very privateness of the *Merzbau's* imagery that caused Schwitters to build around it the formalized covering that he created during the 1920s and 1930s? And if so, what bearing do the forms he created have on the imagery they conceal?

Conceptually, the *Merzbau* was an accumulation of memory banks, of grottos each full of souvenirs documenting the artist's friendships and his public and personal history. Schwitters talked of it as based on the idea of a constantly growing city, but its architectural function is more usefully compared to that of a basement or attic, a place for the storage and preservation of private memories.[112] And as the *Merzbau* developed, the part of Schwitters' home it occupied became as much a place for storage as one for living, as much dedicated to the past as to the present, until he was building a house within his house from the relics of experience. The *Merzbau*, he once said, was the development into pure form of everything that had impinged upon his consciousness.[113]

I spoke earlier of Schwitters' method as a diaristic one. The *Merzbau* was therefore a diary on the grandest of scales. As such, its literary content is usefully illuminated by reference to those works where this kind of content is more directly expressed, namely his prose writings. His previous *Gesamtkunstwerk* project, the *Merzbühne*, was an attempt to create a form that mediated between the plastic values of the Merz pictures

and the private mythology of his more fantastic writings. In transferring his "total" ambitions to the *Merzbau,* Schwitters transferred the general form of these ambitions as well. Certain themes in his prose works are of particular relevance to the literary and symbolic allusions hidden in the *Merzbau* caves, and also provide important clues to his relationship with his material environment, the meaning it had for him, and the way he sought to transform it—in the *Merzbau* itself—not only into a private world, but into an idealized and primordial one.

□ The *Merzbau,* we remember, had its origins in 1919–20, and developed its geometric, environmental format from 1923 onwards. Its content, Schwitters said, was a Dadaist one.[114] It therefore relates particularly to his early prose writings, with which it shares a reciprocity between grotesque content and surprisingly rigid structural order. Writings like "Die Zwiebel" and "Revolution in Revon" (discussed in Chapter 5) contain, like the *Merzbau,* more than a good dose of black comedy, the kind of humor that looks back to the nineteenth-century Hannoverian illustrator Wilhelm Busch, one of whose illustrations appears in the *Merzbau* itself. Schwitters' special brand of fantasy tinged with sadism belongs to that specifically German tradition of the grotesque which affected many members of the Expressionist generation. In Schwitters' case, however, it is mixed up with the merely absurd, with contemporary slogans and aphorisms, and matched against the sheer linguistic invention of his work—which is finally of equal importance to the imagery it contains.

From around 1922–23 (as we shall see later) this changed. While most of his poetry became increasingly abstract, his prose was purged of much of its grotesque imagery and linguistic disruptions. Much of the fantasy was sublimated into the form of comic narrative fables and fairy tales. But if the form was changed, the essential content was not. Talking of "Revolution in Revon," Schwitters stated: "This work was written during my Dada period. Dada holds up the mirror to the world: Here is mirrored the Revon of 1919."[115] All his prose works are mirrors of different kinds, reflecting his immediate Hannoverian environment. The principal themes of his German prose writings, regardless of period, are: the situations of daily life transformed into fantasy; the language and habits of bourgeois Hannover society; the creation of a new illogical world parallel to the real one which he inhabited.

According to Käte Steinitz, Schwitters' own language "was very Hannoverian, deliberately so, because he consciously adopted all the idiomatic expressions of the region."[116] He wrote about a world of which he was very much a part. He collected epigrams from family friends, from conversations overheard and from the popular press, in the same way that he collected objects. His writings are full of colloquial Hannoverian speech, and of "found" aphorisms of all kinds. He even wrote stories about the objects of his household: the history of a family visitor's umbrella; the stove; Hahnepeter, his son's fantasy pet; and so on.[117] People that Schwitters knew were transformed into mythical figures. In *Auguste Bolte,* of 1923 the heroine is modelled on Frau Tatje, the family seamstress.[118] In "Revolution in Revon," Frau von Feuerhake, a regular family visitor, appears in the guise of an art critic's wife (while, as Frau Heuer, she is the heroine of *Der Schürm*),[119] and her husband is modeled on a visitor to the Kestner-Gesellschaft, a

certain Dr. Cohn-Wiener, who had spoken there on the relation between social and artistic radicalism.[120] *Franz Müllers Drahtfrühling,*[121] Schwitters' continuing (but unfinished) novel, of which "Revolution in Revon" was to have been only the first chapter, was clearly based on Hannover society. "*Franz Müllers Drahtfrühling [Franz Müller's Wire Springtime]—The Love Story of Anna Blume* is set in the village where Herr Schwitters is compelled to live and recounts the doings of the natives," read the publisher's announcements.[122]

Schwitters' principal characters were Anna Blume and Franz Müller. Anna Blume we know well; not so Franz Müller. We learn who he is, however, in "Revolution in Revon," from Anna herself. She makes only the briefest of appearances in this story, but she is the only person in it to notice what the standing man of Revon actually looks like:

> She now saw the man very distinctly, a handsome man, noticeably a little ragged—very much the popular idea of the way Franz Müller looks. His clothing was really something peculiar. Anna Blume thought it reminiscent of the author's Merz sculptures. It was not darned or mended but nailed up with planks and surrounded with wire. Anna Blume thought it reminiscent of the author's Merz sculpture; disgusting—in fact, such a thing overwhelmed you—a perambulating Merz sculpture, except that the man was not perambulating. The man stood still.[123]

He is Franz Müller, and also of course Schwitters himself—or at least a personification of his art (*Müll* = rubbish or refuse)—just as Anna (whose name when reversed remains the same: a-n-n-a) is a personification of Hannover, where she belongs. Revon is the end of Hannover (n-o-v-e-r) back to front, and Anna and Revon, put together and reversed, make Anna-nover: a "new Anna," Hannover.

According to Steinitz, "the real force of ["Revolution in Revon"] was the voice of Kurt Schwitters as it emerged [in the story] from the stiff, silent little man of Hannover standing in our midst. . . . The city of Hannover was covered by an overall pattern of well-behaved citizens . . . nobody was ever supposed to be found standing inert, passive, and calm in the midst of the city, like a frozen puzzle."[124] In a sense, Schwitters' entire artistic and personal philosophy is contained in this story: his very identification with the objects he collected (which Anna's description of Franz Müller shows to have been a total one), his spiritual and Expressionist notion of the artist as an inspired individual, mute except through his art; his insistence on a purely artistic revolution, despite the hostility of critics or of polemical and political artists (Bäsenstiel, the agitator, may possibly have been based on Huelsenbeck),[125] and his alienation from bourgeois society, but affection for it at the same time. For all his diatribes against the citizens of Revon, their city was his also. "If I ever move from Hannover," he is reported as saying, "where I love and hate everything, I will lose the feeling that makes my 'world point of view.'"[126]

In presenting himself as an outsider and silent observer within bourgeois society and also as a ragged man of rubbish, Schwitters joins his self-image to two long-standing personifications of the contemporary artist. The first is that of the *flâneur,* the voyeuristic stroller of the metropolis, who assumes the costume of its most fashionable (or, in Schwitters' case, in real life, most correct) inhabitants, but is attracted to what goes on behind the bourgeois façade. Schwitters is voyeuristic in his assumption of distance from

his local environment, in casting himself as a collector and recorder rather than a participant, and in disavowing any kind of empathy with what he took from the world. This connoisseur's view of reality meant both that he found security in his Hannover world—by documenting and certifying it in his art—and that he refused its effect on him, moving passively and at random throughout its society converting everything in sight into an instant souvenir.

But Schwitters, for all his assumption of esthetic distance from his materials, was clearly far more enamored of them than he was willing to admit. Neither his writings nor his pictures exhibit that sense of dandyish coolness towards his sources shown by many Surrealist artists, for example. If he collects and records, he also gathers and guards. If he was a *flâneur*, he was also a scavenger, who created for himself a magical, charmed world from the prosaic left-overs of his immediate environment. And that he did so through society's rejects, through the picturesque rather than the polished, links him to a second personification of the modern artist, namely Baudelaire's ragpicker. Indeed, it was Schwitters who finally transformed into reality what had previously been but a metaphor for the life of the artist of the metropolis. In Baudelaire's words:

> Everything that the big city threw away, everything it lost, everything it despised, everything it crushed underfoot, he catalogs and collects. . . . He sorts out things and makes a wise choice; he collects, like a miser guarding a treasure, the refuse which will assume the shape of useful or gratifying objects between the jaws of the goddess of industry.[127]

Schwitters' method is that of Realism made from real things. And in his work, Realism culminates where it began, in an obsession with the transitory elements of everyday existence, with the picturesque of the used, the tawdry and the unnoticed. In this respect, he is a modernized Piranesi of the *Carceri,* a connoisseur of fragments, and therefore of spiritual homelessness, even within his secure Hannover world.[128] As a collector, he salvages the perishable fragments of modernity to build from them what may at first be interpreted as a more disinterested and therefore more accurate picture of the world than sheer representation could provide. But it is in fact a highly charged one. Melancholy as well as mystery is inevitably conferred on what is picked out of the flux of time—especially since it is so very ordinary—and the denial of connections between things other than the esthetic only accentuates the sense that the patchwork built up is now isolated from the world that composes it. And here Realism is turned inside out: instead of celebrating the modern world it is elegiac. Instead of documenting an external reality, it seeks to possess it and to pattern it anew. Of course, Schwitters' writings and pictures do function as social documents, as many of his friends and commentators have claimed,[129] but the documents that he presented served principally to authenticate a highly personalized, indeed an introverted world, in which all objects and situations were adjuncts to himself and his own private imperatives.

To speak again in this way of Schwitters' identification with objects as precious and personalized reflections of reality opens the discussion to blatantly psychological (and particularly Freudian) interpretation. For Schwitters' surrogate invented world is so obviously a region that falls, in Freud's words, "half-way between a reality which

frustrates wishes and the wish-fulfilling world of the imagination, a region in which, as it were, primitive man's strivings for omnipotence are still in full force."[130] Moreover, the image of liberation that Schwitters continually used when describing the function of his art, and the images of metamorphosis and purification he used when describing how materials were altered within the context of his art, also lend themselves to Freudian explanation: namely, that "the artist's first aim is to set himself free . . . [by representing] his most personal wishful fantasies as fulfilled" but that "they only become a work of art when they have undergone a transformation which softens what is offensive in them, conceals their personal origin."[131]

It is indisputable, I think, that Schwitters' writings, both literary and theoretical, tell of a belief in an unsullied and unfettered abstract reality removed from the pain of everyday existence, one that he could manipulate and control and within which his fantasies could be given free rein. It is also indisputable, I think, that the *Merzbau* was so important to Schwitters because it was literally a private and omnipotent universe of just this kind. Within its privacy, his fantasies could be played out, but within it too their offensiveness could be softened and concealed, and transformed into something that both ameliorated the frustrations of which they told and was itself a solidly architectural monument to his own omnipotence.

To speak in these terms, however, is not only to risk generalizing what Schwitters was doing (by linking his aims to a lowest common denominator of artistic psychology), it is also to risk over-individualizing his artistic ambitions. No matter how much weight we may give to Schwitters' individual psychology in shaping the precise character of his art, we must be careful nevertheless not to separate Schwitters from the artistic climate of his period, and his own brand of fantasy from that of his contemporaries. The themes of a modern fantasy art may not be the collective property of contemporary culture, but neither are they unique to an individual. Insofar as we recognize particular fantasies and psychological conflicts in Schwitters' art, they need to be seen as much in the context of his cultural background as of his individual psychology.

I refer not only to the anthropomorphic tendency in earlier German art; to a German tradition of grotesque humor; to the revival of interest, in the first decade of this century, in historical fantasy art. These things do have relevance to Schwitters' preoccupations. So do the specific Expressionist parallels in painting, architecture, film and writing, that have already been noted. More relevant and important, however, to that sense of opposition between a public and a private world, which is central to Schwitters' art and psychology, and a more basic link between Schwitters and his contemporary Expressionist background, is his ambivalence towards his immediate environment and to its urban bourgeois culture.

Expressionism as a whole was anti-materialist and anti-utilitarian. As the literary historian Richard Sheppard well puts it, the most striking Expressionist literature emerges when the writer is sufficiently within the city to appreciate its forms yet sufficiently detached so as not to be overwhelmed by them.[132] The classic Expressionist poem "is torn between a desire to remain still and an urge to lose itself in chaos, and characterized by a disjunction between a rigid verse form and images of rigidity and a vitality which threatens to smash these forms and images."[133] An analogous blend of

firm structure and disruptive content characterizes Schwitters' early prose writings,[134] and his early art in general. But neither his writings nor his pictures have the ecstatic visionary feeling of full-blown prewar Expressionism. With the First World War, Expressionist art as a whole divided in two: one wing moving towards political engagement, the other "towards a quest for the luminous image which forms a point of stasis, order and reference amid chaos."[135] German Dada, as a successor of Expressionism, shows this same division as well: while the Berlin Dadaists turned to politics, Schwitters sought a kind of "luminous image" in the order that art itself—as a way of escape from the material world (as he insisted it was)—could afford.

But Schwitters' Expressionism was not only a late version of it, it was a provincial one as well. Hannover was never the chaotic asphalt metropolis that the Berlin poets and painters knew. Its inhabitants—as represented by Schwitters—were not the anxious spectral beings of the archetypal Expressionist city. Hannover surpassed other German cities in only one respect, Huelsenbeck has written: "its petty bourgeois mentality."[136]

It is really quite amazing [he continued] that an essentially revolutionary artist like Schwitters could live and work in such an atmosphere. This was possible only because he adjusted many of his personal habits to the environment. Thus, his revolt remained romantic. . . . He had no choice but to play the "clown."

According to all accounts, this was certainly true of his public behavior.[137] Not only Huelsenbeck, his avowed opponent, but even close friends found it difficult to reconcile Schwitters' jovial, extravert and clownish nature with the seriousness of his commitment to art. They found his bourgeois appearance and home life ("He lived like a lower middle-class Victorian," Huelsenbeck says)[138] equally puzzling. We too cannot but notice the internal contradictions of his existence, not only in the differences between the character of his art and his own public character, but within his art as well: his continuing production of portraits and landscapes together with collages and constructions; his spiritual-Expressionist understanding of art and his commitment to the nonsensical and absurd; the narrative and the abstract writings; the Dadaist content and the Cubist or Constructivist forms.

It would be specious to put too much of this down to his provincial, and particularly Hannoverian, situation; nevertheless, the contradictoriness of the way he lived, on the margins of bourgeois society (a society that was claustrophobic rather than chaotic), helps to account for the peculiarity of his literary themes, for his separateness from any aggressively modern or metropolitan avant-garde stance, for the preindustrial nostalgia of his work: in fact, for the brand of provincial innocence that continually shows itself in what he did. His very eclecticism is that of an outsider, of someone independent of a mainstream taste. He nurtured his eclecticism as much as he did his provincialism. Indeed, both were an important part of his originality, for they gave him a happy freedom of mobility, and permitted him to achieve a level of artistic quality well beyond that of his more polemical contemporaries.[139] Of course, it was his commitment to form (that is to say, to Cubist-derived, mainstream form) that enabled him to contain his imagery without depriving it of its evocative connotations, but it was to a large extent his sentimental and "literary" preoccupations that inspired his invention.

Moreover, as an outsider Schwitters was highly ambitious, and utterly convinced of his own importance.[140] If at times there seems to be a gap between his ambitions and their capabilities—and if at times he fell into the purely literary and merely sentimental—then his very isolation seems to have strengthened his commitment to create an art that would match that of the metropolitan mainstream, but at the same time be all-inclusively personal and individual. Or perhaps it was just a provincial simplicity that allowed him to hope for something so totally complete.

The increasing formalization of Schwitters' collages and relief assemblages in the early 1920s necessarily inhibited the more fantastic side of his artistic personality. The *Merzbau* was, first of all, an escape valve for the feeling that geometry and cold paint kept out of his contemporary picture. But it was also an attempt to convert private feeling into pure form; as such, its applied structures reveal the influence of Constructivist art. In the final count, however, it was more than a mere artistic covering for the personal. Schwitters built a fantasy house within his bourgeois one, a private autobiographical structure within the very fabric of the publicly respectable space in which he lived, and by trapping and concealing its personal imagery within a formalized shell he began to order the icons of his experience and create from them a fabricated monument to the permanence and durability of his private, invented world. It too became a kind of "luminous image," a point of order if not of stasis. I have taken Carlyle's phrase for the title of this chapter because the *Merzbau* began as a phantasmagoria only to become a dream grotto of an ideal and luxuriant kind.

In its very development, Schwitters' understanding and approach to his art underwent an important change. Although Merz itself never ceased to be assemblage, as the *Merzbau* developed it started to be something else as well. With the ribs and columns that swallowed up the original grottos, Schwitters seems to have been trying to create an amalgam of fabricated objects, each with the same force and potency as the found objects with which he so identified. He began actually to mould luminous Vitalist images, images which took their form from the found objects they contained. The exuberant growths that remained visible were quite literally the stylized radiations of an inner core.

This produced in the end an important stylistic shift in the direction of Schwitters' work. It was finally resolved with the decidedly "rural" emphasis of his late style. It began, however, within the context of geometric formalism: the possibility of generalized metaphorical reference (inherent in "shaped" elements) which Schwitters' interpretation of Constructivism offered, and which he pursued in the relief constructions of the 1920s, helped to bring such images and objects into being. In the next chapter, I will return to the *Merzbau* after following Schwitters' development from his transitional Constructivism of 1922–24 to his discovery of a "new form of expression," for it was in the *Merzbau* that his new "more universal" form of expression was most fully realized. It was not only the most transitory of all his works; it was also the most complete.

8 THE CITY AND THE COUNTRY

□ The contrast of fantasy and formalization in Schwitters' *Merzbau* is only one of a number of contrasts that emerged in his work once the pioneering years of Merz had come to an end. His pioneering work had manifested opposing tendencies; indeed, its internal conflicts were largely responsible for its vitality and drama. In the 1920s, however, the contrasting affiliations thrown up by the pattern of Schwitters' temperament, artistic contacts and methods of working produced overtly contrasted, and conflicting, kinds of art. The 1920s were indeed a time of consolidation for Schwitters, during which he simplified and reorganized his established formal vocabulary; but in this very consolidation the internal tensions and contradictions that marked his established vocabulary were brought out into the open. How Schwitters sought to consolidate his art, and the kinds of contrasts that were revealed, is the subject of this chapter.

How he reconciled these contrasts in the later 1920s and early 1930s is included in this subject, for it was only when this reconciliation was achieved that true artistic consolidation followed. And if the *Merzbau* shows the contrasts of Schwitters' art at their most extreme, equally, it shows their most fulfilled reconciliation. The conflicting impulses of one form of his art, however, proved incapable of being reconciled. I refer to his poetry and prose writings. It is to examples of these from the years 1922–24 that we must turn first, for these show, more clearly than his work in any other medium, how that contrast of fantasy and formalization we saw in the *Merzbau* could produce two distinctly separate bodies of work.

□ By 1923, Schwitters had abandoned his hopes of a theatrical total work of art. The *Normalbühne Merz* was not a success; the path to the *Gesamtkunstwerk* was no longer to begin with the written word. The combination, therefore, of the formally experimental and the fantastic that characterized both the earlier *Merzbühne* and the poetry and prose contemporary to it was largely disbanded; these two sides of his literary art were sent on their separate ways. That at least seems to be the most convincing explanation for the very radical division in Schwitters' writings that developed in the early 1920s. On the one hand, his interests in abstract linguistic order led to the production of word, number and letter poems, including the quasi–musical "Ursonate" that he worked on for almost as long as the *Merzbau*. On the other, his fascination with the colloquial speech and the observed, absurd events of his native Hannover was channeled into fairly traditionally composed, comic narrative fables and fairy tales. The demands of his abstract art and the attractions of his Hannoverian environment are sealed off one from the other, and each is treated in its own separate terms.

Since Schwitters' visual art of the early 1920s became noticeably more abstract and hermetic, his abstract literary work seems therefore far more central to his work as a whole than do the anecdotal and narrative writings. Indeed, most of the abstract poems are not easily dissociated from a visual context, and some depend almost entirely for their force on visual patterning. "Gesetztes Bildegedicht" ("Typeset Picture-poem")[1] is 192 an extreme example in this respect, and as its title concedes is a picture-poem rather than a poem proper. "Cigarren" ("Cigars"), however, although more interesting than most, is fairly representative of the genre. It consists of the German names of the eight letters of the title, and its shape resembles a long stream of smoke:

Cigarren
Ci
garr
ren
Ce
i
ge
a
err
err
e
en
Ce
CeI
CeIGe
CeIGeA
CeIGeAErr
CeIGeAErrErr
CeIGeAErrErr
CeIGeAErrErr
ErrEEn
EEn
En
Ce
i
ge
a
err
err
e
en
Ci
garr
ren
Cigarren (Der letzte Vers wird gesungen). [The last line is sung][2]

From the time of his earliest Stramm-imitations, Schwitters had been interested in the physical shaping of his poems. Of course, the Expressionist word-chain method he inherited itself encouraged concentration on the additive and constructive in poetic composition. But Schwitters, as we have seen, exaggerated this: using his subjects as the excuse for acts of linguistic virtuosity; reveling in the internal mechanics of a poem at the expense of its developmental logic; refusing easy connections of meaning between individual units of composition (and often withdrawing common-sense meanings from the individual units as well), thus enforcing the juxtapositional and constructional form of the whole. However, this never quite produced simply formalist pattern-making: a tension between the grotesque or absurd subjects and the formal, linguistic play gives to Schwitters' Expressionist and Dadaist verse its curious and often compelling mood.

By 1922 this had begun to change. While Schwitters continued occasionally to write in a sobered-down version of his Dadaist style, he also started to produce two new kinds of poetry: extremely traditional (and either humorous or sentimental) verses, which will be considered later, and affirmatively avant-garde works like "Cigarren." The subjects of works of this kind are words and letters (and even numbers) themselves. As a result of this, the special tension between subject and structure characteristic of the earlier work was lost. What replaced it looks a lot like formalist pattern-making (and much of this "concrete" poetry does not escape such a charge), but at its most inventive it replaces the earlier tension of subject and structure with a new one: an opposition and interplay between the verbal and the visual, between the phonetic and linguistic resonances of the poem and its physical, typographical reality.

To use the word (or letter or number) either as a phonetic or a visual unit is to use it as an object or element rather than as an agent of meaning.[3] Or better, it is to subordinate the individual meaning of such a unit to the meaning it acquires by virtue of its relationship (either phonetic or visual) with other such units in the poem as a whole. In Schwitters' earliest theoretical statements about his poetry, he often talked of how words are used as elements to be played off against other words, and how "in poetry, words are removed from their established context, and brought into a new artistic context they become formal parts of the poem, nothing else."[4] Statements like this, however, never quite seem to fit the early poems: as with the contemporary collages, the words or materials that Schwitters used do have more than a purely formal role in the new contexts in which they are placed. But they fit the abstract or "concrete" poems, for in works of this kind the units that compose the poems do not seem to have any significance except as parts of their new abstract contexts. Indeed, the units themselves tend to be abstract: word fragments, letters and numbers.

Of course, units even of this kind do have intrinsic meaning, and it would not be amiss to see Schwitters' poems of the 1920s as still telling of a culture dominated by numbers, prices, charts and figures. Thus "Gedicht 25" and its companion number poems resemble and evoke columns of calculations.[5] It begins:

<div align="center">

25

25, 25, 26

26, 26, 27

27, 27, 28

28, 28, 29

33, 33, 35, 37, 39

42, 44, 46, 48, 52

53

9, 9, 9

</div>

—and continues in this vein for another twenty-seven lines. But, as Christopher Middleton points out in his study of this work,[6] the numbers are there not as ciphers or as referential units of any kind but as parts of a manipulated pattern which can be experienced both visually and phonetically, and which hovers between the extremes of regularity and predictability on one hand and unpredictability and disorder on the other. What Schwitters is doing is to play off the ordered and the chaotic sides of his art in a highly specialized and hermetic form, and one which in addition united his visual and literary interests. His basic ideal had always been to "combine all branches of art into an artistic unity."[7] The building of the *Merzbau* was his major attempt to realize this ideal, and the abstract poetry that he wrote owed its existence to a similar motivation.

It must be acknowledged that the results of this enterprise narrowed and impoverished the expressive and emotional range available to poetry. This "total work of art" actually diminished the possibilities of the forms it combined. It may be that the same is true of all *Gesamtkunstwerk* projects; but here there is little in the combination to make up for what has been lost. And certainly, the most complete blendings of the visual and the verbal, such as "Gesetztes Bildgedicht," present themselves more as curiosities than as convincing works of art. The original drawings for "poems" like this do have a greater impact—and reinforce the relationship of work of this kind to Schwitters' rubber-stamp drawings, which derive from a similar impulse—but even these are obviously minor works.

<div align="right">

192

191

190

</div>

Part of the difficulty of evaluation here is that most of the abstract poems were used as "scores" for recitation by Schwitters; performed well—as Schwitters was able to perform them (which we know both from reports and from recordings)[8]—they do take on quite a different dimension. But once we begin to talk not of poetic art itself but of the art of virtuoso recitation, then almost any kind of source material will serve, as Schwitters himself obviously realized when he made a "poem" out of one single letter ("Das i-Gedicht": "The i-Poem")[9] and another ("Alphabet von hinten": "Alphabet in Reverse")[10] by simply listing the letters of the alphabet in reverse order.

Only one of Schwitters' abstract poems is ambitious enough to escape at least some of the above strictures, and this is the famous "Ursonate" (Primal Sonata). It was apparently the first begun of all his abstract poems,[11] and owed its beginnings to a journey that Schwitters and his wife made to Prague in the autumn of 1921 with Raoul Hausmann and Hannah Hoech.[12] During a performance there on September 1, Hausmann recited a poem he had composed in 1918 (the year he began writing phonetic poetry) which began

195 with the line "fmsbwtäzäu". Schwitters must have known of works like this before the date of the Prague performance, since he had been friendly with Hausmann since early 1919, but it was only on the return journey from Prague that he began responding to Hausmann's example. Schwitters readily acknowledged that the "Ursonate" was inspired by Hausmann's poem. It began, in fact, by Schwitters reciting Hausmann's original work under the title "Porträt Raoul Hausmann" ("Portrait of Raoul Hausmann"). Then, starting with the line "Fümms bö wö tää zää Uu," he gradually enlarged it from 193, 194 1922–23 onwards until the definitive version was realized, with typography by Jan Tschichold, as a twenty-nine-page special issue of the *Merz* magazine in 1932.

What lifts the "Ursonate" above Schwitters' other abstract poems is not only its more ambitious length. Since the impact of this kind of poetry depends not on the meaning of the parts but on the richness of its internal patterning, length is obviously important because it allows more complex and more developed patterning. The force of the "Ursonate," however, lies in the way that the developed patterns made possible by its length create (particularly when the work is performed) a remarkable and truly musical sense of interplay between the stuttering, primitivist parts and passages and the solidly architectural, indeed extremely "classical," form of the whole. Schwitters himself drew attention to this in calling the poem his "Ursonate" or "Die Sonate in Urlauten" (The Sonata in Primeval Sounds) and presented on the first page the thematic motifs from which the four movements of the Sonata were developed. Describing these, he referred to "the explosive beginning of the first theme, to the pure lyricism of the Jüü-Kaa cantabile, to the harsh military rhythm of the third theme, which sounds altogether masculine in comparison with the throbbing, lamb-like tender fourth theme."[13] Parts of the work do indeed seem to be specifically onomatopoeic, resembling the sounds of drums, birdsong, and so on, but generally the effect is of sequences of primitive "abstract" sounds that achieve emotional meaning by virtue of the repetitions, variations and thematic climaxes that Schwitters creates, and of the gradual unfolding of a sense of classical order that harnesses and controls the primitivism of the parts.

It was this latter aspect of the work that Hausmann criticized, complaining that Schwitters had "made a 'classical' sonata of my innovation . . . which seemed to me a blasphemy."[14] This, however, misses the essential point, which is that Schwitters uses "words" that reach back to an almost prelinguistic form of communication, orders his "*ur*-language" in equally primitive sequences that recall chants, incantations and naturalistic sounds, then frames all this in a sophisticated "classical" and "urban" structure derived from an established musical form.

If, when compared to the "Ursonate," many of Schwitters' abstract poems seem to achieve but a Pyrrhic victory over conventional language,[15] they at least have interest as linguistic experiments. The same cannot be said of his narrative poems of the 1920s, which have, as poetry, few redeeming features at all. They have been defended as "gently humorous and contemplative, unpretentious . . . in the vein of German poetry that leads from Christian Morgenstern to Joachim Ringelnatz,"[16] but their only interest lies in documenting Schwitters' attraction to the banal, the sentimental and the unconsciously comic. We know that he was fascinated by these things in cheap literature and colloquial speech. The most reasonable (and the most charitable) interpretation of the narrative

poems is that they were conceived as imitations and parodies of the doggerel he admired.

Some are unpretentious nonsense verses, such as the story of a Herr von Doppelmoppel who had a double chin with double dimples and led a double life;[17] others are heavy-handedly mock-serious (or at least we hope they are intended as such, for we are never really sure) pronouncements on "serious" topics like the relativity of all events and the regeneration of new life from the ruins of the old.[18] One of the best is a hilariously straight-faced ode to "Autumn" sometimes alternatively titled "Die letzte Fliege" (The Last Fly).[19] It begins:

> Herbst ist es, und die Gardinen sind leer.
> Die Fliegen ziehen nach dem warmen Süden.
> (It is autumn, and the curtains are empty.
> The flies are departing for the warm south.)

It continues in this vein, apotheosizing the last fly that remains to tickle the poet's ear and eat breadcrumbs from his nose! "Leck dich satt," the poem concludes (Lick your fill), "Denn ich danke es dir, dass du mich an den Sommer erinnerst" (For I thank you for reminding me of summer).

The problem, of course, with parodies is that we are always left with a sneaking suspicion that they might not actually have been intended as such. And while we cannot finally believe, particularly in this case, that Schwitters could be so naive, the fact that the banalities and clichés are not "quoted," and therefore distanced as they were in his Dadaist verse, creates the disorienting feeling that he had adopted in these poems the very identity of those sentimental and unconsciously comic writers who might have seriously produced works of this kind. It is as if he is speaking in the voice of someone else. Schwitters' poetry of the 1920s thus shows an utterly divided personality—the avant-garde experimentalist on the one hand and the conservative parodist on the other—and neither of these faces alone shows us what the complete Schwitters is like.

His colloquially written prose pieces seem less egregious than the comparable poems, probably because he is reporting his vernacular subjects at their most natural and not their most pretentious. The children's story "Der Hahnepeter," with characters based on Schwitters' own family and circle of friends,[20] and the "grotesque" called "Schacko," a tale about a severely molted parrot,[21] are both disarmingly simple and often very funny works; and there are other genre pieces of this kind. Moreover, the most ambitious (and the longest) of the prose works, *Auguste Bolte* of 1923,[22] does join together Schwitters' vernacular and experimentalist concerns, albeit in an extremely curious way. Rather than using his interests in formal patterning and linguistic virtuosity to structure basically neutral materials (as is the case with the abstract poems), Schwitters makes them into the subject of a vernacular tale. Language itself, as Schmalenbach puts it, is the protagonist of *Auguste Bolte,* "while the characters react almost passively, as merely the deliverers of the words. . . . They are ruled with an iron hand by fate and by its proxy, language."[23] The story is about numerical order, about puns and rhymes, about repetitions and variations, about logic and anti-logic, because Auguste, the heroine, is herself preoccupied by these things and her actions directed by their influence.

Auguste Bolte is far too complicated to summarize quickly. Its beginning, however, provides a flavour of what it is like. The heroine sees ten people on the street; she muses on this number and its attributes at great length, only to notice the ten separating into two groups of five going in opposite directions. Affronted by this division, she takes several pages to decide which group to follow, and no sooner has she decided than that group also divides when one of its members leaves. Following the four that remain—the easiest decision so far—she of course finds that group dividing into two pairs, which necessitates as painful, and as lengthy, a decision as her original one. We now learn that Auguste Bolte wants to do a doctorate on Life in order to gain the degree of Dr. Leb. (Doktor des Lebens), which explains why the story is subtitled "eine Doktorarbeit . . . mit Fussnoten" (A doctoral thesis . . . with footnotes)—and it does indeed have a few notes, all irrelevant of course, such as: "Auguste Bolte, Anna Blume, Arnold Böcklin have the same initials: AB." Then, the group of two she has decided to follow separates, each person going into a separate house. The story continues in the same vein.

At times, Auguste Bolte switches from arithmetical to linguistic musings, about rhymes and puns, and these trigger and then sustain actions in the story. Hence, when she wondered what to do now, she discovered that *nun* (now) rhymes with *tun* (do): and when she realized that *Bolte* rhymes with *wollte* (wanted), she suspected that something was happening to Auguste Bolte that she wanted to know more about; and once one rhyme was clear to her, it only served to remind her that *klar* (clear) rhymes with *war* (was). She worried, in fact (and rightly so), that she might finally become smothered in the rhymes that she produced.[24]

Indeed, everything that happens to her is the result of her entrapment in abstract logic, either numerical or verbal, and if the story is "about" anything it is finally about the relationship of abstract order and "real" life, and what happens when order is imposed on life in this way. If this makes it sound rather solemn, nothing could be further from the truth: it is a comical sequence of misunderstandings and absurdities told in an effectively breathless, colloquial and folksy style taken directly from observed life.

There is, of course, a link between a narrative work like *Auguste Bolte* and an abstract poem like the "Ursonate." Each acknowledges the vitality, the self-sufficiency and the forming power of language itself. But whereas the abstract poetry reduces language to its primitive roots, in order to build from this *ur*-form a new order, the narrative work in contrast discovers order of a kind within the "natural" and the vernacular itself.

□ As we saw in Chapter 6, by 1922 Schwitters' collages were showing the influence of Dutch and Russian geometric abstract art. In 1923, the same influences can be found. Hence, *Mz 1600. Rotterdam* alludes in its composition, materials and title to his visit to the Netherlands at the beginning of that year. At the same time, however, he was still making overtly Dadaist works. *Merzbild 12b. Plan der Liebe* (*Plan of Love*), begun in 1919,[25] was completed in 1923 (using Dutch materials) in a rigorous, geometric manner, but its weathered, near-monochromatic surface and Dadaist fragments oppose its new-found order, to produce a hybrid effect not unlike that of *Das Kirschbild* in 1921. The hybrid appearance of the 1923 work is a visual equivalent of the Merz-Stijl collaboration that produced the Dutch performance tour at the beginning of that year.

196

197

VIII

Even more striking contrasts are to be found in other works of the same period. Hence, *Famiglia* of 1922—which adumbrates the jigsaw geometric structures that will develop in 1923—is compositionally not far from an untitled 1923 Dadaist relief, yet clearly opposite in effect. Without their inscribed dates, it would be difficult to place them in the same period; and it would be certainly reasonable to assume, quite wrongly, that the Dadaist work preceded the geometric one. Likewise, it is perhaps difficult to believe, but the very orderly 1923 collage, *Mz 231. Miss Blanche,* actually preceded the *Siegbild* (*Victory Picture*); for that centralized Futuro-Expressionist work was apparently not finished until 1925.[26] Artistic developments are not as orderly and linear as we often assume; these examples suffice to show that the contrast of Dada and Constructivism, like the contrast of Schwitters' anecdotal and abstract writings, was an important polarity in his art of the early 1920s.

<div style="float:right">198
199

XII
200</div>

In Schwitters' visual art the contrasting tendencies were reconciled, as in literature they were not. The important 1923 "Merzmappe" lithographs, issued as a special number of the *Merz* magazine,[27] showed how Dadaist elements could be very firmly locked into a secure Constructivist composition. A very impressive series of often large-sized collages of the mid 1920s developed the clarity and frankness of this approach, while allowing greater freedom and independence to the individual elements. Another—and crucial—contrast in Schwitters' art of the 1920s is between the interlocking grid structure he adopted from International Constructivist (and especially De Stijl) art and the separate identities of the materials that built this structure. This relates to the contrast of Dada and Constructivism, for the use of materials in such a way that their separate identities are manifested is Dadaist; and yet, it is not the same. In Schwitters' pioneering collages, he generally chose to efface the *Eigengift* of materials to make them belong in the geometric structures he was already then creating. By the mid 1920s he was tending to use cleaner materials in even more geometric compositions, with less "painterly" layering; and the earlier Futuro-Expressionist drama had (with only the rarest exceptions) disappeared. As a result, a sense of emotive cooling begins to overtake the work: the pace is slower; part-to-part adjustments are more noticeable; the surfaces can seem colder as well as cleaner. This releases Schwitters' color with a new force and gives to his compositions a new frankness and clarity, but it brings with it the problem of over-consolidation.

<div style="float:right">204</div>

Schwitters' art of the 1920s is by no means alone in showing that the use of simple geometric elements in simple geometric structures can easily become monotonous. Except in the rarest hands, it was an approach that produced, in that decade, a body of over-confined, unadventurous art, for it tended to offer too little variety in the way of design—which was why "biotechnical" elements became popular beside more basic ones, and why even De Stijl artists like Van Doesburg were forced to enlarge their formal vocabularies. Schwitters' dilemma was not unique, then, but it was a particularly difficult one: he had consolidated his art to arrive, by 1923, at a new post-Dada order, only to find that it was a potentially boring one. He could continue using textured, patterned and otherwise allusive materials, thus to enliven the geometry of his compositions; and indeed he did. That, however, was simply to prolong an older approach in a more methodical way; it was not a new solution and therefore risked becoming mechanical.

The opposite solution was new. Instead of energizing the surfaces of his materials, he could relax the recently established compositional geometry, and allow materials a greater independence than they had even in the early collages—in which case, the materials could remain clear and geometric; indeed, they would need to be. Their clarity and geometry would compensate for what had been surrendered on these counts in the newly relaxed compositions. As with the mature pioneering collages, the materials would create the structure. Just as, in those collages, Schwitters had to free himself from dependence on *a priori,* Futuro-Expressionist and Cubist-influenced structures, so in the early 1920s he had to free himself from *a priori* Constructivist, and especially De Stijl, structures. When he wrote of having "condensed" his effects in 1924, and made then his "first attempts at a greater rigor, simplification and more universal expression," it was not to the influence of Constructivism, but to his beginning to achieve a new, personal order out of Constructivism, that he referred.

The larger, mid 1920s collages show how this new order was established. An untitled

XX collage of *c.* 1925, known as *elikan,* reprises the composition of apparently falling materials that we noticed in the early work. The materials, however, are cleaner, crisper, and juxtaposed with stronger figure-ground contrast. They speak more separately than they did before—but because of their common character they speak in a similar voice. In this case, the architectural connotations of both the block-like and the diagonally overlapping materials cause the collage to resemble some views of the *Merzbau.*

203 In *Mz 1926,5 mit lila Sammet* (*with Lilac Velvet,* 1926), Schwitters seems closer to his pre-1922 collages. And yet the clarity of the materials, and their presentation as frankly shaped large, flat planes, makes this a characteristic work of the new mid 1920s order. Even when he used materials as marked and patterned, and compositions as complex, as

202 any earlier collage—for example, in *Mz 26,30 rotes Dreieck* (*Red Triangle*) and *Mz*
201 *26,41 okola* (both 1926)—we see a new expansiveness and openness in his work, and a new sense of materials as tangible shaped planes. While the shape of the materials is as geometric and therefore as "neutral" as ever, we do tend to notice it more. In *Dieser ist*

205 *Friedel Vordemberges Drahtfrühling* (*This is Friedel Vordemberge's Wire Springtime*) of 1927, circular forms reappear after having been suppressed for the past six years. The contrast not merely of grid structure and distinct materials, but of grid structure and distinct *shaped* materials, becomes an important one after the mid 1920s.

Before we proceed to the relief assemblages that Schwitters started making again in 1923, which reveal a similar development to these collages, two problematic aspects of his relationship to Constructivism deserve notice. These concern the place of the humble and the handmade in Constructivism itself.

In a 1925 essay on the Machine Esthetic, Léger remarked: "Every object has become valuable in itself. There is no more waste." Just as during the war, "a nail, a stub of candle, a shoelace can save a man's life or a regiment's," so "in contemporary life, if one looks twice, and this is an admirable thing to do, *there is no longer anything of negligible value.* Everything counts, everything competes, and the scale of ordinary and conventional values is overturned."[28] Much earlier, in 1914, he had written of how ordinary objects, freed from their familiar contexts, could become materials for works of art; this was an early justification of collage, and Schwitters' was very close to it. In the 1920s,

Léger expanded it, and began talking of a "New Realism" in which ordinary, common-place objects were ennobled by being presented in the context of a classic, abstract style.[29] A similar justification underlies the Purist paintings of Le Corbusier and Amédée Ozenfant, who additionally considered humble objects to be often already noble. While these post-Cubist developments were French not German, they were nevertheless generally related to International Constructivism, and certainly to Schwitters' ordered 1920s version of Merz.

In Germany itself, there was a greater gulf between realism and abstraction. However, the preliminary exercises in the use of materials that students at the Bauhaus had to undertake were modeled on Schwitters' collages and assemblages.[30] While the intention of these was to prepare the students for dealing with more rigorously geometric structures—just as Dada was generally viewed as a preparation for Constructivism—they also served to preserve the tradition of Dada collage (and when the students were allowed to relax, the festive art-works they produced were often overtly Dadaist). Although Schwitters' collages were viewed at the Bauhaus as pioneering rather than fulfilled Constructivist works, and only his explicitly Constructivist art met with full approval,[31] the artistic use of humble and waste elements from the modern world was by no means judged irreconcilable with the new esthetic. It was just that they expressed the contradictory, mismatched impulses of the present instead of providing a blueprint for the future.

The place of the handmade was a vexing question for Constructivist esthetics in general after 1923, when machines and manufactured objects became paradigms of the new order. Moholy-Nagy's ideal of paintings ordered by telephone, and Mies van der Rohe's handmade but machine-produced-looking chairs, were opposite but equally perverse solutions to the problem of reconciling hand-production to an ideal of machine finish so exacting that machines were often incapable of realizing it. In the early 1930s, Schwitters had two reliefs made by a skilled carpenter with the idea of producing multiples, but never went through with the project.[32] Whether those prototypes dissatisfied him or his potential customers we do not know. On occasion, he produced replicas of his Constructivist-style works, as if to demonstrate that their form language was so basic and universal as not to depend on the nuances of the hand.[33] And he did make prints, and engaged in mechanical reproduction in the form of typographic design.

Some of his theoretical writings in the 1920s give the impression that he was fully committed to a form language so basic that artistic individuality had no place in it; however, the majority of such pronouncements date from early 1923, when he had not yet overcome his infatuation with De Stijl art—and, indeed, he referred to this universal language as Style (*Stijl*).[34] But even by October 1923, he was writing that Merz meant artistic creation within a universal style.[35] By 1926, he was saying that art was fettered by connections with industry, and that if the modern age wanted an alternative to individualistic creation, not only machines could provide it: that the decline of interest in fine art had led to an increase in popularity both of technology and of sport.[36]

Only when using a mechanical process, as in his typographic work, would he defer—and then not completely—to the machine. Outside that, the calculated use of found machine-made forms in his collages was the nearest he got to the Machine Esthetic. And

234, 236 where "modern" images of this kind do occur—as in group of late 1920s collages with monochrome photographs of machine parts, and even with added parts from a machine—they may certainly have a certain oily metallic look that seems to be celebrative of their sources, but they also reveal a sense of detachment and irony, even, that 96 looks back to the Dada irreverence of *Frau-Uhr* and comparable works. Similarly, a number of the 1920s assemblages I will presently discuss have carefully painted surfaces and laboriously crafted forms. But Schwitters could never transform himself into a meticulous workman, and we sense his relief, as we experience our own, when he stops trying to be one. And when he does try, the results are at times so rudimentary that, again, we wonder if this is not a kind of Dada irreverence in such a rigorously geometric context. Almost without exception, there is a flaw in the geometry. A particularly stark combination of rectangles will be spoiled by a tear in one of the pieces; "straight" lines will veer slightly away from the true; crumples, creases and other irregularities in the papers he used will personalize a first-glance purist effect. And by and large Schwitters wanted it that way. For him, there was finally no "problem" of the handmade: if a work was handmade, it showed it.

However, to produce work that was both obviously handmade and used humble, found objects risked stepping outside the Constructivist esthetic altogether. A group of 206 rough wooden reliefs he made in Arp's company in 1923 do so. His amusing description of collecting the materials for these shows that he knew how far he was from the Constructivists, and also from Arp:

> Once I went with Arp along the sea and picked up material, merz material. Arp was interested and gave me also some pieces of wood or stones. Usually I could not use them, for there were no relations. But I saw him in the pieces. He tried and tried, but he very seldom found a piece of wood with my typical feelings. But an artist as Lissy [Lissitzky] or Does [Van Doesburg] would be quite unable to.[37]

207 To see Schwitters' work beside a similar Arp is to understand what Schwitters means by "relations." Schwitters chose formally compatible materials; while Arp's work depends for most of its impact on the "poetry" of the found, rough materials, Schwitters' additionally forms the materials into a general grid pattern implicit in the chosen forms of the materials themselves.

This relief was made in the Dutch North Sea town of Kijkduin, where the painter Lajos 209 d'Ebneth had a summer home. There he also produced the magnificent *Merzbild Kijk-* XIX *duin* and, on another visit three years later, its companion *Kleines Seemannsheim* (*Small Sailors' Home*). Here are two works that use the Constructivist principle of generic repetition, and reveal the influence of Constructivist geometry, yet Schwitters has produced two indisputably personal masterpieces that have finally very little to do with International Constructivist art. The disposition of bulky forms across a flat, plain 68 background looks back to *Das Kegelbild* of 1921, one of the last high-relief pictures he had made: the combination of circular and linear forms recalls earlier *Merzbilder*.

It is reasonable to assume (as I argued in Chapter 6) that Schwitters' return to making high-relief assemblages in 1923 was influenced by the Russian Constructivist reliefs he saw at the "Erste russische Kunstausstellung" towards the end of the previous year: there

is a general resemblance between these two reliefs and works like Tatlin's 1915–16 *Counter-Relief,* shown at the Van Dieman gallery. However, to Schwitters, Russian art 208 was not merely something excitingly new. It was something familiar transformed, in such a way as to suggest a resolution of the problems which had beset the *Merzbilder* in 1921 and to which *Das Kegelbild* had not been a satisfactory answer: how to continue to use high-relief elements without fitting them into *a priori* compositional arrangements. Tatlin's "culture of materials," which stressed the innate properties of materials and their capability of generating their own intrinsic repertory of forms, led Schwitters to produce these commanding relief-assemblages, *Merzbild Kijkduin* and *Kleines Seemannsheim,* with their broad expressive range of elements—painted and unpainted, rough and relatively smooth, rigid and elastic, geometric and irregular, and so on—in a style that is entirely his own.

He himself referred to them as "transitional" pictures in that they still depended on "the stimulus of details not formed by myself."[38] This was written in 1927, by which time, he continued, he was making pictures with "fewer stimuli, and their contrapuntal elaboration has become so important that the works should be referred to as compositions and only secondarily as Merz." It is unfortunate that he did not recognize what he had achieved in *Merzbild Kijkduin* in 1923 and repeated in *Kleines Seemannsheim* in 1926: a perfect balance between the demands of external stimuli and internal composition. *Albert Finslerbild* of 1926 shows the difficulties that Schwitters found himself in 211 when he deferred too much to the compositional, and to International Constructivist principles. It may be true, as Werner Schmalenbach points out,[39] that the collaged rhomboid subverts the geometric principles on which this painting was based; but it is a sad use of painting's language to tell so poor a joke at its own expense.

Schwitters' artistic progress through the 1920s was not a smooth one, when it came to works other than collages. It properly began in Hannover in 1923, when a number of conflicting impulses emerged in the more ambitious forms of his two-dimensional art. *Für Tilly (For Tilly)* of 1923 (dedicated to another Dutch artist he knew, Hannah 210 Hoech's friend, Til Brugman) is an early example of the characteristic "jigsaw" style that Schwitters regularly used in paintings and reliefs of the 1920s, *Albert Finslerbild* being a later example. In *Für Tilly,* the round metal object screwed to the surface and the balance of circular and linear forms generally recall his earlier relief style. However, the flatly abutted planes of his composition, the absence of overlapping and spatial grading, and the bland, regularized handling of the paint are quite new. Virtually all of the compositional units are painted, and lock firmly one with the next across the flat surface. In other works of this "jigsaw" type, Schwitters would set occasional planes slightly forward of their neighbors: *Albert Finslerbild* is typical of this shallow-relief Constructivist method. In all these works Schwitters relies upon original invention, with little or no help from his materials, and in so doing often falls back into forced, cramped compositions and unoriginal heavy color. These are far indeed from even the most tightly and severely constricted of the contemporary collages; and also as far, it has to be said, from the crisp *moderne* feeling of much International Constructivist art. Schwitters' problem, of course, was to use Constructivism to extend and enlarge Merz, but in the "jigsaw" style he rarely managed to do so.

In fact, those paintings in which Schwitters submitted wholeheartedly to Constructivism, in materials and facture as well as in composition, are often finer. For example, though the sharpness and clarity of *Merz 1003. Pfauenrad (Peacock's Tail)* of 1924 may seem to remove it from what we think of as Schwitters' own style, as a painting it gains from these qualities nevertheless. And the same is true of even more programmatic works of this period, where Schwitters totally committed himself to specific influences, as with two paintings of 1926 in the De Stijl vocabulary and one of 1933 in Feininger's style.[40] None of the oil paintings of the 1920s is both successful and original.

Far more interesting are the Constructivist-style painted reliefs that Schwitters began making in 1923, which arrange a limited number of high-relief elements across a usually plain ground. Works of this kind extend and geometricize, in effect, the approach of *Merzbild Kijkduin,* and in doing so replace found objects with found geometric forms. The 1924 *Relief mit Kreuz und Kugel (Relief with Cross and Sphere)* is at once more direct and more dynamic than any of the jigsaw pictures. It depends less on inventing geometric forms than on using found geometric elements in intuitively realized arrangements, a method Schwitters would obviously find more comfortable and familiar. Although many of these works too are not easily dissociated from contemporary works by other minor Constructivists—bearing comparison, for example, with reliefs by Schwitters' friends Domela and Vordemberge-Gildewart—this format offered Schwitters a way of formalizing his art while still permitting a decidedly manual and manipulative adjustment of its forms.

In the mid 1920s, these painted high-relief pictures took two general directions. The first produced a group of usually quite small, blocky reliefs with relatively few geometric elements arranged in a grid-like way. *Blau (Blue)* of *c.* 1923–26 is characteristic of these simple, sturdy and very beautiful works, which are at one and the same time objects (its ground of vertical planks and geometrically disposed objects producing a symbiosis between the inside of the picture and its literal shape) and containers of objects, albeit objects disguised by paint. They are reminiscent in some respects of early, small *Merzbilder* like *Merzbild Rossfett.* Other works of this kind, like *Merzbild mit Kerze (Merzpicture with Candle)* of *c.* 1925–28, specify this Dadaist connection by including undisguised waste elements among the painted geometric forms. These are all among Schwitters' most successful attempts to "Constructivize" Merz—or, if we prefer it, to Merz Constructivism.

One surprising feature of these pictures is their color. Perhaps we should not be surprised that Schwitters turned out to be such a very fine color painter, given the many coloristically superb collages we have looked at. The process of color juxtaposition in collage and painting is not that different. And yet, the latter requires that colors be chosen and mixed; nothing in his earlier paintings prepares us for the beauty and originality of pure color that we find here. Schwitters seemed unable to control the color balances of very complex compositions, as is shown by the "jigsaw" pictures; but with simpler ones—where color could spread to occupy relatively large areas—he proved himself very adept indeed. As with the Constructivist-style collages of this period, it is the color as well as the roughness of the materials that lift these works out of the ordinary. Many of the reliefs are limited to primary hues and mixed variants of primaries. Their

impact, however, is astonishingly removed from that of De Stijl art, which uses the same color vocabulary. It is not only the more obviously hand-crafted appearance but also the color mixtures themselves that make Schwitters' reliefs seem so personal. They often introduce a certain discordant acidity of color among warmer, more compatible hues.

The same originality in color is to be found in the second group of high-relief pictures: usually larger and more overtly Constructivist works with fewer applied elements and broader expanses of paint. An untitled oval construction, made around 1925, seems less 216
personal to Schwitters than the smaller relief pictures, but within its own terms is a highly impressive work. It is additionally interesting in revealing that, as the size of Schwitters' pictures increases, the elements draw more attention to themselves as discrete, shaped forms. In the case of the oval construction, they have been interpreted as resembling either a schematic human face looking left or the mast and sails of a ship above a horizon, with a rising or setting sun.[41] Whether these interpretations are valid is less to the point here than the fact that the elements so draw attention to themselves as to admit interpretations of this kind. As we saw earlier, when considering the collages of the mid 1920s, Schwitters is admitting stronger figure-ground contrasts into his work and is allowing the separate materials a greater independence within their geometric compositions. Even highly Constructivist works—like a *Weisses Relief* (*White Relief*) of *c.* 1924– 242
27, which at one time was part of the *Merzbau*—allows the relatively anonymous materials a sculptural identity like that of the *objets trouvés* in his early *Merzbilder*. Indeed, this is natural to the relief form, and especially to works of such high relief as this work, where some of the predominantly linear elements run over the boundary of the picture support into the surrounding space. Increasingly, Schwitters seems to be conceiving his pictures less purely as bounded, interlocking wholes made up of neutrally shaped elements and more as grounds for vividly shaped elements to be displayed.

The original conception of Merz required the materials not to be too unusual in shape, lest they detach themselves visually from their neighbors and thereby escape being purged of their worldly connotations. Now that "unworldly," painted materials are being used, the same prohibition does not apply. Indeed, to use materials of unusual shapes—and actually to *form* materials into such shapes—was a logical next step after giving to materials a greater independence. After 1924, moreover—and after the "Nasci" issue of *Merz*—Schwitters was conscious of a wider, "biotechnical," interpretation of Elementarism than that offered by De Stijl in 1923. In *Bild 1926,3. Cicero* (1926), we XVIII
see him using organic, curvilinear elements within a geometric composition. That same year, he wrote an article called "Art and the Times" for the English magazine, *Ray*. There he returned to the "Nasci" theme and said that art was "like nature," and—returning further, to paraphrase what he had written for *Der Ararat* in 1920—that it was a flower of a special kind.[42] In *Cicero,* an organic, flame-like shape burns brightly in the center of a geometric "urban" picture.

Cicero additionally reveals the extent to which Schwitters would simply present or display clusters of shapes on open, hardly inflected grounds. That splendid and witty paraphrase picture, *Wie bei Picasso* (*As with Picasso*) of *c.* 1925–28, makes an object 217
from such shapes, which further separates them from the ground. Schwitters has attempted to mediate between the guitar and the picture-surface by placing the guitar on an

upright rectilinear board, and painting around that in a quasi-*Pointilliste* way to camouflage the division; but it is clear that the two-part division of figure and ground produced by this new compositional method caused him the same difficulties that had beset some of the early, high-relief *Merzbilder*.

218 The 1927 picture, *Richard Freytagbild,* adopts a similar solution to that used earlier: it grades the pictorial space through elements of varying relief and echoes their shapes in the shapes of the background. And just as earlier this had produced a combination of Schwitters' two previously separate kinds of *Merzbilder*—the high-relief "A" type and the flatter, large-collage "B" type—so now this produced a combination (in *Richard Freytagbild* and similar works) of Schwitters' Constructivist high-reliefs and flatter "jig-saw" pictures. The result is a kind of bas-relief painting; in this case, a part geometric,

219 part organic one, which relates to some of Arp's earlier bas-reliefs. Schwitters found this bas-relief approach to be particularly effective and extended it into the 1930s, for

220 example in *Drei Kugeln* (*Three Spheres*), an early picture of *c.* 1920 totally reworked in 1936 to extraordinarily dramatic effect. I will return to it later.

 We have now passed the point (1926) at which Schwitters himself felt he had reached his characteristic new style, a style he described as being concerned with "accuracy of form" and containing fewer external stimuli. Referring again to the polarities that emerged in his art of the 1920s, this meant, in effect, using formal "elements" not found objects, and stressing internal order over external reference; both of which tell of a post-Dada and pro-Constructivist concern for pure form. But the new style also meant that details and shapes were as important as wholes, and even that organic details and shapes were more important than geometric wholes.

 The shaping of individual pieces was inimical to Schwitters' early, Cubist-based collage method, and very few of the mature collages we looked at in Chapter 4 contained shaped pieces. The early 1920s collages, made after Schwitters' exposure in 1922 to International Constructivism (and discussed in Chapter 6), expelled them almost entirely. While the mid 1920s collages discussed earlier in this chapter used pieces that read as individual shapes, they rarely detached themselves from their neighbors to such an extent as to read as isolated "elements," and were never shaped by hand in a way that would thus isolate them. But one medium in which Schwitters worked did use "elements" of this kind, and in an overtly Constructivist style. I refer to his typographical design, which he began seriously to practice in 1924. This may well have been the source for his use of individually charged shapes, for typography, perhaps more than any other art, allowed basic elements of form to be used directly as a vocabulary of expression in a true Constructivist manner. Before returning to Schwitters' collages, and following their progress in the later 1920s, we should briefly look at his typographical work of the same period. Not only do a number of collages include elements from his own typography; many of them use shaped materials as if they were elements from a typographical vocabulary.

221 The cover of *Die neue Anna Blume* of 1922 first shows Schwitters turning against the whimsical Dadaism of his earlier book covers towards simplified typefaces and an asymmetrically organized geometric design, in this instance decorated by the kind of linear abstract shape that appears in some later collages. His definition of good typogra-

phy as "evaluation of all parts in relation to one another for the purpose of bringing out some detail to which one wishes to attract special attention"[43] well fits many of the collages of the late 1920s as well. As was the case with the other aspects of his Constructivist alliance, Schwitters' involvement with the New Typography was motivated first by his contact with Van Doesburg in 1922-23 and then by his work with Lissitzky on "Nasci" in 1924. He had always, of course, been fascinated by printed matter, but only 153, 154
in 1924 did he begin working professionally as a graphic designer, setting up his own agency, the Merz-Werbezentrale, in Hannover that year. It was an immediate success. The issue of the *Merz* magazine following "Nasci" in 1924 (*Merz 11.* "Typoreklame") 225
was devoted to typography and design, and especially to advertising material that he had prepared for the Hannover firm of Günther Wagner, manufacturers of Pelikan ink.[44]

The Günther Wagner contract led to others. He was commissioned to design the official printed matter for the cities of Hannover and Karlsruhe, worked for a number of important commercial clients, produced catalogs and books (not only his own), and in 1929 served as director of typography for the famous Dammerstock-Siedlung architectural exhibition, at which he was apparently able to expand his work to mural- 228
like scale.[45] In 1927, he established an association of advertising artists, "der ring neuer werbegestalter," with Moholy-Nagy, Domela, Vordemberge-Gildewart, and Robert and Ella Michel, and through this organization was in contact with all the important designers of the New Typography. He seems to have spent so much time traveling in this period to promote his contacts and ideas that uninitiated Parisians were known to ask: "Est-il homme d'affaires, le *Merz*, M. Schwitters?"[46] And in many ways he *was* a businessman. Merz became a paying business in the later 1920s.

The "Typoreklame" issue of *Merz* included Schwitters' "Thesen über Typographie," statements outlining his theory of the New Typography.[47] They talk of the necessity of simple, clear typefaces, of the importance of using all parts of the sheet—printed and non-printed—to achieve a well-balanced design, of the superiority of impersonal and functional layouts over ornate and individualistic ones. Yet Schwitters still admonished his colleagues: "never do what anyone else has done, or, to put it another way, always do otherwise than the others." His own accompanying designs are somewhat more static than Lissitzky's in the previous issue of *Merz*, but at their best, as with a double-spread advertising Pelikan ink, are richly imaginative versions of the New Typography. In a brochure published by his own Merz-Werbezentrale in the mid 1920s, he printed a long article, "Die neue Gestaltung in der Typographie" ("New Construction in Typography"), which illustrated how the elements of typographical design should be used.[48] His 222
illustrations show the same isolated "elements" that we find in the contemporary paintings, reliefs and collages. Certainly, his attraction to highly personal colophons, to broad bold rules, and to abstract typographical symbols, and letters used as symbols, speaks of the same sensibility as informs his emblematic collages. In the 1920s, the different 226, 227
aspects of his art—despite all their contrasts and oppositions—do come together under the general umbrella of his flexibly interpreted Constructivist style.

In the typographical picture-books of the 1920s typography was brought to play on the poetic as well as visual side of Schwitters' art. *Die Scheuche*, for example, is com- 155

posed entirely of typecase elements, so that illustration and text become one. Schwitters' "concrete" poems of the 1920s that we looked at earlier should also be seen in this context. Some of his works in this form entirely erase the boundaries between conven-

192 tional genres ("Gesetztes Bildgedicht" of 1922 is perhaps the most startling example), but all of Schwitters' various number and letter poems of the 1920s do so to some extent and are combinations of signs, sounds and images together. So are, if in a rather different sense, some of the collages composed exclusively of typographical elements, as for

224 example, an untitled 1929 work known as *Tortrtalt*. And certainly, the "Ursonate" can likewise be thought of as combining the different facets of his activities—visual, typographic and poetic—and as containing its primordial message in a modern Constructivist form. We are reminded here of a passage from Malevich's "On Poetry" which Schwitters probably read in Lissitzky's translation: "There is poetry, in which the poet destroys objects for the sake of rhythm, leaving tattered scraps of form in unexpected confrontation."[49] "Of such importance to the present time," Lissitzky noted.[50] Schwitters could hardly have missed its relevance to his own art.

Schwitters also said that it was for the sake of rhythm that he chose the fragments he used (both verbal and visual). "In the world of phenomenal forms around him," he wrote in 1923, "the artist discovers some detail or other that need only be torn out of its context to give rise to a work of art, i.e., a rhythm which can also be perceived as a work of art by other artistically minded people."[51] In the 1920s, that is to say, a detail was sometimes sufficient to provide the evocative rhythm. He had always been involved with the "dissociation" of objects from their original contexts so that they would work with others in their new esthetic frame of reference. Particular to his work from around the mid 1920s is the new concentration he pays to individual details. His notion of good design as the adjustment of all elements to bring out a particular detail is only a part of this. The more economical form that his poems assumed in this period was also informed by this idea: that one motif (as the subject for improvisations) could do the same job that a number of motifs did previously. In the case of the "Ursonate," it was the single rhythmic phrase, "fmsbw," which formed the basis for a long, discursive work.

The most extreme form, and the theoretical source, of this concentration on details was a conception he described as "*i*", and manifested in *i-Zeichnungen* and *i-Gedichte*. These were essentially ready-found images and texts not composed by himself, but

92, 124, 125, 235
223 chosen from larger contexts. In the case of the drawings they were formed by cropping out sections usually of discarded proof sheets and in the case of the poems by vertically dividing columns of printed text. This was originally a Dadaist conception (which he first

76 used in his *Aphorismen* of 1918) but was properly codified only in a special issue of *Merz* (no. 2, "*i*") in 1923. Obviously related to Duchamp's idea of the Readymade, it differs, however, in lacking his anti-esthetic intent. Indeed, its motivation was entirely opposite. "I am the *i* artist," Schwitters wrote in 1923. "Kurt Schwitters is the artist of the work *des autres*. I am the artist who turned the song of others, however bad, into a work of art."[52] "The only act of the artist in the case of *i*," he added in "Nasci," "is the metamorphosis of a given object by singling out a part that is rhythmic in itself."[53]

In his 1919 text, "Die Merzmalerei," he had said that Merz painting as a whole sought to shorten the interval between the intuition and realization of the work of art.

i now reduces this distance to zero [he wrote in 1922]. Idea, material and work of art are identical. *i* grasps the work of art in its natural state. The only artistic forming that comes in is the recognition of rhythm and expression in some part of nature.[54]

Art is thus instantaneously created because it is, in effect, already there, waiting only to be cropped out from the flux that contains it. As Schwitters explained with reference to the illustrations in "Nasci," it is already there because nature and chance together are creators of form:

> you will take the photographed surface of Mars for an abstract painting, maybe by Kandinsky, only because it is framed by a black strip. From my "*i*" picture you will see that Nature or Chance often carries together things which correspond to that which we call Rhythm. The only task of the artist is to recognize and limit, to limit and recognize.[55]

The Dadaist principle of randomness thus finds common ground with the "Nasci" one of form as "the frozen instantaneous picture of a process."[56] The year after Schwitters wrote the foregoing statement on his *i-Zeichnungen* (1926), he wrote a long letter to Kandinsky criticizing his book, *Punkt und Linie zur Fläche* (*Point and Line to Plane*), complaining that its theoretical approach to form was unworkable and that the artist should concentrate on recognizing natural rhythms.[57] This Dadaist stress on discovering order amidst the flux of nature may have cost him the chance of having a book published in the *Bauhausbücher* series, for the drafts for that book too, and other writings of 1926, stressed the same themes: art is nature and must search out natural rhythms.[58] To single out rhythmic details in *i-Zeichnungen* was to gain direct access to form in its most basic and elemental state. Searching for such rhythmic details led Schwitters to produce some of his most refined and minimal works.[59] However, as he recognized, "such things are hard to find; nature does not often produce rhythmically balanced things which have only to be recognized as such and cut out."[60] In his collages of the mid 1920s onward, as in his paintings and reliefs, he therefore set out to make them himself.

Two small collages of the mid-1920s—*Mz 1926,12. liegendes emm (reclining m)* 230
(1926), and *Schwarze Punkte und Viereck* (*Black Dots and Quadrangle*) (1927)—are 229
characteristic of the very simplified works of this period. The fragment of typography in the first and the bold forms in the second read as isolated, emblematic shapes to an even greater extent than did the elements in the contemporary larger collages we looked at earlier. Schwitters generally adopted such an approach only in small collages, where the isolated shapes would never lose contact with the edges of the compositions, and order could therefore be maintained even if the shapes seemed merely cropped-out and presented, like those in *i-Zeichnungen*. When making larger collages of this type, such as *Lockere Vierecke* (*Loose Quadrangles*) of 1928, he was impelled to reinstate grid-like 231
compositions, albeit now more relaxed ones—as the title of this work indicates—and with more eccentrically shaped pieces than before.

The more tightly composed collages likewise indicate a change in procedure. To compare *Auf dem Karton*, of *c.* 1923-26, and an untitled collage of *c.* 1926-28 with an 233, 234
illustration of machine parts, is to see a generally similar composition that "points" to

the illustrative material at the right. In the later work, however, the pointing forms are more clearly expressed, and while it contains as much layering as the earlier work, the effect is much crisper. It is constructed from elements or images rather than from shapes: that is to say, from tangible rod-like forms and not from more neutral rectangles and squares. This *c.* 1926-28 collage, and some works like it, use such forms because they resemble rods and pistons and therefore provide iconographic consistency in telling of the apparatus of the machine age; but other collages show that Schwitters was using

232 tangible forms of various other kinds very regularly in this period. The collage *9 of 1930*, for example, is focused on the number from which it takes its name, above and below which misprinted photographs of shoes appear, to tell of an age of commerce and consumerism. Many of the collages of the later 1920s contain thematically related materials, and refer to different parts of an industrial, mass-production world of prices, charts, figures, advertising, and so on; in them, the staccato geometric bustle of the 1920s finds a sympathetic record. Increasingly, however, the molecular flux of the city—as expressed in all-over, contrapuntal compositions—is slowed down, its parts separately examined, and only particularly rhythmic elements are preserved to focus and calm the movement of the collages they dominate.

Around 1930, there was a final Constructivist upsurge in Schwitters' work. Collages

238 of that date like *Mz 30,15 (ENIX)* are sober, dignified, highly geometric compositions. At the same time, however, the number of bold figure-ground contrasts is reduced, to achieve greater force, and the surrounding materials are kept closer to each other tonally.

XXII *Oorlog*, also of 1930, is mostly restricted to beautifully subdued tans and brown, with sudden vivid black and white contrasts. Its looser composition and use of transparency reinforce what its color suggests: a return to the more wistful spirit of the early *Merzzeichnungen*. The stability and openness of this work would have been inconceivable then, and it is not melancholic as many of the early collages were. Nevertheless, it does have something of their spirit.

The isolated figure-ground contrasts of works like these become the very subjects of other collages around 1930. In an untitled work known as *Rot, Grau, Schwarz* (*Red,*

240 *Gray, Black*) they are created from bold geometric elements that resemble thickened-out pieces of typography. But Schwitters was not averse to using anti-Constructivist forms. The flutter of eccentrically shaped pieces in the middle of *Oorlog* offsets its geometry.

239 *Dol 333* (c. 1930) radiates with arching curves. Schwitters had used elements like this in

237 an earlier painting, *Bild mit weissen Sicheln* (*Picture with White Crescents*) (c. 1925-28). In the early 1930s, the dominant shapes in his collages would often be organic ones.

XXIII Hence the huge pear shape in *Pino Antoni* (c. 1933-34), and the distended globe above

241 the engraving labeled *Römischer Park* in the 1934 illustrative collage of that name. *Römischer Park* (*Roman Park*) is a fascinating collage: pictures of the natural world are grafted onto an "urban" geometric structure.

□ By the early 1930s, Schwitters' most important work of the whole period treated in this chapter, the *Merzbau*, was dominated by forms expressive of natural organisms. We must now go back to the *Merzbau* and see how its geometric, Constructivist appearance was gradually softened, for of all Schwitters' works of the 1920s and early 1930s, it was

the *Merzbau* and the sculptures associated with it that most overtly expressed the new interests in shaped and increasingly organic elements that we see emerging in his two-dimensional art.

Schwitters has written that a memorial he made to his father was his first piece of sculpture.[61] It was probably made in 1923, after his return from Holland, for it shows De Stijl influence. He is therefore distinguishing fabricated works like this from his early Dada constructions. Another 1923 sculpture, which seems indebted to Vantongerloo, is close in style to the most geometric parts of the *Merzbau*. At the same time, as we saw in Chapter 7, the *Merzbau* also contained Dada constructions; indeed the contrast of Dadist content and Constructivist form, within an Expressionist whole, was characteristic of the *Merzbau* during its first five or six years. By the later 1920s, however, this had changed: forms began to swell away from the geometric, and twist as they developed linearly to produce a feeling of internal growth. This can be seen in the Big Group which Schwitters illustrated alongside the earlier Gold Grotto in *abstraction, création* in 1933, discussing them as follows:

> The *Merzbau* is the construction of an interior from sculptural forms and colors. In the glazed grottos are Merz compositions arranged in cubic volumes and which blend with the white cubic forms in creating the interior. Each part of the interior serves as an intermediary element to its neighboring part. There is no detail which makes a unified and circumscribed composition. There are a large number of different forms which serve to mediate between the cube and indefinite form. Sometimes, I have taken a form from nature, but more often I have constructed the form as the function of different lines parallel or crossing. In this way I have discovered the most important of my forms: the half spiral.[62]

Needing new elements for the *Merzbau* that would link the earlier Cubic forms to free interior space, Schwitters therefore either simply used elements found in nature or, more often, constructed them around directional lines that he traced out across the open areas of the rooms. The fixed cubic geometry was gradually dissolved as he became attracted to curvilinear, spiraling and organic forms. The few sculptures that still exist from this period (most were destroyed with the *Merzbau*) give us only a limited idea of what he was striving at. *Die Herbstzeitlose (The Autumn Crocus)* of c. 1926-28 does show that he would actually abstract from specific natural forms. More often, however, he seems to have either chosen elements that seemed expressive of growth and painted them to generalize their reference, or carved such elements himself and then painted them, or built up such elements out of plaster. *Schlanker Winkel (Slim Angle)* of c. 1930 and an untitled column of 1936 are representative of such approaches. In the *Merzbau* itself, the Big Group and the section of wall behind the Gold Grotto used even more overtly organic forms, as did a branch-like sculpture shown in a mid 1930s photograph. The *Merzbau* "was like some jungle vegetation," Richter remembers, "threatening to keep on growing forever."[63]

His real aspiration here, it has been said, was towards infinity, but an infinity located inside space and at its imaginary center.[64] It was also a way of breaking that deadlock between formal rigidity and fantastic, imaginative content that had characterized the

Margin notes: 243 | 246, 245 | 168 | 247 | 248 | 250 | 168, 170 | 252

Merzbau's previous development. By using forms taken from nature less often, and searching instead for a fabricated vocabulary of analogous forms with the same charge that found objects possessed, Schwitters set out to create for himself an environment that was private and primitivist at the same time. And this was his way out of pure geometry—one which his own organicist interpretation of Constructivism allowed. It was a liberation from the more rigorous, constrictive forms of that esthetic.

> As the structure grows larger and larger [he wrote of the *Merzbau* in 1930], valleys, hollows, caves appear, and these live a life of their own within the all-over structure. The juxtaposed surfaces give rise to forms twisting in every direction spiraling upward.[65]

In this way he transcended the rigidity of geometricism and recovered, in the very forms of the *Merzbau*, something of its original fantastic content: in a romantic ideal of growing, spiraling forms. It was, moreover, a fantasy that was no longer grotesque but luxuriant, and one that no longer harbored the most uneasy and Expressionist of Schwitters' emotions, but offered an escape from them—and indeed from all the local and particularized facets of his personality—to something more generalized and more ideal.

Given the importance of the *Merzbau* to Schwitters, it would seem entirely proper to suggest that it contained the central conceptual themes of his art between 1923 and 1937, and to discover in its formal development the seeds of his increasing preoccupation first with "shaped" forms and then with organicist ones. Certainly, by the early 1930s he had become fascinated by forms that have some sense of "natural" structure, that have individual weight and presence, and that declare themselves as fabricated objects. Given the assemblage basis of Schwitters' art, its emphasis upon syntax rather than upon vocabulary—that is to say, upon connecting neutrally shaped units rather than upon forming units themselves—this is indeed a change in direction. Although Schwitters never abandoned assemblage, what began to happen with the *Merzbau* modified his conception of the technique, and finally carried him, in some respects, beyond the Cubist principles that had hitherto always informed it.

His sculptures had never had much to do with Cubism. Once the "Nasci" interpretation of Constructivism had been codified and the *Merzbau* began to grow, their increasing organicism took them almost completely outside the Cubist orbit. As far as Schwitters' assemblages and collages are concerned, the "Nasci" idea that art was an organism of a special kind did not radically alter their basic Cubist structure: "shaped" elements often replace neutral ones, but their compositions are still Cubist-based. The "Nasci" idea meant that a work of art, like a work of nature, was the picture of a process; but it did not mean that art should resemble nature. With Schwitters' sculpture of this period, however, and with the *Merzbau*, we see that he espoused not merely an internal or functional organicism but the very appearance of natural organisms as well. There is a direct formal analogy between a work of art and a work of nature, whereas a true Constructivist would analogize only the principles of natural growth and never its appearance. The fusion we see in Schwitters' sculpture, of organicist conception and what is best called soft geometricism of form, places it within that cross-stylistic category known as "Vitalist."

"Vitalism," as applied to the visual arts, refers to work, particularly sculpture, that uses generalized biomorphic or zoomorphic forms.[66] It derives from a long-standing belief that basic organic elements can be discovered, which express the underlying order of all forms of natural creation behind their specific appearances. By the time of Romanticism, it had become attached to another belief, that art objects, as created things, share (or should share) this order too. In English, the most famous expression of this idea is Coleridge's refutation in *Biographia Literaria* of Hartley's mechanistic philosophy. Coleridge asserts that, while "objects *as* objects are essentially fixed and dead," the product of the imagination is "essentially *vital*." Art, as the product of Coleridge's "imagination" or later of Henri Bergson's *élan vital*, was a manifestation of "becoming"; it seemed to grow from inner direction. But it was not merely organic—that is to say, something whose processes reflected those of nature—it was *vital*, and therefore should actually resemble nature in its most purified, basic form. Art was a kind of plant, and its tendrils grew in increasingly curvilinear forms from William Blake to Art Nouveau and into the twentieth century.

Arp's early Dada *Urwelt*, or primeval world, was one of the most important first manifestations of modern Vitalism, and expressed—as Vitalism always had—opposition to the dark satanic mills of modern technology. Arp's biomorphic form-language became the basis of Surrealist art, and the modern contrast of Surrealism and Constructivism recapitulated the old Vitalist-Mechanist dispute. The Lissitzky-Schwitters attempt, in "Nasci," to demonstrate that "the modern world is but the other half of nature, the half that comes from man," was motivated by a desire to reconcile this dispute, which for Schwitters, certainly, was one of the most important of the many oppositions he addressed in this period—if not the most important, for it had been in existence since the very beginning of Merz. He had begun his artistic career as a landscape painter; had continued to paint landscapes, believing (as his son puts it) "that the human mind eventually becomes stale if it does not receive new impressions constantly through the study of nature";[67] and had always insisted that art itself was something primordial. But Merz was an urban art, made from the refuse of cities and expressive both in materials and form of the structure of a manmade environment. The Constructivist alliance had reinforced its urban connotations. "Nasci," in 1924, had been Schwitters' way of reconciling Vitalism and Mechanism. By the end of the 1920s, however, it seemed to have been only a compromise—judging, at least, by what was happening to the *Merzbau*.

In 1930, in the French magazine *Cercle et carré*, he returned to the "Nasci" idea, writing that "art is never anything but structure, creative clarity. There is no difference between that and the growth of a plant or a crystal, the life of stars or the construction of a machine."[68] But biology and crystallography offer rather different examples of natural structure. The latter was especially attractive to Constructivist artists because it allowed them to claim that their geometric universe was organic too; the geometric stage of the *Merzbau* was broadly crystalline. In the last stage of the *Merzbau*, biomorphic forms replace crystalline ones; in 1933, replying to a questionnaire from *abstraction, création,* Schwitters said that a machine (a locomotive was his example) is not a work of art and that his own *abstract* compositions were influenced by everything that he had observed

in nature, for example trees.[69] And he illustrated sections of the *Merzbau* which show organic forms; the "most important" of his forms, he writes, is that quintessential symbol of Vitalism, the half-spiral.

The Parisian *abstraction, création* group, to which Schwitters was affiliated, was a coalition of mostly late Cubist and Surrealist French artists and of International Constructivists from Germany and beyond. It constituted a melting pot of pioneering modern styles, as the impetus of pioneering modernism was coming to an end and earlier partisan stances were relaxed. Insofar as there was a characteristic *abstraction, création* style, it was one that combined the abstractness of synthetic Cubist space, the non-figuration of International Constructivism, and the illusionism and biomorphism of Surrealism. Schwitters' work of the 1930s should therefore be seen in the context, say, of Kandinsky's Paris-period paintings, Barbara Hepworth's early sculptures, Arshile Gorky's Cubist-Surrealist hybrids, Auguste Herbin's curvilinear form of Synthetic Cubism, and Arp's "Concretions," all of which appeared in the pages of *abstraction, création* in its five issues, published from 1932 to 1936.[70] It should also be seen in relationship to the disenchantment with things urban and modern produced by the Depression; the collapse of the Constructivists' hopes for a new, ordered environment, with the failure of utopian ideologies in Germany and the Soviet Union and the suppression of advanced art there; and the widespread revival of interest in the natural world. This interest manifested itself in things both delightful (the popularity of Blossfeldt's 1929 book, *Urformen der Kunst* [*Primal Forms of Art*], with its magnified photographs of nature) and pernicious (the Nazis' *völkisch* ideology); with all manner of bland, harmless things like 1930s Realism and the craze for *objets trouvés* in between.

Schwitters had always been fond of the countryside. In 1929, he made his first visit to Norway on the recommendation of Hannah Hoech. So impressed was he, that he returned in 1930, again in 1932, and from 1933 through 1936 spent more and more time each year on the island of Hjertøy in the Moldefjord in western Norway. It was only to be expected, perhaps, that the character of his work should change: after all, its materials had always reflected the environment in which he lived.

Around 1930, Schwitters enrolled Moholy-Nagy's help to make a "White Palace" for the *Merzbau*, in which his guinea pigs could live; it resembled a little modern villa.[71] Shortly thereafter, in 1933, he made a glass-fronted grotto similar to those from which the *Merzbau* began. But whereas the earlier grottos had contained urban refuse, this grotto—entitled *Zur Erinnerung an Molde* (*In Remembrance of Molde*)—is packed full of organic matter and looks like a Wardian case, a Victorian glazed miniature environment for growing ferns and exotic blooms. Photographs of the *Merzbau* show any number of curling "growing" forms, silhouetted against the Blue Window, bending through the Big Group, protruding above more crisply geometric planes. These forms required a change in materials: whereas the earlier, geometric parts of the *Merzbau* could be constructed from wood, these had to be modeled from plaster.

In some respects, Schwitters' Vitalist esthetic relates to that of his friend Arp (whose "Concretions" probably influenced Schwitters' turn from sharp-edged to softer organic forms in the 1930s).[72] Both conceived of their forms as primordial, talked of art as growth, and sought to express this in their sculptures. Unlike Schwitters, however, Arp

253

made the surface of a sculpture look like a thin flexible membrane deformed by internal pressure. While the meticulous finish of Arp's sculptures gives the impression that forms have grown (and only just grown, at that) somehow independently of an external forming agent, Schwitters' surfaces always look handled. He never fully embraced any kind of purist esthetic, even the Vitalist one. In consequence, where Arp's surfaces appear to have been generated from inside, the plaster of Schwitters' sculptures never quite escapes looking like a skin which contains the armature of objects beneath. The tension thus provided between the natural and the handmade—between the chosen objects and organic forms and their artistic covering—affords a sense of continuity with Schwitters' assemblages, where the tension was between urban objects and the artistic context in which they were placed. Now, however, his methods have been turned inside out. No longer are objects placed and displayed on surfaces that we recognize as being artistic; they are buried within them. Even in his plaster sculptures, Schwitters never entirely relinquished his attachment to found objects. They became the source and inspiration for the modeled surfaces that he applied to them. A contrast therefore still remains between the world of art, which received the "foreign" elements, and the world of external reality, from which they derive. This is a link to his earlier art, with its basic Cubist focus on the conflict between reality and artifice. However, the manner in which it is now presented is not Cubist at all.

251
252

The use of an enclosing and containing skin is profoundly anti-Cubist, precluding as it does the openness and spatiality of part-to-part organization. But Schwitters had never been interested in making fully three-dimensional versions of his collages, for he felt that "only within a limited space is it possible to assign compositional values to each part in relation to other parts."[73] He could not have been unaware of Cubist openwork sculpture which proved that space could be limited without being two-dimensional,[74] but he clearly felt that three dimensions demanded a different approach. Hence the duality, from the mid 1920s onwards, of open, Cubist-structured collages and assemblages and monolithic anti-Cubist sculptures. And yet, these hermetic, self-enclosed sculptures were generated out of Schwitters' desire to organize three-dimensional space in an open and spatially dynamic way, that is to say, in the context of the *Merzbau*. In the limited space of the *Merzbau*, Schwitters was indeed able to assign to these sculptural forms part-to-part compositional values, and thus create quite a new kind of Cubist architectural interior, organized not by anonymous geometry but by elements that seem organically alive.

□ Around 1930, I wrote earlier, there was a final Constructivist upsurge in Schwitters' work. It was accompanied by an anti-Constructivist one. Hence we find such contrasting works as *Bild mit drehbarer Glasscheibe* (*Picture with Revolving Glass Disk*), with its industrial materials, and *Plastische Merzzeichnung* (*Sculptural Merz-Drawing*), with its weathered pieces of natural wood. The most important development of that year, however, and one which finally carried his art beyond the orbit of International Constructivism, was extrapolated from what we have just observed in the *Merzbau*: the principle of enclosing objects within a continuously modeled skin.

255
254

217 The relief *Wie bei Picasso* of *c.* 1925–28 had made use of quasi-*Pointilliste* painting in an attempt to prevent the cluster of shaped forms resembling a guitar from visually detaching itself from the background plane. In a 1930 picture made in Norway, *Hoch-*
256 *gebirge (Gegend Øye) (High Mountains[Øye Neighborhood])* Schwitters overpainted the found materials with organic shapes treated in a dappled, overall manner. The next year he produced a major assemblage whose title as well as structural method constitutes
XXI virtually a manifesto: *Neues Merzbild (New Merzpicture).* Its formal vocabulary looks
VII, 67 back to old *Merzbilder,* like *Konstruktion für edle Frauen* or *Bild mit Drehrad,* with their
XIX machine-like elements. It also relates to certain reliefs of the 1920s—*Kleines Seemanns-*
214 *heim,* for example, or *Merzbild mit Kerze*—and suggests that Schwitters was trying to synthesize the methods of his most ambitious Dada and Constructivist works. But the loose, dappled brushwork is neither Dada nor Constructivist. It camouflages the added materials so that they appear to lie within and behind a variegated frontal membrane of multicolored paint. Schwitters seems to have wanted to dissolve the geometric elements within a shifting Impressionist surface that looks back, beyond Merz, to his early landscape paintings. He thus liberates himself from the austerity and anonymity of things modern by using an individualistic, and atavistic, painterly touch.

Virtually all the contrasts of the 1920s are encapsulated in *Neues Merzbild.* It is Dada and Constructivist, anecdotal and abstract, environmentally allusive and self-contained. It has machinist connotations but is patently handmade. It is vividly colored in part yet tonal in conception. It contains shaped elements that combine in an all-over, contrapuntal composition. The elements are both geometric and organic. It alludes in materials, forms and composition to the city and the country. In 1931, when *Neues Merzbild* was made, Schwitters finally made public the content of the *Merzbau,* divulging private and introspective feelings which he had withheld while Constructivism had been his declared allegiance. *Neues Merzbild* is an elegy to the Machine Age, a machine in a garden overgrown by the patterns of the natural world.

☐ Schwitters' artistic contacts grew year by year in the 1920s. By the second half of that decade he was a widely traveled and widely exhibited artist with an international reputation.[1] In 1927, he organized a major retrospective of his work, the "Grosse Merz-Ausstellung," which was shown in several German cities. His collages, paintings and assemblages were included in exhibitions both inside Germany and abroad. And his other areas of interest were not neglected either: theater designs, typography, even photographs he had made, were represented in international survey exhibitions. He was an adviser for the 1926 New York exhibition of Katherine Dreier's Société Anonyme, where his work was shown in depth;[2] a contributor to the important Abstract and Surrealist Painting and Sculpture Exhibition in Zurich in 1929; and included in the 1930 "Cercle et carré" exhibition in Paris, from which the *abstraction, création* group developed. Additionally, his own *Merz* magazine and Merz-Werbezentrale advertising agency were thriving; he was in demand for articles, lectures and performances; his work was selling quite well; and he was leading a busy life in Hannover, which, though not as active an avant-garde center as it had been in the mid-1920s, nevertheless provided plenty of outlets for his seemingly inexhaustible energies. As Lionel Trilling once wrote of Dickens, "the mere record of his conviviality is exhausting." Schwitters was indeed a Dickensian figure in his Hannover world; and like Dickens, beneath his high spirits there was a permanent emotional insecurity and restlessness, which flavors the rich mixture of ingredients that Merz was made from, giving to it at times a disturbing taste.[3]

Part of the reason that Schwitters was exhibiting abroad so often by the end of the 1920s was that, even as early as 1925, the effect of fascism had begun to make itself felt in provincial Hannover. Art lectures were disrupted by right-wing demonstrations, and anti-modernist sentiments increasingly gained a hold.[4] By the early 1930s this was being repeated right across Germany. There was, it is true, an Expressionist revival from 1930 to 1933, when it seemed for a time that at least one form of modern art could be absorbed within the new *völkisch* ideology; but only for a short time. In 1933, the earliest "Entartete Kunst" ("Degenerate Art") exhibitions were set up in German provincial capitals (but not in Hannover; the art administration there remained intransigently pro-modern far longer than most) and the attacks on modern art continued to gain in pace, culminating in the "Entartete Kunst" exhibition of 1937 in Munich, which included a group of collages and assemblages by Schwitters, among them the work that launched the word "Merz", *Das Merzbild* of 1919.

In 1936, Schwitters made a large group of collages using pages from the Koran and parts of Camel cigarette packs.[5] A whole series of iconographically similar collages is

42

very unusual in his work. He seems to have been making an imaginary journey to a more hospitable land. But Mussolini annexed Abyssinia that year; the Middle East was not much more desirable than Germany, where internal conditions were fast becoming dangerous for artists like Schwitters. He was not Jewish but he was outspoken in his distaste for Nazism. A story, both amusing and frightening, is frequently told of how Schwitters, forced into jurying an exhibition to which portraits of Nazi leaders were submitted, spontaneously said of these works: "Shall we hang them or stand them up against the wall?"[6] Many of his friends had moved to Paris, encouraged by their experiences as members of *abstraction, création*. Only in January 1937 did Schwitters finally leave Hannover, just escaping the arrest that his old colleague Christof Spengemann suffered.[7] His visits to Norway since 1929 had become more and more extended; to move there entirely was an obvious choice.

Norway had gradually loosened his contacts with the lively urban culture that had so stimulated him. He had never, of course, lived for any length of time in a large metropolitan center, preferring to visit Berlin, Paris and other major cities from the security of his provincial home. This helps to explain why he did not move to Paris in the 1930s, accepting isolation (and it came to that) rather than surrender the kind of independence, and perspectival distance from the avant-garde center, that living in the provinces allowed.

His son, Ernst, traveled with him to Norway and they found an apartment at Lysaker, near Oslo. Schwitters' wife, Helma, remained in Hannover to look after the four houses the family owned, which were its main source of income by this time. But she regularly visited Lysaker; after all, conditions might improve. The outbreak of war in 1939 finally put an end to any such hopes. Schwitters never saw his wife again. The last decade of his life was spent in exile, much of it in discomfort, illness and penury. He had escaped certain persecution in his own homeland, and was happy in many respects to live in close proximity to the spectacular Norwegian scenery he had come to admire. He had his privacy. But he had abandoned not only all hope of a regular income but also the *Merzbau*, which had preoccupied him for over a decade. He was regularly pressed by the Norwegian authorities to leave the country, for he had no work permit, no visible means of supporting himself, and Germans were not particularly welcome guests. There were plans to move to America, where he had contacts and friends, but they were never realized. He apparently remained in good humor. It is clear, however, that these were sad and very frustrating years. No longer was he in control of his own world. At nearly fifty years of age, he had to begin again.

□ A "hankering after the primitive" had been noticed by Huelsenbeck even in Schwitters' earliest work, a desire to get away from "the complicated, overcharged, perspectively seen present."[8] In the twenty years or so of work we have considered thus far, we have indeed recognized conflicting affiliations on Schwitters' part between the bustling urban environment, which was the background and source for his art, and a primeval, even mystical, understanding of art itself, which opposed this background and attracted him to the natural world. Outside Germany, the physical sources of his art were changed because he spent much of his last decade in rural settings. More importantly, however,

the tension between urban and natural inspiration—which persisted even in his work of the early 1930s which used natural materials and painterly surfaces that alluded to nature—now gradually faded. As a result, the crisp, urban and Cubist-derived structures of his art of the German period were relaxed. It is not just that organic forms accompany natural materials; the Cubist basis of his art underwent major revision. Since a modern art of assemblage is, virtually by definition, a Cubist art, the revision could never erase the most fundamental aspects of his Cubist heritage; nevertheless, the character of his work was very significantly changed once he moved from an urban to a rural environment.

His work had always been a kind of running autobiography. The structures as well as materials and forms of his late work tell eventually of a rather different artist from the one who had lived in Hannover; an artist who had been forced to make a new start. There came a time when Schwitters declined to use the German language, in his art as in his writings and speech.

Failure to grasp that Schwitters was indeed using a new language has caused his late work to be misunderstood, and consequently undervalued. I am not arguing that his work should be judged according to what we understand to be his changed intentions, for we cannot, of course, really know these intentions except from their embodiment in his work. Rather, I am suggesting that to approach his late work with the expectation that it speak the same language as his earlier work is bound to lead to misunderstanding. While a comparable problem of appreciation exists in the changed character of his Constructivist from his Dadaist work, there we have the benefit of knowing, from other artists' work, the language of International Constructivism. In his late work, as in his life, Schwitters is on his own. It is true that his late style was not achieved without difficulty, and that there are more failed works than hitherto. At the same time, the best of the late work is stylistically original and qualitatively very impressive indeed.

Not all of the late work, however, is that different from what we have already seen. Schwitters continued his practise of recapitulating older forms even as he established newer ones, and as we shall see much of the late work involved modification and revision rather than replacement of earlier procedures. Certainly, at the very beginning of this exile period, it looked as if very little had changed. Collages like *N* (*c.* 1936–37) and *Oscar* (1939) use Norwegian as well as German materials, but are stylistically no different from earlier German collages. The *c.* 1937–38 collage known as *Qualit* includes part of a photograph of the chairs designed by Hans Nitzschke that were sent from Hannover to Lysaker. Like the chairs themselves, this is a metallic modern work. Also patently urban is *Glückliche Ehe* (*Happy Marriage*) of 1939, although we might be prompted to ask whether the marriage referred to is between the female (Anna Blume?) head and the fashionable male attire, or between both of these and the fruit and landscape setting in which they appear.

Another 1939 collage with illustrative elements, however, is very different indeed from anything Schwitters had made since the early 1920s. *Prikken paa Ien (The Dot on the I)* is loosely and openly structured; includes strongly directional, linear elements as well as flat, planar shapes; contains much textural overlapping and transparent glazing; and is very large—nearly 30 by 36 inches (76 x 91 cm). In the spring of 1938, Schwitters

257
259
258

260

261

had managed, with difficulty, to have a lot of his earlier work sent from Hannover to Lysaker.[9] The very ambitious format of *Prikken paa Ien* recalls his early large collage-type *Merzbilder*. It eschews, however, the tightness and compression of those works, its unusual horizontal format itself telling if not of a post-Cubist then of a late Cubist attitude to design. The broadness of the surface, and the expansive "breathing" space that it provides, speaks of a release from the constraints of urban existence, even while the claustrophobic mass of geometric, overtly urban materials recalls such an existence. This is a fascinating, transitional work.

As early as 1937, Schwitters had been producing even more loosely structured and more "painterly" collages. One such work—containing a pair of German customs labels, inscribed *zollamtlich geöffnet* (*Opened by Customs*), a reminder of Schwitters' separation from his homeland—opposes an underlying grid with swirling surface forms. *Rotterdam* does something similar with textured materials. Here, the kind of variegated surface treatment that we noticed in *Neues Merzbild* of 1931 illusionistically dissolves the flatness of the materials into a loose, impressionistic space and overall atmospheric mood. In both of these collages, as in *Neues Merzbild*, geometry is present but opposed. Whereas in *Neues Merzbild* it was opposed by an actual painterly surface, here it is opposed by an illusion of painterliness. Schwitters would regularly use both approaches in his late work. His continued attraction to photographic and other illustrative materials would seem to have been prompted, in part, because they too allowed him to make collages that were still patently flat yet dissolved illusionistically across their surfaces at the same time. The large English-period collage known as *Counterfoil* (*c.* 1942–43) thus shows a crisp Cubist structure "camouflaged" by the use of photographic materials. Schwitters began using this approach at the beginning of the 1930s; but it may not be fortuitous that the appearance of collages like these coincides with the Second World War, when camouflage was established in its characteristically organic, "painterly" form. (First World War camouflage was far more geometric.)

Two topical influences would seem to explain Schwitters' very untypical interest in *objets trouvés* in the years 1937 through 1939. He had always insisted that the individual potency of his materials should be effaced in the process of picture-making. While the objects he chose for presentation in these 1937–39 works share a compositional "geometry" of ovals, circles and straight lines that is very familiar from his earlier art, this is overwhelmed by the blatant literal presence of the objects themselves, which range from pieces of cork and unusual coiled branches to fragments of animals' jawbones, with attached teeth. One influence on these works is obviously Schwitters' move to Norway. His existing interest in shaped forms led to this new interest in the more unusual products of the natural world: with rare exceptions they are all "rural" objects. But the publicity which Surrealist objects had received in 1936 could also have influenced his return to the *objet trouvé* form.[10] If this is true, these works represent a rare instance of direct Surrealist borrowing on his part. Surrealism, Schwitters wrote, "is litterature [*sic*] with wrong means, not painting, therefore wrong."[11]

Some paintings of 1937 and later, containing grotesque faces and still-life objects, in the new *Pointilliste* style can also be attributed to Surrealist influence,[12] as can the few late reliefs he made with pure, smooth biomorphic forms.[13] The general shift in his late

262

264
XXI

283

263

work to illusionistic space and organic, curvilinear elements associates it with 1930s Surrealism. And yet, the influence of natural scenery would seem to have been greater than that of any artistic style. A photograph album that Schwitters kept in the 1930s 265 shows us that he was interested in details of organic and geological forms. His late naturalistic paintings generalize the landscape in fluid, atmospheric brushwork. Abstract paintings like *Mz Oslofjord* (1937) could well have been painted either from 266 photographs or directly from the landscape. What Schwitters learned from nature in these works had its effect on his more ambitious and resolved assemblages and collages.

The small assemblages, *Everybody's hungry for* (c. 1938) and *Merzbild Alf* (1939), 268, XXVI bring together, to varying degrees, the characteristic components of his late style: rural *objets trouvés*; blatantly shaped, organic forms; illustrational or other inherently illusionistic materials; painterliness or the illusion of painterliness; compositional openness, with more "breathing" spaces between elements than hitherto; and planar surfaces and materials whose planarity is "camouflaged" in some way, causing it to seem partly to dissolve. The former work is part urban, part rural, and reminds us of wartime hardships ("Study the food pages, too," is one of the messages it contains); the latter is a purely rural work. The scrap of Gothic lettering that gives it its name reminds us of the early *Merzbilder,* only to show what has been changed. Instead of urban refuse taken from the streets of Hannover, we have here flowers and leaves, and a surface that is scratched and scored, and softly painted to evoke the effect of natural terrain. Schwitters' German art, be it Dadaist or Constructivist, had evoked the city: "If I ever move from Hannover, where I love and hate everything," he had said, "I will lose the feeling that makes my 'world point of view'."[14] In the art of his post-German period, nature, both its whole and its parts, is seen esthetically through city-bred eyes, as a kind of grand *objet trouvé* to be absorbed into his work. The art historian Arnold Hauser has spoken of Dadaism as a romantic Rousseauism in its advocation of chaos;[15] Schwitters' late work reveals a Rousseauist view of nature as an ideal, primitive wonderland, a view entirely different from his love-hate relationship with city life. In the last decade of his life, he finally manages to rebuild the enchanted garden of his childhood, which was also the subject of his earliest abstract art.

I mentioned that *Prikken paa Ien* of 1939 recalls the early, collage-type *Merzbilder* 261 which were among the pictures that Schwitters managed to have sent to Lysaker in the previous spring. *Bild mit Raumgewächsen (Picture with Spatial Growths)* of 1920 was 270 one of these pictures. In November 1939 (as shown by the inscription in its upper right corner), Schwitters drastically reworked it, renaming it *Bild mit 2 kleinen Hunden (Picture with 2 Small Dogs)*, after the miniature dogs that can be seen in the box to the left of the 1939 inscription. The swirling, "painterly" effect of the revisions, and particularly the way in which materials are blended to produce a single dominant arc-shape, returns in some respects to the *a priori* compositional approach of the early *Merzbilder*. The identities of materials are submitted to large compositional movements. Unlike the early *Merzbilder,* however, *Bild mit 2 kleinen Hunden* is free from Futuro-Expressionist geometry and from the kind of contrapuntal, all-over balances that earlier opposed such dominant compositional movements.

67 *Merzbild 29A. Bild mit Drehrad* (*Picture with Flywheel*), also of 1920, was another picture sent to Lysaker. While its changes seem to have been less drastic than in the case of *Bild mit 2 kleinen Hunden* (Schwitters changed neither its title nor date, and it has hitherto always been published and exhibited as a 1920 picture), this may well have been because it was already the least evenly inflected of the early *Merzbilder*, its large materials and horizontal format giving it a slower sense of momentum and suggesting less instantaneous reading than other comparable 1920 works. In the three most important large relief assemblages that Schwitters made in Norway, he built on these particular aspects of his earlier work.

XXV Of the three, *Merzbilde med regnbue* (*Merzpicture with Rainbow*) of 1939 is most compatible with earlier assemblages. Its disposition of rough wooden planks, flat painted boards and fragment of a wheel against an open background recalls the best of XIX the mid 1920s reliefs, like *Kleines Seemannsheim,* and looks back further even to espe-VII cially dramatic *Merzbilder* like *Konstruktion für edle Frauen,* of twenty years before. However, the more natural appearance of the materials and the broad atmospheric brushwork (including the "rainbow" effect which gives the picture its title) are new. Schwitters has opened and expanded the pictorial space—the picture is more than 61 by 47 inches (155 x 119 cm) in size—to more relaxed, though still dramatic, effect. The materials seem to be not so much fastened down upon the surface as strewn, floating *across* it, like debris lying on top of a pond in which the sky is reflected. *Merzbilde med regnbue* is at one and the same time an illusionistic picture, which evokes the climate and atmosphere of nature, and a factual picture, which refers to the natural world through representative tokens. This magnificent work encapsulates these two principal directions of Schwitters' late style.

220 In *Drei Kugeln* (*Three Spheres*), the 1920 picture reworked in 1936 referred to in the previous chapter, Schwitters had adjusted high-relief elements to an open background by painting the background with forms as assertive as the relief elements themselves. The XXIV second of the three most important Norwegian assemblages, *Die Frühlingstür* (*The Spring Door*) of 1938, adopts a similar juxtaposition of graphically painted and bulky relief forms, and similarly pulls the relief forms away to the edges of the composition to give the act of framing a new structural emphasis. This also makes the relief elements read very abstractly, for the associative function of Schwitters' materials tends to be lessened to the extent that the materials seem actually to constitute the pictorial structure of any given work. It follows, therefore, that materials that lie within, and near the center of, a pictorial rectangle read most strongly in an associative way, and those that stay close to the edges, or repeat the geometry of the edges, read most abstractly. It also follows that materials placed on illusionistic surfaces read in a more associative way than materials placed on surfaces that are patently flat and abstract, for materials placed on illusionistic surfaces (as in *Merzbilde med regnbue*) appear to float separately across such surfaces, and therefore to speak separately, whereas materials placed on flat, abstract surfaces (as in *Die Frühlingstür*) more obviously belong to the physically constructed totality of the picture.

However, what is extraordinary about Schwitters' late assemblages is that, whether his materials' associative functions seem more important than their abstract functions,

or vice-versa, the materials themselves seem to have generated the structures of the works. With the exception of one kind of late assemblage—which is only a partial exception, in any case—it is the physical substance of the materials, and their intuitive adjustment and juxtaposition, that provides the pictorial logic of Schwitters' late work. Whether or not the materials seem associative, whether or not Schwitters sets them against illusionistic backgrounds, whether or not he camouflages them with dappled overpainting, they are the tangible components from which his art is made. The underlying sense of an organizing, Cubist geometry never entirely disappears, but it is far less noticeable. The *a priori* compositional approach of the early *Merzbilder* and of most of the Constructivist-style reliefs is replaced by a more casual and improvisatory order, discovered in the materials themselves.

The exceptional, because overtly "composed," type of late assemblage is typified by the third of the great Norwegian assemblages, *Glass Flower* of 1940. Here, the "flower" formed by the piece of a broken glass bottle and the painted wooden "stamen" is indeed placed within an *a priori* composition of organic forms. Even here, however, the materials (painted and unpainted) declare themselves with a vividness and directness that is no less candid than in the other two assemblages, and the composition of the work is based on, and recapitulates, the rhythms suggested by the materials. Indeed, the use of illusionistic painting reinforces their sculptural presence (not opposes it, as in *Merz-bilde med regnbue*); painting and modeling come together here to produce an effect analogous to that of found objects. Once again, we see Schwitters attempting to create fabricated objects with the same potency as found ones. Previously, this attempt was focused around his work on the Hannover *Merzbau*. In Norway, it accompanied a new *Merzbau* that he built near to the house at Fagerhøyvien 22, in Lysaker, where he lived.

XXIX

Like the Hannover *Merzbau*, the Lysaker "Haus am Bakken" or house on the slope, as Schwitters referred to his second *Merzbau*, is now destroyed. It perished without trace in a fire in 1951 and no photographs were apparently ever made of it. Our knowledge of it, therefore, is very sparse.[16] According to Schwitters' son, the work was planned out from the start (unlike the Hannover *Merzbau*), and it seems in fact to have been an attempt to recreate something close in effect to the later sections of the Hannover structure. It was a two-storeyed building, approximately 15 by 16½ ft. (4.5 x 5 m) in size, set against the hillside down from Schwitters' house, the pitch of the roof following that of the hillside, so that the upper storey sloped from around 18½ ft. (5.6 m) at the side nearer the house to around 13 ft. (4.0 m) at the far side. The upper storey was a wood-frame construction—"built with my own hands, every bit of it," Schwitters wrote; "I carried the lumber, sawed it to specifications, and did all the carpentry."[17] It was intended to be transportable, in case he had to move again, and was painted in camouflage and covered with mud and pine-needles because he did not have a building permit, and it could be seen from the Lysaker police station down the hill. The lower storey was built from stones unearthed in clearing the site, and since the whole structure nestled quite closely into the slope, half of this storey was actually underground. (The plan shown here is based on the recollections of Ernst Schwitters, who encouraged his father to begin this work, and helped him in its construction.)

316

The entrance, approached by a winding path, led into the upper storey, and directly opposite the entrance there was a tall, narrow window, about 2 by 6 ft. (60 cm by 2.5 m) with ladder-like horizontal divisions. This was glazed with blue glass and in front of it

249 was placed a curvilinear sculpture based on the *Madonna* sculpture that stood in front of the Blue Window in the Hannover *Merzbau*. A broader window—approximately 5 ft. 6 in. (1.6 m) wide and 4 ft. (1.2 m) tall—faced down the slope to the fjord below just as a similar window had overlooked the Eilenriede in Hannover. There were apparently three other windows,[18] including a skylight in the sloping roof, towards which "grew" a branching sculptural motif similar to the one that can be seen to the right of the Blue

175 Window in the photograph of that part of the Hannover *Merzbau*. This centrally placed sculpture reached up to and melded with the geometric forms that covered the ceiling, and from the ceiling hung long, tapered and twisting beams, again like those in the Hannover *Merzbau*. The walls were covered with cubic forms, which thickened to

168 obliterate the corners of the room with an effect similar to the Big Group at Hannover. There were a few grottos containing found objects and collage materials, but white plaster forms, with a few bright accents in reds, blues and yellows, dominated the interior.

The only important differences between the appearance of the Hannover and Lysaker interiors were: first, that the "forms of air" (as Schwitters put it)[19] between the shaped plaster elements were more considered and more crucial in the Lysaker interior (as were the open "breathing" spaces in his contemporary assemblages and collages); second, that the Lysaker interior was more firmly rooted in nature (as was his late work in general); and third, that it was more of a whole, having been preplanned. (Likewise, the late assemblages and collages—though not preplanned—are more homogeneous than hitherto.) This was, in effect, the quickly built interior that Schwitters had offered to Alfred Barr in 1936, except that it was built in Norway not in America.

Schwitters had told Barr that, with professional help, such an interior could be built in approximately nine months. The Lysaker building was begun in 1937 and the basic structure finished by January 1938.[20] The work on the interior then started. It was all roughly laid out by mid May,[21] and continued for the next two years. But during that time, Schwitters also built a curving staircase that led down to the basement level, disappearing underneath the centrally placed sculpture as it did so, and began to plan the disposition of the lower space. So, given the fact that he had only his son to help him, his estimate was not that far wrong.

☐ In April 1940, Schwitters had only got as far as leveling the stone and earth floor of the lower level, prior to beginning construction there, when the German invasion of Norway put an end to his plans. Although he had made this *Merzbau* in a dismantlable form, the urgency of his flight northwards, to escape the advancing lines, obviously meant that it had to be left behind. Schwitters was loath to have to move again, and (according to his son) his instinctive wish was just "to lie down and die."[22] But he did leave Lysaker, along with his son and his son's wife, missing capture by only three days. After being refused access to the island of Hjertøy (where they had spent part of each year since 1933), and after having been briefly interned as potential spies (along with 300 captured German

soldiers!), they fled by fishing boat to Tromsø, the temporary seat of the fugitive Norwegian government. On June 8, they managed to gain passage from Spitsbergen on an icebreaker bound for Great Britain. Ten days later, they arrived in Edinburgh and were promptly arrested by the British authorities. Having thus escaped his own countrymen, Schwitters spent his first sixteen months in Britain interned as an enemy alien.

After being moved through a succession of camps (including Midlothian, Edinburgh, York and Manchester), Schwitters was finally sent to Hutchinson Camp at Douglas on the Isle of Man, where he spent the last year of his internment. Many of those who were with Schwitters at the camp, which held a large number of non-Jewish as well as Jewish German intellectuals, have spoken rather fondly of their time there, as guests of the British Government in what seemed rather like a well-staffed university.[23] Schwitters contributed to the lectures and poetry recitals, wrote for the camp newspaper, and continued his own work. On the surface at least, he remained as extravert as ever. It seems certain, however, that he found his new situation a cruel and humiliating as well as a disorienting one. His conviviality had always concealed a need for privacy, and his slapstick humor an unswerving belief in the seriousness of what he was doing. Of all the scholars, artists and other intellectuals at the camp, writes Fred Uhlman, one of the internees, "not one took Schwitters, the artist, seriously."[24] This was but a foretaste of the neglect that would continue until his death. Admired as an entertainer, as an artist he was thought to be, if not an impostor or a madman, then a relic of the 1920s cultivating an outdated Dadaist role.[25] It is ironical, of course, that earlier he had seemed too much an artist to be a Dadaist. In the 1940s, his work seemed too much like Dada to be art. Schwitters, for all his gregariousness, kept finding himself cast as an outsider. Now, without the security that Hannover had provided, he found the situation almost intolerable. According to his son, he felt simply helpless.[26] A childhood epileptic ailment returned. Throughout the last years of his life he was dogged by increasingly serious illness.

But he was able to continue his work. The sympathetic camp commander allowed him to use his garret room as a studio, and in it, writes Fred Uhlman, "hung his collages, made of cigarette packets, seaweed, shells, pieces of cork, strings, wire, glass, and nails."[27] And there were some even more surprising things in this tiny room; out of them he seems even to have attempted starting a new *Merzbau*:

A few statues made of porridge stood about, a material more impermanent than any known to mankind, and it emitted a faint but sickly smell and was the colour of cheese; a ripe Danish blue or Roquefort. On the floor were plates, bits of stale bread, cheese and other remnants of food, and among them some large pieces of wood, mostly table and chair legs stolen from our boarding-houses, which he used for the construction of a grotto round a small window. There was a bed, a table, and possibly also a chair in a room about 12 ft. x 8. The rest of the space was taken up with paintings of all kinds done on lino, which came from the floor of our lodgings, no other materials being available. He always carried a sharp knife with him for such purposes, and I often saw him carefully helping himself to a nice piece of lino from some unfortunate Manx lady's house.[28]

Schwitters' jackdaw instincts were clearly irrepressible. Had he been kept longer at the camp, other grottos might well have been constructed. But he was finally released in October 1941, and moved to a two-room attic apartment at 3 St. Stephen's Crescent in the Bayswater section of London W2, where his son and daughter-in-law already lived, Ernst Schwitters having been released from internment earlier. Schwitters remained in Bayswater until early 1943, when he moved to join his son, who had rented a house at 39 Westmoreland Road in Barnes, London SW13. Gert Strindberg, a relative of the playwright and a friend of Ernst Schwitters', lived with them. Both Ernst and Strindberg had found employment. "My job," Schwitters wrote later, "was doing the cleaning and cooking, tending two gardens and sometimes I even managed to paint."[29]

In London, things were certainly brighter than they had been in the internment camp. Schwitters was able to make contact with friendly artists and critics—Naum Gabo, Roland Penrose, Herbert Read, among others—and with Jack Bilbo and E.L.T. Mesens, who arranged exhibitions of his work.[30] But modern art as a whole was being neglected. Even his figurative paintings, let alone his collages, would not sell, and other employment was not open to him. A German but not a Jew, and what is more a man unwilling to join German exile organizations,[31] he found things hard, even desperate at times. As a last resort, he visited the National Gallery and insisted upon introducing himself to the director, but to no end. "He does not know that I belong to the *avant-garde* in art," Schwitters noted afterwards, "That is my tragedy."[32] He was isolated, poor, and virtually unknown.

It would be wrong, however, to leave the impression that Schwitter' life outside Germany was one of total disillusionment. His had always been a highly adaptable personality, and what he faced was neglect rather than hostility or persecution, which would have been the case had he remained in Hannover. By all accounts, he mostly remained as ebullient and active as ever. There were, however, tragedies beyond the poverty and the neglect. In October 1943, his house in Hannover was destroyed in an air raid, and with it all the pictures and documents he had left there, and the *Merzbau* as well.[33] Exactly a year later, his wife, Helma, died of cancer in Hannover.[34] In 1944 he himself suffered a stroke that temporarily paralyzed one side of his body and left him with extremely high blood pressure and in constant danger of cardiac arrest. In these difficult circumstances, a young woman called Edith Thomas, whom Schwitters had first met in the house in Bayswater, where she too lived, came to his assistance. Schwitters and Wantee (as he renamed her) had become friends in 1941. After his stroke in 1944, she nursed him through convalescence and moved into the house in Barnes. That summer, they took a vacation together in the English Lake District. The scenery reminded Schwitters of Norway, and he vowed to return. Early the following year, with the liberation of Norway, Ernst Schwitters returned to Oslo, soon to become a Norwegian citizen. His father, however, was now living with Wantee and chose to remain in England. In June 1945, they set out for another short vacation together to the Lake District. This time, however, they stayed there, in Ambleside at the head of Lake Windermere, where they lived for the remaining three years of Schwitters' life.

In Ambleside, they rented two rooms at 2 Gale Crescent, on the hillside above the town, where they were befriended by a young schoolteacher, Harry Bickerstaff, and his

wife. Early in 1946, Schwitters suffered another stroke, which left him blind for a time, and it was feared that he might die. He recovered, however, but was no longer strong enough to make the daily climb to Gale Crescent, so they moved to become neighbors of the Bickerstaffs at 4 Millans Park, where he was also able to procure an attic studio. He had sold his only remaining possession of any commercial value—his stamp collection; he collected everything, it seems—in order to pay for the journey to Ambleside, and now his only income came from his naturalistic paintings, which he sold to local people and to visitors from the steps of a tourist attraction in the town,[35] and from a monthly stipend of £5, which he received from a German friend in London, Dr. Walter Dux, each installment of which he reciprocated by sending an assemblage or a collage. Even fifteen years later, when I first followed his trail to Ambleside, he was commonly remembered there— though not, obviously, by the circle of new friends he had made in the town—only as a penniless, eccentric foreigner who eked a living out of the tourist trade.

Now that the war was over, he was able to make contact with old friends too. In June 1946, he heard from Raoul Hausmann, now living in Limoges, and an enthusiastic correspondence soon developed.[36] They exchanged photographs and poems, began discussing their theories of language, and before too long, Hausmann was suggesting that they collaborate on "a little booklet, a thing of fantasy to be called 'Schwittmail' or 'Pinhole-Mail,'" with poems by each of them and illustrations in the form of Hausmann's photograms. *Pin* (as the title was abbreviated) was to be the manifesto of a new postwar spirit, just like the manifestos its authors had produced after the previous war.

Schwitters was still writing both abstract and anecdotal poetry and prose: the division in his literary work that occurred in the early 1920s persisted through to the end. So did the essential character of each of its two branches, and each was to have been represented in *Pin*. The most inventive of the poems intended for the booklet are the onomatopoeic phonetic ones, like "Super-Bird-Song"[37] and this "Fury of Sneezing":

Tesch, Haisch, Tschiiaa
 Haisch, Tschiiaa
 Haisch, Happaisch
 Happapeppaisch
 Happapeppaisch
 Happapeppaisch
 Happapeppaisch
 Happa peppe

TSCHAA![38]

To write like this, however, is to transform phonetic poetry from an abstract to a descriptive art; one inevitably misses the more daring use of language that characterized the earlier work. The "collaged" poems from this period, especially the "London Symphony" of 1942, are more interesting if only because they bear a very direct relationship to the English collages in the use of collected slogans, advertisements, telephone messages, and so on:

Halt, we are specialists
To be let
To be sold
High class clothiers
Apply first floor
Artistic plumber
Enough said, we save you money.
Monarch hairdressing
Crime and Companion
ABC
Preston Preston Preston Preston
Bank
Bovril the power of beef
Bovril is good for you
John Pearce
Riverside 1698
What you want is Watney's
Dig for victory
Prize beers
Sell us your waste paper
Rags and Metals
Any rags and bones any bottles to-day
The same old question in the same old way
Milk bar
LMS
ABC
Tools of all kinds
All kinds of tools
Watney's Ale
Always something to eat
Monday to Friday
In a raid
Apply[39]

This is a fascinating work: for its collage-like mixture of images, for its highly topical evocation of wartime London, for its explicit references to the collage-like activities of the ragpicker, and for its oblique reference to Schwitters himself (RIVerside 1698 was his own London telephone number). But apart from the fact that Schwitters is now writing in English, little has changed; if anything, the degree of linguistic inventiveness has slackened. And certainly, with the exception of a few comic rhymes ("constipations" with "United Nations," for example),[40] the anecdotal and humorous verses of the period are weaker and more sentimental in content than ever before.

The same is true of those poems in which Schwitters alludes to the problems of his weakness and age. Knowing that Schwitters did suffer from both illness and loneliness in

England, and that some of his poems of this period do obviously speak of his sense of approaching death, gives to them a poignancy in the resignation that they express. Still, works like those that begin, "One day/You finish to be a boy" and "I build my time/In gathering flowers"[41] only achieve whatever impact they have by reminding us of the wretchedness of Schwitters' situation; without prior knowledge of that situation, it is unlikely that we would find them very compelling. Exceptional, therefore, is a poem of 1947 called "The Prisoner." Loosely based on his "Der Gefangene" of around 1920,[42] it retrieves the grotesque and nonsensical mood of the earlier work and transforms it into an absurd, but still curiously moving, reverie on objects of his affection as well as family and friends, and frames the kind of imagined violence characteristic of the earlier work with factual reminders of the just-ended war:

Shooting not allowed
Sour saussage towers in itself
The little violet has an eye with which it
Green little fish cry round about them
A dead body baked together from yellow seagulls.
Eight o'clock Segall is their father and mother. (Express).
Because my wife has a very much salted tongue back on her head wigs pale sour cream
Raoul Hausmann breaks softly towered up redamaged wheels left from right
Blood boils in streams of uteries before Apollinaire round peaks feet mountains
Left and right—left and right—left and right—right and left.
One two, one two, one two, one two,—one![43]

This, as I say, is exceptional. The weakness of the late poetry is partly to be explained by its not being written in Schwitters' native tongue: not only did he apply for British citizenship but he refused to use the German language whenever he could avoid it, although his command of English was never that strong. But it might also be attributed to the fact that Schwitters was not using materials and incidents that were culturally familiar. The vitality of his abstract poetry had owed much to his interaction with an experimental avant-garde, and that of his narrative and anecdotal poetry to his interaction with the environment of Hannover. Wartime London and postwar Ambleside were very different indeed from Hannover; and neither possessed an avant-garde.

The effect of Schwitters' cultural estrangement is even more obvious in his narrative prose, for this, of all the forms of his writing, had most depended upon confrontation with the Hannoverian setting. The later prose often verges on the purely reportorial in style. Although nearly always presented as fiction, much of it is obviously autobiographical.[44] This gives it interest, in recording the often melancholy situations of Schwitters' life in exile, but missing more often than not is the vigorous colloquialism that made the best of the earlier stories so compelling. Little of the late prose, however, was written for publication, and it should perhaps best be considered as unformed diaristic material. Schwitters did try to have some of the late poetry published, though not with great success. In any case, it ultimately took second place to his visual art.

The work on *Pin* was his most sustained post-German attempt to re-establish himself as an active writer. From June through September of 1946, the Hausmann-Schwitters

correspondence becomes ever more enthusiastic about having the booklet published. Then, in early October, Schwitters fell and fractured his thigh: he was bedridden for nine weeks, and was unable to get around easily until the beginning of February the following year. Dispirited, he wrote to Hausmann telling him he wanted to give up work on *Pin*.[45] But he was persuaded to continue, and his period of incapacitation provided him with the leisure to do so. During this same period, however, a new idea began gradually to occupy his mind, and so came to obsess him that all else was soon forgotten: a new *Merzbau*. Schwitters' concern with its planning was probably one of the reasons he finally did abandon *Pin*. Its building certainly hastened his death.

□ The new *Merzbau*, begun in the summer of 1947, was so very different from either the Hannover or Lysaker structures that, in order to appreciate it, we must turn first to Schwitters' English paintings, assemblages, collages and sculptures; its forms derive from these works, in particular from their emphasis on painterly modeling and their ever-increasing rural connotations.

Schwitters' output of work was not consistent, year by year. There were certain periods when his production dropped drastically: the years 1932 through 1934, for example, when he was living a rather unsettled existence, moving backwards and forwards between Hannover and Norway. Conversely, the year 1926, prior to his major retrospective exhibition, the "Grosse Merz-Ausstellung," was an extremely productive one. In England, the early years were somewhat below average in output (and also, by and large, in quality). In Ambleside, however, this changed. The years 1946 and 1947 in particular were probably the most productive in his life. This is partly to be explained because he was bedridden or confined indoors for long periods. But it also tells of a great last creative surge. Although Schwitters was only 60 in 1947, he knew that he did not have long to live. The number and quality of the last works are extraordinary. They bring to fruition, in many different ways, themes and approaches that had interested him throughout his life.

One kind of collage is very rare in Schwitters' late period: the kind that refers to important worldly events. While it is clear from many of the materials he used that he was living in a time of war and austerity, he hardly ever referred to this in a programmatic way. If the late collages carry a political message it is of gentle pacifism and of rural isolation from the machines of war. *Hitler Gang* of *c*. 1944 is the major exception to this, with its "German" red and black coloring, its target towards which a black wedge points, and the strident fragment of typography which gives it its title. It is worth noting, however, that the title actually refers to a film, and that the words of praise (from the *Daily Mail's* film critic) given above the title could well have been included to "advertise" the collage itself: it is an "EXTRAORDINAR[Y PICT]URE WHICH YO[U] MUST SEE." For also to be seen in the collage is a cutting from, presumably, an astrology column, which begins: "Your hand denotes a rather masterful nature . . ." and, most surprisingly, a fragment of material which symbolizes the invention of collage itself, a piece of imitation chair-caning of exactly the same type that had appeared in Picasso's very first collage, *Still Life with Chair Caning, 1912*.[46]

XXXI

Stylistically, *Hitler Gang* belongs with a group of late collages in which strong figure-ground contrasts are emphasized, and the disposition of materials remains relatively open to give "breathing" room to the forceful, dramatic shapes that such contacts allow. *Milk Flower* of 1947 is a related work, but shows stronger directional thrusts in its composition. Another figure-ground contrasted collage of 1947, known as *WA*, softens its contrasts by placing them within tonally similar and torn materials. Directional collages and muted, worn-looking collages were among the principal stylistic types of the last years.

273
271

Difficult of *c.* 1942–43 is virtually a reprise of *Mz 299. für V.I. Kuron*, more than twenty years earlier, except that its splaying composition is expanded to a far larger scale. This collage is over 30 in. (76 cm) tall, and typifies the grandeur of many of the late works. Especially in Ambleside, Schwitters made many large collages: as his compositions opened and expanded, so did their size. We sense in works like this a generosity, freedom, and largeness of conception very different in kind from the tight, urban works of the earlier years. Even on a smaller scale, other directional collages use their diagonal, vertical and (less frequently) horizontal thrusts to expand the pictorial space.

XXX, 121

Works like *c35. paper clouds* (1946) are expansive in another way. This collage also looks back to the early years of Merz: to torn, "painterly" collages like *Mai 191*. But here the contrast of early and late works is even stronger: the declamatory, topical, manifesto-like feeling of *Mai 191* is replaced by a moody evocation of the natural world in *paper clouds,* whose atmospheric, climatic connotations are reinforced by its title. In the same year, *c63. old picture* shows Schwitters returning to illustrative and photographic materials in order to accentuate this atmospheric feeling. As we saw earlier, when looking at the *c.* 1942–43 collage, *Counterfoil,* Schwitters found that such materials allowed him to produce works that seemed visually flat and spatially illusionistic at the same time. Now, he tears and overlaps these materials, even more drastically camouflaging the Cubist geometry on which the collages still depend. In doing so, he breaks not only the tightness of Cubist geometry but its abrupt spatial dislocations. Instead of composing the materials as elements that float in a fictive, imagined space, each piece of paper denoting a spatially very distinct plane, he drastically narrows the pictorial space. He addresses surface before space, and creates space by layering the surface: by allowing us to see how the surface itself, as a naturally flat, planar entity, can be both stripped away and overlaid in a way that maintains its flatness and planarity, and reveals parallel surfaces to it besides. And lest the spatial compression thus produced seem too claustrophobic, illusionism is carried in the very materials themselves. Instead of opening space compositionally, in a Cubist manner, Schwitters lets his materials open the pictorial space.

277
X

276

283

In 1942, around the time he made *Counterfoil,* Schwitters produced an important group of collages which use illustrative materials in a far more anecdotal way. These were made by pasting topical clippings from newspapers and magazines on top of reproductions of paintings by the popular German nineteenth-century artist, F. Defregger, published in the Galerie Moderner Meister series. *Der verwundete Jäger (The Wounded Hunter)* thus superimposes on the reproduction of this painting photographs of GIs (the hunter's modern equivalent) relaxing in a service-club bar.[47]. In 1947, Schwitters obtained another set of reproductions, and similarly reworked them, making

278

279, XXVII Merzed madonnas after Botticelli and Correggio, though now in a more complex layered
88 style. These necessarily recall Dada photocollages like *Wenzel Kind* of 1921, where Raphael's *Sistine Madonna* was humorously defaced. Schwitters obviously preferred to work with female imagery. His last illustrative works used it almost exclusively.

280, 281 Compositionally, *Merz 42 (Like an Old Master)* of 1942 and *Ladygirl* of 1947 are very similar. The latter, however, shows a modern woman from popular advertising, not
282 a historical woman from a high-art source. *47,20. Carnival* (1947) tells of his fascination with both pretty women and popular culture, and the pun of "AN . . . AL" and "the tall gable" was surely intentional. In 1947, Schwitters' popular source material was suddenly expanded. He reestablished contact with Käte Steinitz, who had moved to America. He sent her one of the comic poems he had taken to writing again, called "The Ballad of the Mermaid." Steinitz found a Valentine card with a mermaid on it, and sent it in return. It was transformed into a whimsical collage. "Another metamorphosis of Anna Blume," Steinitz realized, "unfortunately her last."[48] This whole group of feminine-image collages clearly tells of the same theme. In June of 1947, Schwitters wrote to Steinitz: "You sent me those short stories like American jokes in newspaper form. I use them now as materials for Merz drawings."[49] He is referring to comic strips. The best-known of the
XXXII collages which resulted is the tiny *For Käte* often quoted as a prototype for Pop art, although it is certain that it and similar works had no direct influence on that movement. (Schwitters' earlier work, however, undoubtedly did have such an influence.) Schwitters himself did not have enough time to develop the possibilities of these images any further. In the summer of 1947 he was a very sick man and had but a few months to live. Most of his energies that remained were directed not to the popular world but to the natural one.

Schwitters had always enjoyed the spectacle of nature. His move to Norway and then to the English Lake District brought him to a landscape towards which he did not have that same sense of ambivalence he felt toward his native Hannover. The tension that often exists in the early *Merzbilder* between rigidity of structure and the "personality" of materials; the calming of that tension by the use of more anonymous materials in the period when Schwitters made common cause with metropolitan Constructivism; and then the newly relaxed structures (as well as rural materials) that characterize the post-German work, would all seem to mirror changes in his relation to the environment in which he lived. And yet, if Hannover generated tension and ambivalence, Schwitters had grown accustomed to these things, indeed dependent upon them. To move to the countryside was only to replace one kind of ambivalence with another: if the environment was physically delightful to him, it must have also been strange and disorienting, given his professional isolation and the rootlessness and uncertainty of his situation. This, too, shows in his art, which in some respects exiles itself, with its creator, from the modern movement as it then existed. It steps outside the mainstream of contemporary art.

It was not merely the materials or mood of Schwitters' late work that changed. In Norway and then in England, the Cubist sense of a solid resistant plane began to disappear. Integrated within a painterly continuum, the materials of many late assemblages seem to be not so much fastened down upon surfaces as floating *across* them. An illusion of deeper space is provided, often to such an extent that one can hardly talk of a

consistently expressed flat ground anymore. The *Red-Rubber-Ball Picture* of 1942 is a 287
compound mass of soft blurred forms and loose casual painting which together dissolves
the surface in a swirling, impermanent flux. This dissolution of a resistant Cubist plane in
Schwitters' late work is something for which he has often been criticized. Some have
noted a steady decline in his work done outside Germany. Certainly, the quality of the
work is extremely uneven (though no more so than in the Constructivist period), and it
disappoints critical expectations based on urban Merz. But what takes place is not so
much a decline as a reassessment. In an important sense, the late assemblages are the
most daring of Schwitters' works.

Schwitters in his late work reinstates the illusion of deep space that Cubism had
dispelled, and on whose very absence his earlier work depended, but he also balances this
new illusionism with an increased emphasis on surface. The emphatic painterliness of the
late works dissolves their flatness only to reinforce the physicality of their surfaces. As
whole objects, late works like *In the Kitchen* (*c*. 1945–47) or the 1942–47 large "Aer- 284, 286
ated" series of collages[50] are more physical than ever before. One might say that whereas
Schwitters had previously contained objects in pictures, now his whole pictures are like
objects; and that whereas his concern had previously been to relate objects to flat
surfaces, it was now to make added objects an integral part of that larger object, the
picture itself. His art had always involved a sense of reciprocity between objects and
surfaces. Now, illusionistic but physical surfaces enclose the added objects in an atmos-
pheric painterly web, causing them to seem embedded in pictorial space. This newly
illusive spatial containment of objects represents a daring attempt on Schwitters' part to
resolve problems that had dogged his art from the very beginning.

This said, however, the freedom from Cubism that many of the late works proclaim
was not won without cost. The late works seem at times unbearably casual, uncomfort-
able in Schwitters' refusal to be bound by the structures he had depended upon for so
long, although these structures would have guaranteed him (as they had done in the past)
more coherent and ordered results. Here again we may be tempted to see the uncertainty
and disorientation of Schwitters' personal life reflected in the changes in his art. Unlike
the earlier pictures with their clearly defined planes, an assemblage like *Red-Rubber-Ball
Picture* comes close to confounding our apprehension of the real and the illusive. An art
of clarity has been made into an art of camouflage.

Schwitters continued to make assemblages with firmly contoured objects presented
against a flat resistant plane, which therefore do not offer the kind of illusionistic reading
discussed above. *Relief with Half-Moon and Sphere* of 1944 is exceptionally bare; it 288
resembles a Russian Constructivist relief. By and large, these works either contain layers
of found objects, and thereby recapitulate in this more physical form the surface layering
of the contemporary collages: *Pink and Yellow Merz Picture* of 1943 is of this kind. Or 289
they contain found objects scattered across a textured or patterned background: *Pro- 291
tected with yellow artificial bone* (worked on in 1941, 1945 and 1947) and *Small Merz
Picture of Many Parts* (1945–46) are typical of this approach. The latter approach is 290
close to that of more fully "camouflaged" pictures in that the patterned ground plane
tends to dissolve visually. And yet the bulk of the objects reminds us of its flat, resistant
quality, while the assertive shapes of the objects refuse to dissolve into the ground. The

persistence of works like this, through to Schwitters' last years, reminds us that he was still interested in charged, shaped, and sculptural forms. The 1942 collage known as
293 *White, Beige, Brown* and the compositionally similar *c*. 1943–45 assemblage known as
292 *Wood on Black* show that this interest had led him to use boldly contrasted shapes, which read extremely abstractly even though they veer into the center of the pictorial space.

Whether or not Schwitters covered surfaces or materials with painterly camouflage, we recognize an ever more casual and improvisatory order than before, and a new feeling of surface density as well. Although the sense of an implicit organizing geometry never entirely disappears, it is far less obvious now. Objects are related one to the next, not as geometric components of a geometric whole, but as unlikely clusters set against the geometric whole. The often eccentrically shaped parts are composed in terms of their weight and presence as shapes: they reach out to, and push up and jostle against, each other, and are spread out laterally across the surface, often making only the simplest and most straightforward of accommodations to the geometry of the picture's edges.

As on previous occasions, Schwitters interest in shaped elements led him to fabricate
294 elements with an analogous force to those that he found. In *C72* (1946) the fresco-like
295 overpainting disguises the original function of the found circle and strip. In *Beautiful Still Life* (1944) a comparably holistic effect is created from mostly tinted plaster forms. The
XXVIII large, impressive *Heavy Relief* (1945) contains both found and manmade elements, but the thick skin of paint and plaster that covers nearly everything makes it virtually impossible to distinguish between the sources of the materials. Here, an approach first used in sculpture is applied to making reliefs. And occasional relief assemblages, like
300 *Drama* (1944), where it is clear that Schwitters is still using found materials, have such a commanding sculptural presence that it simply overpowers the associative connotations of the materials.

To an extent quite new in Schwitters' work, assemblages of this kind (even those with elements of fairly high relief) are conceived across the breadth of the surface. Because elements of widely differing sizes are used, not only do they abut each other, but some seem to be surrounded and enclosed like landlocked countries on a map. In fact, it is the layering of smaller over larger shapes that produces this effect. Unlike the collages, however, works of this kind rarely have multiple overlappings. As a result, the sense of a continuous surface is always retained, albeit a stepped one that occupies different levels. In any case, the heavy, dense paint joins objects and ground in a relatively uniform texture, and is manifestly there as a spreading, covering substance to enhance both the combination of the parts and the solid, object-like character of the whole.

Highly physical surfaces and casual, improvisatory compositions are shared, then, by both the painterly illusionist assemblages and the barer reliefs. And there are, of course, reliefs that bridge these two forms. However, what they also, and perhaps most obviously, share is provided by their new range of materials. Schwitters' work had always been self-relevant. In his last years, the objects he used very often tell of rural patterns of living. The familiar bus tickets and wrappers continue to appear, though at times in an utterly changed and far more casual context. And increasingly, not only the waste of civilization was rescued, but also pieces of timber, stones, feathers even, which had not before been

touched by man's hand, and all manner of objects he found upon his walks. Their worn, rough appearance speaks now of natural evolution, of the effects of the elements and not of man, except of the one who stopped to pick them up. At times, Schwitters seems to be making real landscapes. The *Small Flower Picture* of 1941 confounds categorization: at 299 one level it is a landscape painting, at another a found fragment of the nature world. The *Dotty Picture* of 1947 is likewise both an abstract painting and a "realistic" one. In one 297 untitled late assemblage, a toy motorcyclist appears, driving into the primeval forest. 285

The view of nature that Schwitters expresses in his late work is a lyrical and often overtly sentimental one. But it is always esthetic: the forms and instances of nature are selected, excerpted, and framed for contemplation like pocket-sized picturesques that formalize, however gently, the rural scene. It seems especially fitting that the last of these works were created in the English Lake District, where earlier visitors, the eighteenth-century Picturesque travelers, had looked at landscape through city eyes in a similar way. The cultivated sophistication of the eighteenth century may have been very far from Schwitters' spontaneous and often naive enthusiasms, but the concept of the Picturesque is the ultimate source of his attraction to the beauty of ruin and decay, and of his discovery of it in framed excerpts. Just as it was the aim of Picturesque description "to bring the images of nature as forcibly and as closely to the eye as it can,"[51] so Schwitters' use of the collage technique selects objects and pushes them forward into the perceiver's space. Schwitters' esthetic use of waste throughout his career reveals a Picturesque sensibility, but one transposed to the modern city. His late work returns the Picturesque to its original rustic source—and to its interest in ruins and grottos as well. As we shall see, the English *Merzbau* is, in effect, a kind of rustic cave. But Schwitters' interest in nature was by no means new to the late period: landscape perceived and recorded had always been an integral part of his art.

☐ It is in this context that we should look at the really problematic part of Schwitters' *oeuvre:* his naturalistic paintings. Most of his commentators have either chosen to 296, 298 ignore them, or else have approached them with embarrassment. Certainly, his continued preoccupation with naturalistic painting caused distrust among those who were sceptical about the collages anyhow. Uhlman recalls that many of those who were with Schwitters in the internment camp at Douglas were forced to conclude that Schwitters made collages simply because he was so incompetent as a representational painter: Uhlman himself says that the landscapes "remind me of poached eggs on spinach."[52]

Schwitters' own attitude to these paintings was strangely ambivalent. On the one hand, he is reported as describing such work as mere potboiling, not only defensively in letters to artist friends, but also to those (for example, in Ambleside) who valued it more than his collages and assemblages.[53] And yet there is his constant obsession with things seen, and his unceasing record of, and defense of, naturalistic painting throughout all phases of his career. It may perhaps be assumed that it was done for relaxation, as a kind of Sunday painting after a week at the Merz office, as it were. This is surely part of the truth, but I think not all of it. For we have seen that Schwitters talked of an unbroken line of development from the early naturalistic studies to the Merz abstractions, that he affirmed in the 1920s and 1930s the importance of studying nature, and that he felt that

nature replenished his vision as nothing else could. In short, as he wrote to Raoul Hausmann from Ambleside, naturalistic and abstract painting were not incompatible at all:

> In my soul live as many hearts as I have lived years. Because I can never give up or entirely forget a period of time during which I worked with great energy—I am still an impressionist, even while I am Merz . . . I am not ashamed of being able to do good portraits and I do them still.[54]

He said at the same time that the idea of an avant-garde was something that existed apart from personalities, and depended as much on the public as on artists themselves. That is to say, the public looks selectively at an artist's work, choosing for consideration only those aspects of it that fit an ideal of historical progress, often necessarily at the expense of the artistic personality as a whole. He said this in 1946, at the height of his "rural" period; but in 1927, in the "Katalog" issue of *Merz* that celebrated the climax of his urban Constructivism, he said much the same thing. After explaining that he devoted at least a part of every year to naturalistic painting, he went on to defend this seemingly inconsistent practise:

> This is possibly a purely private diversion; in any case I should not like to lose the connection with the earlier stages of my development. For I consider it important that at the end of one's life nothing should be lost, even if it is false and dull; regardless, one's aspirations should stand forth *entire*. For with our thousand weaknesses and the tiny spark of the ideal, we human beings can at best merely give *ourselves*, openly and honestly, and work, in the ideal sense, towards ourselves. We cannot make ourselves into an ideal being. That ambition usually ends in hypocrisy. I have nothing to hide, not even the fact that today I cling to the sentimental pleasure of painting from nature, without any artistic aims, merely for orientation.[55]

This is remarkably frank—and also curious for being so self-effacing and so supremely self-confident at one and the same time. A confession of his weaknesses is also an affirmation of the importance of everything that he does. The entirety of his artistic personality, good and bad together, was what finally counted for him.

It is true, of course, that criticism looks selectively at any artist's work, but only because value judgments are central to criticism. I can imagine that even Schwitters' naturalistic paintings—and certainly his late abstract paintings generally based on nature—might find the same kind of critical support that has been extended to the late De Chirico or Picabia. I happen to find these works of lesser quality and ambition: of interest, certainly, as subsidiary areas of Schwitters' art, and revealing for what they tell us about the mind that produced far more important works, but not the kind of pictures on which claims for his artistic greatness can be based. It is, therefore, for critical and not (as Schwitters claimed) for historical reasons that the naturalistic paintings deserve less attention. They are not aberrations which have nothing to do with the rest of Schwitters' career. His defense of them shows that his ultimate goal was simply being true to himself, in all his aspects, as the source and center of his art. And if his production of such works did cause him to be out of step with his time, then it was, ironically, the modern stress on

authenticity that led him to believe that the entirety of his artistic personality was what counted.

To paint from nature, then, was for Schwitters a way of retaining contact with an earlier part of himself, just as continuing to use other earlier established forms was. (I have already pointed out how styles tend to accumulate in Schwitters' development.) This may be, as Schmalenbach says, rather naive: to see stylistic pluralism as intrinsically better and more honest than a single style.[56] But it was a principle that Schwitters followed. In the *Der Ararat* article on "Merz" of 1920, he had written of his concern for various branches of the arts, saying he did not want to become a specialist in any one art, but rather a complete artist, for his ideal was the total work of art.[57] His insistence on the merits of stylistic pluralism is but another aspect of this ideal, which encompassed not only the different arts he practiced but also the different styles. Completeness was the ideal. Towards the end of his life he seemed determined to use the entire arsenal of his previous work, and finally to bring everything together.

Schwitters clearly enjoyed the manual and the manipulative in oil painting, irrespective of the quality of the results. He also enjoyed nature, and in order to preserve his "orientation" toward nature continued to paint landscapes even during the period of his Constructivist alliance; at the same time he began viewing his geometric work as a kind of new naturalism.[58] In Norway and then in England, he brought the new and the old naturalism together in the painterly surfaces of the late assemblages. He had conceived of the possibility of this sort of synthesis as early as 1920, when he wrote (in the *Der Ararat* article cited above) that while representations of nature are not essential to a work of art they can be used as elements of a picture if played off against other elements. This is in effect what happens in many of the late works. Applied painterliness brings to the assemblages a kind of vegetable density that, while not actually descriptive of landscape, nevertheless refers to the natural world. That is to say, natural reference is provided in the texture of the painterly surface which is an analogy for the surface of a landscape. To add "naturalistic" painting to the assemblages, however, was not without its particular risks. The excellence of Schwitters' work is usually in direct proportion to the quantity of its added materials: when he relied more on painting than assemblage, the results were frequently disappointing. To bring together the Cubist structure of his assemblages and the Impressionist painterliness of his naturalistic work was often to dilute the strongest of Schwitters' aspirations with the most feeble.

One thing further must be said, and then qualified, before leaving this topic. To bring together Cubist and Impressionist stylistic methods may have been justifiable to Schwitters himself as the compound realization of his entire aspirations. In practise, however, no such compound was completely possible, for it meant using the discontinuous surface of Cubist assemblage and the continuous surface of Impressionist painting at the same time. These are finally irreconcilable, at least as equals: one or the other inevitably predominates. The best of Schwitters' late work is where assemblage—and therefore Cubism—is still the underlying and directing force, however much it is modified or revalued in the way it is employed. When illusionism and Impressionism—and Vitalism too, for this is often also a part of Schwitters' new compound—gain the upper hand, the work is rarely as fully resolved as it is within a Cubist-based system. At its best, as with

XXIX pictures like the dramatic *Glass Flower* of 1940, the illusionist-Vitalist approach points to a remarkable new potential in Schwitters' late work. But it was a potential that was never completely realized.

This, however, must be qualified. The techniques of Schwitters' naturalistic painting bear some comparison with those of his collages and assemblages. He constantly insisted that "imitation remains imitation. Imitation is weakness and error."[59] And strictly speaking, his naturalistic work is not based on imitative principles. These had been abandoned when he left the academy at Dresden. He creates not so much likenesses of things as expressive moods. As we saw in discussion of his early landscapes and portraits, the kind of reference these paintings make to the observed world is highly schematic and generalized. Moreover, while Schwitters' summary Impressionist manner of working provides an illusion of three-dimensional space, it does so within a concrete and tangible surface crust. In his letters from England, Schwitters made much of the fact that the English did not appreciate thick impastos. "My pictures have brushmarks, and therefore

296 I have difficulties," he complained.[60] Mr. Harry Bickerstaff of Ambleside, whose portrait Schwitters painted in 1946, was surprised at Schwitters' method of working: he always kept very close to the canvas, never standing back to judge an overall effect, but absorbed in the manipulation of heavy paint, although he could therefore never see how the work as a whole was progressing.[61] If this failure to consider the whole helps to explain why Schwitters' naturalistic paintings are so often unsuccessful, then the tactile involvement with materials parallels the way that he made his collages. I mentioned in Chapter 3 that Schwitters had come to collage from the wet processes of oil painting, and how its adaptation to the "dry" medium of assemblage was important to the development of his work. It was, therefore, not at all out of character for Schwitters to transform his assemblages into continuous fluid surfaces, painting with and within the materials he used.

He used a similar "painterly" approach in sculpture too. Writing to Alfred Barr in 1945 about his sculptures, he said: "I modellised the color and the form of the surface with paints, so that modellising and painting became only one act."[62] As in works like *Glass Flower,* so in the sculptures, painting and modeling are combined to produce

XXVIII fabricated objects with the potency of found ones; and as in works like *Heavy Relief,* Schwitters builds plaster and paint on top of found objects to generalize them.

Some of the late sculptures are simple compositions of found objects, left in their raw state, where Schwitters relied on the act of composition itself to "dissociate" them from

304 their former functions: hence, a *c.* 1943–45 sculpture made from a wooden cotton-spool and part of a coathanger. Others use raw materials of a more neutral nature, which are frequently painted to further dissociate them from the world. These include a pair of

301 related sculptures from the early 1940s, one known as *Cathedral,* the other inscribed

303 with the word *Fant,* which is Norwegian for "Devil." Seen together, they can only appear as an organic and an angular interpretation of the same theme: the aspirant form of the *Merzbau* Cathedral image given overt sexual connotations. And if the angular sculpture, seen without its added title, *Cathedral,* is not quite so supportive of his interpretation, then the fact that Schwitters did see the cathedral image in these terms is

302 confirmed not only by his writings on the *Merzbau* but by a unique and curious drawing

made on the notepaper of a hotel at Olden in Norway in 1939. Here Schwitters revives the cave and cathedral theme that was central to the *Merzbau,* and impales upon the cathedral steeple an obsessively realistic eye to create an image both of omniscient vision and of sexual aspiration.[63]

But these are anomalies: the majority of Schwitters' sculptures relate quite clearly to structures in nature. Thus, the early Norwegian *Small Twisted Sculpture* is a purely 306 fabricated structure that resembles an angular plant, and the English-period *Exhausted* 314 *Dancer* is a piece of tree root chosen for its anthropomorphic connotations. He made a few sculptures that actually depict animals and plants. Most, however, allude to the natural world in a far more generalized way. Without the title, *Little Dog,* it is unlikely 307 that we would consider this particular sculpture a referential work. And it is reasonable to assume that, as with *Exhausted Dancer,* the associative title was added to the work after its completion. By and large, Schwitters' sculptures are as abstract as any Vitalist sculpture can be.

Most are plaster sculptures, and Schwitters' attraction to plaster seems to have been threefold:

First, it allowed him to contain the armature of found objects as it covered them, and therefore was compatible with the original idea of Merz as the formal assimilation of things taken from the world. It was first used, in the Hannover *Merzbau,* in precisely this way, and in the majority of his sculptures both armature and applied plaster are expressed in their design: hence, on the one hand, works like *Elegant Movement* (*c.* 309 1943–45) or *Red Wire Sculpture* (*c.* 1944), where the loops of wire that form the 305 armature surface to become visible parts of the composition, and on the other, those curious painted piles of pebbles of the 1940s, where paint (this time) is the agent of 313 containment and dissociation. (Schwitters probably added paint to many of his plaster pieces for the same reason: it kept them from belonging solely to the natural world.)

Second, plaster allowed Schwitters to paint and model at the same time. In fact, to build on top of objects an impasto skin of plaster was not only to combine painting and sculpture, it was to graft those activities onto assemblage. He was indeed seeking, in these small and unassuming plaster sculptures, to draw together the different strands of his art. Works like *The All-Embracing Sculpture* (*c.* 1943–45) are nowhere near his most important achievements, but do represent an important attempt at artistic synthesis. 308

Third, and finally, the act of modeling in plaster seems to have become even more important to Schwitters because it was closer to organic creation than assemblage. Through modeling (and this applies to his two-dimensional work as well) he seems to have found a way of literally identifying art and growth. The "Nasci" stress on "becoming" thus led eventually to an anti-Constructivist kind of art. Urban assemblage was itself contained and dissociated by modeled surfaces that allude to the natural world. The third and last *Merzbau* was planned on this principle.

☐ In the early spring of 1946, Schwitters learned from his old friend Christof Spengemann that parts of the Hannover *Merzbau* might be salvageable.[64] His immediate reaction was to plan a restoration trip to Hannover, and on April 30 he wrote to Oliver Kaufmann in New York (who had earlier offered to help Schwitters move from Germany

to America) asking if he would sponsor the restoration in return for receiving art.[65] Oliver Kaufmann wrote to his nephew, Edgar, who was associated with The Museum of Modern Art, saying that he was prepared to help Schwitters, but suggesting that the Museum might want to organize the transaction. In early July, Schwitters informed Edgar Kaufmann that he had learned it would be impossible to begin restoration work in Hannover until the spring of 1947. The correspondence continued through the summer: proposals were discussed for an exhibition at The Museum of Modern Art; there was enthusiasm on both sides that the *Merzbau* could be restored.

Then, in October 1946, Schwitters fell and fractured his thigh. By the time he recovered, he had learned that the Hannover *Merzbau* was beyond repair. By December 1946, he was walking on crutches, and though still weak began thinking of going to Norway instead of Hannover in order to complete the Lysaker *Merzbau*, abandoned in 1940. In the meantime, the official wheels had been turning in New York and by February 1947 a fellowship was established for Schwitters by The Museum of Modern Art in order for him to restore the Hannover *Merzbau*. It now had to be modified to cover the Lysaker *Merzbau,* which meant a delay.

Schwitters, however, had been developing new plans. He and Wantee spent most of February and early March of 1947 in London; the main purpose of the trip was to give two poetry readings at E. L. T. Mesens' London Gallery.[66] The BBC was invited to make a recording of the "Ursonate," but its two representatives walked out halfway through the performance. Perhaps The Museum of Modern Art would sponsor such a recording? The proposal was discussed in New York, as was another of Schwitters' ideas: that the Museum mount an exhibition of salvaged fragments and photographs of the Hannover *Merzbau*. On June 16, 1947 the Museum's Assistant Secretary wrote to Schwitters telling him of an award of $1,000 "in order that you may proceed with your plans for continuing your work in creative fields and including such restorations of the Merzbau as is possible." The letter arrived on June 20, Schwitters' sixtieth birthday, and can be seen protruding from his pocket in a photograph of the celebration that ensued.

323

"It is the understanding of the Trustees," read the Museum's letter, "that you have two alternatives: to return to Hanover to restore the original Merzbau or to go to Oslo to resume work on the second Merzbau. . . . The choice of these projects is left entirely to your discretion." The Museum of Modern Art doubtless thought that every possible contingency had now been covered. However, Schwitters wrote back not only to thank the Museum for the award but to say that he had now decided he would like to use the funds to build a third *Merzbau* on the property of a Mr. Harry Pierce near Ambleside. The Museum's award was made in four installments. On November 5, shortly before the second was made, Schwitters learned from the Museum that not only did it agree to this proposed use of the funds but that an additional $2,000 had been authorized to help him in his work. As it turned out, this additional sum was not needed: the last two payments of the original award went to meet the costs of Schwitters' burial.

What had caused Schwitters to change his mind was this:[67] early in 1947, he had met Harry Pierce, a landscape architect from nearby Elterwater, and had been commissioned to paint his portrait. He soon became a regular visitor to Pierce's estate, called Cylinders, about five miles from Ambleside, some 350 feet up the Langdale Valley and set against

the towering forms of the Langdale Pikes overlooking Lake Elterwater. At Wantee's prompting, Pierce offered Schwitters the use of a somewhat derelict, disused straw barn, built during the war from old stone, as his studio. Once the offer was made, there was no doubt in Schwitters' mind that a third *Merzbau* should be built. As befitted its location, it was to be called tne Merzbarn. 312

Schwitters enjoyed the spectacular scenery around Lake Elterwater. The Merzbarn drew inspiration from its environment. Schwitters even recognized in the inventive garden that Pierce had made around the barn something analogous to what his conception of Merz had become:

> He is a genius . . . he lets the weeds grow, yet by means of slight touches he transforms them into a composition as I create art out of rubbish. He wants to give me every assistance. The new *Merz* construction will stand close to nature, in the midst of a national park, and afford a wonderful view in all directions.[68]

The barn itself was set into the hillside, probably reminding Schwitters of the Haus am Bakken at Lysaker, and like the Lysaker building it had a small window facing up the slope. Schwitters arranged to have this window constructed when Pierce fitted a new roof to the barn, and planned to build a column beneath it. It seems likely, therefore, that he took a motif from the Lysaker *Merzbau* to begin the Elterwater *Merzbau*, just as he had started the Lysaker work with the Hannover one in mind. And again like the Lysaker 317 *Merzbau,* this one was planned from the start. All the walls were whitewashed, and strings on short posts were laid out to divide up the floor area and form a kind of directed walkway through the composition. Another small window was made against the door jamb, and it was hoped to incorporate this in the final effect. A stone wall was built jutting diagonally into the room, which obscured the principal relief, but contained a niche, complete with a sculpture (*Chicken and Egg*), through which could be glimpsed 318 the space beyond. Another, curving, wall was considered, but got no further than being provisionally laid out with string. From its proposed position it is evident that it would have emphasized the organic feeling of the interior by beginning the movement carried upward by the relief to the top window. That window, Schwitters' friend Hilde Goldschmidt reports, "was supposed to act both as the sole source of light and as the fulcrum of the whole conception. From there various strings were spanned throughout the room to indicate how the barn space would be interpenetrated."[69]

Accounts vary, but it seems that one set of strings was established in a vertical position from floor to ceiling beside the wall to the left of the relief and that another set was stretched from nails along the uppermost ridge of the relief to nails along the left wall.

> He had planned the work to be three-dimensional [Pierce has written] for from the top ridge was to be produced for some distance a low roof or ceiling so that light from the window in the adjoining wall should be carried past it to the far corner where a column was to rise from the floor some little distance from the walls, leaving the far corner for a culminating feature lit from a skylight in the roof. He had begun another portion diverging at an angle from the door and returning to the window previously mentioned. . . .[70]

We can only guess how it would have all turned out had Schwitters lived to complete it. Perhaps realizing that it would never all be finished, he chose to concentrate on one wall. That too was left unfinished, and was removed from its setting in 1965 because of its continuing deterioration, later to be installed in the Hatton Gallery of the University of Newcastle-upon-Tyne.

Before beginning the Merzbarn, Schwitters had apparently made small models and designs for architecture, furniture from stones and branches he had collected, and had immersed himself in the structural questions that its building involved. Although he only had time to work on the principal bas-relief, the Merzbarn was certainly intended as a three-dimensional work. He called it "the greatest sculpture of my life."[71] In fact, it brings together the Impressionist methods of the late assemblages and Schwitters' long-standing sculptural preoccupation with Vitalist forms which generated his manipulated surfaces in the first place. It was conceived as a culminating artistic statement.

No sooner had it been conceived, however, than there was a serious setback. On July 17, 1947, Schwitters suffered a lung hemorrhage lasting twelve hours. He made what seemed to be a rapid recovery and resumed work. But there was not much time left. From a letter he wrote to Margaret Miller of The Museum of Modern Art on August 11, it is clear that Harry Pierce was still thinking about letting Schwitters use the barn not as a studio but as a site for the new *Merzbau*. On August 20, at the height of an extremely hot summer, he wrote to her again, delighted with the good news: "Mr. Pierce gave me the house for the Merzbau, and I started it already . . . *I have already started. I have. I have.*" "I do regret the loss of my lifework, the *Merzbau,*" he wrote to Spengemann of the Hannover structure;[72] but then, enthusiastically, to Käte Steinitz: "I am building a lifework . . . in Cylinders, five miles from here."[73]

315, 320 The principal wall of the Merzbarn on which he worked was about fifteen feet (about 4.6 m) long and eight feet (or 2.4 m) high, at the far end of the square barn room, opposite the door, and therefore better lit than the rest. In difficult conditions (the door and windows were at first open to the elements and the roof leaked, causing a stream to run across the bare earth floor), he covered most of this wall with plaster, strengthened by twigs, wire, garden canes and similar materials, in a kind of wattle-and-daub technique. Some sections of the wall were built out with plasterboard to form ribs and flat plateaux which seem to grow organically towards the small window in the roof. They are

XXIX reminiscent of those in the assemblage, *Glass Flower* of 1940, but whereas many of the curves and concavities that surround the flower image are painted illusions, here they are real. In the righthand corner, the modeled ribs press upwards to the light.

"Whether I paint from nature or abstractly," Schwitters had written in Norway, "to me, light is the essential thing, and this is what links all my works."[74] We have seen how the broken Impressionist surfaces of many of his later works evoke the effect of light and shade on landscape; the Merzbarn relief is like an abstracted relief landscape animated by light. To see it is to be reminded of the "Nasci" definition of nature as everything that develops, forms and moves of its own volition, or of Schwitters' description of the Hannover *Merzbau,* where he talks of the growth of valleys and hollows within the whole.[75]

Although the Merzbarn as a whole was planned, the relief itself was simply allowed to grow—beginning, according to Pierce, from the segment of a circular gilt picture-frame

near the center of the wall. In this respect, it recalls the Hannover construction, and its organic conception ultimately derives from the later stages of that work. But the Hannover *Merzbau* had been formed on the analogy of a cathedral. The last of Schwitters' *Merzbauten* is like a single grotto, and one that is far indeed in feeling from the dark fetishistic grottos from which the first *Merzbau* developed. It is a softly primitive cave whose walls grow like plants to the light, beginning to assume those serpentine forms characteristic of the Lake District landscape.

For Schwitters, though, nature was not only forms but objects, and soon found debris was added to the relief: a tin can painted bright red, a piece of metal framing which encloses a miniature "collage," a china egg, hidden in a crevice. As usual, materials came from wherever Schwitters could find them: stones from Langdale Beck, a rubber ball, part of a child's watering can, a hank of twine, a segment of cartwheel from outside the barn. But all of these objects need looking for in the relief. Hidden in niches were pieces of tree roots, even gentians from the garden: all contained and sheltered by a large projecting ridge of plaster.

The center part of the relief is of smoothed-off plaster, colored in part. One small area was tinted orange, another green and yellow, and below a patch of indian-red. Schwitters may well have intended parts of it to be smoother, to increase the effect of soft illusionistic space. As it stands, however, some sections of the plaster remain rough and textured, like the dappling and stippling in the contemporary paintings and assemblages—the roughness of the stone walling added to this effect. He is reported to have liked the contrast of smooth and rough surfaces,[76] and it seems very unlikely that he would have totally effaced this "natural" look. The envisaged effect of the whole appears to have been a kind of "roughness and sudden variation joined to irregularity," typical of Picturesque taste;[77] and also, it must be said, limited by it. As it was left, the Merzbarn evoked the same kind of wonder as a natural curiosity does. It is a fitting monument to Schwitters' last years, sadly incomplete. His "lifework," as he called it, was never finished.

10 POSTSCRIPT: MERZ AND MODERNISM

□ Work on the Merzbarn had gone fairly well in the early autumn of 1947. Once the weather worsened, however, the difficult conditions in the barn made progress very slow. At times, rain streamed through the unprotected door and window openings, softening the plaster as soon as it was applied; at others, the plaster froze soon after it had been mixed. And the daily journey up from Ambleside was becoming increasingly difficult, for Schwitters' health was now seriously in decline and he was forced to rest for longer and longer periods. "I sleep 20 hours a day and work 4," he wrote despairingly to Käte Steinitz, "I am always sick."[1] Although pressed by his friends to take greater care of himself, "his answer was always," Edith Thomas has written, "I have so little time."[2] He died in the middle of this work on January 8, 1948. He was sixty.

The day before he died the British nationality he had applied for was finally offered, but then it was too late.[3] Within two weeks of his death an exhibition he had been planning, and which he had hoped would recoup his fortunes, opened in New York.[4] Memorial exhibitions soon followed, and tributes from old friends.[5] He had not entirely been forgotten. Nevertheless, Hans Richter is substantially correct in lamenting the fact that Schwitters was allowed to die unrecognized and in poverty and exile.[6] And recognition did not come quickly even after his death: when Schwitters had left Germany in 1937, his reputation had all but disappeared with him. A first full retrospective was not produced until 1956,[7] and only in the late 1950s did publications on his art begin to appear.

By then of course, Dada as a whole was being revived. Once Abstract Expressionism had challenged the hegemony of Cubism in the modern movement, Dada like Surrealism assumed a new importance; and once Abstract Expressionism was transformed from a painting movement to an "art of assemblage" in the mid 1950s, it was if Dada had been reborn. There is no question that Schwitters and his colleagues had anticipated and influenced many of the activities of what was once called Neo-Dada; and, with its growth to popularity, Schwitters' work received new attention and acclaim.

It must be recognized, however, that as often as not—at least in the popular mind—it was misrepresentation that followed neglect. For one thing, the bracketing of Dada and Surrealism that Abstract Expressionist criticism reinforced minimized the equally important link between Dada and Constructivism, and tended to exaggerate the significance of French over German Dadaists. But even more crucially: before the 1950s Dada had seemed to many merely an unruly incident, not seriously affecting the mainstream of modern art; it was revived mainly as a movement supposedly directed against mainstream modernism, despite the protests of former Dadaists that it was both more and less

than this. Certainly, Schwitters' (and others') special, pro-modernist place within Dada was often overlooked. Only since the mid 1960s, with the emergence and assimilation of a new period of more rigorous abstract art, has this view been generally modified, and it been increasingly recognized that Schwitters in fact straddled the opposite poles of the art of our time, and made Dada into a fine art. And only more recently, even—with the rekindling of more allusive and expressionist forms of modernism—have hitherto neglected aspects of Schwitters' artistic achievement become apparent.

Many aspects of his work still await fuller exploration. By now, however, his reputation is a secure one. His combination of the use of "liberated" materials and the idea of a purely abstract formal structure—the two central innovations of twentieth-century art—has guaranteed his importance to an extraordinarily wide range of subsequent artists and his appreciation by as wide a range of critical taste. Furthermore, the historical place that he holds has further secured his reputation as a classic modern master whose achievement is a bridge not only between Dada and fine art but between the pioneering pre-First-World-War modernists and the new, post-Second-World-War generations, and whose influence reaches down even to our own time.

□ It was, of course, Schwitters' absorption in fine art that kept him from official membership of Dada and brought Merz into existence. This is not to say, however, that he should be separated from his Dadaist friends. He was, Tzara has written, "one of those personalities whose inner structure was always Dada by nature. He would have still been Dada even if the Dada call had not been sounded."[8] But to say that Schwitters had a "Dada personality" is by no means the same thing as saying he was a Dada artist, unless of course it is by personal character alone that Dada is to be defined. For the Dadaists themselves this was an important yardstick, which is why Tzara, who liked Schwitters and thought him a free spirit, calls him a Dadaist, and Huelsenbeck, who disliked him and thought him an untrustworthy bourgeois, does not. At its most basic, Dada was an assertion of personal freedom and individual rights outside of systems, tradition and conventional mores, and was therefore to be measured as much on personality as on good works. But the merits of an artist's work were also to be judged by these same standards, which is why art itself, as a systematic, traditional and conventional activity, posed a special kind of threat for a number of the Dadaists, and caused Schwitters to be ostracized as he was.

In saying this, I do not mean to give further credence to the unfortunately still persisting idea that Dada was essentialy a nihilistic anti-art movement. Dada was not primarily a movement in the visual arts (and certainly not an artistic style); but even the most aggressive and polemical of Schwitters' colleagues (or opponents) were not "against" art as such. They either practiced it or encouraged its practise. They all began from some definition of art, if only to disparage the form that this art took. And if some found satisfaction merely in disparagement it was because they had a vision of a kind of art that would embody an implicit critique—"a critique of the self, the self always reflecting society," as Huelsenbeck put it[9]—and were utterly opposed to the art they saw being made in the society whose values they abhorred. But the art they saw being made was

real, and realized, and theirs was only a vision—and a vision that was founded not in hope but in doubt: "Our critique began, as all critique begins," Huelsenbeck says, "with doubt. *Doubt became our life.* Doubt and outrage."[10]

Schwitters' art never embodied the kind of doubt to which Huelsenbeck refers, a kind of doubt that suspects even the language in which it is expressed, and that can only be spoken, therefore, in a tone of irony. There is irony, certainly, in much of Schwitters' poetry and in the more casual forms of his visual art—in areas, I will argue, where idea or conception is more noticed than material execution. And his playful refusal, in almost all branches of his art, to fully commit himself to those characteristic Dada principles he made use of—chance, nonsense, flux, primitivism—may be deemed ironical.[11] But if it is ironical, it is directed against Dada itself, and against the presumption that principles of this kind can be counted on to produce achieved art. It is certainly not that deep-seated irony of doubt that lies at the heart of the Dadaist imagination and led many of the Dada artists to handle their inherited vocabularies at an ironical distance, as if art were merely what André Breton later called "a lamentable expedient."[12] Schwitters accepted the Dadaist critique of the art of the past, "not because it was art, but because it was *past*," as Robert Motherwell aptly puts it.[13] And even then, he sought to revitalize and not to escape from the tradition that he inherited. His was a remedial revolution.

It is not unusual, of course, to see the whole of Schwitters' *oeuvre* referred to as the product of an experimental avant-garde impulse. Because he was particularly open to what happened around him—the nature of his art depending on it—he tended to be receptive to anything new. Nevertheless, many of his artistic failures lie in precisely those areas where he submitted to current avant-garde trends. Much of his work of the mid and later 1920s in the new forms (for him) of geometric relief construction and especially abstract painting is unrealized because it is not personal. (The more intrinsically impersonal forms of typography and design offered greater chances of success.) Much of his Expressionist and Dadaist poetry, though clearly very personal in its themes, is unable to rise beyond the merely experimental in the way that the best of his visual art always does. Also extremely problematic are those non-modern forms in which he worked: narrative writing and naturalistic painting. But the fact that he did work in such forms—inconceivable, it would seem, for any self-respecting avant-gardist—only accentuates his ambivalence towards the whole idea of the avant-garde.

Dada, it has been suggested, did no more than make "avant-gardism" an end in itself, so that what had previously been the side-effects of advanced art—the shocking, the mystifying and the obscure—were sought out for their own sakes and the pressure of taste thus evaded.[14] This does less than justice to the ideas contained in Dada but is not, in fact, too severe a judgment on the majority of Dada works, which tend to be minor and ephemeral, often presenting themselves as documents more than as works of art. The minority of achieved Dada works, on the other hand, like all successful artistic creations, tend to make superfluous the very ideas that engendered them. Schwitters separates himself from Dada—and from "avant-gardism"—in his concern for tangible, durable works of art and in his consequent distrust of an art of mere ideas.

More than any earlier modern movement, Dada made an outright attack on the peculiarly modernist preoccupation with esthetic values and particularly on the ground-

ing of those values in exploratory technique.[15] Dada sought to remove emphasis from what had been basic not only to modernism but to Western art since the Renaissance: the individual controlling hand in dialogue with a circumscribed medium as the source of esthetic value and the moral center of art. Dada attacked this "formalism" in a way that was clearly unpalatable to Schwitters, who found inspiration in a medium that he had made his own.

Dada was indeed an anti-art movement, then, in its distrust of self-contained works of art. Its opposition to the permanent and the stable necessarily meant that such works of art were suspect, for as Hannah Arendt has pointed out, they are the most durable of fabricated things.[16] It also meant that ideas, and arts overtly expressive of ideas, were more important to the Dadaists than durable objects. Within the arts, the Dada approach was most inherently suited to those forms based on writing, music and action because they are—to follow Arendt's description of poetry—"the most human and least worldly of the arts . . . in which the end product remains closest to the thought that inspired it."[17] It was least appropriate to the visual arts, where thought must be transformed into material things. Dada sculptures—or rather, Dada objects—are the exceptions to this, for they capitalize upon the fact that sculptures are less easily separated than paintings from the ordinary world of less permanent objects, and therefore are able to play on the boundaries of thought and art, just as Dada poetry and performance can.

This is as true of Schwitters as of any other Dadaist. His poetry and performance, and his early sculpture, bear this out. When he dealt with arts close to thought or to action, where the demands of material fabrication were minimized or not required, he produced his most obviously Dadaist work. And when his found materials were allowed to leave the two-dimensional picture-plane, and the discipline it imposed, the same thing happened in his visual art too—at which point, in the early sculptures and in the grottos of the *Merzbau*, the already autobiographical bias of his art was transformed to reflect a characteristically Dadaist desire to fuse art and life.

However, his later plaster sculptures, and the constructed *Merzbau* shell that covered the grottos, tell of a desire to return the autobiographical to the confines of a formalized artistic discipline. Like most of the Dadaists, Schwitters was impatient with boundaries and was clearly concerned with testing them, even to breaking point; in the last resort, however, he reaffirmed them, albeit in new and at times surprising ways. His preoccupation with the *Gesamtkunstwerk*, as expressed first in the *Merzbühne* then in the *Merzbau*, involved him in the Dadaist opposition to the autonomy of the individual arts, but the ideal of esthetic self-sufficiency to which he was committed tended to reestablish this autonomy. The consequences of this dual affiliation are present in the very structures of his art. The tension and reciprocity between his concern for artistic purity and for the life of the images and objects he used affects his art at all its levels.

Schwitters, however, was hardly ever a pure image-maker, and in this he separates himself from most Dada artists, for whom explicit image-content (however mystifying) was important. As a result, his work seems more conservative than that of Dadaists like Duchamp and Picabia or Hausmann or Ernst: there is little in his collages and assemblages that had not been predicated by Cubists or Futurists. It was through image-content that Dada transmitted its revolutionary message. At the same time, it was the concern for

image-content—and indeed with art as a way of transmitting messages—that comprom-
ised the revolutionary character of much of Dada art.

Given the loss of faith in purely esthetic values that characterized Dada, and the
underlying doubt, even about its own language of expression, that produced it, Dada
(following Futurism in this respect) sought to open the private dialogue of artist and
artistic practise to admit more public and ideological concerns. That is to say, the
Dadaists sought to replace what they viewed as hermetic and escapist in modern art with
forms that could comment upon, and hopefully produce change in, a world that needed
change. In effect, Dada replaced the traditional dialogue of artist and medium with that
of artist and ideology. In doing so, it was both revolutionary and traditional, both elitist
and libertarian—just like the established modern tradition against which it rebelled, but
in an opposite way. Dada was revolutionary and libertarian because it rejected the
traditional cultivated norms of taste that earlier modernists, because of their heightened
concern with esthetic value, had embraced more self-consciously than ever before. It was
traditional and elitist, however, because it returned art to the service of a select ideology,
whereas the modernist revolution had sought to set art free from such concerns.

That the ideological content of Dada was dissident, and that of art before modernism
had been "official," should not disguise the fact that both reflected values formulated by
an elite, nor that both placed restraints on certain liberties—particularly stylistic
liberties—that modernism as a whole especially valued. As modern art emerged in the
nineteenth century, style gradually assumed more important a role in painting than
descriptive or image content, which declined in favor of the communication of content
by formal values in a less particularized way.[18] Dada, however, resurrected the tradition-
al image-maker. In Dada, as in art before modernism, image content was more impor-
tant than style. Art became ideology objectified, in a way that was antithetical to the
spirit of original modernism. And yet, because Dada attacked modernism from within, it
cannot in the final count be labeled anti-modernist. Neo-modernist is better,[19] for its
particular fifth-column revolt attacked modernist positions with an arsenal of estab-
lished modernist forms. In effect, it split modernism into two camps, dividing the tradi-
tional or "classic" modernists from the neo-modernist avant-garde. It was because
Schwitters was at heart a "classic" modernist that he never quite belonged with the
avant-garde.

Of course, Schwitters, like any other classic modernist, was not untouched by the
ideologies—the dominant and the dissident ideas, prejudices and values—of his time. He
was no less formed and moved by his time than any full-fledged Dadaist. But he did not
experience that time through the filter of an ideology. As a creator, he acts on the
assumption, in Harold Rosenberg's words, that

in drawing on all available energies, he is bound to be be in tune with the time, that his
move is the correct move for the moment in which he acts. His insight into time is
embedded in his practise. In contrast, the avant-gardist has an *idea* of the present as a
means of transition to the future; instead of communing with the present as the
container of the past and the possible, he seeks to use it to fulfill the commands of his
system.[20]

The art of the avant-gardist, that is to say, arises out of a specifically ideological consciousness of present systems (artistic as well as social) and finds its energy and motivation in surpassing and demolishing them. In the case of Dada at its most extreme, the present order was to be destroyed for a state of permanent revolution, which makes it the "purest" of all avant-garde movements—and therefore the least stable and durable of artistic ones: for while the revolution continued no new order could be affirmed.

In fact, the continuing search and experiment that is implied by the idea of the avant-garde cannot finally be reconciled with the discovered solutions that the post-Dadaist avant-garde hoped to provide. Which is why Schwitters was more at ease with the Constructivist avant-garde than the Dadaist one. But even in the Constructivists' company, Schwitters sets himself apart: not so much by his Dadaism as by his obstinate refusal to follow an ideological blueprint of any kind. Moreover, while both the Dadaist and the Constructivist avant-gardes sought, in their different ways, to surpass and demolish the present, Schwitters made the present the very subject of his art. As creator rather than avant-gardist, he "recovers the moment which avant-gardes have passed over, bringing to light the demons lurking in it to frustrate the forward march of the idea."[21] His subject is things as they are—even things as they were—not as they should have been.

□ Schwitters' belief in order was not, of course, unique among Dada artists. Even those most opposed to the autonomy of pure painting necessarily made esthetic decisions in the creation of their art. I referred earlier to the opinion that, by seeking out the shocking or mystifying for their own sakes, the Dadaists evaded the pressures of taste. To this it should be added that it was because the pressures of conventional taste are not easily evaded that the fine arts assumed such a problematic role within Dada. Revolutions in art are not achieved by fiat, and when the Dadaists were successful as artists it was because what Robert Motherwell calls "the anti-structure position in their search for the new" turned out to be a search for structure after all. He explains:

> We see now . . . that the dada painters were never able to reduce themselves to mere sensation or social activity as many of the writers were able to do. It is as though the desire to shake off structure and the search for new structure had to arrive at the same place, because in both cases the means had to be the same, rejection of traditional modes of composition.[22]

With the caveat that traditional compositional modes were not in fact totally rejected, and that the revolutionary impulse of Dada shook up rather than shook off the structures of the past, this is very much to the point here. Despite the "new" Dadaist preoccupation with image-content, Dada visual art (with the single exception of Arp's work) did not produce any significantly new mode of pictorial composition. In Schwitters as much as in Ernst, and in Grosz as much as in Duchamp, the taste and the syntax continue to be informed by Cubist, Futurist or Expressionist models, no matter how extreme the anti-art techniques, and no matter how vivid the imagery, that modify them. (Even Ernst's De-Chirico-influenced spaces are finally Cubist in organization; as are, of course, De Chirico's too.) Indeed, the particular visual excitement of Dada art is precisely due to the

internal pictorial battle it reveals between the traditional sources and the new techniques and images. However new the Dada idea was, insofar as Dada was an art movement it was a transitional one, and its sheer energy as an art movement is comparable to that of other transitional movements or phases in modern art: Fauvism in Matisse's art or the immediately pre-Cubist phase in Picasso's, for example, both of which preceded more classically ordered styles. Schwitters acknowledged this when he wrote that Dada was "the means for making art, art which is not dada, but the result of it."[23]

Motherwell rightly points out that insofar as the Dadaists did produce new structures they turned out to be not unrelated to the new structures of the abstract artists of the same period. Necessarily so, for abstraction emerged in modern art at approximately the same time as Dada art, drew on the same sources, and strove as energetically to overcome them. It is not to be wondered at that Dada and Constructivism came to have much in common, nor that it was—as far as the visual arts are concerned—in Constructivism that the new structure many of the Dadaists were seeking was eventually found.

It hardly needs saying that Surrealism is the generally acknowledged successor to Dada, and that the philosophical connections between Dada and Surrealism are greater than those between Dada and Constructivism. Surrealism in France extended and institutionalized the Dadaist revolution while Constructivism in Germany ended it in order to build a new rationalist state (a turn of events not unlike the socio-political ones that produced Weimar). But there is, in the visual arts, at least as close a historical link between Dada and Constructivism as between Dada and Surrealism. Of course, Dada provided the basic formal language for Surrealist art, or at least Arp did. His Dadaist invention, biomorphism, became the formal common denominator of Surrealist art, whose development therefore reads as a "saga of biomorphism."[24] But the link between Dada and Surrealism remains essentially at the level of inherited, and then modified, philosophy and style (that is to say, like the link between Cubism and Futurism, for example). We look in vain for a group of Dada artists who themselves developed from Dadaist to Surrealist styles. In fact, Max Ernst was the only Dada artist of any importance to do so. Arp's allegiance to Surrealism did not substantially alter the character of his work, and he retained his Dada-Constructivist contacts even as he established his Surrealist ones. Moreover, while both of these artists worked in France as well as in Germany, neither, of course, was French. In Germany between 1918 and 1923/24 we see a continuity of artistic debate and development from Dada to Constructivism which is not to be found from Dada to Surrealism in France. It involved "constructive" Dadaists like Schwitters, Richter and Eggeling, formerly "anarchical" Dadaists like Hausmann, and part-time Dadaists like Van Doesburg. And just as importantly, for many of the young Constructivists-to-be, Dada was the kindergarten from which they graduated into their mature styles.

Dada has been presented as a two-pronged attack on tradition: at its most extreme an "anti-art" movement and at its least iconoclastic a way through which "poetic painting" (or *peinture-poésie*, as opposed to *peinture-peinture*, or pure painting) was revived.[25] In fact, its basic demand for a *tabula rasa* prepared the way for new forms of both "poetic" and "pure" painting to be established. If the Dada-Surrealist axis shows how the original Swiss-German Dadaist source, based in northern fantasy and chaos, was transformed

into French poetry and lucidity,[26] then the Dada-Constructivist axis shows how north ern fantasy and chaos was turned on its head in northern purity and order.

I stress this here for two reasons: First, to point out that the path that Schwitters' art took in the 1920s was in no sense at all an exceptional one, and cannot itself be used to affirm his "formalist" biases, for many others traveled in the same direction. Certainly, as a late version of Dada, Merz was from the time of its invention in 1919 already as much a response to the call for a new postwar order as the expression of revolutionary ferment. In this sense, its subsequent development confirms its original "formal" bias. But because it was a late version of Dada, Merz actually straddles Dada and Constructivism, disengaging itself from one as it aligns itself with the other. In fact, to speak too dogmatically here of individual movements disguises the way that Dada elided into Constructivism in Germany, just as it had emerged from German Expressionism in the first place.

The second point that needs to be stressed here is that emphasis on the Dada-Surrealist link unduly gallicizes Dadaism as a whole. Except for Duchamp, who rejected painting, none of the important Dada painters was French. The majority by far were German, and came to modernism through German Expressionism, and founded or joined Dada as a schism of it. This accounts for their Expressionist-influenced styles, their heated objections to the "hoaxes of reason,"[27] which were often, in effect, objections to German *Kultur*, and their "impure" and ecumenical interpretations of modern art, which are Expressionist in origin. But it also tells us that sheer provincial ambitiousness was one of the things that fueled their rebellion against mainstream modernism as it then existed. Their isolation from the Cubist sources from which their styles ultimately derived meant at times that they merely dressed-up received Cubist structures in a superficially new way. It also meant, however, that the most flexible and resilient of their company were able to recast and even to reform Cubism because of their freedom from the culture of its source.

Both Dadaists and Constructivists talked of themselves as "new men." Many of them behaved as if art only started in 1900[28]—and life on this planet only a few years earlier. Although the Dadaists' attitude to the present was as sceptical and cynical as the Constructivists' was optimistic, they leave us in no doubt at all that they are "modern" figures. The hopes and the fears of members of both of these groups are intimately involved with their twentieth-century situation; with few exceptions, their art and their thought is preoccupied by twentieth-century themes. Both groups, moreover, were "millennialist" in positing a future social ideal that art would herald and help to create; then art itself would wither and disappear along with all other older forms and institutions. Constructivism, of course, was more explicitly millennialist in providing in its actual work a blueprint for the designed utopia of the future and in confidently expressing its faith in modern technological progress as the path to man's individual and social perfectibility. This oversimplifies the Constructivist position; but it is a simpler position in this regard than the Dadaist one, which deserves more detailed discussion if we are to fully appreciate why Schwitters could never have been one of the "new men."

The optimism of the Constructivist position was to a significant extent a postwar optimism. It may indeed seem curious that the First World War, as a horrifying triumph

of modern mechanism and industrialism, should produce an avant-garde movement that celebrated these very things. But they were celebrated in the 1920s—and not despite, but because of, what had happened, for how else could that technological war be justified except to produce a technological peace? For Dada, however, born during the war, technology could never again be something benevolent. Indeed, the whole belief in progress itself was seriously damaged by the events of the war, for that belief had largely modeled itself on the image of progress presented by science and technology which, in contrast to the arts, do advance and improve from generation to generation. And what had always been a drawback of the idea of progress was made painfully evident by the war: it sacrificed the present for the sake of the future.

That Constructivism could revive the progressive ideal (like the Russian and German Revolutions which laid the foundations of the Constructivists' optimism) is evidence of its deep-seated hold on the Western imagination; but certainly for the Dadaists it was no longer the unmixed blessing it had once seemed. Hence that basic Dadaist conflict and dilemma of those who thought of themselves as modern and progressive figures, dedicated to social change, but felt nothing but horror and disgust at what their modern age had made of the progressive ideal; in wanting to change their times they found that the weapons they had inherited were only instruments of conciliation. I refer here to the vocabulary of Cubism.

Dada appeared when the original impulse of Cubism was losing some of its authority and stylistic sects were beginning to develop, all seeking to replenish the original style by challenging its abstractness and autonomy, and seeking greater contact with the forms of external reality once again.[29] High Analytical Cubism had expressed, more completely than any earlier modern style, a sense of competition between reality and its representation: the painted marks upon the surface make two conflicting claims upon our attention—as signs for objects in the world and as autonomous painterly units. And the invention of collage before the First World War, though possibly intended to repair this conflict, if anything exacerbated it. To introduce "foreign" elements from the external world into paintings was actually to stress the division between the world of art, which received these elements, and the world of external reality, from which they derived. Moreover, in Analytical Cubism itself, the conflict had always been softened by the generalized illusionistic spaces in which it occurred, whose poetic chiaroscuros affirmed contact with reality in an abstract, idealized, and contemplative way. Once, however, these spaces were expelled by the spreading flatness of pieces of collage, what had been an implicit conflict often became an explicit one—which is, of course, why the Dadaists were attracted to the collage technique. Collage embodied, in its very structure, the way that reality challenged and opposed the abstractness and the autonomy of modernist art.

Synthetic Cubism, along with the various Cubist offshoots that emerged in France around the same time as Dada, likewise sought more overt contact with external reality. However, it also sought to harmonize the conflict created by collage: it locked together painted symbols of the external world in a jigsaw whose abstractness and stability reaffirmed the idealistic order of the original Cubist style. Dada opposed that order. As William Rubin has noted, the very structure of Cubism was anathema to the Dada spirit:

Its [Cubism's] prevailing verticality and horizontality are not so much the properties of man as of the man-made world, the structured environment that man creates in order to function with maximum stability. The Cubist picture speaks of this external order from a contemplative position in idealistic, abstract terms. To the Dada and Surrealist generations this attitude seemed too reserved, too disengaged from man's passions and fantasies.[30]

Some of the Dada artists, I will argue, are heirs to this Cubist idealism and reserve. For the majority, however, Cubism was at its best too passive and at its worst a symbol, if not an instrument, of the repression they were fighting—of the modern rationalism which, as they saw it, had produced the First World War. And yet, if they transformed Cubism into an aggressive, combative style, and thus hoped to attack what the war stood for, it was only to find that others (the Futurists) had used such a style actually to support it. How to be modern and progressive while avoiding the technological and the rational, and without damaging the present in the name of the future, was the Dadaists' dilemma.

Northrop Frye has spoken of an "alienation of progress" in our modern century.[31] It was exactly this that the Dadaists were among the first to feel. But as Frye says, self-awareness in this respect operates like a drug, stimulating a sense of responsibility but weakening the will to express it.[32] Alienation itself was what they mostly expressed. First, in their disengagement from the progressive ideal as founded on scientific analogy. True, a belief that things could be altered and bettered fueled the Dadaists' call for a *tabula rasa*: they sought to abolish the past so as not to have to build on its mechanistic systems, and in order to start again. But the Dadaist act itself was essentially gratuitous. The whole notion of engagement, of serving a particular program and of providing solutions to the problems they raised, was alien to the Dada spirit. And this holds true for virtually all of the Dadaists, Huelsenbeck as well as Schwitters; only the Communist alignment of Grosz, Heartfield and a few others belies it (and this alignment was effectively a post- and anti-Dadaist one). Although ideological and purposive in a way that classic modernism was not, Dada was ideological without a specific ideology and purposive without a purpose—which is why, of course, Dada actions themselves (as well as Dada objects) could be considered "artistic." They were always disinterested. Dada was "progressive" in that it aimed and pushed toward the future, but there was no future in Dada itself—which is why it soon disappeared.

Insofar as a specifically Dadaist (as opposed to post-Dadaist) order was ever codified, it was an *ordre déraisonnable*[33]—an unreasoned order, not another rationalist one. In rejecting the myth of a rational, technological utopia the Dadaists first fell back on the myth of a primitivist one, resurrecting the Rousseauist precultural ideal that had been positing an alternative kind of utopia since the eighteenth century. This primitivist tradition was an important source of the Dadaists' "anti-art" ideas, for basic to this tradition was the belief that what was wrong with modern civilization was its artificiality: "that 'art,' the work of man, has corrupted 'nature,' that is man's own nature," and destroyed his original organic equilibrium.[34]

Symptomatic of this corruption and destruction was the First World War. "If the opposite of war is peace," wrote Paul Fussell, noting the way that the war unleashed

rather than repressed mythic and arcadian thought, "the opposite of experiencing moments of war is proposing moments of pastoral."[35] This is certainly what Arp proposed in Zurich during the war: a new, organic formal vocabulary that escaped the static rectilinearity of the rational world (and of Cubism) and put in its place the improvisatory, instinctive freedom of movement and action that the Dadaists so valued.

But Arp's peaceable kingdom of childlike innocence was finally less typical of early Dada than the dark and even demonic pastoral of primitive and irrational instinct that characterized the more riotous assemblies at the Cabaret Voltaire, which themselves set the pattern for future Dada events. Dada meant the freedom, the spontaneity, the instinctiveness and the ritualistic fantasy that had always belonged to the idea of an anti-cultural pastoral arcadia, but without the pastoral comfort that such an arcadia had traditionally hoped to provide; for to seek that kind of comfort would be to shut out and sacrifice the present as much as did any technologically progressive ideal, albeit for opposite reasons. It seemed for a brief moment—when Dada was under the direction of Hugo Ball and when Arp's example was preeminent—that this was indeed the aim: that although Dada itself was not offering a pastoral arcadia, it was to be a kind of ritual exorcism through which such an arcadia could be reborn. But once the Cabaret Voltaire closed, this explicitly—even ideologically—primitivist phase of Dada was ended, and Dada developed in a continual state of inner conflict between the two poles of commitment to its "natural" instinctive ideal and sense of responsibility to its own time.

Almost without exception, this sense of dual affiliation is manifested in the structure of Dadaist art itself, which is rarely either purely instinctive or purely topical, but usually a combination of both. And since the instinctive meant a repudiation of Cubism and the topical an acceptance of it, Dadaism in practise was stylistically rarely either purely anti-Cubist or purely Cubist, but usually a combination of both. In Schwitters' case, we see this in the ambivalence between his openness to the outside world, which carried him beyond Cubism, and his belief in artistic autonomy, which drew him back. But it is something that runs through Dada art as a whole. At times it meant clothing primitivist obsessions in modern dress, as with Duchamp's and Picabia's use of machine images—organized into Cubist-derived structures—as a way of musing on the loss of instinctive sexuality; and Ernst's use of scientific illustrations—laid out with strict deference to a flat, Cubist picture-plane—to tell of autobiographical fantasies and hallucinations. At others, it meant subverting the modern Cubist idiom to attack selected modern targets, as with Grosz's transformation of Futuro-Expressionism into an aggressively satirical form, and with the Berlin photomontagists' reorganization of the materials of the mass media—and of Cubist collage—to distort the messages they originally conveyed. But common to all this was an assertion of "natural" and spontaneous personal freedom that opposed manmade orders (and Cubism) yet did not finally seek to escape them—for to uncover the instinctive and primitive within the manmade world (and to alter the vocabulary of Cubism in order to do so) was to attack its rationality from within its very own order. In this sense, certainly, Dada was a fifth-column attack on modern society and modern art.

Collage, I said earlier, was important to the Dadaists because it embodied in its very structure the challenge of external reality to the abstractness of modern art. It was also

important because it was the path that led beyond painting, even beyond art. Here, the contrast of Schwitters and Duchamp is a particularly telling one. For both, the Cubist opposition between painting and its subjects (accentuated by the Cubists' use, in painting, of collaged elements) was the starting point, and both sacrificed painting for the sake of the subjects with which they identified. Both realized that the collaged elements in Cubist paintings could be allowed a greater independence than Cubism allowed. But whereas Duchamp, in effect, retrieved them from painting to put them back in the world, as Readymades—counting on the fact that, after Cubism, any object esthetically presented would seem expressive—Schwitters retrieved them from painting in order to make from them new kinds of pictures, which go beyond painting but never beyond art. Both these artists were preoccupied with the process of dissociation, through which found objects would be displaced from their familiar contexts and new expressive possibilities would be released from them. Duchamp stressed the enigmatic in an object, and therefore its formal isolation; he professed a "visual indifference"[36] to the esthetic form of his Readymades. This indifference was obviously anathema to Schwitters, whose understanding of dissociation stressed the release of an object's esthetic properties, and therefore its formal association with other similarly dissociated objects. He was concerned with the individual expressive life of each object he used, but within the confines of art. To recast Cubist collage in a purely abstract form, as he did, was certainly to lose descriptive reference to the world, but only to replace it with a vivid and heightened kind of reality; for the objects included in his pictures were authentic quotations, salvaged from the world, that let the world speak for itself, as a far more disjointed and incongruously constructed place than we have previously imagined.

And yet, the artist who speaks through quotations speaks at a distance. Schwitters' disinterested presentation of the world's fragments links his approach to the contemplative stance of the Cubists, just as Duchamp's dandyish "indifference"—or Arp's unworldly detachment and Ernst's self-observing coolness, for that matter—does the same. All espoused an improvisatory freedom of method that rejected Cubist stability, yet in the final count each of these most important Dada artists was heir to its reserve.

"The Dadaist is a mirror carrier," Schwitters said;[37] and that sense of apparently just reflecting the conditions and the apparatus of the modern world was what allowed the Dadaists to make the modern world their subject without falling into either Expressionist subjectivity or Futurist dramatization. Although "committed" artists, they assumed in their art a stance of disengagement, of documentary disinterestedness and even at times indifference, making it seem as if the alogicality they presented was not theirs but the world's. And this was particularly true of the Berlin artists, in confrontation with whose positions Schwitters defined his own. In Berlin, Huelsenbeck noted, "Dada . . . loses its metaphysics and reveals its understanding of itself as an expression of this age which is primarily characterized by machinery and the growth of civilization. It desires to be no more than an expression of the times."[38] A quotation, all this implies, is more authentic than a picture or a narrative (which is why "art" was to be opposed; it lied).

But there is no such thing as inchoate experience, and no such "innocent" a relation to the world is truly possible. This was all a fiction, a Dadaist strategy: a way of giving

factual shape to the alogical world of animality and instinct that the Dadaists could not easily "describe" because it was not real in the sense that the world's objects were real. Hannah Hoech was most honest in this respect when she said that "the Dada *photomonteur* set out to give to something entirely unreal all the appearance of something real that had actually been photographed," and that the essential strategy here was "imposing, on something which could only be produced by hand, the appearance of something that had been entirely composed by a machine" and "trying to suggest, with elements borrowed from the world of machines, a new and sometimes terrifying dream world."[39]

Technology is thus subverted by technological means, as unmodified elements of the modern outside world are recomposed to create a primitive internal world of dream, fantasy and instinct as "real" as the world outside. But since its components are indeed modern ones, the world presented in Berlin photomontages is simultaneously modern and primitive, simultaneously external and internal. Insofar as it is primitive and internal it implicitly criticizes and opposes the idea of public progress: "The word 'improvement' is in every form unintelligible to the Dadaist," Huelsenbeck wrote.[40] And yet, the Dadaist "is entirely devoted to the movement of life." Dada in Berlin was opposed to utopias as it was to arcadias—indeed it was "opposed to the idea of paradise in every form." Not, however, because it was opposed to progress itself or to the modern experience itself. Far from it. It was merely opposed to the ways in which these things had previously been conceived.

The Dadaists recognized that a response to modern experience had often been described, but what modern experience itself was like had never properly been shown. And in wanting simply to present this experience—as an "obvious, undifferentiated, unintellectual" continuum[41]—they necessarily opposed anything that seemed to be shaping and molding, and therefore distorting, it; which is why the progressive ideal was anathema to them. They recognized that what was wrong with the progressive ideal was that it sought to bring progress to an end: that utopias as well as arcadias "imply a static view of the world which is incompatible with reality, for the human condition has always been to move on."[42] Their ideal, then, was to reject all fixed ideals and live in a state of flux that was true both to the public and modern present and to the personal and instinctive self. It is because "the word Dada symbolizes the most primitive relation to the reality of the environment," Huelsenbeck wrote, that "life . . . is taken unmodified into Dadaist art."[43]

This Berlin Dadaist sense of being true to oneself by being true to one's times—and vice versa—was clearly absent from Schwitters' esthetic. He was not a "new man" in this way, despite the derivation of his art from the documents of his time. As observed earlier, to speak through quotations is not only to speak authentically but also to speak at a distance. In Schwitters' case, the additional distancing effect of their overtly esthetic, abstract ordering compromises the authenticity of his quoted materials. They are absorbed into what is obviously a fictional work and not—as with the Berlin Dadaists—presented in what pretends to be a documentary one. As a result, even when the components of his art are patently "modern" (and they are usually not), the effect of his art is only very rarely to confirm their modernity. It confers importance on the fragments that can be taken to stand for the whole urban landscape from which they derive, but at the

same time it distances them—and with them, that landscape—from the modern moment itself. In Schwitters' art, his materials become souvenirs, stored memories of the world, and speak of the world nostalgically and often indeed in a tone of melancholy. Far from being a celebration of the modern experience, his art is its elegy. It tells always of the world in the past tense, not the present, and instead of evoking the active, instinctive—living—momentum of its times, as most Dadaist art does, it functions as a kind of modernist *memento mori*.

☐ There are four particularly significant words—*Entformung, Eigengift, konsequent* and *Urbegriff*—that Schwitters often used when describing the character and function of his art. *Entformung* was a neologism of his own invention that he used to describe what happens to materials when brought into his pictures and collages. I have translated it as "metamorphosis" and as "dissociation" but it resists exact translation. *Formung* is "forming"; the prefix *ent*-corresponds to the English "dis-," "de-," or "un-." It meant turning old materials into new art—making new art from the remains of a former culture, as Schwitters put it, talking of his early assemblages—but also something nearly opposite, for the old materials and "former culture" were in fact things of the present. It meant, then, making something timeless and primeval—art, that is to say—from something temporal and modern, from the perishable fragments of the present. And in order to achieve this esthetic transubstantiation, the materials and fragments that Schwitters used needed to be purged of what he called their *Eigengift*, their inherent vice or personality poison. The image is of esthetic cleansing. (Indeed, Schwitters would often carefully wash the materials he found before including them in his collages).[44] Objects taken from the world had to be purified to become part of a work of art; to include and contain them within a work of art was an act of purification. Art itself was the antidote to the *Eigengift* that the world's objects contained (and that the world, by proxy, also contained)—which was why Schwitters so insisted upon the abstractness of what he made: abstractness and purity were one and the same thing.

Art, therefore, had to be *konsequent*—consistent, rigorous, logical, subject only to its own autonomous laws. It was by submitting found materials and objects to these laws—by esthetically evaluating them one against the other—that they were "dissociated" from their original functions in the world and their *Eigengift* thus effaced. Moreover, since the "laws" of art were in fact the invention of the artist—since "the artist has his laws within himself, and this is why he can be consistent"[45]—to "dissociate" materials from the external world was also to associate them with a world of the artist's own making.

A deep-seated subject of Schwitters' art, then, is his struggle to create from the raw materials of the world a cleansed and corrected version of reality—based on his own urgent demand for personal order—that could be counted on to last. It was with his collages and assemblages, and on the solid foundation of the delimited picture-plane, that he was most successful in doing so. However, his multidisciplinary and synthesist ambitions are attributable to exactly the same motive. The attempt actually to join the different arts that produced the *Merzbühne* and the *Merzbau* drew first on Expressionist hopes for a *Gesamtkunstwerk*, then on Dada ideas about the fusion of art and life, and finally on Constructivist beliefs in a planned environment: all offered Schwitters a way of

building a secure home for his most literary, and least ordered, interests to thrive in—and a way of structuring his autobiography. And his understanding of Merz itself as a unifying principle for everything he did, one that could absorb and collate the styles and techniques and media that accumulated as his career developed, likewise was a way of reconciling the disjointed, the dissociated and the anomalous—like a gigantic collage. Indeed, Schwitters' *oeuvre* as a whole presents itself as a panoramic collage, a personalized collection of borrowings on the grandest of scales, full of oddities and contradictions but whole and complete.

All this reveals an understanding of art as something that soothed and ameliorated the noisy modern experience the Berlin Dadaists embraced. Indeed, it was an escape from that experience. Art was a "a spiritual function of man, which aims at freeing him from life's chaos (tragedy)."[46] This was what Schwitters called an *Urbegriff*, a primeval concept, not a modern one; and the creation of art was the creation of timeless order out of temporal chaos, and the creation of a private retreat from the remains of the outside world. There is, in fact, in Schwitters' esthetic, something that is close in spirit to the original primitivism of Zurich Dada, to Arp and Ball's idea of Dada as a way of overcoming the exigencies of the present, of exorcizing the demons of the present, to recreate a world of purity and instinctive order. The difference, however, is that whereas Arp used forms that themselves escaped the modern experience, Schwitters did not.

We therefore see in his work not only the picture of a new instinctive order but a picture of its creation: since the material components that create this order are drawn from quite an opposite state, the tension and competition between parts and whole is necessarily given along with the new order itself. It does present an idealized order, but it also presents within its very fabric the difficulty of its attainment. A sense of rivalry between the external world and its esthetic idealization is necessarily at least part of the effect of Schwitters' art. The way in which the world of objects, styles and materials imposes itself upon the artist, and the way in which his art imposes itself upon the outside world,[47] is there to be seen in almost everything he did. But since the world as absorbed into Schwitters' art is taken, more often than not, in a used and tattered state, no sooner do we notice this rivalry than we also notice its conciliation. The urgencies of the world have already been softened and the present already returned to the nostalgic past.

Like many others amidst the bewildering tumult of Weimar Germany, Schwitters seemed both estranged and fascinated by the machinery of urban civilization. The result was an art that looked inward and outward at the same time. Even at his most introspective—in the creation of the *Merzbau* grottos and in his fantastic writings—his private universe was built from and modeled upon the world outside. And if it offered an escape and retreat from that world, this was not into sheer subjectivity. Schwitters was not lost or overcome by his urban civilization as was the Expressionist generation from which he emerged: it was the very subject of his art, to be altered and transformed but not to be put aside. True, we see in his work something of that obsessive self-regard of the first Freudian age; but we see it only obliquely, in his personal attachment to those materials that, dissociated from the world, served as emblems of himself. This was a kind of escapism, but also a way of capturing and possessing for himself a world in which he felt insecure. In the wasteland of actuality, the waste itself offered a sense of consolation:

to possess that was to possess and control, if not the world as it was, at least its archeology.

Even at his most introspective Schwitters still trafficked with his times; and yet even at his most extravert he stood back from them. Not only did he live and work outside the metropolitan mainstream, but when he did commit himself to public action—as first a Dada performer and then a propagandist for Constructivism—he did so as an outsider, and an eccentric one at that. Combining the personality of a Dadaist with the purism of a Constructivist, he associated with both of their camps while belonging to neither. His priorities were quite different: not to alter the present to prepare for a modernist future but to qualify and to correct its frenetic momentum, and to fuse or imbue his own modernism with an authority that was of an unashamedly conservative kind. For all his commitment to modernism—and once Schwitters had found his own voice he joined the company of the great moderns—he still had roots, and commitments, in a German past, and particularly in a preindustrial and Romantic ideal of organic wholeness.

His continual preoccupation with nature is what, in this respect, most obviously gives him away. To return periodically to nature, he said, was to revive his inspiration; it was a traditional form of purification, this withdrawal to a greener world that brought about a renewal of energies and provided the model for a more authentic life.[48] Schwitters did eventually escape the urban to find refuge in such a restorative terrain. The *ur*-myth led straight back from the city to the country, and when forced to leave the security of his provincial Hannover, Schwitters did not turn to the New World, as nearly all of his colleagues did, but retreated further into the old one. Of course, this organic haven, when finally reached, created its own difficulties, artistic as well as personal. As Harry Levin has observed of comparable Arcadian explorations, "the privilege of undergoing a fresh experience is one thing, and the problem of writing about it is another."[49] Schwitters' existing (urban) vocabulary had to be severely ruptured to tell of his new surroundings.

The damage this did to the quality of his art has certainly been exaggerated in earlier accounts of his work, and we see now that the late Schwitters is comparable in many respects to the late Klee—or to the late work of many great artists, for that matter. With increase in ambition, and in confidence, after an astonishingly productive career, risks were taken that brought a higher percentage of failed works than previously but which opened new and daring avenues hitherto little explored. The larger late assemblages and collages, especially, have a forthrightness and generosity about them that makes the preceding, Constructivist-style work seem over-controlled by contrast. As Schwitters' art developed beyond the pioneering years, his early preoccupation with putting order into his materials led him to fear inexactness lest it fall into mere randomness, and it was only in the 1930s—after he began cutting his ties with Germany and after he acknowledged in print that right through the Constructivist period he had been harboring, in the *Merzbau*, atavistic Dada beliefs—that he overcame this fear and allowed sheer feeling to reassert itself. At which point, in Norway and then in England, his long-standing primordial ideal was finally made manifest.

At the same time, it is, I think, indisputable that he was at his very best when his primordial ideal was just that, an ideal, and not within geographical grasp. In the great

early years in Hannover, where he loved and hated everything around him, he was able to present in pictures drawn from the world the image of a serene but extraordinarily vital order that escapes both the stifling bourgeois correctness of that city (and of one side of his own personality) and the frenetic vanguard experimentalism of many of his colleagues (and of the other side of his self). The sense of a quiet, contemplative and private order, made from and within his claustrophobic surroundings—and ineluctably opposed to them—that we find in his work gives to it its characteristic note of wistfulness, even at times of pathos. Schwitters is telling of an order that he himself could never expect to attain.

Nevertheless, his was not a simply quiescent or merely nostalgic art. The creation of order, as much as the order itself, was the subject of what he did: the sense of competition between the artist and his surroundings that is given along with the order adds drama and excitement even to his smallest creations. And that, as much as the order itself, carries with it the power to touch us—if only because it tells of a struggle we all must know.

For Schwitters, it was a kind of struggle that admitted no final or single victory, but had to be fought out daily as new surroundings, new styles, new influences kept on altering the context in which he worked. Neither this nor the order to which he was committed was ever changed. The point of order he wrested from the tumult of his early revolutionary years became the ideal to which he was henceforth committed. The fight for that order continued throughout his life. "Kurt Schwitters was born a rebel," writes one of his friends. "He died a lyrical poet."[50] The lyrical, in fact, was there from the start, and the rebellion to the very end.

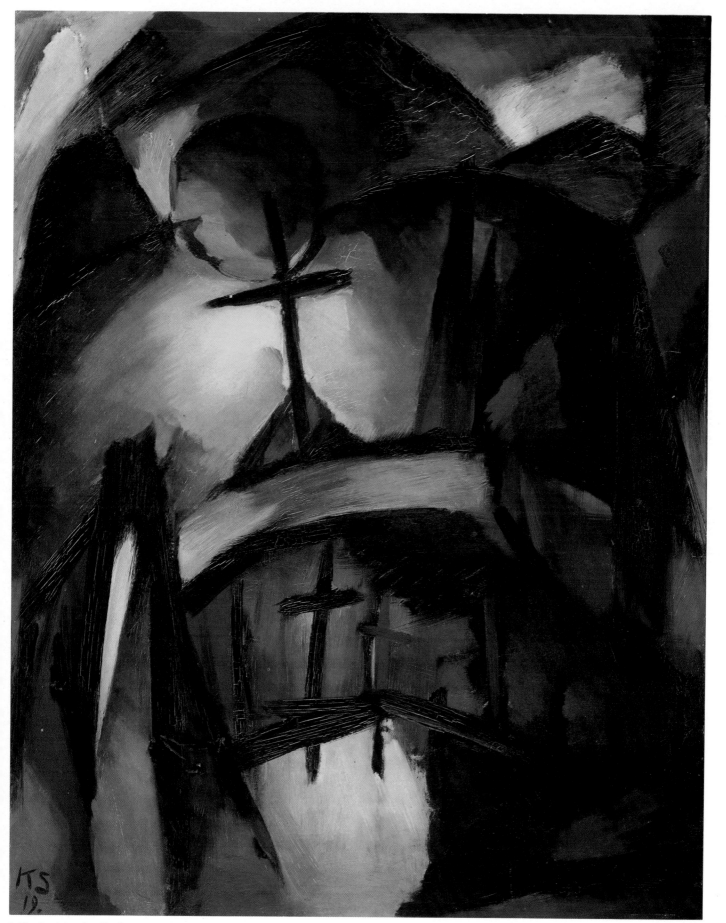

I *Hochgebirgsfriedhof* (*Mountain Graveyard*), 1919

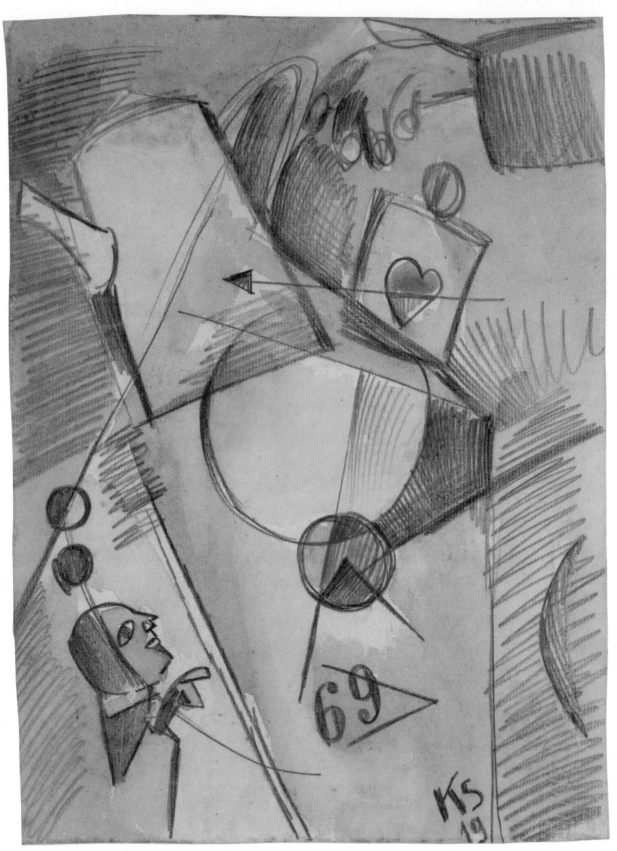

II *Aquarell no. 1 Das Herz geht vom Zucker zum Kaffee* (*The Heart Goes from Sugar to Coffee*), 1919

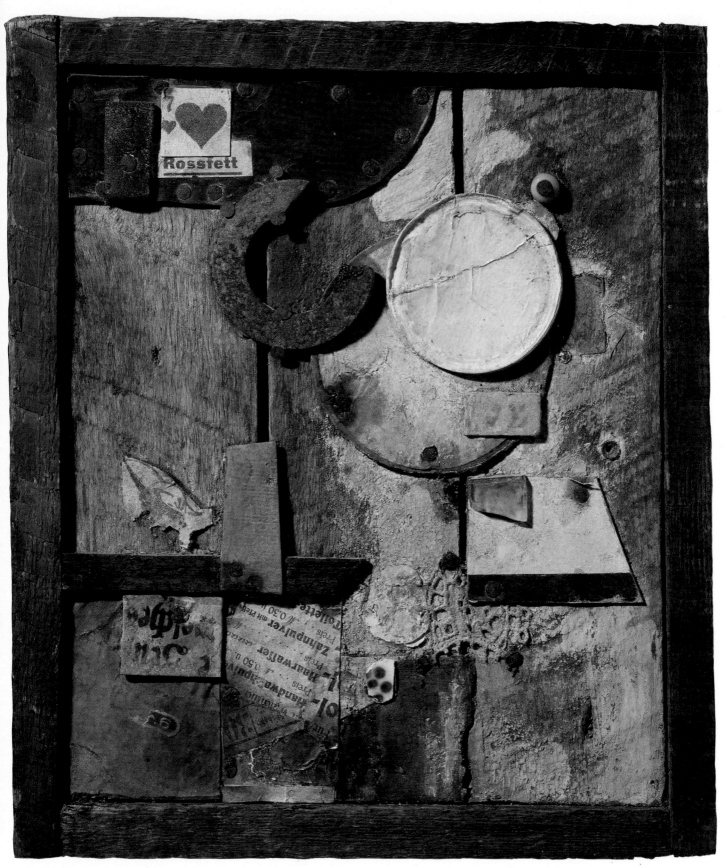

III *Merzbild Rossfett, c.* 1919 *8" × 6⅞"*

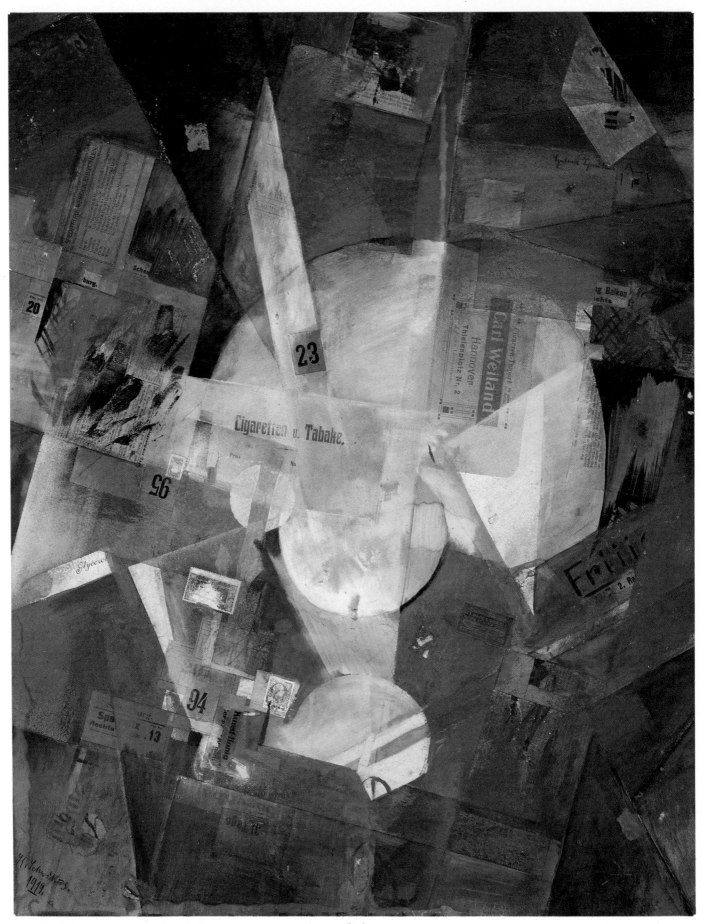

IV *Bild mit heller Mitte (Picture with Light Center)*, 1919 33¼" x 25⅞"

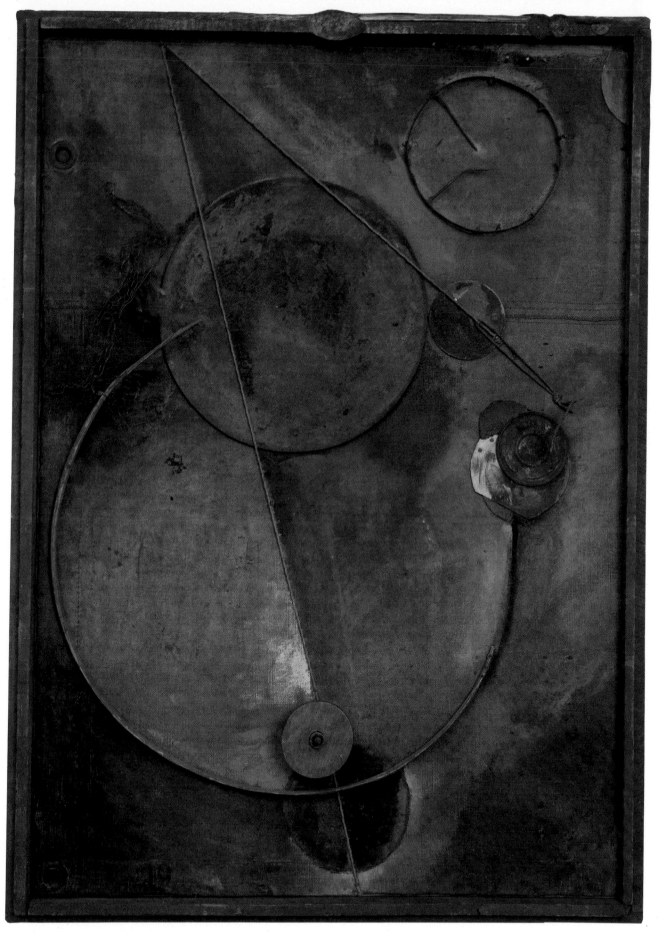

V *Das Kreisen (Revolving)*, 1919

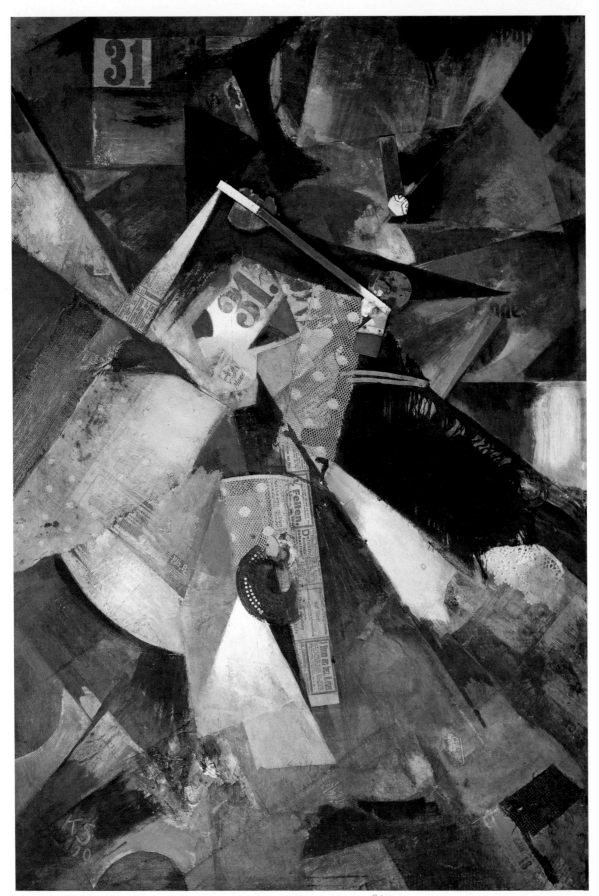

VI *Merzbild Einunddreissig (Merzpicture Thirty-One)*, 1920 38 ½ x 25 ⅞"

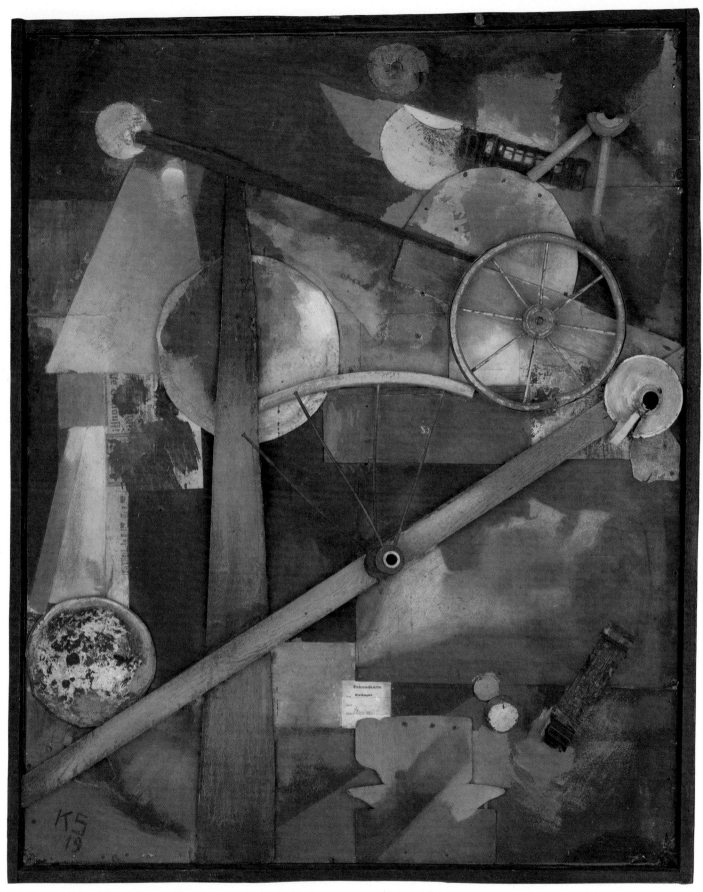

VII *Konstruktion für edle Frauen (Construction for Noble Ladies)*, 1919 40½" x 33"

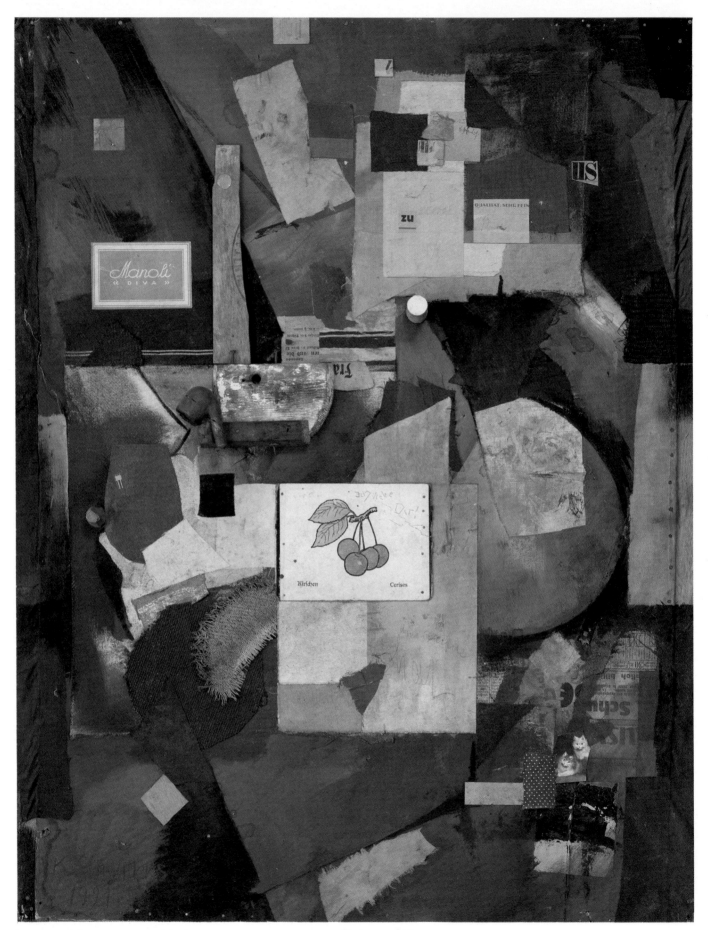

VIII *Merzbild 32A. Das Kirschbild* (*The Cherry Picture*), 1921 36⅛″ × 27¾″

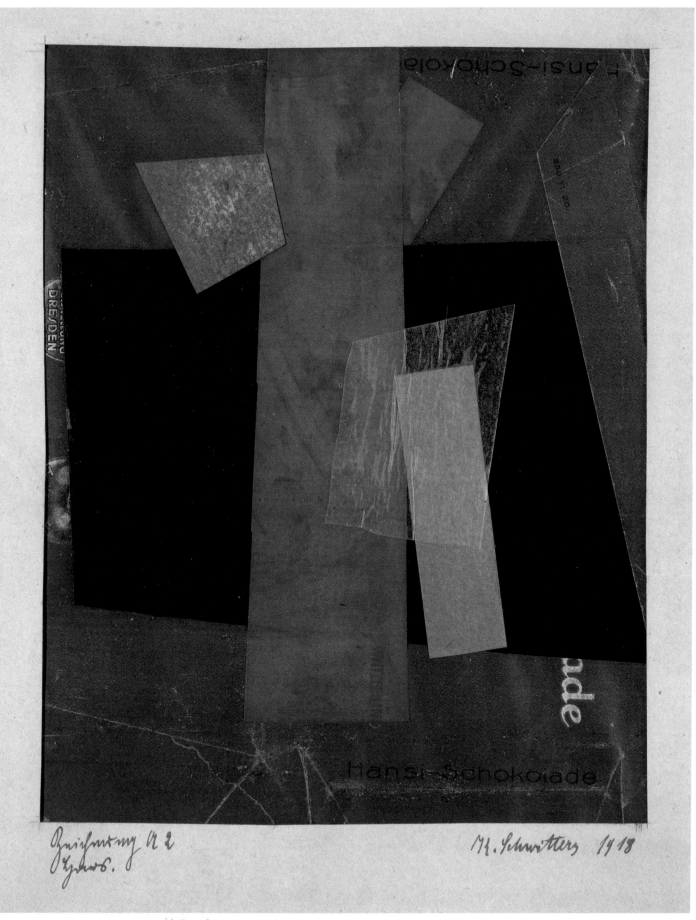

IX *Zeichnung A2. Hansi,* 1918 7⅛" × 5¾"

X (*Mai 191*), *c.* 1919 8½" x 6¾"

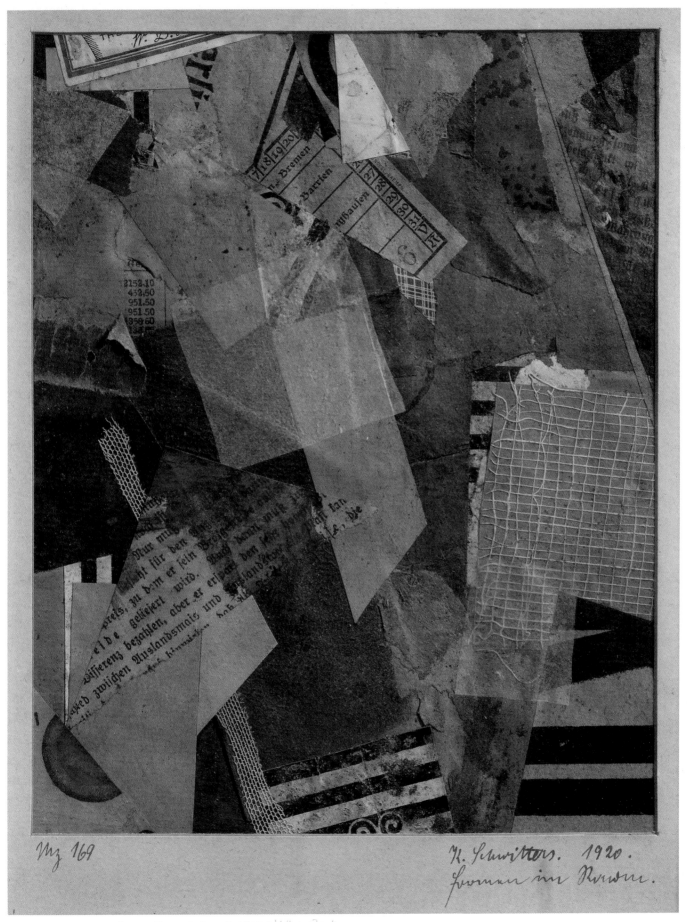

XI *Mz 169. Formen in Raum (Forms in Space)*, 1920 7⅛" × 5⅜"

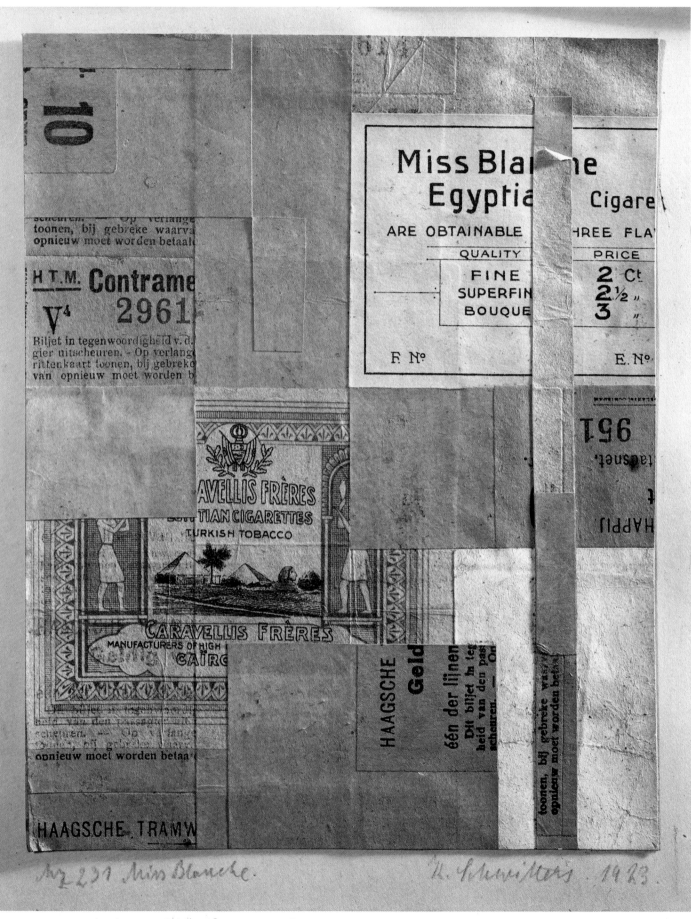

XII *Mz 231. Miss Blanche*, 1923 6¼" x 5"

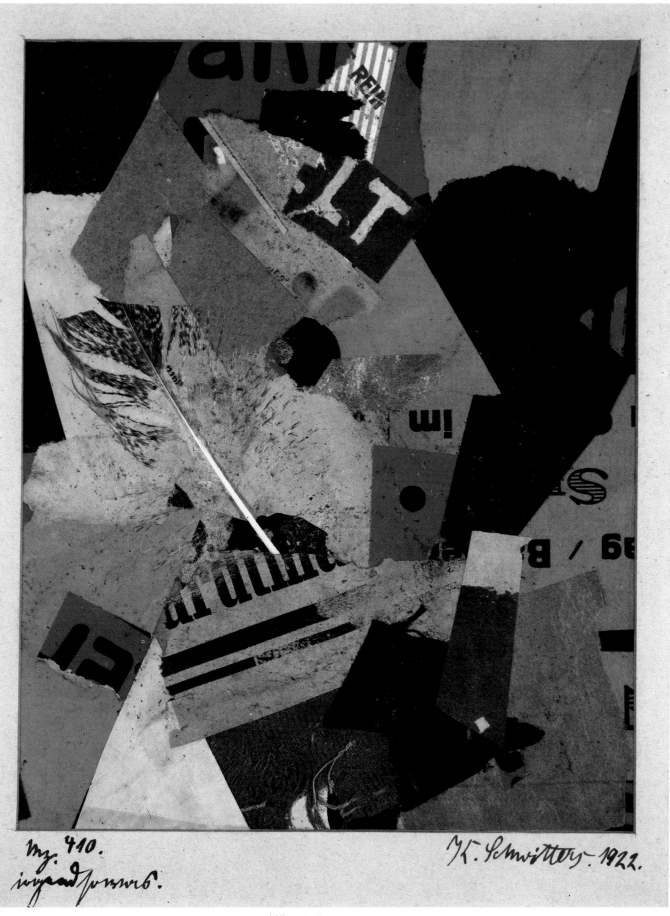

XIII *Mz 410. irgendsowas (something or other)*, 1922 7 1/8" x 5 3/4"

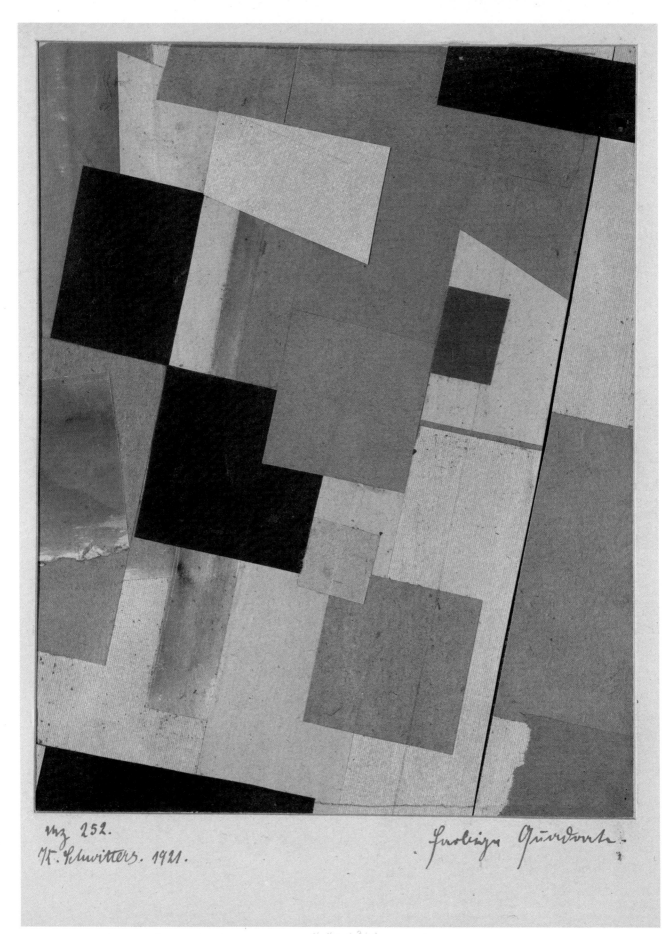

XIV Mz 252. *Farbige Quadrate (Colored Squares)*, 1921 7⅛" × 5¾"

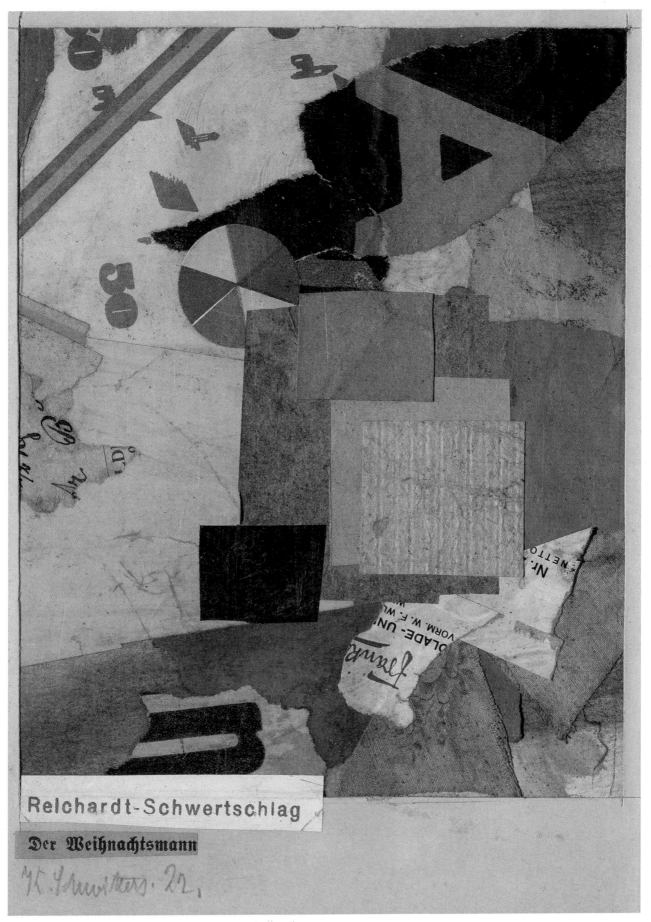

XV *Der Weihnachtsmann (Santa Claus)*, 1922 11¼" x 8¼"

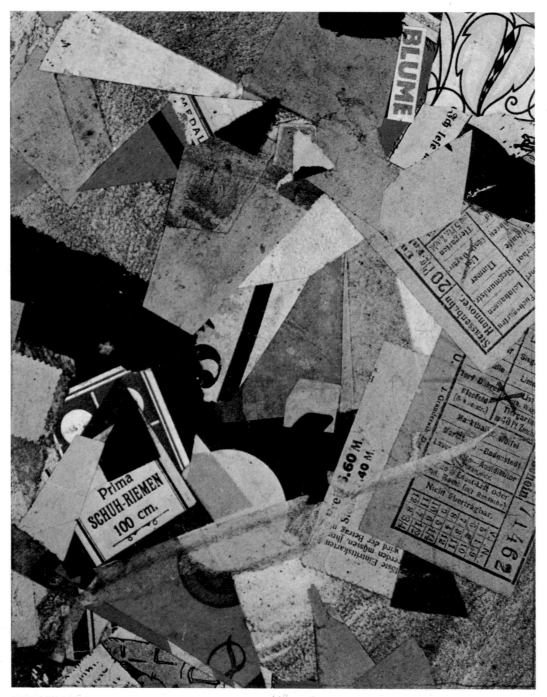

XVI *MZ 250.Grosser Tanz (Large Dance)*, 1921. 7⅛" x 5¾"

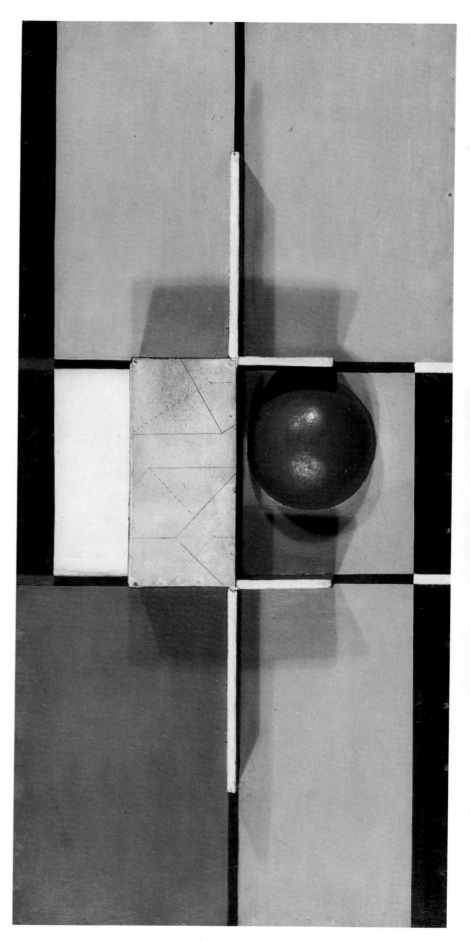

XVII *Merzbild 1924, I. Relief mit Kreuz und Kugel* (*Relief with Cross and Sphere*), 1924

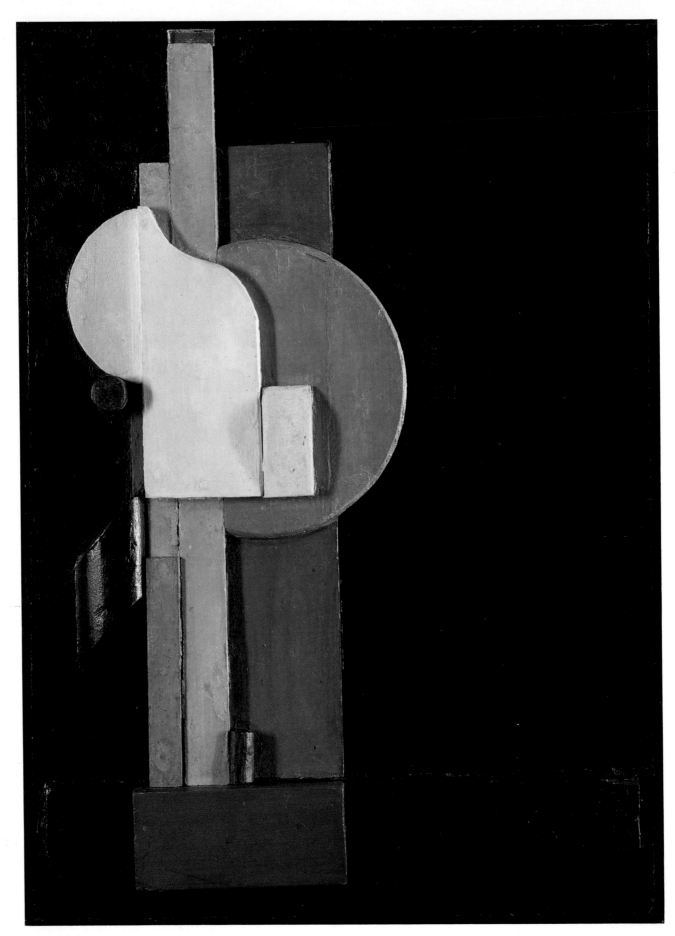

XVIII *Bild 1926, 3. Cicero,* 1926

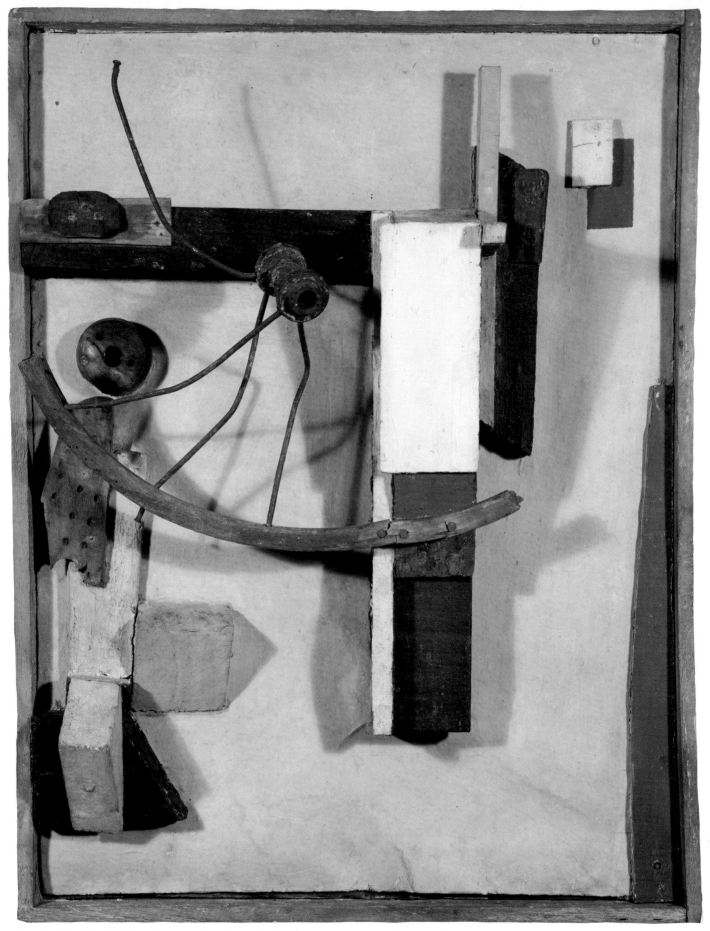

XIX *Bild 1926, 12. Kleines Seemannsheim (Small Sailors' Home)*, 1926 26½" x 20½"

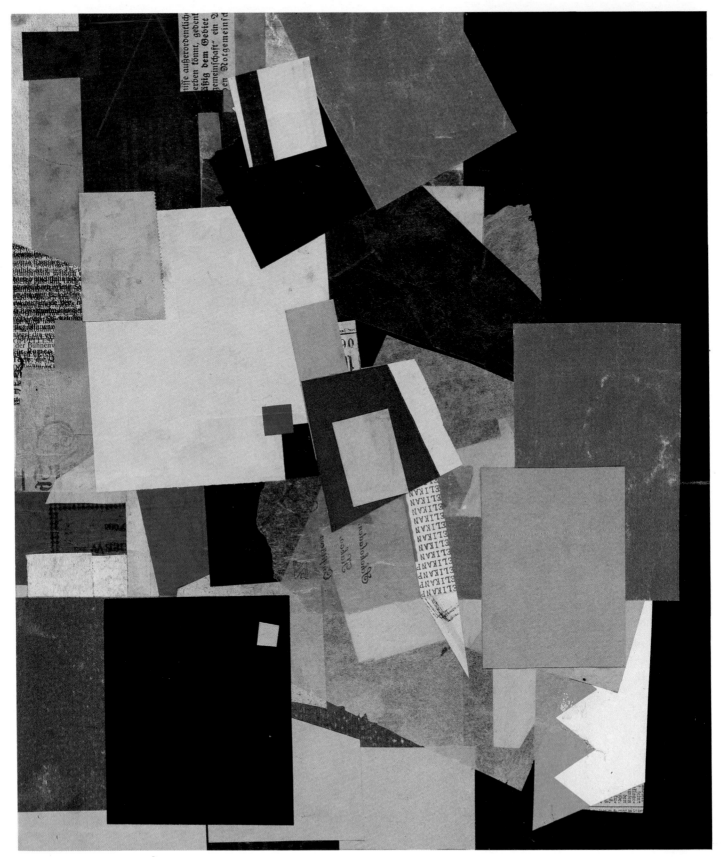

XX (*elikan*), *c.* 1925 17 1/8" × 14 1/4"

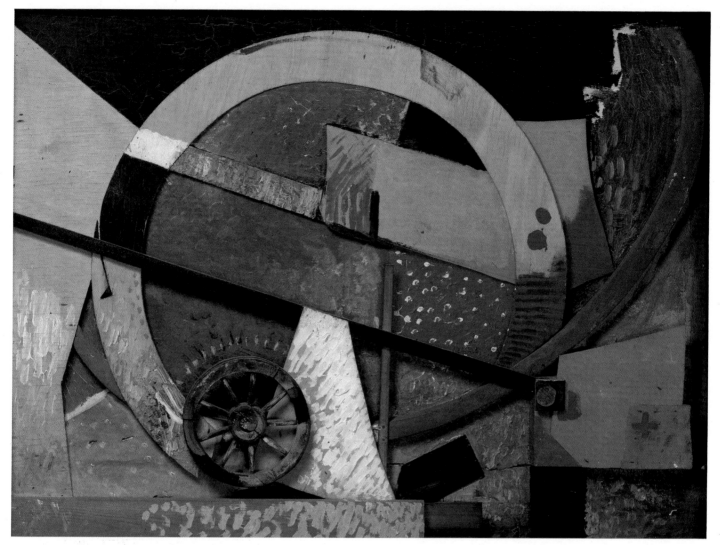

XXI *Neues Merzbild* (*New Merz picture*), 1931

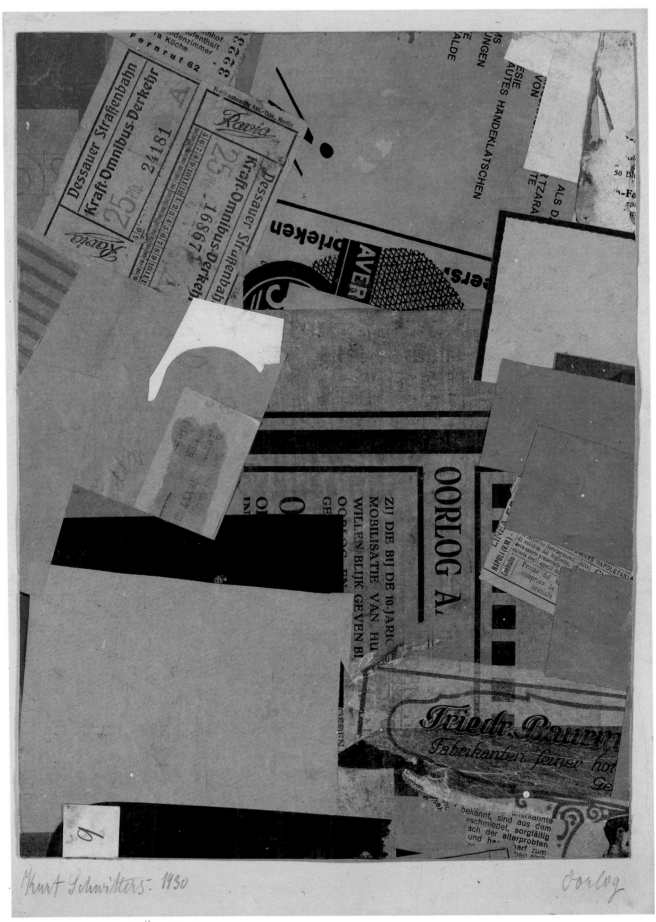

XXII *Oorlog*, 1930

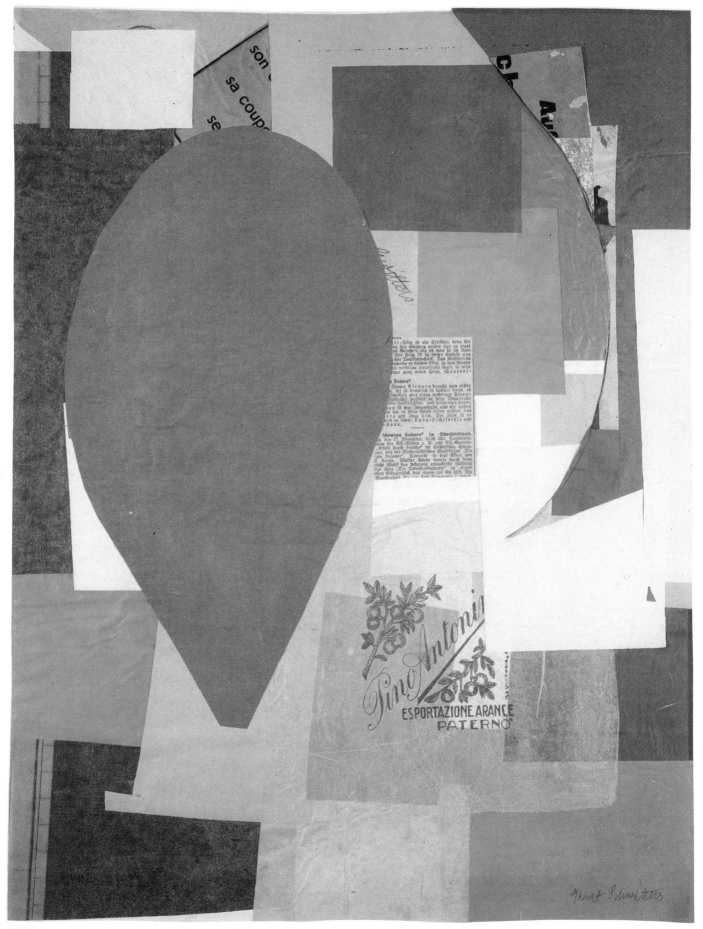

XXIII (*Pino Antoni*), *c*. 1933-34 23¼" x 17⅞"

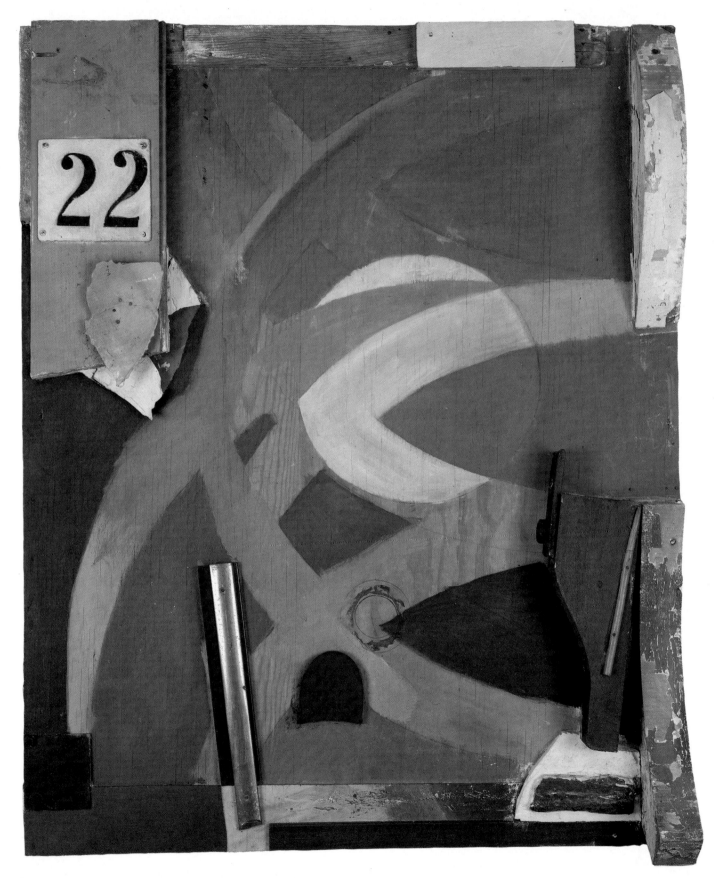

XXIV *Die Frühlingstür (The Spring Door)*, 1938

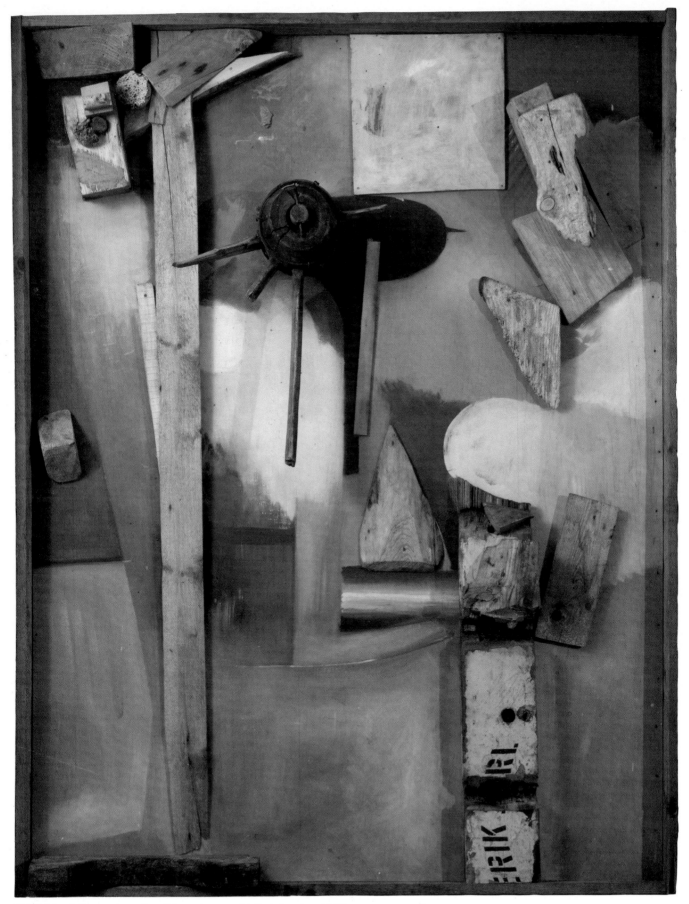

XXV *Merzbilde med regnbue (Merz picture with Rainbow), c.* 1939

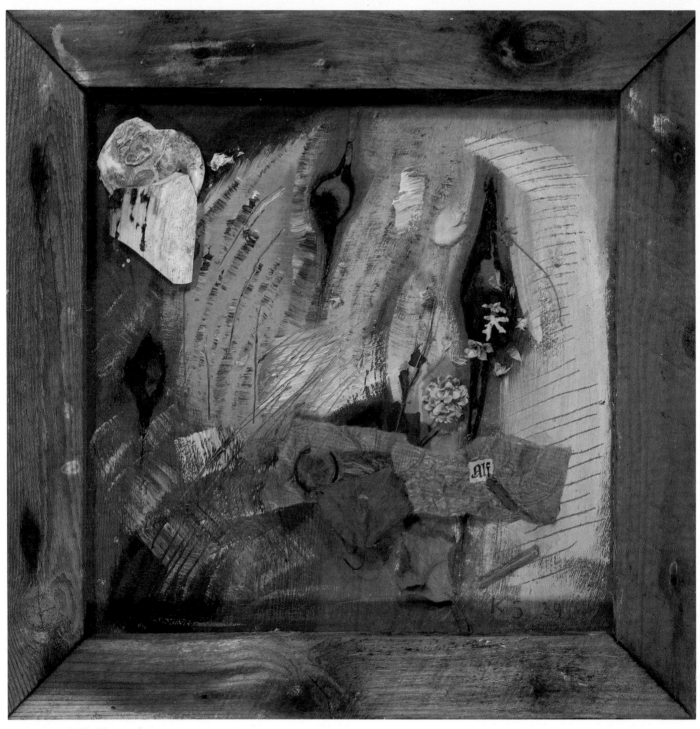

XXVI *Merzbild Alf*, 1939

XXVII *Die heilige Nacht von Antonio Allegri gen. Correggio, worked through by Kurt Schwitters (The Holy Night by Antonio Allegri, known as Correggio . . .)*, 1947

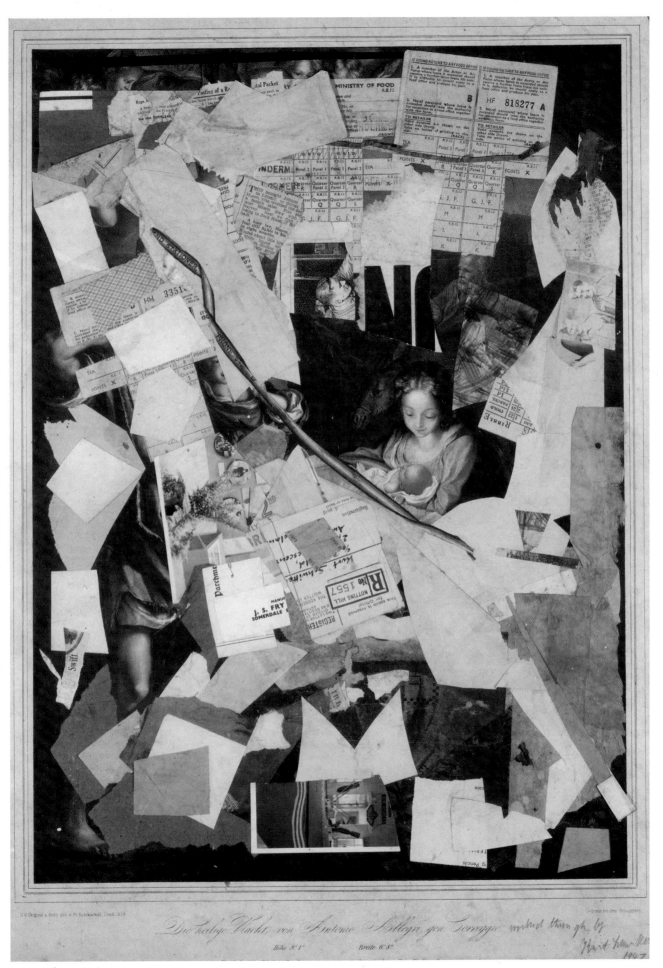

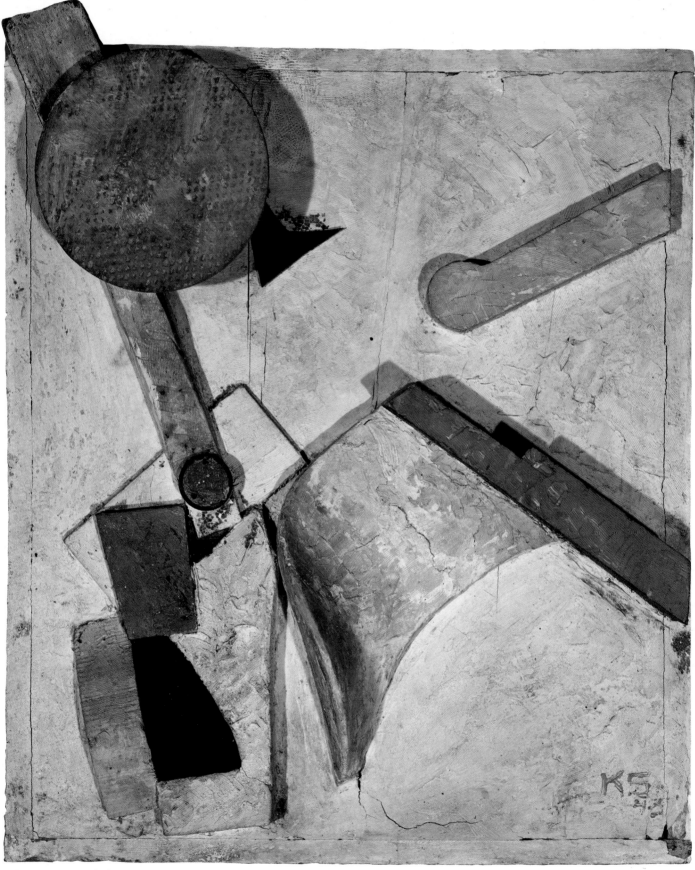

XXVIII *Heavy Relief*, 1945

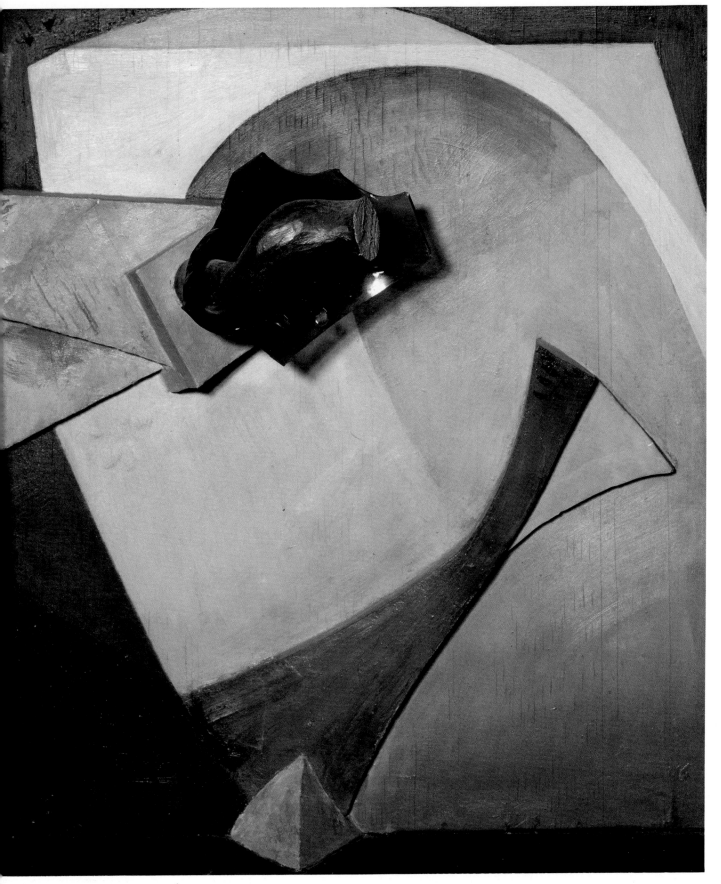

XXIX *Glass Flower*, 1940

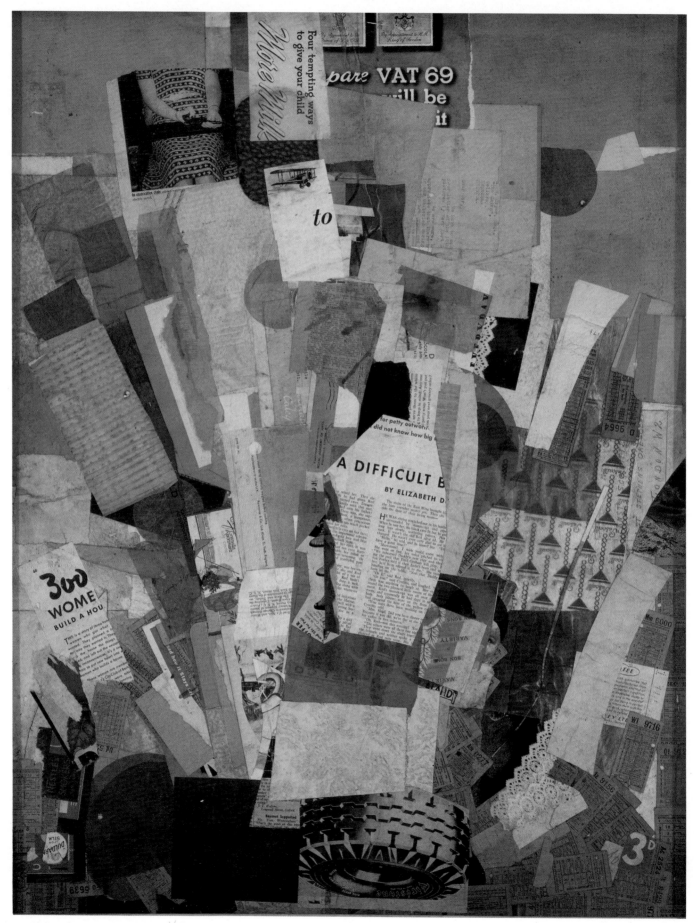

XXX (*Difficult*), *c.* 1942-43 31¼" x 24"

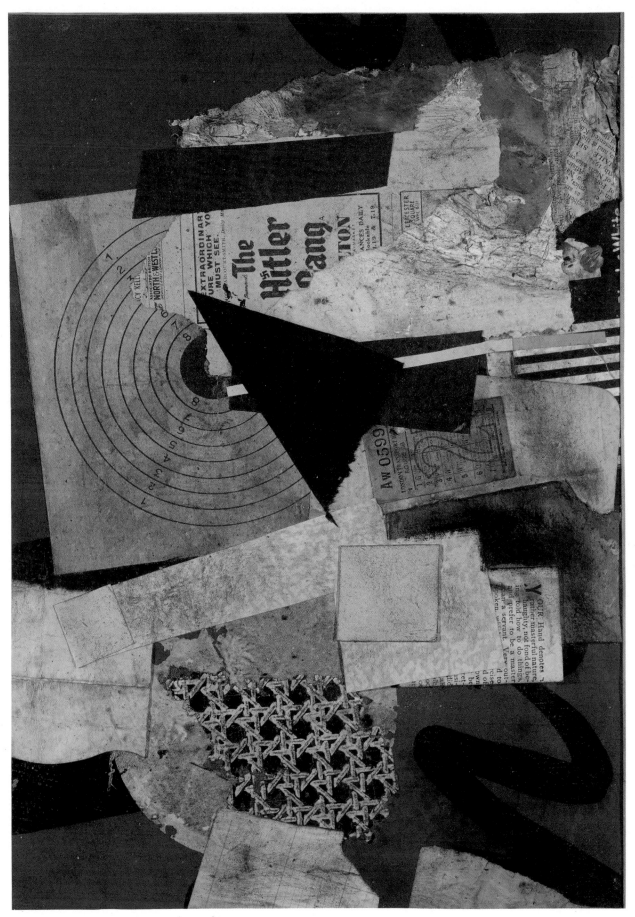

XXXI (*Hitler Gang*), c. 1944 13⅝ x 9⅜"

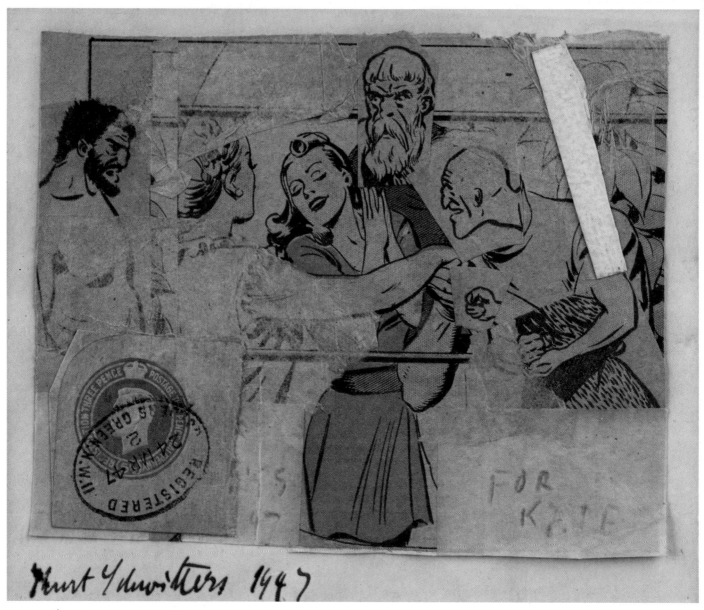

XXXII *For Käte*, 1947

1 Schwitters, *c.* 1920. Advertising postcard published by Paul Steegemann, Hannover

2 *Landschaft aus Opherdicke (Landscape from Opherdicke)*, 1917

3 *Überschwemmte Wiesen (Flooded Fields)*, 1914

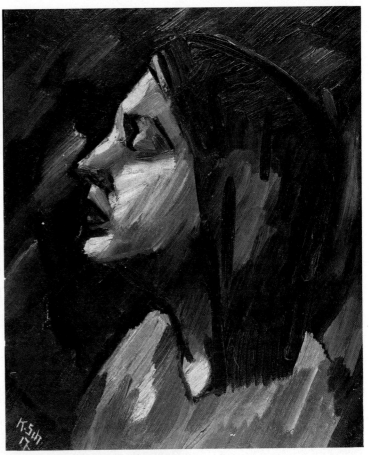

4 *Vision*, 1916–17

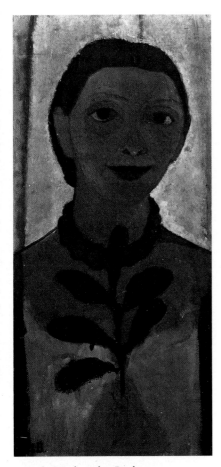

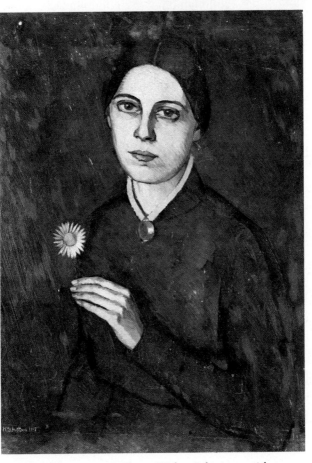

5 Paula Modersohn-Becker.
Selbstbildnis mit Kamelienzweig (Self-Portrait with Camelia), 1906–07

6 *Helma Schwitters mit Blume (Helma Schwitters with a Flower)*, 1917

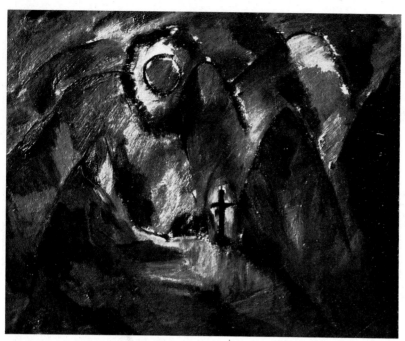

7 G Expression 2 (*Die Sonne im Hochgebirge*) (*Sun in the High Mountains*), 1917

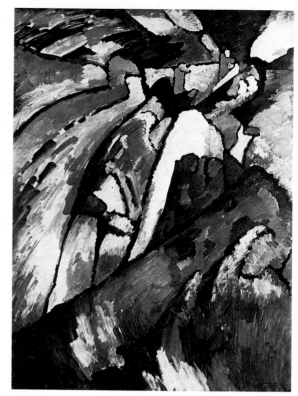

8 Wassily Kandinsky. *Improvisation 7*, 1910

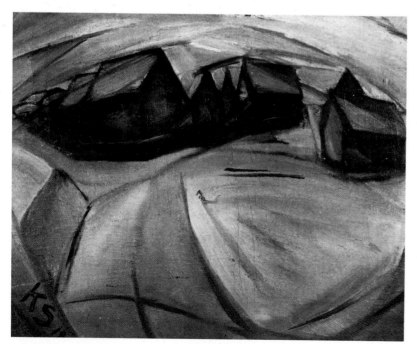

9 *Verschneite Häuser* (*Snowcovered Houses*), 1918

10 Ludwig Meidner. *Apokalyptische Landschaft* (*Apocalyptic Landscape*), 1912–13

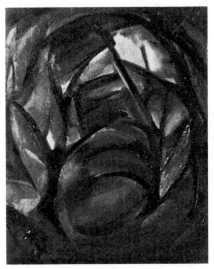

11 G *Expression 1* (*Der Wald*)
(*The Forest*), 1917

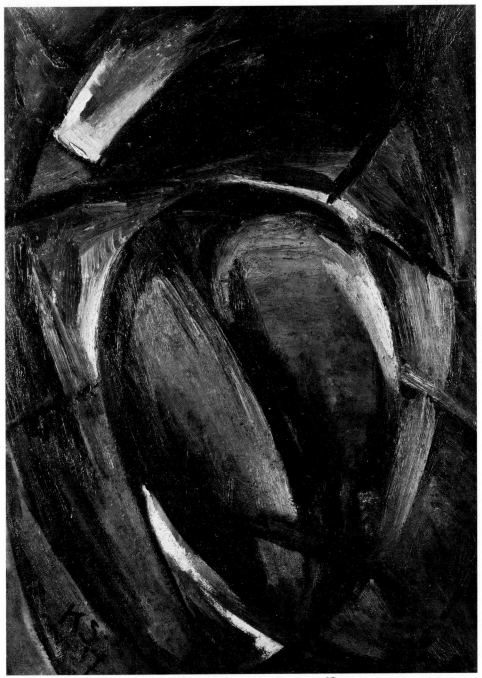

12 *Abstraktion 2* (*Die Gewalten*) (*The Forces*), 1917

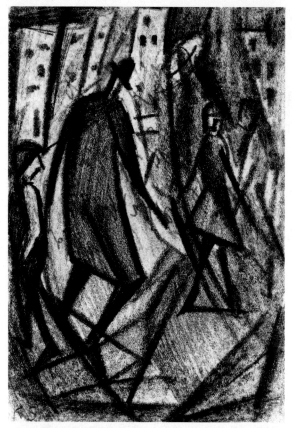

13 Z42 *Der Einsame* (*The Lonely One*), 1918

14 Ernst Ludwig Kirchner. *Die Strasse, Berlin* (*Street, Berlin*), 1913

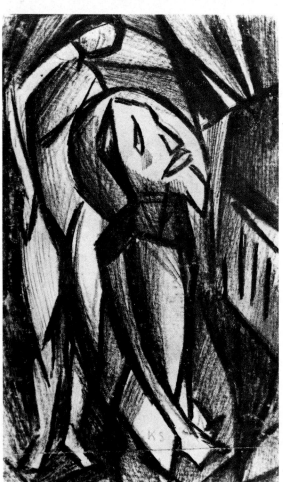

15 Z122 *Die Versuchung des heiligen Antonius* (*The Temptation of St. Anthony*), 1918

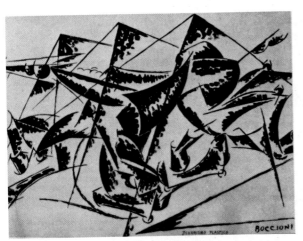

16 Umberto Boccioni. *Dinamismo Plastico, Cavallo +
Case (Plastic Dynamism, Horse + Houses)*, 1913–14

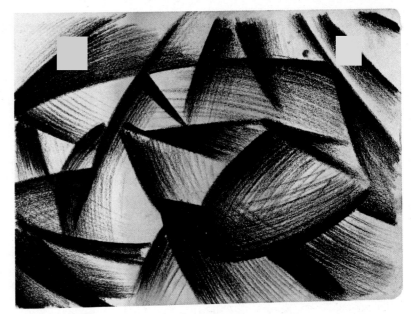

17 *Z57 Abstraktion*, 1918

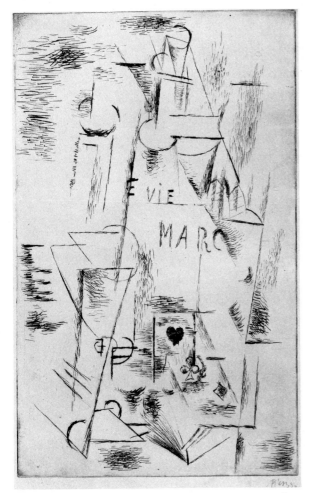

18 Pablo Picasso. *Nature Morte, Bouteille de Marc (Still
Life with Bottle of Marc)*, 1911

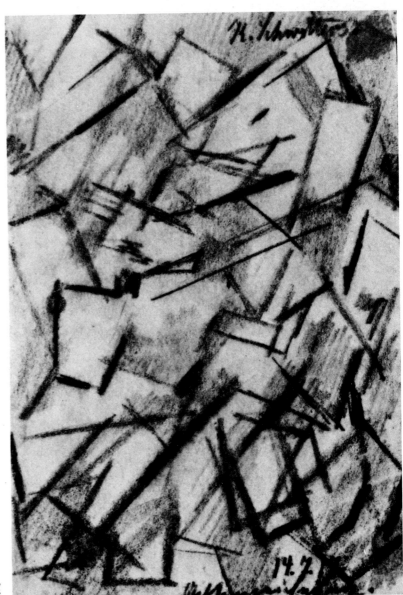

19 *Achsenzeichnung
(Axle-Drawing)*, 1917

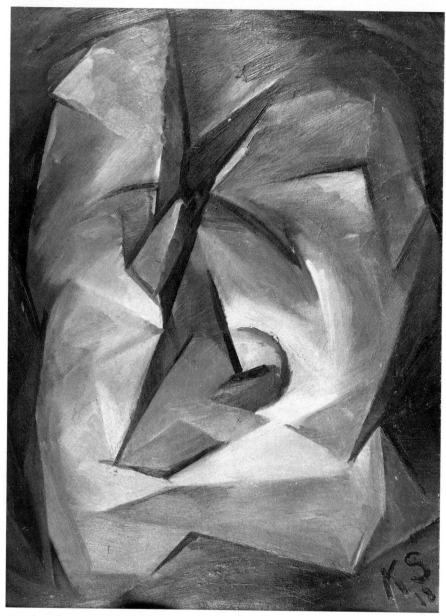

20 *Abstraktion 9* (*Der Bindeschlips*) (*The Bow Tie*), 1918

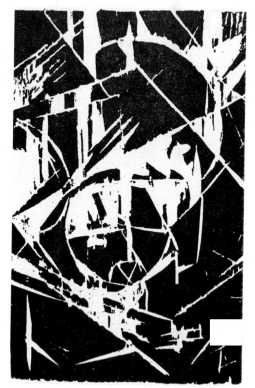

21 Untitled woodcut from *Das Kestnerbuch*, 1919

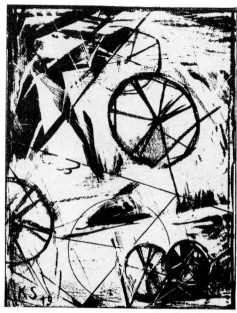

22 Untitled lithograph from *Der Zweemann*, 1919

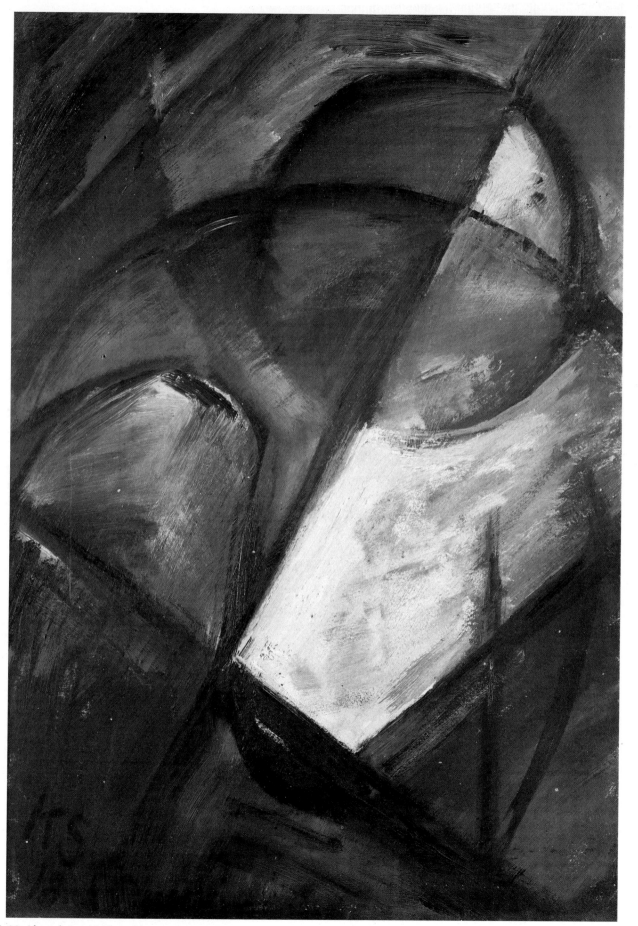

23 *Abstraktion 19 (Entschleierung) (Unveiling)*, 1918

24 *Der Kritiker* (*The Critic*), 1921

25 Untitled lithograph from the portfolio *Die Kathedrale* (*Cathedral*), 1920

26 Cover of the portfolio *Die Kathedrale* (*Cathedral*), 1920

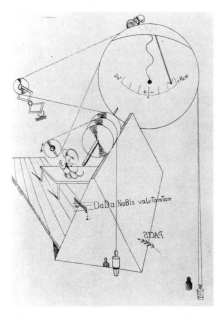

27 Max Ernst. Lithograph from the portfolio *Fiat Modes: pereat ars, c.* 1919

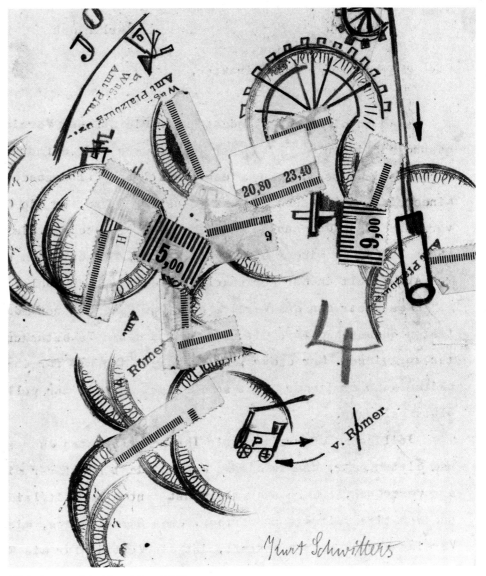

29 (*mit roter 4*) (*with red 4*), *c.* 1919

28 Francis Picabia. *Réveil-matin* (*Alarm Clock*). Title page for *Dada*, no. 4–5, 1919

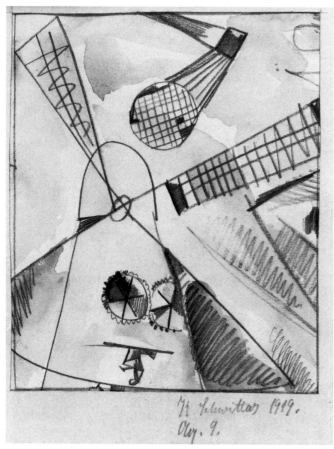

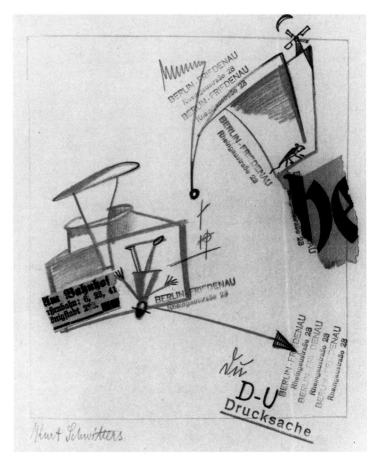

30 *Aq. 9 Windmühle (Windmill)*, 1919

31 *(D-U Drucksache) (D-U Printed Matter)*, c. 1919

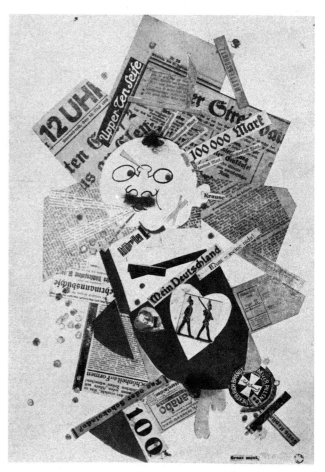

32 George Grosz.
Krause!, c. 1920

33 Cover design for *Anna Blume, Dichtungen*, 1919

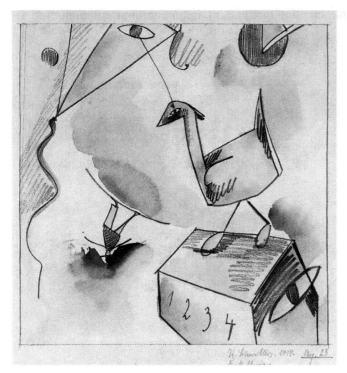

34 *Aq. 23 Koketterie (Coquetry)*, 1919

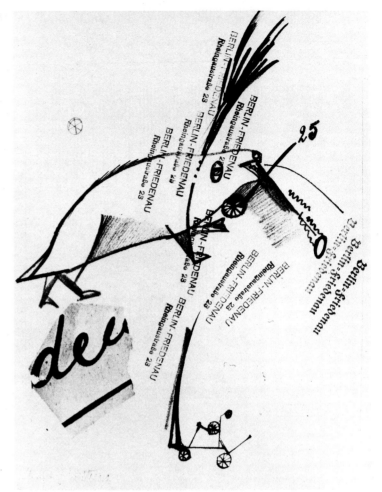

35 *(Komisches Tier) (Funny Beast)* c. 1919

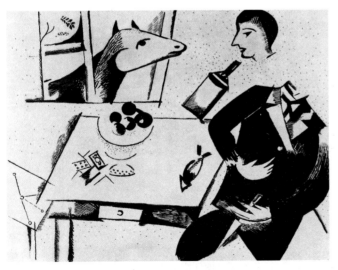

36 Marc Chagall. *Der Trinker (The Drinker)*, 1913

37 Paul Klee. *Ausschreitende Figur (Striding Figure)*, 1915

38 (*Bussum*), 1923

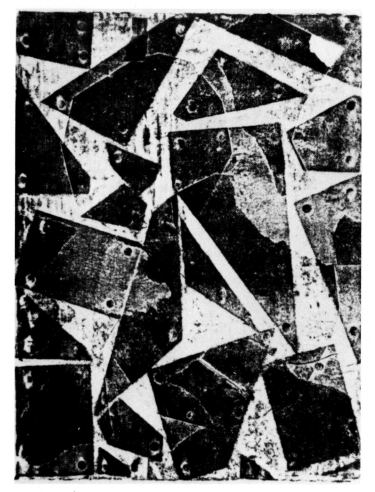

39 Untitled, *c.* 1919

40 Christian Morgenstern. "Fisches Nachtgesang" from *Galgenlieder*, 1905

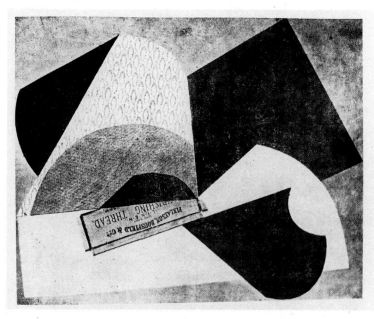

41 Hans Arp. Untitled collage reproduced in *Cabaret Voltaire*, 1916

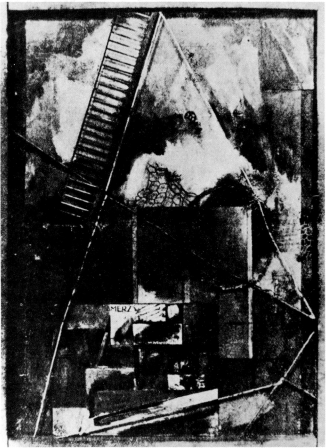

42 *Das Merzbild* (*The Merzpicture*), 1919

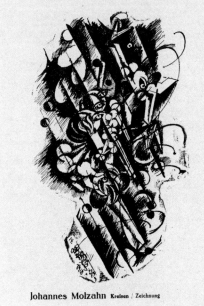

44 Johannes Molzahn. *Kreisen* (*Revolving*), 1918. Reproduced on the cover of *Der Sturm*, June 1919

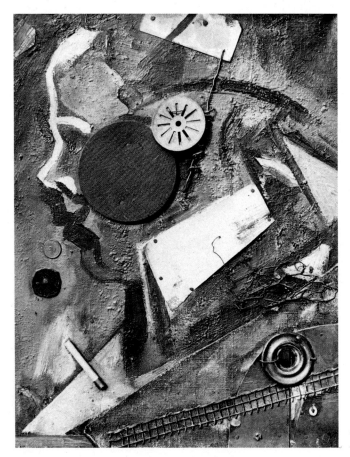

45 Marc Chagall. *Half Past Three* (*The Poet*), 1911

43 *Merzbild 1A. Der Irrenarzt* (*The Alienist*), 1919

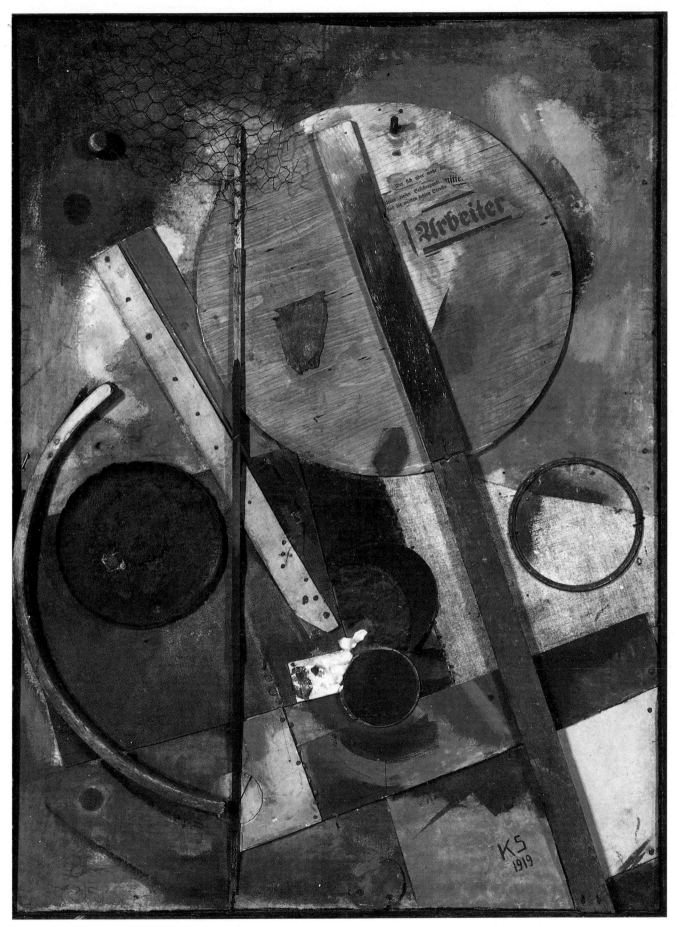

46 *Das Arbeiterbild* (*The Worker Picture*), 1919

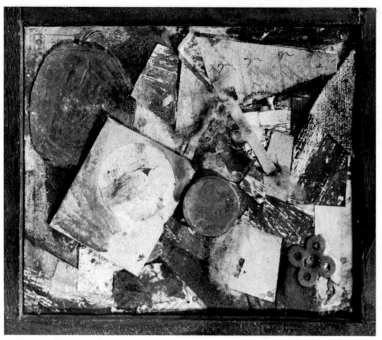

47 *Merzbild 9A.Bild mit Damestein (Picture with Checker)*, 1919

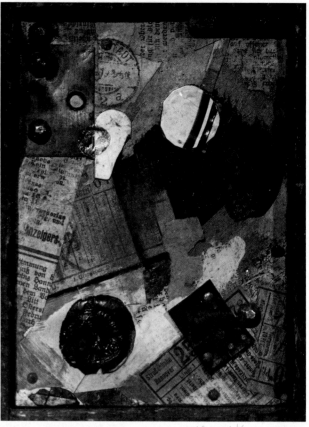

48 *Merzbild 14C. Schwimmt*, 1921 6 ¼ X 4 ¼

49 Objects assembled and mounted by a psychopathic patient, 1878. Formerly collection of André Breton

50 Giorgio de Chirico. *Natura Morta Evangelica (Evangelical Still Life)*, 1916

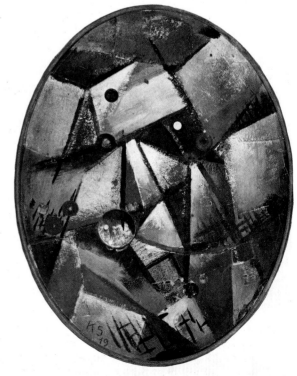

51 *Merzbild 13A. Der kleine Merzel (Small Merzel)*, 1919

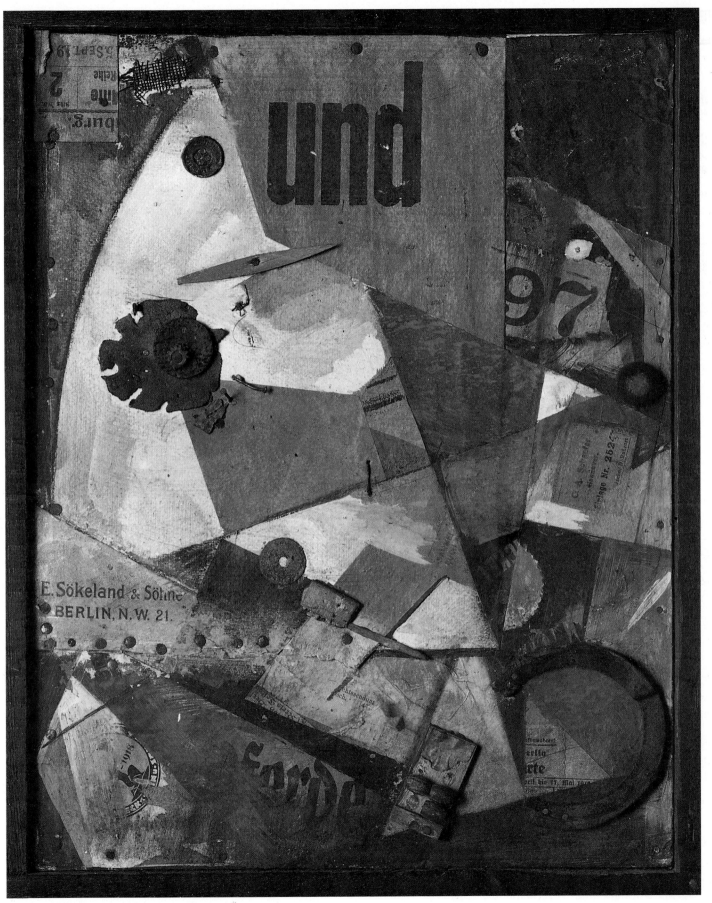

52 *Das Undbild (The And Picture)*, 1919 14" x 11"

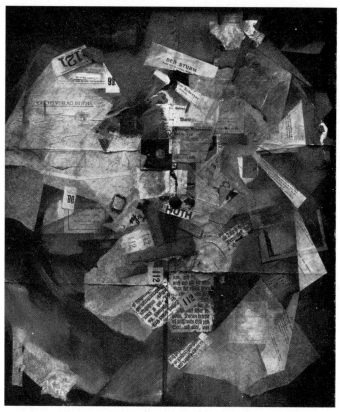

53 *Das Huthbild* (*The Huth Picture*), 1919

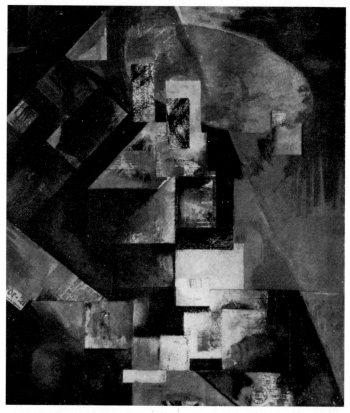

54 *Merzbild 1B.Bild mit rotem Kreuz* (*Picture with Red Cross*), 1919

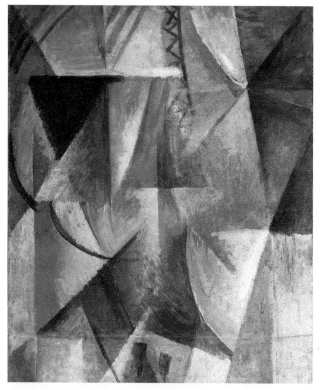

55 Robert Delaunay. *Une fenêtre* (*Etude pour les trois fenêtres*) (*A Window* [*Study for the three windows*]), 1912–13

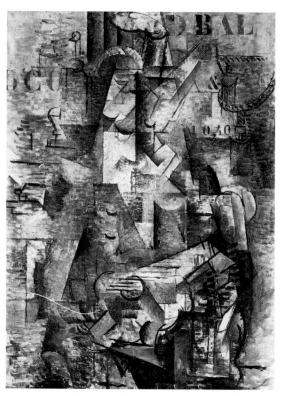

56 Georges Braque. *Le Portugais* (*The Portuguese*), 1911

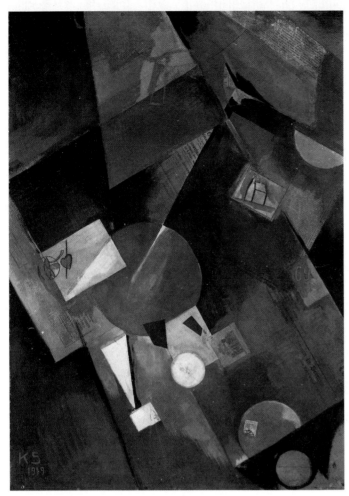

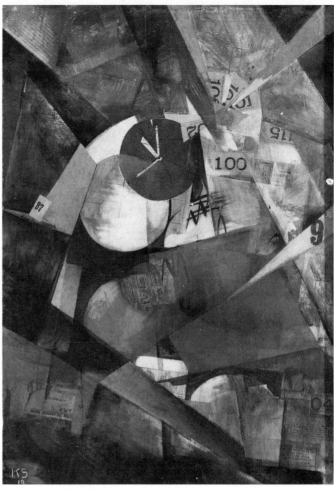

57 Merzbild 5B.Rot-Herz-Kirche (Red-Heart-Church), 1919

58 Merzbild 9B.Das grosse Ichbild (The Great Ich Picture), 1919

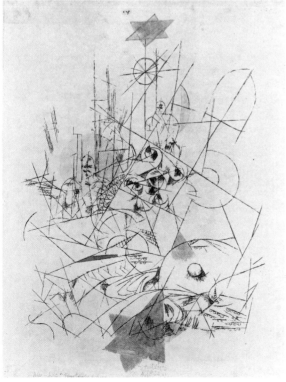

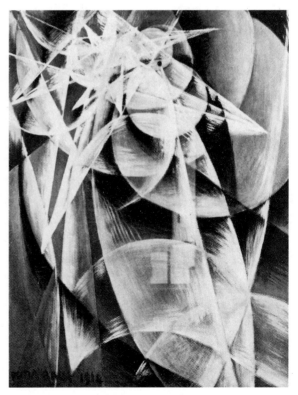

59 Paul Klee. Zerstörung und Hoffnung (Destruction and Hope), 1916

60 Giacomo Balla. Study for Il Mercurio che passa davanti al Sole (Mercury Passing Before the Sun), 1914

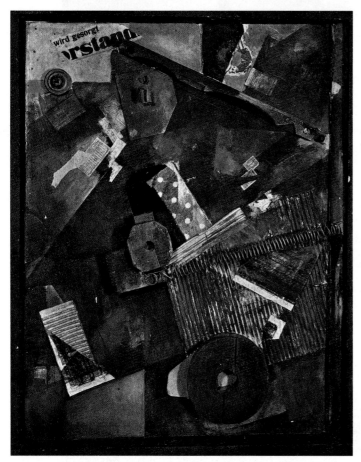

61 *Ausgerenkte Kräfte (Disjointed Forces)*, 1920

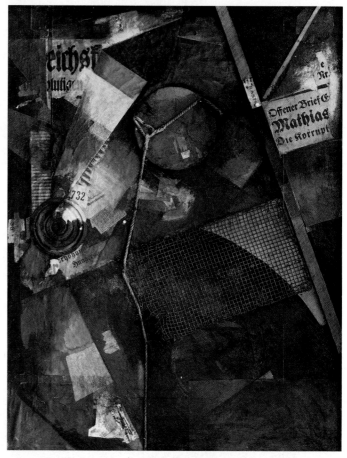

62 *Merzbild 25A.Das Sternenbild (The Stars Picture)*, 1920

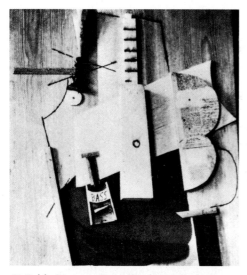

63 Pablo Picasso. *Guitare et bouteille de Bass (Guitar and Bottle of Bass)*, 1913. Reproduced in *Les Soirées de Paris*, November 1913

64 Alexander Archipenko. *Femme à l'éventail (Woman with Fan)*, 1914

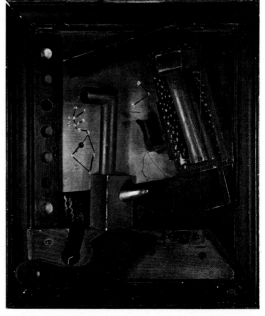

65 Max Ernst. *Frucht einer langen Erfahrung (Fruits of Long Experience)*, c. 1919

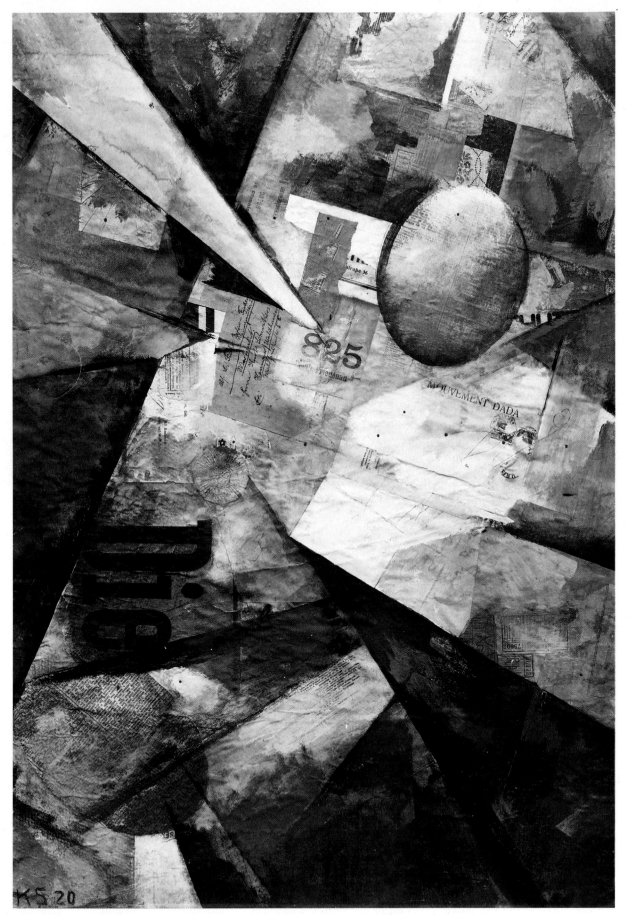

66 *Merzbild 31B. Strahlenwelt (Radiating World)*, 1920

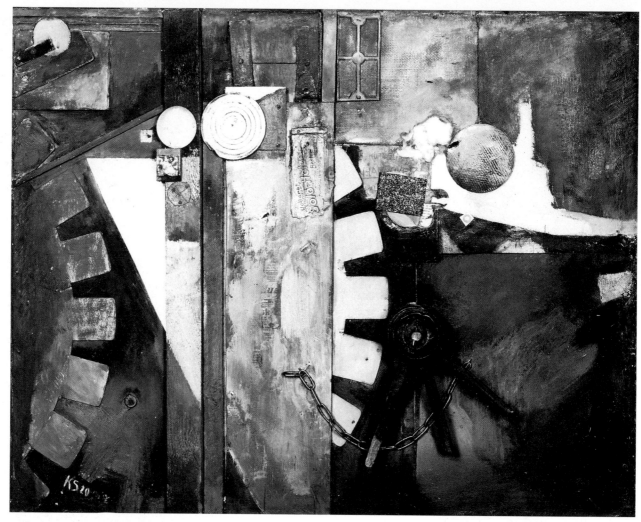

67 *Merzbild 29A. Bild mit Drehrad*
(*Picture with Flywheel*), 1920 and 1939

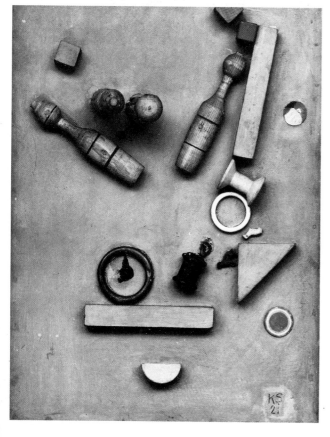

68 *Merzbild 46a. Das Kegelbild*
(*The Skittle Picture*), 1921

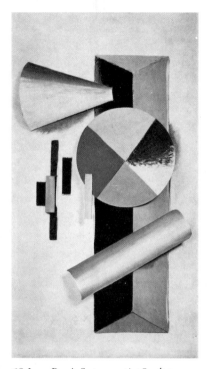

69 Ivan Puni. *Suprematist Sculpture*.
Reconstruction of 1915 original from
a *c.* 1920–21 gouache drawing in
Puni's February 1921 Sturm
exhibition

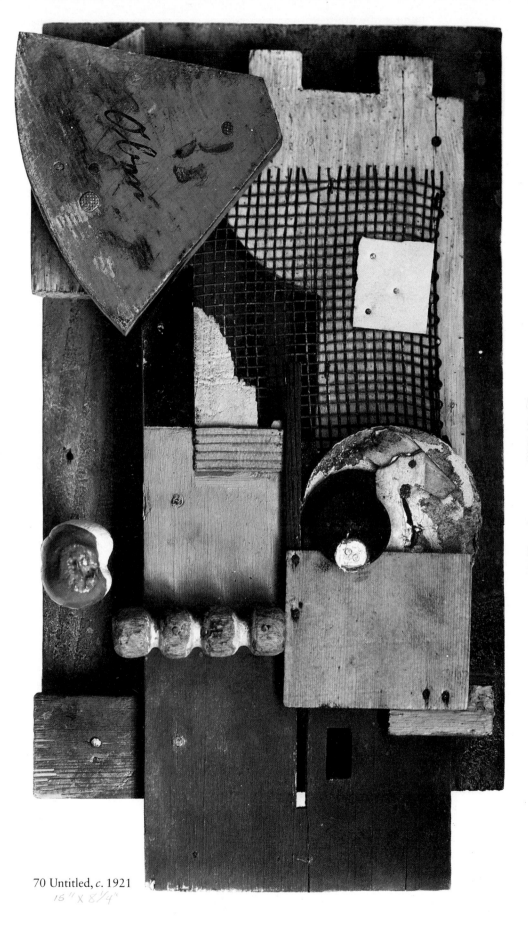

70 Untitled, *c.* 1921
15" x 8¼"

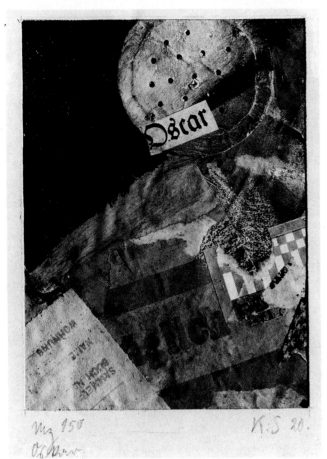

71 *Mz 150.Oskar,* 1920 5⅛" X 3⅞"

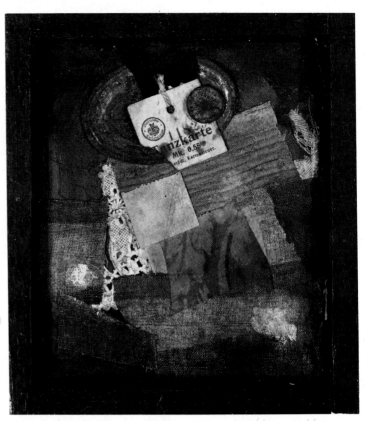

72 *Merzbild 14B.Die Dose (The Box),* 1919 6½" X 5½"

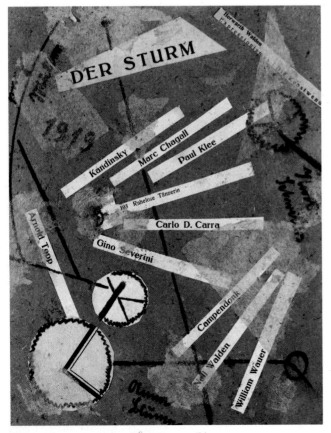

73 *(Der Sturm),* 1919 8¾" X 6⅞"

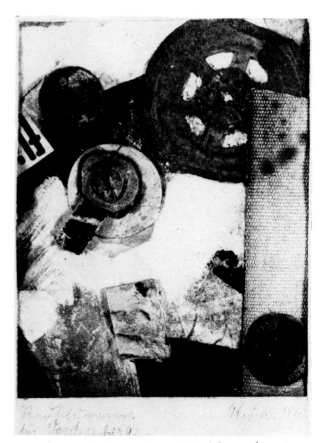

74 *Radblumen für Vordemberge (Wheel-flowers for Vordemberge),* 1920

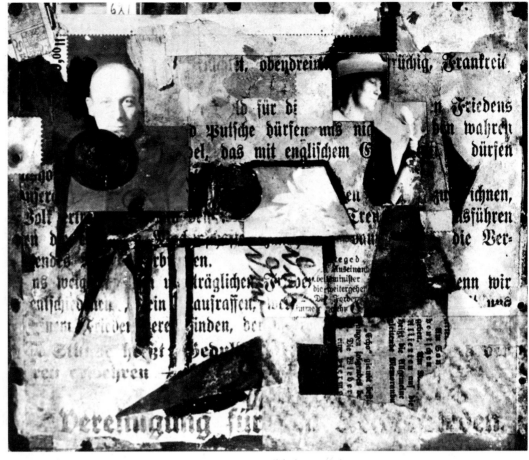

75 *Das Bäumerbild* (*The Bäumer Picture*), 1920 6⅞″ × 8¼″

76 (*Zeitu*), 1918

77 (*fec*), 1920

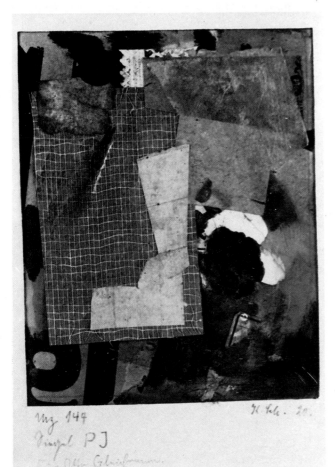

78 *Mz 144. Siegel PJ*, 1920 5¾" × 4¾"

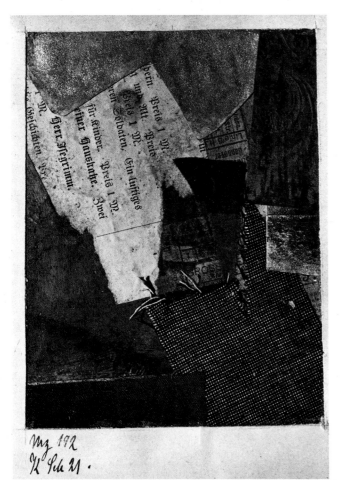

79 *Mz 192*, 1921 4¾" × 3¾"

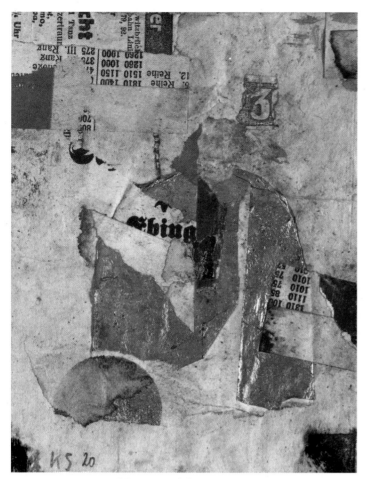

80 (*Ebing*), 1920 5⅞" X 4¾"

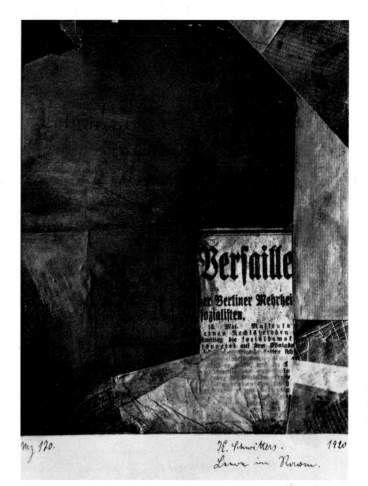

81 *Mz 170. Leere im Raum* (*Void in Space*), 1920 7⅛" X 5¼"

82 Maximilian Mopp. *Der Weltkrieg* (*The World War*), 1916

83 *Mz 79.Herz-Klee* (*Heart-Clover*), 1920

5⅞" X 4⅝"

84 (*Die Handlung spielt in Theben*) (*The Action Takes Place in Thebes*), c. 1918–19 6⅜" × 7⅞"

85 Collage over postcard of *Das grosse Ichbild*, 1922

86 Collage over postcard of *Das Kreisen*, 1922 5½" × 3½"

87 Collage over postcard with photograph of Schwitters, 1921

88 *Mz 151. Wenzel Kind* (*Knave Child*), 1921 6¾" x 5½"

89 (*König Eduard*) (*King Edward*), c. 1918–19
5⅜" x 4 ⁄₁₆"

90 (*Das Engelbild*) (*The Angel Picture*), c. 1920
2" x 2⅝" collage

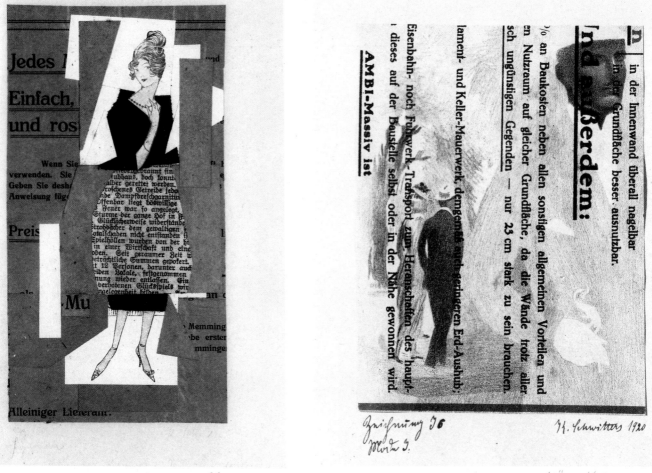

91 *Mz 180.Figurine*, 1921 6¾" x 3⅝"

92 *Zeichnung I6. Mode I (Fashion I)*, 1920 5½" x 4⅛"

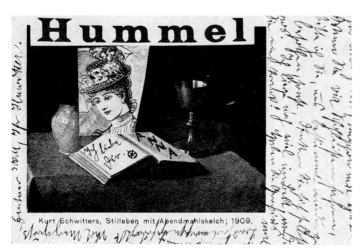

93 Collage over postcard of *Stilleben mit Abendmahlskelch*
(*Still Life with Chalice*), 1923 5½" x 3½"

94 Title page for *Memoiren Anna
Blumes in Bleie (Memoirs of Anna
Blume in Lead [Pencil])*, 1922

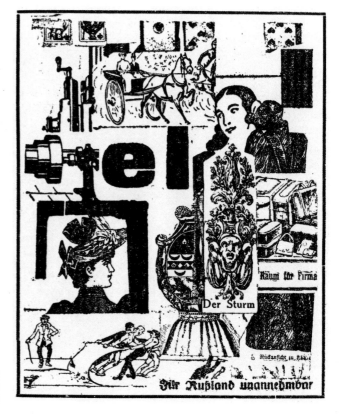

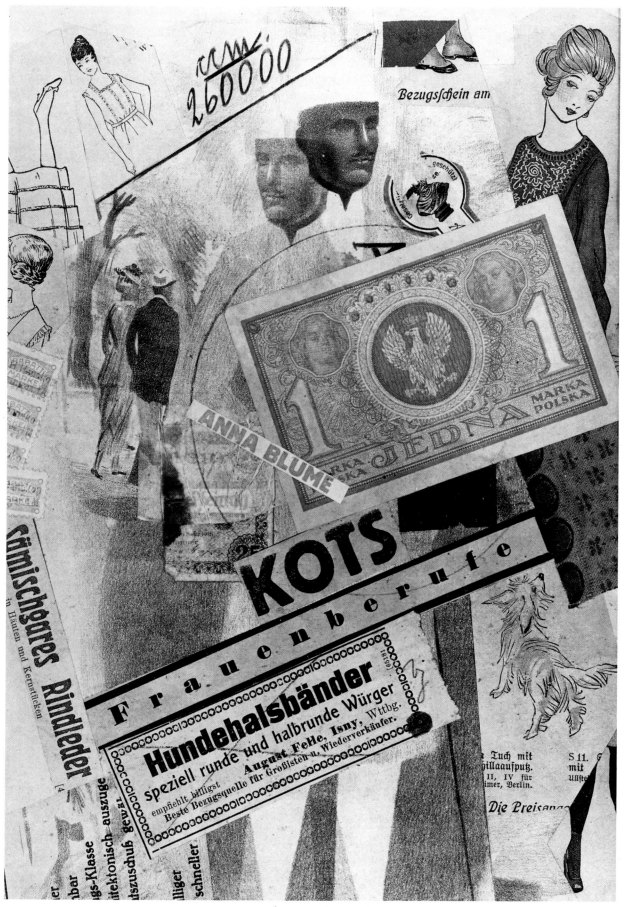

95 Mz 158. *Das Kotsbild* (*The Kots Picture*), 1920 10 5/8" x 7 5/8"

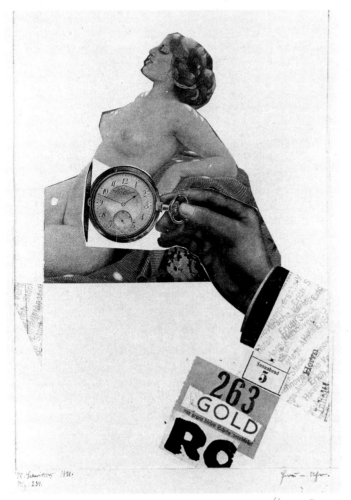

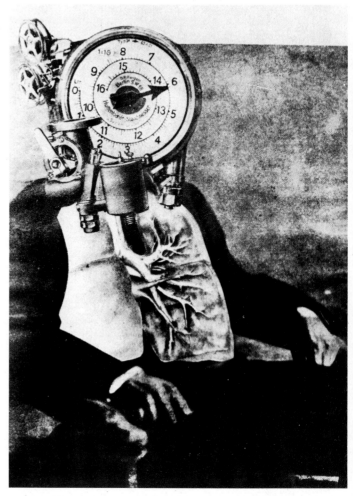

96 *Mz 239. Frau-Uhr (Woman-Watch)*, 1921 12 1/4" x 8 3/4"

97 Raoul Hausmann. *Festival Dada, c.* 1920

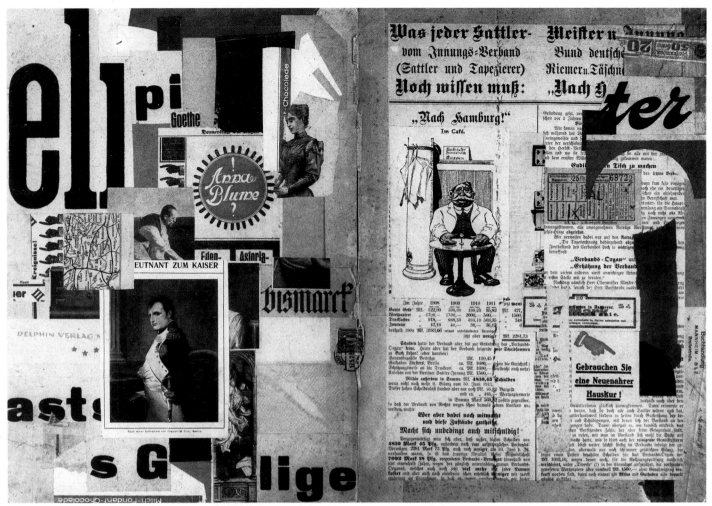

98 *Die Sattlermappe* (*The Saddler Portfolio*), 1922 15⅛" X 22"

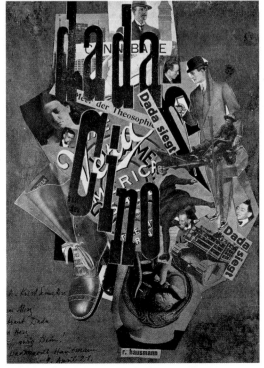

99 Raoul Hausmann. *Dada Cino*, c. 1920

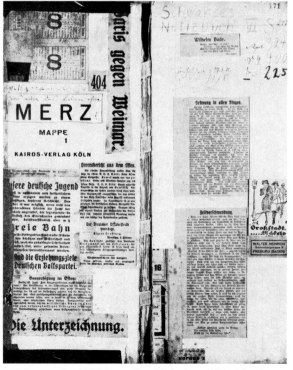

100 Pages of *c.* 1921 from *Das "Schwarze" Notizbuch*
(*The "Black" Notebook*), 1910–1922

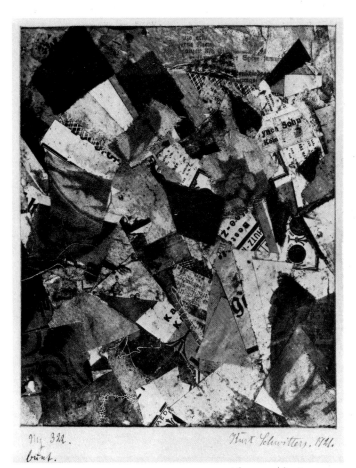

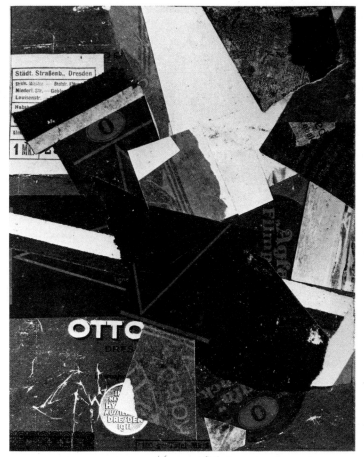

101 *Mz 322.bunt* (many-colored), 1921 7 1/8 x 5 1/2"

102 *Mz 313. Otto*, 1921 7 1/8" x 5 3/4"

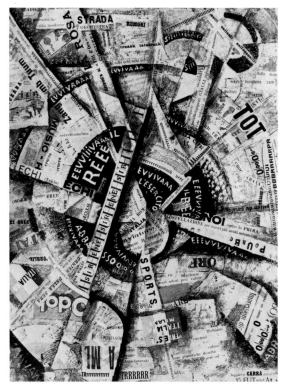

103 Carlo Carrà. *"Free-Word" Painting* (*Patriotic Celebration*), 1914

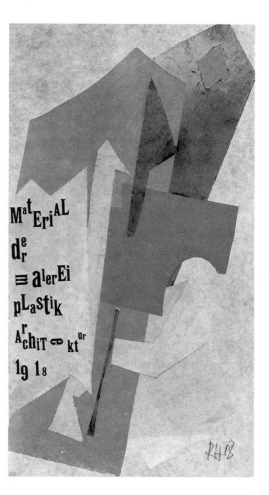

104 Raoul Hausmann.
Cover design for *Material der Malerei, Plastik, Architektur* (*Material of Painting, Sculpture, Architecture*), 1918

12 1/2 x 7 1/8"

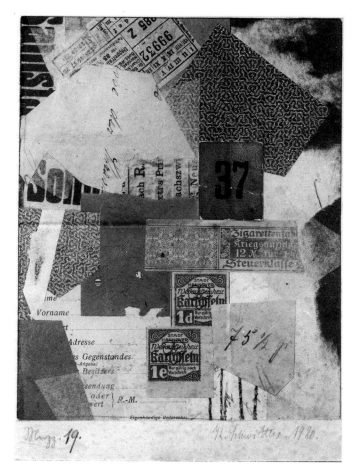

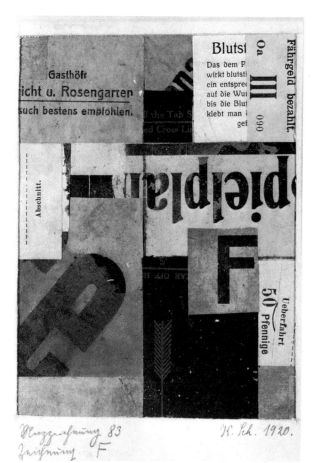

105 *Merzz 19,* 1920 *8″ × 6¾″*

106 *Merzzeichnung 83. Zeichnung F,* 1920 *5½ × 4¾″*

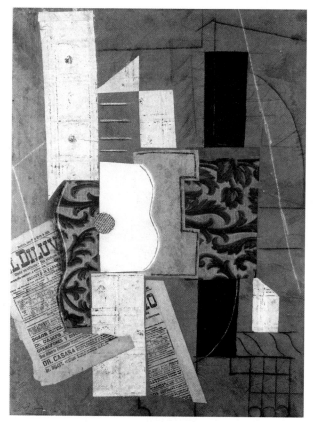

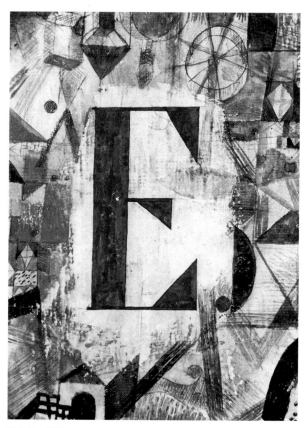

107 Pablo Picasso. *Guitare (Guitar),* 1913

108 Paul Klee. *"E,"* 1918

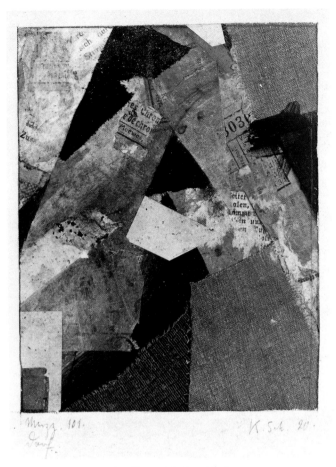

109 *Merzz 101. Dorf (Village),* 1920 6½" × 5"

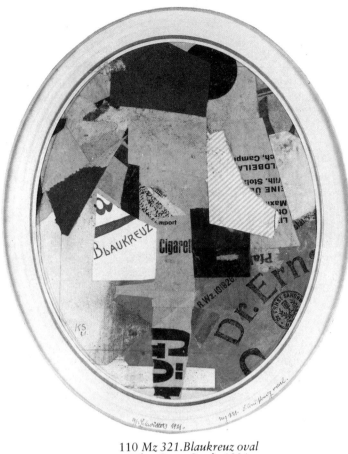

110 *Mz 321.Blaukreuz oval*
(Blue Cross Oval), 1921
9" × 7"

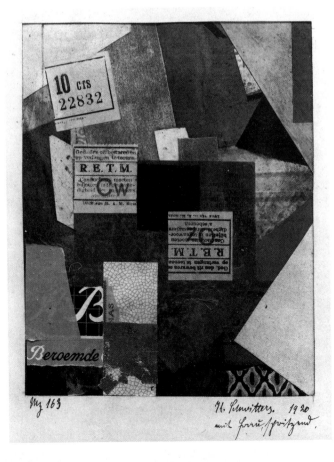

111 *Mz 163. mit frau, schwitzend*
(with woman, sweating), 1920 7" × 5⅝"

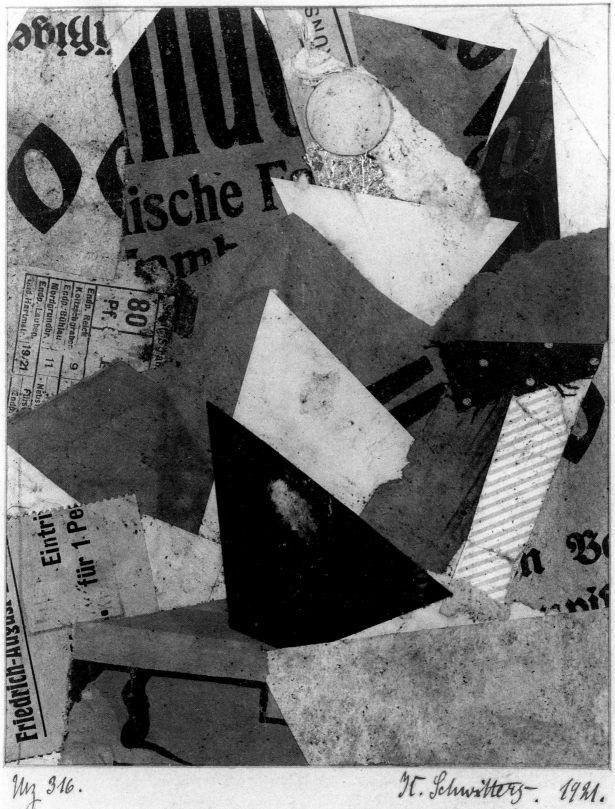

112 *Mz 316. ische gelb (ish yellow)*, 1921 12" x 9¼"

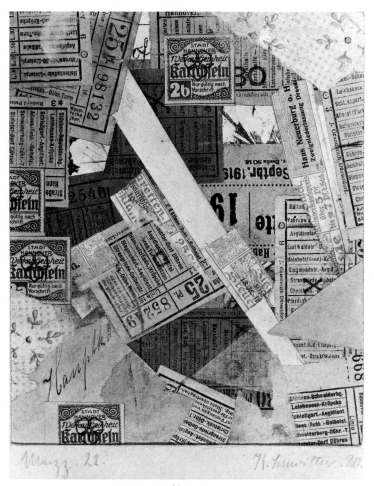

113 *Merzz 22*, 1920 6 3/4 x 5 1/2"

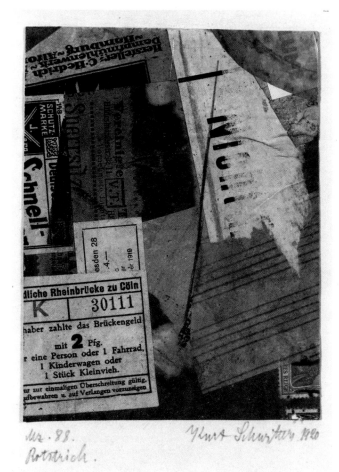

114 *Mz 88. Rotstrich (Red Stroke)*, 1920 5 1/4" x 4 1/8"

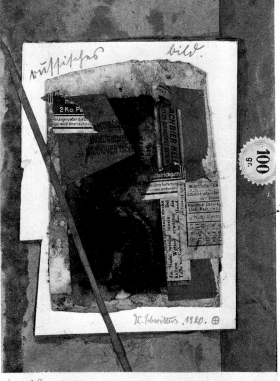

115 *Mz 39. russisches bild (russian picture)*, 1920 7 3/8 x 5 5/8"

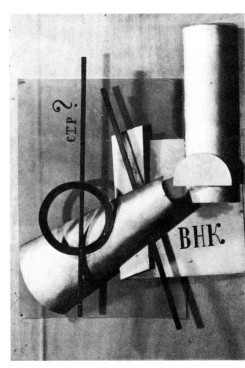

116 Ivan Puni. *Sculpture.* Reconstruction of 1915 original from a 1916 drawing in Puni's February 1921 Sturm exhibition

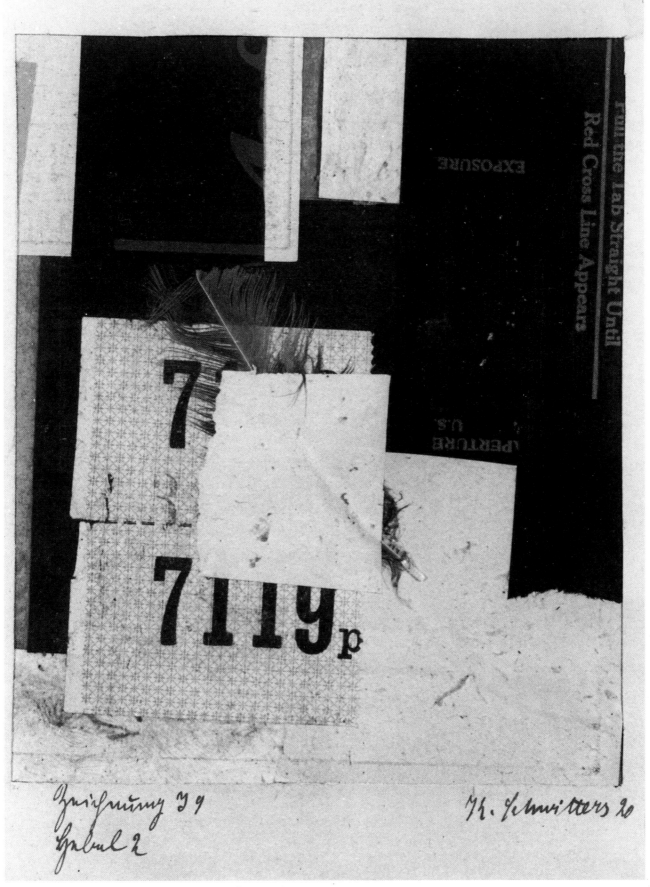

117 *Zeichnung I9. Hebel 2* (*Lever 2*), 1920 5³/₈″ × 4¹/₄″

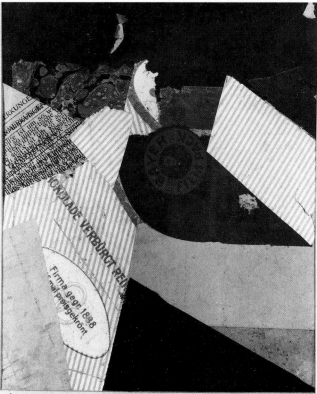

118 Mz 334. Verbürgt rein
(Warranted Pure), 1921 7″ × 5⅝″

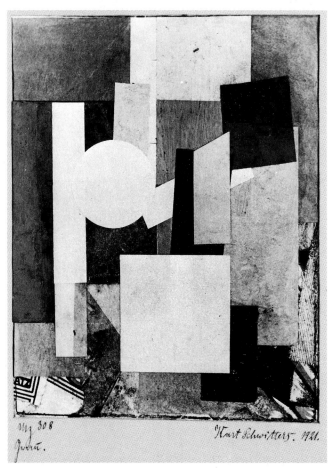

119 Mz 308. Grau (Gray), 1921 7″ × 5⅝″

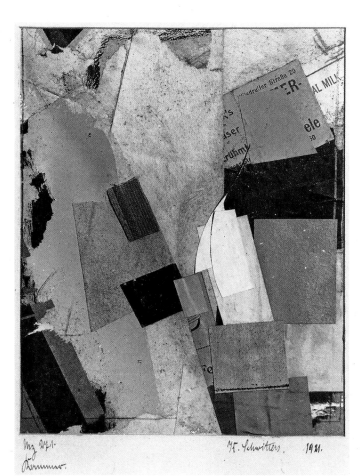

120 Mz 271. Kammer (Cupboard), 1921 7″ × 5⅝″

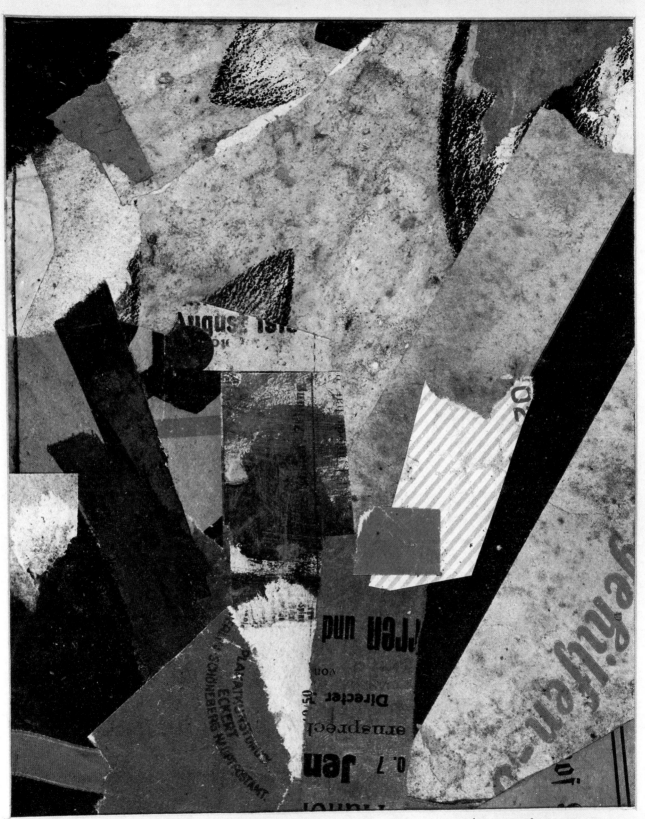

121 Mz 299. *für V.I. Kuron, 1921* 7⅛″ x 5½″

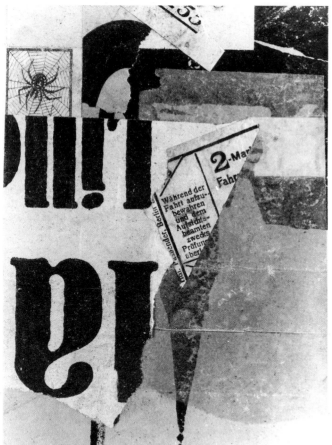

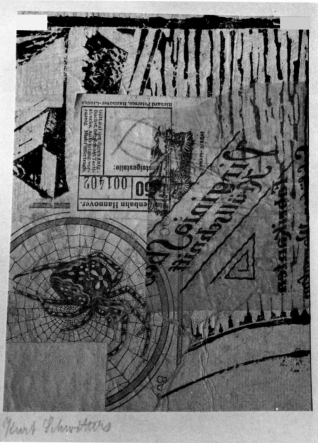

122 (*mit Kreuzspinne*) (*with Spider*), c. 1921 5 1/4" x 3 7/8"

123 (*mit grosser Kreuzspinne*) (*with Large Spider*), c. 1921 5 7/8" x 4 1/2"

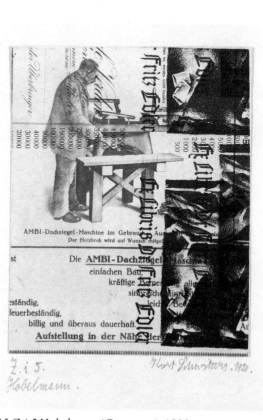

124 *Z.i.3 neu ausgestattet* (*newly appointed*), 1920 5 3/4" x 4 1/4"

125 *Z.i.5 Hobelmann* (*Carpenter*), 1920

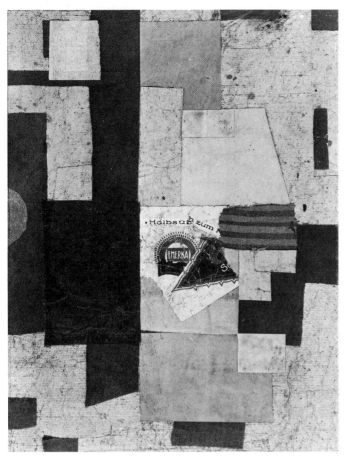

126 (*Emerka*), *c.* 1922 13 3/4" x 10 3/8"

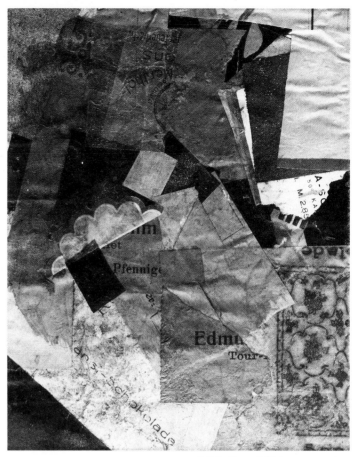

127 *Mz 387. Kaltensundheim*, 1922 6 7/8" x 5 1/2"

128 Pablo Picasso. *Joueur de cartes (Card Player)*, 1913–14

129 Otto Dix. *Kartenspielende Kriegskrüppel (Card-Playing War-Cripples)*, 1920

130 Kurt Schwitters reciting the "da steht ein Mann" section of "Revolution in Revon," cartoon published in *Het Leven*, Jan. 27, 1923

131 (*Kleine Dada Soirée*), 1922. Poster designed by Schwitters and Theo van Doesburg for the 1923 Holland Dada tour

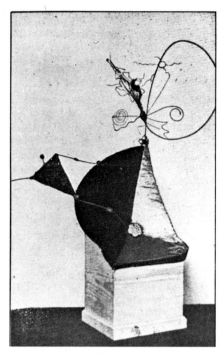

132 Marcel Janco. *Construction 3.*
Reproduced in *Dada*, July 1917

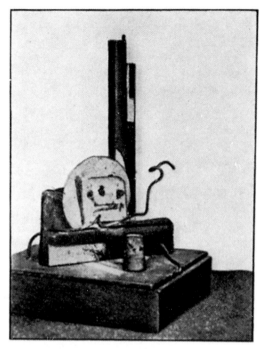

133 *Die Kultpumpe (The Cult Pump), c.* 1919

134 *Konstruktion (Construction),* 1919

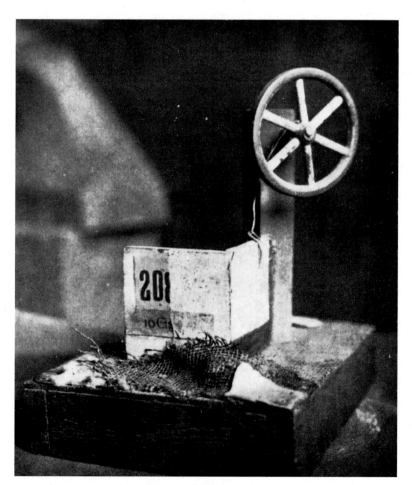

135 *Der Lustgalgen (The Pleasure Gallows), c.* 1919

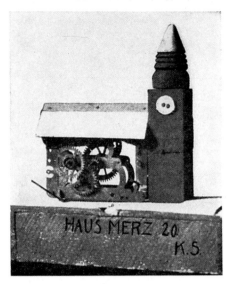

136 *Haus Merz* (*Merz House*), 1920

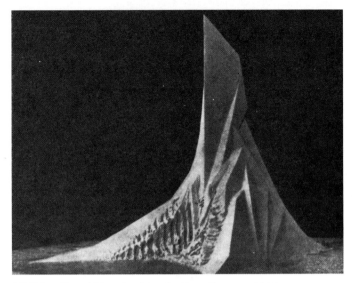

137 Wassili and Hans Luckhardt. *Form Fantasy*, 1919

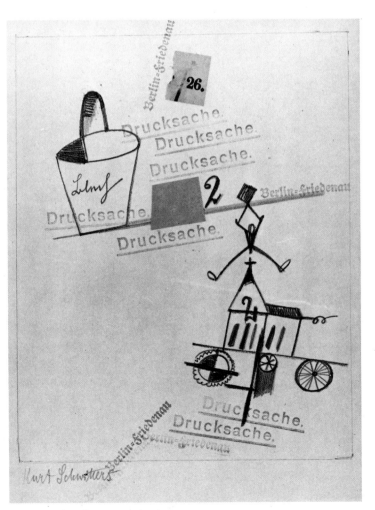

138 (*Drucksache*) (*Printed Matter*), *c.* 1919

139 Lyonel Feininger. *Kathedrale* (*Cathedral*). Design for the title page of *Programm des staatlichen Bauhauses in Weimar*, 1919

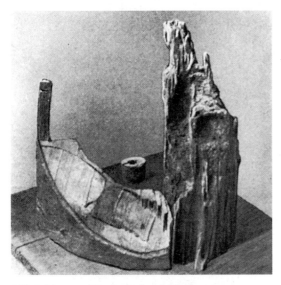

140 *Schloss und Kathedrale mit Hofbrunnen* (*Castle and Cathedral with Courtyard Well*), c. 1922

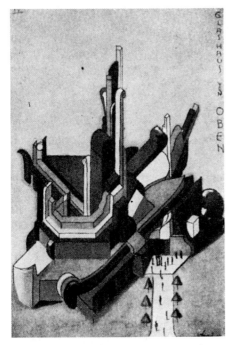

141 Carl Krayl. *Glashaus von oben* (*Glass House Seen from Above*), 1920

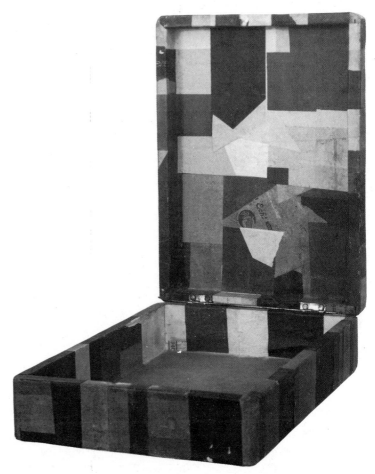

142 *Der Schokoladenkasten, Anna Blume, Kasten 7* (*The Chocolate Box, Anna Blume, Box 7*), 1922

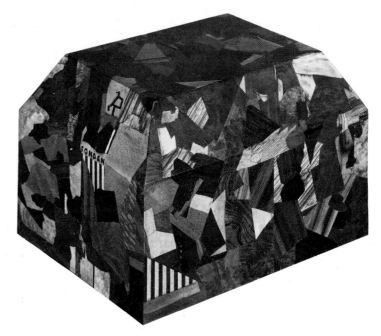

143 (*Intarsienkästchen Anna*) (*Small Inlaid Box Anna*), c. 1920–21

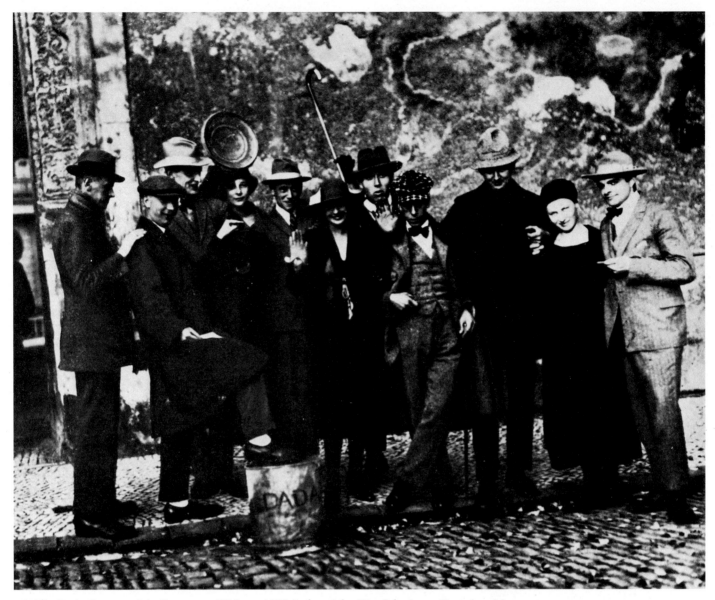

144 The Dada-Constructivist Congress at Weimar, 1922. Left to right: Kurt Schwitters, Hans Arp, Max Burchartz, Frau Burchartz, Hans Richter, Nelly van Doesburg, Cornelis van Eesteren, Theo van Doesburg, Peter Rohl, Frau Rohl, Werner Graeff

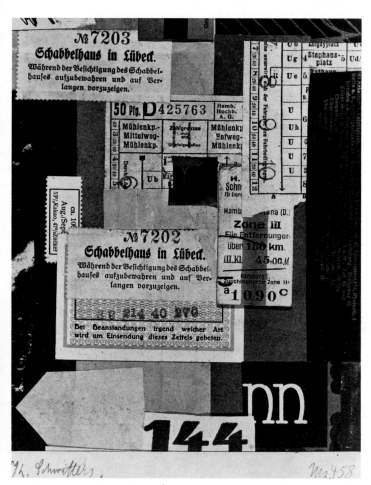

145 Mz 458, c. 1922　7″ x 5 5/8″

146 Mz 336. Dreieins (Three-One), 1921　7 1/4″ x 5 1/2″

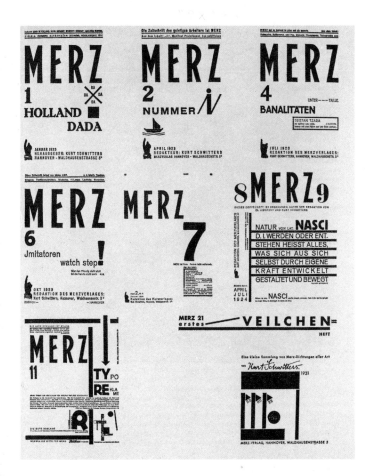

147 Title pages of the magazine *Merz* from 1923

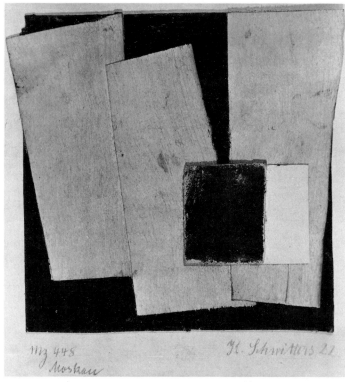

148 Mz 448. Moskau (Moscow), 1922 6″ × 6¼″

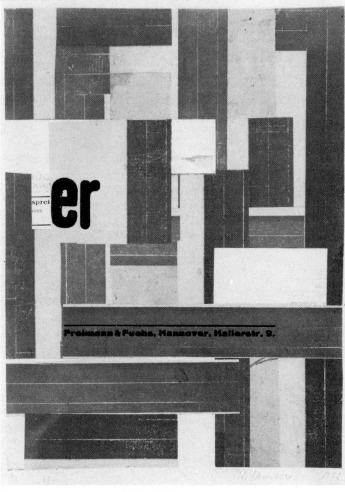

149 Mz "er," 1922 12″ × 9″

150 Kasimir Malevich. *Suprematist Elements: Squares, c.* 1915

151 Vilmos Huszár. *Hamer en Zaag* (*Hammer and Saw*), 1919.
Reproduced in *De Stijl*, January 1918

Schlotheim

152 *Mz 380. Schlotheim*, 1922 8 3/4" x 7 1/2"

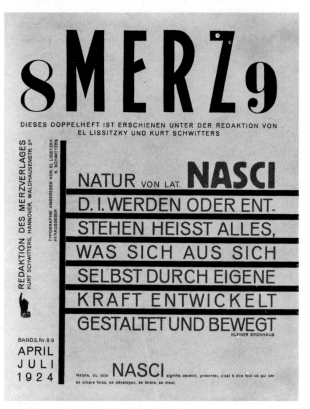

153 Cover of "Nasci" issue of *Merz*, 1924

154 Double page spread from "Nasci" issue of *Merz*, 1924

155 Page from *Die Scheuche* (*The Scarecrow*), 1925. Produced with Käte Steinitz and Theo van Doesburg

156 El Lissitzky. Double page spread from Vladimir Mayakovsky's *Dlya Golosa* (*For the Voice*), 1923

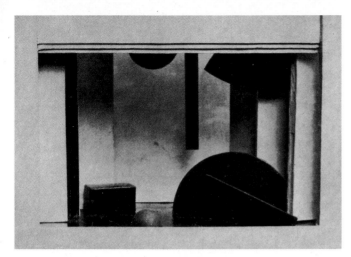

157 *Normalbühne Merz,* model, *c.* 1924

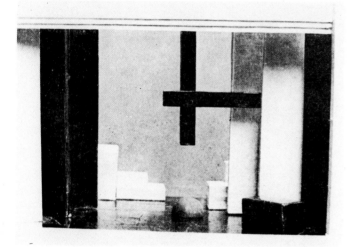

158 *Normalbühne Merz,* model, *c.* 1924

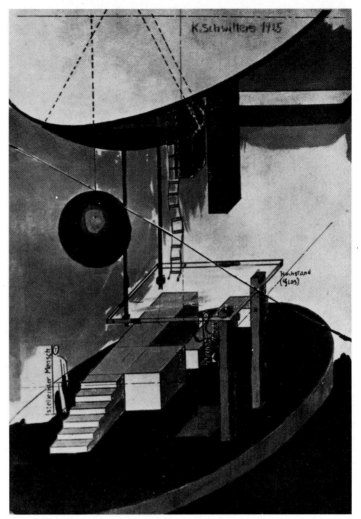

160 Design for *Normalbühne Merz,* 1925

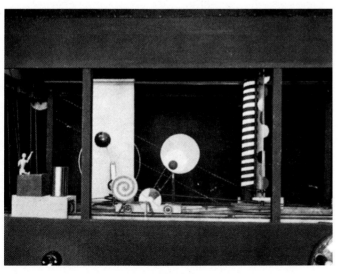

159 Heinz Loew. *Model for a Mechanical Stage, c.* 1926–27

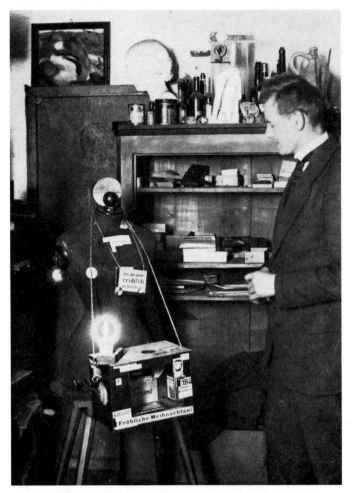

161 *Die heilige Bekümmernis* (*The Holy Affliction*), *c.* 1920

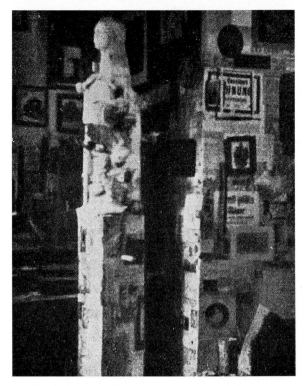

162 Hannover *Merzbau: The Merz-Column, c.* 1920

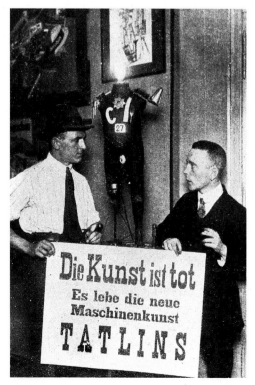

163 The First International Dada Fair, Berlin, June 1920

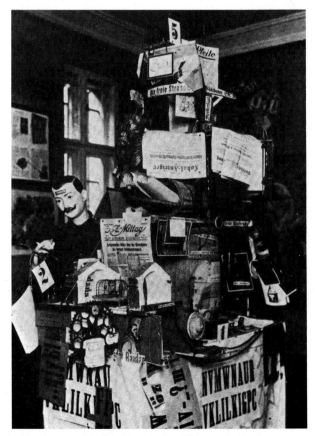

164 Johannes Baader, *Das grosse Plasto-Dio-Dada-Drama "Deutschlands Grösse und Untergang"* (*The Great Plastic Dio-Dada-Drama "Germany's Greatness and Downfall"*), *c.* 1920

166 Photograph of Schwitters' house at Waldhausenstrasse 5, Hannover (with the artist's son, Ernst Schwitters, in foreground at right), 1926

165 Ground floor plan of Schwitters' house at Waldhausen-strasse 5, Hannover; shaded areas indicate the principal rooms occupied by the *Merzbau*.
1: Schwitters' first studio, *c.* 1918–21
A: Site of the 1920 column (illus. 162)
2: Schwitters' principal studio and the most fully developed room of the *Merzbau,* 1923 ff. (see also illus. 167)
B: Site of 1923 column (illus. 176)
3: Balcony: Merzbau extended here *c.* 1925–26 ff.
4: Room taken over as studio then as part of the Merzbau *c.* 1925–26 ff.
5 and 6: Kitchens
7: Entrance hall
8: Street entrance to house

167 Plan of the principal room of the Hannover *Merzbau* (room 2 on the ground floor plan, illus. 165), indicating the positions from which the photographs of the *Merzbau* illustrated here were taken, as follows:
A: Illus. 175, 249
B: Illus. 178, 179
C: Illus. 170
D: Illus. 168, 169
E and F: Illus. 187, 188, 189

168 Hannover *Merzbau: Die grosse Gruppe* (The Big Group), photographed *c.* 1932

169 Hannover *Merzbau: Die Goldgrotte* (The Gold Grotto) photographed *c.* 1932

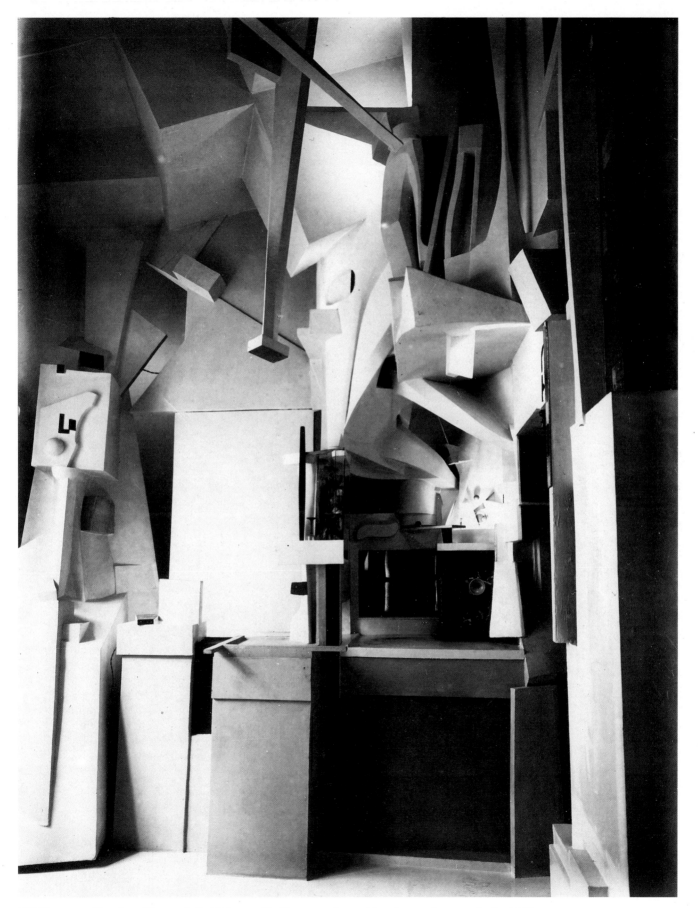

170 Hannover *Merzbau:* View with Gold Grotto, Big Group, and movable column, photographed *c.* 1930

171 Antoni Gaudí. Chapel for the Colonia Güell near Barcelona, 1898–1915. Porch of the completed crypt

172 Max Taut. *Watercolor Study, c.* 1920

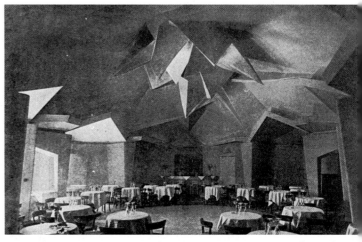

173 Hans Poelzig. Grosses Schauspielhaus (Grand Theater), Berlin, 1919

174 Walter Würzbach and Rudolf Belling. Dance Casino at the Scala-Palast, Berlin, *c.* 1920

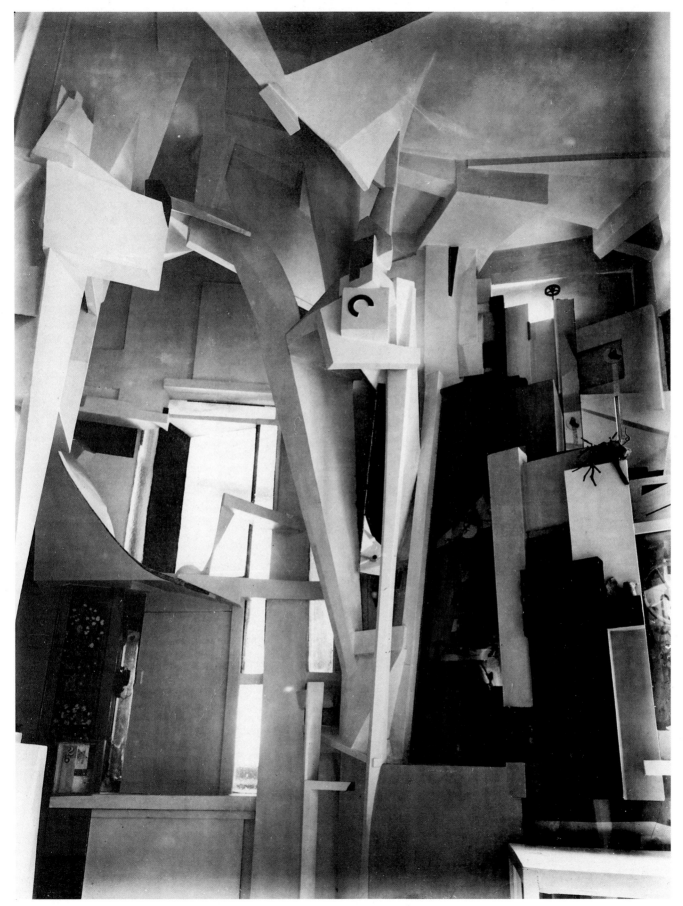

175 Hannover *Merzbau:* View with *blaues Fenster* (Blue Window), photographed *c.* 1930

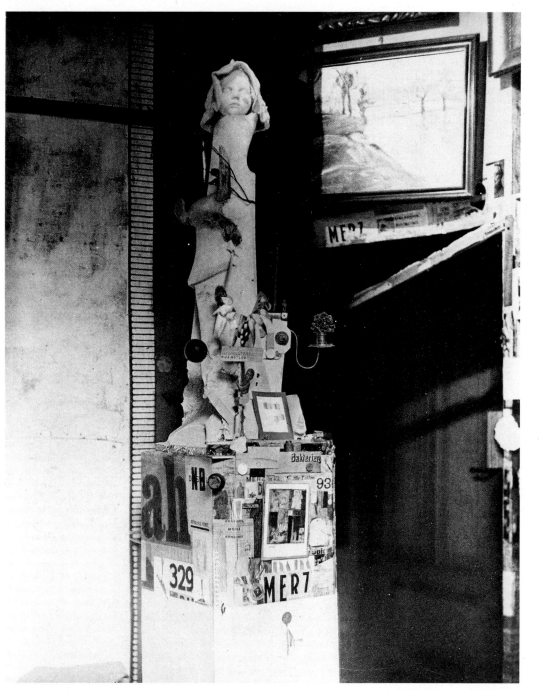

176 Hannover *Merzbau:*
Merz-column, *c.* 1923

177 Der erste Tag
(The First Day), c. 1918–19

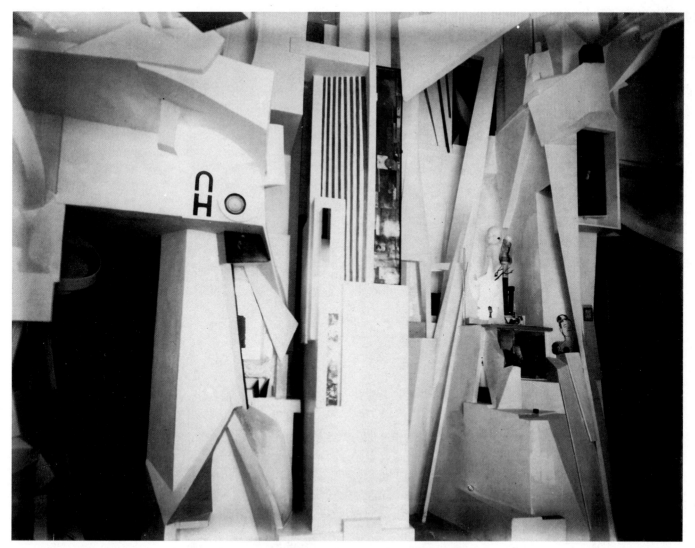

178 Hannover *Merzbau:* General view with 1923 column, photographed *c.* 1930

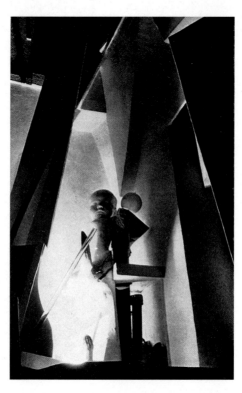

179 Hannover *Merzbau:*
1923 column in later state,
photographed *c.* 1930

180 Wilhelm Busch. *Die
fromme Helene (Devout
Helene)*

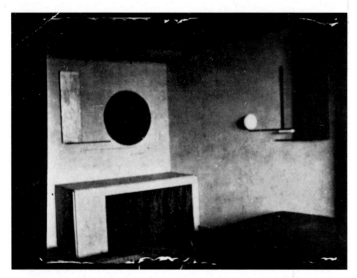

181 Erich Buchholz. Room at Herkulesufer 15, Berlin, 1922

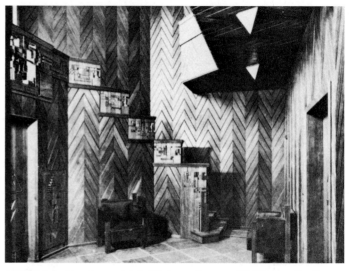

182 Walter Gropius and Adolf Meyer. Sommerfeld House, Berlin-Dahlem, 1920–21

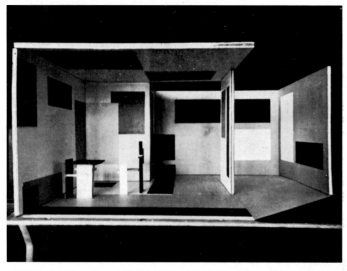

183 Vilmos Huszár and Gerrit Rietveld. Project for an interior, 1923

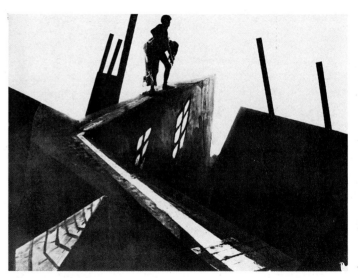

184 Still from *Das Kabinett des Dr. Caligari*, directed by Robert Wiene, 1919

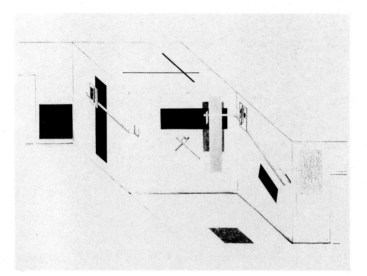

185 El Lissitzky. Design for *Prounenraum*, 1923

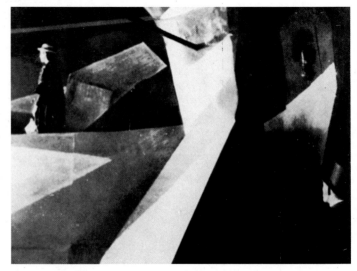

186 Still from *Raskolnikow*, directed by Robert Wiene, 1923

187 Hannover *Merzbau: Kathedrale des erotischen Elends* (*KdeE*) (*Cathedral of Erotic Misery*), photograph taken 1928

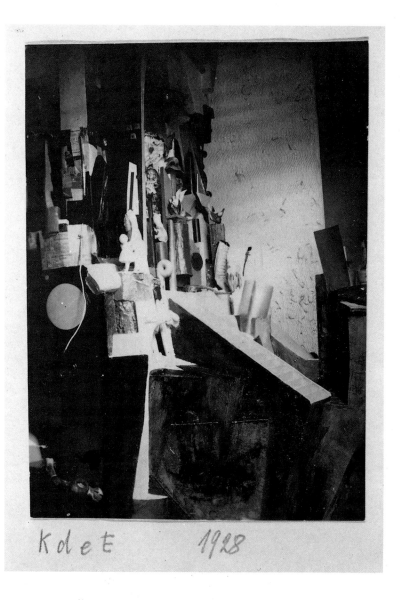

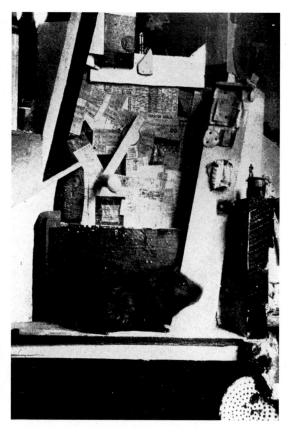

188 Hannover *Merzbau: Kathedrale des erotischen Elends* (*KdeE*) (*Cathedral of Erotic Misery*). Detail with guinea pig, photograph taken *c*. 1930

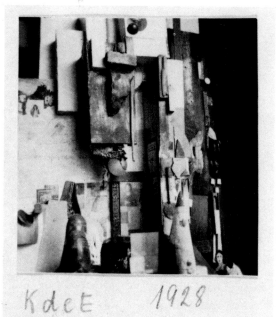

189 Hannover *Merzbau: Kathedrale des erotischen Elends* (*KdeE*) (*Cathedral of Erotic Misery*), photograph taken 1928

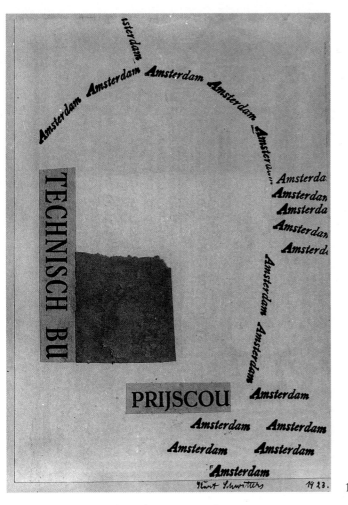

190 (*Amsterdam*), 1923

191 "A O Bildgedicht" ("A O Picture-poem") 1922

192 "Gesetztes Bildgedicht" ("Typeset Picture-poem") 1922

193 Opening page of "Ursonate," 1922–32, from *Merz 24*

194 Page from "Ursonate," 1922–32, from *Merz 24*

195 Raoul Hausmann. "fmsbw," 1918

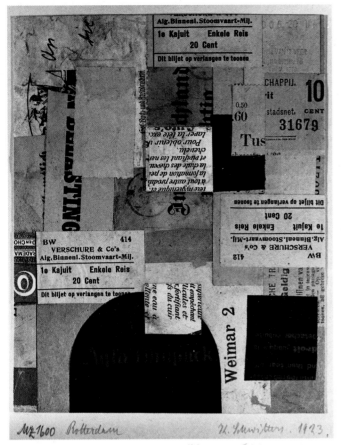

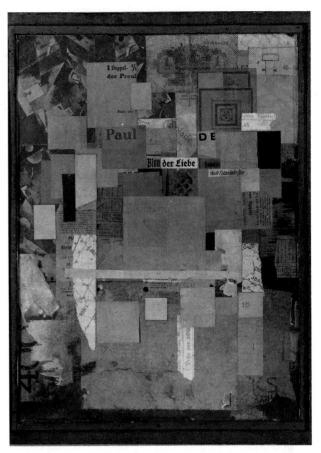

196 *Mz 1600. Rotterdam*, 1923 6⅞" × 5⅝"

197 *Merzbild 12b. Plan der Liebe (Plan of Love)*, 1919 and 192[...] 17" × 12⅞"

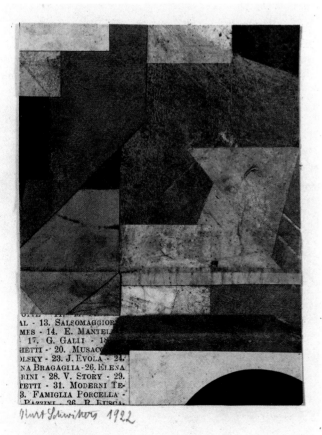

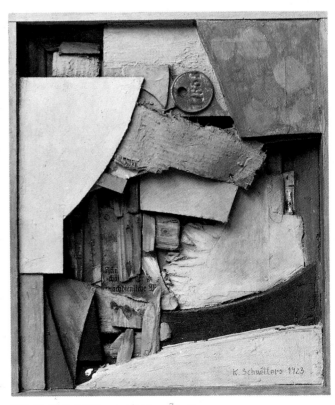

198 *(Famiglia)*, 1922 5¾" × 4½"

199 *(Relief)*, 1923 14" × 11¾"

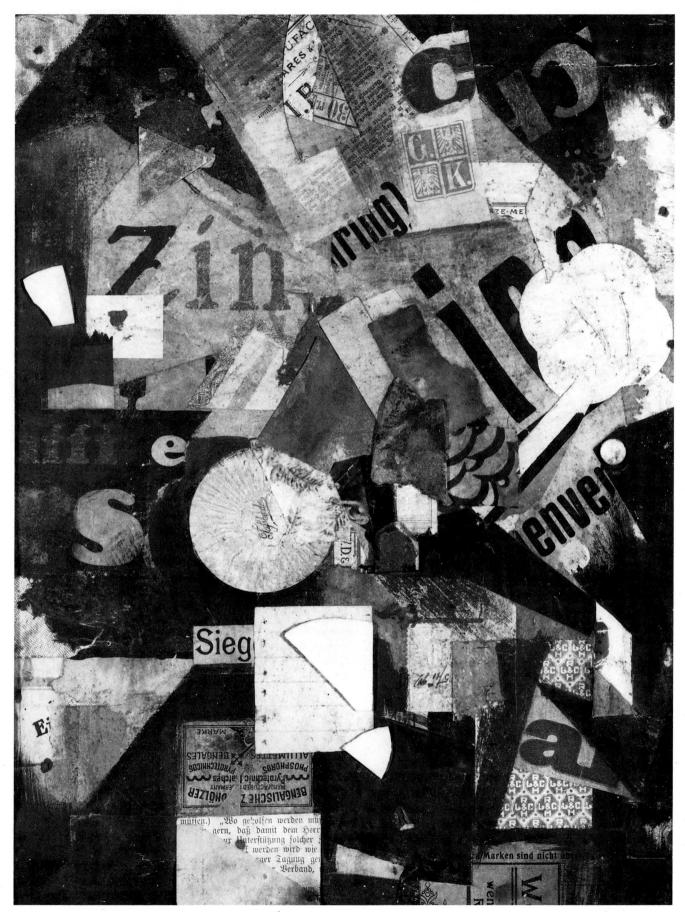

200 *Siegbild* (*Victory Picture*), c. 1925 15" X 12⅝"

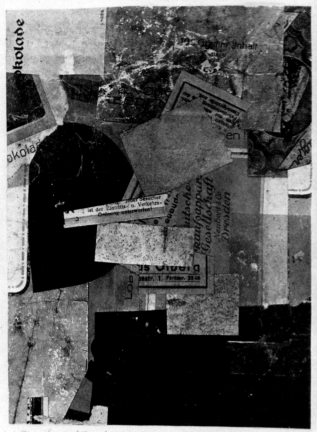

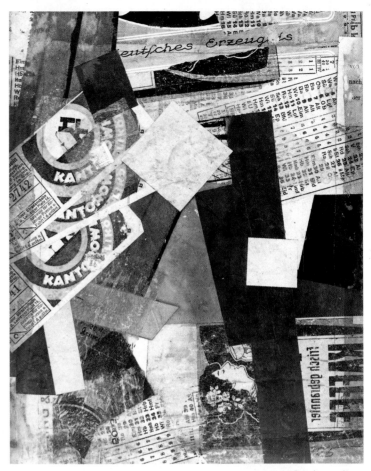

201 Mz 26, 41. okola, 1926 *6⅞" × 5⅜"*

202 Mz 26,30. rotes Dreieck (*Red Triangle*), 1926 *9¾" × 8"*

203 Mz 1926,5. mit lila Sammet (*with Lilac Velvet*), 1924 and 1926 *11¼" × 9⅜"*

204 Untitled lithograph from the *Merzmappe* (*Merz Portfolio*) issue of *Merz*, 1923

205 *Dieser ist Friedel Vordemberges Drahtfrühling (This is Friedel Vordemberge's Wire Springtime)*, 1927 10⅝″ × 8″

206 *Die breite Schmurchel* (*The Wide Schmurchel*), 1923

207 Hans Arp. *La trousse du voyageur* (*The Traveler's Bundle*), 1920

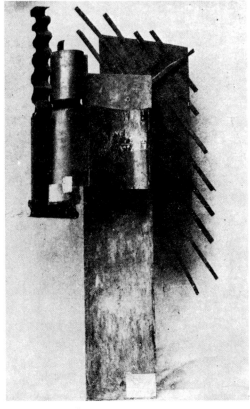

208 Vladimir Tatlin. *Counter-Relief*,
c. 1915–16. Exhibited at the "Erste
russische Kunstausstellung," 1922

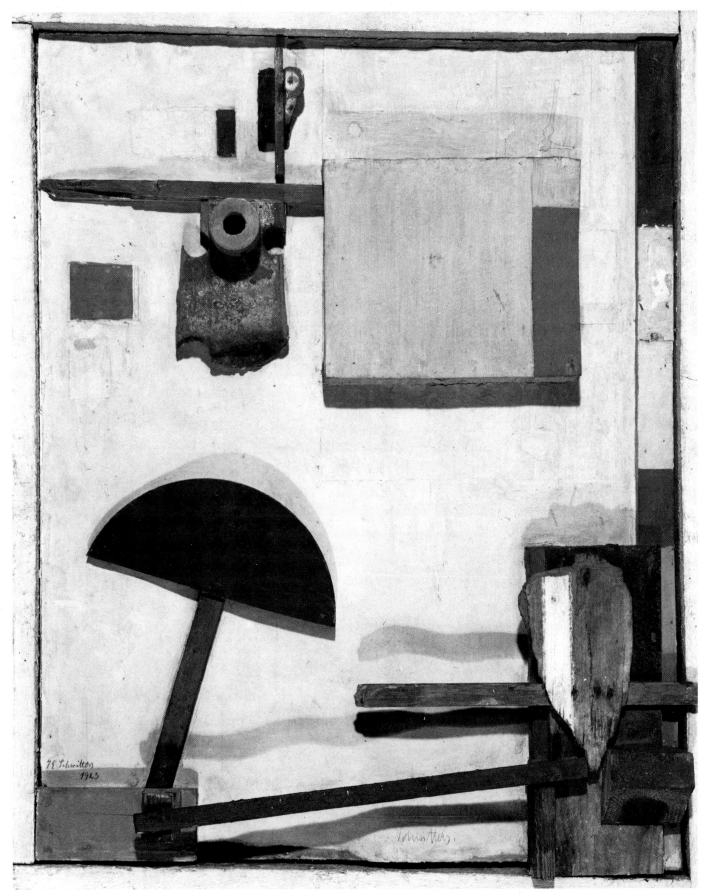

209 *Merzbild Kijkduin,* 1923

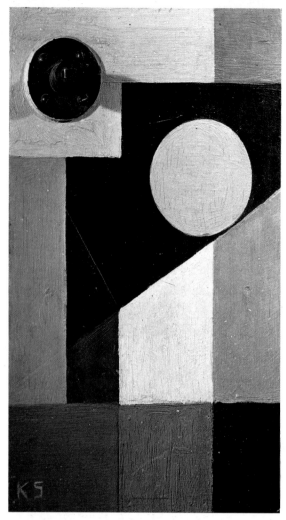

210 *Für Tilly*, 1923

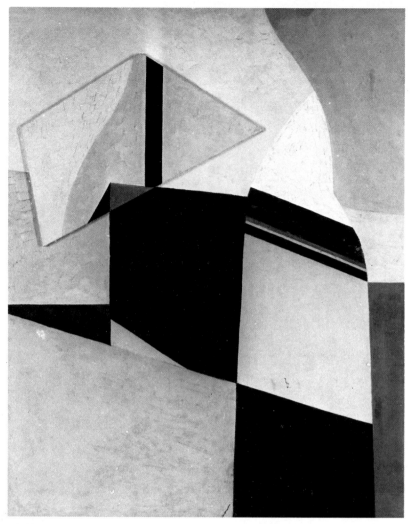

211 *Albert Finslerbild*, 1926

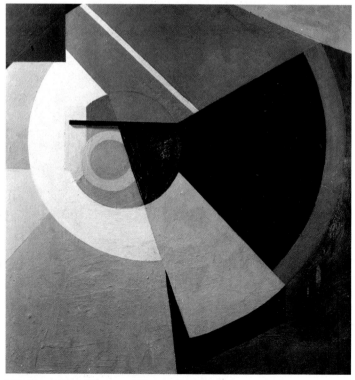

212 *Merz 1003.Pfauenrad (Peacock's Tail)*, 1924

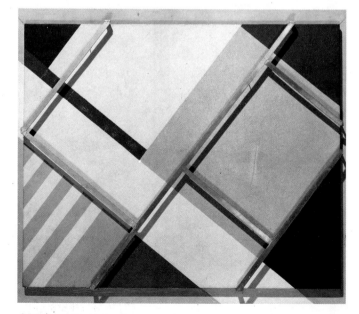

213 Cesar Domela. *Construction*, 1929

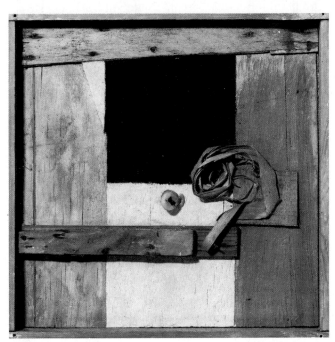

214 *Merzbild mit Kerze (Merzpicture with Candle), c.* 1925–28

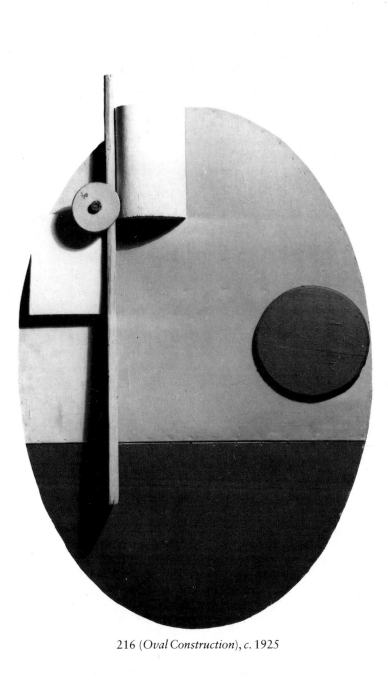

216 *(Oval Construction), c.* 1925

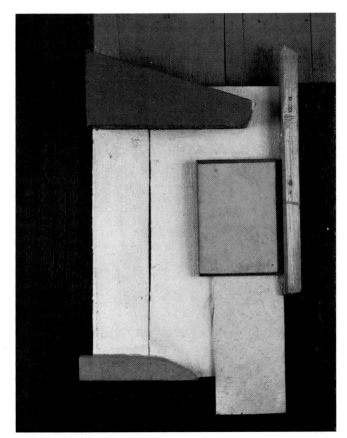

215 *blau (blue), c.* 1923–26

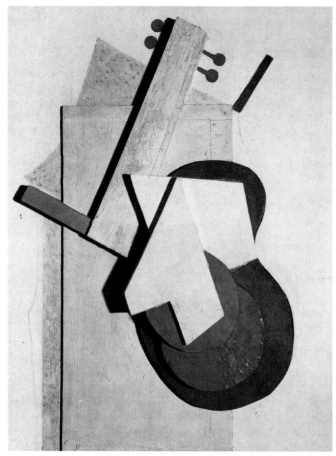

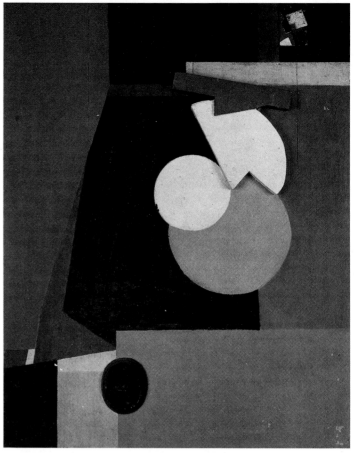

217 *Wie bei Picasso* (*As with Picasso*), *c.* 1925–28

218 *Richard Freytagbild*, 1927

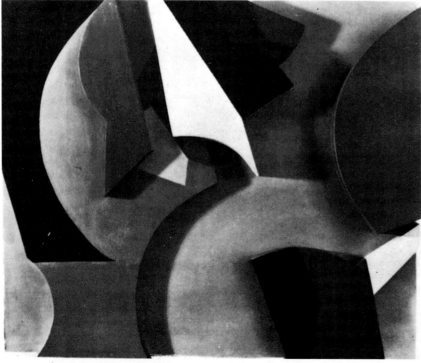

219 Hans Arp. *Composition abstraite* (*Abstract Composition*), 1915

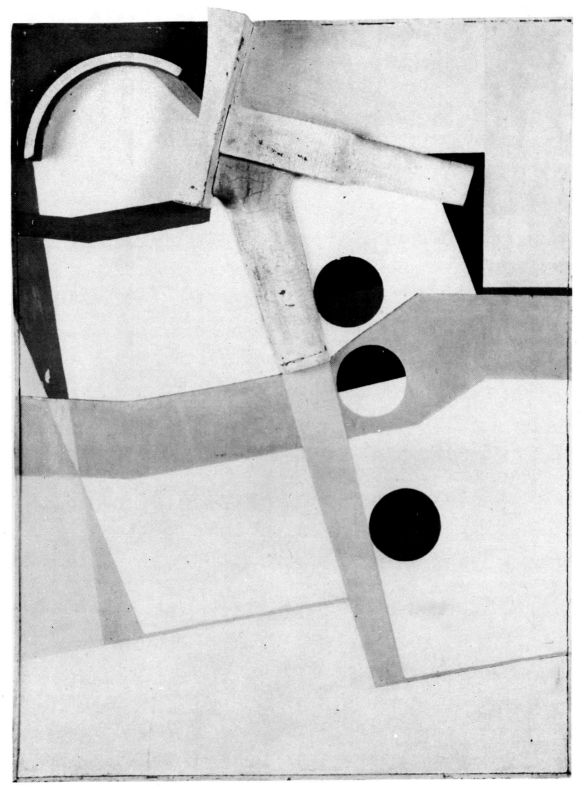

220 *Drei Kugeln* (*Three Spheres*), *c*. 1920–36

221 Cover of *Die Blume Anna. Die neue Anna Blume*, 1922

222 Double page spread from the pamphlet *Die neue Gestaltung in der Typographie*, c. 1925

223 "Pornographisches *i*-Gedicht" (Pornographic *i*-poem) from *Merz 2*, 1923

224 (*Tortrtalt*), 1929 4" x 4¾"

225 Double page spread from "Typoreklame" issue of *Merz*, 1924

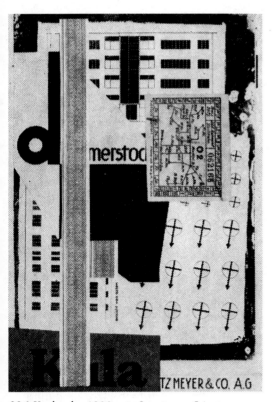

226 *Karlsruhe*, 1929 11 3/8" x 7 3/4"

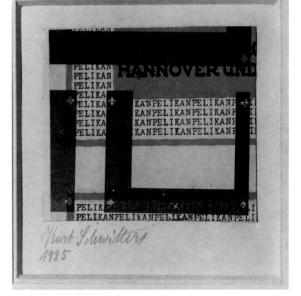

227 (*Pelikan*), 1925

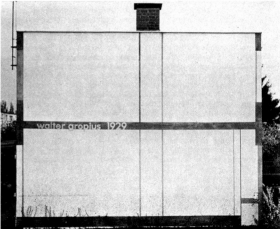

228 Attributed to Schwitters: Mural on a building by Walter Gropius at the Dammerstock-Siedlung architectural exhibition, Karlsruhe, 1929

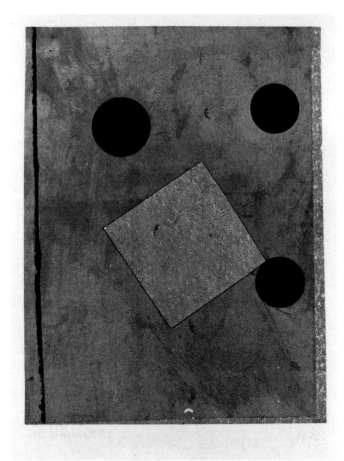

229 (*Schwarze Punkte und Viereck*) (*Black Dots and Quadrangle*), 1927 7 1/4" X 5 1/2"

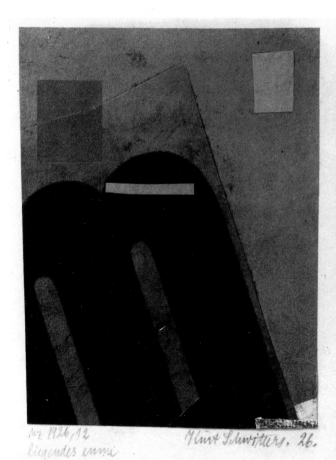

230 Mz 1926, 12. *liegendes emm* (*Reclining m*), 1926 5 3/4" X 4 1/8"

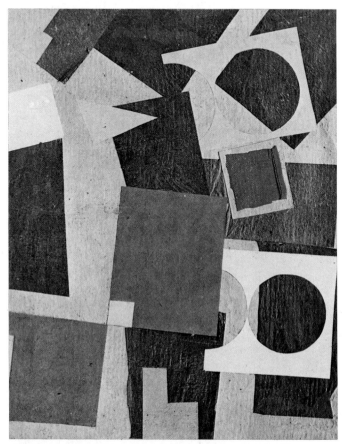

231 *Lockere Vierecke* (*Loose Quadrangles*), 1928 12 3/4" X 10"

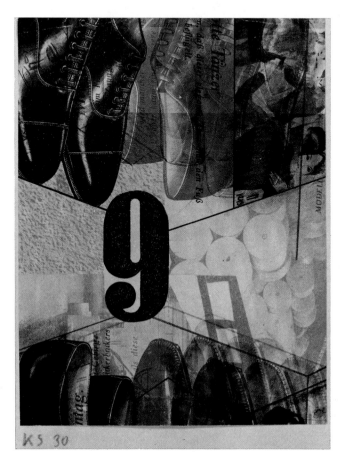

232 (9), 1930

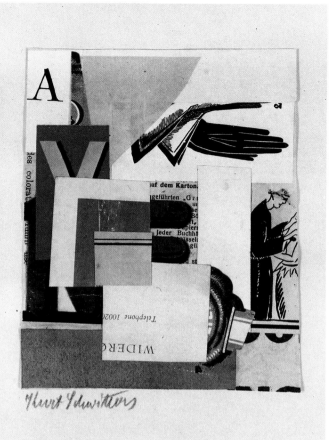

233 (*Auf dem Karton*) (*On the Cardboard*), *c.* 1923–26

5" × 4 ⅛"

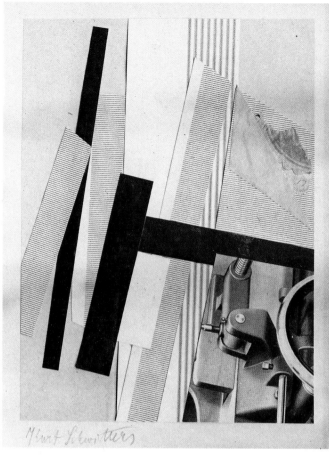

234 (*mit Maschinenteil*) (*with Machine Part*), *c.* 1926–28

235 *i-Zeichnung "Pferd"* (*Horse*), 1928

236 (*250 Gramm*), 1928

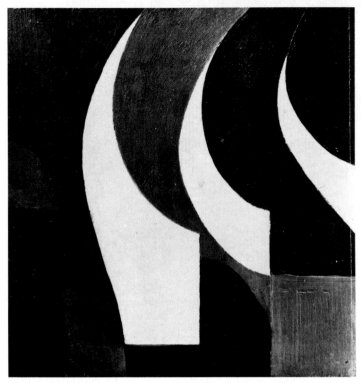

237 *Bild mit weissen Sicheln* (*Picture with White Crescents*),
c. 1925–28

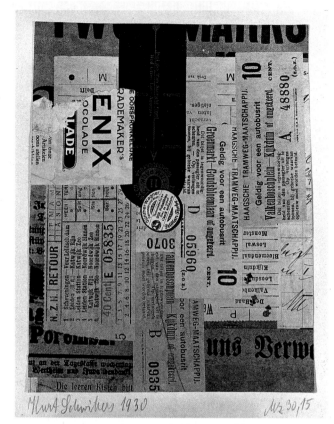

238 *Mz 30, 15 (ENIX)*, 1930 7 1/8" x 5 1/2"

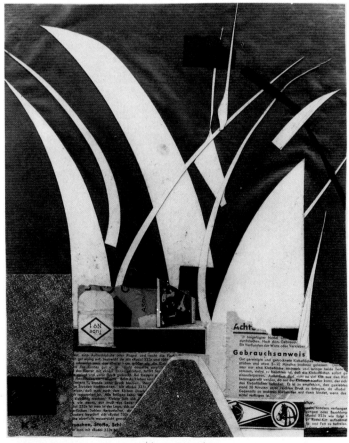

239 (*Dol 333*), c. 1930 11 1/4" x 9 1/4"

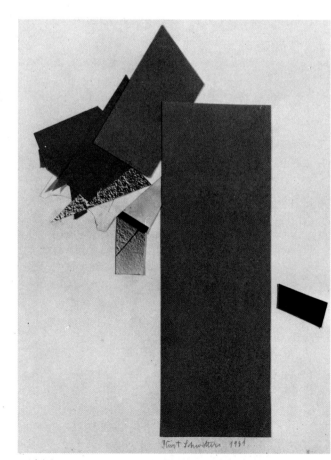

240 (*Rot, Grau, Schwarz*) (*Red, Gray, Black*), 1931
11" x 7 7/8"

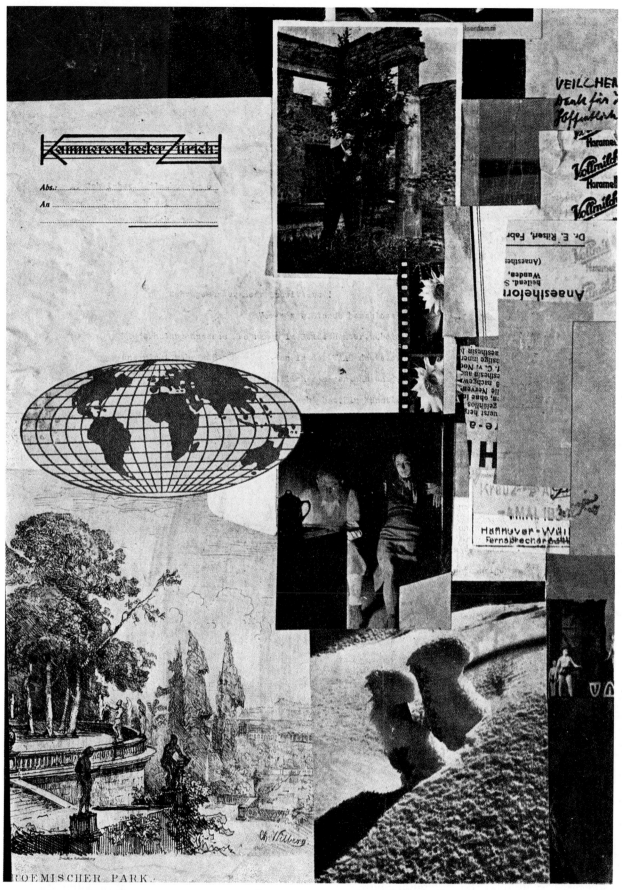

241 (*Römischer Park*) (*Roman Park*), *c.* 1934 13¾" × 10"

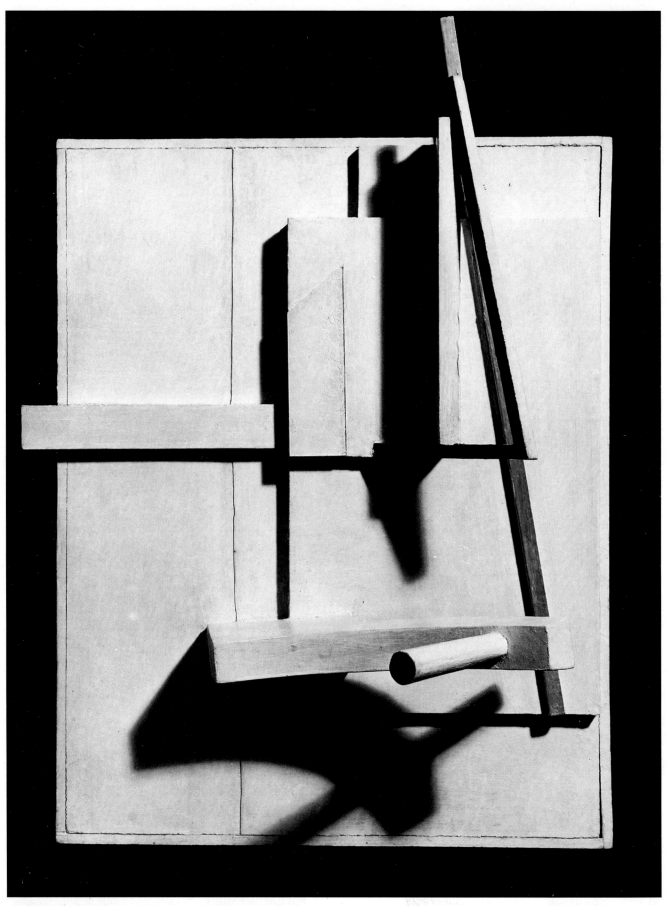

242 *Weisses Relief (White Relief), c. 1924–27*

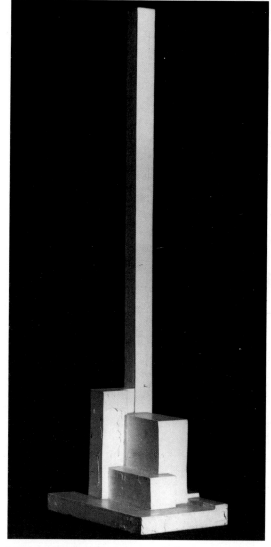

243 Untitled, 1922–23. Later titled *Monument to the Artist's Father*

244 *Kleine Säule (Little Column)*, c. 1922

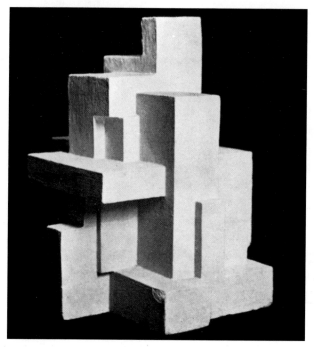

245 Georges Vantongerloo. *Constructie van Volumen (Volume Construction)*, c. 1918

246 Untitled, c. 1923

247 *Die Herbstzeitlose (The Autumn Crocus), c.* 1926–28

248 *Schlanker Winkel (Slim Angle), c.* 1930

249 Hannover *Merzbau: Madonna* sculpture, 1930, 1932, and 1936

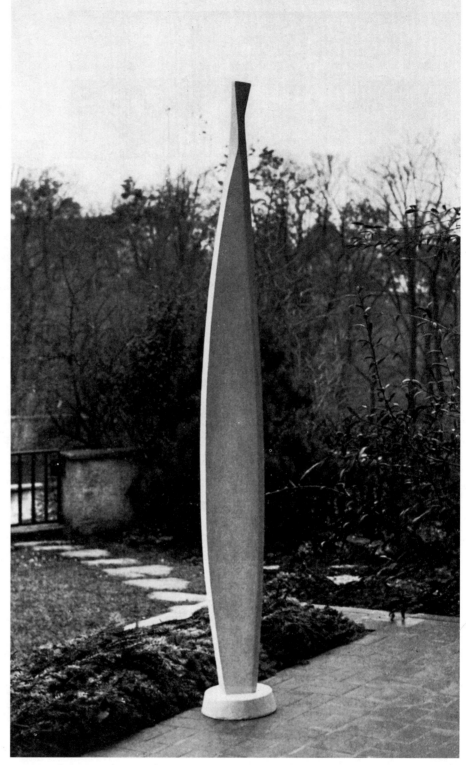

250 Untitled, 1936

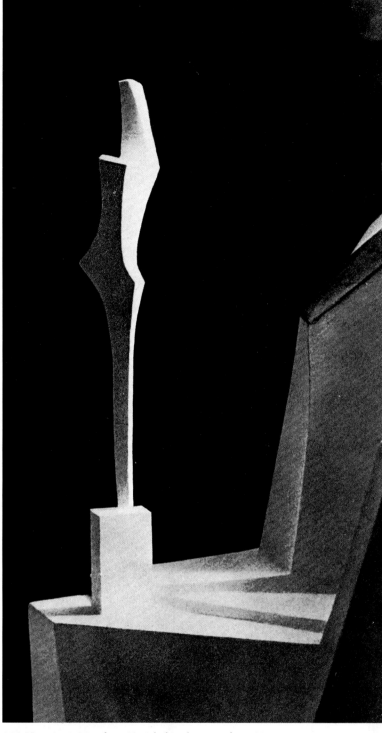

251 Hans Arp. *Growth*, 1938

252 Hannover *Merzbau:* Untitled sculpture, after 1930

253 Hannover *Merzbau: Grotte zur Erinnerung an Molde (Grotto in Remembrance of Molde)*. Begun 1933

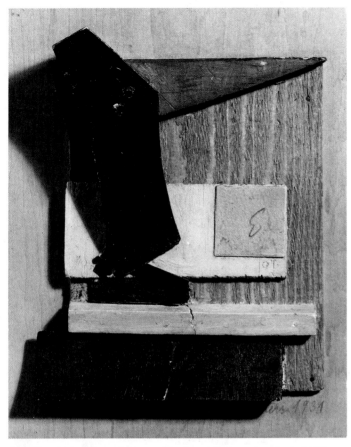

254 *Plastische Merzzeichnung (Sculptural Merz-drawing)*, 1931

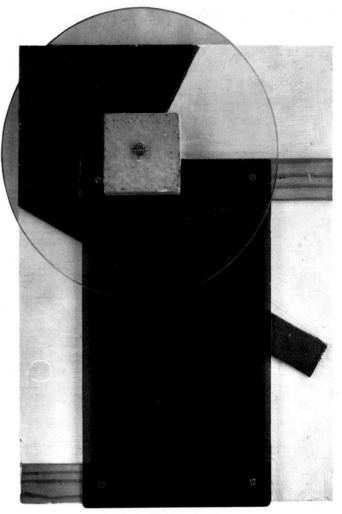

255 *Bild mit drehbarer Glasscheibe (Picture with Revolving Glass Disk), c.* 1930

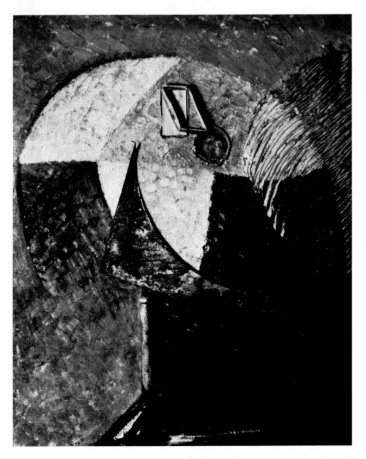

256 *Hochgebirge (Gegend Øye)*
(*High Mountains [Øye Neighborhood]*), 1930

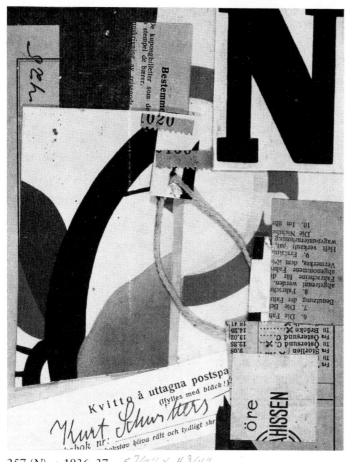

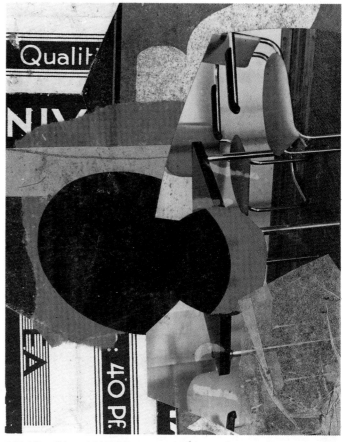

257 (N), c. 1936–37 5 7/8" × 4 3/4"

258 (Qualit), c. 1937–38 6" × 4 5/8"

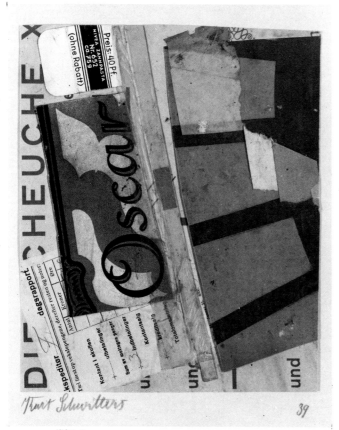

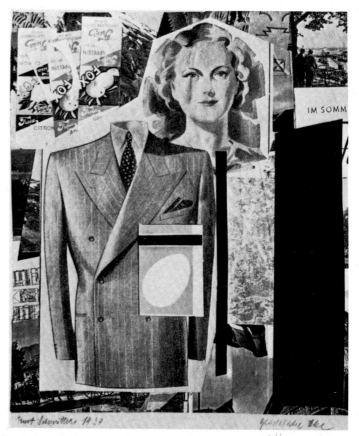

259 (Oscar), 1939 8 1/4" × 6 7/8"

260 Glückliche Ehe (Happy Marriage), 1939 12 1/2" × 10"

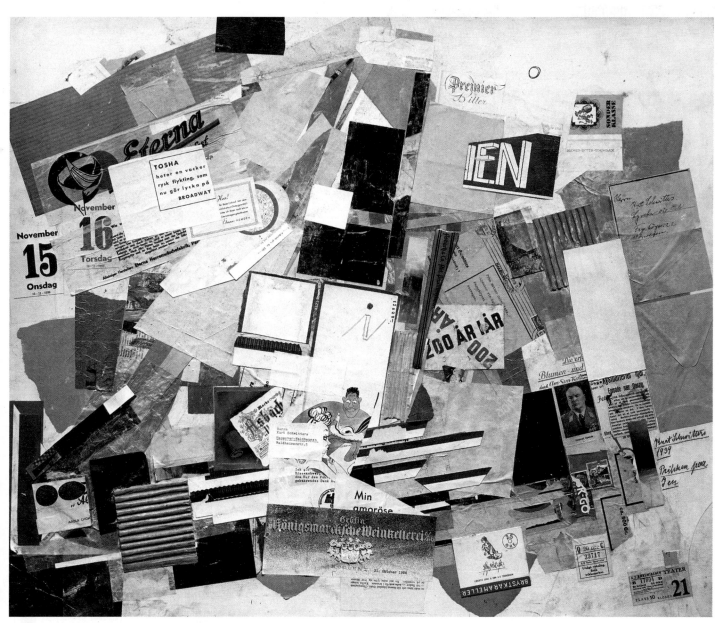

261 *Prikken paa Ien (The Dot on the I)*, 1939 29¾" × 35¾"

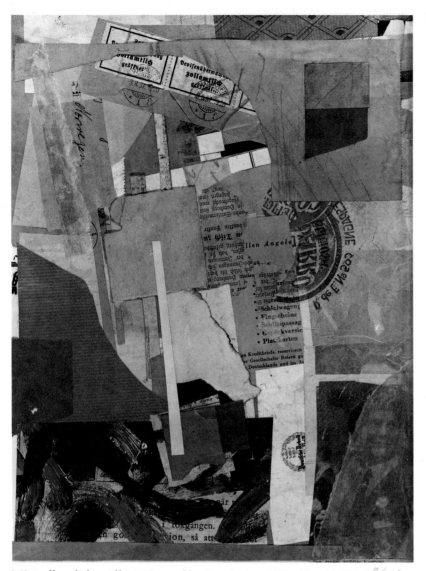

262 (*zollamtlich geöffnet*) (*Opened by Customs*), *c.* 1937–38 13" X 9 7/8"

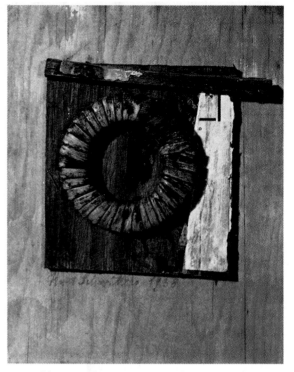

263 *Bild mit Korbring* (*Picture with Basket Ring*), 1938
4 3/4" X 4 3/8"

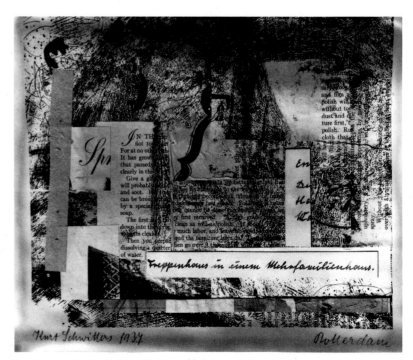

264 *Rotterdam*, 1937 6 1/4" X 7 1/4"

265 Page from Schwitters' photograph album showing photographs taken by himself in Djupvasshytta, Norway, in the 1930s

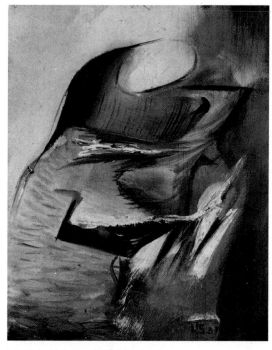

266 Mz Oslofjord, 1937

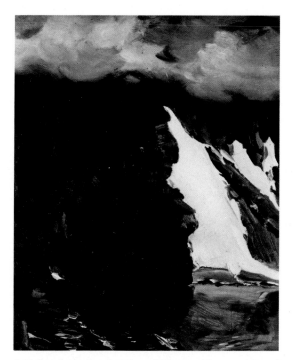

267 Landschaft mit Schneefeld. Oppblusegga (Landscape with Snowfield. Oppblusegga), 1936

268 *Everybody's hungry for, c. 1938*
11½" × 11½"

269 *Skøyen, 1942*

270 *Bild mit Raumgewächsen—Bild mit 2 kleinen Hunden*
(*Picture with Spatial Growths—Picture with 2 Small Dogs*), 1920 and 1939 38 × 26¾

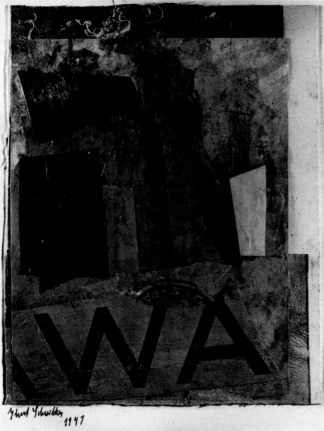

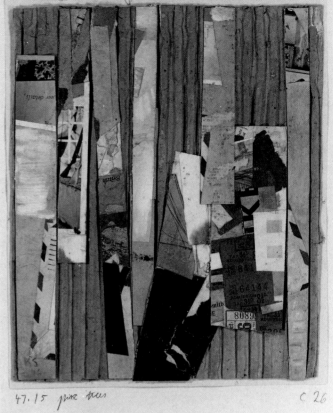

271 (WA), 1947

272 47.15 *pine trees, c 26,* 1946 9 7/8" × 8"

273 *Milk Flower,* 1947 11 3/8 × 9 1/2"

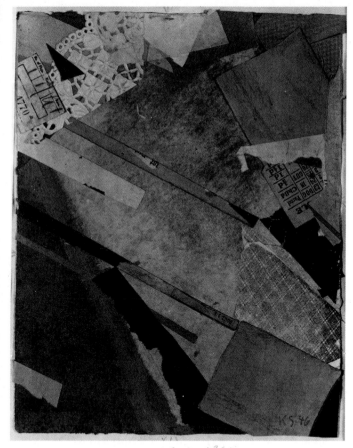

274 c 77. *wind swept*, 1946 9⅝″ × 7⅜″

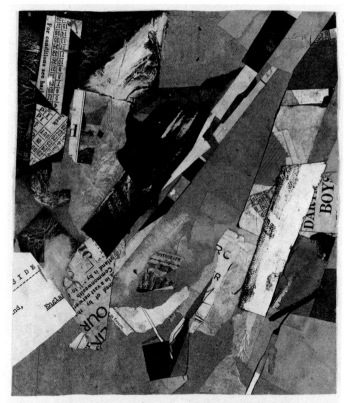

47 12
very complicated

Kurt
Schwitters 47

275 47.12 *very complicated*, 1947 9⅝″ × 8¼″

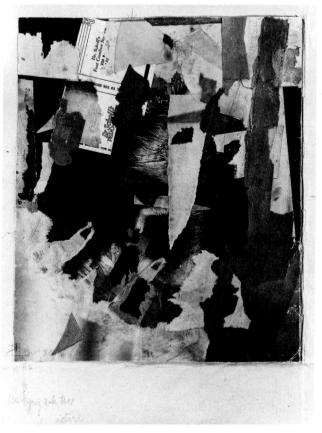

276 c 63. *old picture*, 1946

277 c 35. *paper clouds*, 1946

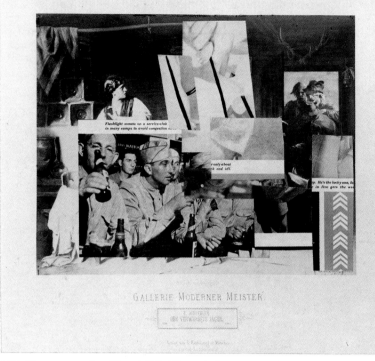

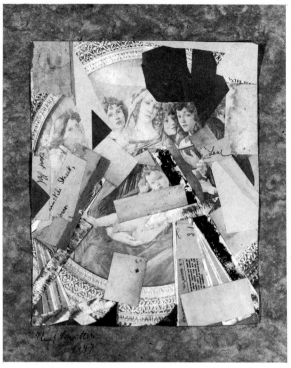

278 (*Der verwundete Jäger*) (*The Wounded Hunter*), 1942

279 (*with Madonna and Angels*), 1947

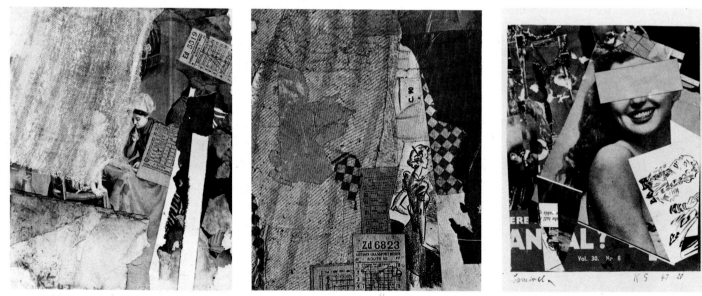

280 Merz 42 (*Like an Old Master*), 1942

10½" × 8½"

281 *Ladygirl*, 1947 6¾" × 5⅞"

282 47,20. *Carnival*, c. 80, 1947

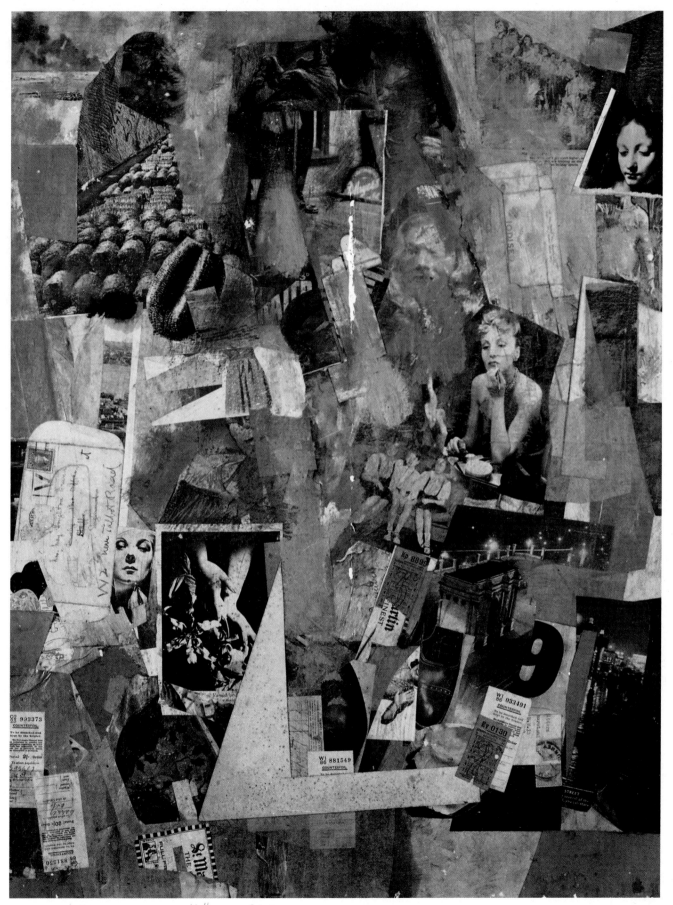

283 (*Counterfoil*), c. 1942–43 31½" x 23¾"

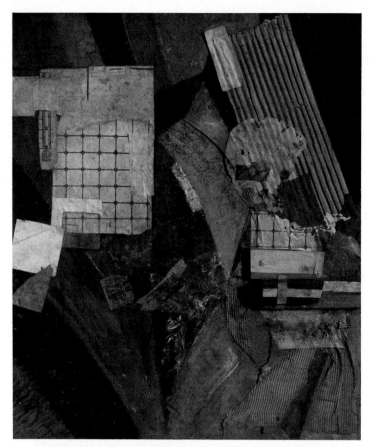

284 *In the Kitchen, c.* 1945–47 24″ × 19″

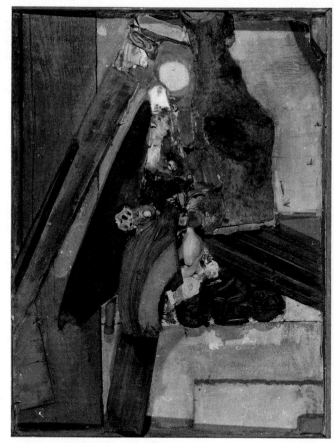

285 *As You Like It,* 1942–43

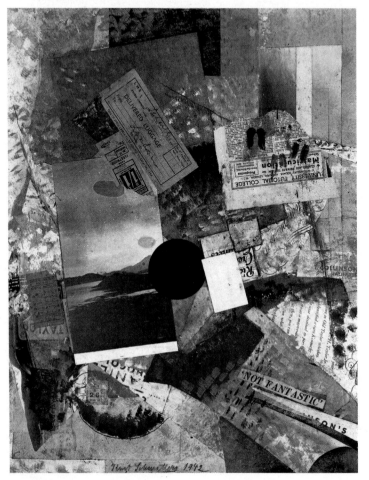

286 *Aerated VIII,* 1942
19½″ × 15½″

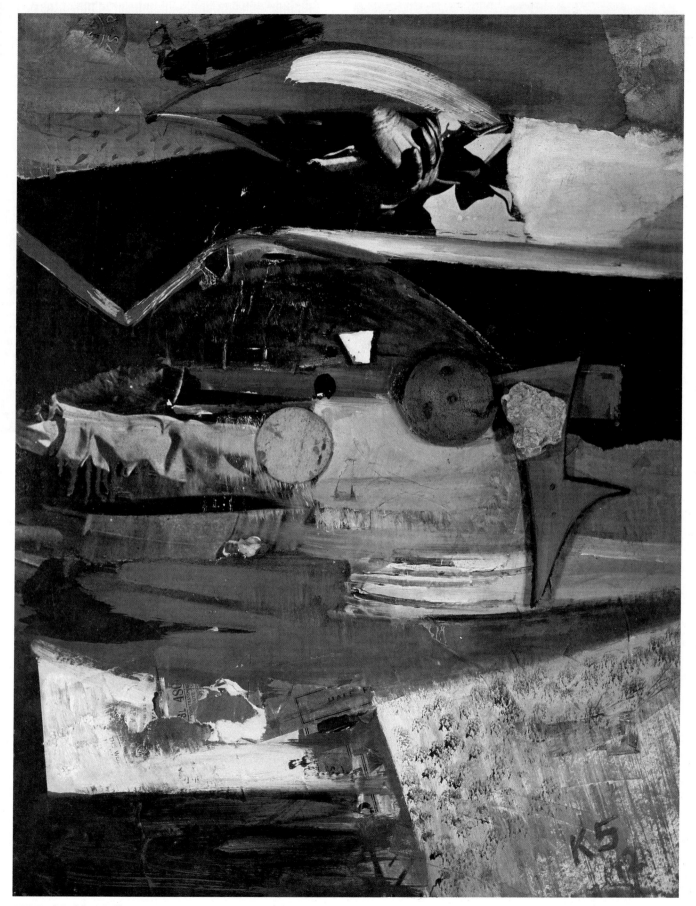

287 *Red-Rubber-Ball Picture*, 1942

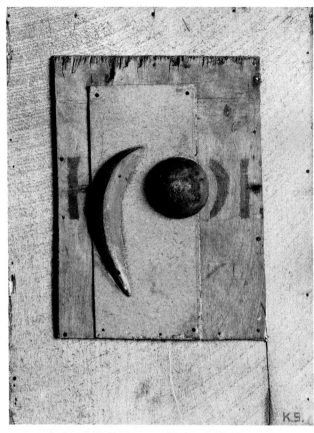

288 (*Relief with Half-Moon and Sphere*), 1944

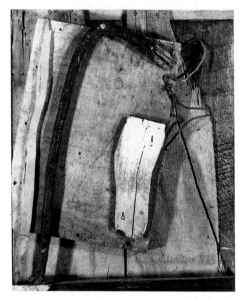

289 (*Pink and Yellow Merz Picture*), 1943

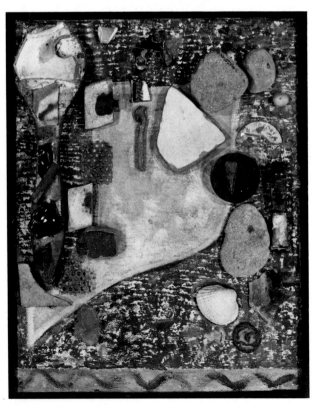

290 (*Small Merz Picture of Many Parts*), 1945–46

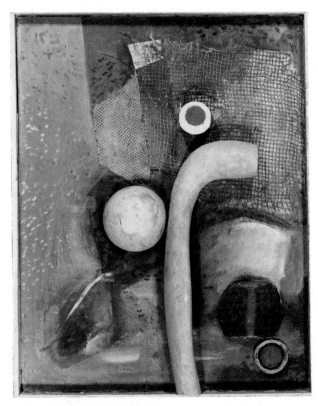

291 *Protected with yellow artificial bone*, 1941–45–47

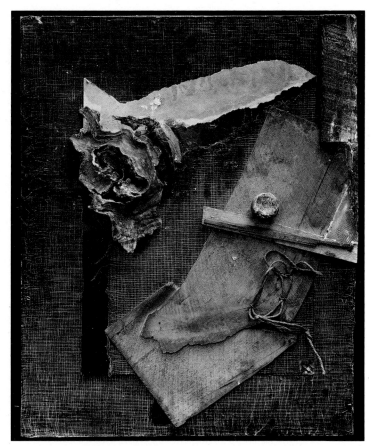

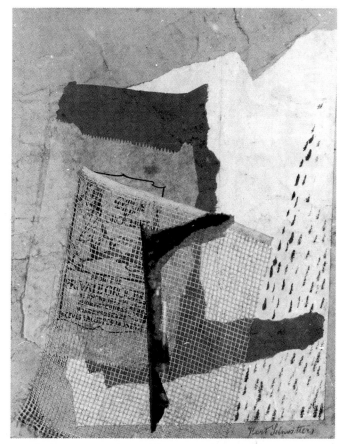

292 *Wood on Black, c.* 1943–45

293 *(White, Beige, Brown),* 1942 *16½" × 12⅞"*

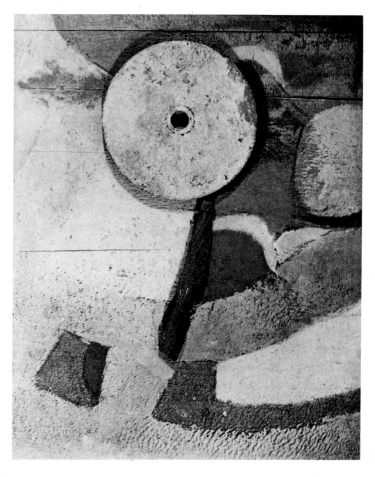

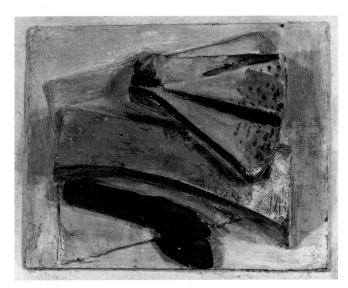

295 *Beautiful Still-Life, c.* 1944

294 *C72,* 1946

296 *Portrait of Harry Bickerstaff*, 1946

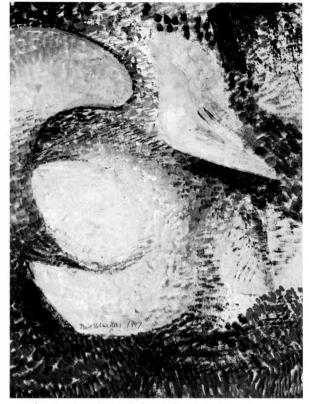

297 *Dotty Picture*, 1947

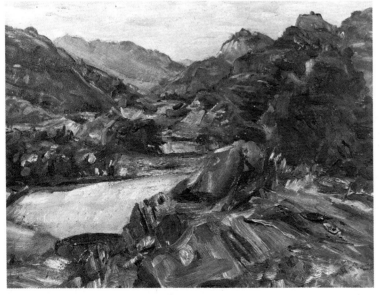

298 Untitled, 1945

299 *Small Flower Picture*, 1941

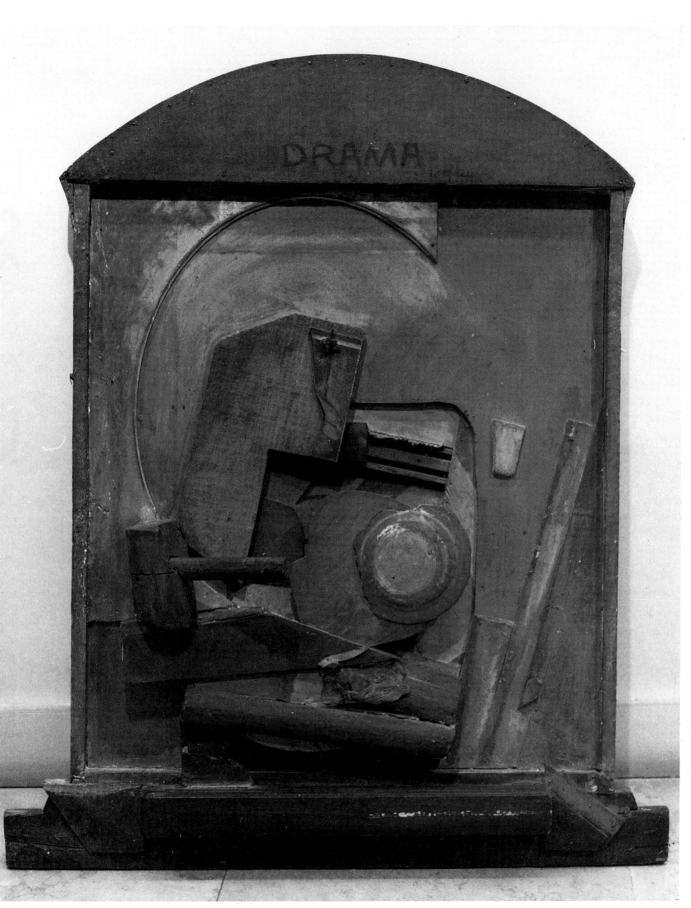

300 *Drama*, 1944

301 (*Cathedral*), *c.* 1941–42

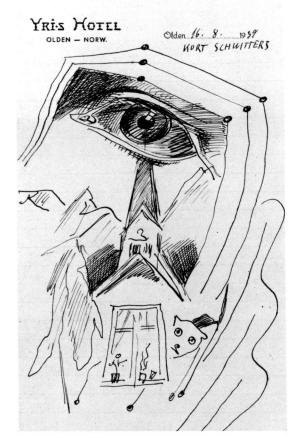

302 (*Yri's Hotel*), 1939

303 *Fant* (*Devil*), 1944

304 Untitled, *c.* 1943–45

305 *Red Wire Sculpture, c.* 1944

306 *Small Twisted Sculpture,*
1937–38

307 *Little Dog, c.* 1943–44

308 *The All-Embracing Sculpture,*
c. 1943–45

309 *Elegant Movement, c.* 1943–45

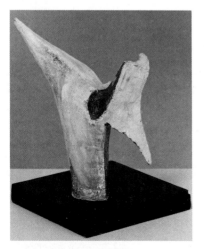

310 Untitled, *c.* 1945–47

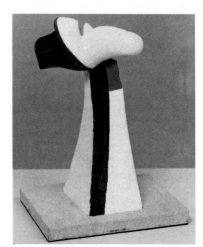

311 *Lofty, c.* 1945–47

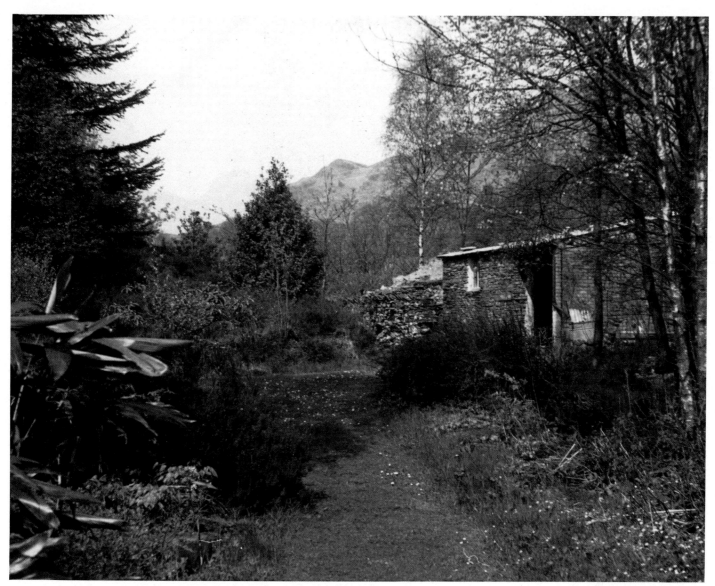

312 Exterior view of the Elterwater Merzbarn, 1947

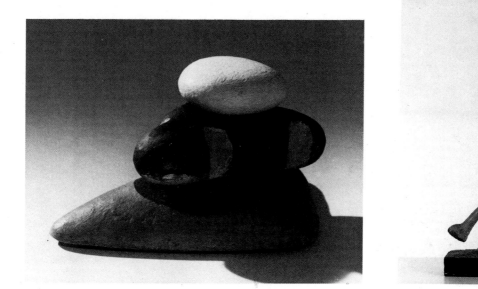

313 *Pebble Sculpture, c.* 1946–47

314 *Exhausted Dancer,* 1943

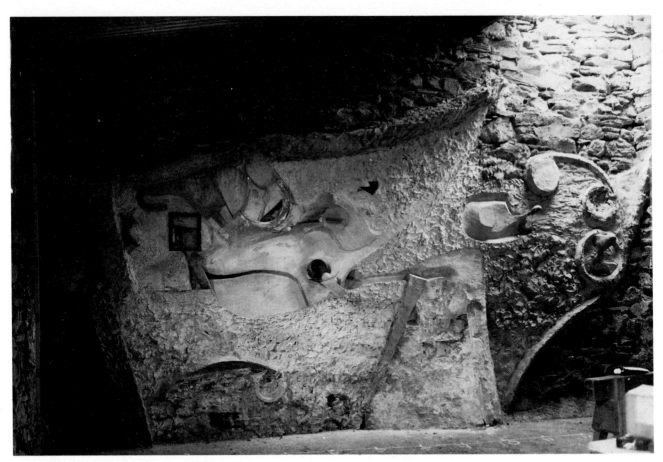

315 Elterwater Merzbarn: the relief, 1947

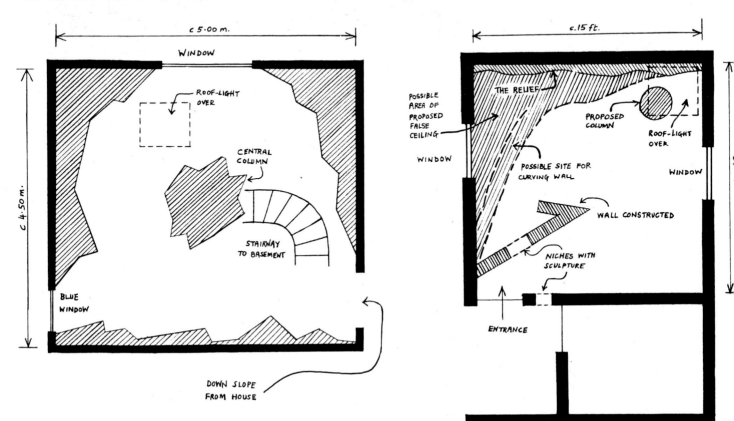

316 Plan of Lysaker *Merzbau*, 1937–40. Shaded areas give an approximate indication of the extent of the sculptural plaster elements

317 Plan of the Elterwater Merzbarn, 1947, showing constructed and proposed elements

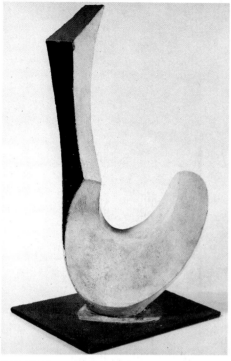

318 *Chicken and Egg, c.* 1946

320 Elterwater Merzbarn: the relief (side view), 1947

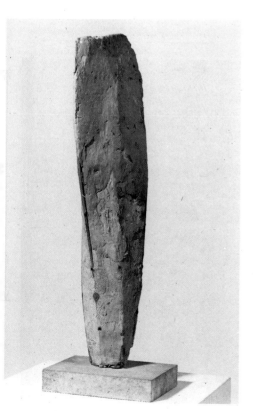

319 Untitled, 1947. From the Elterwater
Merzbarn

321 Schwitters in London, 1944

322 Schwitters in London, 1944

323 At Cylinders on Schwitters' 60th birthday, June 20, 1947, with Bill Pierce and Edith Thomas. In Schwitters' pocket is the fellowship award letter from The Museum of Modern Art

NOTES

SELECTED BIBLIOGRAPHY

LIST OF ILLUSTRATIONS

INDEX

NOTES

Works referred to frequently are given in abbreviated form according to the system used in the Selected Bibliography. For the convenience of students, references to statements by Schwitters give not only the contemporary published source but also (in parentheses) details of republication in the five-volume collected edition of Schwitters' writings (*LW*–1, etc.), unless the statement in question does not appear there. If no page reference is given after the date of a statement by Schwitters, this indicates that the statement was not published by him but is taken from the collected writings.

1 PROLOGUE: SCHWITTERS BEFORE MERZ
pp. 12–28

1 "Daten aus meinem Leben" 1926 (*LW*–5, p. 241).
2 See Steinitz 1968, p. 25.
3 Autobiographical statement: Rasch 1930, pp. 88–89 (*LW*–5, p. 335).
4 See note 1, above.
5 See note 3, above.
6 See note 1, above.
7 "Katalog" 1927, pp. 99–100 (*LW*–5, pp. 252–253).
8 E.g., he told his son: "No man can create from his fantasy alone. Sooner or later it will run dry on him, and only by the constant study of nature will he be able to replenish it and keep it fresh." (London 1963, p. 3.) See also note 24, below.
9 "Das Ziel meiner Merzkunst" 1938 (*LW*–5, p. 365) and "Merz" 1920, p. 5 (*LW*–5, p. 76).
10 "Merz" 1920, p. 4 (*LW*–5, p. 75).
11 Ibid., pp. 3–5 (*LW*–5, pp. 74–77).
12 Ibid., p. 3 (*LW*–5, p. 74*).
13 For Schwitters' early writings on abstraction, most of which have been dated to 1910, see *LW*–5, pp. 26–37. None was published, and not all their dates can be confirmed. They are interesting in revealing a theoretical interest in the issues of abstraction but are unrelated to his own later writings on this subject as well as to the contemporary student paintings. Schwitters' professors at Dresden were Carl Bantzer (portraiture), Gotthard Kühl (genre painting) and Emmanuel Hegenbarth (animal painting and color theory). The student portraits are more freely painted than the still-lifes, which is probably due to Bantzer's influence, for Schwitters told many of his friends that his admiration of Dutch painting, and especially of Frans Hals, dated to his years at Dresden under Bantzer. A *malerisch* or painterly handling is important in Schwitters' early work, and reappears from time to time with other elements in the assemblages (and becomes particularly noticeable in his late work). In general, however, Schwitters' training was aimed at developing a meticulous draftsmanlike method, in which he never excelled. Nevertheless, he did keep some of these paintings and even exhibited them on occasion together with his abstractions and collages. His second one-man show, at the Galerie Goltz, Munich, in 1920–21, included *Stilleben mit Abendmahleskelch* (*Still-life with Chalice*) of 1909, which was also used to illustrate the 1921 *Der Ararat* article (note 10, above); afterwards a postcard of it was used in a collage

(illus. 93). Student works dating to 1913 were shown in the traveling "Grosse Merz-Ausstellung," commemorated by the "Katalog" issue of *Merz* in 1927. These also are timid works—which is surprising since Schwitters' classmate at Dresden, George Grosz, was already seeking out advanced art. Grosz was at Dresden from 1909 to 1911 and later wrote that he had known Schwitters there (letter to Willi Heymann, Dec. 13, 1948, in *George Grosz. Briefe, 1913–1959*, ed. Herbert Knust [Reinbek bei Hamburg, 1979], p. 420), but there is no record of contact between the two. (Nor is there any record of contact then between Schwitters and Otto Dix, another fellow-student at Dresden and later a friend.) However, Grosz confirms that the Dresden professors were hostile to modernism (George Grosz, *An Autobiography* [translation of *Ein kleines Ja und ein Grosses Nein*, 1946] [New York, 1983] pp. 46–64). While at Dresden, Schwitters apparently applied for admission to the academy in Berlin, but was rejected as ungifted (*Sturmbilderbuch* 1920), p. 1 [*LW*–5, p. 83]).
14 Schwitters had left the Dresden Kunstakademie at the beginning of the war and returned to Hannover. A year later, on Oct. 5, 1915, he married Helma Fischer, to whom he had been engaged since 1908. Schmalenbach 1967, p. 30, says that the six-month trip to Opherdicke took place in 1915–16, but the dates of the Opherdicke paintings suggest that it must have been in the following winter. Schwitters was certainly back in Hannover by Mar. 12, 1917, for he began his military service then, and obtained his release on June 19. (Biographical information from *Sturmbilderbuch* 1920, p. 1 [*LW*–5, p. 83].)
15 "Merz" 1920, p. 4 (*LW*–5, p. 76).
16 Of Schwitters' known works of this period, only two or three reveal anything resembling conventional perspectival drawing. For typical frontal compositions: Schmalenbach 1967, illus. 2–5.
17 See note 15, above.
18 Ibid.
19 See Willett 1970, p. 77 ff. and Donald Gordon, "On the Origin of the Word 'Expressionism'," *Warburg and Courtauld Institute Journal*, vol. 29 (1966), pp. 371–373.
20 For Hannover as an artistic center, see especially Berlin-Hannover 1977, Cauman 1958, Rischbieter 1962, Schmied 1967.
21 Modersohn-Becker enjoyed an important reputation in Hannover at this time: the large Kestner exhibition of 1917 was accompanied by publication of her letters and diaries by this same society (*Eine Künstlerin, Paula Modersohn-Becker, Briefe und Tagebuchblätter*, 1917). Her work was also represented in the local Garvens and Bahlsen collections. *Trauernde* is illustrated in Schmalenbach 1967, illus. 6.
22 Relevant Kestner exhibitions include: Nolde, Jan. 6–Feb. 6, 1918; Macke (with Heinrich Nauen), Apr. 10–May 12, 1918; César Klein and Ludwig Meidner, July 28–Aug. 27, 1918; "Junge Berliner Kunst," Dec. 8, 1918–Jan. 12, 1919; Heckel, Jan. 15– Feb. 25, 1919; Klee and Feininger, Nov. 30, 1919–Jan. 1, 1920. On Feb. 9, 1918, Wilhelm Worringer lectured to the society on "Anmerkungen zur neuen Kunst."
23 *Briefe*, p. 20. Schwitters presumably had previous written contact with Walden in order to arrange for inclusion of his

works in the June 1918 Sturm exhibition. Schwitters' name first appears in Walden's visitors' book on June 27, 1918, and at the end of that month, the planned Sturm exhibition took place (with also works by Albert Bloch, Emmy Klinker and Elisabeth Niemann). For this and other Sturm exhibitions mentioned below: Walden and Schreyer 1954, pp. 257–266. For the Sturm group generally, see also; *Der Sturm* (Zurich: Kunstgewerbemuseum, 1955); *Der Sturm. Herwarth Walden und die Europäische Avantgarde* (Berlin: Nationalgalerie, 1961); Georg Muche, *Blickpunkt. Sturm, Dada, Bauhaus, Gegenwart* (Munich 1961); Brühl 1983.

24 Letter to Raoul Hausmann, Dec. 9, 1946. Reichardt 1962, p. 15.

25 Given Schwitters' interest in new art in 1917, it would be likely that he had seen Kandinsky's *Über das Geistige in der Kunst* (Munich, 1912), with its three-part division of work into *Impressionen, Improvisationen,* and *Kompositionen.* In Schwitters' *Der Ararat* article (note 10, above), he referred to his early landscapes as being *Impressionismus.* His *Expressionen* and *Abstraktionen,* and his explanations of them in this article, roughly approximate to Kandinsky's division between the expression of an inner character and the precise pictorial control of such expression. Kandinsky, of course, was well represented in Sturm exhibitions. He exhibited there in Sept. 1916 and July-Aug. 1918, as well as being represented in the important group show, "Expressionisten, Futuristen, Kubisten," of July 1916, which formed the basis of Walden's book, *Einblick in Kunst. Expressionismus, Futurismus, Kubismus* (Berlin, 1917), in which his work was illustrated (pp. 69–79). His work was also represented in the Garvens collection in Hannover.

26 *Die Liebe* is illustrated in Schmalenbach 1967, fig. 14. Marc was also shown in Walden's exhibition "Expressionisten, Futuristen, Kubisten" and his work illustrated in the subsequent book (Walden 1917, pp. 45–59). There was also a large memorial exhibition at the Sturm gallery in Nov. 1916.

27 See, for example, Schwitters' statement to this effect in "Katalog" 1927, p. 99 (*LW–5,* p. 252).

28 Ibid.

29 "Merz" 1920, p. 5 (*LW–5,* p. 76).

30 Ibid. (*LW–5,* p. 77).

31 See note 8, above.

32 "Merz" 1920, p. 3 (*LW–5,* p. 74).

33 *Sturmbilderbuch* 1920, p. 1 (*LW–5,* p. 83).

34 "Merz" 1920, p. 3 (*LW–5,* p. 74).

35 Ibid., p. 9 (*LW–1,* p. 32), translated after Ralph Manheim in Motherwell 1951, p. 65.

36 Hannah Arendt, *The Human Condition* (Chicago and London, 1958), p. 169.

37 *LW–1,* p. 36, translated after Watts, p. 85. *LW–1* dates this poem 1914–18; however, it seems to belong with works of 1917–19. In the catalog of June 1918 Der Sturm exhibition, Schwitters retitled his first *Abstraktion* painting *Erhabenheit.*

38 *Hochgebirgsfriedhof* is dated simply 1919 and cannot be proved to predate the first *Merzbilder,* which date to the Spring of 1919 (see p. 49). Stylistically, however, it obviously precedes them. It was exhibited as cat. 36 at the Kunstverein, Jena, May 11–June 15, 1919, along with *Abstraktionen,* and may well have been the work described as *Hochgebirge* (cat. 60) in Schwitters' January 1919 Der Sturm exhibition, a work shown together with 10 *Abstraktionen.*

39 In the Hannoversche Sezession exhibition, Feb. 10–Mar. 10, 1918, Schwitters exhibited 5 works (cats. 131–135), among them *Abstraktion I (Der verwunschene Garten)* and *Abstraktion II (Die Gewalten).* In his June 1918 Der Sturm exhibition he showed *Abstraktionen* 1–14 plus 5 other works (cats. 51–69); from this exhibition onwards, he used arabic numerals before the titles of these works. In his Jan. 1919 Der Sturm exhibition, he showed *Abstraktionen* 15–24 plus *Hochgebirge* (cats. 50–60), which suggests that this group was made after the June 1918 exhibition. In the Kunstverein Jena exhibition of May 11–June 15, 1919, Schwitters showed *Hochgebirgsfriedhof* plus *Abstraktionen* 28, 30, 31, 33 and eight drawings, also called *Abstraktionen* (cats. 36–48). The last recorded *Abstraktion* is 39, exhibited at Der Sturm in February 1925. Schwitters' numbers for the *Abstraktionen* mentioned in the text are: *Die Gewalten,* 2; *Raumkristalle,* 7; *Bindeschlips,* 9; *Schlafender Kristall,* 16; *Entschleierung,* 19; *Eisenbetonstimmung,* 31. The dates of these works can be extrapolated from their date of exhibition.

40 "Katalog" 1927, p. 99 (*LW–5,* p. 252). For example, *Raumkristalle* is in a sharp, angular style and *Die Eisenbetonstimmung* is rendered by means of a dense textured surface with linear reinforcements (See Schmalenbach 1967, figs. 15, 16).

41 *Schlafender Kristall* is illustrated by Schmalenbach 1967, fig. 18.

42 Walden's *Einblick in Kunst* (Berlin, 1917) provides a fascinating view of his tastes, but more as an impresario than as a critic. Futurism and Cubism are viewed as preludes to Expressionism; Gleizes and Metzinger (for whom Walden was German dealer) are seen as the principal Cubists, and not Picasso "as is mistakenly supposed" (p. 18). Although Picasso and Braque were in fact originally less well known than the other Cubists, this does not explain Walden's statement, for this was no longer true in 1917. In the 1918 *Der Sturm: Eine Einführung,* a pamphlet presumably written (and certainly sanctioned) by Walden, is similarly stated: "The most significant representatives of Cubism are the Frenchmen Metzinger and Gleizes, Léger and Delaunay" (p. 4). Walden had in fact exhibited both Picasso and Braque, in 1912 and 1913, and in 1913 published Apollinaire's "Die moderne Malerei" in *Der Sturm* (vol. 3, no. 148–149 [Feb. 1913], p. 272), which spoke of their invention of collage. In any case, Walden's exhibition schedules show him to have preferred the angularized Cubism of Delaunay, Feininger and the early Chagall above all other versions of this style.

43 For Delaunay and Germany, see John Golding, *Cubism. A History and an Analysis, 1907–1914,* 2nd ed. (London and New York, 1968), pp. 44–46.

44 In Apr. 1912, the Futurists' Bernheim-Jeune (Paris) exhibition was transferred to the Sturm gallery, and Walden persuaded one of his backers, Dr. Borchardt, to buy 24 out of the 29 paintings and circulate them further in Germany. In 1912 and 1913, Walden published items on Futurism in 16 issues of *Der Sturm.*

45 Quoted by Willett 1970, p. 80.

46 Lissitzky and Arp 1925, p. VIII.

47 Samuel and Thomas 1939, p. 11.

48 The highest known number in this series is Z122. *Die Versuchung des heiligen Antonius* of 1918 (illus. 15). However, not all of these works have a "Z" prefix and some are not numbered.

49 E.g., Z100 *Hochgebirge* and Z119 *Eisgebirge* (New York 1965, cats. 12, 13).

50 Meidner exhibited at the Kestner-Gesellschaft in 1918 (see above n. 25), and his visionary and often apocalyptic city views seem to have been a strong influence on Schwitters' city drawings.

However, since the angularized city was such a popular Expressionist subject, it is difficult to be sure which artist or artists affected Schwitters most. For example, a drawing, *Ein Regentag,* by one Arnold Topp, reproduced in Walden 1917, p. 145, is also close to Schwitters' work. Although the Brücke group was not represented by Walden, it is almost inconceivable that Schwitters was ignorant of Kirchner's famous city paintings. He must have known of Feininger's, for Feininger had a one-man exhibition at the Sturm gallery in Sept. 1917.

51 In 1918, Walden published his *Umberto Boccioni* (Berlin: Der Sturm, 1918).

52 See note 39, above.

53 *Sturmbilderbuch* 1920, p. 2 (*LW–5,* p. 84).

54 *Das Kestnerbuch,* ed. Paul Erich Küppers (Hannover, 1919), pl. XII. The work is especially reminiscent of Balla's *Mercurio passa davanti al Sole* series of paintings of 1914, though it could have been influenced by any number of Futurist prototypes.

55 *Der Zweemann,* vol. 1, no. 1 (Nov. 1919), opp. p. 10.

56 "Merz" 1920, p. 5 (*LW–5,* p. 76).

57 Ibid., (*LW–5,* p. 77).

58 Rasch 1930, pp. 88–89 (*LW–5,* p. 335).

59 Ibid.

60 *Sturmbilderbuch* 1920, p. 1 (*LW–5,* p. 83).

2 THE KASPAR DAVID FRIEDRICH OF THE DADAIST REVOLUTION pp. 30–48

1 In addition to borrowing paintings from Walden, the Galerie Dada produced a special Sturm-Soirée on Apr. 14, 1917. Hugo Ball recalls that it created opposition because of Walden's patriotic German stance. (Exactly the same complaint was made of Walden in Berlin and helped to keep Schwitters out of Berlin Dada because of his Sturm affiliation.) See Hugo Ball, *Flight out of Time,* ed. John Elderfield (New York, 1974), entry for Apr. 14, 1917; and pp. xiii–xlvi for Expressionist elements in Zurich Dada.

2 See *Société Anonyme* 1984, pp. 4, 7.

3 "Kunst in Berlin," *Frankfurter Zeitung,* Nov. 25, 1920. Schwitters, who was often extremely sensitive to adverse criticism, replied in kind in "TRAN Nummer 16. Das Leben auf blindem Fusse," *Der Sturm,* vol. 11, no. 11–12 (Dec. 1920), pp. 152–153 (*LW–5,* pp. 72–73).

4 *Sturmbilderbuch* 1920, p. 2 (*LW–5,* p. 84).

5 "Merz" 1920, p. 7 (*LW–5,* p. 79).

6 Kandinsky and Marc 1912, p. 190.

7 Ibid., p. 112.

8 Franz Marc's phrase: ibid., p. 59.

9 Quoted by Lankheit: ibid., p. 37, to whose discussion of Blaue Reiter ideas this paragraph is indebted.

10 "Merz" 1920, p. 5 (*LW–5,* p. 76), and for the following quotation.

11 Kandinsky and Marc, 1912, p. 147.

12 Ibid., p. 173.

13 "Merz" 1920, p. 6 (*LW–5,* p. 79).

14 See Franciscono 1971, pp. 119–121.

15 *Sturmbilderbuch* 1920, p. 2 (*LW–5,* p. 84).

16 At first sight this seems surprising, given not only the Zurich Dadaists' Expressionist connections (see above, note 1), but the fact that Huelsenbeck, Hausmann, and most of the other Berliners had earlier been associated with the *Die Aktion* circle.

However, Huelsenbeck, the principal ideological spokesman for the Berlin Dadaists, had come to believe that, given the social conditions of the time, Expressionism was an escape from life. His *Erstes Dadaistisches Manifest* of April 1918 (Huelsenbeck 1918) was directly anti-Expressionist, while the contemporaneous programme, *Was ist der Dadaismus und was will er in Deutschland?* (reprinted in Huelsenbeck 1920–1) attacks Kurt Hiller, the leader of the "Activists," as does *En avant Dada* (Huelsenbeck 1920–1), which also attacks the Expressionist poets Däubler and Edschmid. Similar anti-Expressionist sentiments are articulated in Huelsenbeck's "Die Dadaistische Bewegung," *Die Neue Rundschau,* vol. 1, no. 31 (1920), pp. 972–979 (translated in Raabe 1974, pp. 352–354). For the Dada-Expressionist quarrel, of crucial importance to Schwitters' relation to Dada, see Middleton 1961 and Elderfield 1970.

17 Hausmann 1958, p. 25. The reference is to Walden's essay "Das hohe Lied des Preussentums," published in the Jan. 1916 issue of *Der Sturm,* which praised the sobriety, order, and military pride of Prussia. See Sheppard 1982, pp. 40, 80.

18 Willett 1978, p. 29, suggests that the foundation of Club Dada was in response to the October Revolution of 1917. There was certainly a lull in Huelsenbeck's activities between his arrival in Berlin and the founding of Club Dada. Moreover, his attitude to Expressionism changed from May 1917, when he published an Expressionist-style statement in *Neue Jugend,* to his attacks on Expressionism in 1918 and thereafter (see note 16, above). This would seem to reflect the politicization of his artistic views.

19 The lecture is printed in Huelsenbeck 1920–2, pp. 104–108.

20 See note 16, above.

21 See p. 72.

22 See p. 47.

23 Hausmann 1958, pp. 109–110.

24 Rasch 1930, pp. 88–89 (*LW–5,* p. 235).

25 "Katalog" 1927, p. 99 (*LW–5,* p. 252).

26 For the constitution of the Novembergruppe: *Kunst der Zeit,* vol. 3, no. 1–3, 1928 (special number: "Zehn Jahre Novembergruppe"); Helga Kliemann, *Die Novembergruppe* (West Berlin, 1969). Among the Dadaists, Richter, Eggeling, Hoech, and Hausmann were members. According to Hausmann 1958, p. 46, Grosz, Heartfield, Hoech, and he himself exhibited with the Novembergruppe in 1919 and 1920.

27 The last public Dada meeting of 1918 took place in June. After the summer (when several of the Dadaists were away from Berlin), there was little activity until the early Spring of 1919. Baader's interruption of a sermon at Berlin Cathedral on Nov. 17, 1918, may be viewed as an immediate hostile reaction to the proclamation of the new republic nine days earlier, but if so it was only an individualist act. It was not until street fighting broke out in Berlin that the Dadaists as a group recommenced their activities. This external stimulus seems to have revived them. On Feb. 6, 1919, the leaflet *Dadaisten gegen Weimar* was published, which initiated the politicized phase of the movement.

28 Huelsenbeck 1961, p. 56.

29 Hausmann 1958, p. 110.

30 Huelsenbeck 1918, p. 40.

31 *Der Sturm,* vol. 10, no. 5 (Aug. 1919), p. 72 (*LW–1,* pp. 58–59). See *LW–1,* pp. 291–294, and Schmalenbach 1967, pp. 41–42, on the multiple publications and extraordinary success of the poem. Although "An Anna Blume" did not appear in *Der Sturm* until Aug. 1919, it must have had some circulation prior to that date, for Christof Spengemann referred to it in his article on

Schwitters, "Der Künstler," which accompanied Schwitters' "Die Merzmalerei" in *Der Sturm*, vol. 10, no. 4 (July 1919), p. 61. It is uncertain exactly when in 1919 Paul Steegemann published the anthology *Anna Blume*, but it was presumably in the late Autumn, for the earliest published reactions to it seem to date from Dec. 1919. See Spengemann 1920–1 and 1920–2.

32 *LW*–1, pp. 58–59; Themerson 1958, p. 25.

33 Schmalenbach 1967, p. 205.

34 Huelsenbeck 1961, p. 58; Huelsenbeck 1974, p. 64.

35 See Last 1973, pp. 48–51, to whose interpretation of "An Anna Blume" much of this paragraph is indebted.

36 See Sheppard 1984, p. 50.

37 *Anna Blume* 1919.

38 Spengemann 1920–1; Spengemann 1920–2 (reprinted in *Almanach* 1982, pp. 99–120).

39 See Schmalenbach 1967, pp. 44–46.

40 Huelsenbeck 1961, p. 58. Huelsenbeck does not himself give a date for his quarrel with Schwitters, but merely states that he visited Hannover "for talks with Paul Steegemann . . . regarding my book *En avant Dada*" and that "it was shortly before Christmas" (ibid., p. 58). *En avant Dada* was published by Steegemann in 1920, which gives Dec. 1919 as the date of the quarrel. See also Huelsenbeck 1974, p. 66, for another account of this affair.

41 Huelsenbeck 1961, p. 58.

42 Ibid., p. 58.

43 Letter from Huelsenbeck to Tzara, Jan. 12, 1920. Sheppard 1982, pp. 39, 81.

44 Letter from Huelsenbeck to Tzara, Aug. 9, 1919, Sheppard 1982, p. 17. Only one issue of *Der Zeltweg* appeared (Nov. 1919). It included reproductions of Schwitters' assemblages *Anna Blume hat ein Vogel* (also known as *Das Kreuz des Erlösers*) and *Konstruktion für edle Frauen* (pp. 6, 28) and the poem "Welt voll Irrsinn" (pp. 19–20).

45 Huelsenbeck 1920–2, p. 9.

46 Ibid., p. 96.

47 Richter 1965, p. 145. Schwitters, however, maintained friendly relations with Hausmann and through him with Hannah Hoech. He certainly must have visited the 1920 Berlin Fair. A photograph of that exhibition shows among the visitors a figure seen from the back who strongly resembles Schwitters (*Tendenzen* 1977, p. 3/71).

48 *Die Kathedrale. 8 Lithos von Kurt Schwitters* (Hannover 1920). Schwitters wrote later, however, that this did not actually mean that he was against Dada, only that both Dada and anti-Dada currents exist in the world: "Merz" 1920, p. 6 (*LW*–5, p. 78).

49 "Merz" 1920, p. 6 (*LW*–5, p. 78).

50 Ibid., pp. 5–6 (*LW*–5, pp. 77–78).

51 Hausmann 1971, p. 165.

52 "Manifest Proletkunst" 1923, p. 24 (*LW*–5, p. 143).

53 See note 36, above.

54 Letter of Mar. 29, 1947, in Reichardt 1962, pp. 15, 17.

55 There are poems dedicated to Rudolf Bauer, Rudolf Blümner, Johannes Molzahn and Herwarth and Nell Walden, among others. See *LW*–1, pp. 66–69.

56 The four books of this period are: *Anna Blume* 1919; *Anna Blume* 1922; *Die Blume Anna* 1922; *Memoiren* 1922.

57 Schmalenbach 1967, p. 117.

58 *Anna Blume* 1919, p. 8 (*LW*–1, p. 41). The translation is from Watts, p. 71.

59 "Holland Dada" 1923, p. 11 (*LW*–5, p. 134).

60 "Merz" 1920, pp. 5, 7 (*LW*–5, pp. 77, 80).

61 See note 59, above.

62 "Merz" 1920, pp. 6–7 (*LW*–5, p. 79).

63 The highest known number in this series is *Aq. 37. Industriegebiet* of 1920 (Sprengel Museum Hannover). Numbers 1–33 are dated 1919, with the exception of *Aq. 24*, which is dated 1920 in Schwitters' hand.

64 "Merz" 1920, p. 6 (*LW*–5, p. 78).

65 Schwitters was receiving Dada periodicals from Zurich by early 1919 (see p. 47) and probably knew of Picabia's work from them. In "Merz" 1920, p. 6 (*LW*–5, p. 78), Schwitters wrote of his admiration of the work of Picabia and Ribemont-Dessaignes. He did not meet Max Ernst until the spring of 1920, but was familiar with the 1919 Cologne Dada publication, *Bulletin D*, which included some similarly whimsical illustrations of figures and machine forms. Also, on Dec. 31, 1919, Ernst wrote to Tzara saying that he had sent Schwitters photographs of his, Ernst's, work (Werner Spies, *Max Ernst, Collagen, Inventar und Widerspruch* [Cologne, 1974], p. 236). The photographs were probably for the issue of *Der Zweemann* that Schwitters helped organize (see p. 40).

66 Grosz's Futurist-influenced style of *c.* 1917–19, with figures and buildings scattered across the whole picture area in angular arrangements, directly prefigures Schwitters' drawings. It is probable that Schwitters knew of Grosz's two 1917 albums, *Erste George Grosz Mappe* (Berlin, Spring 1917) and *Kleine Grosz Mappe* (Berlin-Halensee, Autumn 1917), if not Grosz's paintings as well.

67 "Merz" 1920, p. 5 (*LW*–5, p. 77).

68 *Anna Blume* 1919, p. 29, (*LW*–1, p. 70). Chagall's painting, *Der Trinker*, was in Herwarth Walden's collection.

69 See p. 188.

70 Schwitters did not number these works, or give them any separate generic title, as with his other series of works. It is therefore impossible to guess at how many were produced. The groupings given here are made on stylistic grounds. One was first published in *Der Sturm*, vol. 11, no. 3 (June 1920), p. 43, advertising Schwitters' forthcoming *Sturmbilderbuch* (containing a large selection of these works), which has been dated to 1921 but which almost certainly appeared in August 1920 (cf. the advertisement in *Der Sturm*, vol. 11, no. 6 [Sept. 1920], p. 96).

71 The cover of Hausmann's *Material der Malerei, Plastik, Architektur* (Berlin 1918) includes illogically disposed typography (see illus. 104). His first poster-poems, dating to 1918, are more conventionally laid out, however. In *Raoul Hausmann* (Malmö: Kunsthalle, 1981), p. 41, is illustrated a typographically more advanced drawing for a poster-poem, dated May 25, 1918, but this does not seem to have been executed. In general, a specific Berlin Dada typographical style was not in common use until 1919.

72 Letter of May 24, 1919. Schmalenbach 1967, p. 44.

73 Tristan Tzara, ed. *Dada 4–5. Anthologie Dada*, Zurich (May 15, 1919); Francis Picabia, ed. *391*, no. 8, Zurich, Feb. 1919.

74 The majority of articles on Futurism in *Der Sturm* dealt with the literary side of that movement. Moreover, at the very time of making the stamp-drawings, Schwitters may have seen Marinetti's *Les mots en liberté futuristes* (Milan, 1919), which included classic examples of Futurist typography. Apollinaire's *calligrammes* had been appearing since 1914 in avant-garde journals like *Les Soirées de Paris*, but were not collected in a single

volume until *Calligrammes* of 1918. Schwitters probably knew of this work through Walden, who had met Apollinaire in 1913 on the occasion of Delaunay's exhibition at the Sturm gallery, and had published Apollinaire in *Der Sturm*.

75 Although the Dadaists were notoriously unwilling to acknowledge their sources, Huelsenbeck did admit familiarity with Morgenstern's work (Huelsenbeck 1974, p. 1, and "Dada als Literatur" in the catalog *Dada*, Amsterdam, Stedelijk Museum, 1958), while Hausmann mentions him as a precursor of phonetic poetry (Hausmann 1958, pp. 54–55). However, Hausmann later insisted that he had forgotten about Morgenstern's work when he began his own poetic experiments (letter to the author, Nov. 15, 1970).

76 Robert Rosenblum, *Cubism and Twentieth-Century Art* (New York, 1966), p. 66.

77 "Merz" 1920, p. 7, (*LW–5*, p. 79).

3 MERZBILDER: THE ART OF ASSEMBLAGE
pp. 49–70

1 *Sturmbilderbuch* 1920, p. 2 (*LW–5*, p. 84).

2 Both the above-quoted statement and one in "Daten aus meinem Leben" 1926 (*LW–5*, p. 241) link the change to a mixed-material format to the end of 1918 and the period of the German Revolution, but they could be referring to the collages (some of which were certainly made in 1918) rather than to assemblages. A statement in Rasch 1930, pp. 88–89 (*LW–5*, p. 335), refers to nailing as well as gluing refuse in the period of the German Revolution and therefore presumably to the assemblages. Certain assemblages have been dated to 1918 (e.g. *Merzbild Rossfett* in London 1972, cat. 12; the dating is Ernst Schwitters'), though none by Schwitters himself. We remember that Hausmann dated his first meeting with Schwitters to 1918 and reported Schwitters saying he was making nailed-together pictures—but lacking corroborative evidence we may be forced to conclude that this meeting took place in early 1919 (see p. 35). Hans Richter has claimed he was shown photographs of Schwitters' work by Tzara "in early 1918" and that in these photographs "there appeared the word 'Merz'" (Richter 1965, pp. 137, 150). What Richter remembers, however, is likely the photographs that Schwitters sent to Tzara in *1919* for inclusion in the Zurich periodical *Der Zeltweg* (no. 1, Nov. 1919) or a special edition of *Zweemann* on which Schwitters was consulted but which never appeared. (See Sheppard 1982, p. 39.)

3 *Merzbild 5B. Rot-Herz-Kirche* is dated on the verso in the artist's hand: Apr. 26, 1919.

4 No checklist of this exhibition seems to exist, but we know from a contemporary letter (*Briefe*, pp. 21–22), from Schwitters' "Die Merzmalerei," and from the reviews of this exhibition that *Merzbilder* were shown (see notes 5–8, below). It seems safe to assume that the following *Merzbilder* were among those in the exhibition: *Merzbild 1B. Bild mit rotem Kreuz, Merzbild 6B. Bild "Iga-Lo," Das Merzbild, Das Arbeiterbild,* and *Das Undbild* (see illustrations accompanying Spengemann 1919 [note 7, below] and Schwitters' 1927 statement on his first *Merzbilder* [Ch. 1, note 7, above]).

5 Mehring 1919, p. 462.

6 "Der Maler Kurt Schwitters," *Das hohe Ufer*, June 1919.

7 Spengemann 1919, pp. 578–581. Reproduced are *Merzbild mit rotem Kreuz, Das Arbeiterbild* and *Merzbild "Iga Lo"* as well as *Die Sonne im Hochgebirge, Abstraktion Nr. 9, Die Eisenbetonstimmung,* and two untitled Dada watercolors.

8 "Merzmalerei" 1919, p. 61 (*LW–5*, p. 37). This article later appeared, with an additional paragraph, in *Der Zweemann*, vol. 1, no. 1 (Nov. 1919), p. 18, and in an abridged form was appended to Spengemann 1919, p. 580. It was prefaced by Spengemann's "Der Künstler: an Kurt Schwitters," which was later reprinted as the introduction of *Anna Blume* 1919.

9 The earliest of the "A" series works is *Merzbild 1A. Der Irrenarzt* (1919); the earliest of the "B" series, *Merz 1B. Bild mit rotem Kreuz* (1919), which was included in Schwitters' July 1919 Der Sturm exhibition. The highest known "A" number work in 1919 is *Merzbild 20A*, a tiny work in the Philadelphia Museum of Art; the highest "B" number that year, *Merzbild 14B—Die Dose*, also small. In 1920, two "A" numbered works are known: *Merzbild 25A. Das Sternenbild* and *Merzbild 29A. Bild mit Drehrad*, both impressive large works. Among the 1920 "B" series, the earliest known is *Mz 20B. Das Frühlingsbild*, which was exhibited at that year's Hannover Sezession exhibition in Feb.–Mar., and the last known, *Merz 31B. Strahlenwelt*. There are no known "B" works after 1920; indeed Schwitters' system was already breaking down that year, for "B" works like *Merzbild 21B. Das Haar-Nabelbild* contained some high-relief elements—and he also then instituted a "C" series with *Merzbild 1C—Das Dubelbild*. This is a very small work, and it might be surmised that after making the small late 1919 "A" and "B" works mentioned above, Schwitters instituted the "C" series for small works. *Merzbild 14C. Schwimmt* of 1921 supports this proposition, but there are no other known "C" *Merzbilder*. Apart from this "C" work of 1921, the only known numbered works of that year are three "A" series works: *Merzbild 32A. Kirschbild*, exhibited at the 1921 Hannover Sezession in March; *Merzbild 35A*, a small work; and *Merzbild 46A. Das Kegelbild*. Finally, Schwitters gave occasional works just a number prefix (e.g. *Merzbild 36. Kuba Knopf* of 1919) and gave at least two "B" pictures of 1919 a subsidiary "K" prefix (e.g. *Merzbild K2. [Merzbild 6B. Bild "Iga-Lo"]*).

Many early *Merzbilder* are known only by descriptive titles or titles derived from word-fragments they contain. Schwitters never exhibited a *Merzbild* with a number or letter prefix. It would seem therefore that the prefixes were used for personal cataloging purposes, and that the works we know only by title probably had prefixes assigned to them too. It is difficult to be sure how many *Merzbilder* were made in the years 1919–21; the highest-known numbers of the "A," "B," and "C" series combined suggest around 90, of which approximately 40 now exist or are known through photographs. Early exhibition checklists include the names of a considerable number of unlocated and unidentified works. After 1921, Schwitters' classification system was abandoned.

10 See note 8, above. This article was Schwitters' only major theoretical discussion of the *Merzbilder* until "Merz" 1920 appeared in Jan. 1921; and these two together remained his most important theoretical statements about his pictures, to be recast and enlarged upon later (particularly after 1923, with a shift in emphasis under the influence of Constructivist ideas) but not supplanted.

11 See note 9, above.

12 Letter to Margaret Miller, Dec. 11, 1946. Archives of The Museum of Modern Art, New York.

13 Spengemann 1919, p. 577.

14 "Holland Dada" 1923, p. 10 (*LW–5*, p. 134).
15 "Katalog" 1927, p. 99; "Holland Dada" 1923, p. 10; "Merz" 1920, p. 5 (*LW–5*, pp. 252, 134, 76).
16 It was purchased by the Dresden Stadtgalerie, and confiscated by the Nazis in 1937 for inclusion in the "Entartete Kunst" exhibition of that year, after which it disappeared, presumably destroyed. It should be added here that *Das Arbeiterbild* is no longer in the state that Schwitters made it. An extra wheel can be seen on it in several photographs published in the 1920s, for example in the revised edition of Walden's *Einblick in Kunst* (Berlin, 1924), p. 141.
17 Mehring 1919, p. 462.
18 The work is listed in the checklist *Sammlung Walden: Gemälde, Zeichnungen, Plastiken* (Berlin, Oct. 1919), which mentions that the collection is open to the public for four hours each day. It can also be seen hanging in Walden's apartment in a photograph reproduced in Walden's *Der Sturm, Eine Einführung* (Berlin, 1918), opp. p. 9, a photograph reprinted in several studies of Der Sturm, most recently Brühl 1983, p. 52. In Oct. 1917, there was a Chagall exhibition at Der Sturm, and in July-Aug. 1918 a Chagall-Kandinsky-Wauer exhibition.
19 See note 12, above.
20 It is part of a postscript to "Du Meiner, Ich Deiner, Wir Mir," an open letter to Martin Frehsee on the subject of "An Anna Blume" in *Der Zweemann*, vol. 1, no. 2 (Dec. 1919), pp. 20–21. The poem also appeared in the 1919 anthology *Anna Blume* (*LW–5*, p. 66). It is relevant to add here that a number of Schwitters' titles for his pictures relate to titles of his poetic compositions. Hence, for example, there is an "Arbeiterlied" of 1920 (*LW–1*, p. 80).
21 *Der Sturm*, vol. 10, no. 6 (Sept. 1919), pp. 90–91. The manifesto also served as the foreword for the 79th Der Sturm exhibition in October 1919, which included the work of Karl Herrmann and Jacoba van Heemskerck as well as Molzahn. Schwitters' introduction to his poem cites a review of this exhibition.
22 *Der Sturm*, vol. 10, no. 3 (June 1919), cover.
23 Mehring 1919, p. 462.
24 Spengemann 1919, p. 574, 576.
25 Mehring 1919, p. 462.
26 "Merz" 1920, p. 6 (*LW–5*, p. 78).
27 They were, for example, illustrated in *Soirées de Paris*, no. 18 (Nov. 1913), among them a rare work made within a traditional frame (illus. 63).
28 "Das Ziel meiner Merzkunst" 1938 (*LW–5*, p. 362).
29 See note 12, above.
30 Ibid.
31 Cf. Paul Fussell, *Abroad. British Literary Traveling Between the Wars* (New York, 1982), p. 165. The following reference to the Elector of Saxony derives from Kynaston McShine, ed., *Joseph Cornell* (New York, 1980), p. 10.
32 Carter Ratcliff in *Joseph Cornell*, pp. 58–59.
33 Cf. Dawn Ades in *Joseph Cornell*, p. 24.
34 Schwitters refers to *Valori Plastici* in "Berliner Börsenkukukunst," *Der Zweemann*, vol. 1, no. 4 (Feb. 1920), pp. 13–14 (*LW–5*, p. 51) and inscribed the name of this Italian avant-garde art journal on one of the lithographs in his 1920 portfolio *Kathedrale*. *Valori Plastici* was the first source of information on De Chirico in Germany.
35 Gertrude Stein, *The Autobiography of Alice B. Toklas* (New York, 1933), p. 102.
36 See p. 122.

37 In 1921, Puni began exhibiting at Der Sturm, and that year joined with Arp, Hausmann and Moholy-Nagy in signing the "Aufruf zur Elementaren Kunst" (see p. 123). For discussion of his remaking earlier reliefs: Rowell 1979, p. 62. The Puni relief reproduced here (illus. 69) was based on a gouache, *Suprematist Drawing 3*, in Puni's 1921 Der Sturm exhibition and illustrated in the catalog of that exhibition. (See Hermann Berninger and Jean-Albert Cartier, *Pougny: Catalogue de l'oeuvre* [Zurich, 1972], vol. 1, p. 127, and *Société Anonyme* 1984, pp. 542–544.
38 According to an old friend of Puni's, in conversation with Maurice Tuchman, Curator of The Los Angeles County Museum of Art.
39 "Merzmalerei" 1919, p. 61 (*LW–5*, p. 37).
40 Cf. Fussell, *Abroad* (note 31, above), p. 36.
41 Nill 1981–1, p. 117, n. 32.
42 See note 12, above.
43 Cf. "Die Geheimlade," *Anna Blume* 1922 (*LW–2*, p. 51).
44 "Ich und meine Ziele" 1930, pp. 113–·114 (*LW–5*, pp. 340–341).
45 Rasch 1930, pp. 88–89 and "Daten aus meinem Leben" 1926 (*LW–5*, pp. 335, 241).
46 Lach 1971, p. 14.
47 See note 45, above.
48 "Merz" 1920, p. 5 (*LW–5*, p. 77).
49 Ibid. (*LW–5*, p. 76).
50 "Holland Dada" 1923, pp. 9–10 (*LW–5*, pp. 133–134).
51 "Merz" 1920, p. 5 (*LW–5*, pp. 76–77), and for the following quotations.
52 Quoted in the catalog *Jasper Johns* (London: Whitechapel Art Gallery, 1964), p. 27.
53 "Das Ziel meiner Merzkunst" 1938 (*LW–5*, p. 365).
54 Here I am excepting figures close to the center of original Cubism (like Léger or Delaunay) or those of Schwitters' generation who only later developed their personal styles (like Hofmann). But all found that their first task, taken up also by Synthetic Cubism, was to overcome the way a Cubist grid dissolves at its edges; and all their solutions involved (to a greater or lesser degree) creating some kind of pictorial "container" for the dramatic interactions of forms or colors.
55 "Holland Dada" 1923, p. 9 (*LW–5*, p. 133).
56 "Banalitäten" 1923, p. 40 (*LW–5*, p. 148).
57 *Sturmbilderbuch* 1920, p. 2 (*LW–5*, p. 84).
58 According to Ernst Schwitters, his father was introduced to this medium by Walter Dexel and prefaced the title of each of these works with the letter *U* (for *Unterglas*). Schwitters, we know, admired Dexel's own works of this kind (Letter to Dexel, May 27, 1921, *Briefe*, p. 50). According to Schmalenbach 1967, p. 17, one of Schwitters' works was included in the 1921 Galerie von Garvens exhibition "Alte und neue Hinterglasmalerei". The only one known in reproduction is *U. 11* (which suggests that there were at least ten more) in *Der Sturm: Herwarth Walden und die Europäische Avantgarde. Berlin 1912–1932* (Berlin, 1961), p. 75.
59 See, for example, *Mz 20B. Das Frühlingsbild, Merzbild 21B. Das Haar-Nabelbild* and *Ja-was?-Bild* (Schmalenbach 1967, illus. 21, 18, 20).
60 Examples of the spare 1920 small reliefs include *Radblumen für Vordemberge* (illus. 74).
61 See p. 201-202 for further discussion of these works.
62 See, for example, the two lost assemblages, *Papierfetzenbild* and *Merzbild Lackleder* (Schmalenbach 1967, figs. 22, 23); also

the curious 1921 painted collage *Dein Treufrischer* (see *Selections from the Joseph Randall Shapiro Collection* [Chicago: Museum of Contemporary Art, 1969], cat. 60) and the even odder *Das Geistreich* of 1922, named after the Berlin museum run by Rudolf Bauer (see *Solomon R. Guggenheim. Collection of Non-Objective Paintings* [Charleston, 1936], cat. 398; now no longer in that collection). The latter two works reveal Schwitters' uncertainty in his 1921–22 assemblages as he began to move beyond the earlier Futuro-Expressionist compositions.

63 "Katalog" 1927, p. 2 (*LW–5*, p. 254).

4 COLLAGE: MEDIUM AND MEANING pp. 71–93

1 See Apollinaire's "Die moderne Malerei," *Der Sturm*, vol. 3, no. 148–149 (Feb. 1913), p. 272, and *Les Peintres Cubistes* (Paris, 1913), p. 38.

2 If Schwitters' numbering system is to be trusted, *Hansi* is the earliest known collage of this 1918 series. *Zeichnung A3* (formerly Arman collection, Paris; location unknown) and *Zeichnung A6* (Schmalenbach, fig. 32; location unknown) are the only other known survivors from the series. Other collages to which 1918 dates have been given include *Schwarz auf gelb grün*, *Das Engelbild* and *Für Bendien*. *Schwarz auf gelb grün* is listed as a 1918 collage in *Gesamtkunstwerk* 1983, p. 26, but was unavailable for inspection. *Das Engelbild* is certainly later (see note 20, below). *Für Bendien* has been assigned to 1918 on the grounds that Schwitters' own impossible date of 1913 was a mistake for 1918 (London 1972, cat. 18). Schmalenbach 1967, p. 366, n. 91, suggests 1919 for this work, but Schwitters' "1913" was probably, in fact, a mistake for "1923." Schwitters illogically later returned to a "Zeichnung A" designation for *Zeichnung A9. Berliner*, 1922 (Indiana University Museum, Bloomington) and *Zeichnung A1. Delft*, 1926 (Winterthur Kunstmuseum), but used a Roman rather than German "A." The early A series presumably was made before the word Merz was invented. Although Schwitters did not always use the prefix "Mz," "Mzz," or "Merzz" (all for "Merzzeichnung") before the number and/or title of his early collages, he never used the form "Zeichnung" instead of "Merzzeichnung" for collages after Merz was invented, except in the case of the 1922 and 1926 collages mentioned above.

3 *Zeichnung A6* suggests so. See note 2, above.

4 See Arp's "Erinnerung an Schwitters," in Paul Raabe, ed. *Expressionismus. Literatur und Kunst 1910–1923* (Munich, 1960) p. 240; and Schmalenbach 1967, p. 43.

5 Arp's rectilinear-unit collages were first shown at the Galerie Tanner, Zurich in 1915, and were illustrated in several Zurich Dada publications which Schwitters could easily have seen (e.g. *Cabaret Voltaire*, 1916; *Dada*, no. 2, Dec. 1917). Also, Huelsenbeck's "Die Arbeiten von Hans Arp" (written in 1916) appeared in *Dada*, no. 3, Dec. 1918, but this did not include reproductions of collages.

6 E.g., Hilla von Rebay, Johannes Molzahn and Nell Walden. See Wescher 1969, pp. 81–84, 252–258.

7 In drawing attention to the fact that "Hansi" alludes to Hans Arp, Nill 1981–1, p. 116, suggests that the composition of the collage reinforces this allusion: that the rectangular strip of paper "leaning" against the right-hand side of the central upright (whose short "arms" make it resemble a cross) is in the position traditionally occupied by St. John the Evangelist in scenes of the crucifixion; and that Hans or Hansi is a version of Johannes.

Readings of this kind cannot be proven or disproven, but if they are meant to attribute specific allegorical intentions to Schwitters' abstract works they do seem problematic. (Nill 1984, on *Das Bäumerbild*, is more convincing.) In the case of *Hansi*, there is in fact some question whether that is indeed the title of the collage. Ernst Schwitters is convinced that his father's Gothic handwriting should be deciphered as *Haus* (*House*); The Museum of Modern Art retains *Hansi* simply because it has become the accepted title.

8 Mehring 1919, p. 462.

9 E.g., *Aph* reproduced in Stockholm 1965, p. 12.

10 None of the literature on Schwitters explicitly addresses the question of which works were in his July 1919 Der Sturm exhibition (which in fact opened on June 29: see *Briefe*, p. 21). Exhaustive enquiries have failed to uncover a catalog or checklist of this exhibition, and, until one is discovered, the exact contents of the exhibition will be unknown. It certainly included *Merzbilder* (see ch. 3, note 4, above) and, judging from the reviews of the exhibition (see ch. 3, notes 5–8, above), Dada drawings. Leaving aside several later statements by Schwitters to the effect that his collages were first shown in 1919 (because he also made later statements giving 1918 as the year, which we know from evidence of checklists is untrue), the only contemporary evidence for suggesting that they were shown in July 1919 (they were not shown in January) is Mehring 1919, p. 462, where he refers to the *Aphorismen* as a third kind of drawing in the exhibition, one which provides in small size the effect of the large works. There were almost certainly Dada drawings in the exhibition, which would account for one kind of drawing. There may well have also been abstract drawings, for Schwitters showed 8 of these works in the May-June 1919 Kunstverein Jena exhibition, which also included *Eisenbetonstimmung*, which was brought from Jena to the July 1919 Sturm exhibition. Since Schwitters did refer to his collages as drawings, and given the context of Mehring's statement, the *Aphorismen* that Mehring mentions may have been collages. (Schmalenbach 1967, p. 249 note 129, assumes that Mehring used the term *Aphorismen* to mean collages, and that they were therefore in the July 1919 exhibition, but elsewhere, p. 120, says that the collages were first shown at the Hannover Sezession exhibition of 1920. *Merzzeichnungen*, so described, were certainly shown then, in Feb.–Mar. 1920, cat. 88–95.) And yet, no known work with an *Aph.* (for *Aphorismen*) prefix is a collage. Moreover, Schwitters made very few collages indeed in 1919: those fairly securely datable to that year are *Mz 10*, *Mz 12*, *Mz 13* (Madrid 1982, cat. 11; Schmalenbach 1967, figs. 29, 35) and *Der Sturm* (illus. 73); possibly *Mai 191* (illus. X) and *Kynastfest* (Schmalenbach 1967, fig. 34), though this may be later. (Only 8 collages were shown in the Feb.–Mar. Hannover Sezession show). It is quite conceivable that Schwitters did not show collages until the following year, for it was not until then that he began to make them regularly. (See also note 16, below).

11 Nill 1981–1, pp. 115–116.

12 E.g., Schmalenbach 1967, fig. 29, 35.

13 "Daten aus meinem Leben" 1926 (*LW–5*, p. 241).

14 As this text was being finally revised, Nill 1984 appeared, which offers a fascinating, detailed iconographic analysis of *Das Bäumerbild*.

15 In 1920, Hohlt, Schwitters, and others signed an "Erklärung" complaining of the 1920 Sezession catalog, which categorized their work according to conventional artistic movements and neglected their announced spiritual-artistic aims (*LW–5*, p. 56),

16 Once Merz was invented, Schwitters numbered his collages sequentially, but probably not necessarily in the order in which they were made, using the prefix "Mz," or "Merzz," or "Merzzeichnung," followed by a number, title and date. (That, at least, is the most complete titling form; frequently one or more elements are missing.) The system lasted until 1923, but even in those few years seems to have broken down at several points. For example, there are two collages numbered *Mz 600*, one from 1922, one from 1923; the highest known number of the 1919 collages is *Mz 13*, yet there is a *Mz 11* from 1921 (though this is numbered on the mat and in a different form of Schwitters' hand, suggesting a later addition). Moreover, after 1920, the earliest of any year's collages have numbers lower than the highest numbers of the previous year's output. Hence, in 1920 (by which time Schwitters was making collages regularly), there is a fairly regular (albeit incomplete) sequence of numbers from 19 to 170, then a 203 (but on the mat, and probably later) and *apparently* a 219 (i.e. the number of this collage is unverified). In 1921, there is, as mentioned above, an 11, then another sequence from 172 to 356, then apparently a 457 and a 460 (on the mat). In 1922, there is apparently a 344, then a sequence from 369 to 464, then apparently a 600 and 601. Leaving aside the questionable numbers, it would appear that Schwitters was fairly consistent in his numbering, the secure numbers reaching 13 by the end of 1919; 170 by the end of 1920; 356 by the end of 1921; and 464 by the end of 1922. (There may well be, of course, higher numbers in each year that are unknown to me.) It would also seem clear that Schwitters did number and title in batches. Hence, for example, *Mz. 169. Formen im Raum* (1920); *Mz 170. Leere im Raum* (1920); *Mz 172. Tasten zum Raum* (1921), a sequence which also confirms the number Schwitters had reached by the end of 1920. In 1923, the numbers pass 700, then suddenly jump to over 1,500. Schmalenbach 1967, p. 119 suggests that Schwitters had lost count and made a new start from an arbitrarily chosen large number. In 1924, he began a new system: e.g. *Mz 24/32* (1924), beginning with 1 after the abbreviation for the year. In 1926, he initiated yet another system: e.g., *Mz 1926.17 Lissitzky* (1926). In this case, the system would seem to have been embarked on to catalog works ready for the 1927 "Grosse Merzausstellung": the catalog of that exhibition ("Katalog" 1927) shows a regular sequence of 1926 collages reaching *Mz 1926.63*. In 1930 (another important year in Schwitters' development) he returned to the 1926 numbering system after having abandoned any consistent system in the later 1920s. In Norway, he sometimes described collages as *Merz-tegninger* and in England as *Merzdrawings*, in the latter case sometimes additionally using the prefix "C" (for collage). Also in England, there is a group of large collages designated "Aerated" followed by roman numerals, and in 1947 a sequence with the prefix ✕.

17 It is difficult to give a realistic estimate as to the extent of Schwitters' oeuvre. According to Ernst Schwitters (who is preparing a catalogue raisonné), his father produced approximately 4,000 abstract works (including assemblages, collages, paintings and drawings) of which some 2,500 remain; approximately 4,000 naturalistic works, of which some 2,000 remain; and approximately 400 sculptures, of which only around 30 or so remain (many having been destroyed with the Hannover *Merzbau*). See also note 16, above.

18 *Braque. The Papiers Collés* (Washington, D.C.: National Gallery of Art, 1982), p. 147.

19 Huelsenbeck 1918 (Motherwell 1951, pp. 242–246).

20 The postcard of the sculpture, *Die Kultpumpe*, on which the collage is made was one of a series published by Paul Steegemann *c*. 1920. Also, it seems that Schwitters' earliest assembled sculptures date from 1919 or 1920 (see p. 112).

21 These works were dated 1918 in New York 1963, cat. 5 and 6, but some other dates in this catalog are certainly incorrect. The works are not dated, but they do seem to precede the other photomontages I discuss below. The date 1918–19 is suggested in Pasadena 1962, cat. 7 and 8.

22 Hausmann's claims that he invented photomontage and introduced it to Schwitters may be studied in Hausmann 1958, pp. 37–50, and Hausmann 1972, pp. 45–53.

23 See p. 35 for explanation of the date when they met.

24 Hausmann 1958, pp. 41–42. It is interesting to note here that Hausmann added a map of Pomerania, where he was on vacation in the summer of 1918, to his 1920 photomontage *Tatlin at Home* (see his "Tatlin at Home prend forme" [1967], in the catalog *Raoul Hausmann* [Stockholm, Moderna Museet, 1967], n.p.) and in Michel Giroud, ed., *Raoul Hausmann: "Je ne suis pas un photographe"* (Paris, 1975), p. 52.

25 Evidence for a 1919 dating of this photomontage design is presented in Elderfield 1975, pp. 381–384.

26 For Heartfield's claims to have invented photomontage, see Wieland Herzfelde, *John Heartfield. Leben und Kunst* (Dresden, 1962), p. 18, and *John Heartfield, 1891–1968* (London: Arts Council of Great Britain, 1969), p. 6. The cases for both Hausmann and Heartfield, and the related claims of Grosz (and of Hoech and Baader) are summarized, with considerable variation, in: Richter 1965, p. 117; Wescher 1969, pp. 138–139, 142–144; *Tendenzen* 1977, pp. 37–38; Dawn Ades, *Photomontage* (London and New York, 1976), pp. 10–11; *Dada Photomontagen* (Hannover: Kestner-Gesellschaft, 1979), pp. 34–36.

27 See Richter 1965, opp. p. 113.

28 *Fiat Modes. Pereat Ars. 8 originallithografien* (Cologne, Verlag der ABK, n.d. [1919]). This was advertised in *Die Schammade*, [Feb.] 1920. For the Hausmann collage, see Giroud (note 24, above), p. 39.

29 Tatlin, however, did not make his utilitarian suit of clothes until 1924. Hausmann had apparently long been interested in reforming German trouser design! (Huelsenbeck 1974, p. 67.) He is pictured in a suit of his own making in his 1920 photomontage, *Dada Siegt*. Later, he published an article called "Mode" in *G*. no. 3 (1924), pp. 50–52. Surprisingly, fashion seems to have been a fairly widespread interest among the artists of revolutionary Berlin: when Adolf Loos came to lecture at the Sturm gallery, it was to speak on modern male fashions (ibid., pp. 66–67).

30 "PRÉsentismus, gegen den Puffkeïsmus der Teutschen Seele," *De Stijl*, vol. 4, no. 9 (Sept. 1921), p. 139.

31 For the Berlin Dadaists' machine interests in the context of their contemporaries: K.G. Pontus Hultén, *The Machine as seen at the end of the Mechanical Age* (New York, 1968), pp. 110–112, 114–115, 117.

32 *John Heartfield* (London, 1969), p. 6. Grosz has claimed authorship of the word as a name for Heartfield as early as 1915. See Wescher 1969, pp. 142, 144, where it is correctly stated that 1915 is too early, if only for the fact that Grosz was on active military service until 1916. The word first appeared in print in *Der Dada*, no. 3 (Apr. 1920).

33 Autobiographical text, "Katalog" 1927, p. 99 (*LW–5*, p. 251).

34 It was advertised as being in preparation in Schwitters' *Die Märchen vom Paradies* (Hannover, 1924).

35 The inscription reads:

Papier ist die grosse Mode	Paper is the great fashion
Besatz Holz.	Wood edging.
Ecken abrunden!	Round off the corners!

36 E.g., *Untitled* (*Hektoliter YL*), 1922; *Untitled*, 1922/23 (Schmalenbach 1967, figs. 58, 59). *Schönheitspflege*, 1920 (*Art of the Dadaists* [New York: Helen Serger, la boëtie, 1977], cover). There is also the curious *Modemadonna*, 1924, a modified reproduction of an icon, formerly in the collection of Hannah Hoech. (Galerie Kornfeld, Berne, Auction 169, June 1979, lot 1220).

37 Northrop Frye, *Anatomy of Criticism*, (Princeton, N.J., 1971), p. 17.

38 cf. The collage, *Blauer Vogel*, discussed in the first English edition of this book, pp. 80–81, which subsequently has been challenged by the artist's son, Ernst Schwitters, as not authentic.

39 Steinitz 1968, p. 9.

40 Quoted by Janis and Blesh 1962, p. 76.

41 Käte Steinitz to the collagist William Dole. Reported in Gerald Nordland, "William Dole," *Art International*, vol. 23, no. 3–4 (Summer 1979), pp. 96, 112, where it is said that Schwitters would wash and dry his materials, and catalog them according to their color and design properties.

42 Waldemar George, "Braque," *L'Esprit Nouveau*, Mar. 6, 1921; Maurice Reynal, "Qu'est-ce que . . . le 'Cubisme'?", *Comoedia illustré*, Dec. 20, 1913.

43 The general problem of color in Cubism is perceptively discussed by Walter Darby Bannard in "Hofmann's Rectangles," *Artforum*, vol. 7, no. 10 (Summer 1969), pp. 38–41. In some respects, Schwitters is comparable to Hofmann (his near contemporary, born in 1880) in seeking to create a coloristic version of Synthetic Cubism.

44 My reference to Fauvist color features is indebted to Kenworth Moffett's general discussion of this characteristic in his *Jules Olitski* (Boston, Museum of Fine Arts, 1973), p. 12.

45 See Rubin 1969, pp. 99–110, to which sections of this discussion are indebted.

46 "Holland Dada" 1923, pp. 10, 9 (*LW–5*, pp. 134, 133).

47 E.g., *Spielkartenharmonika*, 1919 and *Untitled*, 1921 (Schmalenbach 1967, illus. 27 and fig. 24). See also Nill 1981–2, pp. 119–121.

48 Themerson 1958, pp. 14–15, talks of Schwitters' art as a form of social commentary or protest, and Schwitters' son has noted that there was something of this in what Schwitters did (note 55, below). Among the "mystical" interpretations: Guy Burn talks of Schwitters as a Zen Buddhist ("Kurt Schwitters," *Arts Review*, vol. 15, no. 5, Mar.–Apr. 1963, p. 5) and Nigel Gosling of him as evidencing specifically Christian attributes ("A Voice Crying in the Wilderness of Wealth," *The Observer*, Mar. 17, 1963).

49 André Gide, *The Counterfeiters, with Journal of "The Counterfeiters"* (New York, 1955), p. 189.

50 It could even be suggested , therefore, that for the viewer the weighing of formal and iconographical responses is directly proportional to that of saccadic and fixation time in his viewing. But the "reading" of pages and pictures is different and the analogy cannot be exact. Relevant to the idea of confrontation being in terms either of individual elements or of the whole are some notes to Michael Fried's "Manet's Sources, Aspects of his Art, 1859–1865," *Artforum*, vol. 7, no. 7 (Mar. 1969), where he discusses the relationship of picture and viewer in terms of total confrontation (n. 27) and the problems of portraiture when the subject-matter rather than the whole painting effects "facing" (n. 91).

For Schwitters, the comparison with *group* portraiture (as well as with still-life) is instructive.

51 Meyer Schapiro, "The Apples of Cézanne: An Essay on the Meaning of Still-Life" (1968) in his *Modern Art. 19th and 20th Centuries. Selected Papers* (New York, 1978), p. 19 (quoting from George H. Mead, *The Philosophy of the Act*, 1938).

52 This point was made by Carter Ratcliff, "Collage," *Art International*, vol. 15, no. 8 (Oct. 1971), pp. 56–59.

53 "Katalog" 1927, p. 100 (*LW–5*, p. 253).

54 Rasch 1930, pp. 88–89; "Daten aus meinem Leben" 1926 (*LW–5*, pp. 335, 241).

55 Cover note to the recording of Schwitters' poems "An Anna Blume" and "Die Sonate in Urlauten" published by Lords Gallery, London, 1958.

56 London 1944, n.p.

57 Lach 1971, p. 22.

58 "Tran 35. Dada ist eine Hypothese," *Der Sturm*, vol. 15, no. 1 (Mar. 1924), p. 30 (*LW–5*, p. 172).

59 See Schmalenbach 1967, p. 33.

60 Rubin 1969, p. 104.

61 Ibid.

62 John McHale's phrase, quoted in Gillo Dorfles, "Communication and Symbolic Value," *Living Arts*, no. 3 (1964), p. 84.

63 *Société Anonyme* 1984, p. 598.

64 "Ich und meine Ziele" 1930, p. 115 (*LW–5*, p. 343).

65 See especially Benjamin's "On Some Motifs in Baudelaire" and "The Work of Art in the Age of Mechanical Reproduction," in *Illuminations* (London, 1973), pp. 157–202, 219–254.

66 "Manifest Proletkunst" 1923, p. 24 (*LW–5*, p. 141).

67 Huelsenbeck 1961, p. 58.

68 Schmalenbach 1967, p. 117.

69 Kandinsky and Marc 1912, pp. 162, 164.

70 Ibid., p. 173.

71 Quoted here from the translation in Robert L. Herbert, *Modern Artists on Art* (Englewood Cliffs, N.J., 1964), pp. 23–24.

72 "Tran 35," *Der Sturm*, vol. 15, no. 1 (Jan.–Feb. 1924), p. 32 (*LW–5*, p. 174).

73 Letter to Herbert Read, Nov. 1, 1944, *Briefe*, p. 177.

74 London 1944, n.p.

75 Letter to Margaret Miller, Jan. 22, 1947. Archives of The Museum of Modern Art, New York.

76 "Ich und meine Ziele" 1930, p. 114 (*LW–5*, p. 342).

77 Huelsenbeck 1961, pp. 56, 58.

78 "Banalitäten" 1923, p. 40 (*LW–5*, p. 148).

79 Claude Lévi-Strauss, *The Savage Mind* (Chicago 1966), p. 21. Although Lévi-Strauss does not mention him, Schwitters seems a far more appropriate personification of the *"bricoleur"* of this famous passage than the *facteur* Cheval and others mentioned. Finite tools for diverse tasks, reordering the remains of events, a "significant" treasury, and so on: these all bring Schwitters to mind. Lévi-Strauss' later discussion of scale factors is also relevant here.

80 *Sturmbilderbuch* 1920, p. 2 (*LW–5*, p. 84).

5 POETRY, PERFORMANCE, AND THE TOTAL WORK OF ART pp. 94–118

1 "Merzbühne" 1919, p. 3 (*LW–5*, p. 42).

2 *Sturmbilderbuch* 1920, p. 2; "Holland Dada" 1923, p. 2 (*LW–*

5, pp. 84, 134).

3 "Katalog" 1927, p. 100 (LW–5, p. 253).

4 "Merz" 1920, p. 7, quoting in part from "Merzbühne" 1919 (LW–5, p. 79).

5 For general discussions of Sturm poetry, see the works cited in Ch. 1, note 23, above. For the relationship of Schwitters' own poetry to his Sturm models, see Jones 1971, Thomson 1972, Last 1973, Scheffer 1978.

6 "Selbstbestimmungsrecht der Künstler" in Anna Blume 1919, p. 36 (LW–5, p. 38).

7 Anna Blume 1919, pp. 11–12 (LW–1, pp. 45–47). The translation is adapted from Watts, pp. 81–82.

8 Der Sturm, vol. 10 no. 3 (June 1919), pp. 35–36 (LW–1, p. 40). The translation is adapted from Watts, pp. 81–82.

9 See Last 1973, p. 44, for a useful discussion of this poem.

10 Anna Blume 1919, p. 6 (LW–1, p. 54). The translation is from Watts, p. 73.

11 Der Sturm, vol. 12, no. 10 (October 1921), p. 172 (LW–1, p. 85). The translation is adapted from Watts, p. 88.

12 "Die Geheimlade," Anna Blume 1922, pp. 31–37 (LW–2, pp. 49–52).

13 "Selbstbestimmungsrecht der Künstler," p. 37 (LW–5, p. 38).

14 "Holland Dada" 1923, p. 11 (LW–5, p. 134).

15 Anna Blume 1919, pp. 24–27 (LW–2, pp. 26–27). The translation is adapted from Watts, pp. 116–118.

16 Lach 1971, p. 130; Last 1973, p. 40.

17 Anna Blume 1919, p. 16 (LW–2, p. 22), translated after Watts p. 110.

18 Ibid., p. 18 (LW–2, p. 23), translated after Watts, pp. 111–112.

19 Ibid., p. 21 (LW–2, p. 25), translated after Watts, p. 114.

20 Lach 1971, p. 130.

21 Last 1973, p. 45.

22 The work is discussed in detail in Elderfield 1971, pp. 256–261, from which the following analysis is derived.

23 Last 1973, p. 55.

24 See Elderfield 1971, p. 259.

25 Steinitz 1968, p. 24.

26 Ibid.

27 Ibid.

28 "Revolution in Revon" 1922, p. 158 (LW–2, p. 29).

29 Merz, no. 13, 1925, comprised a "Merz-Grammophon-platte" of Schwitters reciting his "Scherzo der Ursonate." In 1958, Lords Gallery, London, produced a record that included Schwitters reciting "An Anna Blume" and a selection of "Die Sonate in Urlauten."

30 Richter 1965, p. 143.

31 "Holland Dada" 1923, p. 3 (LW–5, p. 127).

32 My account derives from the following sources: "Holland Dada" 1923, pp. 3–8 (LW–5, pp. 127–132); "Theo van Doesburg" 1931; Letter to Theo van Doesburg, Sept. 13, 1922 (Briefe, pp. 70–75); Letter to Raoul Hausmann, Nov. 14, 1946 (Briefe, p. 247–248 and Reichardt 1962, p. 13); Op de Coul 1968, pp. 33–39 (who cites useful contemporary newspaper reports of the performances). See also Schippers 1974, pp. 54–91 and Op de Coul 1983, pp. 141–157.

33 Printed as Wat is Dada? (The Hague, 1923).

34 Reichardt 1962, p. 13.

35 Het Vaderland, Jan. 11, 1923 (Op de Coul 1968, p. 37).

36 Reichardt 1962, p. 13.

37 Helmut von Erffa, "Bauhaus: First Phase," Architectural Re-view, vol. 122, no. 727, Aug. 1957, p. 105. Petro (Nelly) van Doesburg had studied piano and was acquainted with Rieti (b. 1898). The composition was entitled "Marcia nuziale per un coccodrillo," one of "Tre marcie per le bestie" composed in 1920. See Op de Coul 1968, pp. 37–38.

38 Algemeen Handelsblad, Jan. 20, 1923 (Op de Coul 1968, p. 38).

39 Letter to Hausmann Nov. 14, 1946. Briefe, p. 247. A reproduction and description of Huszár's Mechanische Dansfiguur, appeared in "Holland Dada" 1932, p. 13.

40 "Theo van Doesburg" 1931, p. 57 (LW–5, p. 351).

41 "Merzbühne" 1919, p. 3; "Erklärungen" 1919, p. 3 (LW–5, pp. 42–43).

42 Kandinsky and Marc 1912, pp. 190–206.

43 For the German Expressionist theater, see Samuel and Thomas 1939; H.F. Garten, Modern German Drama (London, 1959); Horst Denkler, Drama der Expressionismus: Programm, Spieltext, Theater (Munich, 1967); G. Erken, D. Rückhaberle and C. Zieschke, ed., Theater in der Weimarer Republik (Berlin, 1977).

44 See Kracauer 1947, ch. 5.

45 Sancta Susanna was produced in Oct. 1918. For the Sturm theater, see the works cited in Ch. 1, note 23 above. In 1919, a short-lived Kestner-Bühne was established by the Kestner-Gesellschaft in Hannover (See Rischbieter 1962 and Schmied 1967).

46 See László Moholy-Nagy, "Theater, Circus, Variety," in The Theater of the Bauhaus, ed., Walter Gropius (Middletown, Conn., 1961), p. 50 (a translation of Die Bühne im Bauhaus, 1925).

47 "Merzbühne" 1919, p. 3 (LW–5, p. 42).

48 Kandinsky and Marc 1912, pp. 194 ff., 210.

49 "Merzbühne" 1919, p. 3 (LW–5, p. 42), and for the following quotation.

50 "Erklärungen" 1919, p. 3 (LW–5, p. 43–44) and for the following quotations and subsequent descriptions of the Merz-bühne unless otherwise noted.

51 Sturmbilderbuch 1920, p. 2 (LW–5, p. 84).

52 "Holland Dada" 1923, p. 8 (LW–5, p. 133).

53 "Merz" 1920, p. 5 (LW–5, p. 76).

54 Der Weltbaumeister. Architektur-Schauspiel für symphonische Musik (Hagen, 1920).

55 "Merzbühne" 1919, p. 3 (LW–5, p. 42).

56 See Franciscono 1971, ch. 4.

57 None has apparently survived. The photograph of Die heilige Bekümmernis (illus. 161) shows one in the background.

58 "Merz" 1920, p. 6 (LW–5, p. 79). Writing in December 1920, Schwitters states in this article: "Now I am making Merz-sculptures: Lustgalgen and Kultpumpe." This suggests that they were first made in 1920. However, Schmalenbach 1967, p. 129, says that they were shown at the Sturm gallery in 1919, and accounts by visitors to Schwitters' studio in 1920 imply that they were already familiar to Schwitters' audience (see p. 144). Additionally, Huelsenbeck noted the presence of an assembled column in Schwitters' studio in 1919 (see p. 145).

59 "Das Ziel meiner Kunst" 1938 (LW–5, p. 363).

60 "Merz" 1920, p. 6 (LW–5, p. 78). Archipenko had exhibited at the "Erste deutsche Herbstsalon," Berlin, in 1913 and was promoted in Germany by Walden.

61 Schwitters visited Ernst in Cologne in Spring 1920 after having seen Bulletin D (ed. J.T. Baargeld and Max Ernst [Cologne,

1919]) and showed Ernst his collages and reliefs (Waldberg 1958, pp. 160–161). This meeting likely took place in April 1920 at the time of the famous "Dada-Vorfrühling" at the Brauhaus Winter in Cologne. Schwitters had earlier exchanged photographs with Ernst (see ch. 2, note 65, above), but this would have been the first time that Schwitters could have seen actual examples of Ernst's work. Ernst's famous *Fruits of Long Experience* (illus. 65) and other early assemblages are contemporaneous with Schwitters' first assemblages. Ernst's first three-dimensional constructions date to 1920 and one at least was exhibited in the "Dada-Vorfrühling." When Schwitters' first three-dimensional works were made is uncertain (see note 58, above). For details of Ernst's works see Werner Spies, *Max Ernst. Oeuvre-Katalog. Werke 1906–1925* (Cologne, 1975), cat. 296–299, 337–338.

62 It was reproduced in the Zurich periodical *Dada*, no. 1, July 1917.

63 This work is lost. It was first reproduced, along with a commentary, in Spengemann 1920–2, opposite p. 38, and was exhibited at Der Sturm in April 1921 (cat. 70), there described as "Merzarchitektur." Also thus described was *Das Dorf* (cat. 69), while *Der Obelisk, Die Kultpumpe* and *Der Lustgalgen* (cats. 66–68) were each described as "Merzplastik."

64 Gröttrup 1920, pp. 149–152.

65 This work is lost. It was first reproduced in the Berlin *Börsenkurier,* Oct. 31, 1924.

66 See note 64, above.

67 A collaged-over postcard of this lost work is illustrated in Schmalenbach 1967, illus. 25. A collaged-over postcard of *Der Lustgalgen,* reproduced in Ernst Nündel, *Kurt Schwitters* (Reinbek bei Hamburg, 1981), p. 46, is fascinating in the way it accentuates the grotesque aspect of the work, adding a hanging pin-man (labeled "Kritiker") and a picture of the crucifixion to the gallows and the image of a church to the background.

68 Rasch 1930, pp. 88–89; *Sturmbilderbuch* 1920, p. 2 (*LW–5,* pp. 335, 84).

69 "Merz" 1920, p. 6 (*LW–5,* p. 79).

70 Spengemann 1920–2. Spengemann, as well as others from Hannover whom Schwitters knew, like Paul Erich Küppers, were in contact with the Arbeitsrat für Kunst. See Elger 1984, pp. 66–67.

71 As early as 1914, Bruno Taut was talking of the Gothic cathedral as the greatest example of the unification of the arts ("Eine Notwendigkeit," *Der Sturm,* vol. 4, no. 196–197 [Feb. 1914], p. 175), but the *Zukunftskathedrale* of the Bauhaus proclamation was of course its most celebrated manifestation. There is a host of recent literature on this subject, usefully summarized by Franciscono 1971, ch. 1, 3.

72 *Ausstellung für unbekannte Architekten veranstaltet vom Arbeitsrat für Kunst* (Apr. 1919), n.p. See Conrads and Sperlich 1962, p. 137.

73 Ibid.

74 For the constitution of the Novembergruppe, see the references given in Ch. 2, note 26 above; for the Arbeitsrat für Kunst, see Conrads and Sperlich 1962, pp. 135–141; Franciscono 1971, ch. 3, 4; Barbara Miller Lane, *Architecture and Politics in Germany, 1918–1945* (Cambridge, Mass., 1968), ch. 2; *Arbeitsrat für Kunst Berlin 1918–1921* (Berlin: Akademie der Künste, 1980).

75 *Frühlicht*. Supplement to *Stadtbaukunst. Alter und neuer Zeit*, vol. 1, no. 3, 1920; letter of July 15, 1920, quoted in Conrads and Sperlich 1962, p. 147.

76 "Schloss und Kathedrale" 1922, p. 87 (*LW–5*, pp. 95–96). See Elger 1984, pp. 65–70, for a discussion of Schwitters' possible knowledge of and contacts with Expressionist architects.

77 "Ich und meine Ziele" 1930, p. 116 (*LW–5*, p. 345).

78 See p. 163.

79 It is highly unlikely that Schwitters knew of either of these works. Ferdinand Cheval's "Palais Idéal" in Hauterives (Drôme), France, was constructed between 1879 and 1912 but apparently not illustrated or discussed in print until J.B. Brunius' article in *Variétés* of June 15, 1929 (cited by Marcel Jean, *The History of Surrealist Painting* [London and New York, 1960], p. 210). Schwitters may eventually have learned of it from a notice by Brunius in *Cahiers d'Art*, vol. 11, no. 1–2 (1936), p. 51, a special number devoted to the Surrealist object. Rodilla's towers at Watts, Los Angeles, were not begun until 1921 and not completed until 1924.

80 "I said to Kurt, 'You call the Expressionists painters of their own sour souls . . .'" (Steinitz 1968, p. 91).

81 "Manifest Proletkunst" 1923 (*LW–5*, p. 143).

82 See pp. 137–138.

83 See, for example, Ernst's account in Waldberg 1958, pp. 160–161.

84 See, for example, Richter's funny story of Schwitters unscrewing a sign from a moving tram, in Janis and Blesh 1962, p. 64.

85 Claude Lévi-Strauss, *The Savage Mind* (Chicago, 1966), p. 21.

86 "Mein Merz" 1926, p. 106 (*LW–5*, p. 243).

87 See, for example, "Holland Dada" 1923, p. 9, and "Merz" 1920, p. 5 (*LW–5*, pp. 134, 76–77).

88 Because this is a more guarded image, it is difficult to specify with quotations taken out of context, and yet Schwitters' often-stated notion that expression is "injurious" seems to imply this. In "Merz" 1920, p. 5 (*LW–5*, p. 76), he says that he abandoned the idea of art as an intermediary between the artist and the spectator, realizing that striving after expression weakens art. Certainly after 1923, when Schwitters was influenced by Constructivist theory, he was unwilling to see art as a revelation of the self. Indeed, he viewed his own *neue Sachlichkeit* as a turn from things personal and individual to the impersonality of pure "style."

89 According to Ernst Schwitters, approximately 16 of these boxes were made, each one unique. One was exhibited at the Galerie von Garvens, Hannover in 1921 (*Albert Schulze, Hannover. Intarsien nach entwürfen von Joh. Thorn-Prikker und Kurt Schwitters*). One collaged prototype is known, *Kasten 7*, 1922 (illus. 142), on the bottom of which is an inscription in Schwitters' hand saying that Schulze had executed 5 boxes based on Schwitters' designs.

90 "Ich und meine Ziele" 1930, p. 114 (*LW–5*, p. 342).

91 "Kunst und Zeiten" 1926 (*LW–5*, p. 239).

92 "Ich und meine Ziele" 1930, p. 114 (*LW–5*, p. 341).

93 Samuel and Thomas 1939, p. 71. My gloss on the phrase is indebted to Stanley Cavell, *The World Viewed. Reflections on the Ontology of Film* (New York, 1971), p. 22.

94 "Merz" 1920, p. 5 (*LW–5*, p. 76).

6 MERZ IN THE MACHINE AGE pp. 120–143

1 See Ades 1984, p. 36.

2 Cf. George Rickey, *Constructivism: Origins and Evolution* (New York 1967); Willy Rotzler, *Constructive Concepts* (Zurich 1977).

3 See Ades 1984, p. 36.

4 This point, expanded upon below, is also taken up again in Chapter 10.

5 See Franciscono 1971, p. 150.

6 See Peter Nisbet, "Some Facts on the Organizational History of the Van Dieman Exhibition," in *First Russian Show* 1983, p. 68.

7 Franciscono 1971, p. 243. By Sept. 1919, *De Stijl* had included an illustration of Feininger's work (vol. 2, no. 11, plate XXI).

8 For accounts of the constitution of the group: Moholy-Nagy 1947, p. 74; Lissitzky-Küppers 1968, p. 22–26.

9 Konstantin Umanskij, *Neue Kunst in Russland, 1914–1919* (Potsdam and Munich 1920). Umanskij also published an article specifically on Tatlin, from whose title the Dadaists' poster may have derived: "Der Tatlinismus oder die Maschinenkunst," *Der Ararat*, Jan. 1920, pp. 12–14; Feb.–Mar. 1920, pp. 32–33. For the impact of Soviet Art in the West see: Eberhard Steneberg, *Russische Kunst Berlin 1919–1932* (Berlin, 1969); Galerie Gmurzynska, *Die 20er Jahre in Osteuropa* (Cologne, 1975); *Berlin-Hannover* 1977; Willett 1978, ch. 2; *First Russian Show* 1983.

10 For the founding of G and the G group: Werner Graeff, "Concerning the so-called G group," *Art Journal*, vol. 23, no. 4 (Summer 1964), pp. 280–282, and Raoul Hausmann's reply, "More on Group G," ibid., vol. 24, no. 4 (Summer 1965), pp. 350, 352. Also Hans Richter, *Hans Richter* (Neuchâtel, 1965), pp. 36–37: idem, "*G*: Introduction," *Form*, no. 3 (Dec. 1966), p. 27.

11 The name Bonset first appeared in print in *De Stijl* in May 1920; however, it appears to have been actually invented by Van Doesburg in the period *c.* 1916–18. See Beckett 1979, pp. 2–3.

12 *Mécano* lasted only four issues, 1922–23 (and in some respects Schwitters' *Merz*, founded in 1923, can be said to extend its Dada-Constructivist message). For bibliographical details and excerpts: *Form*, no. 4 (Apr. 1967), pp. 30–32.

13 "Dada ist mehr als Dada." *De Stijl*, vol. 4, no. 3 (Mar. 1921), pp. 40–47; "PRÉsentismus, gegen den Puffkeïsmus der Teutschen Seele," *De Stijl*, vol. 4, no. 9 (Sept. 1921), pp. 136–143.

14 Hausmann 1971, p. 165. For details of the Prague tour see Hausmann 1958, pp. 62, 112–116.

15 "Drie laatste verzen van Kurt Schwitters (Gedicht 60, Gedicht 62, Gedicht 63)," *De Stijl*, vol. 4, no. 7 (July 1921), pp. 107–108.

16 *De Stijl*, vol. 4, no. 10 (Oct. 1921), p. 156. In a letter to the author, Dec. 4, 1970, Hausmann claimed that the "Aufruf" was written exclusively by himself, the others merely signing it.

17 *Veshch*, no. 1–2 (Mar.–Apr. 1922), p. 1.

18 The Congress took place on 29–31 May 1922. The Apr. 1922 issue of *De Stijl* (vol. 5, no. 4) was delayed to include details of the Congress. It printed a review of the proceedings (pp. 49–52), the statements by Lissitzky (pp. 56–57), Richter (p. 57–59) and Van Doesburg (pp. 59–61), and the joint statement by these three (pp. 61–64). Details given here are derived from this source.

19 *Veshch*, no. 1–2 (1922), p. 2

20 For Van Doesburg's espousal of this principle in relation to Schwitters' work: Beckett 1979, p. 16.

21 Ibid., p. 3.

22 For reports of the Weimar Congress: Theo van Doesburg, "Chroniek Mecano: Internationaale Congres van Konstruktivisten en Dada 1922 in Weimar," *Mécano*, no. 3 (1922), n.p.; Tristan Tzara, "Conférence sur Dada," *Merz*, no. 7 (Jan. 1924), pp. 68–70; László Moholy-Nagy, *Vision in Motion* (Chicago, 1947), p. 315.

23 See Andor Weininger, "Bauhaus und Stil," *Form* (Cologne), no. 6 (1959), pp. 7–8; H.M. Wingler, "The Bauhaus and De Stijl," in Theo van Doesburg, *Principles of Neo-Plastic Art* (London, 1968).

24 Beckett 1979, p. 15.

25 There is some confusion in the literature on this period as to the precise dates of the Dada performances at Weimar, Jena, and Hannover in late September 1922. See Beckett 1979, pp. 17–18. Wherever there is doubt, the account given here follows the dates in Schwitters' contemporaneous letters (*Briefe*, pp. 72–74).

26 Moholy-Nagy, *Vision in Motion* (note 22, above), p. 315. It is hard to believe, but according to Moholy-Nagy the identity of Bonset was still a secret at the time of the Weimar Congress.

27 Although the Weimar meeting preceded the "Soirée du coeur à barbe" of July 1923, the latter was a purely internal affair for the Paris Dadaists, if indeed they still could be so-called after the Paris Congress of Jan.–Apr. 1922. In effect, Dada ends as an international movement with the Weimar Congress. According to Willett 1978, p. 78, the Constructivist International established at Düsseldorf was indeed ratified at Weimar, and set up a provisional committee based in Berlin, consisting of Van Doesburg, Lissitzky, Karel Maes, Richter, and Burchartz. If this was so, it seems to have functioned only as a social organization, for nothing is heard of it in periodicals of the years following.

28 Letter to Christof and Luise Spengemann, Sept. 27, 1922, *Briefe*, p. 74. According to Schwitters, the group was invited to attend what became the Dutch tour, described on pp. 105–106. ("Theo van Doesburg" 1931, p. 55; *LW–5*, p. 350).

29 For Hannover in the 1920s, see the references given in ch. 1, note 20, above.

30 "Tran 31" Oct. 1922 (*LW–5*, p. 118–119).

31 See p. 162.

32 See *die abstrakten hannover*, 1975.

33 *Das Tagebuch*, July 11, 1931. Quoted Cauman 1958, p. 106.

34 In appearance, however, Hannover was virtually untouched by modernism. While Otto Haesler's housing estates (*Siedlungen*) at nearby Celle set new standards in public design, Hannover remained conservative in appearance. Moreover, the Hannover architectural magazine, *Deutsche Bauhütte*, was from as early as 1924 a consistent opponent of modernism, and came to play an important part in the notorious "flat roof controversy" which sought to undermine the new architecture on both constructional and racialist lines. See Barbara Miller Lane, *Architecture and Politics in Germany, 1918–1945* (Cambridge, Mass., 1968), p. 136.

35 "Katalog" 1927, p. 100 (*LW–5*, p. 253). It is interesting to note that Schwitters abandoned his old numbering system for his collages in 1924 and started again with a new system. See ch. 4, note 16.

36 Ibid.

37 Beckett 1979, p. 15. (Schwitters later reproduced an Arp collage compositionally close to *Farbige Quadrate* in "Nasci" 1924, p. 80.)

38 Ibid.

39 Steinitz 1968, p. 18.

40 "Holland Dada" 1923, pp. 7–8 (*LW–5*, pp. 131–132).

41 *Neue Schweizer Rundschau*, vol. 5 (May 1929), p. 376.

42 See Beckett 1979, pp. 2–5, 8 ff.

43 Ibid., p. 4.

44 Ibid., p. 17.

45 See below, p. 176.

46 "Konsequente Dichtung" 1924, p. 46 (LW–5, p. 191).

47 I.K. Bonset, "Tot een Constructieve Dichtkunst," Mécano, no. 4–5 (1923), n.p. Quoted here after the translation in Form, no. 4 (Apr. 1967), pp. 31–33.

48 See note 46, above.

49 "Merzmalerei" 1919, p. 61; "Merz" 1920, p. 5; "Holland Dada" 1923, p. 9 (LW–5, pp. 37, 76, 134).

50 Richter, "G. Introduction" (note 10, above), p. 27.

51 Vordemberge-Gildewart settled in Hannover in 1919, from which time he was closely associated with Schwitters. He contributed to De Stijl from 1926 onwards. Schwitters would not have been so unlikely a member of the De Stijl group: his friend Arp joined in 1925, as did Brancusi and Georges Antheil. Hugo Ball was coopted a member in 1927.

52 Steinitz 1968, p. 41.

53 De Stijl, vol. 5, no. 10–11 (1922), n.p. (a special number devoted to Lissitzky), reproduced in Lissitzky-Küppers 1968, plates 85–108.

54 See Lissitzky-Küppers 1968, p. 343 ff.; Alan C. Birnholz, "El Lissitzky's writings on art," Studio International, vol. 183, no. 942 (Mar. 1972).

55 See note 53 above.

56 Veshch, no. 1–2 (1922), p. 2.

57 Quoted here after the translation from the Russian in Lissitzky-Küppers 1968, pp. 341–342.

58 For Lissitzky in Hannover: Lissitzky-Küppers 1968, p. 26 ff.

59 See the exhibition catalog, Erste russische Kunstausstellung (Berlin, 1922), and First Russian Show 1983 (a commemoration of the 1922 exhibition with useful essays on it).

60 The Merz number that Schwitters assigned to Moscow (448) shows that this work was executed late in 1922, which supports the idea of influence from works in the Oct. 1922 exhibition. For discussion of the contents of the exhibition see First Russian Show 1983, p. 21 ff. According to John Willett, Schwitters saw the exhibition at Lissitzky's invitation and made notes in a copy of the catalog indicating his admiration of the work of Altman, Gabo, Malevich, Rodchenko and Medunetzky (Willett 1978, p. 79).

61 Figuren—Die plastische Gestaltung der elektromechanischen Schau—sieg über die sonne (folio of 10 lithos with introductory note) (Hannover, 1923).

62 Lissitzky-Küppers 1968, p. 36.

63 "Dadaizm" 1924–25, n.p. (LW–5, pp. 193–196).

64 Schwitters advertised the magazine in "Typoreklame" 1924, p. 97, by printing his friends' congratulatory comments.

65 The phrase is Stephen Bann's who mentions "Nasci" in this context in his Experimental Painting (London 1970), pp. 24–26.

66 The text of "Nasci," unlike those of the other Merz magazines, is not reprinted in LW, presumably because its editor assumes that Lissitzky is its author. While Lissitzky had primary responsibility for the text, it is clear from Lissitzky-Küppers 1968 that it was a collaboration.

67 The best survey of Elementarist ideas in the broad context of the 1920s is Banham 1960, pp. 14–22, 185–200 and passim.

68 As Banham well puts it, the "Aufruf" was calling for "an art made of Malevich's elements minus Malevich's aesthetic philosophy" (Banham 1960, p. 189).

69 Veshch, no. 1–2 (1922), p. 2; De Stijl, vol. 5, no. 4 (Apr.

1922), p. 64.

70 "Der Wille zum Stil," De Stijl, vol. 5, no. 2 (Feb. 1922), pp. 23–32; vol. 5, no. 3 (Mar. 1922), pp. 33–41.

71 "Zur elementaren Gestaltung," G, no. 1 (July 1923), pp. 1–2.

72 Richter 1965, p. 63.

73 For comparison of Richter's and Van Doesburg's views: Beckett 1979, p. 7.

74 This was made explicit in the very first article in the first issue of De Stijl (Oct. 1917), Mondrian's "De Nieuwe Beelding in de Schilderkunst," where he says that "the life of contemporary cultivated man is turning gradually away from nature; it becomes more and more an abstract life."

75 Beckett 1979, p. 8.

76 Ibid., p. 17.

77 De Stijl, vol. 5, no. 3 (March 1922), pp. 33, 34.

78 De Stijl, vol. 6, no. 6–7 (1924), pp. 89–92. Although not published in De Stijl until 1924, the manifesto is dated "Paris 1923."

79 Gropius' "Idee und Aufbau des Staatlichen Bauhaus in Weimar," which announced the art-with-technology theme, was given as a lecture at the Bauhaus exhibition of Aug. 1923 and published in Staatliches Bauhaus in Weimar, 1919–1923 (Munich 1923). For summaries of L'Esprit Nouveau theories on the machine: Banham, p. 202 ff.; Christopher Green, "Léger and L'Esprit Nouveau," in J. Golding and C. Green, Léger and Purist Paris (London, The Tate Gallery, 1970), pp. 25–84.

80 "Kurt Schwitters" (1949), in Hans Arp, Arp on Arp (New York, 1972), p. 251.

81 See Lissitzky-Küppers 1968, p. 344.

82 Lissitzky's 1923 Hannover lecture made this explicit (see Lissitzky-Küppers 1968, pp. 334–336). See also Birnholz, "El Lissitzky's writings on art" (note 54, above), pp. 90–92, on Lissitzky's position vis-à-vis Constructivism and Suprematism.

83 "Nasci" 1924, p. 73.

84 Lissitzky-Küppers 1968, p. 334.

85 "Nasci" 1924, p. 73.

86 "Element und Erfindung" is the title of an article Lissitzky published in ABC no. 1 (1924), n.p., and which he was working on while preparing "Nasci." See Lissitzky's letters to Sophie Küppers in Lissitzky-Küppers 1968, pp. 37–51, which provide a fascinating background to the development of "Nasci."

87 Imitatoren 1923, p. 58 (LW–5, p. 168).

88 "Merz" 1920, p. 5 (LW–5, p. 77).

89 "Manifest Proletkunst" 1923, pp. 24–25 (LW–5, p. 143).

90 "Kunst und Zeiten" 1926 (LW–5, pp. 236–237) translated in "Art and the Times" 1927, pp. 4–5.

91 "Nasci" 1924, p. 73.

92 Ibid., pp. 81–82. This statement reappeared almost verbatim in Blok, no. 6–7, 1924, as point 10 of an editorial definition of Constructivism, which shows just how quickly such slogans were transmitted across the Constructivist network.

93 Lissitzky opposed Schwitters' intention of replacing a Braque illustration by a Klee, saying that "Nasci" must not become "a visitors' book," and he had a very specific point to make. Schwitters in turn had some reservations about a section of Lissitzky's introduction which made a veiled comparison between artistic and political developments, but Lissitzky amended a few sentences and Schwitters was satisfied. Lissitzky was extremely concerned that "everything must work out perfectly": the extent of his involvement caused Schwitters once to complain that he was being pushed out, but in the end everything did work out to their

mutual satisfaction. See Lissitzky-Küppers 1968, pp. 40, 45–46.

94 Henri Bergson, *Creative Evolution* (London, 1964), pp. 319, 335.

95 Constant references to Malevich and other Russian contacts appear in Lissitzky's letters to Sophie Küppers from Switzerland (note 86, above). References to the Malevich translations appear in letters from Feb. 23, 1924 onward. On Mar. 21, Lissitzky writes to say he has done a lot of work on the translations (Lissitzky-Küppers 1968, p. 39 ff.).

96 "From Cubism and Futurism to Suprematism. The New Realism in Painting" (3rd edition of the first Suprematist manifesto). Translated in *Malevich. Essays*, vol. 1, p. 25.

97 "On New Systems in Art," *Malevich. Essays*, vol. 1, pp. 100–101.

98 The argument is outlined in "On New Systems in Art" (*Malevich. Essays*, vol. 1, pp. 83–117). For Malevich's understanding of Cézanne, Cubism and collage, and his attitudes to nature: John Golding, "The Black Square," *Studio International*, vol. 189, no. 974 (Mar.–Apr. 1975), pp. 96–106.

99 "From Cubism and Futurism to Suprematism," *Malevich. Essays*, vol. 1, pp. 37–38.

100 Letter to Sophie Küppers, Feb. 23, 1924. Lissitzky-Küppers 1968, p. 39.

101 See Lissitzky's letter to Sophie Küppers, Mar. 23, 1924. Ibid., p. 47.

102 "Nasci" 1924, p. 75.

103 *Von Material zu Architektur* (Munich, 1928). Quoted here from the English translation (Moholy-Nagy 1947, p. 46). Earlier in his book, Moholy had spoken of the principles of biotechnics and quoted from Raoul H. Francé's 1920 "Die Pflanze als Erfinder" as follows: "Each process in nature has its necessary form. All technical forms can be deduced from forms in nature. The laws of least resistance and of economy of effort make it inevitable that similar activities shall always lead to similar forms. So man can master the powers of nature in another and quite different way from what he has done hitherto" (Moholy-Nagy 1947, p. 29).

104 Lissitzky-Küppers 1968, pp. 45–46. In a further letter, of Mar. 23, 1924 (above, n. 83), Lissitzky thanks Sophie Küppers for sending him Francé's address. Lissitzky was in contact with Moholy-Nagy in this same period and may well have passed on his interest in Francé to him (unless, of course, Moholy was the original source of the interest).

105 Robert Goldwater, *Primitivism in Modern Painting* (New York, 1938), pp. 131–140; see also pp. 24–28 for details of the Riegl and Worringer writings mentioned below.

106 W. Hausenstein, *Klassiker und Barbaren* (Munich, 1923).

107 H. Kuehn, *Die Kunst der Primitiven* (Munich, 1923).

108 Goldwater (note 105, above), p. 27.

109 Tönnies' *Gemeinschaft und Gesellschaft* has now been translated as *Community and Society* (East Lansing, Michigan, 1957).

110 "Katalog" 1927, p. 100 (*LW–5*, p. 253).

111 "Merz" 1920, p. 9 (*LW–5*, p. 82).

112 "Aus der Welt" 1923, pp. 49–56; "Stegreiftheater MERZ" 1924, pp. 26–38 (*LW–5*, pp. 153–166).

113 Schwitters' many writings on the *Merzbühne* are collected in *LW–5*, pp. 202–312.

114 See note 61, above.

115 László Moholy-Nagy, "Theater, Circus, Variety," in *The Theater of the Bauhaus*, ed. Walter Gropius (Middletown,

Conn., 1961), p. 62 (translation of *Die Bühne im Bauhaus*, 1925).

116 "Normalbühne Merz" 1925 (*LW–5*, p. 202).

117 "Normalbühne" 1925 (*LW–5*, p. 206). Illustrations in "Typoreklame" 1924, p. 91 and "Katalog" 1927, p. 101.

118 "Normalbühne" 1925 (*LW–5*, p. 206).

119 Raoul Hausmann has described a project Schwitters outlined to him, which used a stage divided into two levels, with groups of actors on each, who would shout alternately, "high, high, high," and "low, low, low," according to their level. From time to time they would change positions, the piece lasting up to two hours. (Hausmann 1958, p. 117–119.)

120 "Katalog" 1927, p. 101 (*LW–5*, p. 254).

121 Influenced by Appia and Craig, the Russian "stylistic" theater developed in opposition to the naturalism of Stanislavsky. Although professional enemies, Tairov and Meyerhold were equally influential in the development of a more formalized theater. Tairov's foundation of the Kamerny theater in Moscow in 1914 marked the first important step in this direction. By 1920 he was using Cubist-Constructivist settings. Meyerhold's production of *The Magnificent Cuckold* in Apr. 1922 was the first to use movable sets (by Popova) which "responded" to the action of the play; but Tairov was the first to introduce the ideas of an "emancipated" theater to the West: his *Das entfesselte Theater* was published in Potsdam in 1923.

122 Lissitzky's Hannover lecture was likely the same as the 1922 one entitled "Neue russische Kunst" in Lissitzky-Küppers 1968, pp. 330–340. There (p. 339), Lissitzky talks of a three-part division of stage elements: 1, the movement of actors; 2, the stage apparatus; 3, the whole structure.

123 See note 115, above; *MA*, "Musik und Theater Nummer," Sept. 15, 1924; *Die Form, Monatsschrift für Gestaltende Arbeit*, vol. 1, no. 3, 1922.

124 *LW–4* presents Schwitters' theatrical writings, discussed in the introduction to that volume and in Lach 1971, p. 161–177.

125 It was composed jointly with Steinitz (see Steinitz 1968, pp. 54, 59–66).

7 PHANTASMAGORIA AND DREAM GROTTO
pp. 144–172

1 Alfred Dudelsack in *Beilage zur Braunschweiger Illustrierten Woche* (Braunschweig, 1920), as cited by Elger 1982, p.28.

2 *Börsenkurier*, Oct. 31, 1924.

3 I am indebted to David Britt for this suggestion.

4 *Börsenkurier*, Oct. 31, 1924. See Schmalenbach 1967, p. 249, n. 167; Richter 1965, illus. 69. If Schwitters did, in fact, call this his "Christmas tree" it is ironical that his hostility towards Huelsenbeck was exacerbated after Huelsenbeck, when visiting Hannover, found Schwitters' decorated Christmas tree evidence of his bourgeois taste (see Huelsenbeck 1961, p. 58). However, Huelsenbeck also saw another "tree" in Schwitters' studio, which was probably an early stage of the *Merzbau*. See below.

5 "Ich und meine Ziele" 1930, p. 115 (*LW–5*, p. 344).

6 Ibid.

7 Steinitz 1968, p. 90.

8 Huelsenbeck 1974, p. 66.

9 Huelsenbeck 1920–2, p. 91 ff.

10 Waldberg 1958, p. 162-163; and for the following details of the visit.

11 *G*, no. 3 (June 1924) p. 46; Lissitzky and Arp 1925, p. 11,

illus. 68. The inscription "Schwitters 1920" between illus. 68 and 69 in *Kunstismen* could equally refer to illus. 69, an untitled assemblage which Schmalenbach 1967 (p. 363, n. 57) describes as *Spielkartenharmonika* of 1919. It is not this work, in fact, but an untitled assemblage which Schmalenbach 1967 (fig. 24) dates to 1921, but which is probably no later than 1920.

12 Elger 1982, pp. 30–32. After the text of this book had been completed, Elger's book on the *Merzbau* appeared (Elger 1984), which enlarges on the material presented in his 1982 article. It has been possible only to add some references to the book in a few of the following footnotes.

13 Ernst Schwitters also notes that this room was originally Schwitters' father's bedroom. For details of the development of the *Merzbau*, I am indebted to a number of conversations with Ernst Schwitters and to his account in Schmalenbach 1967, pp. 136–138.

14 Tokyo 1983, p. 142.

15 Gröttrup 1920, pp. 149–152.

16 Elger 1982, p. 30, suggests that Schwitters moved to his new studio (room 2) in 1921, but this is not certain. It is possible that he used part of his three-room apartment to work in until room 2 was available. For if it was available in 1921, why was that not used for billeting during the housing shortage?

17 If the move took place in the winter of 1922–23 it would presumably have happened after Schwitters' visit to Holland, i.e. early in 1923. If this is the case, the photograph of the "1923 column" (illus. 176) was taken shortly after the move.

18 Among the identifiable fragments are: the framed collage, *Der erste Tag* (now lost, presumably destroyed with the *Merzbau*, but illustrated in "erstes Veilchenheft" 1931, p. 113; the cover of the "Anthologie Bonset" issue of *De Stijl* (vol. 4, no. 11, Nov. 1921) on the left face of the column; and the "Holland Dada" issue of *Merz* (no. 1, Jan. 1923), recognizable from its first page with the words "Merzidee Merz Merzidee" to the left of *Der erste Tag*, and from its front cover below the collage.

19 For example Richter 1965, illus. 73, 74, dates the *Merzbau* as begun in 1918, while virtually every older publication on the work suggests that it began in a sheerly intuitive way. Although, of course, the debris in Schwitters' studio was necessary to the *Merzbau's* construction, and while Schwitters may indeed have begun to combine elements intuitively in his first studio, the fact that he began again in his second studio indicates that the *Merzbau* was not simply a "spontaneous" work.

20 "Ich und meine Ziele" 1930, pp. 115–116 (*LW–5*, pp. 344–345).

21 Steinitz 1968, p. 89 ff.

22 Tokyo 1983, p. 142.

23 See "erstes Veilchenheft" 1931, pp. 115–116, where the work is referred to as "Kathedrale des erotischen Elends" (*LW–5*, pp. 343–345).

24 "Holland Dada" 1923, p. 8 (*LW–5*, p. 132).

25 "Imitatoren" 1923, p. 58 (*LW–5*, p. 168).

26 Steinitz 1968, p. 90.

27 If the *Merzbau* was not in fact very far advanced in 1924–25, that could explain why Schwitters chose to have published the earlier photographs.

28 See note 23, above.

29 "Le Merzbau" 1933, p. 41 (*LW–5*, p. 354), when it is first referred to in print as the *Merzbau*.

30 "Schloss und Kathedrale" 1922, p. 87 (*LW–5*, pp. 95–96).

31 *De Stijl*, vol. 6, no. 6–7 (1924), pp. 89–92.

32 This distinction was first formulated by Schwitters in the first issue of *Merz*, and thenceforward appeared regularly in the writings of the 1920s.

33 "Imitatoren" 1923, p. 58 (*LW–5*, p.108).

34 "Katalog" 1927, p. 100 (*LW–5*, p. 253).

35 Schwitters' interest in architecture first makes itself visible in the "Schloss und Kathedrale" article of 1922; thenceforward he regularly published illustrations of architecture in *Merz*. However, only one of his planned architectural publications appeared: Hilberseimer's *Grosstadtbauten* as *Merz*, no. 18–19, 1925.

36 "Neue Architektur" 1929, p. 176 (*LW–5*, p. 321).

37 "Holland Dada" 1923, p. 11 (*LW–5*, pp. 134–135).

38 Steinitz 1968, illus. preceding p. 67.

39 See Erich Buchholz, "1922, Raum Herkulesufer 15," *Bauwelt*, no. 18, 1969, p. 629. Reprinted in Frederick W. Heckmanns, ed., *Erich Buchholz* (Cologne 1978), pp. 30–32. See also the catalog *Erich Buchholz* (Berlin-Charlottenburg: Galerie Daedalus Berlin, 1971), n.p.; and Rowell 1979, pp. 28–29, for discussion of the projects by Buchholz, Peri, and Lissitzky.

40 Heckmanns, *Erich Buchholz* (note 39, above), pp. 26, 31.

41 Ibid., p. 28.

42 Rowell 1979, pp. 29–30, 137.

43 Theodore M. Brown, *The Work of G. Rietveld, Architect* (Utrecht, 1958), pp. 26–27, 168.

44 Statement of 1928, in Lissitzky-Küppers 1968, p. 325.

45 "PROUN" 1920, *De Stijl*, vol. 5, no. 6 (June 1922), translated ibid., p. 343.

46 For details of the project: "Proun Room, Great Berlin Art Exhibition, 1923," *G*, July 1923, translated ibid., p. 361.

47 Lissitzky held an exhibition at the Kestner-Gesellschaft in Jan.–Feb. 1923, lectured there that June, and illustrated the Berlin *Prounenraum* on one of the lithographs he prepared for the society (illus. 185).

48 See note 31 above. The collaboration of these three also led to a joint exhibition of their architectural projects at the Galerie de l'Effort Moderne in Paris, which they must have been preparing when Schwitters was in Holland. See also Elger 1984, pp. 51–52.

49 See note 31, above.

50 Richter 1965, p. 152.

51 Schmalenbach 1967, p. 141.

52 For Schwitters' De Stijl-influenced sculpture, see p. 191. Since he did not exhibit at Der Sturm in 1923, the "De Stijl" sculpture could not have been added to the *Merzbau* until 1924 at the earliest.

53 Barr 1936, p. 244, and catalog entry p. 262.

54 According to Ernst Schwitters, this photograph, together with illus. 168, was taken around 1932. When first published in "Le Merzbau" 1933, p. 41, it was captioned "Kurt Schwitters 1933." According to Ernst Schwitters, illus. 170, 175, and 178 were taken in 1930.

55 Schmalenbach 1967, p. 141.

56 See Schmalenbach 1967, figs. 179, 184.

57 This was originally reproduced with the 1933 article "Le Merzbau," together with the photographs of the *Goldgrotte* which Barr used in *Fantastic Art, Dada, Surrealism*.

58 According to Ernst Schwitters, this photograph (illus. 170) was taken around 1930.

59 Quoted by Elger 1982, pp. 34–35.

60 Richter 1965, pp. 152–153.

61 "Ich und meine Ziele" 1930, pp. 115–116 (*LW–5*, p. 344–345).

62 In *abstraction, création, art non–figuratif*, no. 3 (1934), p. 40, with the caption "Schwitters 1933." The same image appears in Barr 1936, p. 294, with the caption "Blue Window 1933." The color of this window has Symbolist–Expressionist connotations of infinity.

63 Although the covering has been removed from the head on top of this column, it is clearly the same work. There was a copy of this photograph in the ownership of Mr. Stefan Themerson, which is signed by Schwitters and dated to 1932. However, see note 54 above for Ernst Schwitters' suggested date of 1930. If Ernst Schwitters is right, the Themerson print may have been signed and dated later, possibly along with the other photographs published in "Le Merzbau" 1933. Moreover, it is entitled "Grand Corniche" (possibly a French title for the *grosse Gruppe*).

64 See note 54, above.

65 The dimensions of the room given here are derived from the plan published in Elger 1982, p. 31, except for the height, which is Ernst Schwitters' estimate.

66 Presumably, part of the *KdeE* is visible to the right of illus. 175. Schmalenbach 1967, fig. 185, shows a detail of the Barbarossa Grotto in the *KdeE*.

67 Ernst Schwitters, in conversation with the author.

68 Letter to Alfred Barr, Nov. 23, 1936. Archives of The Museum of Modern Art, New York.

69 E.g. Richter 1965, pp. 152–153; Steinitz 1968, p. 91; Hans Arp, "Kurt Schwitters" in *Onze Peintres vus par Arp* (Zurich, 1949), pp. 26–27.

70 The reconstruction was made for a 1983 exhibition (see *Gesamtkunstwerk* 1983 and *Der Hang zum Gesamtkunstwerk. Liste der ausgestellten Werke und Dokumente* [Zurich: Kunsthaus, 1983]), and is now at the Sprengel Museum in Hannover.

71 Letter to Christof and Luise Spengemann, Sept. 18, 1946. *Briefe*, p. 229–30.

72 Steinitz 1968, caption to illus. of the White Palace, preceding p. 67.

73 "Ich und meine Ziele" 1930, p. 115 (*LW–5*, p. 343).

74 See note 18, above.

75 The sections of drapery in this collage are also taken from the same Lochner source, specifically from the Madonna's dress. Since the head of the Madonna appears in *Die Handlung spielt in Theben* (illus. 84), it is reasonable to assume that these works are contemporaneous.

76 I am indebted to Professor Norbert Lynton for this identification.

77 Käte T. Steinitz, "The Merzbau of Kurt Schwitters," unpubl. MS., quoted in William C. Seitz, *The Art of Assemblage* (New York, 1961), p. 50.

78 "Ich und meine Ziele" 1930, p. 116 (*LW–5*, p. 345).

79 *Bauwelt*, vol. 50, no. 13 (Mar. 1959), p. 405.

80 Richter 1965, p.152.

81 Steinitz 1968, p. 90.

82 Ibid., p. 91.

83 Janis and Blesh 1962, p.63.

84 Steinitz 1968, pp. 90–91.

85 Richter 1965, p. 152.

86 Steinitz 1968, p. 90.

87 This is the approximate total of the named grottos and features of the *Merzbau* listed in "Ich und meine Ziele" 1930, pp. 113–117 (*LW–5*, pp. 340–348), Richter 1965, pp. 151–153, and Steinitz 1968, pp. 89–94.

88 Steinitz 1968, p. 90.

89 "Ich und meine Ziele" 1930, p. 116 (*LW–5*, p. 345). In fact, of these three, only Arp has provided an account of the *Merzbau*, and that a very fanciful one. See note 69, above.

90 Ibid., pp. 115–116 (*LW–5*, pp. 344–345).

91 It is visible in illus. 189, lower center.

92 "Ich und meine Ziele" 1930, p. 115 (*LW–5*, p. 344). For more on Haarmann, see Elger 1984, pp. 134–135.

93 London 1972, p. 13.

94 Steinitz 1968, p. 91.

95 Lissitzky–Küppers 1968, p. 36.

96 Quoted by Cauman 1958, p. 36.

97 *Contemporary Sculpture* (New York, 1960), p. XXVII, a quotation she attributes to Schwitters.

98 "Ich und meine Ziele" 1930, p. 115 (*LW–5*, p. 343).

99 "Tapsheft" 1924, p. 66 (*LW–5*, p. 177).

100 Although not mentioning Taut by name, Schwitters was discussing architecture with special reference to Magdeburg, where these house fronts were created. Taut visited Hannover to lecture at the Kestner–Gesellschaft in 1924.

101 See the references listed at ch. 5, note 74, for examples of designs from the Arbeitsrat circle relevant to the *Merzbau*. Schwitters may well have been also affected by Paul Scheerbart's writings in favour of a freely imaginative architecture, which lie behind many Arbeitsrat projects. Elger 1984, pp. 71–72, points out that the crystalline forms of the *Merzbau* itself and the organic ones visible from its principal window recapitulate the two principal stylistic forms of Expressionist architecture. See also ch. 5, on Schwitters' Expressionist architectural contacts.

102 *Frühlicht*, vol. 1, no. 3 (Spring 1922), p. 86 (opposite *Schloss und Kathedrale* 1922).

103 At least, according to Adolf Behne, "Berlin: Bauten," *Sozialistische Monatshefte*, vol. 27, (Feb. 14, 1921), pp. 165–166. In illus. 188, above and to the right of the handle, a fragment of paper reading "THEATER SCALA" can be found.

104 E.g., Schmalenbach 1967, p. 138.

105 Mrs. Edith Thomas, in conversation with the author.

106 Kracauer 1947, p. 74.

107 Jean Cassou's phrase, ibid., p. 75.

108 Lotte Eisner, *The Haunted Screen* (London and New York 1969), p. 92.

109 A fascinating precedent in Expressionist literature for this aspect of the *Merzbau* may be found in Kubin's *Die andere Seite: Ein phantastischer Roman* (Munich, 1909), where he describes wandering through dark streets with grotesque houses into a teashop with waitresses like wax dolls moved by hidden mechanisms. At the far end of the shop, a barrel organ conceals a scene of bizarre horror. Speaking of the perception of objects, Kubin notes (part 2, ch. 5) how, "alienated from its context with other objects, everything gained a new significance."

110 Eisner (note 108, above), p. 106.

111 Statement in *Führer durch die Ausstellung der Abstrakten*, catalog of the "Grosse Berliner Kunstausstellung," 1926.

112 See Bletter 1977, pp. 97–98.

113 "Ich und meine Ziele" 1930, p. 5 (*LW–5*, p. 343).

114 Ibid., p. 116 (*LW–5*, p. 345).

115 *Transition*, no. 8 (Nov. 1927), p. 60.

116 Steinitz 1968, p. 18.

117 "Der Schürm" in *Festschrift zum Zinnoberfest* (Hannover, 1928), n.p. (*LW–2*, p. 335); "Das Thema," in *Memoiren 1922*, pp. 15–22 (*LW–2*, pp. 61–65); "Der Hahnepeter," *Merz*, no. 12,

1924, 16 pp. (*LW–2*, pp. 109–117). Schwitters also used the generic title "Familie Hahnepeter" for several of his fairy stories of the 1920s. See Steinitz 1968, pp. 30–46 and *LW–2*, pp 413–415.

118 *Auguste Bolte* 1923 (*LW–2*, pp. 68–93). See Schmalenbach 1967, pp. 245–246; also Lach 1971, pp. 137–140, for an alternative reading of this work.

119 See Steinitz 1968, p. 10; and note 117, above.

120 Lach 1971, pp. 131–134.

121 For details of the sections of the novel that were produced: *LW–2*, pp. 29–46, 391–392.

122 In *Der Marstall*, no. 1–2, [1920], p. 11.

123 "Revolution in Revon" 1922, pp. 162, 164 (*LW–2*, pp. 34–35).

124 Steinitz 1968, p. 24.

125 In an introductory note to the English–language version of this work, Schwitters mentioned that Bäsenstiel was "an irresponsible agitator who was not a citizen of Revon" (*Transition*, no. 8 [Nov. 1927], p. 60; *LW–2*, p. 384). Given Schwitters' quarrel with Huelsenbeck in the period that "Revolution in Revon" was written, it could well be that he was the model.

126 To Huelsenbeck. Quoted in Janis and Blesh 1962, p. 73. For further discussion of "Revolution in Revon" see Elderfield 1971, pp. 256–261; Last 1973, pp. 51–57. See also Lach 1971, pp. 137–140, for *Auguste Bolte* as a comparable fable of the artist in society.

127 This discussion of Schwitters' attitude to his environment is indebted to ideas presented in Susan Sontag's *On Photography* (New York, 1977), especially pp. 75–82, where Baudelaire's image is quoted.

128 Cf. Carter Ratcliff in Kynaston McShine, ed., *Joseph Cornell* (New York, 1980), p. 60.

129 Themerson 1958, pp. 14–15, is a fairly typical example of this kind of interpretation.

130 See "The claims of psychoanalysis to scientific interest" (1913), in *Freud. Standard Edition*, vol. 13 (London, 1955), pp. 165–190.

131 Ibid.

132 Richard Sheppard, "Expressionism," in Roger Fowler, ed., *A Dictionary of Modern Critical Terms* (London, 1973), pp. 65–67.

133 Ibid., p. 66.

134 For discussion of this in the context of "Revolution in Revon," see Elderfield 1971, passim.

135 See note 133, above.

136 Huelsenbeck 1974, p. 65.

137 E.g., Steinitz 1968, *passim*. Various of Schwitters' friends with whom this author has spoken or corresponded (including Raoul Hausmann, E. L. T. Mesens, Stefan Themerson, Edith Thomas) all confirm that this was so.

138 Huelsenbeck 1961, p. 58.

139 See Tillim, "Surrealism as Art," *Artforum*, vol. 5, no. 1 (Sept. 1966). pp. 66–71, for the advantages available to "provincial" and "outsider" artists in the 1920s. Schwitters' openness and eclecticism in this respect parallels that of Léger within Cubism and Miró within Surrealism.

140 Schwitters' large number of writings against hostile critics collected in *LW–5* reveal just how strongly he felt the need to justify his own art. In "Ich und meine Ziele" 1930, p. 116 (*LW–5*, pp. 345–346) he wrote that he was "an important factor in the development of art and shall forever remain so."

8 THE CITY AND THE COUNTRY
pp. 172–196

1 *Die Blume Anna* 1922, p. 31 (*LW–1*, p. 200).

2 Ibid., pp. 7–8 (*LW–1*, p. 199).

3 See Last 1973, pp. 57–58, and Middleton 1969, pp. 346–349, to which my discussion of Schwitters' abstract poetry is indebted.

4 "Holland Dada" 1923, p. 11 (*LW–5*, p. 134).

5 *Die Blume Anna* 1922, pp. 18–19 (*LW–1*, p. 204).

6 See note 3, above.

7 "Merz," 1920, p. 7 (*LW–5*, p. 79).

8 See p. 104.

9 *Die Blume Anna* 1922, p. 30 (*LW–1*, p. 206).

10 Ibid.

11 *LW–1*, p. 198, prints a "simultaneous poem" from a MS. dated Dec. 5, 1919. Apart from this, however, the abstract poems date no sooner than 1921 and first began appearing in print in *Die Blume Anna* in 1922.

12 For details of the Prague visit: Hausmann 1958, pp. 62, 112–116.

13 See "erklärungen zu meiner ursonate," in "Ursonate" 1932, p. 153 (*LW–1*, p. 312).

14 "29 Jahre Freundschaft mit Kurt Schwitters," unpublished MS., quoted by Schmalenbach 1967, p. 214.

15 See H. Kreuzer, as quoted in Last 1973, p. 60.

16 Schmalenbach 1967, p. 205.

17 *LW–1*, p. 103.

18 See, for example, "Relativität" and "Stumm" in *LW–1*, pp. 97, 89.

19 *LW–1*, p. 102, and pp. 299–300 for variant texts and publication details.

20 *Merz 12*. "Der Hahnepeter," Hannover, 1924. See *LW–2*, pp. 109–117; also Schmalenbach 1967, pp. 179–180, 236, and Lach 1971, pp. 140–143, for discussion of this work.

21 "Schacko/Jacco," "erstes Veilchenheft" 1931, pp. 110–112 (*LW–2*, pp. 289–292).

22 For details and discussions of this work see: *LW–2*, pp. 396–397; Schmalenbach 1967, pp. 234–236; Lach 1971, pp. 137–140.

23 Schmalenbach 1967, p. 236.

24 The rhyming aspects of *Auguste Bolte* are quoted and discussed more fully in Schmalenbach 1967, p. 236.

25 The work is inscribed on the verso in Schwitters' hand: "*Merzbild 12b* . . . 1919, 1923, *Plan der Liebe*" (Records of the Metropolitan Museum of Art, New York). The number *12b* indicates a 1919 date for Schwitters' beginning this work (see Ch. 3, note 9, above).

26 According to Schmalenbach 1967, p. 248 note 103, "the picture has on the back the date 1925, to which Schwitters himself affixed a question mark. It presumably dates from an earlier year but after 1920." The museum owning this work, however, chooses to retain the 1925 date.

27 *Merz 3. 6 Lithos auf den Stein gemerzt (Merzmappe)* (Hannover, 1923).

28 "The Machine Aesthetic: Geometric Order and Truth" (1925) in Fernand Léger, *Functions of Painting*, ed. Edward F. Fry (London and New York, 1973), p. 65.

29 "Contemporary Achievements in Painting" (1914), ibid., pp. 11–19; "A New Realism," *Little Review*, vol. 11, no. 2 (Winter 1926), pp. 7–8.

30 See Moholy–Nagy 1947, p. 27.

31 See, for example, László Moholy-Nagy, *Vision in Motion* (Chicago, 1947), p. 65.

32 The works in question are *Lampenbild (liegender weisser Cylinder)*, 1932 (Tokyo 1983, cat. 95) and *Das Tropfenbild*, 1934–36 (Schmalenbach 1967, fig. 138). (Information courtesy Ernst Schwitters.)

33 E.g. *Albert Finslerbild*, 1926 (illus. 211) and *Gustav Finslerbild*, 1926–37 (Schmalenbach 1967, p. 199); *Merzbild mit grünem Ring*, 1926 (Schmalenbach 1967, illus. 125) and *Merzbild mit grünem Ring*, 1926–37 (not reproduced; whereabouts unknown). (Information courtesy Ernst Schwitters).

34 "Holland Dada" 1923, p. 8 (*LW–5*, p. 132).

35 "Imitatoren" 1923, p. 58 (*LW–5*, p. 168).

36 "Kunst und Zeiten" 1926 (*LW–5*, p. 238).

37 Letter to Margaret Miller, Dec. 11, 1946 (Archives of The Museum of Modern Art, New York).

38 "Katalog" 1927, p. 100 (*LW–5*, p. 253). Quite how Schwitters left *Kleines Seemannsheim* is uncertain. A number of early photographs—including one that Schwitters mounted in his own 1928 photograph album (now in a New York private collection)—shows it without the wheel fragment. It is reproduced like this in Giedion-Welcker 1948, p. 218. It may have been one of the works that Schwitters sent for and reworked when he was in Norway (see p. 200), for Giedion-Welcker presumably used an earlier photograph.

39 Schmalenbach 1967, 142.

40 See Schmalenbach 1967, figs. 130, 131, illus. 129.

41 *Société Anonyme* 1984, p. 607.

42 "Kunst und Zeiten" 1926 (*LW–5*, p. 238), translated in "Art and the Times" 1927, p. 7.

43 "Gestaltende Typographie" 1928, p. 266 (*LW–5*, pp. 313–314).

44 For additional details of Schwitters' design work: Schmalenbach 1967, pp. 56–57, 180–193; Anon. 1964, pp. 22–29.

45 The work is reproduced here after *Paris-Berlin 1910–1933* (Paris: Centre Georges Pompidou, 1978), p. 219, where it is tentatively attributed to Schwitters. It should be noted here that the name "Merz" which appears in the pamphlet, *Karlsruhe. Ausstellung Dammerstock–Siedlung. Die Gebrauchswohnung* (Karlsruhe, 1929), which Schwitters designed, does not refer to Schwitters but is the name of a building engineer who collaborated with some of the architects at the Dammerstock–Siedlung exhibition.

46 Steinitz 1968, p. 17.

47 "Typoreklame" 1924, p. 91 (*LW–5*, p.192).

48 *Werbe-Gestaltung* (undated) (*LW–5*, pp. 214–230).

49 *Malevich. Essays* vol. 1, p. 73.

50 Letter to Sophie Küppers, Mar. 23, 1924. Lissitzky-Küppers 1968, p. 47.

51 In "nummer i" 1923, p. 19 (*LW–6*, p. 139).

52 Ibid., pp. 17–18 (*LW–5*, p. 137–138).

53 "Nasci" 1924, p. 85.

54 "i (Ein Manifest)," *Der Sturm*, vol. 13, no. 5 (May 1922), p. 80 (*LW–5*, p. 120).

55 "Kunst und Zeiten" 1926 (*LW–5*, p. 237), in "Art and the Times" 1927, p. 5.

56 "Nasci" 1924, p. 73.

57 "Meine Ansicht zum Bauhaus–Buch 9" 1927 (*LW–5*, pp. 256–258).

58 See *LW–5*, pp. 237, 243–249.

59 See, for example, *Mz. 2009. Lichtkegel*, 1925 (New York, 1959, cat. 21), an unusual work which prefigures (albeit in a geometric context) Schwitters' later more sustained interest in atmospheric and dissolved "painterly" effects. Among the few comparable works of the 1920s is an undated *Blau in blau* in the Peggy Guggenheim Collection.

60 "Katalog" 1927, p. 102 (*LW–5*, p. 254).

61 Letter to Margaret Miller, Dec. 11, 1946 (Archives of The Museum of Modern Art, New York). Schwitters' father, however, did not die until 1931, which is why I assume the title was given after its completion—if, indeed, it was Schwitters' first piece of sculpture.

62 "Le Merzbau" 1933, p. 41 (*LW–5*, p. 354). Schwitters' reference to the importance of the spiral may owe something to the statement in "Nasci" 1924, p. 84 on Tatlin's tower, to the effect that the spiral is the symbol of our age (an interpretation of the form derived from Tatlin and Russian art theory). Schwitters, however, seems to have viewed the spiraling organic forms the *Merzbau* assumed in the early 1930s as symbolic of a personal liberation, comparable in some ways to the original liberation of Merz itself. The 1931 assemblage *Neues Merzbild* (discussed below), which initiates his changed late style, suggests as much in its title. It cannot be merely coincidental that these changes in Schwitters' art in the early 1930s took place around the time of the death of his father in 1931; it is not unusual that an artist's development undergoes change around the time of his father's death.

63 *Dada Profile* (Zurich, 1961), p. 101.

64 Schmalenbach 1967, p. 139.

65 "Ich und meine Ziele" 1930, p. 115 (*LW–5*, p. 344).

66 For Vitalist ideas generally and in relation to modern sculpture: Frank Kermode, *Romantic Image* (London, 1957), p. 43 ff; Jack Burnham, *Beyond Modern Sculpture* (New York, 1968), ch. 2.

67 E. Schwitters 1958, p. 8.

68 *Cercle et carré*, vol. 1, no. 1 (Mar. 1930), p. 6 (*LW–5*, p. 323).

69 See note 62, above.

70 *abstraction, création, art non–figuratif*, nos. 1–5, 1932–1936.

71 Steinitz 1968, opp. p. 67.

72 Arp's first sculpture in the round dates to 1930. The *Concretions* date from 1933. A third Dadaist, Max Ernst, turned to sculpture in the round in this same period.

73 "Das Ziel meiner Merzkunst" 1938 (*LW–5*, p. 363).

74 Cubist and Cubist-influenced openwork sculpture is illustrated in *Merz*, passim, in 1923 and 1924; and of course Schwitters was friendly with practitioners of Constructivist versions of this style.

9 SCHWITTERS IN EXILE
pp. 197–223

1 A fairly comprehensive list of Schwitters' exhibitions is given in Schmalenbach 1967, pp. 369–370.

2 See Ruth Bohan, *The Société Anonyme's Brooklyn Exhibition* (Ann Arbor, 1982) pp. 47–48, 115.

3 See Angus Wilson's "Charles Dickens," which introduces each of the volumes in the Penguin English Library (Harmondsworth) edition of Dickens' works.

4 Lissitzky-Küppers 1968, p. 61.

5 E.g. *Katarinahissen* (London 1972, cat. 59), *Cam 20's 20 öre* and *Övergangsbiljett* (New York 1965, cats. 133, 134).

6 See also Richter 1965, pp. 153–154 and Sibyl Moholy-Nagy, *Moholy-Nagy. Experiment in Totality* (New York, 1950), pp. 100–103, for other examples of Schwitters' anti-Nazi activities.

7 Ernst Schwitters was apparently involved in anti-Nazi activities, which made his escape necessary, and Schwitters decided to accompany his son into exile. (See London 1981, p. 37.)

8 Huelsenbeck 1961, p. 58.

9 See Schwitters' letter to Sophie Taeuber, May 10, 1938 (*Briefe*, p. 145), where he says that the works arrived eight days ago and that he is working on them.

10 In May 1936, the Galerie Charles Ratton in Paris presented the "Exposition surréaliste d'Objets," and a special issue of *Cahiers d'Art* (no. 1–2, 1936) was produced on the Surrealist object.

11 Letter to Nelly van Doesburg, May 21, 1947. *Briefe*, p. 276.

12 E.g. *Bildnis eines frommen Mannes*, 1937, and *Regenbogen-Säule*, 1945–47 (Tokyo 1983, cat. 108 and 192).

13 E.g. *Konfrontasjon*, 1938 (New York 1965, cat. 144).

14 To Huelsenbeck. Quoted in Janis and Blesh 1962, p. 73.

15 *The Social History of Art* (London, 1962), vol. 4, p. 222.

16 The only known sources of information are a text by Schwitters, "Bogen 1 für mein neues Atelier," of Apr. 6, 1938 (*LW–5*, pp. 365–366); some brief mentions of the work in letters to friends (*Briefe*, pp. 145, 148, 149); and the recollections of Ernst Schwitters (see Schmalenbach 1967, pp. 166–168 and London 1981, p. 51). I am indebted to Ernst Schwitters for showing me the site of this work and describing it to me.

17 Letter to Mrs. Annie Müller-Widmann, Jan. 28, 1938 (Schmalenbach 1967, p. 159).

18 Ibid.

19 See note 9, above.

20 Letter to Alfred Barr, Nov. 23, 1936. Archives of The Museum of Modern Art, New York; see note 17, above.

21 See note 9, above.

22 Nicholas Wadley in London 1981, p. 37.

23 I am indebted to Richard Friedenthal and Fred Uhlman, who spoke to me of their time at Douglas. Friedenthal's novel *Die Welt in Nusschale* (Munich, 1956) is based on the Douglas camp and uses Schwitters as a model for one of the characters. See also Uhlman 1960, Uhlman 1964, and Fred Uhlman, "Kurt Schwitters," *The Listener*, June 3, 1954, pp. 957–958.

24 Uhlman 1964, p. 64.

25 Uhlman 1960, p. 235.

26 E. Schwitters 1958, p.8.

27 Uhlman 1960, p. 235.

28 Ibid.

29 Quoted after Nicholas Wadley in London 1981, p. 38.

30 In Dec. 1944, Bilbo's Modern Art Gallery presented a Schwitters exhibition with a catalog introduction by Herbert Read (see London 1944). Mesens' London Gallery exhibition came in 1950, after the artist's death.

31 Schwitters' son has written that his father "resisted the so-called 'Deutscher Kulturbund,' an association of refugee artists in England, because of their definite political tendencies. He rather suffered their hatred . . . than yield to their view." (Motherwell 1951, p. xxiii.) See also *Briefe*, p. 182.

32 "On the bench," from Schwitters' London notebook, in Themerson 1958, p. 43. That Schwitters did indeed contact Kenneth Clark at the National Gallery was confirmed to me in conversation by Edith Thomas who accompanied him there.

33 Schwitters first learned of the destruction of his house in Hannover and the *Merzbau* from a letter sent by Marguerite Hagenbach, Jan. 7, 1945. (Letter to Marguerite Hagenbach, Feb. 27, 1945. *Briefe*, p. 178.)

34 Schwitters learned of Helma's death from a telegram sent by Marguerite Hagenbach in December of 1944. (Ibid. Letter to Raoul Hausmann, June 18, 1946. *Briefe*, p. 200).

35 Bridge House in Ambleside spans the river there, and is still a tourist attraction. It was then an antique shop.

36 The Hausmann–Schwitters correspondence is reprinted in Reichardt 1962, pp. 2–18, from which the details of *Pin* given here are derived. See also *Briefe*, p. 199 ff.

37 Reichardt 1962, p. 38.

38 Ibid., p. 34.

39 Themerson 1958, p. 51.

40 "Organisation" 1946 (*LW–1*, p. 154).

41 *LW–1*, pp. 162, 157.

42 Ibid., p. 79.

43 Ibid., p. 164.

44 Schwitters' English prose writings are collected in *LW–3*, pp. 282–301.

45 Reichardt 1962, pp. 13–14.

46 It may be relevant that Schwitters referred to Picasso as a "gangster" in a letter to Raoul Hausmann of Dec. 19, 1946 (*Briefe*, p. 254).

47 Cf. Nicholas Wadley in London 1981, p. 67. In addition to the five collages from this series reproduced in London 1981 (cats. 56, 63–66), three others are known: *Number 17* (New York 1959, cat. 59) *What is Morale?* (Düsseldorf 1971, cat. 229) and *Untitled* (*The Courtship*) (Schmalenbach 1967, fig. 93).

48 Steinitz 1968, p. 107, where the collage is illustrated. For details of the Schwitters–Steinitz correspondence, see Steinitz 1968, pp. 96–109, and New York 1965, pp. 11–12.

49 Steinitz 1968, p. 100.

50 Although the title "Aerated" is descriptively appropriate to these open, painterly works, it in fact derives from a fragment of paper in one of them advertising the Aerated Bread Company.

51 Gilpin, *Northern Tour*, 1786. Quoted by Christopher Hussey, *The Picturesque* (London, 1927), p. 34.

52 Uhlman 1964, p. 65; Uhlman 1960, p. 239.

53 See Schmalenbach 1967, pp. 158–159.

54 Letter of Dec. 9, 1946. Reichardt 1962, p. 15.

55 "Katalog" 1927, p. 100 (*LW–5*, pp. 253–254).

56 Schmalenbach 1967, p. 162.

57 "Merz" 1920, p. 7 (*LW–5*, p. 79).

58 "Kunst und Zeiten" 1926 (*LW–5*, p. 237).

59 Ibid. (*LW–5*, p. 236).

60 Letter to Hausmann, June 27, 1946. Reichardt 1962, p. 5.

61 In conversation with the author.

62 Letter to Alfred Barr, Nov. 1, 1945. Archives of The Museum of Modern Art, New York.

63 For discussion of a related pierced-eye image in Miró's work, see *Joan Miró. Magnetic Fields* (New York: The Solomon R. Guggenheim Museum, 1972), pp. 77–78.

64 Letter to Christof and Luise Spengemann, April 25, 1946. *Briefe*, pp. 193–194.

65 Details of Schwitters' contacts with The Museum of Modern Art are derived from the correspondence and memoranda preserved in the Museum's Archives.

66 Nicholas Wadley in London 1981, p. 40.
67 My account of Schwitters' work on the Merzbarn, and his life in Ambleside in general, is especially indebted to conversations with Mrs. Edith Thomas, and also with Messrs. Bickerstaff. Pierce and Lancaster, who knew him there.
68 Quoted by Giedion-Welcker 1948, p. 221. Giedion-Welcker was in correspondence with Schwitters in England.
69 Quoted in Feaver 1974, p. 34.
70 See Nicholas Wadley in London 1981, p. 54.
71 Letter to Ludwig Hilberseimer, Oct. 25, 1947. *Briefe*, p. 293.
72 Letter to Christof and Luise Spengemann, Jan. 26, 1946. *Briefe*, p. 187.
73 Steinitz 1968, p. 102.
74 "Licht," *c.* 1935 (*LW–5*, p. 369).
75 "Nasci" 1924, p. 74; "Ich und meine Ziele" 1930, p. 115 (*LW–5*, p. 344).
76 According to Mr. Harry Pierce, in conversation with the author.
77 Sir Uvedale Price, *On the Picturesque* (London, 1942, ed.), p. 430.

10 POSTSCRIPT: MERZ AND MODERNISM
pp. 224–240

1 Steinitz 1968, p. 102.
2 Wantee (Edith Thomas), statement in Themerson 1958, p. 41.
3 It has long been assumed that because Schwitters received notification of the formal approval of his British citizenship on Jan. 7, 1948 (the day before he died), he therefore died a British citizen. However, an enquiry from Mary Giffard of Marlborough Fine Art to the British Home Office produced the reply on Feb. 18, 1983, that since there had been no response to Home Office letters to Schwitters in 1948 his application for British citizenship was treated as abandoned on Sept. 16, 1948. Schwitters in fact died a German citizen.
4 See New York 1948.
5 Memorial exhibitions were presented at the Galerie d'Art Moderne, Basel (Feb. 1948). The London Gallery, London (1950), and the Sidney Janis Gallery, New York (1952). *K, revue de la Poésie* presented a special issue, "Hommage à Kurt Schwitters" (no. 3, May 1949), with tributes by Arp and Giedion-Welcker and a selection of Schwitters' work.
6 Richter 1965, p. 138.
7 Hannover 1956, organized by Werner Schmalenbach.
8 "Kurt Schwitters, 1887–1948," in New York 1952, n.p.
9 Quoted by Hans J. Kleinschmidt in his introduction to Huelsenbeck 1974, p. xxxiii.
10 Ibid.
11 See Sheppard 1984, p. 50.
12 As quoted by Maurice Nadeau, *The History of Surrealism* (New York, 1965), p. 110.
13 Motherwell 1951, p. xxi.
14 Clement Greenberg, "Counter Avant-Garde," *Art International*, vol. 15, no. 5 (May 1971), p. 16.
15 On this aspect of modernism, see Clement Greenberg, "Necessity of 'Formalism'," *New Literary History*, vol. 3, no. 1 (Autumn 1971), pp. 171–175.
16 Hannah Arendt, *The Human Condition* (Chicago and London, 1958), p. 167.
17 Ibid., p. 169.
18 Rubin 1969, p. 15.
19 See Frank Kermode's useful distinction between palaeo- and neo-modernism in his *Modern Essays* (London, 1971), p. 46.
20 "Collection, Ideological, Combative," *Art News Annual*, vol. 34 (1968), pp. 75–78.
21 Ibid.
22 Motherwell 1951, p. xxi.
23 Letter to Hausmann, Mar. 29, 1947, in Reichardt 1962, p. 17.
24 Rubin 1969, p. 18.
25 Ibid., p. 15.
26 Lucy R. Lippard, "Dada into Surrealism. Notes on Max Ernst as Proto–Surrealist," *Artforum*, vol. 5, no. 1 (Sept. 1966), p.10.
27 Arp's term, used in his *On My Way: Poetry and Essays, 1912–1947* (New York, 1948), p. 91.
28 Reyner Banham observes this of Moholy-Nagy. See Banham 1960, p. 314.
29 See Sidney Tillim, "Surrealism as Art", *Artforum*, vol. 5, no. 1 (Sept. 1966), p. 69.
30 *Dada, Surrealism, and Their Heritage* (New York, 1968), p. 40.
31 *The Modern Century* (Toronto, 1969), p. 23.
32 Ibid., p. 30.
33 Arp's term, used in his *On My Way* (note 27, above), p. 91.
34 Arthur O. Lovejoy, quoted in Leo Marx, *The Machine in the Garden* (New York, 1967), p. 369, n. 11.
35 Paul Fussell, *The Great War and Modern Memory* (New York and London, 1975), p. 231.
36 Statement at *The Art of Assemblage: A Symposium*, The Museum of Modern Art, New York, Oct. 19, 1961.
37 Quoted in I.K. Bonset, "Karakteristiek van het Dadaisme," *Mecano*, no. 4–5 (1923), n.p.
38 Huelsenbeck 1920–1 (Motherwell 1951, p. 42).
39 "Interview with Hannah Höch," in Lucy R. Lippard, ed., *Dadas on Art* (Englewood Cliffs, N.J., 1971), pp. 73, 76.
40 Huelsenbeck 1920–1 (Motherwell 1951, p. 42, and for the following quotation, p. 43).
41 Ibid., p. 43.
42 René Dubois, quoted in Harry Levin, *The Myth of the Golden Age in The Renaissance* (New York, 1972), p. 164.
43 Huelsenbeck 1918, p. 38 (Motherwell 1951, p. 244).
44 See ch. 4, note 41.
45 *Imitatoren* 1923, p. 60 (*LW–5*, p. 170).
46 "Manifest Proletkunst" 1923, p. 24 (*LW–5*, p. 143).
47 Cf. André Gide, *The Counterfeiters, with: Journal of "The Counterfeiters"* (New York, 1955), p. 189.
48 Levin, *The Myth of the Golden Age* (note 42, above), p. 125.
49 Ibid., p. 59.
50 Stefan Themerson, "Kurt Schwitters on a Time-chart," *Typographica*, no. 16 (Dec. 1967), p. 37.

SELECTED BIBLIOGRAPHY

A complete bibliography of Schwitters' own writings and of publications on him and the full range of his artistic contacts would constitute a book in itself. Full details of Schwitters' writings are given in *LW* and a selection of his letters in *Briefe* (see full references below). An extensive bibliography on Schwitters by Hans Bolliger is to be found in Schmalenbach 1967; for more recent references, see the bibliographies in Lach 1971, Elderfield 1975, Scheffer 1978 and Nündel 1981. For background material, and updated Schwitters bibliography, see Kuenzli 1982 and Kuenzli 1984. Archival material is to be found in the Kurt Schwitters Archive, Oslo (much published in *LW*); the Stadtbibliothek, Hannover (see *SAH* 1983); the Dada Archive and Research Center, Iowa City: and the Archives of The Museum of Modern Art, which now includes the material assembled for the preparation of this book (among it early exhibition checklists not itemized below).

The following, highly selective list is intended to provide a useful starting point for future research and gives abbreviations where they are used in the notes. It comprises three sections: essential writings by Schwitters himself (anthologies given first); important works on Schwitters; and selected background material. Since Schwitters' own magazine *Merz* included short untitled statements by the artist as well as longer articles, reference is made here both to important articles and to the titles of important issues. Those issues of *Merz,* and other publications by Schwitters, containing only pictorial material are not included here. Details of these, and additional bibliographical information, can be extracted from the notes to this book.

SELECTED WRITINGS BY SCHWITTERS

Anna Blume und Ich. Die gesammelten "Anna Blume" – Texte, ed. Ernst Schwitters, Zurich, 1965.

Briefe. *Kurt Schwitters. Wir spielen, bis uns der Tod abholt. Briefe aus fünf Jahrzehnten,* ed. Ernst Nündel. Frankfurt, 1975.

LW. *Kurt Schwitters. Das literarische Werk,* ed. Friedhelm Lach. Vol. 1 Lyrik; vol. 2 Prosa 1918–1930; vol. 3 Prosa 1931–1948; vol. 4 Schauspiele und Szenen; vol. 5 Manifeste und kritische Prosa. Cologne, 1973–1981.

Kurt Schwitters Merzhefte als Faksimile-Nachdruck. Berne and Frankfurt, 1975. Facsimile edition of magazine issues of the *Merz* series, with an introduction by Friedhelm Lach.

Watts. Watts, Harriett, ed. *Three Painter-Poets, Arp, Schwitters, Klee. Selected Poems.* Harmondsworth, 1974.

"Merzmalerei" 1919. "Die Merzmalerei," *Der Sturm,* vol. 10, no. 4 (July 1919), p. 61. (*LW–5,* pp. 37.)

"An Anna Blume" 1919. "An Anna Blume," *Der Sturm,* vol. 10, no. 5 (Aug. 1919) p. 72. (*LW–1,* pp. 58–59.)

"Zwiebel" 1919. "Die Zwiebel," *Der Sturm,* vol. 10, no. 7 (Oct. 1919), pp. 99–103. (*LW–2,* pp. 22–27.)

"Merzbühne" 1919. "Die Merzbühne," *Sturm-Bühne, Jahrbuch des Theaters der Expressionisten.* 8th ser. Berlin, Oct. 1919, p. 3. (*LW–5,* p. 42.)

"Erklärungen" 1919. "Erklärungen meiner Forderungen zur Merzbühne," *Sturm-Bühne. Jahrbuch des Theaters der Ex-*

pressionisten. 8th ser. Berlin, Oct. 1919, p. 3. (*LW–5,* pp. 43–44.)

Anna Blume 1919. *Anna Blume, Dichtungen.* (Die Silbergäule, 39/40.) Hannover, 1919.

"Selbstbestimmungsrecht" 1919. "Selbstbestimmungsrecht der Künstler," in *Anna Blume* 1919, pp. 36–37. (*LW–5,* pp. 38–39.)

Sturmbilderbuch 1920. *Sturm-Bilderbücher IV: Kurt Schwitters.* Berlin (Aug. 1920). (Includes introduction by Otto Nebel and statement by the artist.) (*LW–5,* pp. 82–84.)

"Merz" 1920. "Merz" (dated Dec. 19, 1920). *Der Ararat,* vol. 2, no. 2 (Jan. 1921), pp. 3–9. Translated by Ralph Manheim in Motherwell 1951, pp. 55–65 (*LW–5,* pp. 74–82; 404–409.)

"Aufruf (ein Epos)," *Der Sturm,* vol. 12, no. 12 (Dec. 1921), pp. 201–204. (*LW–1,* pp. 60–63.)

"i (Ein Manifest)," *Der Sturm,* vol. 13, no. 5 (May 1922), p. 80. (*LW–5,* p. 120.) Translated in Cologne 1978, p. 41. (*LW–5,* pp. 411–412.)

"Schloss und Kathedrale" 1922. "Schloss und Kathedrale mit Hofbrunnen," *Frühlicht,* vol. 1, no. 3 (Spring 1922), p. 87. (*LW–5,* pp. 95–96.)

"Revolution in Revon" 1922. "Franz Müllers Drahtfrühling. Erstes Kapitel: Ursachen und Beginn der grossen glorreichen Revolution in Revon." *Der Sturm,* vol. 13, no. 11 (Nov. 1922), pp. 158–166. Reprinted in English as "Revolution. Causes and outbreak of the great and glorious revolution in Revon," *Transition,* no. 8 [Nov. 1927], pp. 60–76, translation by Eugène Jolas. (*LW–2,* pp. 29–38, 384–391.)

Anna Blume 1922. *Anna Blume, Dichtungen.* (Die Silbergäule 39/40.) Revised ed. Hannover, 1922.

Die Blume Anna 1922. *Elementar. Die Blume Anna. Die neue Anna Blume.* Berlin 1922.

Memoiren 1922. *Memoiren Anna Blumes in Bleie.* Freiburg im Breisgau, 1922.

"Holland Dada" 1923. *Merz 1. Holland Dada.* Hannover, Jan. 1923. (Includes "Dada complet. Dadaismus in Holland.") (*LW–5,* pp. 124–135.)

Merz 2. nummer i. Hannover, April 1923. (Includes "Manifest Proletkunst" 1923.) (*LW–5,* pp. 136–145.)

"Manifest Proletkunst" 1923. "Manifest Proletkunst," signed also by Hans Arp, Theo van Doesburg, Christof Spengemann and Tristan Tzara, in *Merz 2. nummer i* (April 1923), pp. 24–25. (*LW–5,* p. 143–144.) Translated into English in London 1981, pp. 23–24.

"Aus der Welt" 1923. "Aus der Welt: 'Merz'," *Der Sturm,* vol. 14, no. 4–6 (Apr.–June 1923), pp. 49–56, 67–76, 95–96. With Franz Rolan. (*LW–5,* pp. 153–166.)

"Banalitäten" 1923. *Merz 4. Banalitäten.* Hannover, July 1923. (Includes "Dada complet," cont. from "Holland Dada.") (*LW–5,* pp. 147–153.)

"Imitatoren" 1923. *Merz 6. Imitatoren watch step!* Hannover, Oct. 1923. (Includes "Aufruf," "Watch your step.") (*LW–5,* pp. 167–170.)

Auguste Bolte 1923. *Tran Nr. 30. Auguste Bolte (ein Lebertran)* Berlin: Der Sturm, 1923. (*LW–2,* pp. 68–93.)

"**Tapsheft**" **1924.** *Merz 7. Tapsheft.* Hannover, Jan. 1924. (Includes "Dadaisten.") (*LW–5*, pp. 176–185.)

"**Nasci**" **1924.** *Merz 8–9. Nasci.* Hannover, Apr.–July 1924. With El Lissitzky.

"**Konsequente Dichtung**" **1924.** "Konsequente Dichtung," *G*, vol. 1, no. 3 (June 1924), pp. 45–46. (*LW–5*, pp. 190–191.)

"**Typoreklame**" **1924.** *Merz 11. Typoreklame.* Hannover, 1924. (Includes "Thesen über Typographie," "Normal-Bühne-Merz".) (*LW–5*, pp. 192, 292.)

Merz 12. Hahnepeter. Hannover, 1924. With Käte Steinitz. (Also published as *Hahnepeter* [Familie Hahnepeter. Nr. 1] [Aposs 1]. Hannover, 1924.) (*LW–2*, pp. 109–117.)

Merz 16–17. Die Märchen vom Paradies. Hannover, 1924. With Kate Steinitz. (Also published as *Die Märchen vom Paradies* [Aposs 2]. Hannover, 1924.) (*LW–2*, pp. 109–139, 146–154.)

"**Stegreiftheater MERZ**" **1924.** "Stegreiftheater MERZ," in *Internationale Ausstellung neuer Theatertechnik* (exhibition catalog). Vienna, 1924, pp. 26–38. With Franz Rolan. (*LW–5*, pp. 153–166.) A reprint of "Aus der Welt," 1923.

"**Dadaizm**" **1924/25.** "Dadaizm," *Blok: Revue internationale d'avant-garde,* no. 6–7 (1924–25). (German translation in *LW–5*, pp. 193–196.)

"**Normalbühne Merz**" **1925.** "Normalbühne Merz" (dated July 1925). Manuscript in the Kurt Schwitters Archive, Oslo. (*LW–5*, pp. 204–205.)

"**Normalbühne**" **1925.** "Normalbühne" (dated Dec. 10, 1925). Manuscript in the Kurt Schwitters Archive, Oslo. (*LW–5*, pp. 206–212.)

Merz 14–15. Die Scheuche. Hannover, 1925. With Käte Steinitz and Theo van Doesburg. (Also published as *Die Scheuche.* Hannover, 1925. (*LW–2*, pp. 155–167.)

"**Kunst und Zeiten**" **1926.** "Kunst und Zeiten" (dated Mar. 1926). Manuscript in the Kurt Schwitters Archive, Oslo. Partially translated as "Art and the Times" 1927. (*LW–5*, pp. 236–240.)

"**Daten aus meinem Leben**" **1926.** "Daten aus meinem Leben" (dated 7 June 1926). Manuscript in the Kurt Schwitters Archive, Oslo. (*LW–5*, pp. 240–242.)

"**Mein Merz**" **1926.** "Mein Merz und meine Monstre Merz Muster Messe im Sturm," *Der Sturm*, vol. 17, no. 7 (Oct. 1926), pp. 106–107. (*LW–5*, pp. 242–244.)

"**Katalog**" **1927.** *Merz 20. Katalog.* Hannover, 1927. (Includes autobiographical text dated Mar. 4, 1927; catalog; "Merzbühne," "Merzzeichnungen und i-Zeichnungen.") (*LW–5*, pp. 250–255.)

"Meine Ansicht zum Bauhaus-Buch 9" (dated Apr. 26, 1927). Manuscript in the Kurt Schwitters Archive, Oslo. (*LW–5*, pp. 256–259.)

"Anregungen zur Erlangung einer Systemschrift," *i. 10*, no. 8–9 (Aug.–Sept. 1927), pp. 312–316. (Also in *Der Sturm*. vol. 19, no. 1 [Apr. 1928], p. 196; ibid., no. 2–3 [May–June 1928], pp. 203–206.) (*LW–5*, pp. 274–278.)

"Meine Sonate in Urlauten," *i. 10*, no. 11 (Nov. 1927), pp. 392–402. (*LW–5*, pp. 288–292.)

"**Art and the Times**" **1927.** "Art and the Times," *Ray*, no. 1 (1927), pp. 4–8. Partial translation of "Kunst und Zeiten" 1926.

"**Gestaltende Typographie**" **1928.** "Gestaltende Typographie," *Der Sturm*, vol. 19, no. 6 (Sept. 1928), pp. 265–269. (*LW–5*, pp. 311–315.)

"**Neue Architektur**" **1929.** "Urteile eines Laien über Neue Architektur," *i. 10*, vol. 2, no. 21–22 (June 1929), pp. 173–176. (*LW–5*, pp. 319–320.)

"**Ich und meine Ziele**" **1930.** "Ich und meine Ziele" (dated Dec. 27, 1930) in "erstes Veilchenheft" 1931, pp. 113–117. Reprinted in English as "CoEM". *Transition* no. 24 (June 1936), pp. 91–93. (*LW–5*, pp. 340–348, 423–424.)

Rasch 1930. Autobiographical statement in Rasch, Heinz and Bodo, *Gefesselter Blick. 25 kurze Monografien und Beiträge über neue Werbegestaltung.* Stuttgart, 1930, pp. 88–89. (*LW–5*, pp. 335–336.)

"**Theo Van Doesburg**" **1931.** ("Theo Van Doesburg 1917–1931") (dated June 1931), *De Stijl*, Van Doesburg Memorial Number (January 1932), cols. 55–57. Translated by Ralph Manheim in Motherwell 1951, pp. 275–276. (*LW–5*, pp. 350–351, 424–425.)

"**erstes Veilchenheft**" **1931.** *Merz 21. erstes Veilchenheft.* Hannover, 1931. (*LW–5*, pp. 340–349.)

"**Ursonate**" **1932.** *Merz 24. Ursonate.* Hannover, 1932. (*LW–1*, pp. 214–242, 311–313.)

"**Les Merztableaux**" **1932.** "Les Merztableaux," *abstraction, création, art non-figuratif*, no. 1 (1932), p. 33. (*LW–5*, pp. 352–353.)

"**Le Merzbau**" **1933.** ("Le Merzbau . . ."), *abstraction, création, art non-figuratif*, no. 2 (1933), p. 41. (*LW–5*, p. 354.)

"Bogen 1 für mein neues Atelier" (dated Apr. 6, 1938). Manuscript in the Kurt Schwitters Archive, Oslo. (*LW–5*, pp. 356–366.)

"**Das Ziel meiner Merzkunst**" **1938.** "Das Ziel meiner Merzkunst" (dated Apr. 10, 1938). Manuscript in the Kurt Schwitters Archive, Oslo (*LW–5*, pp. 362–365.)

SELECTED WORKS ON SCHWITTERS

Almanach 1982. Erlhoff, Michael, ed. *Kurt Schwitters Almanach, 1982.* Hannover, 1982.

Almanach 1983. Erlhoff, Michael, ed. *Kurt Schwitters Almanach, 1983.* Hannover, 1983.

Arnold, Heinz Ludwig, ed. *Kurt Schwitters.* Munich, 1972.

Arp, Hans. "Franz Müllers Drahtfrühling," *Quadrum*, no. 1 (May 1956), pp. 88–94.

Bletter 1977. Bletter, Rosemarie Haag. "Kurt Schwitters' unfinished rooms," *Progressive Architecture*, vol. 58, no. 9 (Sept. 1977), pp. 97–99.

Brookes, Fred. "Schwitters' Merzbarn," *Studio International*, vol. 177, no. 911 (May 1969), pp. 224–227.

Cologne, Wallraf-Richartz-Museum. *Kurt Schwitters* (exhibition catalog), 1963. With text by Gert van der Osten.

Cologne 1978. Cologne, Galerie Gmurzynska. *Kurt Schwitters* (exhibition catalog), 1978. With texts by Hans Bolliger, Werner Schmalenbach, Ernst Schwitters.

Danieli, Fidel A. "Kurt Schwitters," *Artforum*, vol. 3, no. 8 (May 1965), pp. 26–30.

Döhl, Reinhardt. "Kurt Merz Schwitters," in W. Rothe, ed. *Expressionismus als Literatur.* Berne and Munich, 1969.

Düsseldorf 1971. Düsseldorf, Städtische Kunsthalle. *Kurt Schwitters* (exhibition catalog), 1971. With essays by Werner Schmalenbach, Ernst Schwitters, Dietrich Helms, et al.

Elderfield, John. "Kurt Schwitters' last Merzbarn," *Artforum*, vol. 8, no. 2 (Oct. 1969), pp. 56–65.

Elderfield, John. "Merz in the Machine Age," *Art and Artists*, vol. 5, no. 4 (July 1970), pp. 56–59.

Elderfield 1971. Elderfield, John. "Schwitters' Abstract 'Revolution'," *German Life and Letters*, n.s., vol. 24, no. 3 (Apr. 1971), pp. 256–261.

Elderfield, John. "The Early Work of Kurt Schwitters," *Artforum*, vol. 10, no. 3 (Nov. 1971), pp. 54–67.

Elderfield, John. "Private Objects. The Sculpture of Kurt Schwitters," *Artforum*, vol. 12, no. 1 (Sept. 1973), pp. 45–54.

Elderfield 1975 Elderfield, John. "Kurt Schwitters in the history of collage." Ph.D. dissertation, Courtauld Institute of Art, University of London, 1975.

Elderfield, John. "On a Merz-Gesamtwerk," *Art International*, vol. 21, no. 6 (Dec. 1977), pp. 19–26.

Elger 1982. Elger, Dietmar. "Zur Entstehung des Merzbaus," in *Almanach* 1982.

Elger 1984. Elger, Dietmar. *Der Merzbau. Eine Werkmonographie.* Cologne, 1984.

Feaver 1974. Feaver, William. "Alien in Ambleside," *The Sunday Times Magazine* (Aug. 18, 1974), pp. 27–34.

Giedion-Welcker 1948. Giedion-Welcker, Carola. "Schwitters: or the Allusions of the Imagination," *Magazine of Art*, vol. 41, no. 6 (Oct. 1948), pp. 218–221.

Gröttrup 1920. Gröttrup, Bernhard. "Ein Besuch bei Anna Blume," *Die Pille*, vol. 1, no. 7 (Oct. 1920), pp. 149–152.

Hannover 1956. Hannover, Kestner-Gesellschaft. *Kurt Schwitters* (exhibition catalog), 1956. Introduction by Werner Schmalenbach.

Heissenbüttel, Helmut. *Versuch über die Lautsonate von Kurt Schwitters.* Wiesbaden, 1983.

Hirscher, Heinz E. *Der Merz-Künstler Kurt Schwitters und sein Materialbild.* Stuttgart, 1978.

Jones 1971. Jones, M.S. "Kurt Schwitters, *Der Sturm* and Expressionism," *Modern Languages*, vol. 52 (1971), pp. 157–160.

K. Revue de la poésie, no. 3 (May 1949). Special issue, "Hommage à Kurt Schwitters," with contributions by Arp, Giedion-Welcker and Schwitters.

Kendal 1964. Kendal (England), Abbot Hall Art Gallery. *Kurt Schwitters in the Lake District* (exhibition catalog), 1964. Introduction by Harry Pierce.

Lach 1971. Lach, Friedhelm. *Der Merz Künstler Kurt Schwitters.* Cologne, 1971.

Last 1973. Last, Rex W. *German Dadaist Literature: Kurt Schwitters, Hugo Ball, Hans Arp.* New York, 1973.

Liede, Alfred. "Der Surrealismus und Kurt Schwitters' Merz," in *Dichtung als Spiel. Studien zur Unsinnspoesie an den Grenzen der Sprache.* Berlin, 1963, vol. 1, pp. 124–141.

London 1944. London, the modern art gallery, ltd. *Painting and Sculpture by Kurt Schwitters (The Founder of Dadaism and Merz)* (exhibition catalog), 1944. Introduction by Herbert Read.

London, The London Gallery. *An Homage to Kurt Schwitters* (exhibition checklist), 1950.

London, Lords Gallery. *Kurt Schwitters* (exhibition catalog), 1958.

London, Marlborough Fine Art. *Schwitters* (exhibition catalog), 1963. Introduction by Ernst Schwitters.

London 1972. London, Marlborough Fine Art. *Kurt Schwitters* (exhibition catalog), 1972. Introduction by C. Giedion-Welcker.

London 1981. London, Marlborough Fine Art. *Kurt Schwitters in Exile: The Late Work 1937–1948* (exhibition catalog), 1981. Contains essays on the late work by Nicholas Wadley.

Los Angeles, University of California at Los Angeles Art Gallery. *Kurt Schwitters* (exhibition catalog), 1965.

Madrid 1982. Madrid, Fundación Juan March. *Kurt Schwitters* (exhibition catalog), 1982.

McClain, Meredith. "Kurt Schwitters' 'Gedicht 25': A Musicological Addendum," *German Life and Letters*, n.s. vol. 23, no. 3 (Apr. 1970), pp. 268–270.

Mehring 1919. Mehring, Walter. "Kurt Schwitters im 'Sturm'," *Der Cicerone*, vol. 11, no. 15 (July) 1919, p. 462.

Middleton 1969. Middleton, J. Christopher. "Pattern without Predictability, or: Pythagoras Saved. A Comment on Kurt Schwitters' 'Gedicht 25'," *German Life and Letters*, n.s. vol. 22, no. 4 (July 1969), pp. 346–349.

Moholy, Lucia. "Der dritte Merzbau von Kurt Schwitters," *Werk*, vol. 53, no. 3 (March 1966), pp. 110–111.

Muche, Georg. "Ich habe mit Schwitters gemerzt," in *Blickpunkt. Sturm, Dada, Bauhaus, Gegenwart.* Munich, 1961, pp. 175–180.

New York 1948. New York, Pinacotheca Gallery. *Kurt Schwitters* (exhibition catalog), 1948. Introduction by Naum Gabo and mimeographed statement: Katherine Dreier, "Kurt Schwitters: the dadas have come to town."

New York 1952. New York, Sidney Janis Gallery, *Kurt Schwitters* (exhibition catalog), 1952. Introduction by Tristan Tzara.

New York, Sidney Janis Gallery. *57 Collages by Kurt Schwitters* (exhibition catalog), 1956.

New York, Sidney Janis Gallery. *Schwitters. 75 Collages* (exhibition catalog), 1959.

New York 1963. New York, Galerie Chalette. *Kurt Schwitters* (exhibition catalog), 1963.

New York 1965. New York, Marlborough-Gerson Gallery. *Kurt Schwitters* (exhibition catalog), 1965. Introduction by Werner Schmalenbach, "Kurt Schwitters and America" by Käte Steinitz.

Nill 1981–1. Nill, Annegreth. "Rethinking Kurt Schwitters, Part One: An Interpretation of *Hansi*," *Arts Magazine*, vol. 5, no. 15 (Jan. 1981), pp. 112–118.

Nill 1981–2. Nill, Annegreth. "Rethinking Kurt Schwitters, Part Two: An Interpretation of *Grünfleck*," *Arts Magazine*, vol. 5, no. 15 (Jan. 1981), pp. 119–125.

Nill 1984. Nill, Annegreth. "Weimar Politics and the Theme of Love in Kurt Schwitters' *Das Bäumerbild*," *Dada-Surrealism*, no. 13 (1984), pp. 17–36.

Nündel 1981. Nündel, Ernst. *Kurt Schwitters in Selbstzeugnissen und Bilddokumenten.* Reinbek bei Hamburg, 1981.

Paris, Berggruen et Cie. *Kurt Schwitters: Collages* (exhibition catalog), 1954.

Paris 1980. Paris, FIAC, Grand Palais. *Kurt Schwitters* (exhibition catalog). Organized by the Galerie Gmurzynska, Cologne, 1980.

Pasadena Art Museum. *Kurt Schwitters* (catalog for a circulating exhibition organized by The Museum of Modern Art, New York), 1962.

Passuth, Krisztina. *Schwitters.* Budapest: Corvina, 1978.

Pierce, Harry. "Die letzte Lebenszeit von Kurt Schwitters," *Das Kunstwerk*, vol. 7, no. 3–4 (1953), pp. 32–35.

Reichardt 1962. *Pin*, ed. Jasia Reichardt. London, 1962.

SAH 1983. Hannover, Stadtbibliothek. *Schwitters-Archiv Hannover. Bestandsverzeichnis*, 1983.

Scheffer 1978. Scheffer, Bernd. *Anfänge experimenteller Literatur. Das literarische Werk von K. Schwitters.* Bonn, 1978.

Schmalenbach 1967. Schmalenbach, Werner. *Kurt Schwitters.* London and New York, 1967.

Schreyer, Lothar. "Der Lumpensammler," in *Erinnerungen an Sturm und Bauhaus.* Munich, 1966, pp. 65–70.

E. Schwitters 1958. Schwitters, Ernst. "Some points on Kurt Schwitters," *Art News and Review*, vol. 10, no. 20 (Oct. 1958), p. 8.

Sheppard 1984. Sheppard, Richard. "Kurt Schwitters and Dada. Some preliminary remarks on a complex topic," in *Dada-Constructivism* 1984, pp. 47–51. Also in German in *Almanach* 1983, pp. 56–64.

Spengemann 1919. Spengemann, Christof. "Kurt Schwitters," *Der Cicerone*, vol. 11, no. 18 (1919), pp. 573–581.

Spengemann 1920–1. Spengemann, Christof. *Die Wahrheit über Anna Blume.* Hannover, 1920.

Spengemann 1920–2. S. Sp. (Christof Spengemann). "Merz—die offizielle Kunst," *Der Zweemann*, vol. 1, no. 8–10 (June–August, 1920), pp. 40–41.

Steegemann 1920. Steegemann, Paul. "Das enthüllte Geheimnis der Anna Blume," *Der Marstall*, no. 102 (1920), pp. 11–31.

Steinitz 1962. Steinitz, Käte T. "K. Schwitters 1919," *Bulletin of the Los Angeles County Museum of Art*, vol. 14, no. 2 (1962), pp. 4–14.

Steinitz 1968. Steinitz, Käte T. *Kurt Schwitters: A Portrait from Life.* Berkeley and Los Angeles, 1968. Introduction by John Coplans and Walter Hopps. (An expanded English edition of her *Kurt Schwitters. Erinnerungen aus den Jahren 1918–30.* Zurich, 1963.)

Stockholm 1965. Stockholm, Konstsalongen Samlaren. *Kurt Schwitters* (exhibition catalog), 1965. With texts by Ernst Schwitters, *et al.*

Text und Kritik 1972. *Text und Kritik*, no. 35–36, Oct. 1972 (special issue devoted to Kurt Schwitters) includes articles by Helmut Heissenbüttel, Armin Arnold, Hans Burkhard Schlichting, Helgard Bruhns, Bernd Scheffer, Hans-Georg Kemper, Friedhelm Lach, Otto Nebel, and Ernst Nündel.

Themerson 1958. Themerson, Stefan. *Kurt Schwitters in England.* London, 1958.

Thomas 1950. Thomas, Edith. "Kurt Schwitters," in Michel Seuphor, *L'Art Abstrait: ses origines, ses premiers maîtres.* Paris, 1950, pp. 311–313.

Thomson 1972. Thomson, P. "A Case of Dadaistic Ambivalence: Kurt Schwitters' Stramm-Imitations and 'An Anna Blume'," *German Quarterly*, vol. 45 (1972), pp. 47–56.

Tillim 1963. Tillim, Sidney. "Dada as Fine Art," *Arts*, vol. 38. (Dec. 1963), pp. 54–59.

Tokyo 1983. Tokyo, Seibu Museum of Art and Museum of Modern Art, Seibu Takanawa. *Kurt Schwitters* (exhibition catalog), 1983.

Tzara 1964. Tzara, Tristan, "Kurt Schwitters, 1886–1948," *Portfolio*, no. 8 (Spring 1964), pp. 66–71.

Uhlman 1964. Uhlman, Fred. "My Friend Kurt Schwitters," *Portfolio*, no. 8 (Spring 1964), pp. 62–65.

Vahlbruch 1953. Vahlbruch, Heinz. "Kurt Schwitters: Maler und Dichter," *Das Kunstwerk*, vol. 7, no. 3–4 (1953), pp. 27–30.

Venice, XXX Biennale internazionale d'arte. *Kurt Schwitters* (exhibition catalog), 1960.

Vordemberge-Gildewart 1948. Vordemberge-Gildewart, Friedrich. "Kurt Schwitters," *Forum*, no. 12 (1948), pp. 356–362.

SELECTED BACKGROUND MATERIAL

abstrakten hannover 1975. Cologne, Galerie Bargera. *die abstrakten hannover.* (exhibition catalog), 1975.

Ades 1984. Ades, Dawn. "Dada-Constructivism," in *Dada-Constructivism* 1984, pp. 33–45.

Anon. 1964. "The Graphic Arts in Pelikan Publicity," *Pagina*, no. 4 (1964), pp. 22–29.

Berlin, Akademie der Künste. *Arbeitsrat für Kunst Berlin 1918–1921* (exhibition catalog), 1977.

Banham 1960. Banham, Reyner. *Theory and Design in the First Machine Age.* London, 1960.

Barr 1936. Barr, Alfred H. *Fantastic Art, Dada, Surrealism.* New York, 1936.

Beckett 1979. Beckett, Jane. "Dada, Van Doesburg and *De Stijl*," *Journal of European Studies*, vol. 9, nos. 33–34 (Mar./June 1979), pp. 1–25.

Berlin-Hannover 1977. Dallas, Museum of Fine Arts. *Berlin-Hannover: the 1920s* (exhibition catalog), 1977. With texts by Robert M. Murdock and John E. Bowlt.

Brinkmann, Richard. *Expressionismus. Internationale Forschung zu einem internationalen Phänomen.* Stuttgart, 1980.

Brühl 1983. Brühl, Georg. *Herwarth Walden und Der Sturm.* Cologne, 1983.

Cauman 1958. Cauman, Samuel. *The Living Museum. Experiences of an Art Historian and Museum Director, Alexander Dorner.* New York, 1958.

Conrads and Sperlich 1962. Conrads, Ulrich, and Hans G. Sperlich. *The Architecture of Fantasy.* New York, 1962.

Dada-Constructivism 1984. London, Annely Juda Fine Art. *Dada-Constructivism. The Janus Face of the Twenties* (exhibition catalog), 1984.

London, Arts Council of Great Britain. *Dada and Surrealism Reviewed* (exhibition catalog), 1978. Mainly by Dawn Ades.

Elderfield 1970. Elderfield, John. "Dissenting ideologies and the German Revolution," *Studio International*, vol. 180, no. 927 (Nov. 1970), pp. 180–187.

Elderfield, John. "On the Dada-Constructivist Axis," *Dada-Surrealism*, no. 13 (1984), pp. 5–16.

First Russian Show 1983. London, Annely Juda Fine Art. *The First Russian Show. A Commemoration of the Van Dieman Exhibition, Berlin 1922.* (exhibition catalog), 1983.

Foster and Kuenzli 1979. Foster, Stephen C., and Rudolf E. Kuenzli, ed. *Dada Spectrum. The Dialectics of Revolt.* Iowa City, 1979. Includes Richard Sheppard: "Dada and Mysticism: Influences and Affinities." See also Iowa City, Iowa Museum of Art.

Franciscono 1971. Franciscono, Marcel. *Walter Gropius and the Creation of the Bauhaus in Weimar. The Ideals and Artistic Theories of Its Founding Years.* Urbana, Ill., 1971.

Gesamtkunstwerk 1983. *Der Hang zum Gesamtkunstwerk: europäische Utopien seit 1800* (exhibition catalog), 1983.

Giedion-Welcker 1965. Giedion-Welcker, Carola, ed. *Poètes à l'Ecart. Anthologie der Abseitigen.* Bern-Bümplitz, 1946. Revised ed., Zurich, 1965.

Hannover, Kunstmuseum Hannover mit Sammlung Sprengel. *Gemälde, Skulpturen, Aquarelle und Zeichnungen des 20. Jahrhunderts* (exhibition catalog), 1979.

Hausmann 1958. Hausmann, Raoul. *Courrier Dada*, Paris, 1958.

Hausmann 1971. Hausmann, Raoul. "Dada riots moves and dies in Berlin," *Studio International*, vol. 181, no. 932 (April 1971), pp. 162–165.

Hausmann 1972. Hausmann, Raoul. *Am Anfang war Dada.* Steinbach-Giessen, 1972.

Helms 1963. Helms, Dietrich. "The 1920s in Hannover," *Art Journal*, vol. 22, no. 3 (Spring 1963), pp. 141–144.

Huelsenbeck 1918. Huelsenbeck, Richard. *Erstes Dadaistisches Manifest.* Berlin (1918). Translated by Ralph Manheim in Motherwell 1951, pp. 242–246, where it is erroneously dated to 1920.

Huelsenbeck 1920–1. Huelsenbeck, Richard. *En Avant Dada. Eine Geschichte des Dadaismus.* Hannover, 1920. Translated by Ralph Manheim in Motherwell 1951, pp. 21–48.

Huelsenbeck 1920–2. Huelsenbeck, Richard. *Dada Almanach.* Berlin, 1920.

Huelsenbeck 1961. Huelsenbeck, Richard. "Dada and Existentialism," in Willy Verkauf, ed. *Dada: Monograph of a Movement.* Teufen, 1961, pp. 50–63.

Huelsenbeck, Richard, ed. *Dada. Eine literarische Dokumentation.* Hamburg, 1964.

Huelsenbeck 1974. Huelsenbeck, Richard. *Memoirs of a Dada Drummer*, ed. Hans J. Kleinschmidt. New York, 1974.

Iowa City, Iowa Museum of Art. *Dada Artifacts* (exhibition catalog), 1978. Ed. Stephen C. Foster and Rudolf E. Kuenzli.

Janis and Blesh 1962. Janis, Harriet, and Rudi Blesh. *Collage. Personalities, Concepts, Techniques.* Philadelphia, 1962.

Jones, Malcolm. "The Cult of August Stramm in *Der Sturm*," *Seminar*, vol. 13. no. 4 (Nov. 1977), pp. 257–269.

Jürgens-Kirchhoff, Annegret. *Technik und Tendenz der Montage in der bildenden Kunst des 20. Jahrhunderts.* Lahn-Glessen, 1978.

Kandinsky and Marc 1912. Kandinsky, Wassily, and Franz Marc, ed. *The Blaue Reiter Almanac* (1912), documentary edition by Klaus Lankheit. London and New York, 1974.

Kassák, Ludwig, and László Moholy-Nagy, ed. *Buch neuer Künstler.* Vienna, 1922.

Kemper, Hans-Georg. *Vom Expressionismus zum Dadaismus.* Kronberg/Taunus, 1974.

Kracauer 1947. Kracauer, Siegfried. *From Caligari to Hitler. A Psychological History of the German Film.* Princeton, 1947.

Kuenzli 1982. Kuenzli, Rudolf, E. "Dada Bibliography: 1973–1978," *Dada-Surrealism*, no. 10–11, (1982), pp. 161–201.

Kuenzli 1984. Kuenzli, Rudolf E. "Bibliography on Dada, 1978–1983," *Dada-Surrealism*, no. 13 (1984), pp. 129–164.

Lissitzky and Arp 1925. Lissitzky, El, and Hans Arp. *Die Kunstismen—Les Ismes de l'Art—The Isms of Art.* Zurich, 1925.

Lissitzky-Küppers 1968. Lissitzky-Küppers, Sophie. *El Lissitzky. Life, Letters, Texts.* London and New York, 1968.

Malevich. Essays. Malevich, Kasimir. *Essays on Art, 1915–1933*, ed. Troels Andersen. New York, 1971.

Meyer, Reinhardt, *et al. Dada in Zurich and Berlin 1916–1920.* Kronberg/Taunus, 1973.

Middleton 1961. Middleton, J. Christopher. "Dada versus Expressionism, or The Red King's Dream," *German Life and Letters*, n.s., vol. 15, no. 1 (Oct. 1961), pp. 37–52.

Middleton, J. Christopher. "'Bolshevism in Art': Dada and Politics," *Texas Studies in Literature and Language*, vol. 4, no. 3 (Autumn 1962), pp. 408–430.

Middleton, J. Christopher. "The Rise of Primitivism and its Relevance to the Poetry of Expressionism and Dada," in Peter F. Ganz, ed. *The Discontinuous Tradition.* Oxford 1971, pp. 182–203.

Moholy-Nagy 1947. Moholy-Nagy, László. *The New Vision.* New York, 1947.

S. Moholy-Nagy 1950. Moholy-Nagy, Sibyl. *Moholy-Nagy. Experiments in Totality.* New York, 1950.

Motherwell 1951. Motherwell, Robert, ed. *The Dada Painters and Poets: An Anthology.* New York, 1951.

Op de Coul 1968. Op de Coul, Paul. "Dada, la musique et la Hollande," *Cahiers Dada-Surréalisme*, no. 2 (1968), pp. 33–39.

Op de Coul 1983. Op de Coul, Paul. "Dada in den Niederlanden: Bericht eines Feldzuges," *Almanach* 1983, pp. 141–57.

Paris, Centre national d'Art et de Culture Georges Pompidou. *Paris–Berlin 1900–1933* (exhibition catalog), 1978.

Philipp, Eckhard. *Dadaismus: Einführung in den literarischen Dadaismus und die Wortkunst des "Sturm"-Kreises.* Munich, 1980.

Raabe 1974. Raabe, Paul, ed. *The Era of German Expressionism.* Woodstock, N.Y., 1974.

Münster, Westfälisches Landesmuseum für Kunst und Kulturgeschichte. *Reliefs* (exhibition catalog), 1980.

Richter 1965. Richter, Hans. *Dada: Art and Anti-Art.* London and New York, 1965.

Rischbieter 1962. Rischbieter, Henning, ed. *Hannover. Die zwanziger Jahre in Hannover. Bildende Kunst—Literatur—Theater—Tanz—Architektur, 1916–1933.* Hannover, 1962. (Includes Marianne Prohl, "Kurt Schwitters: Merzdichtung und Merzbau".)

Rowell 1979. Rowell, Margit. *The Planar Dimension, Europe 1919–1932.* New York: The Solomon R. Guggenheim Museum, 1979.

Rubin 1969. Rubin, William S. *Dada and Surrealist Art.* New York (1969).

Samuel and Thomas 1939. Samuel, Richard, and R. Hinton Thomas. *Expressionism in German Life, Literature and the Theatre.* Cambridge, 1939.

Schippers 1974. Schippers, K. *Holland Dada*, Amsterdam, 1974.

Schmied 1967. Schmied, Wieland. *Wegbereiter zur modernen Kunst; 50 Jahre Kestner-Gesellschaft.* Hannover, 1967. With contributions by K. Steinitz, W. Schmalenbach, W. Schumann.

Sheppard, Richard. "Dada and Expressionism," *Publications of the English Goethe-Society*, NS, no. 49 (1979), pp. 45–83.

Sheppard 1980. Sheppard, Richard, ed. *Dada: Studies of a Movement.* Chalfont St. Giles, 1980. First published as a double issue of *Journal of European Studies* in 1979, from which it reprints Beckett 1979; Richard Sheppard, "Dada and Politics," etc.

Sheppard, Richard, ed. *New Studies in Dada: Essays and Documents.* Driffield, 1981.

Sheppard 1982. Sheppard, Richard, ed. *Zurich-"Dadaco"-"Dadaglobe": The Correspondence between Richard Huelsenbeck, Tristan Tzara and Kurt Wolff (1916–1924).* Fife, 1982.

Société Anonyme 1984. Herbert, Robert L., Eleanor S. Apter, and Elise K. Kenney, ed. *The Société Anonyme and the Dreier Bequests at Yale: A Catalogue Raisonné*. New Haven, 1984.

Tendenzen 1977. Berlin: Nationalgalerie, Akademie der Künste, Grosse Orangerie des Schlosses Charlottenburg. *Tendenzen der Zwanziger Jahre* (exhibition catalog), 1977.

Uhlman 1960. Uhlman, Fred. *The Making of an Englishman*. London, 1960.

Waldberg 1958. Waldberg, Patrick. *Max Ernst*. Paris, 1958.
Cologne, Rheinhallen. *Westkunst* (exhibition catalog), 1981.

Walden 1917. Walden, Herwarth. *Einblick in Kunst.*
Expressionismus, Futurismus, Kubismus. Berlin, 1917.
Walden, Herwarth. *Die neue Malerei*. Berlin, 1919.

Walden and Schreyer 1954. Walden, Nell, and Lothar Schreyer. *Der Sturm. Ein Erinnerungsbuch an Herwarth Walden und die Künstler aus dem Sturmkreis*. Baden-Baden, 1954.

Wescher 1969. Wescher, Herta. *Collage*. New York, 1969.

Willett 1970. Willett, John. *Expressionism*. London, 1970.

Willett 1978. Willett, John. *The New Sobriety*. London, 1978. US ed. as *Art and Politics in The Weimar Period. The New Sobriety 1917–1933*. New York, 1978.

Photo Credits

LIST OF ILLUSTRATIONS

Original titles (followed by English translations) are given in the form and language used by Schwitters whenever known through inscriptions on the recto or verso of the work or through contemporary documents. In the case of those works on paper for which popular titles derived from words, word-fragments or images in the works, but presumed not to have been given by Schwitters, have become established, these titles are enclosed in parenthesis.

Definite dates are given to those works that either bear inscribed recto or verso dates in the artist's hand or can be firmly dated through contemporary documents; otherwise a *c.* (*circa*) designation is used.

Dimensions have been verified wherever possible but in most cases have been supplied by the owners of the works. They are given in inches then in centimeters, height preceding width; a third dimension, depth, is given for sculptures.

Generic descriptions of Schwitters' media have been used throughout, since it has not been possible to provide detailed inventories of the contents of each work. The term *collage* has been reserved for works mainly composed of cut or torn and pasted papers; *painted collage* for (usually large) works where collage and painting is combined; and *assemblage* for works with prominent relief elements. The remaining generic descriptions are self-explanatory.

Collections have been identified in accordance with requests by owners.

I *Hochgebirgsfriedhof* (*Mountain Graveyard*), 1919. Oil on board, 36" x 28½" (91.5 x 72.5 cm.). Solomon R. Guggenheim Museum, New York. Gift of Mr. and Mrs. Frederick M. Stern.

II *Aquarell 1 Das Herz geht vom Zucker zum Kaffee* (*The Heart Goes from Sugar to Coffee*), 1919. Watercolor and pencil on paper, 11⅞ x 8¾ (30.2 x 22.3 cm.). The Museum of Modern Art, New York. Purchase.

III *Merzbild Rossfett*, *c.* 1919. Assemblage, 8" x 6⅞" (20.4 x 17.4 cm.). Private collection.

IV *Bild mit heller Mitte* (*Picture with Light Center*), 1919. Painted collage, 33¼" x 25⅞" (84.5 x 65.7 cm.). The Museum of Modern Art, New York. Purchase.

V *Das Kreisen* (*Revolving*), 1919. Assemblage, 48⅜" x 35" (122.7 x 88.7 cm.). The Museum of Modern Art, New York. Advisory Committee Fund.

VI *Merzbild Einunddreissig* (*Merzpicture Thirty-One*), 1920. Assemblage, 38½" x 25⅞" (97.8 x 65.8 cm.). Sprengel Museum, Hannover. Extended loan from Marlborough Fine Art, London.

VII *Konstruktion für edle Frauen* (*Construction for Noble Ladies*), 1919. Assemblage, 40½" x 33" (103 x 83.3 cm.). The Los Angeles County Museum of Art. Purchased with Funds Provided by Mr. and Mrs. Norton Simon, The Junior Arts Council, Mr. and Mrs. Frederick R. Weisman, Mr. and Mrs. Taft Schreiber, Hans De Schulthess, Mr. and Mrs. Edwin Janss, Mr. and Mrs. Gifford Phillips.

VIII *Merzbild 32A. Das Kirschbild* (*The Cherry Picture*), 1921. Assemblage, 36⅛" x 27¾" (91.8 x 70.5 cm.). The Museum of Modern Art, New York. Mr. and Mrs. A. Atwater Kent, Jr. Fund.

IX *Zeichnung A2.Hansi*, 1918. Collage, 7⅛" x 5¾" (18.1 x 14.6 cm.). The Museum of Modern Art, New York. Purchase Fund.

X (*Mai 191*), *c.* 1919. Collage, 8½" x 6¾" (21.6 x 17.1 cm.). Marlborough Fine Art, London.

XI *Mz 169. Formen im Raum* (*Forms in Space*), 1920. Collage, 7⅛" x 5⅝" (18 x 14.3 cm.). Kunstsammlung Nordrhein-Westfalen, Düsseldorf.

XII *Mz 231. Miss Blanche*, 1923. Collage, 6¼" x 5" (15.9 x 12.7 cm.). Collection Dr. Werner Schmalenbach, Düsseldorf.

XIII *Mz 410 irgendsowas* (*something or other*), 1922. Collage, 7⅛" x 5¾" (18.2 x 14.5 cm.). Sprengel Museum, Hannover.

XIV *Mz 252. Farbige Quadrate* (*Colored Squares*), 1921. Collage, 7⅛" x 5¾" (18 x 14.4 cm.). The Museum of Modern Art, New York. The Sidney and Harriet Janis Collection (fractional gift).

XV *Der Weihnachtsmann* (*Santa Claus*), 1922. Collage, 11¼" x 8¼" (28.4 x 20.8 cm.). The Museum of Modern Art, New York. Purchase.

XVI *Mz 250. Grosser Tanz* (*Large Dance*), 1921. Collage, 7⅛" x 5¾" (18 x 14.5 cm.). Private collection.

XVII *Merzbild 1924, I. Relief mit Kreuz und Kugel* (*Relief with Cross and Sphere*), 1924. Painted relief, 27⅛" x 13½" (69 x 34.2 cm.). Marlborough Fine Art, London.

XVIII *Bild 1926,3.Cicero*, 1926. Painted relief, 26¾" x 19½" (68.1 x 49.6 cm.). Sprengel Museum, Hannover. Extended loan from Marlborough Fine Art, London.

XIX *Bild 1926,12.Kleines Seemannsheim* (*Small Sailors' Home*), 1926. Assemblage, 26½" x 20½" (67.5 x 52 cm.). Kunstsammlung Nordrhein-Westfalen, Düsseldorf.

XX (*elikan*), *c.* 1925. Collage, 17⅛" x 14¼" (43.5 x 36.2 cm.). The Museum of Modern Art, New York. Katherine S. Dreier Bequest.

XXI *Neues Merzbild* (*New Merzpicture*), 1931. Assemblage, 32¼" x 43½" (81.9 x 110.5 cm.). Insel Hombroich.

XXII *Oorlog*, 1930. Collage, 12¼" x 9¼" (31.2 x 23.5 cm.). Collection Donald B. Marron.

XXIII (*Pino Antoni*), *c.* 1933–34. Collage, 23¼" x 17⅞" (59.1 x 45.5 cm.). Collection Branco Weiss, Zurich.

XXIV *Die Frühlingstür* (*The Spring Door*), 1938. Assemblage, 34½" x 28⅜" (87.8 x 72 cm.). Collection Mrs. Antonina Gmurzynska, Cologne.

XXV *Merzbilde med regnbue* (*Merzpicture with Rainbow*), *c.* 1939. Assemblage, 61⅜" x 47⅝" (155.9 x 121 cm.). Private collection.

XXVI *Merzbild Alf*, 1939. Assemblage, 12¾" x 12¾" (32.5 x 32.5 cm.). Private collection.

XXVII *Die heilige Nacht von Antonio Allegri gen. Correggio, worked through by Kurt Schwitters* (*The Holy Night by Antonio Allegri, known as Correggio . . .*), 1947. Collage, 20⅞" x 15¼" (52.9 x 33.8 cm.). Private collection, Lugano.

XXVIII *Heavy Relief*, 1945. Assemblage, 20½" x 17¾" (52 x 45 cm.). Galerie Gmurzynska, Cologne.

XXIX *Glass Flower*, 1940. Assemblage, 30½" x 26⅝" x 10" (77.5 x 67.5 x 25.5 cm.). Ludwig Collection.

XXX (*Difficult*), *c.* 1942–43. Collage, 31¼" x 24" (79.5 x 61 cm.). Albright-Knox Art Gallery, Buffalo, New York. Gift of The Seymour H. Knox Foundation, Inc., 1965.

XXXI (*Hitler Gang*), *c.* 1944. Collage, 13⅝" x 9⅝" (34.7 x 24.5 cm.). Private collection.

XXXII *For Käte*, 1947. Collage, 3⅞" x 5⅛" (9.8 x 13 cm.). Private collection.

Frontispiece
Announcement for a Merz evening at Schwitters' house in Hannover, mid 1920s.

1 Schwitters, *c.* 1920 Advertising postcard published by Paul Steegemann, Hannover.

2 *Landschaft aus Opherdicke* (*Landscape from Opherdicke*), 1917. Oil on board, 21⅞″ x 19¾″ (55.6 x 50.2 cm.). Marlborough Fine Art, London.

3 *Überschwemmte Wiesen* (*Flooded Fields*), 1914. Oil on canvas, 17⅞″ x 23⅜″ (45.3 x 59.3 cm.). Marlborough Fine Art, London.

4 *Vision*, 1916–17. Oil on board, 16½″ x 13¾″ (41.9 x 34.9 cm.). Marlborough Fine Art, London.

5 Paula Modersohn-Becker. *Selbstbildnis mit Kamelienzweig* (*Self-Portrait with Camelia*), 1906–07. Oil on board, 24⅜″ x 11¾″ (62 x 30 cm.). Museum Folkwang, Essen.

6 *Helma Schwitters mit Blume* (*Helma Schwitters with a Flower*), 1917. Oil on board, 26″ x 19¼″ (66 x 48.9 cm.). Marlborough Fine Art, London.

7 *G Expression 2* (*Die Sonne im Hochgebirge*) (*Sun in the High Mountains*), 1917. Oil. Whereabouts unknown.

8 Wassily Kandinsky. *Improvisation 7*, 1910. Oil on canvas, 51½″ x 38¼″ (131 x 97 cm.). Tretiakov Gallery, Moscow.

9 *Verschneite Häuser* (*Snowcovered Houses*), 1918. Oil on canvas, 16⅜″ x 20⅛″ (41.5 x 51.2 cm.). Sprengel Museum, Hannover. Extended loan from Marlborough Fine Art, London.

10 Ludwig Meidner. *Apokalyptische Landschaft* (*Apocalyptic Landscape*), 1912–13. Oil on canvas. Whereabouts unknown.

11 *G Expression 1* (*Der Wald*) (*The Forest*), 1917. Oil. Whereabouts unknown.

12 *Abstraktion 2* (*Die Gewalten*) (*The Forces*), 1917. Oil on board, 27⅝″ x 19¼″ (70 x 49 cm.). Sprengel Museum, Hannover.

13 *Z42 Der Einsame* (*The Lonely One*), 1918. Black chalk on paper, 6¼″ x 4¼″ (16 x 11 cm.). Galerie Stangl, Munich.

14 Ernst Ludwig Kirchner. *Die Strasse, Berlin* (*Street, Berlin*), 1913. Oil on canvas, 47½″ x 35⅞″ (120.6 x 91.1 cm.). The Museum of Modern Art, New York. Purchase.

15 *Z122 Die Versuchung des heiligen Antonius* (*The Temptation of St. Anthony*), 1918. Charcoal on paper, 7 x 4⅝″ (17.7 x 11.7 cm.). Marlborough Fine Art, London.

16 Umberto Boccioni. *Dinamismo Plastico, Cavallo + Case* (*Plastic Dynamism, Horse + Houses*), 1913–14. Ink and wash on paper, 12⅞″ x 16⅝″ (32.7 x 42.2 cm.). Mr. and Mrs. Eric Estorick, London.

17 *Z57 Abstraktion*, 1918. Black chalk on paper, 5⅝″ x 7⅝″ (14.3 x 19.3 cm.). Private collection, Switzerland.

18 Pablo Picasso. *Nature morte, bouteille de marc* (*Still Life with Bottle of Marc*), 1911. Drypoint, 19 11/16″ x 12″ (50.0 x 30.5 cm.). The Museum of Modern Art, New York. Acquired through the Lillie P. Bliss Bequest.

19 *Achsenzeichnung* (*Axle-Drawing*), 1917. Charcoal on paper, 6¾″ x 4¾″ (17.5 x 12 cm.). Private collection.

20 *Abstraktion 9* (*Der Bindeschlips*) (*The Bow Tie*), 1918. Oil on board, 28⅞″ x 22¼″ (73.5 x 56.8 cm.). Marlborough Fine Art, London.

21 Untitled woodcut from *Das Kestnerbuch*, 1919, Hannover, 1919, plate XII. 7½″ x 4⅞″ (19 x 12.4 cm.).

22 Untitled lithograph from *Der Zweemann*, 1919. Vol. I, no. 1 (Nov. 1919), p. 10. 4⅝″ x 3¼″ (11.7 x 8.2 cm.).

23 *Abstraktion 19* (*Entschleierung*) (*Unveiling*), 1918. Oil on cardboard, 27⅜″ x 19⅝″ (69.5 x 49.8 cm.). Marlborough Fine Art, London.

24 *Der Kritiker* (*The Critic*), 1921. Rubber stamp drawing reproduced in *Der Sturm*, vol. 12, no. 4 (Apr. 1921), p. 84. Whereabouts unknown.

25 Untitled lithograph from the portfolio *Die Kathedrale* (*Cathedral*), 1920. Hannover: Paul Steegemann, 1920. 8 13/16″ x 5⅝″ (22.4 x 14.3 cm.). The Museum of Modern Art, New York. Gift of Edgar Kaufmann, Jr.

26 Cover of the portfolio *Die Kathedrale* (*Cathedral*), 1920. Hannover: Paul Steegemann, 1920. Lithograph, 8 13/16″ x 5⅝″ (22.4 x 14.3 cm.). The Museum of Modern Art, New York. Gift of Edgar Kaufmann, Jr.

27 Max Ernst. Lithograph from the portfolio *Fiat modes: pereat ars*, *c.* 1919. 17⅛″ x 12½″ (43.7 x 31.9 cm.). The Museum of Modern Art, New York. Purchase Fund.

28 Francis Picabia. *Réveil-matin* (*Alarm Clock*). Title page for *Dada*, no. 4–5, Zurich, 1919.

29 (*mit roter 4*) (*with red 4*), *c.* 1919. Stamp drawing and collage, 6⅞″ x 6″ (17.5 x 15.2 cm.). Marlborough Fine Art, London.

30 *Aq. 9 Windmühle* (*Windmill*), 1919. Watercolor and pencil on paper, 6¾″ x 5⅝″ (17.3 x 14.4 cm.). Galerie Kornfeld, Bern.

31 *D-U Drucksache* (*D-U Printed Matter*), *c.* 1919. Stamp drawing and collage, 9¼″ x 8″ (23.5 x 20.3 cm.). Sidney Janis Gallery, New York.

32 George Grosz. *Krausel!*, *c.* 1920. Trial proof for unpub. anthology *Dadaco*.

33 Cover design for *Anna Blume, Dichtungen*. Hannover: Paul Steegemann, 1919. Lithograph, 8⅝″ x 5¾″ (22.0 x 14.6 cm.). The Museum of Modern Art, New York. Given anonymously.

34 *Aq. 23 Koketterie* (*Coquetry*), 1919. Watercolor on paper, 7¼″ x 7¼″ (18.6 x 18.6 cm.). Galerie Gmurzynska, Cologne.

35 (*Komisches Tier*) (*Funny Beast*), *c.* 1919. Stamp drawing and collage with crayon, 9½″ x 7⅝″ (24.0 x 19.5 cm.). Private coll.

36 Marc Chagall. *Der Trinker* (*The Drinker*), 1913. Pen, brush and ink, 8¼″ x 11⅜″ (21 x 29 cm.). Private collection, Stockholm.

37 Paul Klee. *Ausschreitende Figur* (*Striding Figure*), 1915. Pen and ink on broadsheet, 10″ x 6½″ (25.4 x 16.5 cm.). Paul-Klee-Stiftung, Kunstmuseum Bern.

38 (*Bussum*), 1923. Stamp drawing, 4⅜″ x 4⅛″ (11.3 x 10.7 cm.). Collection David Neuman, New York.

39 Untitled, *c.* 1919. Lithograph, 4¾″ x 3½″ (12 x 9 cm.). Whereabouts unknown.

40 Christian Morgenstern. "Fisches Nachtgesang," from *Galgenlieder*. Berlin: Cassirer, 1905.

41 Hans (Jean) Arp. Untitled collage reproduced in *Cabaret Voltaire*, 1916. Whereabouts unknown.

42 *Das Merzbild* (*The Merzpicture*), 1919. Assemblage. Destroyed.

43 *Merzbild 1A. Der Irrenarzt* (*The Alienist*), 1919. Assemblage, 18⅞″ x 15″ (48 x 38.2 cm.). Thyssen-Bornemisza Collection, Lugano.

44 Johannes Molzahn. *Kreisen*, 1918. Drawing, reproduced on the cover of *Der Sturm*, June 1919.

45 Marc Chagall. *Half Past Three* (*The Poet*), 1911. Oil on canvas, 77½″ x 57½″ (197 x 146 cm.). Philadelphia Museum of Art. Louise and Walter Arensberg Collection.

46 *Das Arbeiterbild* (*The Worker Picture*), 1919. Assemblage, 49¼″ x 35¾″ (125 x 91 cm.). Moderna Museet, Stockholm.

47 *Merzbild 9A. Bild mit Damestein* (*Picture with Checker*), 1919. Assemblage, 6¼″ x 7⅝″ (16 x 19.5 cm.). Private collection.

48 *Merzbild 14C. Schwimmt*, 1921. Assemblage, 6¼″ x 4¼″ (15.5 x 10.8 cm.). Collection Judith Rothschild, New York.

49 Anon. Objects assembled and mounted by a psychopathic patient, 1878. Wooden panel in five small vitrines. Formerly collection André Breton, Paris.

50 Giorgio de Chirico. *Natura Morta Evangelica* (*Evangelical Still Life*), 1916.

Oil on canvas, 31¾" x 28⅛" (80.5 x 71.4 cm.). The Museum of Modern Art, New York. The Sidney and Harriet Janis Collection (fractional gift).

51 *Merzbild 13A. Der kleine Merzel (Small Merzel)*, 1919. Assemblage, 16¾" x 12⅞" (42.5 x 32.7 cm.). Indiana University Art Museum, Bloomington.

52 *Das Undbild (The And Picture)*, 1919. Assemblage, 14" x 11" (35.5 x 28 cm.). Staatsgalerie Stuttgart.

53 *Das Huthbild (The Huth Picture)*, 1919. Painted collage, 34¼" x 29⅛" (87 x 74 cm.). Private collection.

54 *Merzbild 1B. Bild mit rotem Kreuz (Picture with Red Cross)*, 1919. Painted collage, 26¾" x 20⅞" (68 x 53 cm.). Whereabouts unknown.

55 Robert Delaunay. *Une fenêtre (Etude pour les trois fenêtres) (A Window [Study for the three windows])*, 1912–13. Oil on canvas, 43¾" x 35⅜" (111 x 90 cm.). Musée National d'Art Moderne, Centre Georges Pompidou, Paris.

56 Georges Braque. *Le Portugais (The Portuguese)*, 1911. Oil on canvas, 46⅛" x 32⅛" (117 x 81.5 cm.). Öffentliche Kunstsammlung, Kunstmuseum Basel.

57 *Merzbild 5B. Rot-Herz-Kirche (Red-Heart-Church)*, 1919. Painted collage, 32⅞" x 23⅝" (83.5 x 60.2 cm.). Solomon R. Guggenheim Museum, New York.

58 *Merzbild 9B. Das grosse Ichbild (the Great Ich Picture)*, 1919. Painted collage, 38⅛" x 27½" (96.8 x 70 cm.). Ludwig Collection.

59 Paul Klee. *Zerstörung und Hoffnung (Destruction and Hope)*, 1916. Watercolor over lithograph, 20½" x 13⅜" (52 x 34 cm.). Städtische Galerie im Lenbachhaus, Munich.

60 Giacomo Balla. Study for *Il Mercurio che passa davanti al Sole (Mercury Passing Before the Sun)*, 1914. Gouache on paper, 25¾" x 19¾" (65.5 x 50.2 cm.). Lydia and Harry Lewis Winston Collection, Dr. and Mrs. Barnett Malbin.

61 *Ausgerenkte Kräfte (Disjointed Forces)*, 1920. Assemblage, 41½" x 34" (105.5 x 86.7 cm.). Stiftung Prof. Max Huggler, Kunstmuseum Bern.

62 *Merzbild 25A. Das Sternenbild (The Stars Picture)*, 1920. Assemblage, 41⅛" x 31⅛" (104.5 x 79 cm.). Kunstsammlung Nordrhein-Westfalen, Düsseldorf.

63 Pablo Picasso. *Guitare et bouteille de Bass (Guitar and Bottle of Bass)*, 1913. Reproduced in *Les Soirées de Paris*, November 1913. Assemblage, 35¼" x 31½" x 5½" (89.5 x 80 x 14 cm.). Musée Picasso, Paris.

64 Alexander Archipenko. *Femme à l'éventail (Woman with Fan)*, 1914. Assemblage, 34" x 22" x 5" (86.4 x 55.9 x 12.7 cm.). Tel Aviv Museum, Eric Goeritz Bequest.

65 Max Ernst. *Frucht einer langen Erfahrung (Fruits of Long Experience)*, c. 1919. Assemblage, 18" x 15" (45.7 x 38.0 cm.). Private collection, Geneva.

66 *Merzbild 31B. Strahlenwelt (Radiating World)*, 1920. Painted collage, 37½" x 26¾" (95.2 x 68 cm.). The Phillips Collection, Washington, D.C. Bequest of Katherine S. Dreier, 1953.

67 *Merzbild 29A. Bild mit Drehrad (Picture with Flywheel)*, 1920 and 1939. Assemblage, 32" x 40⅛" (81.2 x 102 cm.). Sprengel Museum, Hannover.

68 *Merzbild 46a. Das Kegelbild (The Skittle Picture)*, 1921. Assemblage, 21⅜" x 16½" (54.3 x 42.2 cm.). Sprengel Museum, Hannover.

69 Ivan Puni. *Suprematist Sculpture.* Reconstruction of 1915 original from a c. 1920–21 gouache drawing in Puni's February 1921 Sturm exhibition. Assemblage, 28¾" x 15¾" x 3⅛" (73 x 40 x 8 cm.). Private collection, Zurich.

70 Untitled, c. 1921. Assemblage, 15" x 8¼" x 2½" (38 x 21 x 6.4 cm.). Philadelphia Museum of Art, A.E. Gallatin Collection.

71 *Mz 150. Oskar*, 1920. Collage, 5⅛" x 3⅞" (13.1 x 9.7 cm.). Kunstsammlung Nordrhein-Westfalen, Düsseldorf.

72 *Merzbild 14B. Die Dose (The Box)*, 1919. Assemblage, 6½" x 5½" (16.4 x 14.1 cm.). Private collection.

73 *(Der Sturm)*, 1919. Collage, 8¾" x 6⅞" (22.4 x 17.8 cm.). Collection Mr. and Mrs. Morton Neumann, Chicago.

74 *Radblumen für Vordemberge (Wheel-flowers for Vordemberge)*, 1920. Assemblage, 4⅛" x 3⅛" (10.5 x 8 cm.). F. Gerber, Zurich.

75 *Das Bäumerbild (The Bäumer Picture)*, 1920. Collage, 6⅞" x 8¼" (17.4 x 21.1 cm.). Marlborough Fine Art, London.

76 *(Zeitu)*, 1918. Ink on found paper, 1⅝" x 1⅞" (4.1 x 4.9 cm.). Private collection.

77 *(fec)*, 1920. Collage, 9⅞" x 7¼" (25.1 x 18.2 cm.). The Museum of Modern Art, New York. Gift of Marlborough-Gerson Gallery, Inc.

78 *Mz 144. Siegel PJ*, 1920. Collage, 5¾" x 4¾" (14.8 x 12.2 cm.). Private collection, Stockholm.

79 *Mz 192*, 1921. Collage, 4¾" x 3¾" (12.2 x 9.5 cm.). Private collection.

80 *(Ebing)*, 1920. Collage, 5⅞" x 4¾" (15 x 12 cm.). Private collection.

81 *Mz 170. Leere im Raum (Void in Space)*, 1920. Collage, 7⅛" x 5¼" (18.1 x 13.4 cm.). Private collection.

82 Maximilian Mopp. *Der Weltkrieg (The World War)*, 1916. Oil on canvas, 21" x 17⅝" (53.3 x 44.8 cm.). The Museum of Modern Art, New York. Given anonymously.

83 *Mz 79. Herz-Klee (Heart-Clover)*, 1920. Collage, 5⅞" x 4⅝" (15 x 11.8 cm.). Private collection.

84 *(Die Handlung spielt in Theben) (The Action Takes Place in Thebes)*, c. 1918–19. Collage, 6⅜" x 7⅞" (16.2 x 20 cm.). Private collection.

85 Collage over postcard of *Das grosse Ichbild*, 1922. 5½" x 3½" (14 x 9 cm.). Galerie Gmurzynska, Cologne.

86 Collage over postcard of *Das Kreisen*, 1922. 5½" x 3½" (14 x 9 cm.). Galerie Gmurzynska, Cologne.

87 Collage over postcard with photograph of Schwitters, 1921. 5½" x 3½" (14 x 9 cm.). Galerie Gmurzynska, Cologne.

88 *Mz 151. Wenzel Kind (Knave Child)*, 1921. Collage, 6¾" x 5⅛" (17.1 x 12.9 cm.). Sprengel Museum, Hannover. Extended loan from Marlborough Fine Art, London.

89 *König Eduard (King Edward)*, 1918–19. Collage, 5⅜" x 4 1/16" (13.6 x 10.3 cm.). Private collection.

90 *(Das Engelbild) (The Angel Picture)*, c. 1920. Collage, 2" x 2⅝" (5.1 x 6.5 cm.). Private collection.

91 *Mz 180. Figurine*, 1921. Collage, 6¾" x 3⅝" (17.3 x 9.2 cm.). Private collection.

92 *Zeichnung I6. Mode I (Fashion I)*, 1920. *i-Zeichnung*, 5½" x 4⅛" (14 x 10.3 cm.). Marlborough Fine Art, London.

93 Collage over postcard of *Stilleben mit Abendmahlskelch (Still-Life with Chalice)*, 1923. 5½" x 3½" (14 x 9 cm.). Galerie Gmurzynska, Cologne.

94 Title page for *Memoiren Anna Blumes in Bleie (Memoirs of Anna Blume in Lead [Pencil])*, 1922. Freiburg, 1922. 7 1/16" x 4" (18 x 10 cm.).

95 *Mz 158. Das Kotsbild (The Kots Picture)*, 1920. Collage, 10⅝" x 7⅝" (27 x 19.5 cm.). Sprengel Museum, Hannover.

96 *Mz 239. Frau-Uhr (Woman-Watch)*, 1921. Collage, 12¼" x 8¾" (31.2 x 22.2 cm.). Mr. Philippe-Guy Woog, Vésenaz.

97 Raoul Hausmann. *Festival Dada*, c. 1920. Photomontage. Whereabouts unknown.

98 *Die Sattlermappe (The Saddler Portfolio)*, 1922. Collage, 15⅛" x 22" (38.4 x 55.8 cm.). E.W. Kornfeld, Bern.

99 Raoul Hausmann, *Dada Cino, c.* 1920. Collage, 12½″ x 8⅞″ (31.7 x 22.5 cm.). Mr. Philippe-Guy Woog, Vésenaz.

100 Pages of *c.* 1921 from *Das "Schwarze" Notizbuch* (*The "Black" Notebook*), 1910–1922. Approx. 10″ x 8″ (25 x 20 cm.). Private collection.

101 *Mz 322. bunt* (*many-colored*), 1921. Collage, 7⅛″ x 5½″ (18 x 14 cm.). Private collection.

102 *Mz 313. Otto*, 1921. Collage, 7⅛″ x 5¾″ (18 x 14.4 cm.). Private collection.

103 Carlo Carrà. *"Free-Word" Painting* (*Patriotic Celebration*), 1914. Collage, 15⅛″ x 11¾″ (38.4 x 29.8 cm.). Collection Dr. Gianni Mattioli, Milan.

104 Raoul Hausmann. Cover design for *Material der Malerei, Plastik, Architektur* (*Material of Painting, Sculpture, Architecture*), 1918. Collage, 12½″ x 7⅛″ (32 x 18 cm.). Mme. Marthe Prévot, Limoges.

105 *Merzz 19*, 1920. Collage, 8″ x 6¾″ (20.2 x 17.2 cm.). Yale University Art Gallery. Collection Société Anonyme and Estate of Katherine S. Dreier.

106 *Merzzeichnung 83. Zeichnung F*, 1920. Collage, 5½″ x 4¾″ (14 x 12 cm.). The Museum of Modern Art, New York. Katherine S. Dreier Bequest.

107 Pablo Picasso. *Guitare* (*Guitar*), 1913. Cut and pasted paper, charcoal, wax crayon, and ink over canvas, 26⅛″ x 19½″ (66.4 x 49.6 cm.). The Museum of Modern Art, New York. Nelson A. Rockefeller Bequest.

108 Paul Klee. *"E"*, 1918. Watercolor, 8⅝″ x 7⅛″ (22 x 18 cm.). Felix Klee, Bern.

109 *Merzz 101. Dorf* (*Village*), 1920. Collage, 6⅛″ x 5″ (15.5 x 12.7 cm.). Sprengel Museum, Hannover.

110 *Mz 321. Blaukreuz oval* (*Blue Cross Oval*), 1921. Collage, 9″ x 7″ (23 x 17.8 cm.). Private collection.

111 *Mz 163. mit frau, schwitzend* (*with woman, sweating*), 1920. Collage, 6 1/16″ x 4⅞″ (15.4 x 12.5 cm.). Solomon R. Guggenheim Museum, New York. Gift, Katherine S. Dreier Estate from Marcel Duchamp, New York.

112 *Mz 316 ische gelb* (*ish yellow*), 1921. Collage, 12″ x 9¼″ (30.7 x 23.5 cm.). Yale University Art Gallery. Collection Société Anonyme and Estate of Katherine S. Dreier.

113 *Merzz 22*, 1920. Collage, 6¾″ x 5½″ (17.1 x 14 cm.). The Museum of Modern Art, New York. Katherine S. Dreier Bequest.

114 *Mz 88. Rotstrich* (*Red Stroke*), 1920. Collage, 5¼″ x 4⅛″ (13.2 x 10.3 cm.). The Museum of Modern Art, New York. The Sidney and Harriet Janis Collection (fractional gift).

115 *Mz 39. russisches bild* (*russian picture*), 1920. Collage, 7⅜″ x 5⅝″ (18.7 x 14.3 cm.). The Museum of Modern Art, New York. Katherine S. Dreier Bequest.

116 Ivan Puni. *Sculpture.* Reconstruction of 1915 original from a 1916 drawing in Puni's February 1921 Sturm exhibition. Assemblage, 30¼″ x 19⅝″ x 3⅛″ (77 x 50 x 8 cm.). Musée National d'Art Moderne, Centre Georges Pompidou, Paris.

117 *Zeichnung I9. Hebel 2* (*Lever 2*), 1920. Collage, 5⅜″ x 4¼″ (13.8 x 11.5 cm.). Yale University Art Gallery. Collection Société Anonyme and Estate of Katherine S. Dreier.

118 *Mz 334. Verbürgt rein* (*Warranted Pure*), 1921. Collage, 7″ x 5⅝″ (17.9 x 14.4 cm.). Marlborough Fine Art, London.

119 *Mz 308. Grau* (*Gray*), 1921. Collage, 7″ x 5⅝″ (17.9 x 14.4 cm.). Marlborough Fine Art, London.

120 *Mz 271. Kammer* (*Cupboard*), 1921. Collage, 7″ x 5⅝″ (17.8 x 14.3 cm.). Kunstsammlung Nordrhein-Westfalen, Düsseldorf.

121 *Mz 299. für V.I. Kuron*, 1921. Collage, 7⅛″ x 5½″ (18 x 14 cm.). Private coll.

122 (*mit Kreuzspinne*) (*with Spider*), *c.* 1921. Collage, 5¼″ x 3⅞″ (13.3 x 9.8 cm.). Moderna Museet, Stockholm.

123 (*mit grosser Kreuzspinne*) (*with Large Spider*), *c.* 1921. Collage, 5⅞″ x 4½″ (15.1 x 11.6 cm.). Private collection.

124 *Z.i.3 neu ausgestattet* (*newly appointed*), 1920. *i-Zeichnung*, 5¾″ x 4¼″ (14.5 x 10.8 cm.). Private collection.

125 *Z.i.5 Hobelmann* (*Carpenter*), 1920. *i-Zeichnung*, 5¼″ x 4⅛″ (13.3 x 10.5 cm.). Private collection.

126 (*Emerka*), *c.* 1922. Collage, 13¾″ x 10⅜″ (35 x 26.3 cm.). The Museum of Modern Art, New York. Katherine S. Dreier Bequest.

127 *Mz 387. Kaltensundheim*, 1922. Collage, 6⅞″ x 5½″ (17.5 x 14.1 cm.). Sprengel Museum, Hannover.

128 Pablo Picasso. *Joueur de cartes* (*Card Player*), 1913–14. Oil on canvas, 42½″ x 35¼″ (108 x 89.5 cm.). The Museum of Modern Art, New York. Acquired through the Lillie P. Bliss Bequest.

129 Otto Dix. *Kartenspielende Kriegskrüppel* (*Card-Playing War-Cripples*), 1920. Oil and collage on canvas, 43¼″ x 34¼ (110 x 87 cm.). Private collection, Constance.

130 Kurt Schwitters reciting the "da steht ein Mann" section of "Revolution in Revon," cartoon published in *Het Leven*, Jan. 27, 1923.

131 (*Kleine Dada Soirée*), 1922. Poster designed by Schwitters and Theo van

Doesburg for the 1923 Holland Dada tour Color lithograph, 11⅞″ x 11 13/16″ (30.2 x 30 cm.). Private collection.

132 Marcel Janco. *Construction 3.* Reproduced in *Dada*, July 1917. Sculpture. Destroyed.

133 *Die Kultpumpe* (*The Cult Pump*), *c.* 1919. Sculpture, height approx. 10″ (25 cm.). Destroyed.

134 *Konstruktion* (*Construction*), 1919. Ink on paper, 7¼″ x 6″ (18.5 x 15.2 cm.). Private collection.

135 *Der Lustgalgen* (*The Pleasure Gallows*), *c.* 1919. Sculpture, height approx. 20″ (51 cm.). Destroyed.

136 *Haus Merz* (*Merz House*), 1920. Architectural model. Destroyed.

137 Wassili and Hans Luckhardt. *Form Fantasy*, 1919. Architectural model. Whereabouts unknown.

138 (*Drucksache*) (*Printed Matter*), *c.* 1919. Stamp drawing, 9″ x 7⅛″ (23 x 18 cm.). Sprengel Museum, Hannover.

139 Lyonel Feininger. *Kathedrale* (*Cathedral*). Design for the title page of the *Programm des staatlichen Bauhauses in Weimar*, 1919. Woodcut, 12″ x 7½″ (30.5 x 19 cm.). The Museum of Modern Art, New York. Gift of Abby Aldrich Rockefeller.

140 *Schloss und Kathedrale mit Hofbrunnen* (*Castle and Cathedral with Courtyard Well*), *c.* 1922. From *Frühlicht*, vol. 1, no. 3 (Spring 1922). Architectural model. Destroyed.

141 Carl Krayl. *Glashaus von oben* (*Glass House Seen from Above*), 1920. From *Frühlicht* vol. 1, no. 3 (Spring 1922). Watercolor. Whereabouts unknown.

142 *Der Schokoladenkasten, Anna Blume, Kasten 7* (*The Chocolate Box, Anna Blume, Box 7*), 1922. Collaged box, 2⅜″ x 7⅞″ x 5⅞″ (6 x 20 x 15 cm.) (box closed). Collection Erica Brausen, London.

143 (*Intarsienkästchen Anna*) (*Small Inlaid Box Anna*), *c.* 1920–21. Inlaid wood box, 6⅞″ x 10½″ x 8⅝″ (17.5 x 26.7 x 21.9 cm.). Marlborough Fine Art, London.

144 The Dada-Constructivist Congress at Weimar, 1922.

145 *Mz 458, c.* 1922. Collage, 7″ x 5⅝″ (17.8 x 14.3 cm.). The Museum of Modern Art, New York. Katherine S. Dreier Bequest.

146 *Mz 336. Dreieins* (*Three-One*), 1921. Collage, 7¼″ x 5½″ (18.5 x 14.2 cm.). Sprengel Museum, Hannover.

147 Title pages of *Merz*, from 1923.

148 *Mz 448. Moskau* (*Moscow*), 1922. Collage, 6″ x 6¼″ (15.2 x 15.9 cm.). The Museum of Modern Art, New York. Katherine S. Dreier Bequest.

149 *Mz "er,"* 1922. Collage, 12" x 9" (30.7 x 23 cm.). Collection Mr. Dirk Lohan.

150 Kasimir Malevich. *Suprematist Elements: Squares,* c. 1915. Pencil on paper, 6¾" x 11¼" (17.1 x 28.5 cm.). The Museum of Modern Art, New York.

151 Vilmos Huszár. *Hamer en Zaag (Hammer and Saw),* 1919. Reproduced in *De Stijl,* vol. I, no. 3, Jan. 1918. Color lithograph after the painting in the Gemeentemuseum, The Hague.

152 *Mz 380. Schlotheim,* 1922. Collage, 8¾" x 7½" (22.2 x 19.2 cm.). Yale University Art Gallery. Collection Société Anonyme and Estate of Katherine S. Dreier.

153 Cover of "Nasci" issue of *Merz,* 1924. 12" x 9¼" (30.5 x 23.5 cm.).

154 Double page spread from "Nasci" issue of *Merz,* 1924. 12" x 18½" (30.5 x 47 cm.).

155 Page from *Die Scheuche (The Scarecrow),* 1925. Produced with Käte Steinitz and Theo van Doesburg. 8" x 9½" (20.5 x 24 cm.).

156 El Lissitzky. Double page spread from Vladimir Mayakovsky's *Dlya Golosa (For the Voice),* 1923. Berlin: RSFSR State Publishing House, 1923.

157–158 *Normalbühne Merz,* model, c. 1924. Whereabouts unknown.

159 Heinz Loew. *Model for a Mechanical Stage,* c. 1926–27. 36¼" x 60¼" x 29⅞" (92 x 153 x 76 cm.). Whereabouts unknown.

160 Design for *Normalbühne Merz,* 1925. Watercolor. Whereabouts unknown.

161 *Die heilige Bekümmernis (The Holy Affliction),* c. 1920. Assemblage. Destroyed.

162 Hannover *Merzbau: The Merz-Column,* c. 1920.

163 The First International Dada Fair, Berlin, June 1920.

164 Johannes Baader. *Das grosse Plasto-Dio-Drama "Deutschlands Grösse und Untergang" (The Great Plastic Dio-Dada-Drama "Germany's Greatness and Downfall"),* c. 1920. Assemblage. Destroyed.

165 Ground floor plan of Schwitters' home at Waldhausenstrasse 5, Hannover. Diagram by the author.

166 Photograph of Schwitters' house at Waldhausenstrasse 5, Hannover, 1926.

167 Plan of the principal room of the Hannover *Merzbau.* Diagram by the author.

168 Hannover *Merzbau: Die grosse Gruppe* (The Big Group), photographed c. 1932.

169 Hannover *Merzbau: Die Goldgrotte* (The Gold Grotto), photographed c. 1932.

170 Hannover *Merzbau:* General view with *Die Goldgrotte* (The Gold Grotto), *Die grosse Gruppe* (The Big Group), and movable column, photographed c. 1930.

171 Antoni Gaudí. Chapel for the Colonia Güell near Barcelona, 1898–1915. Porch of the completed crypt.

172 Max Taut. *Watercolor Study,* c. 1920. Whereabouts unknown.

173 Hans Poelzig. Grosses Schauspielhaus (Grand Theater), Berlin, 1919.

174 Walter Würzbach and Rudolf Belling. Dance Casino at the Scala-Palast, Berlin, c. 1920.

175 Hannover *Merzbau:* View with *blaues Fenster (Blue Window),* photographed c. 1930.

176 Hannover *Merzbau:* Merz-column, c. 1923.

177 *Der erste Tag (The First Day),* c. 1918–19. Collage. Destroyed.

178 Hannover *Merzbau:* General view with 1923 column, photographed c. 1930.

179 Hannover *Merzbau:* 1923 column in later state, photographed c. 1930.

180 Wilhelm Busch. *Die fromme Helene (Devout Helene).*

181 Erich Buchholz. Room at Herkulesufer 15, Berlin, 1922.

182 Walter Gropius and Adolf Meyer. Sommerfeld House, Berlin-Dahlem, 1920–21.

183 Vilmos Huszár and Gerrit Rietveld. Project for an interior, 1923.

184 Still from *Das Kabinett des Dr. Caligari,* directed by Robert Wiene, 1919.

185 El Lissitzky. Design for *Prounenraum,* 1923. (1st Kestner Portfolio.) Lithograph, 23¾" x 17¼" (60.4 x 43.9 cm.). Private collection.

186 Still from *Raskolnikow,* directed by Robert Wiene, 1923.

187 Hannover *Merzbau: Kathedrale des erotischen Elends (KdeE) (Cathedral of Erotic Misery),* photographed 1928.

188 Hannover *Merzbau: Kathedrale des erotischen Elends (KdeE) (Cathedral of Erotic Misery),* photographed c. 1930.

189 Hannover *Merzbau: Kathedrale des erotischen Elends (KdeE) (Cathedral of Erotic Misery),* photographed 1928.

190 *(Amsterdam),* 1923. Stamp drawing and collage, 8¾" x 5¾" (22.2 x 14.6 cm.). Lords Gallery, London.

191 "A O Bildgedicht" ("A O Picture-poem"), 1922. Kurt Schwitters Archive, Oslo.

192 "Gesetztes Bildgedicht" ("Typeset Picture-poem"), 1922. Kurt Schwitters Archive, Oslo.

193 Opening page of "Ursonate," 1922–32, from *Merz 24.* Hannover 1932.

194 Page from "Ursonate," 1922–32, from *Merz 24.* Hannover 1932.

195 Raoul Hausmann. "fmsbw," 1918. 12¾" x 19¾" (32.3 x 50.2 cm.). Collection Mme. Marthe Prévot, Limoges.

196 *Mz 1600. Rotterdam,* 1923. Collage, 6⅞" x 5⅝" (17.5 x 14.3 cm.). Private collection.

197 *Merzbild 12b. Plan der Liebe (Plan of Love),* 1919 and 1923. Collage, 17" x 12⅞" (43.2 x 32.7 cm.). Collection Muriel Kallis Newman.

198 *(Famiglia),* 1922. Collage, 5¾" x 4¼" (14.3 x 10.8 cm.). The Museum of Modern Art, New York. Sidney and Harriet Janis Collection (fractional gift).

199 *(Relief),* 1923. Assemblage, 14" x 11¾" (35.5 x 30 cm.). Museum Ludwig, Cologne.

200 *Siegbild (Victory Picture),* c. 1925. Collage, 15" x 12⅝" (38 x 32 cm.). Wilhelm-Hack-Museum, Ludwigshafen.

201 *Mz 26,41. okola,* 1926. Collage, 6⅞" x 5⅜" (17.7 x 13.6 cm.). Private collection.

202 *Mz 26,30. rotes Dreieck (Red Triangle),* 1926. Collage, 9¾" x 8" (25 x 20.5 cm.). Sprengel Museum, Hannover.

203 *Mz 1926,5. mit lila Sammet (with Lilac Velvet),* 1924 and 1926. Collage, 11¼" x 9⅜" (28.5 x 23.9 cm.). Sprengel Museum, Hannover.

204 Untitled lithograph from the *Merzmappe (Merz Portfolio)* issue of *Merz,* 1923. Photolithograph, 21⅞" x 16¾" (55.5 x 42.5 cm.) (sheet). The Museum of Modern Art, New York. Purchase Fund.

205 *Dieser ist Friedel Vordemberges Drahtfrühling (This is Friedel Vordemberge's Wire Springtime),* 1927. Collage, 10⅝" x 8" (27 x 20.2 cm.). Private collection.

206 *Die breite Schmurchel (The Wide Schmurchel),* 1923. Wood relief, 14¼" x 22" (36 x 56 cm.). Staatliche Museen Preussischer Kulturbesitz, Nationalgalerie, Berlin.

207 Hans (Jean) Arp. *La trousse du voyageur (The traveler's bundle),* 1920. Wood relief, 15⅜" x 10⅝" x 1½" (39 x 27 x 4 cm.). Private collection.

208 Vladimir Tatlin. *Counter-Relief,* c. 1915–16. Exhibited at the "Erste russische Kunstausstellung," 1922. Wood and metal relief. Whereabouts unknown.

209 *Merzbild Kijkduin,* 1923. Assemblage, 29¼" x 23¾" (74.3 x 60.3 cm.). Thyssen-Bornemisza Collection, Lugano.

210 *Für Tilly*, 1923. Painted relief. 10″ x 6¼″ (25.8 x 15.8 cm.). Private collection.

211 *Albert Finslerbild*, 1926. Oil on wood, 29½″ x 24⅜″ (75 x 62 cm.). Private collection.

212 *Merz 1003. Pfauenrad (Peacock's Tail)*, 1924. Oil and wood on composition board, 28⅝″ x 27¾″ (72.7 x 70.6 cm.). Yale University Art Gallery. Collection Société Anonyme and Estate of Katherine S. Dreier.

213 Cesar Domela. *Construction*, 1929. Painted relief, 8″ x 22½″ (20.2 x 57.1 cm.). Philadelphia Museum of Art.

214 *Merzbild mit Kerze (Merzpicture with Candle)*, c. 1925–28. Assemblage, 10⅝″ x 10⅝″ (27 x 27 cm.). Permanent loan to Musée d'Art et d'Histoire, Geneva.

215 *blau (blue)*, c. 1923–26. Painted relief, 20⅞″ x 16¾″ (53 x 42.5 cm.). Collection Mrs. Antonina Gmurzynska, Cologne.

216 *(Oval Construction)*, c. 1925. Painted relief, 45″ x 30″ (114.3 x 76.2 cm.). Yale University Art Gallery. Gift of Collection Société Anonyme and Estate of Katherine S. Dreier.

217 *Wie bei Picasso (As with Picasso)*, c. 1925–28. Painted relief, 30¼″ x 23¼″ (77 x 59 cm.). Private collection.

218 *Richard Freytagbild*, 1927. Painted relief, 31⅛″ x 24½″ (79.2 x 62.1 cm.). Private collection.

219 Hans (Jean) Arp. *Composition abstraite (Abstract Composition)*. 1915. Painted relief, 29¼″ x 35⅝″ (74.5 x 90.5 cm.). Teheran Museum of Contemporary Art.

220 *Drei Kugeln (Three Spheres)*, c. 1920–36. Painted relief, 39⅜″ x 29½″ (100 x 75 cm.). Insel Hombroich.

221 Cover of *Die Blume Anna. Die neue Anna Blume*, 1922. 9″ x 6¼″ (23 x 16 cm.).

222 Double page spread from the pamphlet *Die neue Gestaltung in der Typographie*, c. 1925. 5⅞″ x 8½″ (15 x 21.5 cm.).

223 "Pornographisches *i*-Gedicht" ("Pornographic *i*-poem"), from *Merz 2*, 1923.

224 *(Tortrtalt)*, 1929. Collage, 4″ x 4¾″ (10 x 12.2 cm.). Private collection.

225 Double page spread from "Typoreklame" issue of *Merz*, 1924. 11⅜″ x 17¼″ (29 x 44 cm.).

226 *Karlsruhe*, 1929. Collage, 11⅜″ x 7¾″ (28.9 x 19.7 cm.). The Museum of Modern Art, New York. McCrory Corporation Collection.

227 *(Pelikan)*, 1925. *i*-Zeichnung, 4¾″ x 4¾″ (12 x 12 cm.). Sidney Janis Gallery, New York.

228 Attributed to Schwitters. Mural on a building by Walter Gropius at the Dammerstock-Siedlung architectural exhibition, Karlsruhe, 1929.

229 *(Schwarze Punkte und Viereck) (Black Dots and Quadrangle)*, 1927. Collage, 7¼″ x 5½″ (18.3 x 14.0 cm.). Private collection.

230 *Mz 1926,12. liegendes emm (Reclining m)*, 1926. Collage, 5⅜″ x 4⅛″ (13.5 x 10.4 cm.). Sprengel Museum, Hannover. Extended loan from Marlborough Fine Art, London.

231 *Lockere Vierecke (Loose Quadrangles)*, 1928. Collage, 12¾″ x 10″ (32.2 x 25.4 cm.). Private collection.

232 *(9)*, 1930. Collage, 5⅛″ x 3⅞″ (13.1 x 10 cm.). Permanent loan to Musée d'Art et d'Histoire, Geneva.

233 *(Auf dem Karton) (On the Cardboard)*, c. 1923–26. Collage, 5″ x 4⅛″ (12.8 x 10.5 cm.). Marlborough Fine Art, London.

234 *(mit Maschinenteil) (with Machine Part)*, c. 1926–28. Collage, 5½″ x 4″ (14 x 10.1 cm.). Mr. Philippe-Guy Woog, Vésenaz.

235 *i*-Zeichnung *"Pferd" (Horse)*, 1928. *i*-Zeichnung, 7″ x 5½″ (17.8 x 14 cm.). Lords Gallery, London.

236 *(250 Gramm)*, 1928. Collage, 3¼″ x 2½″ (8.1 x 6.3 cm.). Galerie Gmurzynska, Cologne.

237 *Bild mit weissen Sicheln (Picture with White Crescents)*, c. 1925–28. Oil on wood, 9⅝″ x 9¾″ (24.5 x 24.8 cm.). Private collection.

238 *Mz 30,15 (ENIX)*, 1930. Collage, 7⅛″ x 5½″ (18 x 14 cm.). Private collection.

239 *(Dol 333)*, c. 1930. Collage, 11¼″ x 9¼″ (28.6 x 23.5 cm.). Sidney Janis Gallery, New York.

240 *(Rot, Grau, Schwarz) (Red, Gray, Black)*, 1931. Collage, 11″ x 7⅞″ (27.9 x 20 cm.). Carus Gallery, New York.

241 *(Römischer Park) (Roman Park)*, c. 1934. Collage, 13¾″ x 10″ (35 x 25.4 cm.). Wallraf-Richartz Museum, Cologne.

242 *Weisses Relief (White Relief)*, c. 1924–27. Painted relief, 30″ x 23¼″ (76.2 x 59 cm.). Sprengel Museum, Hannover.

243 Untitled, 1922–23. Later titled *Monument to the Artist's Father*. Painted wood, 50¼″ x 10½″ x 16″ (126.9 x 26.6 x 40.8 cm.). Yale University Art Gallery. Collection Société Anonyme and Estate of Katherine S. Dreier.

244 *Kleine Säule (Little Column)*, c. 1922. Painted wood, 9″ x 8⅝″ x 6¼″ (23 x 22 x 16 cm.). Staatliche Museen Preussischer Kulturbesitz, Nationalgalerie, Berlin.

245 Georges Vantongerloo. *Constructie van Volumen (Volume Construction)*, c. 1918. Stone, 7″ x 4¾″ x 4¾″ (18 x 12 x 12 cm.). Whereabouts unknown.

246 Untitled, c. 1923. Painted wood, 20″ x 5⅛″ x 4¾″ (51 x 13 x 12 cm.). Private collection.

247 *Die Herbstzeitlose (The Autumn Crocus)*, c. 1926–28. Painted concrete, 31¾″ x 11⅝″ x 14″ (80.5 x 29.7 x 35.5 cm.). The Trustees of the Tate Gallery, London.

248 *Schlanker Winkel (Slim Angle)*, c. 1930. Painted wood, height 19″ (48.2 cm.). Galerie Gmurzynska, Cologne.

249 Hannover *Merzbau: Madonna* sculpture, 1930, 1932, and 1936.

250 Untitled, 1936. Wood and plaster, height 86⅝″ (220 cm.). Private collection.

251 Hans Arp. *Growth*, 1938. Bronze, height 31½″ (80 cm.). Philadelphia Museum of Art.

252 Hannover *Merzbau*: Untitled sculpture, after 1930.

253 Hannover *Merzbau: Grotte zur Erinnerung an Molde (Grotto in Remembrance of Molde)*, begun 1933.

254 *Plastische Merzzeichnung (Sculptural Merz-Drawing)*, 1931. Painted relief, 19⅜″ x 14⅛″ (49.2 x 36 cm.). Marlborough Fine Art, London.

255 *Bild mit drehbarer Glasscheibe (Picture with Revolving Glass Disk)*, c. 1930. Relief, 9¾″ x 7¼″ (25 x 18.5 cm.). Staatliche Museen Preussischer Kulturbesitz, Nationalgalerie, Berlin.

256 *Hochgebirge (Gegend Øye) (High Mountains [Øye Neighborhood])*, 1930. Oil with relief elements, 21⅛″ x 18⅛″ (53.7 x 46 cm.). Private collection.

257 *(N)*, c. 1936–37. Collage, 5⅞″ x 4¾″ (15 x 12.2 cm.). Private collection.

258 *(Qualit)*, c. 1937–38. Collage, 6″ x 4⅝″ (15.1 x 11.8 cm.). Marlborough Fine Art, London.

259 *(Oscar)*, 1939. Collage, 8¼″ x 6⅞″ (20.8 x 17.5 cm.). Private collection.

260 *Glückliche Ehe (Happy Marriage)*, 1939. Collage, 12⅛″ x 10″ (30.8 x 25.5 cm.). Whereabouts unknown.

261 *Prikken paa Ien (The Dot on the I)*, 1939. Collage, 29¾″ x 35¾″ (75.5 x 91.0 cm.). Private collection.

262 *(zollamtlich geöffnet) (Opened by Customs)*, c. 1937–38. Collage, 13″ x 9⅞″ (33 x 25 cm.). The Trustees of the Tate Gallery, London.

263 *Bild mit Korbring (Picture with Basket Ring)*, 1938. Assemblage, 4¾″ x 4⅜″ (12 x 11.2 cm.). The Museum of Modern Art,

New York. McCrory Corporation Collection.

264 *Rotterdam*, 1937. Collage, 6¼" x 7¼" (16 x 18.5 cm.). Private collection.

265 Page from Schwitters' photograph album showing photographs taken by himself in Djupvasshytta, Norway, in the 1930s.

266 *Mz Oslofjord*, 1937. Oil on panel, 11⅞" x 9¼" (30.2 x 23.7 cm.). Marlborough Fine Art, London.

267 *Landschaft mit Schneefeld. Oppblusegga* (*Landscape with Snowfield. Oppblusegga*), 1936. Oil on panel, 28⅜" x 23⅝" (72 x 60 cm.). Private collection.

268 *Everybody's hungry for*, c. 1938. Assemblage, 11½" x 11½" (29.3 x 29.3 cm.). Insel Hombroich.

269 *Skøyen*, 1942. Painted collage, 20¼" x 25" (51.5 x 63.5 cm.). Collection Mr. Michael and Dr. Ellen Ringier.

270 *Bild mit Raumgewächsen* (*Picture with Spatial Growths*)—*Bild mit 2 kleinen Hunden* (*Picture with 2 Small Dogs*), 1920 and 1939. Assemblage, 38" x 26¾" (96.5 x 68 cm.). The Trustees of the Tate Gallery, London.

271 *(WA)*, 1947. Collage, 10½" x 8½" (26.7 x 21.7 cm.). Marlborough Fine Art, London.

272 *47.15 pine trees, c 26*, 1946. Collage, 9⅞" x 8" (25.1 x 20.3 cm.). Private collection.

273 *Milk Flower*, 1947. Collage, 11⅜" x 9½" (29.5 x 24 cm.). Marlborough Fine Art, London.

274 *c77. wind swept*, 1946. Collage, 9⅝" x 7⅜" (24.5 x 18.8 cm.). Staatliche Museen Preussischer Kulturbesitz, Nationalgalerie, Berlin.

275 *47.12 very complicated*, 1947. Collage, 9⅝" x 8¼" (24.4 x 21 cm.). Private collection.

276 *c 63. old picture*, 1946. Collage, 14½" x 12¼" (36.7 x 30.9 cm.). Marlborough Fine Art, London.

277 *c 35. paper clouds*, 1946. Collage, 8¾" x 7¼" (22 x 18.2 cm.). The Museum of Modern Art, New York. Gift of Lily Auchincloss (the donor retaining life interest).

278 *(Der verwundete Jäger)* (*The Wounded Hunter*), 1942. Collage, 8" x 10¼" (20.3 x 26 cm.). Marlborough Fine Art, London.

279 *(with Madonna and Angels)*, 1947. Collage, 9" x 7¼" (22.9 x 18.5 cm.). Marlborough Fine Art, London.

280 *Merz 42* (*Like an Old Master*), 1942. Collage, 10½" x 8½" (26.9 x 21.5 cm.). Sprengel Museum, Hannover.

281 *Ladygirl*, 1947. Collage, 6¾" x 5⅞" (17.3 x 15 cm.). Collection Irène Liatowitsch-Diener.

282 *47,20 Carnival, c. 80*, 1947. Collage, 6⅝" x 5⅜" (16.8 x 13.7 cm.). Yale University Art Gallery. Collection Société Anonyme and Estate of Katherine S. Dreier.

283 *(Counterfoil)*, c. 1942–43. Collage, 31" x 23¾" (78.9 x 60.3 cm.). Private collection, West Germany.

284 *In the Kitchen*, c. 1945–47. Assemblage, 24" x 19" (61 x 48.2 cm.). Collection Mrs. Gianluigi Gabetti, New York.

285 *As You Like It*, 1942–43. Assemblage, 27½" x 22⅞" (70 x 58 cm.). Private collection.

286 *Aerated VIII*, 1942. Painted collage, 19½" x 15½" (49.5 x 39.5 cm.). The Art Institute of Chicago.

287 *Red-Rubber-Ball Picture*, 1942. Assemblage, 23¼" x 19⅜" (59 x 49.2 cm.). Marlborough Fine Art, London.

288 *Relief with Half-Moon and Sphere*, 1944. Assemblage, 9¼" x 6⅞" (23.4 x 17.4 cm.). Private collection.

289 *(Pink and Yellow Merz Picture)*, 1943. Assemblage, 13½" x 10¼" (34 x 26 cm.). Private collection.

290 *(Small Merz Picture of Many Parts)*, 1945–46. Assemblage, 14¼" x 11½" (35.9 x 29.2 cm.). Marlborough Fine Art, London.

291 *Protected with yellow artificial bone*, 1941–45–47. Assemblage, 19¼" x 14¾" (48.8 x 37.8 cm.). Private collection.

292 *Wood on Black*, c. 1943–45. Assemblage, 22" x 17¼" (56 x 44 cm.). Kunstsammlung Nordrhein-Westfalen, Düsseldorf.

293 *(White, Beige, Brown)*, 1942. Collage, 16½" x 12⅞" (41.9 x 32.7 cm.). Collection Mrs. Krystyna Gmurzynska, Cologne.

294 *C72*, 1946. Assemblage, 10¼" x 8¼" (26 x 21 cm.). Private collection, Hamburg.

295 *Beautiful Still-Life*, c. 1944. Assemblage, 7¼" x 9¼" (18.1 x 23.2 cm.). Marlborough Fine Art, London.

296 *Portrait of Harry Bickerstaff*, 1946. Oil on canvas, 31" x 25" (78.9 x 63.5 cm.). Private collection.

297 *Dotty Picture*, 1947. Oil on board, 22¾" x 18" (57.6 x 45.8 cm.). Marlborough Fine Art, London.

298 Untitled, 1945. Oil on canvas, 20" x 14" (51 x 35.5 cm.). Private collection, Ambleside.

299 *Small Flower Picture*, 1941. Assemblage, 8" x 6½" (20.2 x 16.5 cm.). Marlborough Fine Art, London.

300 *Drama*, 1944. Assemblage, 43¾" x 36⅝" (111 x 93 cm.). Insel Hombroich.

301 *(Cathedral)*, c. 1941–42. Painted wood, 15¾" x 7⅞" x 7⅞" (40 x 20 x 20 cm.). Private collection.

302 *(Yri's Hotel)*, 1939. Ink on paper, 8½" x 5½" (21.7 x 13.8 cm.). Private collection.

303 *Fant* (*Devil*), 1944. Painted wood, plaster and metal, height 11½" (29 cm.). Marlborough Fine Art, London.

304 Untitled, c. 1943–45. Wood, 8¼" x 4½" x 4¾" (21 x 11.5 x 12 cm.). Lords Gallery, London.

305 *Red Wire Sculpture*, 1944. Painted plaster and metal, 9½" x 5¼" x 5¼" (24 x 13.3 x 13.3 cm.). Collection Mrs. Edith Thomas.

306 *Small Twisted Sculpture*, 1937–38. Painted plaster and wood, h. 38⅞" (98.7 cm.). Marlborough Fine Art, London.

307 *Little Dog*, c. 1943–44. Plaster, h. 17⅞" (45.5 cm.). Marlborough Fine Art, London.

308 *The All-Embracing Sculpture*, c. 1943–45. Painted plaster, iron, and wood, h. 23⅝" (60 cm.). Galerie Gmurzynska, Cologne.

309 *Elegant Movement*, c. 1943–45. Plaster, wood, iron, 15¼" x 4¼" x 10¼" (39 x 11 x 26 cm.). Galerie Gmurzynska, Cologne.

310 Untitled, c. 1945–47. Painted plaster and wood, 9" x 6¼" x 6¼" (23 x 16 x 16 cm.). Collection Mrs. Edith Thomas.

311 *Lofty*, c. 1945–47. Painted plaster, 10¼" x 5¾" x 4¾" (26 x 14.5 x 12 cm.). Collection Mrs. Edith Thomas.

312 Exterior view of the Elterwater Merzbarn, 1947.

313 *Pebble Sculpture*, c. 1946–47. Painted plaster, length 5½" (14.4 cm.). Marlborough Fine Art, London.

314 *Exhausted Dancer*, 1943. Painted plaster, 30¾" x 7⅞" x 6" (78 x 20 x 15 cm.). Private collection, West Germany.

315 Elterwater Merzbarn: the relief, 1947.

316 Plan of the Lysaker *Merzbau*, 1937–40. Diagram by the author.

317 Plan of the Elterwater Merzbarn, 1947, showing constructed and proposed elements. Diagram by the author.

318 *Chicken and Egg*, 1946. Painted plaster, 17½" x 9½" x 7¼" (44.5 x 24 x 18.5 cm.). Collection Mrs. Edith Thomas.

319 Untitled, 1947. From the Elterwater Merzbarn. Plaster and bamboo, 32¼" x 9½" (82 x 24 cm.). Private collection, Hamburg.

320 Elterwater Merzbarn: the relief (side view), 1947.

321, 322 Schwitters in London, 1944.

323 At Cylinders on Schwitters' 60th birthday, June 20, 1947, with Bill Pierce and Edith Thomas.

INDEX

Monochrome illustration numbers are given in *italic;* color plate numbers in roman numerals. The Notes on pp. 386–405 are referred to by chapter and number, thus: n6.36.

Abstract Expressionism, 224
abstraction, création, art non-figuratif (mag.), 154, 191, 193–194, 198
Abstractions. See *Abstraktionen*
"abstrakten hannover, die," 126, 153
Abstraktion (Z57), 24, *17*
Abstraktionen, 19, 22, 25, 33, n1.39, *12, 20, 23*
academic painting by S., 14, 27, n1.13
Achsenzeichnung, 24, *19*
Action Takes Place in Thebes, The. See *Handlung spielt in Theben, Die*
Activism, 33
Aerated VIII, 213, *286*
Aktion, Die (mag.), 33
Alarm Clock. See *Réveil-Matin*
Albert Finslerbild, 183, *211*
Alienist, The. See *Irrenarzt, Der*
All-Embracing Sculpture, The, 219, *308*
"Alphabet von hinten" (poem), 175
Ambleside, 206–207, 209, 218, 220–221
Amsterdam, 190
"An Anna Blume" (poem), 44, 36–39, 97, 102, 106, n2.31
And Picture, The. See *Undbild, Das*
"An eine Zeichnung Marc Chagalls" (poem), 46
Angel Picture, The. See *Engelbild, Das*
Anna Blume (literary character), 16, 45, 73, 78, 80, 110, 167, 212
Anna Blume. Dichtungen (book of poems), 39, 44, 46, 99, *33*
"A O Bildgedicht" (poem), 175, *191*
Aphorismen, 72, 188, n4.10, *76*
Aphorisms. See *Aphorismen*
Apollinaire, Guillaume, 71
Apossverlag, 131
Appia, Adolphe, 107
Ararat, Der (mag.), 14, 19, 20, 41, 65, 141, 185
Arbeiterbild, Das, 13, 26, 50, 52, 63, 73, *46*
Arbeitsrat für Kunst (group), 13, 114–115, 122, 163
Archipenko, Alexander, 55, 113, 131, *64*
Arp, Hans (Jean): abstract composition, 186, *219;* International Constructivism and, 122–128, *passim;* Merzbau and, 160; Merzbilder and, 182, 251, *207, 219;* Merzzeichnungen and, 72, 85, 87, *41;* S.'s prints and, 48, *41;* S.'s sculpture and, 194, 230, *251;* Zurich Dada and, 233–234
"Art and the Times" (article), 137, 185
Art Deco, 91
Art Nouveau. See *Jugendstil*
assemblages. See *Merzbilder*
As with Picasso. See *Wie bei Picasso*
As You Like It, 215, *285*
Auf dem Karton, 189, *233*
Auguste Bolte (novel), 166, 177–178
Ausgerenkte Kräfte, 61, 62, 57, *61*
Autumn Crocus, The. See *Herbstzeitlose, Die*
avant-garde, 216, 226–229
Axle-Drawing, see *Achsenzeichnung*

Baader, Johannes, 33, 113, 145–146, *164*
Bahlsen, Hermann, 126
Ball, Hugo, 34, 234
Balla, Giacomo, 20, 60, n1.54, *60*
"Ballad of the Mermaid, The" (poem), 212
"banalities," 37, 43, 72, 98–99, 177
Bantzer, Carl, n1.13
Barr, Alfred H., 125, 153, 156
Bäsenstiel, Alves (literary character), 102, 113, 167, n7.125
Baudelaire, Charles, 168
Bauhaus, 112, 124–125, 135, 141, 143, 181, *139*
Bäumerbild, Das, 68, 73, 75
Bäumer Picture, The. See *Bäumerbild, Das*
BBC (British Broadcasting Corporation), 220
Beautiful Still-Life, 214, *295*
Beindorff, Fritz, 126
Belling, Rudolf, 163, *174*
Benjamin, Walter, 92
Bergson, Henri, 135, 138, 193
Berlin Dada. See Dada in Berlin
Bickerstaff, Harry, 206, 218
Bilbo, Jack, 206
Bild mit Damestein (Merzbild 9A), 57, *47*
Bild mit drehbarer Glasscheibe, 195, *255*
Bild mit Drehrad (Merzbild 29A), 68, 196, 202, *67*
Bild mit heller Mitte, 59, 67, *IV*
Bild mit Korbring, 263
Bild mit Raumgewächsen (Bild mit 2 kleinen Hunden), 68, 201, *270*
Bild mit rotem Kreuz (Merz 1B), 59–60, 83, *54*
Bild mit weissen Sicheln, 190, *237*
Bild mit 2 kleinen Hunden. See *Bild mit Raumgewächsen*
Bindeschlips, Der (Abstraktion 9), 22, 25, *20*
biotechnical and biomechanical elements, 136, 139, 179. See also Elementarism
Black Dots and Quadrangle. See *Schwarze Punkte und Viereck*
"Black" Notebook, The. See "Schwarze" Notizbuch, Das
Blake, William, 193
blau, 184, *215*
blaue Fenster. See *Merzbau* in Hannover, main room of
Blaue Reiter, Der (group), 15, 17, 31, 92, 106
Blaukreuz Oval (Mz 321.), 83, *110*
Blok (mag.), 128, 133
Blossfeldt, Karl, 194
Blue. See *blau*
Blue Bird. See *Blauer Vogel*
Blue Cross Oval. See *Blaukreuz oval*
Blümner, Rudolf, 17
Boccioni, Umberto, 24, *16*
Bonset, I.K. See Van Doesburg, Theo
Börsenkurier (mag.), 144
Bow Tie, The. See *Bindeschlips, Der*
Box, The. See *Dose, Die*
Braque, Georges, 13, 60, 83, *56.* See also Cubism
breite Schmurchel, Die, 182, *206*
Breton, André, 226
Brik, Osip, 120

Brücke, Die, 14–15
Brugman, Til, 183
Buchheister, Carl, 126
Buchholz, Erich, 151, *181*
bunt (Mz 322), 81, *101*
Busch, Wilhelm, 56, 159, 166, *180*
Bussum, 48, *38*

Cabaret, 81, 104
Cabaret Voltaire (mag.), 72; collage (Arp), *41*
Cabaret Voltaire, Zurich, 104, 234
Cabinet of Dr. Caligari, The. See *Kabinett des Dr. Caligari*
Carnival, c. 80, 47,*20,* 212, *282*
Carpenter. See *Hobelmann*
Carrà, Carlo, 74, *103*
Castle and Cathedral with Courtyard Well. See *Schloss und Kathedrale . . .*
Cathedral. See *Kathedrale, die*
(Cathedral), 218, *301*
Cathedral of Erotic Misery. See *Merzbau* in Hannover, columns
Cathedral of the Future. See *Zukunftskathedrale*
"Causes and Outbreak of the Great and Glorious Revolution in Revon." See "Ursachen und Beginn . . ."
cercle et carré (mag.), 193, 197
Cézanne, Paul, 15
Chagall, Marc, 17, 46, 52, n3.18, *36, 45*
Cherry Picture, The. See *Kirschbild, Das*
Cheval, Ferdinand, 115
Chicken and Egg, 221, *318*
Chocolate Box, Anna Blume, Box 7, The. See *Schokoladenkasten, Der*
Cicero (Bild 1926,3), 185, *XVIII*
Cicerone, Der (mag.), 49
"Cigarren" (poem), 173
Coleridge, Samuel Taylor, 193
Collages. See *Merzzeichnungen*
Cologne Sonderbund exhibition, 15, 17
Colored Squares. See *Farbige Quadrate*
Congress of Dadaists and Constructivists. See Weimar Congress
Congress of International Progressive Artists. See Düsseldorf Congress
Construction. See *Konstruktion*
Construction for Noble Ladies. See *Konstruktion für edle Frauen*
Constructivism: Berlin, 42, 122; Dada and, 121–125, 128–130, 224, 230–231; the handmade and, 181–182; International, 121–125, 126–143 *passim;* materials and, 62, 180–181; Russian, 120–122, 125, 131–132, 213; Russian theater and, 142–143, n6.121; Schwitters' art and, 61, 88, 126–127, 132, 182–185, 190–191, 195; the term, 120
Constructivists, First Working Group of, 120
Coquetry. See *Koketterie*
Corbusier, Le, 181
Cornell, Joseph, 117
Counterfoil, 200, 211, *283*
Craig, Edward Gordon, 107
Critic, The. See *Kritiker, Der*

419

Cubism: Analytical, and S.'s art, 24, 83; Dada and, 232–235; S's *Abstraktionen* and, 25; S.'s early work and, 22–25; S.'s late work and, 199–200, 212–213, 217–218; *Merzbilder* and, 13, 55, 59–61, 66–67, n3.54; *Merzzeichnungen* and, 82–84, 88; S.'s rubber-stamp drawings and, 47–48; S.'s sculpture and, 192; Synthetic, and S.'s art, 83, 88
Cult Pump, The. See *Kultpumpe, Die*
Cupboard. See *Kammer*
Cylinders. See *Merzbau* at Elterwater
C72, 214, *294*

Dada: art and, 34, 41–42, 225–230; in Berlin, 13, 33–42, 77, 80, 115, 121, 170, 235–236; Berlin Dada Fair, 40–41, 122, 144, n2.47, *163;* Constructivism and, 121–125, 128–130, 224, 230–231; "core" and "husk" Dadaism, 41; Cubism and, 229, 231–235; documentation and, 235–236; Expressionism and, 34–35, 115, 121–122, n2.16, n2.18; photomontage and, 78, 234; primitivism and, 34, 201, 233–234; S. in relation to, 33–42, 67, 133, 205, 225–228; Surrealism and, 121, 224, 230; technology and, 232–236; World War I and, 34–35, 232–233; in Zurich, 34–35, 233–234
Dada, Der (mag.), 128
Dadaist drawings by S., 44–45, 109, 113, *II, 30, 31, 33, 34, 134*
Dadaist sculptures by S., 112–118, 144, 159, *133, 135, 136, 140, 161.* See also *Merzbau* in Hannover
"Dadarevon" performance, 125
Dammerstock-Siedlung (housing project), Karlsruhe, 187, n8.45, 226, 228
d'Ebneth, Lajos, 182
De Chirico, Giorgio, 57, 79, 216, *50*
Delaunay, Robert, 17, 23, 60, *55*
(*Der Sturm*), 73, 91, *73*
Devil. See *Fant*
Dexel, Walter, 124
Dickens, Charles, 197
Dieser ist Friedel Vordemberges Drahtfrühling, 180, *205*
(*Difficult*), 211, *XXX*
Disjointed Forces. See *Ausgerenkte Kräfte*
dissociation. See *Entformung*
Dix, Otto, 88, n1.13, *129*
(*Dol 333*), 190, *239*
Domela, Cesar, 126, 184, 187, *213*
Dorf (*Merzz 101*), 75, 91, *109*
Dorner, Alexander, 125–126, 162
Dose, Die (*Merzbild 14B*), 72
Dot on the I, The. See *Prikken paa Ien*
Dotty Picture, 215, *297*
Douglas, Isle of Man, 205
Drama, 111, 214, *300*
Dreieins (*Mz 336*), 127, *146*
Drei Kugeln, 186, 202, 220
Dreier, Katherine S., 125. See also *Société Anonyme*
Dresden, Kunstakademie, 14, 27, n1.13
Drinker, The. See *Trinker, Der*
(*Drucksache*), 47, *138*
Duchamp, Marcel, 78, 188, 234–235
D-U Drucksache, 47, *31*
D-U Printed Matter. See *D-U Drucksache*
Düsseldorf Congress, 123–125, 134
Dutch tour by S., 105–106, 124, 127–128, *130, 131*
Dux, Dr. Walter, 207

(*Ebing*), 74, *80*
Edschmid, Kasimir, 24, 117
Eggeling, Viking, 115, 122, 124, 135
ego-drama, 116
Ehrenburg, Ilya, 122–123
Eigengift (S.'s concept of), 116, 237; *Merzbilder* and, 51, 57, 65, 69; *Merzzeichnungen* and, 71, 85, 93; poetry and, 102; sculpture and, 113
Eilenriede, Hannover, 56, 147, 155
Einsame, Der (*Z42*), 24, *13*
Eisenbetonstimmung, Die, 22
Eisner, Lotte, 164–165
Elegant Movement, 219, *309*
Elementarism, 130, 134–137, 139, 141, 185, 188–189
Elger, Dietmar, 146
(*elikan*), 180, *XX*
Eliot, T.S., 56
(*Emerka*), 88, *126*
Enchanted Garden, The. See *verwunschene Garten, Der*
(*Engelbild, Das*), 78, 90
ENIX (*Mz 30,15*), 190, *238*
Entformung (S.'s concept of), 43, 45, 235, 237; Hannover *Merzbau* and, 163; *Merzbilder* and, 51; poetry and, 99, 110, 116
Entschleierung (*Abstraktion 19*), 25, 26, 52, 54, *23*
"*er,*" Mz., 127, *149*
"Erhabenheit" (poem), 21
Ernst, Max, 45, 55, 79, 113, 146, 234, n2.65, n4.61, *27, 65*
Erste deutsche Herbstsalon, 17, 123, 131–132
Erste russische Kunstausstellung, 123, 131–132, 182–183, n6.60
erste Tag, Der, 158, 159, *177*
Erzberger, Mathias, 64
Esprit nouveau, L', (mag.), 135
"Eve Blossom" (poem), 38. See also "An Anna Blume"
Everybody's Hungry for, 201, *268*
Exhausted Dancer, 219, *314*
expression (S.'s concept of), 26–27, 32, 66, 77
Expressionen, 18–19, *7, 11*
Expressions. See *Expressionen*
Expressionism: architecture and, 112, 114–115, 163–164; Dada and, 34–35, 115, 121–122; film and, 13, 164–165; S.'s art and, 14–18, 21–24, 30–33, 44, 51–54, 63, 72–73, 92, 117, 169–170; S.'s poetry and, 20–21, 43, 95–103; the term, 15, 23; theater and, 13, 107, 116
Expressionist drawings by S., 24–25, n1.48, *13, 15, 17, 19*

(*Famiglia*), 179, *198*
Fant, 218, *303*
Farbige Quadrate (*Mz 252*), 86, 127, *XIV*
fashion imagery, 79, n4.29, n4.36
Fashion I. See *Mode I*
Fauvism, 86, 230
(*fec*), 73–74, *77*
Feininger, Lyonel, 17, 23–24, 114, 122, 184, *139*
Figurine (*Mz 180*), 79, *91*
First Day, The. See *erste Tag, Der*
Flooded Fields. See *Überschwemmte Wiesen*
Forces, The. See *Gewalten, Die*
Forest, The. See *Wald, Der*
For Käte, 212, *XXXII*

Form, Die (mag.), 143
Formen im Raum (*Mz 169.*), 75, 82, 86, *XI*
Forms in Space. See *Formen im Raum*
Francé, Raoul, 139, n6.103
Franz Müllers Drahtfrühling (assemblage), 113
Franz Müllers Drahtfrühling (novel), 102, 113, 167. See also "Ursachen und Beginn . . ."
Frau-Uhr (*Mz 239*), 78, 182, *96*
freie Strasse, die (mag.), 33, 41, 47
Freud, Sigmund, 168–169
Friedrich, Kaspar David, 30, 40, 92
Fronta (mag.), 128
Frühlicht (mag.), 115
Frühlingstür, Die, 202, *XXIV*
Funny Beast. See *Komisches Tier*
Für Tilly, 183, *210*
für V.I.Kuron (*Mz 299*), 83, 211, *121*
"Fury of Sneezing" (poem), 207
Fussell, Paul, 233
Futurism: S.'s art and, 17, 24, 26, 60, 81, 92, 227; S.'s poetry and, 95, 111; *Der Sturm* and, 17, 22, 30–33

G (mag. and group), 122, 125–126, 128, 131
Gabo, Naum, 122, 132, 160, 206
Galerie Dada, Zurich, 30, n2.1
Galerie Der Quader, Hannover, 130
Galerie Garvens, Hannover, 125–126, 131
Galerie Goltz, Munich, n1.13
garden (S.'s), 20, 201
Gaudí, Antoni, 163, *171*
"Gedicht 25" (poem), 174–175
"Gefangene, Der" (poem), 208
gelbe Klang, Der (Kandinsky), 107–108
Generalbass: Goethe and, 31; Kandinsky and, 31–32; Van Doesburg and, 134; Richter and Eggeling and, 135
Gesamtkunstwerk: Der Blaue Reiter and, 31; Der Sturm and, 30–32; S.'s conception of, 26, 30–31, 44, 94–95, 106, 112, 131, 217, 237–238; *Merzbau* and, 114, 146–151; *Merzbühne* and, 109, 112; *Normalbühne Merz* and, 141–143
"Gesetztes Bildgedicht" (poem), 173, 175, 188, *192*
Gewalten, Die (*Abstraktion 2*), 22, *12*
Gide, André, 89
Giedion-Welcker, Carola, 161–162
Glass Flower, 203, 218, 222, *XXIX*
Glückliche Ehe, 199, *260*
Goldgrotte. See *Merzbau* in Hannover, grottos
Goldschmidt, Hilde, 221
Goldwater, Robert, 140
Golysheff, Jefim, 115
Gorky, Arshile, 194
Graeff, Werner, 124
Grau (*Mz 308*), 83, 86, *119*
Gray. See *Grau*
Great Britain: S.'s arrival and internment in, 205; S.'s life in, 205–207, 209, 219–221
Great Ich Picture. See *grosse Ichbild*
Gropius, Walter, 114–115, 124–125, 133, 141, 143, 164, *182, 228*
Grosse Berliner Kunstausstellung, 151
grosse Grotte der Liebe. See *Merzbau* in Hannover, grottos
grosse Gruppe. See *Merzbau,* in Hannover, main room of
grosse Ichbild, Das (*Merzbild 9B*), 59, 60, 67, *58*
grosse Ichbild, Das, collaged over postcard of, 80, *85*

Grosse Merz-Ausstellung, 197
Grosser Tanz (Mz 250), *XVI*
Grosses Schauspielhaus, Berlin, 107, 164, *173*
Grosz, George, 33, 40, 45, 79, 234, n1.13, n2.66, *32*
Grotte "zur Erinnerung an Molde." See *Merzbau* in Hannover
"Grünes Kind" (poem), 96
Guinea pig house. See *Merzbau* in Hannover, grottos in
Günther Wagner, 187, *225*

Haarmann, Fritz, 161
Hahnepeter, Der (Merz 12), 131, 166, 177
(*Handlung spielt in Theben, Die*), 77, *84*
Hannover: S.'s attachment to, 166–167, 201, 205, 239–40, *169–170*; his departure from, 198; effects of Fascism in, 197. See also "Revon"
Hannover Sezession, 17, 125. See also Kestner-Gesellschaft
Hansi (Zeichnung A2), 71–72, 86, n4.7, *IX*
Happenings, 110
Happy Marriage, see *Glückliche Ehe*
Hartley, David, 103
Hasenclever, Walter, 116
Haus am Bakken. See *Merzbau* in Lysaker
Hausenstein, N., 140
Hausmann, Raoul: Berlin Dada and, 33, 35–36, 41, 115; Elementarism and, 123, 143; International Constructivism and, 112, 124, 125, 128; phonetic poetry ("fmsbw") and, 105, 129, 175–176, *195*; photomontage and, 78–80, 97, 99, *104*; *Pin* and, 207, 209–210; Prague tour and, 41, 175–176; "PRÉsentismus" and, 79, 122
Haus Merz, 113–114, 148, *136*
Heart-Clover. See *Herz-Klee*
Heartfield, John, 33, 79
Heart Goes from Sugar to Coffee, The. See *Herz geht vom Zucker zum Kaffee, Das*
Heavy Relief, 214, 218, *XXVIII*
Hebel 2 (Zeichnung I9), 82, *117*
Hegenbarth, Emmanuel, n1.13
heilige Bekümmernis, Die, 113, 144–145, *161*
heilige Nacht von Antonio Allegri gen. Correggio . . ., Die, 211–212, *XXVII*
Helma Schwitters mit Blume, 16, *6*
Helma Schwitters with a Flower. See *Helma Schwitters mit Blume*
Hepworth, Barbara, 194
Herbin, Auguste, 194
"Herbst" (poem), 20
Herbstzeitlose, Die, 191, 247
Herzfelde, Wieland, 33
Herz geht vom Zucker zum Kaffee, Das (Aq. 1), 45, 51, *II*
Herz-Klee (Mz 79), 74, *83*
High Mountains (Øye Neighborhood) see *Hochgebirge (Gegend Øye)*
Hinterglasmalerei, 68, n3.58
(*Hitler Gang*), 210, *XXXI*
Hjertøy, 194, 204
Hobelmann (Z.i.5), 125
Hoech, Hannah, 33, 123, 160, 175, 194, 236
Hochgebirge (Gegend Øye), 196, *256*
Hochgebirgsfriedhof, 22, 26, n1.38, *I*
hohe Ufer, Das (mag.), 49
Hohlt, Otto, 73, n4.15
"Holland Dada" (*Merz 1*), 65, 105, 129, 158
Holy Affliction, The. See *heilige Bekümmernis, Die*

Holy Night by Antonio Allegri gen. Correggio . . . See *heilige Nacht von Antonio Allegri gen. Correggio . . ., Die*
Horse. See *Pferd*
Huelsenbeck, Richard: Berlin Dada and, 34–35, 40, 79, 122, 225–226, 233, 236; conflict between S. and, 36, 40–41; on Expressionism, 34–35; on S., 40, 92, 145, 170, 225
Huszár, Vilmos, 105–106, 127, 151, *151*, *183*
Huthbild, Das, 59, 60, 63, *53*
Huth Picture, The. See *Huthbild, Das*

i (S.'s conception of), 188–189
i-drawings. See *i-Zeichnungen*
i-poems. See *i-Gedichte*
"i-Gedicht, Das", (poem), 175
i-Gedichte, 175, 188–189, 223
"Ich werde gegangen" (poem), 43
Impressionism: and S.'s early work, 14; and S.'s late work, 196, 216–218
(*Intarsienkästchen Anna*), 117, *143*
"Internationale Fraktion der Konstruktivisten," 123, 125, 134
In the Kitchen, 213, 284
irgendsowas (Mz 410), 86, *XIII*
Irrenarzt, Der (Merzbild 1A), 51, 54, *43*
ische gelb (Mz 316), 82, *112*
ish yellow. See *ische gelb*
Isle of Man. See Douglas
i-Zeichnungen, 46, 72, 188–189, *124*, *125*, *235*

Jahns, Rudolf, 126, 153
Janco, Marcel, 113, 124, *132*
Jena, 124–125
Jessner, Leopold, 107
Johns, Jasper, 66
Johst, Hanns, 116
Jugendstil, 18, 193
Junges Rheinland group, 123
Jung, Franz, 33

K (group), 126
Kafka, Franz, 101, 102
Kaltensundheim (Mz 387), 88, *127*
Kammer (Mz 271), 82, *120*
Kandinsky, Wassily: *Gesamtkunstwerk* and, 32–32; *Generalbass* and, 31; on materials, 32, 92; S.'s early work and, 18, n1.25, *8*; S.'s letter to, 17; the Sturm group and, 17, 23, 31–32; the theater and, 106–108; writings by, 92, 106, 122. See also *blaue Reiter, Der*
Karlsruhe, 187, 226
Kassák, Ludwig, 128
"Katalog" (*Merz 20*), 126, 148
Kathedrale des erotischen Elends. See *Merzbau* in Hannover, columns
Kathedrale, Die: 48, 115; cover of the portfolio, 40, *26*; lithograph from the portfolio, 42, *25*
Kaufmann, Edgar, 220
Kaufmann, Oliver, 219–220
Kayser, Friedrich, 126
KdeE. See *Merzbau* in Hannover, columns
Kegelbild, Das (Merzbild 46a), 68, 182–183, *68*
Kestnerbuch, Das, untitled woodcut from, 26, 44, *21*
Kestner-Gesellschaft, Hannover: foundation and early exhibitions there, 16–17, n1.22; poetry recitals there, 17, 105; in the 1920s, 124–125; Lissitzky and, 131–132
King Edward. See *König Eduard*

Kirchner, Ernst Ludwig, 14, 24, *14*
Kirschbild, Das (Merzbild 32A), 68, 76, 178, *VIII*
Klee, Paul, 30, 46–47, 60, 66, 82, 87, 239, *37*, *59*, *108*
kleine Merzel, Der (Merzbild 13A), 58, *51*
Kleine Säule, 244
Kleines Seemannsheim (Bild 1926,12), 182–183, 196, 202, *XIX*
Knave Child. See *Wenzel Kind*
Kok, Antony, 128
Koketterie (Aq. 23), 43–44, *34*
(*Komisches Tier*), 41, *35*
König Eduard, 78, 89
konsequent (S.'s concept), 237
"Konsequente Dichtung," 130
Konstruktion, 134
Konstruktion für edle Frauen, 55–57, 61, 83, 147, 196, 202, *VII*
Kotsbild, Das (Mz 158), 79–80, *95*
Kots Picture, The. See *Kotsbild, Das*
Kotschauer, Siegfried, 164
Krayl, Carl, 115, *141*
Kreisen, Das, 52–54, *V*; collage over postcard of, 80, *86*
Kritiker, Der, 47, *24*
Kuehn, Herbert, 140
Kühl, Gotthard, n1.13
Kultpumpe, Die, 78, 112, 114, *133*
Küppers, Paul, 125
Küppers (later Lissitzky-Küppers), Sophie, 132, 139

Lach, Friedhelm, 64
Ladygirl, 212, *281*
Lake district, England, 206–207, 220–223
Landscape from Opherdicke. See *Landschaft aus Opherdicke*
Landscape with Snowfield. Oppblusegga. See *Landschaft mit Schneefeld. Oppblusegga*
Landschaft aus Opherdicke, 14–16, *2*
Landschaft mit Schneefeld. Oppblusegga, 267
Lang, Fritz, 165
Last, Rex, 39, 103
"Lautsonate." See "Ursonate"
Le Corbusier, 135
Leere im Raum (Mz 170), 74–75, *81*
Léger, Fernand, 131, 180–181
Leni, Paul, 165
"letzte Fliege, Die" (poem), 177
Lever 2. See *Hebel 2*
Levin, Harry, 239
Liebe, Die (G Expression 3), 18–19
liegendes emm (Mz 1926,12), 189, *230*
Like an Old Master (Merz 42), 212, *280*
Lissitzky, El: Arp and, 146; *Gesamtkunstwerk* and, 150, 151, *185*; in Hannover, 131–132; International Constructivism and, 122–125; "Nasci" and, 133, 136–140; on S., 131, 162; S.'s typography and, 131, 187, *153*, *154*, *156*; the theater and, 141–143
Little Column. See *Kleine Säule*
Little Dog, 219, *307*
Lochner, Stefan, 78, 159
Lockere Vierecke, 189, *231*
Loew, Heinz, 142, *159*
Lofty, 219, *311*
London, 206, 220, *321*, *322*
"London Symphony" (poem), 207–208
Lonely One, The. See *Einsame, Der*
Loose Quadrangles. See *Lockere Vierecke*
Love. See *Liebe, Die*

Luckhardt, Wassili and Hans, 115, 163, *137*
Lustgalgen, Der, 112–114, *135*
Lysaker, nr. Oslo, 198, 200, 203–204

MA (mag.), 128, 143
Machine Esthetic: Léger and, 180; S. and, 133ff, 181–182; Van Doesburg and, 135
Macke, August, 17
Madonna, 155, *249*
(*Mai 191*), 73, 86, 211, *X*
Malevich, Kasimir: 66, 132, *150*; "Nasci" and, 138–139; writings by, 138,188,n6.95
"Manifest Proletkunst" (manifesto), 42
Many-colored. See *bunt*
Marc, Franz, 17–18, 22, 92, 106, n1.26
Marinetti, Filippo Tommaso, 47, 95, 111
Marmorhaus, Berlin, 107
Matisse, Henri, 20, 87, 117, 230
Mayakovsky, Vladimir, 131, *156*
Mécano (mag.), 122, 124, 130
Mechanical room, 150
Medunetzky, Kasimir, 132
Mehring, Walter, 49, 53, 72
Meidner, Ludwig, 17, 24, n1.50, *10*
Memoiren Anna Blumes in Bleie (book of poems), 80, *94*
Memoirs of Anna Blume in Lead (Pencil), See *Memoiren Anna Blumes in Bleie*
Memorial to the Artist's Father. See *Untitled*
Merz: and Constructivism, 61, 88, 126–127, 132, 172, 178–179, 181–185, 190–191, 195; and Dada, 32–42, 67, 133, 172, 178–179, 205, 225–228; and Expressionism, 30–33, 43–44, 51–54, 63, 72–73, 95–103, 117, 169–170; invention and meaning of the term, 12–13, 49, 52. See also following entries
Merz (mag.), 121, 128–129, 197, *147*
Merzbarn. See *Merzbau* at Elterwater
Merzbau at Elterwater, 210, 220–224, *312, 315, 317–319, 320, 323*
Merzbau in Hannover: columns in, 144–148, *153, 155, 158–159, 162, 176, 178, 187–189*; Constructivist architecture and, 150–152, *185, 242*; content of, 158–171; destruction of, 157, 206; Elterwater *Merzbau* and, 223; Expressionist architecture and, 163–164; Expressionist film and, 164–165; grottos in, 145, 159–162, *169, 170, 253*; growth of, 144–148, 152–157, 190–195, *165*; Lysaker *Merzbau* and, 204; main room of, 146–148, 152–156, *167–170, 175, 176, 178, 179*; plans for reconstruction of, 219–220; S. on, 148–150, 154–156, 159, 160, 191–192; S.'s writings and, 165–167; sculpture and, 190–195, *249, 252*
Merzbau in Lysaker, 203–204, 220–221, *316*
Merzbild, Das, 12–13, 40, 52, 197, n3.16, 42
Merzbild Alf. 201, *XXVI*
Merzbild Einunddreissig, 67, *VI*
Merzbilder: A series, 49–58, 61–66; B series, 59–60, 67–68; color and, 58–60, 66, 184–185; Constructivism and, 61–62, 88, 182–184, 195, 213; content of, 62–65; Cubism and, 60–62, 198–199, 212–213; first made, 12–13, 44, 49, n3.2; Futurism and, 60; jigsaw type, 183–184; materials in, 54–57, 62, 64–67, 202–203, 213–214; *Merzzeichnungen* and, 73, 76, 110; number and classifications of, 49, n3.9; painterliness and, 50, 59, 196, 200–201, 212–215, 217–218; structures of, 31, 50–58, 62, 65; from 1918 to 1921, 49–70, 200–201; from 1922 to 1931, 182–186,

195–196; from 1932 to 1947, 200–203, 212–215, 217–218, 239
Merzbild Kijkduin, 182–184, *209*
Merzbilde med regnbue, 202–203, *XXV*
Merzbild mit Kerze, 184, 196, *214*
Merzbild Rossfett, 58–59, 63, 184, *III*
Merzbühne: settings and performance of, 107–110; Schwitters' *Merzbilder* and, 108–110; theory of, 94, 106–107, 111–112
Merz drawings. See *Merzzeichnungen*
Merz House. See *Haus Merz*
"Merzmalerei, Die" (article), 49–51, 188
Merzmappe (prints), 179, 204
Merz pictures. See *Merzbilder*
Merzpicture with Candle. See *Merzbild mit Kerze*
Merzpicture with Rainbow. See *Merzbilde med regnbue*
Merzsäule. See *Merzbau* in Hannover, columns
Merz-theater. See *Merzbühne* and *Normalbühne Merz*
Merz-Werbezentrale, 187–197
Merzz 19, 75, 81, 91, *105*
Merzz 22, 75, 82, 91, *113*
Merzzeichnung 83. Zeichnung F, 75, 81, *106*
Merzzeichnungen: color and 85–86, n4.43; content of, 88–93, 181–182, 197–198, 210, n4.48, n4.50; Cubism and, 83–84; Constructivism and, 88, 131–132, 190–191, 195; De Stijl and, 127, 184; details and, 188–189; Expressionism and, 73–76; first made, 12–13, 71–72, n4.2; Futurism and, 81, 92; illusionism and, 67, 87, 200, 211; materials in, 76–77, 88–92, 179; *Merzbilder* and, 73, 76, 110; number and classifications of, 76, 210, n4.16, n4.17; painterliness and, 80, 84, 199–200; photomontage and, 77–81, 181–182, 200, 211–212; rhythm and, 138, 188; shapes in, 87, 180, 185–190; structures of, 81–83, 87–88, 126–127, 177–180, 185–186, 189–190; typography and, 73–74, 82, 87–88, 186–188; from 1918 to 1921, 71–93; from 1922 to 1931, 126–127, 131–132, 177–180, 189–190; from 1932 to 1947, 197, 200, 210–212, 239
Mesens, E.L.T., 202, 206
Meyer, Adolf, 164, *182*
Michel, Robert and Ella, 187
Middleton, Christopher, 175
Mies van der Rohe, Ludwig, 133, 137, 160, 181
Milk Flower, 211, *273*
Miller, Margaret, 93, 222
Miss Blanche (Mz 231), 87, 179, *XII*
mit frau, schwitzend (Mz 163), 75, 82, *111*
(mit grosser Kreuzspinne), 87, *123*
Mit Hilfe der Technik (play), 143
(mit Kreuzspinne), 87, *122*
mit lila Sammet (Mz 1926,5), 180, *203*
(mit Maschinenteil), 190, *234*
(mit roter 4), 29
Mode I (Zeichnung 16), 79, 92
Modersohn-Becker, Paula, 16, n1.21, *5*
Moholy-Nagy, László: International Constructivism and, 122–123, 125, 128, 131, 133, 139, 181, 187; the theater and, 107, 141; *Merzbau* and 160, 194
"Molkenschwere Silberblätterblüte" (poem), 98
Molzahn, Johannes, 30, 53, *44*
Mondrian, Piet, 66, 128–129, 160
Mopp, Maximilian, 74, *82*
Morgenstern, Christian, 47, 176, *40*

Moscow. See *Moskau*
Moskau (Mz 448), 132, *148*
Motherwell, Robert, 226, 229, 230
Mountain Graveyard. See *Hochgebirgsfriedhof*
Mourning Woman: See *Trauernde*
Müller, Franz (literary character), 73, 102, 167
multiples by S., 181
Mural attributed to S., 187, *228*
Museum of Modern Art, New York, The, 125, 220, 222
Mz Oslofjord, 201, *266*
Mz 192, 75, 79
Mz 458, *145*

N, 199, *257*
"Nächte" (poem), 97
"Nasci" (*Merz 8–9*): Elementarism and, 134, 185, 188–189; nature, the machine, and, 136–137; sources of, 138–140; typography of, 133, *153, 154*
National Gallery, London, 206
nature, S. and: attitudes to, 19–22, 137, 239, n1.8; early paintings after, 13–15, 18–20; late paintings after, 215–218; late work and, 212, 214–215; photograph album 201, *265*
Nazism, 198, n9.7
neo-Dada, 224
neo–modernism, 228
neu ausgestattet (Z.i.3), 124
neue Anna Blume, Die (book of poems), 186, *221*
neue Gestaltung in der Typographie, Die (pamphlet), 187, 222
neue Jugend, Die, 33, 79
Neues Merzbild, 148, 196, 200, *XXI*
newly appointed. See *neu ausgestattet*
"New Man, The": Constructivism and, 231, 236; Dada and, 122–123, 231, 236; Expressionism and, 100
New Merz Picture. See *Neues Merzbild*
Niedersächsiches Landesmuseum, Hannover, 56, 125
Nitzschke, Hans, 126, 199
Nolde, Emil, 17
Normalbühne Merz, 141–143, *157, 158, 160*
Norway, S. and: first visits to, 194; flight from, 204; life and art there, 198–203
Novembergruppe, 35, 115, 121–123
(9), 190, *232*

objets trouvés, 194, 200
okola (Mz 26,41), 180, *201*
old picture, c63., 211, *276*
Oorlog, 190, *XXII*
(opened by Customs). See *(zollamtlich geöffnet)*
Opherdicke, 14, n1.14
(Oscar), 199, *259*
Oskar (Mz 150), 73, *71*
Otto (Mz 313.), 81, *102*
Oud, J.J.P., 124, 128
(Oval Construction), 185, 216
Ozenfant, Amédée, 181

paper clouds, c 35, 211, *277*
participatory theater, 143
Pásmo (mag.), 128
Peacock's Tail. See *Pfauenrad*
Pebble Sculpture, 219, *313*
Pechstein, Max, 14
Pelikan. See *Günther Wagner*
(Pelikan), 187, 227

Penrose, Roland, 206
Peri, László, 151
Pevsner, Antoine, 122
Pfauenrad (Merz 1003), 184, *212*
Pfemfert, Franz, 33
"*Pferd*" (*i-Zeichnung*), *235*
Photograph album (S.'s), 201, *265*
photomontage, 78–79, n4.24, n4.26. See also *Merzzeichnungen*
Picabia, Francis, 45, 47, 55, 216, 234, *28*
Picasso, Pablo, 13, 24, 53, 66, 83, 210, 231, *18, 63, 107, 128*. See also Cubism
Picturesque, the, 57, 168, 215
Picture with Basket Ring. See *Bild mit Korbring*
Picture with Checker. See *Bild mit Damestein*
Picture with Flywheel. See *Bild mit Drehrad*
Picture with Light Center. See *Bild mit heller Mitte*
Picture with Red Cross. See *Bild mit rotem Kreuz*
Picture with Revolving Glass Disk. See *Bild mit drehbarer Glasscheibe*
Picture with Spatial Growths. See *Bild mit Raumgewächsen*
Picture with 2 Small Dogs. See *Bild mit Raumgewächsen*
Picture with White Crescents. See *Bild mit weissen Sicheln*
Pierce, Harry, 220–222
pine trees, c 26, 47.15, *272*
Pin (Schwitters and Hausmann), 207, 209–210
(*Pink and Yellow Merz Picture*), 213, *289*
Pino Antoni, 190, *XXIII*
Piranesi, Giovanni Battista, 168
Plan der Liebe (Merzbild 12b), 178, *197*
Plan of Love. See *Plan der Liebe*
Plastische Merzzeichnung, 195, *254*
Plato, 134
Pleasure Gallows, The. See *Lustgalgen, Der*
Poelzig, Hans, 164, *173*
poetry by S.: abstract and phonetic, 44, 129–130, 172–176, 207–209; Dadaist, 36–39, 98–103; Expressionism and, 20–22; Der Sturm and, 43, 95–98; typography and, 174, 176, 188
Pop art, 212
"Pornographic *i*-poem." See "Pornographisches i-Gedicht"
"Pornographisches i-Gedicht," 188–189, *223*
Portrait of Harry Bickerstaff, 218, *296*
portraits by S., 16–17, 218, *4, 6, 296*
portraits of S., *1, 87, 321, 322, 323*
"Porträt Raoul Hausmann" (poem), 176
Postcards collaged by Schwitters, 80, *85–87, 93*
Poster for Dutch tour (Schwitters and Van Doesburg), *131*
Post-Impressionism, 15
Prague tour, 105, 123, 129, 175–176
primitivism: Dada and, 234, 236; Elementarism and, 140; Schwitters and, 92–93, 176–177, 198, 238–239
"Prisoner, The" (poem), 208
Prikken paa len, 199–200, *261*
Printed Matter. See *Drucksache*
Prinzhorn, Hans, 125
prose by Schwitters: Dada, 99–103, 166–167; narrative, 177–178, 209
Protected with yellow artificial bone, 213, *291*
Proun. See Lissitzky
psychopathic patient, objects assembled by, 57, *49*

Puni, Ivan, 61–62, 82, 122–123, 150, n3.37, *69, 116*
Purism, 181

(*Qualit*), 199, *258*

Radblumen für Vordemberge, 74
Radiating World. See *Strahlenwelt*
Rand, Paul, 125
Raumkristalle, 22
Ray (mag.), 137–138, *185*
Read, Herbert, 93, 206
recitations by S., 104–106, 124–125, 131, 175, *130*
Reclining m. See *liegendes emm*
Red, Gray, Black. See *Rot, Grau, Schwarz*
Red-Heart-Church. See *Rot-Herz-Kirche*
Red-Rubber-Ball Picture, 213, *287*
Red Stroke. See *Rotstrich*
Red Triangle. See *rotes Dreieck*
Red Wire Sculpture, 219, *305*
Reinhardt, Max, 107
(*Relief*), 179, *199*
Relief mit Kreuz und Kugel (Merzbild 1924, I), 184, *XVII*
Relief with Cross and Sphere. See *Relief mit Kreuz und Kugel*
(*Relief with Half-Moon and Sphere*), 213, *288*
Revolving, The. See *Kreisen, Das*
"Revon" (anagram for Hannover), 102–103, 167
Richard Freytagbild, 186, *218*
Ribemont-Dessaignes, Georges, 128
Richter, Hans: 105, 115, 122–124, 133, 135, 224; on *Merzbau*, 152, 154, 159–160
Riegl, Alois, 140
Rieti, Vittorio, 105
Rietveld, Gerrit, 128, 151, *183*
Ringelnatz, Joachim, 176
"ring neuer werbegestalter, der," 187
Rodchenko, Alexander, 120, 132
Rodilla, Simone, 115
Rolan, Franz, 141
Roman Park. See *Römischer Park*
Romanticism, 21, 193, 239
(*Römischer Park*), 190, *241*
Rosenberg, Harold, 228
Rosenberg, Léonce, 152
Rotes Dreieck (Mz 26, 30), 180, *202*
Rot, Grau, Schwarz, 190, *240*
Rot-Herz-Kirche (Merzbild 5B), 59–60, *57*
Rotstrich (Mz 88), 82, *114*
Rotterdam, 200, *264*
Rotterdam (Mz 1600), 178, *196*
rubber-stamp drawings by S., 44, 46–48, 109, n2.70, *24, 29, 31, 35, 38, 138, 190*
Rubin, William S., 232
Russian Constructivism. See Constructivism
russian picture. See *russisches bild*
russhiches bild (Mz 39), 82, *115*

Saddler Portfolio, The. See *Sattlermappe, Die*
Santa Claus. See *Weihnachtsmann, Der*
Satie, Eric, 106
Sattlermappe, Die, 80, *98*
Scala-Palast, Berlin, 163, *174*
"Schacko" (poem), 177
Schapiro, Meyer, 89
Scheuche, Die (Merz 14–15), 130–131, 187, *155*
Schiller, Johann Christoph Friedrich von, 22
Schlafender Kristall, 22

Schlanker Winkel, 191, *248*
Schlichter, Rudolph, 40
Schloss und Kathedrale mit Hofbrunnen, 115, 148, *140*
Schlotheim (Mz 380), 127, *152*
Schmalenbach, Werner, 39, 42, 92, 177, 183, 217
Schmidt, Joost, 164
Schmidt, Kurt, 142
Schmidt, Paul, 41
Schmidt-Rottluff, Karl, 14
Schokoladenkasten, Der, Anna Blume, Kasten 7, 17, *142*
"Schreizen" (poem), 98
Schulze, Albert, 117
"*Schwarze*" *Notizbuch, Das*, 80, *100*
(*Schwarze Punkte und Viereck*), 189, *229*
Schwimmt (Merzbild 14C), 48
Schwitters, Ernst (son): 12, 198, 204, 206; on *Merzbau*, 146–148, 152–153, 155
Schwitters, Helma (wife), 198, 206, n1.14
Sculptural Merz-drawing. See *Plastische Merzzeichnung*
Sculpture (Puni), 82, *116*
Sculpture by S.: Cubism and, 192; De Stijl and, 191; the *Merzbau* and, 190–195; modeled, 117–118, 218–219; Vitalism and, 192–219. See also Dadaist sculptures by S.
Siegbild, 179, *200*
Siegel PJ (Mz 144), 75, *78*
Skittle Picture, The. See *Kegelbild, Das*
Skøyen, 269
Sleeping Crystal. See *Schlafender Kristall*
Slim Angle. See *Schlanker Winkel*
Small Flower Picture, 215, *299*
Small Inlaid Box Anna. See *Intarsienkästchen Anna*
Small Merzel. See *kleine Merzel, Der*
Small Merz Picture of Many Parts, 213, *290*
Small Sailors' Home. See *Kleines Seemannsheim*
Small Twisted Sculpture, 219, *306*
Snowcovered Houses. See *Verschneite Häuser*
Société Anonyme, 30, 125, 197
something or other. See *irgendsowas*
Sommerfeld House, Berlin, 164, *182*
"Sonate in Urlauten, Die." See "Ursonate"
Sonne im Hochgebirge, Die (G Expression 2), 18–19, 22, 24, *7*
Soupault, Philippe, 128
Space Crystals. See *Raumkristalle*
Spengemann, Christof: 198, 219, 222; as critic, 39, 49, 51, 53, 114; as publisher, 17, 40, 125
Spengler, Oswald, 140
Spirit of Reinforced Concrete, The. See *Eisenbetonstimmung, Die*
Spring Door, The. See *Frühlingstür, Die*
Staatstheater, Berlin, 107
Stam, Mart, 122
Stars Picture, The. See *Sternenbild, Das*
Stein, Gertrude, 23
Steegemann, Paul: 17, 39, 125; postcards published by, *1, 85–87, 93*
Steinitz, Käte: collaborations with S., 131, 143; on Hannover, 103; Lissitzky and, 139; Schwitters in England and, 212, 222; on *Merzbau*, 145, 150, 160; on S.'s poetry, 104, 106
Stepanova, Varvara, 120
Sternenbild, Das (Merzbild 25A), 61–64, 67, 74, 62
Stijl, De (movement): 121–122, 129–130; Fifth Manifesto of, 135, 149, 152; *Merzbau* and,

150–152, 191; *Merzzeichnungen* and, 127, 132, 184
Stijl, De (mag.), 42, 122–123, 127–128, 158
Still Life with Chalice. See *Stilleben mit Abendmahlskelch*
Stilleben mit Abendmahlskelch; n1.13; collage over postcard of, 80, *93*
Strahlenwelt (*Merzbild 31B*), 67, *66*
Stramm, August, 35, 95, 107, 111. See also Sturm, Der: poetry
Strindberg, Gert, 206
Sturm, Der: gallery, S.'s exhibitions at, 12, 17, 19, 30, 49, 52, 72, 104, n3.4, n4.10; poetry and, 20, 43, 95–96, 107, 111; philosophy and organization of, 17, 23, 30–34, n1.42, n1.44; S.'s contacts and affiliation with, 17, 23, 30–31, 42, n1.23. See also Walden, Herwarth
Sturm, Der (mag.): 17, 30–33, 95; S.'s writings in, 36, 42, 49, 50, 102, 106
Sturm-Bilderbuch (mag.), 42, 46
Sturm-Bühne, 106–107
Style, Schwitters on, 129, 136, 148–150, 181
Stylistic theater, 142–143
Sun in the High Mountains. See *Sonne im Hochgebirge, Die*
"Super Bird Song" (poem), 207
Suprematism, 132, 134. See also Malevich
Surrealism, 57, 121, 200–201, 224, 230
Sydow, Eckart von, 125

Taeuber (-Arp), Sophie, 160
Tatlin, Vladimir, 79, 120–122, 129, 132, 183, n8.62, *208*
Taut, Bruno, 111, 114–115, 125, 163
Taut, Max, *172*
Temptation of St. Anthony, The. See *Versuchung des heiligen Antonius*
Theatertechnik, Internationale Ausstellung neuer (Vienna), 141, 143
Theater Technique, International Exposition of (New York), 142
"Thesen über Typographie" (article), 187
Thirty-one. See *Merzbild Einunddreissig*
This is Friedel Vordemberge's Wire Springtime. See *Dieser ist Friedel . . .*
Thomas, Edith, 206, 220–221, *323*
Three-One. See *Dreieins*
Three Spheres. See *Drei Kugeln*
titles of works by Schwitters, 51, 63
Tod der Anna Blume, Der (Schlichter), 40
Toller, Ernst, 107
Tönnies, Ferdinand, 140
(*Tortrtalt*), 188, *224*
Total work of art. See *Gesamtkunstwerk*
(*250 Gramm*), 236
Trauernde, 16
Tribüne theater, Berlin, 107
Trilling, Lionel, 197
Tschichold, Jan, 176
typography, 47–48, 133, 186–188. See also *Merzzeichnungen*
"Typoreklame" (*Merz 11*), 187, *225*

Tzara, Tristan, 34, 40, 47, 125, 128–129, 225

Überschwemmte Wiesen, 14, *3*
Uhlman, Fred, 205, 215
Umanskij, Konstantin, 122
Undbild, Das, 13, 52, 58, 60, 63, *52*
Untitled (1919 print), 48, *39*
Untitled (1921 Merz construction), 55, 62, *70*
Untitled (1923 relief), 179, *199*
Untitled (c. 1923 sculpture), 101, *246*
Untitled (c. 1922–1923 sculpture later titled *Monument to the Artist's Father*), 191, *243*
Untitled (c. 1925 oval construction), 185, *216*
Untitled (after 1930 sculpture from the Hannover *Merzbau*), 191, *252*
Untitled (1936 sculptural column), 191, *250*
Untitled (c. 1943–45 sculpture), 218, *304*
Untitled (1945 landscape painting), 215, *298*
Untitled (c. 1945–47 sculpture), 219, *310*
Untitled (1947 sculpture from the Elterwater *Merzbau*), 219, *319*
Unveiling. See *Entschleierung*
Urbegriff (S.'s concept of), 31, 111, 115, 238
"Ursonate" (poem), 105, 129, 175–176, 188, *193, 194*
"Ursachen und Beginn der grossen und glorreichen Revolution in Revon" (literary work), 73, 102–105, 113, 166
"Urteile eines Laien über neue Architektur" (article), 150

Van Dieman gallery. See *Erste russische Kunstausstellung*
Van Doesburg, Nelly (Petro), 105
Van Doesburg, Theo: Dutch tour and, 105–106, *131*; Elementarism and, 134–135; Hannover and, 130–131, 160; International Constructivism and, 122–125, 179; S.'s collaboration with, 88, 131; *Merzbau* and, 160; poetry and, 127–130; "X-Beelden," 129. See also De Stijl
Van Eesteren, Cornelis, 122, 152
Van Gogh, Vincent, 15
Vantongerloo, Georges, 152, 191, *245*
Verbürgt rein (*Mz 334*), 83, *118*
Verschneite Häuser, 24, *9*
Versuchung des heiligen Antonius (Z122), 24, *15*
(*verwundete Jäger, Der*), 211, *278*
verwunschene Garten, Der (*Abstraktion 1*), 20
very complicated (*47.12*), 275
Veshch/Gegenstand/Objet (mag.), 123, 131, 134
Victory Picture. See *Siegbild*
Village. See *Dorf*
Vision, 16, *4*
Vitalism: Arp compared to S. and, 194–195; Mechanism and, 193–194; "Nasci" and, 193; S.'s sculpture and, 137–138, 171, 193–195, 222
Void in Space. See *Leere im Raum*
völkisch ideology, 194, 197

Vordemberge-Gildewart, Friedrich, 126, 130, 159, 184, 187

(*WA*), 211, *271*
Wagner, Richard, 31, 106–107
Wald, Der (*G. Expression 1*), 18–19, *11*
Walden, Herwarth, 17, 23, 30, 32–33, 125, n1.25, n1.42, n2.1, n2.17. See also Sturm, Der
Waldhausenstrasse 5, Hannover (S.'s home), 12, 146–147, 152, *166*. See also *Merzbau* in Hannover
Wantee. See Thomas, Edith
Warranted Pure. See *Verbürgt rein*
Watercolor Study (Taut), 163, *172*
Wegener, Paul, 164
Weidler, Charlotte, 85
Weihnachtsmann, Der, 86, *XV*
Weimar Congress, 124–125, *144*
Weisses Relief, 185, *242*
Wenzel Kind (*Mz 151*), 78, 212, *88*
Westheim, Paul, 30
White, Beige, Brown, 214, *293*
White Palace, 150, 194. See also *Merzbau* in Hannover
White Relief. See *Weisses Relief*
Wide Schmurchel, The. See *breite Schmurchel, Die*
Wie bei Picasso, 185–186, 196, *217*
Wiene, Robert, 164, 197, *184, 186*
Wigman, Mary, 125
Windmill. See *Windmühle*
Windmühle (*Aq. 9*), 45, *30*
wind swept, c77, *274*
with large Spider. See *mit grosser Kreuzspinne*
with Lilac Velvet. See *mit lila Sammet*
with Machine-part. See *mit Maschinenteil*
(*with Madonna and Angels*), 212, *279*
with red 4. See *mit roter 4*
with Spider. See *mit Kreuzspinne*
with woman, sweating. See *mit frau, schwitzend*
Woman-Watch. See *Frau-Uhr*
Wood on Black, 214, *292*
Worker Picture, The. See *Arbeiterbild, Das*
World War I: Dada and, 231–233; Expressionism and, 170; Schwitters and, 12, 27, 73, 101
World War II: 157, 198, 204, 206
Worringer, Wilhelm, 140
Wortreihe in poetry, 43, 96, 174
Wounded Hunter, The. See *verwundete Jäger, Der*
Wülfel ironworks, 12, 26, 34
Würzbach, Walter, 163, *174*

(*Yri's Hotel*), 218–219, *302*

(*Zeitu*), 73, 76
(*zollamtlich geöffnet*), 200, *262*
Zukunftskathedrale, 115, 163, *139*
Zurich Dada. See Dada in Zurich
Zweemann, Der, untitled lithograph from, 26, 44, *22*
"Zwiebel, Die" (poem), 99–101, 110, 113, 166